Sabato Rodia's Towers in Watts

CRITICAL STUDIES IN ITALIAN AMERICA

series editors Nancy C. Carnevale and Laura E. Ruberto

This series publishes works on the history and culture of Italian Americans by emerging as well as established scholars in fields such as anthropology, cultural studies, folklore, history, and media studies. While focusing on the United States, it will also include comparative studies with other areas of the Italian diaspora. The books in this series engage with broader questions of identity pertinent to the fields of ethnic studies, gender studies, and migration studies, among others.

Sabato Rodia's Towers in Watts

ART, MIGRATIONS, DEVELOPMENT

Edited by Luisa Del Giudice

FORDHAM UNIVERSITY PRESS NEW YORK 2014

This publication is made possible by a grant from the City of Los Angeles Department of Cultural Affairs and from the Istituto Italiano di Cultura (Ministry of Foreign Affairs, Italy).

A portion of all royalties will benefit the Watts Towers Arts Center.

Thomas Harrison's essay, "Without Precedent: The Watts Towers," was previously published in *California Italian Studies* (*CIS*). Vol. 1, Issue 1/2, 2010. http://escholarship.org/uc/item/3v06b8jt. It is re-published with permission.

Sarah Schrank's essay, "*Nuestro Pueblo*: The Spatial and Cultural Politics of Los Angeles's Watts Towers," was previously published in *The Spaces of the Modern City: Imaginaries, Politics, and Everyday Life*, edited by Gyan Prakash and Kevin M. Kruse. Princeton: Princeton University Press, 2008.

Library of Congress Control Number: 2014935942

Printed in the United States of America

16 15 14 5 4 3 2 1

First edition

Contents

Appendices

Acknowledgments

My gratitude list is very long and spans many years.

First, I express my gratitude to the genius of Sabato Rodia and for his magnificent obsession; then to William Cartwright, Nicholas King, and their band of citizen activists, the Committee for Simon Rodia's Towers in Watts (CSRTW), who back in 1959 saved this international treasure from demolition. Their heroic efforts ensured that the Towers have remained a legacy for us to wonder at, to do battle on behalf of, and, in the process, to build community around. I toast all members of the original CSRTW, most particularly those whom I have come to know directly: the inspiring William Cartwright (who passed away June 1, 2013), the irrepressible Bud Goldstone (who passed away September 12, 2012), the generous Jeanne Morgan—blessings and gratitude to you all. I am certain that history, by ever increasing degrees, will judge you to be heroes. And let us all thank the community of Watts that has loved, cared for, and reanimated the Towers, putting them to exemplary use in the development of human creativity through the Watts Towers Arts Center and beyond.

Our abiding collective challenge is to go on safeguarding the Towers as a cultural nexus, making their story known farther and wider. Through those who continue to work in and around the Watts Towers Arts Center (WTAC) and its many community support groups and task forces, I have witnessed with awe and soul weariness what it truly takes to be a community activist: courage, stamina, a willingness to listen "in a circle" (rather than from a podium), as well as the vision to lead. To all those friends (once strangers) who sat around a dinner table several years ago to consider the feasibility of the Watts Towers Common Ground Initiative (especially Timothy and Janine Watkins, Rosie Lee Hooks, Thomas Harrison, Jo Farb Hernandez, Rudy Barbee, Kai El'Zabar, Rogelio Acevedo, and Edward Landler) and who said "yes": thank you. I have continuing hopes for reciprocally opening doors (see the Afterword).

For me, this Initiative began in partnership with Rosie Lee Hooks, the indomitable director of the Watts Towers Arts Center. Since 2003, while discussing plans for the 2005 Leo Politi exhibition, my experience at the WTAC has proven a rollercoaster ride—exhilarating no less than personally challenging. But despite our initial encounter as strangers, through shared work and many journeys of discovery (some in Los Angeles and others in Italy), I have discovered that beneath the words of "bickering sisters," we also share kindred spirits and similar goals. I also thank Edward Landler who, knowing everyone and everything connected to the Watts Towers through time, has functioned as a personal guide and friend.

To my colleagues and co-organizers Alessandro Dal Lago (University of Genova conference chair) and Serena Giordano, I express thanks for getting the ball rolling and for a marvelous conference in Italy; and to Tom Harrison (chair, Italian Department, UCLA), co-mediator and partner through four years and two conferences, who sometimes appeared dismayed by my (equally) headstrong ways: *grazie infinite* (infinite gratitude). Despite our divergent scholarly discourses and perspectives (mine that of an independent scholar), perhaps we do share some convergent understandings of the university's role in the larger scheme of things (we indeed did make this a genuinely outreaching conference). Without such collaboration, the Watts Towers Common (or, according to Tom, *Uncommon*) Ground Initiative would have been much diminished.

To the many partners in our ambitious Initiative (not merely providers of funds and venues but of equally critical moral support), without which all our good intentions would have come to naught, thank you: UCLA International Institute (Susan McCrary); Department of Italian at the University of California at Los Angeles (Dominic Thomas); UCLA Library Special Collections (Susan D. Anderson); City of Los Angeles, Department of Cultural Affairs (Olga Garay); Los Angeles County Museum of Art (Melody Kanschat, Michael Govan); Armand Hammer Museum (Claudia Bestor); Saving and Preserving Arts and Cultural Environments (Jo Farb Hernández); Watts Towers Arts Center (Rosie Lee Hooks); Watts Labor Community Action Committee (Timothy and Janine Watkins); Museo Etnomusicale, I *Gigli* di Nola (Felice Ceparano); La Contea Nolana (Antonio Napolitano); St. Alban's Episcopal Church (the Reverend Susan Klein); St. Lawrence of Brindisi Church (Father Jesus and Teresa Perez); and Friends of the Watts Towers (Rudy Barbee, Evelyn Davis).

The strong Italian presence in this volume comes as a result of having called on contributors with specific expertise in Italian and Italian diaspora studies, in order to bring these missing discourses into clearer focus. It also reflects the identity of many of the conference and festival sponsoring institutions, to whom I am immensely grateful. Heartfelt *grazie* go to friends and colleagues over the years: to the Italian consuls Diego Brasioli, Nicola Faganello, and, more recently, Giuseppe Perrone; to Mariella Salvatori and Elena Marinelli; to directors, acting directors, and vice directors of the Istituto Italiano di Cultura IIC, Clara Celati, Giuseppina Candia, Francesca Valente, Michela Magrì, Alberto Di Mauro, Massimo Sarti, and their helpful staff, especially Serena Camozzo and Caterina Magrone. The awakening sense of the Watts Towers' centrality to Los Angeles and to its Italian resonances therein has encouraged a stronger Italian presence at, and increasing support for, the Watts Towers, its Art Center, and its broader community. May future Italian representatives continue this open and respectful dialogue with all Watts Towers stakeholders and work unceasingly to cherish and project the legacy of this Italian immigrant worker and artist. Thank you to Consul Faganello besides, for having facilitated the diffusion of the Watts Towers narrative in Italy through our "Watts Towers in Italy" program during the summer of 2011. Without the assistance of Silvia Bizio (and the Italians in Film Festival sponsors and translators), we would not have been able to screen subtitled films (Landler and Byer's *I Build the Tower* and Hooks and Sharpe's *Fertile Ground: Stories from the Watts Towers Arts Center*) in Italy. I sincerely thank the various hosts of those Italian programs: Alessandro Portelli (Casa della Memoria) in Rome; Maria Lauro and Salvatore Ronga (of the association *Pe Terre assaje luntane*) in Ischia; Katia Ballacchino, who facilitated our participation in the *Gigli* festivities at Nola, and the municipal authorities (especially Maria Grazia De Lucia) who extended such generous hospitality during that event and throughout our stay in (Rivottoli di) Serino, Rodia's birthplace. The welcome shown to us by Serino's mayor, Gaetano De Feo, and his municipal administration, by citizens in Rivottoli, and by Sabato Rodia's own descendants (including one Sabato Rodia, curiously resembling Roger Guenveur Smith, writer-performer of the "The Watts Towers Project"!) was astonishing. Our procession–pilgrimage, accompanied by music, dancing, and ultimately with tears in our eyes as we wended our way to Rodia house, was not an experience Rosie or I will easily forget.

The Common Ground festival mounted exhibitions, bestowed awards, screened films, organized tours, produced theater, arranged concerts, and offered hospitality. We are grate-

ful to the many curators, lecturers, presenters, musicians, filmmakers, poets, actors, photographers, administrators, graphic designers, Web masters, translators, chefs, priests, journalists, community and student volunteers (especially Claire Lavagnino, Maira Garza, Camilla Zamboni, and Melina Madrigal), and donors who were an integral part of this initiative. Your names are recorded on conference and festival brochures (cf. Appendix D and www.wattstowerscommonground.org).

The Spring 2011 culminating program of the Initiative, "St. Joseph's Day Tables: Practicing Hospitality and Sustainability," at St. Lawrence of Brindisi Church in Watts (an effort that required specific cultural knowledge, social skills, and a compassionate heart) merits its own list of acknowledgments. Thank you to the artists of the Watts Towers Arts Center and its willing staff (e.g., Rogelio Acevedo, Alex Campos, Michael Bell, Dakota McMahon), all under the guidance of Rosie Lee Hooks; to master chefs Celestino Drago and Evan Kleiman; to the many bread artists (my daughters Elena and Giulia Tuttle, Mattia Bastasin, and friend Nancy Romero); and to volunteer coordinator Claire Lavagnino (who also transcribed interviews in Appendix C). Thank you to the host of donors who made this ritual of hospitality possible, helping to fulfill the primary goal of a St. Joseph's Table: to feed the poor. I thank the Accademia Italiana della Cucina (Italian Academy of Cuisine); Istituto Italiano di Cultura; the Consulate General of Italy in Los Angeles; Watts Towers Arts Center; Sam Perricone Citrus Co., Food Forward, Mudtown Farms; St. Alban's Episcopal Church; St. Alban's Interfaith Beijing Circle; the Food Section of the *Los Angeles Times*; the UCLA Episcopal Campus Ministry; and the residents of Watts.

Thank you to Susan Anderson (curator, Collecting Los Angeles, UCLA Library Special Collections) for co-curating with me, and facilitating the exhibition on the CSRTW in the Powell Library Rotunda, adding critical historical dimensions to our project, and, along with Heather Briston, for facilitating inclusion of select materials from those collections in this publication. Sincere thanks to the staff of UCLA Library Special Collections, in particular Robert Montoya, for their assistance throughout the months of consultation and transcription of materials in Appendices A (Conversations with Rodia) and B (Campaigns to Save the Watts Towers). I also thank Jeanne Morgan, Bud Goldstone, Bill Cartwright, and others who kept such meticulous records throughout their many years of service to the CSRTW and who made all these available to the public so others might witness for themselves the scope of the committee's efforts over the span of half a century. Thank you, too, to those who lent materials from private archives and gave permission to reproduce them in the online appendices to this volume (e.g., Edward Landler, Nicholas King, Jeanne S. Morgan); and to the City Project (Seth Strongin and Robert Garcia) and Womyn Image Makers (Claudia Mercado, videographer), for creating a lasting record of our initiative on film, soon to find its place in the UCLA Library Special Collections.

Special recognition goes to the scholarly input of the Conference Program Committee: Thomas Harrison, Jo Farb Hernández, Paul Harris, Alessandro Dal Lago, and Edward F. Tuttle. Thanks go to those who helped evaluate the merits of the essays assembled here: Laura Ruberto, Joseph Sciorra, Thomas Harrison, Edward Tuttle, Paul Harris, Jo Farb Hernández, and Edward Landler. To Laura and Joe, I add a personal note of appreciation for helping me through some tough moments: Your moral and collegial support make you cherished friends as well as great colleagues.

Thank you to Fordham series editors, Nancy Carnevale and Laura Ruberto, for welcoming this volume into their increasingly prestigious series on the Italian Diaspora; to

Fredric Nachbaur, director, William Cerbone, editorial associate and assistant to the director; and especially to copyeditor Julie Palmer-Hoffman and production editor Deborah Grahame-Smith, who have pored over these words with such great care. The experience of working with Fordham University Press has been delightful and pain-free.

To my own small band, Elena and Mattia, Giulia, and Edward, who are ever willing to help me through "just one more program"—advising, reviewing texts, baking, serving wine, offering encouragement, patience, and an abiding presence around the family table: *non ho parole* (I'm at a loss for words). My debt is truly immense. And finally, to my own ancestors, especially my father, who instilled in me a respect for peasants, immigrants, and the dignity of working people, and who taught me never to betray one's class: You and Sabato Rodia would have had much to say to each other.

For further documentation on the Watts Towers from the UCLA Library Special Collection No. 1388 (The Committee for Simon Rodia's Towers in Watts)—for example, Campaigns to Save the Watts Towers of the late 1950s and late 1970s; miscellaneous documents relating to the life of Sabato Rodia (testimonials, creative writing, and more); and posters, photographs, and programs relating to the 2009–11 conferences and festival around the Watts Towers Common Ground Initiative—see online Appendices B, C, and D at http://tiny.cc/TowersInWatts.

Sabato Rodia's Towers in Watts

Sabato Rodia's Towers in Watts and the Search for Common Ground

Luisa Del Giudice

The Watts Towers Core Narrative

The core Watts Towers narrative serves as the inescapable touchstone for each of the essays in this volume. It narrates the identity of Sabato Rodia and the extraordinary feat of creating his Towers in Watts, as well as the travail of their preservation.[1] Indeed, the Towers built by Sam Rodia in Watts, Los Angeles, not only are wondrous objects of art and architecture in and of themselves, the expression and embodiment of the resolve of a singular artistic genius to do something great, they also recount the heroic civic efforts to save them, both of which (art and social action) continue to this day to evoke awe and inspiration.

Sabato Rodia (pronounced Sábato Rodìa), alternately known as Sam, Simon, or Sabatino, was born on February 12, 1879, according to the parish records in Rivottoli (or Ribottoli di) Serino,[2] a small town in the province of Avellino, in Campania—a southern region of Italy. He was sent as an adolescent to the United States circa 1890 to join an older brother in the coal mines of Pennsylvania. Soon after, following his brother's death in a mining accident, Rodia traveled west. He married Lucy Ucci in 1902, in Seattle, and together they settled in Oakland, California. The marriage proved unsuccessful. Around 1910, he abandoned (or was abandoned by) his wife and children and began a decade of wandering in North, Central, and South America, working at many manual labor jobs, drinking too much, and leading something of a vagabond's life. In 1917, he had a short-lived union with a Mexican woman, Benita Chacón, in El Paso, Texas, and then lived with another Mexican woman, Carmen, in Long Beach, California—who also left him shortly after. By 1919, while living in Long Beach, and after having quit drinking, he resurfaced with a new purpose in life.

Having dabbled with various artistic building projects around his home, Rodia searched for and bought the triangular plot of land in Watts, where he began to build "something big," "something they never got 'em in the world." In this multiethnic, working-class, still

semirural district, decidedly on the margins of urban Los Angeles, he set to work on an unusual building project in his own yard. Over the span of thirty-three years (1921–54), alone and with very basic hand tools, Rodia built many towers, a ship, fountains, ovens, and assorted garden art, inlaying bits of tile, glass, pottery, and seashells into the reinforced concrete, signing them "SR," dating them (both 1921 and 1923), and naming them in Spanish: *Nuestro Pueblo* (Our Town/Our People). The tallest of his towers, among an assortment of seventeen structures, measured 99 $^1/_2$ feet, rising from an eighteen-inch footing.

His hard-earned dollars went for steel and cement, the base materials of his structure, while decorative elements were collected along the streets, railway tracks, and beaches and from neighbors. He called himself a "steel man." Such a definition could easily apply to his own will of steel as to his favored building material. In and around his paying day jobs, Rodia worked with focused discipline in the mornings, into the nights, on Sundays and on holidays. By night he dreamed and excogitated, and by day he built—seamlessly and completely engaged in his creative work, "like bees in a hive," "a spider in a web" (Appendix C.2, Byer interview). He experimented with form, color, texture, cement mixtures, and construction techniques. He built, tore down, and rebuilt. As an artist completely possessed by his work, he was often derided as an incomprehensible crazy man, and his property was at times vandalized. Rodia marched to a music all his own.

Finally, in 1954, after suffering a stroke, he realized it was time to pack up and rejoin his family in Martinez, Northern California, in order to not "die alone like a dog." He deeded the Towers to a neighbor, Louis H. Sauceda, locked the door, departed, and never returned. Sauceda soon sold them for about $1,000 to a neighbor, Joseph Montoya, who wanted to convert them into a Mexican fast-food stand. Rodia's house burned down in the mid-1950s. A few years later, a curious film school student, William Cartwright, having learned of this artwork via a 1954 documentary by William Hale, and together with the actor Nicholas King, found Montoya. They put down a $20 deposit and promised to purchase the Towers for $3,000, to build a caretaker's cottage on the premises, and to save them from neglect. They soon discovered, however, that any building plan was impossible because the city's Department of Building and Safety had issued a demolition order on February 5, 1957.

Thus began the public saga of the Towers. The events, struggles, and bureaucratic challenges that ensued are scarcely less complex than Rodia's feat of building them. Cartwright, King, and a diverse band of friends (art experts, architects, engineers, attorneys, and concerned citizens), first known as the Watts Towers Committee, and then as the Committee for Simon Rodia's Towers in Watts (CSRTW), rallied around the "Campaign to Save the Watts Towers," which pitted art lover against dour bureaucrat and the common man against the establishment and created an international cause célèbre, spreading word of the artwork around the world.

Nonetheless, the effort to dissuade the municipal authorities from destroying what many considered to be a major work of twentieth-century art and what the building inspector considered to be "a pile of junk" resulted in a public hearing with expert witnesses engaged by the CSRTW to defend the Towers. A compromise was reached whereby the authorities agreed to a dramatic load test (which came to be known as the "stress test") devised by aerospace engineer Bud (Norman) Goldstone, to prove that the Towers were structurally sound and not a public hazard. On October 10, 1959, hundreds watched as the cable attached to the main tower, designed to apply 10,000 pounds of pressure to

bring it down, instead raised the heavy truck's back wheels off the ground—to the cheers of supporters. With the test (which some considered barbaric) behind them, the Committee turned to the task of preservation.

But they soon discovered that the tasks that lay ahead would prove yet more daunting—a decades-long, (financially and humanly) costly endeavor not only to save the Towers but to work on behalf of the community of Watts. That is, the CSRTW quickly understood that it could not, in all good conscience, care for the Watts Towers while neglecting the pressing needs of its immediate neighbors. Watts had become an increasingly impoverished, crime-ridden, and marginalized place in the post–World War II period and would soon become the site of violent unrest in August 1965 (known as the Watts Riots or Rebellion),[3] just a month after Sabato Rodia's death. Among the various tasks the CSRTW addressed over the years were the struggle to secure funding for Towers conservation and community arts education, the battle against "false restorations" (and damage to the Towers), byzantine negotiations regarding oversight and ownership, as well as the building of the Watts Towers Arts Center (WTAC). These and other subplots in the continuing Watts Towers saga are best recounted in this volume by a longtime member of the CRSTW (and a former chair), Jeanne S. Morgan, in her essay, "Fifty Years of Guardianship: Committee for Simon Rodia's Towers in Watts (CSRTW)"; whereas the Department of Cultural Affairs' Jeffrey Herr speaks for the city, in "A Custody Case: Ownership of Rodia's Towers."

During the early 1960s, the CSRTW made the extraordinary discovery that Sabato Rodia was still living. They found him walking the streets in Martinez, California, and made many subsequent visits (or pilgrimages) to speak with their heroic artist ("their god," as King notes, in Landler and Byer 2006). Such encounters between Rodia and members of the CSRTW are captured in the interviews and reports that followed, all recording the questioning of Rodia's motives, techniques, and artistic sources, as well as efforts to return Rodia to his Towers in Watts, to materially aid him, and to assure him of the public recognition he had so desired—and had achieved. These written, audio, and film recordings are the most poignant and reliable sources for an understanding of the Watts Towers narrative. In the archival record are to be found Rodia's own words in his own voice, providing direct evidence for tackling the mystery of Rodia as a man and artist and the perennial questions: Why did he build the Towers? And what did they signify? Rodia proved elusive, frequently refusing to answer some of these questions directly and adamantly rejecting any notion of returning to Watts: "When someone like your mother has died you don't want to talk about it," he insisted. He did, however, personally enjoy a moment of public recognition (and standing ovations) at the University of California, Berkeley, and at the San Francisco Museum of Art in 1961, where CSRTW members (Bud Goldstone and Seymour Rosen among them) made presentations on the Watts Towers and invited Rodia along. Here he was able to interact with curious and appreciative members of the audience and articulate some of his ideas. Therefore, by his death on July 16, 1965, thanks to experiences such as these, the many people searching him out, as well as the newspaper clippings and reports shared with him, he knew that the world had recognized his Towers as a great work of art.

This core narrative has proven both canonic and fluid, having developed variant tellings and even an oral tradition of its own, with variation concerning even the most basic questions of Rodia's date of birth, death, and migration,[4] why he came to America,[5] not

to mention the more complex questions of why he embarked on this project and what was the source of his inspiration. As a scholar of orality, I consider such fluctuations to be inherent in the process of oral transmission, while others may be attributable to the mischief perpetuated by the written record (e.g., journalistic error, interviewers' own biases). Written sources are not immune to anecdotal (oral) evidence, of course, and variation may also be attributable to a certain puckishness in Rodia himself, who seemed to enjoy varying his storytelling according to mood and audience, and who, as he senesced, perhaps contributed his own evolving understanding of his life's work.

It is well to remember, therefore, that in its richly layered oral tradition, several Watts Towers narrative variants coexist, circulating alongside one another, each with its own adherents and detractors, some possessing unique lives of their own, and passed along in a variety of media and by word of mouth (cf. Barra's essay on the Towers within the context of narrativization). But also typical of such oral narrative evolutions, historic detail becomes less relevant in time and may fall away, while critical elements remain fixed and provide its narrative core (e.g., Rodia's life struggles, his determination to "do something big," his transformation through creative achievement). That is, the narrative's "truest" meaning becomes distilled and even transformed into the transcendent universal, the mythic. In so doing, Rodia's own life stands as an exemplary, heroic tale, inspiring creativity and a sense of purpose in others. His Towers become a symbol of great vision, spiritual resistance, and transcendence.

Identifying Key Issues

Because the Towers can be mined for the culturally specific as well as the universally human, both approaches are represented in this volume. *Sabato Rodia's Towers in Watts* brings together more documentary evidence and hence further sharpens our focus on the man, his life, and his art, while offering broader interpretive meanings of the artwork on several fronts. This has been a goal of several collaborative scholarly endeavors from their inception: to enhance the historic and ethnographic discourse vis-à-vis Rodia's cultural heritage and immigrant experience, while also providing myriad and significant interpretative essays on how we might better read and understand the artwork and situate its legacy within the art world, as well as within specific urban landscapes and social cartographies. In other words, the Watts Towers have proven polyvalent, and they have come to subsume many discourses, issues, and broader contexts.

This collection advances along three fronts, reflected in its tripartite organization. First, it places the artist and his artwork within various interpretative contexts of artistic and literary movements while elaborating the historic and cultural contexts of this Italian immigrant artist within local and global migrations and within the Italian diaspora. Second, it considers the issues of art and conservation, the struggle to save the Towers (as recounted by municipal authorities and by a longtime CSRTW member), as well as the contested cultural and political axes occupied by the Towers (and kindred heritage sites) today. Third, it turns to the Watts Towers' legacy in predominantly African American communities of creativity and the issue of "development" in Watts itself.

Given the many intersecting issues surrounding Rodia's Towers in Watts, the organization of this volume has proven a challenge, defying any linearity. The issues of contested cultural and artistic identity, conservation and guardianship, meaning and interpretation

recur throughout this volume. Conversely, it may be argued that it is precisely this semantic layering that attests to the richness of Rodia's artistic achievement, its enduring appeal, as it continues to generate controversy and heated debate. In other words, over half a century after they were saved from obliteration, we return time and again to the enigmatic Watts Towers, which continue to challenge us with fundamental questions: What are they? What do they mean? Why did he build them? Rodia would not, and perhaps could not, fully explain his art or his motives—not even to himself.

Academics make careers out of debating these questions. Rodia's art has been considered a masterpiece of "intuitive engineering," avant-garde, *art brut*, raw, naïf, outsider, visionary, folk, environmental art, and fantastic architecture. The Towers have been called a "mind print," an act of pure creative invention welling up from some Jungian repository of archetypes (Appendix C.1, Morgan interview). Did he build the Towers as an act of redemption for a misspent life, achieving personal transformation through his act of creativity?[6] As a distant remembrance and recreation of lost cultural landscapes? Or did this artistic folly aim to create a ship (of fools?) to take him on that long and impossible journey "home"? I don't believe there are single answers to these questions. The reasons he set out on this monumental project may have been many, some contradictory, some ineffable, and others too painful to recount. Rodia himself warned, when pressed about what they signified: "they mean lotsa things, son."

Debate surrounds the Towers' historic identity: For example, are they best understood within the context of California Modern (Cándida Smith), global art environments (Hernández), fantastical architecture (Bilancioni), or the literary–architectural (Harris)? Was Rodia the ultimate "outsider artist," his work the outcome of unprecedented individual genius (Harrison), or should it be contextualized within a collective identity framed by Italian immigrant culture and history (Scambray, Sciorra, Del Giudice, Ruberto, Epolito)? How critical is the migration narrative (specific or generic) to understanding the Watts Towers? As for a possible ethnographic source, do the *Gigli* of Nola, the eight ceremonial towers carried in the Italian religious feast in the town of Nola, provide a significant point of reference for the Towers in Watts? Or are these Italian historical and cultural factors of less significance than Rodia's American experiences? And are the social legacies left on various cartographies of the city (once the Towers were abandoned by this Italian American artist) of greater significance than the details of their construction, or even of the artist's life history?

The fact is that National Historic Landmark number 77000297 (California Historical Landmark number 993; City of Los Angeles Historical Cultural Monument number 15) in Watts continues to stand at the center of controversy, challenging city management, museum conservators, community activists, and others, with regard to their physical integrity and guardianship, their role in community art and development, as well their symbolic value on the local and global front. Should our focus shift away from Rodia and the Watts Towers per se toward the Watts Towers Arts Center in Watts? How and why should the Towers been "used" to achieve specific social goals (e.g., community development)? If our focus does shift toward community concerns, who is ultimately responsible for the well-being of the Watts Towers themselves? How can we best achieve a balance between the specific concerns of the Towers, the arts center, and the community? Many such debates are captured within these pages. Indeed, this volume represents an exercise in open dialogue across many diverse geographic, social, and disciplinary boundaries and allows

each perspective on the Watts Towers narrative to be expressed in its words and with its own voice—alternately loud, angry, measured, whimsical, impassioned, or lyrical.

It also gives voice to long silent archival materials from the UCLA Library Special Collections, edited and transcribed so that many more readers might discover the treasures hidden there. Some of these previously unedited materials give us a renewed appreciation for the historic perspective and for those who have been consistently involved with saving the Watts Towers from the very start: the Committee for Simon Rodia's Tower's in Watts. We owe much to the original members of the CSRTW (e.g., William Cartwright, Nicholas King, Bud Goldstone, Jeanne Morgan, Mae Babitz, Jack Levine, Seymour Rosen, Ed Farrell, and Kate Steinitz)—most now gone,[7] and others joining their ranks in recent times. Morgan represents a rare Watts Towers living treasure. She provides first-person accounts of her visits with Rodia, of the Committee's heroic Campaign to Save the Watts Towers and its subsequent efforts to run, safeguard, publicize, and make arrangements for oversight and funding, and of the emergence of the Watts Towers Arts Center (see her essay and my interview with Morgan in Appendix C.1). Despite distance and age, she has continued the struggle with boldness, in a style of advocacy that has not diminished since the 1960s.

A word on behalf of the historic perspective and the critical role of archives: In a city emblematic of transience, demographic change, and a shifting sense of place, a greater respect for the historic record is critical. As far as the Watts Towers are concerned, an informed long-term appreciation of the diverse perspectives and stakeholders in the site might even help resolve various impasses and advance us toward establishing common ground. Perhaps it was even in an attempt to remedy a lack of historic memory that recent municipal administrations began publically marking (through signage) the diverse and changing identities of neighborhoods, villages, and ethnic enclaves throughout Los Angeles.[8] But transience affects public administrations and institutions no less than the urban landscapes they are charged to administer. Brief terms of office do little to help institutional memory (while changing fiscal and political realities cause fluctuations in the degree of attention paid to specific monuments). We may even posit that some of the ongoing debates around the Watts Towers may, in part, be attributable to a lack of historic perspective tout court. The historic perspective offered by archival research (i.e., UCLA Library Special Collection No. 1388), in my opinion, may be vital to both city administrations and to citizen action groups, to clarify and revive institutional memory, to remind us of past pitfalls and triumphs, to demonstrate what citizens can accomplish (sometimes in direct opposition to municipal bureaucracies), and to inspire us all to make public commitments in support of such extraordinary sites on our urban landscape, enriching and defending our sense of place.

To read the minutes and reports of the CSRTW is to realize how gargantuan and daunting were their challenges, how fierce were their battles, and how idealistic their goals. We are immensely grateful to them. We also come to appreciate how, given the range of civic, nonprofit, arts, and conservation entities responsible for, or affiliated with, the Watts Towers (e.g., the city's Department of Cultural Affairs and Office of Historic Preservation, the California Park Service, the CSRTW, and the Los Angeles County Museum of Art, or LACMA), they might have alternatively collided and aligned over the span of decades. To be fair, we also acknowledge how successive municipal administrations inherited a proverbial can of worms, each challenged to sort out the Towers' complex history and conservation goals, while keeping the broader economic and political issues in focus. But the

archival record, together with the evolving situation around the Watts Towers, also demonstrates that saving the Watts Towers from demolition in 1959 was but the first in a series of social actions required to "save" them time and again: from exposure to the natural elements, from plain neglect, and from man-made crises. Among the last we may include challenges ranging from incompetent conservation attempts in the 1970s, to recurring financial shortfalls and the latest ill-advised proposal to introduce a skateboard park onto the Watts Towers campus. The Towers require ongoing vigilance and informed advocacy.

Only through the process of poring over the CSRTW's archived materials in the UCLA Library Special Collections (e.g., correspondence, legal documents, architectural drawings, minutes of meetings, fundraising drives, and so forth) have I come to more fully appreciate the CSRTW's heroic advocacy efforts. True to a vision (just like Rodia), the Committee has been composed of people of conviction, stamina, and idealism for over five decades. In 2009 and 2010, original members of the Committee received public recognition for their efforts by the City of Los Angeles and by the government of Italy.[9]

But there was no greater fascination for me while working in the archives than hearing Rodia's own voice as he reflected on his life and work, in interviews conducted by members of the Committee (see Appendix A). Such materials provide a compelling counterpoint of words by Rodia to the many words printed about Rodia. Transcriptions of, and first-person reports about, the interviews conducted with him from 1953 to 1964, are here published in their entirety for the first time, as are archival treasures from several private collections. To these are added further interviews I conducted with those who continue to work on behalf of the Towers (Hooks, Landler) and with some who shared firsthand knowledge of Rodia himself (Morgan; Rodia's great-nephew Byer). In pursuing the tedious task of retranscription (where sound recordings were available) and of editing, I imagine that Rodia's own words will prove most enduring, even after our academic wordplay has long been forgotten.

International Conferences: Genova 2009 and Los Angeles 2010

This volume presents selected essays based on papers delivered at two recent international conferences: "Art and Migration: Sabato (Simon) Rodia's Watts Towers in Los Angeles," held at the University of Genova (Italy) on April 2–4, 2009; and "The Watts Towers Common Ground Initiative: Art, Migrations, Development," held in Los Angeles (UCLA in Westwood and WLCAC in Watts) on October 22–24, 2010 (see Appendix D for conference and festival programs). They represent reflections on the artist and his artwork from many perspectives, including those of artists, sociologists, architectural historians, anthropologists, folklorists, oral historians, filmmakers, scholars of literature and cinema, community activists, heritage and conservation specialists, as well as civic arts administrators. They cover contested political, social, and administrative issues, conservation and guardianship, and a theoretical framework within art movements, local and global migrations, and cultural imaginaries. The Genova conference highlighted the challenges of bridging divergent discourses and goals and considered ways of emerging from an impasse by affirming a sense of common ground around the Watts Towers. It helped identify the roles and goals of local and global stakeholders in this site.

The 2010 Los Angeles conference brought discussions closer to home and included many more local participants. While continuing to explore the same issues and themes

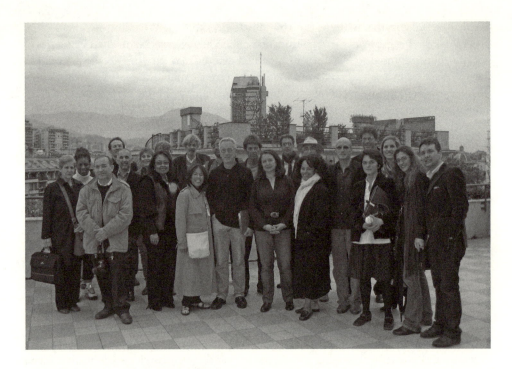

A group photograph taken on the final day of the international conference Sabato Rodia's Towers in Watts: Art and Migration, *at the University of Genova, Italy,* 2009.

of the Genova meeting, the Initiative also presented some tangible examples of how to create common ground—for example, through geographic boundary crossings (West-wood in Watts or Watts in Westwood), open forums, performances, exhibitions, films, poetry readings, and communal tables. The meeting featured two highly regarded pan-els: "Artists in Conversation" (see the first chapter in Part 3, this volume), which demon-strated how the Towers have inspired many individual artists and how the WTAC became the cultural heart of Watts (as well as a major cultural historical site on the map of black Los Angeles); and a conservation panel, with J. Paul Getty Museum and LACMA conservators and Department of Cultural Affairs representatives, who examined past and the much-anticipated future conservation prospects for the Towers (cf. the CSRTW's controversial report entitled "Damage in Progress" circulated, in absentia, in Genova). However, with the exception of Jeffrey Herr, who on behalf of the city provides a status report of the situation (as of October 2010), no other member of the latter panel has left a written record here. An assessment of the monument's new conservation management under conservator Mark Gilberg (LACMA), in consultation with other experts (e.g., Getty conservator Frank Preusser), will be left to future scholars.

The meeting also offered audiences the opportunity of meeting members of the orig-inal CSRTW in person (Cartwright) and via videotape (Goldstone, Morgan), all of whom addressed the UCLA gathering and offered their half-century-long perspectives on the Towers. Several recent documentary films drawing on oral testimony and archival

materials on the Watts Towers were also screened during these conferences, among them Edward Landler and Brad Byer's seminal film, *I Build the Tower* (2006), as well as a 2005 film recounting the history and development of the WTAC: *Fertile Ground: Stories from the Watts Towers Arts Center* (Rosie Lee Hooks and S. Pearl Sharp). The latter narrative was touched upon in the "Artists in Conversation" panel as well, by former (John Outterbridge) and current (Rosie Lee Hooks) WTAC directors and by several artists involved with the Center over the years, beginning with Judson Powell (who had worked with its first director and artist, Noah Purifoy in the early 1960s) and including Charles Dickson, Betye Saar, Augustine Aguirre, and Kenzi Shiokava. Further, the history of community development, told from the perspective of others within the community, was offered by Timothy Watkins, director of the Watts Labor Community Action Committee (WLCAC), who cautioned how development in a community of poverty ought to play out, bearing in mind the insider–outsider divide.

The Watts Towers and Migration

Perhaps the most novel element in this volume was introduced in Genova, when conference chair Alessandro Dal Lago added "Art and Migration" to the conference title. Although earlier writings on a potential link between the *Gigli* of Nola and the Towers in Watts had already begun to consider this important theme as far back as the mid-1980s (Ward and Posen 1985), formalization of the migration theme has more fully articulated its ramifications vis-à-vis Rodia's life and his artwork and has offered a critical and intriguing prism through which to consider the Watts Towers narrative.

Indeed, migration was central to the life experiences, cultural identity and worldview, as well as the art of Sabato Rodia. After all, pre-Towers Rodia led the life of a migrant worker, traveling all over the Americas in search of work (and perhaps adventure). And as Dal Lago and Giordano (2008) note, too, we must consider the literally migratory nature of Rodia as an artist, constantly on the move, integrating into his work ("metabolizing") all that he saw and collected along his many journeys by rail or on foot. If a *Gigli* heritage for the Watts is affirmed, we may also consider Rodia's artwork to be "migrating towers" themselves (see Exhibition "Migrating Towers" in Appendix D.5), having crossed an ocean and a continent to be transformed and reiterated on the Pacific coast.

The Towers are in constant flux as they are exposed to the elements, subject to the vagaries of nature (e.g., earthquakes, rain, sun, fire) and human destruction (e.g., vandalism, demolition). Hernández, intimately aware of the vicissitudes affecting such art environments worldwide, discusses the many challenges to preserving such treasures (i.e., in Spain), in her essay, "Local Art, Global Issues: Tales of Survival and Demise Among Contemporary Art Environments." Her essay may inadvertently cause us to express optimism and gratitude for the extraordinary attention, care, and public funds the Watts Towers have received, compared with those many others that languish forgotten, deteriorating or destroyed, in less favorable places and contexts.

Furthermore, migration concerns the historic and evolving community of Watts. Rodia moved to a diverse working-class community in the 1920s, one to which Mexicans, Asians, and Europeans had migrated, as had many blacks from the American South during the Great Migration, before and during the World War II era. Indeed, we could speculate that Rodia may have even chosen Watts because he felt at home among those on the margins

of mainstream America. And Watts continued to change even as Rodia was leaving it for Martinez in 1954. Increasing numbers of African Americans then, and a newer Latino influx in more recent times, demographically transformed the community. Like much of Los Angeles, Watts presents a history of evolving identity, of overlapping and sometimes contested cultural cartographies, as the city continues to prove a magnet for local, national, and global migrations—along all socioeconomic axes. Mobility is Los Angeles's modus operandi. Perhaps for no other city does transience form such a pivotal aspect of its self-identity. A relatively small portion of its population counts Los Angeles as their city of origin. Antonio Villaraigosa, as newly elected mayor of Los Angeles, recognized the Watts Towers' highly symbolic value, vis-à-vis this migration theme, by focusing on the Towers' mosaic, which seems to mirror the city's human patchwork.[10] In his inaugural speech of 2005 (and reiterated in a letter to Genova conference organizers), he observed:

> Rodia's Nuestro Pueblo represents what Los Angeles has become, a City that truly embodies his idea of "our town," a place where people from 140 countries speaking 224 languages and dialects have made their home. (March 3, 2009)

What more appropriate symbol for Los Angeles than the Towers, a beautiful assemblage of diversity, created by an artist who was the very embodiment of a state of displacement and flux?

Sabato Rodia: Italian Immigrant Artist and Worker

Despite the centrality of the migration experience to Rodia's life, times, and art, the theme had been curiously underdeveloped or simply absent until recently. The migration subnarrative for the Watts Towers is not without its hazards. It is a polemical and thorny issue in a city often engulfed by cultural politics, in an era that has seen the worst side of ethnic nationalisms globally and turf wars locally, and which may have led to a general backlash against multiculturalism. The Watts Towers, too, have witnessed such conflicts. Thus, even amid hopeful signs of coming together on common ground, we remain alert to ever-present fractiousness (see "Contested Cartographies, Fault Lines, and Common Ground," below, as well as the volume's Afterword).

The fact remains, though, that very little has been said about Rodia's cultural past and his historic experience as an immigrant worker, and this lacuna is unacceptable. Prominent among the many goals of this volume, therefore, is expanding a cultural understanding and the historic record of Sabato Rodia (beginning with his very name, which I have insisted on restoring wherever possible). It is my contention that without such knowledge, as well as information regarding Rodia's cultural identity and personal experiences as an Italian immigrant, we cannot fully appreciate or understand the Watts Towers, why he built them, what they are, and what their broader social and artistic significance might be. Conversely, while seeking to identify and mark this as an Italian diaspora site within a global migration narrative, this endeavor does not seek to appropriate the Watts Towers for any one ethnic or social group. The reality of Rodia's complex identity and his own wide range of experiences, together with the historic vicissitudes of the Watts Towers, cannot constrain the monument into any such narrow perspective.

Nevertheless, we return to the Towers' Italian cultural context. The Ward–Posen hypothesis that there is indeed a cultural precedent for the Watts Towers in the *Gigli* of

Nola cried out for further study. According to folklorist Joseph Sciorra, these earlier scholars "offered an opportunity to further explore other southern Italian aesthetic and building folk traditions influencing Rodia with a seriousness of attention and history that simply did exist before their article." The question of historic source and Italian cultural practices are addressed by several scholars in this volume: Sciorra (on Italian American aesthetics and philosophy) and my essay (on Italian ethnography and folk imaginaries); while a focus on the *Gigli* is specifically addressed by Felice Ceparano and Katia Ballacchino and is further explored in Sciorra's and my contributions as well. As co-curators of "Migrating Towers: The *Gigli* of Nola and Beyond," a photographic exhibition at the Charles Mingus Youth Arts Center (WTAC), Ceparano and Ballacchino brought the astonishing physical echoes of the obelisk in the Towers into focus. Ceparano had been involved in efforts to promote the Italian festival apparatus to UNESCO's list of intangible world cultural treasures, while the anthropologist Ballacchino here explores the problematic nature of heritage management within contested cultural politics and urban space (see Schrank, Morgan, Herr), as well as the role of such sites in tourism development. Ballacchino's contribution also serves as a cautionary tale. The centuries-long *Gigli* festival, one of the most extraordinary in the entire south of Italy (and a transnational festival celebrated in New York since 1903),[11] has become a strong Italian candidate for UNESCO intangible heritage nomenclature.[12] The Nola's *Gigli* festival, therefore, makes an excellent case study for the political, financial, and social issues at stake in converting a cultural site, festival, or practice into World Heritage. Ballacchino frames the discussion by reviewing academic and nonacademic debates around the *Gigli* festival in Nola ("debates much like those swirling around the Watts Towers"), focusing on "'valorization' through a complex and highly articulated system of 'patrimonialization,' on 'museification' . . . and finally on tourism marketing and 'mediatization.'"

Rodia's life itself speaks of an early mass migration of Europeans to American shores between the late nineteenth and early twentieth centuries and specifically of the challenges faced by that generation of Italian immigrants. His life, in fact, paralleled those of millions of other Italian workers who left behind the economic repression and rigid social hierarchies of southern Italy—which had only recently been unified as a nation at the end of the nineteenth century—to seek a new and better life in the Americas (even though Rodia was an unwilling emigrant, sent away as an adolescent by parental decision). His immigration experience in America also straddled two world wars, during the second of which Italians were classified as "enemy aliens" (see Japanese and Italian wartime internments and relocations in Di Stasi 2001). Heightened xenophobia and hostility toward the foreign-born caused much psychological and cultural damage. Loyal Americans, for example, were warned "not to speak the enemy language." Despite his many decades in America, Rodia's English was still broken, marking him as an unassimilated immigrant. His unorthodox art and solitary ways must surely have increased in observers a perception of his otherness. Being an outsider was a constant factor in his life. Perhaps it was an attempt to disarm potential hostilities that Sam spoke of doing something (i.e., building the Towers) to show gratitude toward the "nice" people of the United States. Indeed, in 1959, the issue of Sam's American patriotism became a leitmotif in the Campaign to Save the Watts Towers.[13] Some supporters considered the city's demolition order to be an offensive and even un-American gesture because it sent a message that not only did the city not care to understand or appreciate new immigrants, it went out of its

way to destroy what they had contributed to American society. Others affirmed that this artwork made evident how immigrants made good use, even something marvelous, out of our consumer society's discards (e.g., letter to TV host Jack Linkletter, from Joe E. Smith, in Culbertson, Nebraska, July 13, 1959, Appendix B.3).

Scholars of the "Italian American Experience" deem the context of Rodia's migration to be highly significant. Several contributions in this volume's first section present emergent considerations in the Rodia-as-immigrant narrative, by placing him squarely within the framework of Italian diaspora history, literature, and material cultural practices, while largely avoiding, as Sciorra puts it, "invoking dogmatic or essentialist arguments." These essays examine the cultural and historic contexts out of which Rodia emerged— but which few of his contemporaries (and ours) knew or understood—noting how, in the many interviews conducted with Rodia, it is painfully evident that there existed a "booming dissonance of cultural disconnect" (Sciorra). What is evident was Rodia's "frustration resulting from his interlocutor's incomprehension" (Del Giudice) of his linguistic and cultural references.

Literary scholar Scambray evokes the cultural context of California and Los Angeles Italian Americans into which Rodia may be placed, thereby indirectly addressing the vexed question of Rodia's connections with his immediate Italian community. Italian Americans, significant in numbers throughout the state, dominated many occupational sectors at this time. We may infer that Rodia was likely aware of his local compatriots, to some degree participated in their gatherings, and visited their commercial establishments—at least to purchase food staples (see Del Giudice, this volume, n. 17).

In short, Rodia shared in many Italian migration experiences, enriched by new cultural practices overlaying many remembered ones. Indeed, because Rodia had spent his formative years in an Italian mountain village, high up the Sabato River Valley in southern Italy, he was also profoundly shaped by its geographic, historical, and cultural milieus. As I seek to make clear in my essay "Sabato Rodia's Towers in Watts: Art, Migration, and Italian Imaginaries," many of his ideas, tastes, expressive traditions, and imaginaries are decipherable in the Towers themselves. I specifically explore motifs such as ships, (bell)towers, treasure, as well as forms of popular devotion that may be present in the artwork (e.g., the Watts Towers as ex-voto, as a street festival).[14] I explore aspects of Rodia's life (e.g., his birthplace, his name, speech patterns, and song heritage, as well as his political, economic, and social ideas) as expressions of an Italian peasant–immigrant life and worldview. There can be no doubt that Rodia himself was keenly aware of his own cultural past and highly stimulated by its grander history, articulated in narratives of great civilizations (e.g., ancient Rome), great men (e.g., Galileo, Columbus, and Marco Polo), and great monuments (e.g., the Tower of Pisa)—all too typical of the rhetoric of Italian immigrants to this day. By doing "something big," he sought to situate himself within that grand tradition of builders, aspiring to leave an (Italian) historic legacy in America.

In his contribution, Sciorra similarly asserts that Rodia's architectural fantasy "emerges in relationship to a larger set of interrelated sociocultural precepts immersed in southern Italian peasant and Italian American immigrant laborer perspectives." Paradoxically, Rodia worked both within and against "a set of aesthetic and philosophical elements involving survival and achievement, frugality and practicality, craft and building prowess, masculinity, beauty, Catholic aesthetics, and the spectacle, as well as a host of vernacular art traditions," reimagining and reconfiguring many of these cultural elements in the Watts Towers.

Additional sites on the Italian diaspora map, as they relate to art, are considered in Ruberto's and Epolito's essays. Ruberto explores how, taken together, Italian American "site-specific art construction sites" within the state of California, such as Rodia's Towers (Watts), Baldassare Forestieri's Underground Gardens (Fresno), Romano Gabriel's Wooden Sculpture Garden (Eureka), and Damonte's Hubcap Ranch (in Napa wine country) "form a kind of mirrored mosaic that reflects not only an Italian immigrant experience but a particular West Coast variety of that experience." According to Ruberto, these are all creative instances of Western Italian American "place making." By examining art in con- temporaneous Italian diasporas, Epolito examines another little-considered site: South America. Epolito notes that as Italian émigrés, Rodia and the future South Americans shared realities upon departing Italy but that initially, "more receptive attitudes by the nations in the Basin would eventually serve to propel [these] Italians . . . from the mar- gins of society into the center of zeitgeist debates regarding the development of national cultural identities."

Yet not all contributors consider Italianness to be especially relevant to the discourse around Rodia or his Towers in Watts. For example, Harrison notes the highly individual and unprecedented nature of Rodia's Towers, that the monument is about the creative pro- cess, about doing, and that the Towers "figure the unending nature of beginnings, whose end lies in achieving no end, or in accepting their nature as unfulfilled bridges." Invoked by Calvino's *Cosmicomics*, the blind mollusk's "invocation to form" is a "blind act of cre- ation." So, too, with the Towers themselves. It is once they are "terminated" (not finished) that the images themselves provide us with the ability to see and challenge us to decipher what they are. Harrison notes that Rodia strategically placed the artwork for maximum effect, to be seen and admired by many. Such gratuitous acts of creation, as Dal Lago and Giordano articulated in their 2008 volume, *Fuori cornice,* are "Out of Frame" (see also "Without Nation," the title of their 2010 oral presentations)[15] and hence outside the bounded confines of an art establishment, a social, ethnic, or national group. Rodia was a solitary creative genius. As another Italian colleague confessed to me at the conclusion of the Genova conference, "Il discorso sull'italianità di Rodia mi fa schifo!" ("[the] talk of Rodia's Italianness disgusts me!"). Such a vehement denial of the relevance of Rodia's cul- tural heritage speaks volumes. It highlights a deep historic divide between Italian and Italian American perspectives (including a not-so-latent hostility of the former toward the latter) on issues of ethnicity and migration. Our insistence on pursuing the topic, how- ever, demonstrates an increasingly vocal response of the periphery (the diaspora) toward a center (Italy) that has long denied, or at least ignored, its own migration history.[16] Suf- fice it to say that these conferences exposed old fault lines and revealed that not merely *inter-* but *intra*cultural bridges of communication required mending (see Afterword).

Continuing an art historical discourse, that is, Rodia's place within national and inter- national art movements, Cándida Smith notes that because California art was largely invisible in New York and barely known on the world stage, "it is not tenable (at least in terms of logical deduction) to consider Rodia an 'outsider' artist." Cándida Smith identi- fies Rodia instead as the "quintessential California modern artist . . . because he provided an exemplary model for transcending the dual challenge of personal marginality and regional provinciality." He continues: "for many in the generation of artists, of various social and racial backgrounds, who came of age during or after World War II, Rodia was indeed the equal of Pablo Picasso, Marcel Duchamp, Max Ernst, or Paul Klee in providing

a model for what a great modern artist could accomplish. The reasons given for what made Rodia important are quite literally 'all over the map.'"

Other theoretical perspectives on the artwork are provided in essays that look at the Towers through a literary–architectural or architectural lens. Literary scholar Paul Harris (a.k.a. Tall Pall Harras) considers how the whole site, like the written page, is "one continuous surface covered in signs, with Rodia's intricate ornamentations forming a kind of private language." Harris attests how, over the span of twenty years, the Watts Towers have continued to "stimulate theoretical thinking, induce spiritual reflection, and inspire all manner of writing creativity" in him. Indeed, Harris's reflections are a form of "creative synthesis," a conceptual and creative tribute to Rodia's work that answers the question: "How can an architectural work like Rodia's Watts Towers dictate structural constraints for a written work?" He responds with a tour de force poem entitled "Sam's Ark: An LA Landmark," whose exclusive use of the vowel *A* corresponds to the structural frame of Rodia's Towers. Architectural historian Giuglielmo Bilancioni, in a somewhat lyrical and highly theoretical essay, reflects on how such visionary endeavors represent "the serious game of projection between *iam* and *nondum*, of the *already* and the *not-yet*, between something that has always been here and something that, almost certainly, will never exist." The Watts Towers, he notes, "are a building from Elsewhere, late-antique and nostalgic, transient and ephemeral, made out of enchantment and disenchantment."

Watts Towers, Contested Space, and Development

The Towers may appear as fantastical and visionary; they may speak of specific arts movements and grand schemes; or they may be seen as the work of a culturally bound immigrant. What cannot be disputed about Rodia's Towers, however, is that they are located in Watts (Los Angeles). The implications of this fact are profound, entailing an exploration of the specific history of the Watts Towers within these municipal confines, as they relate to urban cartographies and cultural politics and as they are envisioned in various urban development projects. It is this third and last section of the volume to which we now turn: The Watts Towers and Community Development.

As explored in Part II, the Watts Towers have represented contested space: from the moment a demolition order was issued and action was taken to resist it; from the earliest efforts to conserve them and sustain an adjacent community arts center; and in the ongoing debates about how to manage, fund, and develop the entire Watts Towers campus. An ongoing tug-of-war between municipal center (the city) and periphery (the Watts community) on issues of ownership (both literal and figurative) and of development continues to this day.

Contributions that specifically address such thorny issues of contested urban, political, and social space are variously explored in essays by Morgan, Herr, Schrank, and Barra. Morgan and Herr deal specifically with the L.A. municipal administration–CSRTW axis around issues of conservation. The historian Schrank provides a frank assessment of the politics of cultural identity swirling around the Towers and how a focus on community economic development has shifted attention away from the monument itself (a view articulated long before by CSRTW member Seymour Rosen). Monica Barra explores the challenges of narrating and interpreting the monument within the context of urban history. Generally speaking, we note in current debates around the campus's present and

future how Rodia's life history and the Towers' cultural heritage do not receive more than passing (and ever-diminishing) consideration. In other words, these issues simply do not coincide with immediate concerns or prevailing sensibilities. More compelling local imperatives, such as development and preserving the campus as an essentially African American cultural site for the "Community,"[17] seem to have trumped most others. More recently, however, conservation issues have returned to the forefront.

But let us briefly return to a historic perspective on Watts. In the early twentieth century, Watts was a sort of "Hicksville, U.S.A.," according to writers such as Mencken ([1919] 1938).[18] When Rodia moved into Watts in the early 1920s, it was a semirural periphery of Los Angeles; when he left the area in 1954, Watts was in economic and social decline; and by the 1960s, it seemed the very emblem of urban blight. Once war-related industries vanished, unemployment rose, large housing projects built, and the Red Line (the public transportation system that connected much of the southland to downtown Los Angeles) was severed, Watts became an isolated and further marginalized area of the city, with rising poverty, crime rates, and police repression.[19] A deepening sense that Watts had been abandoned and repressed was to feed unrest and ultimately lead to an explosion of violence and rage known as the Watts Riots or Rebellion. During the span of mere days (August 11–16, 1965), inestimable damage to life, property, and community occurred. Such losses are still remembered and mourned. And more unrest followed in South Central with the Rodney King beating in 1992.

Watts residents are well aware of the many forces working against their community, as well as the abiding negative associations with its very name. According to Thomas J. (Tom) Bradley (the first African American mayor of Los Angeles and a former police officer in Watts), writing in the 1980s: "Watts is known more for arson than art," although he also acknowledged that the Watts Towers were "the past, present, and future of Watts." Some still perceive the Watts Towers (the "heart of Watts") to suffer from the same neglect affecting the community at large. As Cecil Fergerson (d. September 18, 2013), former curator of African American art at LACMA and co-founder of the Black Arts Council (who grew up in Watts and whose portrait adorns the south wall of the Watts Towers Arts Center), has said: "It's a community of poverty. Always was. When they take care of that problem, the Towers will be bigger than the Statue of Liberty" (in *I Build the Tower*).

Although the challenge of the initial stress test had been met, the CRSTW would face many others over the decades, including cracks within their own ranks[20] in debates over Towers conservation efforts versus community development. Some members maintained that the CSRTW was not a social service agency and was ill equipped to solve Watts's many pressing needs. Those who prevailed felt that the CSRTW was morally compelled to try to address some of these needs, arguing that a community arts center, besides offering much to the area's youth, would also create a local community capable of appreciating and caring for the monument; that by investing in arts education, a mutually enhancing bond between monument and community could be forged. And thus was born the community-based Watts Towers Arts Center in 1961. It was clear, however, that the Center would require management by a prominent member of its own (i.e., African American) community, and so Noah Purifoy became its first director.

But precisely what form of development could be expected from the Watts Towers and its Arts Center? Economic and/or artistic? Some have sought fiscal outcome through development of the Watts Towers campus, variously seeking to position the monument

Cecil Fergerson at center, flanked by Mayor Antonio Villaraigosa, family, and Rosie Lee Hooks,
on the occasion of the opening of the Charles Mingus Youth Arts Center, in 2008.

and its arts center to generate tangible returns for the benefit of the general (and the arts) community. (Would Rodia have been pleased to learn that his Towers had been embraced by the community and that his monument might serve the poor, given that he was always keenly aware of social and economic divides and largely sided with the working class?) Acclaimed artist and former director of the WTAC John Outterbridge seems to best articulate the other side of the debate. He maintains that the Watts Towers' role in the community ought to be that of focusing on human creative potential. According to Outterbridge, once we address this form of (human) development, anything can result—whether in the areas of art and music, science, and beyond. The Towers were a beacon of light radiating out into the world in a hundred unpredictable ways. That transformative work departed from the story of Rodia himself, as an extraordinary example of vision, creativity, persistence, and accomplishment (cf. Lee Hook's mantra for the arts students: "If I stick to it, I can do it"). Ideally therefore, the Watts Towers and the Watts Towers Arts Center form a synergistic and reciprocating bond.

From this perspective, the Towers represent a living icon in community. Their inherent power rests in their ability to inspire, to develop hidden potential and instill a sense of purpose. Indeed, the Center's goal is to nurture and sustain creativity in the community. The "Artists in Conversation" panel at the UCLA conference eloquently demon-

The sculpture of "Momma Watts" in front of the Watts Towers Arts Center entrance, a symbol of community nurture through creative development.

strated how the monument and its arts center have accomplished this task in the lives of specific artists. Since the 1950s, engaged artists, musicians, and poets at the WTAC have been nurturing generations of creative individuals (see *Fertile Ground*). It is the Arts Center's business to ask: How many other human treasures do we harbor in our midst, right outside the Towers' perimeter? Like the sculpture "Momma Watts," at its entrance, the WTAC highlights its nurturing community role. Rosie Lee Hooks, in some real sense, sees her efforts as enhancing the work of the many other "Momma Watts" found in Watts, its impressive matriarchs and staunch defenders, such as Mrs. Lillian "Mother" Mobley (d. July 18, 2011) Emily Ware (d. October 25, 2013) and Mrs. Willia Moore, still active with the Watts Towers Community Action Council. Fostering a new generation willing to continue their work remains a challenge (see Appendix C.4, Hooks interview).

Just as the CSRTW had hoped, the Watts Towers have indeed been embraced by its community. As proud local residents insist, Rodia did, after all, choose Watts. And as artist Judson Powell reminds us, the monument does, in some literal sense, belong to the entire community:

> By collecting from all the community and involving them on [Rodia's] finished work . . . everybody living in the city of Watts from 1920 through 1940 has something from their personal families embedded in the structure. That's why they all feel that they are a part of it; it belongs to them because they are indeed represented on it. . . . That's one of the things that makes it so viable. ("Artists in Conversation," this volume)

And current Watts artists, such as Augustine Aguirre, continue to engage directly with the community. In *Mi Tierra* (My Land), perhaps echoing Rodia's nomenclature (Nuestro Pueblo), a mosaic work directly across the street from the Watts Towers projects a Mexican cultural heritage in the neighborhood.

But economic (and not only artistic) development projects, to rebuild Watts, were also present in the pre-Riots 1960s: for example, the Watts Labor Community Action Committee, founded in 1964. And development projects beyond those of the WTAC and the WLCAC (with its "Don't move, Improve!" philosophy) are abundant to this day: the Watts/Century Latino Organization; the Watts Towers Community Action Council; faith communities; recreation and park facilities and seniors' centers; health and social services agencies (e.g., the Watts Health Foundation); and many independent initiatives besides. One is almost bewildered (but certainly encouraged) by the host of education, antipoverty, and drug-, gang-, and crime-prevention programs[21] that have appeared in Watts over the decades—some more successful than others, some hotly contested (e.g., the recent skateboard proposal).[22]

Many efforts specifically foster the arts, including the Watts Village Theater Company ("theater for and with the people of Watts") and the Watts House Project ("an artist-driven neighborhood redevelopment project," originally under the guidance of Edgar Arceneaux).[23] The vast majority, however, have emanated from the WTAC in partnership with other entities and with the support of groups such as the Friends of the WTAC. The Jazz Mentorship Program, graphic art, film, and writing workshops, and an array of others are precious to the community (see the commemorative program *The Watts Towers: 50 Years of Inspiring Art, 1959–2009;* Watts Towers Arts Center and Los Angeles Department of Cultural Affairs, 2009). Gail Brown, a professional photographer and teacher, has been engaged in one such program, teaching narration through word and image, as described in her essay. The WLCAC has been responsible for yet other mentorship programs. For instance, in her essay, Shirmel Hayden, a former intern at the WLCAC, shares her perceptions of Watts and her experience in a program designed to encourage high school students to pursue a college education. Hayden sees Rodia as an example of someone who opposed "social paradigms that governed societies, stereotyped people, and allowed inequality to exist." His life and his work expressed a vision "that spoke silently against preconceived notions about America." In Watts she sees a community "that fights every day for equality with regard to food, housing, education, health, and employment." Both Brown and Hayden have been immersed in the day-to-day realities of the community through engaged interaction with its youth, and they understand the daunting challenges faced by Watts families. Both offer compelling examples of efforts on a capillary level to develop human potential among the youth of Watts and to advocate for change.

Contested Cartographies, Fault Lines, and Common Ground

As I have noted throughout this introduction, the Watts Towers have trailed a long history of contestation, in divergent narratives, interpretations, and goals for the monument, exposing many fault lines that have at times placed their integrity and survival at risk. Some oppositions seem to have become structurally entrenched and even iconic: the City versus the CSRTW, a.k.a. the Establishment versus the Citizen; and the City versus Watts, that is, "a distant controlling bureaucracy" versus "the disenfranchised

local community." Other dichotomies are more elusive, as, for example, Watts Towers vis-à-vis the Watts Towers Arts Center—separate yet ideally synergistic—and the "Community" (i.e., Insiders) versus "Outsiders."[24] A range of questions arise along these more elusive and problematic axes: Have the needs of the WTAC come to overshadow those of the Towers?[25] Or conversely, have millions been poured into art conservation while the Center's programs struggle for lack of funds? Do the Watts Towers need a circle of Friends similar to the nonprofit Friends of the WTAC? Can any "community" speak with one voice? Have the Towers been "hijacked" by the community (or a faction thereof) to attain specific local social and economic goals? Do "outsiders" have any right telling "insiders" what to do in their community and with their monument? But didn't "outsiders" (starting with the CSRTW) make all subsequent Watts Towers campus events possible by saving the Towers in the first place? If the Watts Towers are a public monument, who is to be considered an "outsider"? Such are the (sometimes unvoiced) concerns swirling around the Towers. In the final analysis, it appears to me that many of these represent false dichotomies, for indeed the health of the Towers likely depends on the health of the Watts Towers Arts Center and the health of Watts. Destabilize or ignore any one of the three components—Watts Towers, WTAC, Watts—and the others suffer.

Other lines of demarcation seem to be evolving as well, specifically as they concern the ethnic identity of the Watts Towers and the community's historic and current migrations. I offer a personal sidebar regarding the former, while leaving to others the exploration of the current Latino cultural evolutions in Watts. I may have unexpectedly provoked a hornet's nest regarding the ethnic space of the Watts Towers back in 2003 while presenting a proposal for a Leo Politi exhibition (a decidedly multicultural one, given the Italian California artist's own inclinations; see Afterword) at the Watts Towers Arts Center, as part of a festival program I was organizing, entitled "Italian Los Angeles: Celebrating Italian Life, Local History, and the Arts in Southern California" (see Afterword). I was not alone in noting the WTAC's less than warm reception throughout the planning stages, up to its opening reception on October 23, 2005. Concurrently, I had been invited to a meeting at the Hollyhock House (in Barnsdall Park) to discuss an educational resource being written on the Towers for children but was taken aback by a pointed question from a staff member of a prominent African American institution in Los Angeles. With festival brochure in hand, she asked (echoing the WTAC's chilly reception of the Politi exhibition proposal): Why were the Watts Towers figuring in a festival devoted to Italian Los Angeles? Didn't I have the wrong cartography? "But . . . he was an Italian immigrant," I sputtered. Either historic memory had lapsed (indeed, it was widely assumed that the artist who created the Watts Towers had been an African American),[26] or I had unwittingly stumbled onto the minefield of cultural politics in this ethnically hypersensitive city. Of course, the Watts Towers had become a conspicuous and unmistakable site on the cartography of black Los Angeles.[27] But, at the very least, I argued, the Watts Towers campus was a case of overlapping cartographies (not to mention the current Latino overlay, little of which is ever represented at the WTAC). These personal encounters, and subsequent ones, prompted my colleague and conference co-organizer, Thomas Harrison, to (only half in jest) suggest we name our endeavor the Watts Towers *Uncommon* Ground Initiative.

We are all formed and informed by our own specific culture, history, geography, class, gender, even migration status—not to mention disciplinary biases. When we interact with

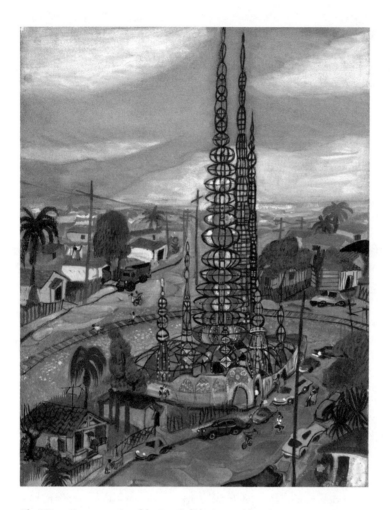

The Watts Towers, painted by Leo Politi, circa mid-1960s.

the Watts Towers, we inescapably bring our own stories and histories to bear on what we see. Perceiving the Watts Towers as a "Jazz Cathedral" (De Lillo) or as a "Street Festival" (Del Giudice) are examples of deep and culturally enhanced ways of perceiving and understanding them. Both metaphors are informed by specific cultural traditions (an African American musical genre in the first case, an Italian cultural practice in the second) and resonate within cultural worldviews and approaches to "place making" (to use Ruberto's phrase). I would insist, however, that a search for common ground does not erase cultural specificity or historic memory or disciplinary understanding, but rather does just the opposite. Our appreciation and understanding of this symbolically dense monument is enhanced by listening to each other's "Watts Towers narratives," personal and collective, historic and contemporary, local and global. The parable of the elephant and the blind men, so frequently invoked in the context of interfaith dialogue (to explain the nature of

Italian Oral History Institute festival program for Italian Los Angeles: Celebrating Italian Life, Local History, and the Arts in Southern California, *October 19–December 9, 2005.*

Italian Los Angeles: The Italian Resource Guide to Greater Los Angeles *(www.ItalianLosAngeles. org), 2005, featuring the Watts Towers on the homepage banner (a project of the Italian Oral History Institute, funded by National Italian American Foundation and the Italian Consul General of Los Angeles, Diego Brasioli).*

ultimate reality), here comes to mind: None of us has the entire picture, only a piece of the puzzle. The dialogic structure and intent of our two international conferences, reflected within this volume, sought to give voice to this wide range of perspectives.

I have come to recognize around the Watts Towers a creative oral narrative tradition wherein our own projections are embroidered into its interpretive tapestry, ultimately demonstrating how the Towers have been perceived, embraced, and relativized across time. For African Americans, as Outterbridge recounts in *I Build the Tower,* the man who carried out such an extraordinary feat was presumed to have been one of their own (for

reasons it would be interesting to explore). I predict that for Italians and Italian Americans (as they come to learn more about Rodia and his monument), the Watts Towers may become an immigrant's site of collective commemoration. Here they will confront the truth that migration for so many was a traumatic experience: Some became loners, unable to fit in, while others, such as Rodia, called on great inner resources (as well as cultural memory and skills) to overcome personal hardship, create what is beautiful and good and grand, and thereby enrich the world. This offers a life lesson for us all.

Indeed, as the historically specific (i.e., Rodia as an Italian immigrant) evolves into a transcendent universal (i.e., Rodia as Everyman), the core of the Watts Towers' meaning (its common ground) seems to point to this enduring existential truth: We must discover our own great purpose in life, be responsible for achieving it (despite the obstacles that stand in our way), and then share it with others. The Towers can inspire us to do things greater than we thought possible. As such, they are a spiritual resource for us all,[28] showing us how to make something beautiful out of the broken stuff of life. Rodia's words may have been broken, but his structures are eloquent: They look within, they look around, and they look up. And they have retained their ability to evoke wonder and awe. In *I Build the Tower,* John Outterbridge observed, "Rodia was a master at giving shape to the invisible. He had faith in the unseen. . . . He gives substance to that which does not exist." For me, what is remarkable about the Watts Towers is that they are a joyous and literally uplifting image—a symbol of love (filled with hearts). They are a site of personal suffering and redemption through artistic achievement and a joyous celebration. For thousands they have become a pilgrimage site of sorts,[29] straddling a divide between soaring aesthetic and spiritual experience.

But a persistent and often unspoken question revolving around the monument is still a thorny one: Who "owns" the Watts Towers? Who ought to control its fate? The stakeholders in the Watts Towers are many, and together they must find a way to conserve and enhance the site for the benefit of local, national, and (often invisible) international communities. In fact, rather than lament and exacerbate perceived divides around the Watts Towers, we can rejoice that this extraordinary arts environment—unlike so many others—enjoys the great good fortune of having an adjacent arts center, fiercely loyal citizen guardians, a proactive local community, expert conservators, several levels of government oversight, and international advocates, all (more or less) on its side. The challenge, of course, is to unite efforts and work collaboratively. But as anyone who has dealt with the realities of cultural heritage sites can attest, these issues are not limited to the Watts Towers (see Ballacchino, this volume).

Throughout the 1965 Watts uprisings, while buildings were burned and looted only blocks away, the Watts Towers were spared—perhaps because they were perceived as neutral or common ground, something good for all. We would do well to remember this. We can only hope for a paradigm shift, a renewed sense of common cause around the Watts Towers, in order that we might remain passionate but also reasonable, applying our energies to building up rather than demolishing and to inclusion rather than exclusion. How can the Watts Towers, a de facto "world heritage site" (whether officially designated by UNESCO or not), be better valued by all of Watts, all Angelenos, and around the globe? For the long-term and long-distance common good (and not for commercial gain or partisan branding). Let us remind ourselves that the man who created Nuestro Pueblo intended that they stand with arms open to all. His project was an expression of community

consciousness, a gesture of hospitality and shared abundance. Perhaps the assemblage even expressed an act of inclusion (*Nuestro* Pueblo) he might have hoped for himself—in a not always hospitable land: "I build the tower, people like, everybody come." That everyone "wants a piece of the Watts Towers" (see Afterword), in other words, is a good thing. Rodia wanted it that way. Indeed, gates and hearts must remain open,[30] for the Towers to fulfill their purpose and to be "something big"—even bigger—all over again.

Current Realities and Future Prospects

It is my hope that we are entering a golden age for the Watts Towers. With sun and wind at our backs, (see: cover illustration) might we be moving forward with full sails (to use a Rodian maritime metaphor) even as we acknowledge that others have sailed this way before (e.g., the 1987 University of Southern California–*Herald Examiner* conference and the equally idealistic consortium it hoped to achieve; see Whiteson 1989), ready to face the stormy weather ever threatening the Watts Towers and its arts center (sometimes literally)?[31] During the 2010 Watts Rescue Campaign, which sought to prevent the privatization of the WTAC, we were once again moved by the overwhelming support that came from across Los Angeles and around the world. The many online testimonials witnessing to the personal meanings of the Towers recalled those found in the archives of the 1959 Campaign to Save the Watts Towers, with its letters, postcards, and telegrams pouring into the mayor's office, from prominent and ordinary citizens alike (see Appendix B.2).

Economic recessions and an assortment of other obstacles make administrative, programming, and conservation tasks challenging, of course. But there are steps we can nonetheless take that might improve the Towers' prospects for the future. I offer some suggestions. As Angelenos, we must immediately insist that study of the Watts Towers be integrated into the curriculum of every elementary school in the Los Angeles area: first, because of the narrative's inherent value (e.g., how to find purpose and do much with little, how to achieve a goal through work and persistence); second, because it teaches the complex and overlapping realities of our city's history; and third, because it positively integrates the theme of migration for a population for whom it continues to be a reality. The Watts Towers are proof of the "freedom to do" as they continue to speak to artists such as Watts-based Japanese Brazilian sculptor Kenzi Shiokava, who states:

> We came here because of the freedom to do, the opportunity [f]or endless creativeness. . . .
> Simon Rodia . . . has that drive that nothing could stop. He could move mountains. . . . It's
> the essence of America to come here and do something like that. ("Artists in Conversation,"
> this volume)

The Watts Towers can rival the Statue of Liberty as a national symbol. A focus on the monument therefore could also positively contribute to the national (beyond a local) discourse on migration, based on values of human creative potential, achievement, and mutual enrichment.

The WTAC visitor's book itself attests to the international renown of the Watts Towers. Can such an international chorus lend tangible and intangible support to the Watts Towers? The Watts Rescue Campaign recently confirmed that it could. Concerted and coordinated efforts in our increasingly interconnected world mean that an international support network is easier to envision and maintain (e.g., see the Watts Towers Common

Ground Initiative Facebook page). It might even be advisable to establish an international Watts Towers Advisory Board not only in an effort to increase global attention on the monument but as an added circle of appreciation, support, and advocacy.

Other partnerships, too, are on the horizon as Italian interest in this site seems to be growing, among Italian consular and cultural representatives[32] and among Italian scholars.[33] With such support, one might expect wider connectivity, reciprocity, and joint programs.[34] Given their historic experience of migration, Italians and Italian Americans might provide forms of cultural mediation and appreciation for the migration narrative, both as it is inherent in the Towers and as it is evolving in the community of Watts today. Being an arts and culture magnet, Italy could offer opportunities for cultural exchange programs with the WTAC. And given the preeminence of Italians in the area of art and art conservation, could they also facilitate and assist professional conservators in their efforts? New partnerships and a widening circle of stakeholders in the Watts Towers (and the WTAC) may help them flourish with physical integrity, financial stability, and cultural equity.

The Watts Towers narrative must continue to be told so that the Watts Towers may increasingly become a destination—both globally and locally. We trust that the recent scholarly activity in Genova and Los Angeles, and especially the Watts Towers Common Ground Initiative, may have played some significant role in refocusing broader attention on the extraordinary Sabato Rodia and his Towers in Watts: Nuestro Pueblo.

Works Cited

Briscese, Rosangela and Joseph Sciorra, eds. 2012. *Graces Received: Painted and Metal Ex-Votos from Italy: the Collection of Leonard Norman Primiano.* New York: John D. Calandra Italian American Institute.

Bucci Bush, Mary. 2011. *Sweet Hope.* Toronto: Guernica Editions.

Calvino, Italo. [1965] 1968. *Cosmicomics.* Translated by William Weaver. San Diego: Harcourt Brace.

Dal Lago, Alessandro, and Serena Giordano. 2008. *Fuori cornice: L'arte oltre l'arte* [*Out of Frame: Art Beyond Art*] Torino: Einaudi.

Davis, Erik, and Michael Rauner. 2006. *The Visionary State: A Journey Through California's Spiritual Landscapes.* San Francisco: Chronicle Books.

Del Giudice, Luisa. 1990. Preliminary Survey of Italian Folklife in Los Angeles, for the Folk and Traditional Arts Program, Department of Cultural Affairs, Los Angeles, 1990; see www.ItalianLosAngeles.org.

———, ed. 2009. *Oral History, Oral Culture and Italian Americans* (Selected papers from the 38th AIHA annual meeting, Los Angeles, 2005). New York: Palgrave Macmillan.

———. 2011 "Sabato Rodia e le Torri di Watts a Los Angeles: Arte, migrazione, e l'immaginario italiano." [Sabato Rodia's Towers in Watts, Los Angeles: Art, Migration, and the Italian Immaginary] In Gabriele Mina (ed.), *Costruttori di Babele: Sulle tracce di architetture fantastiche e universi irregolari in Italia,* [*Builders of Babel: On the Trail of Fantastic Architecture and Irregular Universes in Italy*], edited by Gabriele Mina, 121–32. Milan: Elèuthera.

Di Stasi, Lawrence. 2001. *Una storia segreta: Secret History of Italian American Evacuation and Internment During World War II.* Berkeley: Heyday Books.

Finkel, Jori. 2012. "Edgar Arceneaux Steps down as Head of Watts House Project." *Los Angeles Times,* April 8.

Foote, Donna. 2008. *Relentless Pursuit: A Year in the Trenches with Teach for America.* New York: Knopf.

Gilmore, Mikal. 1989. "The Musicians of Watts." In *The Watts Towers of Los Angeles,* edited by Leon Whiteson, 59–65 Oakville, Ontario, Canada: Mosaic Press.

Goldstone, Bud, and Arloa Paquin Goldstone. 1997. *The Los Angeles Watts Towers.* Los Angeles: Getty Conservation Institute and the J. Paul Getty Museum.

Hale, William. 1954. *The Towers.* Los Angeles: Creative Film Society.

Hernández, Jo Farb. 2001. "A Struggle to Prevail: A Brief History of Sabato Rodia's Towers in Watts." *Raw Vision* 37 (December): 32–39.

Hooks, Rosie Lee, and S. Pearl Sharp. 2005. *Fertile Ground: Stories from the Watts Towers Arts Center.* (film) Los Angeles.

Isoardi, Steven. 2006. *The Dark Tree: Jazz and the Community Arts in Los Angeles.* Berkeley: University of California Press.

Kent, Steven Kyle. 1965. *Watts Towers Theatre Workshop.* (film) Los Angeles: KCET.

Landler, Edward, and Brad Byer. 2006. *I Build the Tower.* (film) Los Angeles: Bench Movies.

McNamara, Michael. 2005. *The Watts Towers.* Toronto: Markham Street Films.

Mencken, Henry L. [1919] 1938. The *American Language: An Inquiry into the Development of English in the United States.* 4th ed. New York: Knopf.

Mina, Gabriele, ed. 2011. *Costruttori di Babele: Sulle tracce di architetture fantastiche e universi irregolari in Italia (Builders of Babel: On the Trail of Fantastic Architecture and Irregular Universes in Italy.* Milan: Elèuthera.

Roe, Stuart, producer. 1965. *Felicia* (film).

Rosen, Seymour. 1979. *In Celebration of Ourselves.* San Francisco: California Living Books, San Francisco Museum of Modern Art.

Ward, Daniel Franklin. 1984. *Personal Places: Perspectives on Informal Art Environments.* Bowling Green, Ohio: Bowling Green State University Popular Press.

Ward, Daniel Franklin, and I. Sheldon Posen. 1985. "Watts Towers and the *Giglio* Tradition." In *Folklife Annual* 1985: A Publication of the American Folklife Center at the Library, 142–57. Washington, D.C.: Library of Congress.

Ward, Daniel Franklin. 1986. *Simon Rodia and His Towers in Watts: An Introduction and a Bibliography.* Monticello, Ill.: Vance Bibliographies.

———. 1990. "Authenticity in the Cultural Hybrid: A Critique of the Community Paradigm in Folk Studies." Unpublished dissertation, Bowling Green University.

Watts Towers Arts Center and Los Angeles Department of Cultural Affairs. 2009. *The Watts Towers: 50 Years of Inspiring Art, 1959–2009* (Commemorative Book). Los Angeles: Watts Towers Arts Center and Los Angeles Department of Cultural Affairs.

Whiteson, Leon. 1989. *The Watts Towers of Los Angeles.* Oakville, Ontario, Canada: Mosaic Press.

Wojcik, Daniel. Forthcoming. *Outsider Art Realms: Visionary Worlds, Trauma, and Transformation.* Jackson: University Press of Mississippi.

Situating Sabato Rodia and the Watts Towers:
Art Movements, Cultural Contexts,
and Migrations

Local Art, Global Issues: Tales of Survival and Demise Among Contemporary Art Environments

Jo Farb Hernández

It was not until I came to Los Angeles in 1974 to pursue my master's degree in folk art at the University of California, Los Angeles, that I visited Sabato Rodia's Watts Towers. I was instantly captivated by them, not only because of their astounding and immediate aesthetic impact, but because I had already been particularly attuned to the genre and, in fact, my final thesis project ultimately focused on a selection of art environments in the center of the United States. Now, having experienced, researched, and documented such sites for more than forty years, I will here share a few general considerations regarding the distinctive genre of these monumental works rather than concentrate on the Towers per se, with the intent that these reflections might be constructive in confronting the challenges of maintaining the future safety and security of Rodia's masterpiece.[1] I will reinforce these thoughts by briefly introducing the work of six contemporary creator-builders of art environments in Spain whose experiences bear out the broader nature of the area under discussion.

The Field: Definitions, Issues, and Concerns

The increasingly well-known phenomenon of art environments has been variously described as folk art, outsider art, *art brut*, intuitive fine art—or as unsightly rubbish. In fact, the very idiosyncrasy of these sites has made it difficult to classify and provide a clear appellation for the genre. Past researchers such as Seymour Rosen, founding director of the nonprofit organization Saving and Preserving Arts and Cultural Environments (SPACES),[2] appended the term "folk art" to distinguish them from contemporary environmental works created by mainstream artists such as Ant Farm's *Cadillac Ranch* in Amarillo, Texas, or Robert Smithson's *Spiral Jetty* on the Great Salt Lake in Utah. However, the term "folk" implies work linked to a collective heritage, reflective of shared standards and aesthetics, and transmitted across generations. In contrast, the types of monumental structures treated in this essay are more often based on a unique personal aesthetic; therefore, it is now standard to drop the label "folk" from the genre designation. As further discussed below, these structures also differ from mainstream environmental artworks as these are typically located on sites with little connection to the artist's personal life or residence, whereas most art environments, such as those discussed here, are constructed on or within the creator's gardens, farm, or home.[3]

Composed of handmade sculptural, garden, and/or architectural structures, art environments have typically been created by "self-taught" artists in the later years of their lives, after developing certain related skills, pursuing a vocation, and making a life for him- or herself and family.[4] Although some artists build more quickly or more productively than others, most sites are assembled over the minimum span of a decade and others for up to thirty or forty years, or even more. It is rare that an artist will voluntarily stop working on his or her site; typically it is only illness, incapacity, or death that finally brings these efforts to a close.[5]

Art environments are generally immobile and monumental in scale or in number of components and are meant to be considered as a whole, rather than as a grouping of discrete parts. They owe less allegiance to popular or mainstream art traditions and the desire to produce anything marketable, and more to personal and cultural experiences and the desire for creative expression. Because of this, these works of art serve to push back the boundaries of aesthetic categories that have been developed in response to a more linear and less wide-ranging historical paradigm; thus, their study argues for a greater inclusiveness in defining such categories and their often complex interrelationships.

In the mainstream art world, concepts of "environment" did not emerge as a generally accepted genre until the 1950s, despite heralded earlier experiments such as artist Kurt Schwitters's celebrated *Merzbau*, begun in 1923.[6] Although tentatively exhibiting such work in the 1950s and 1960s,[7] however, the contemporary art world, despite its relentless efforts to expand the genres considered within its purview, did not begin to take wider notice of such constructions until the following decades. This overdue interest may have resulted in part from the belated recognition that the constructions or their creators have often been equated with a certain degree of eccentricity: Rather than maintaining, expressing, and passing on shared community values, they instead may generate a certain degree of discord or opprobrium within their communities, which, of course, parallels a not-uncommon response to contemporary art from those unfamiliar with that genre as well. In addition, monumental constructions or sculpture made out of recycled

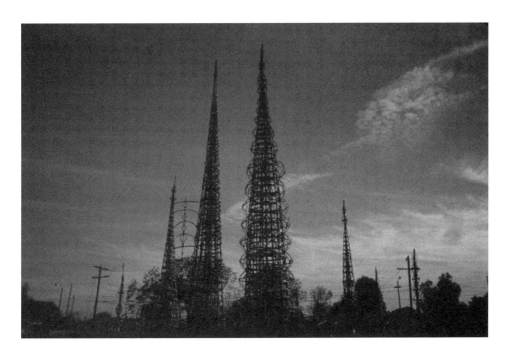

Sabato Rodia (Italian, 1879–1965), Towers, *Los Angeles, Calif., December 2000.*

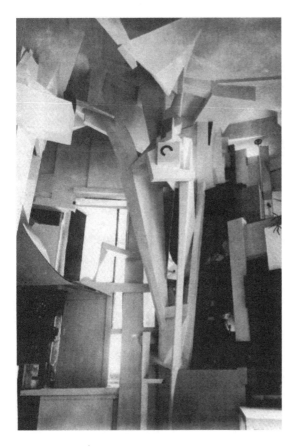

Kurt Schwitters (German, 1887–1948),
Merzbau, *Hannover, Germany,*
www.merzbau.com.

materials—particularly those materials that might be described as "trash" or discards—
were not, until the 1970s, readily desired or acquired by the collector or museum, as they
do not fit the "traditional" form or scale of "Art."[8] Historical documentation typically pre-
sented this kind of work, if it was noted at all, as an esoteric curiosity, and the tone of the
authors was often laced with condescension or derision at what were frequently described
as useless (albeit at times whimsical) "follies"[9] or, inappropriately and at times conde-
scendingly, as folk or primitive art.[10] " 'Don't call me a folk artist, OK?' " one San Francisco
Bay Area artist cautioned a visitor. " 'That's just a way for people to call you a dumb guy.' "[11]

In contrast, concepts of place have always had significant historical resonance in folk-
loric studies.[12] Numerous folklorists have noted its importance in the development of a
sense of self and community, and how the physical attributes of the creator's surround-
ings play an important role in shaping creative output. Yet art environment sites are in-
tuitive and idiosyncratic: They transcend all boundaries of regional style or historical
convention and suggest a process in which the unconscious overwhelms the conscious.[13]
As such, defining them as folk art tends to miss the mark:

- although construction techniques may have been learned through folk-style intergen-
 erational or vocational group transmission; and
- although perhaps in some instances the monumentality or "otherness" of these sites
 may be interpreted as simply a function of scale, moving along a creative continuum
 from the ordinary or even traditional act—such as Rodia's birdbaths constructed in
 the yard of his former home in Long Beach—to the extraordinary and more personal
 act—such as the Towers themselves; and
- although these sites often reveal overt references to orally transmitted myths, leg-
 ends, and tales, as well as to general cultural aesthetics and practices; and
- although in certain instances there may be legitimate and credible formalist or con-
 ceptual connections that can be drawn between traditional aesthetic manifestations
 such as, in the case of Rodia, the towers of the *Gigli* of Nola (Ward and Posen 1985:
 143–157).

For the most part these environments are singular, creative acts: contemporary works
of art that can stand on their own without a qualifying adjective. This does not, however,
change the need to explore and seek to understand the social and cultural ways that each
site affects its creator, as it defines a new identity for him or her within his or her commu-
nity. Documenting and preserving the cultural heritage of these environments is, therefore,
an essential component of a holistic concept of the sense of place, as well as an essential
complement to research into the individual artist who has created each unique site.

An important constituent element of the form and even the content of the construction
of these types of monumental artworks is the availability of locally accessible materials,
which are wrested from their ordinary contexts and metamorphosed by the artist into
something else entirely. The imagery can be highly imaginative, fanciful, or quixotic,
and, whether abstract or more representational, is frequently characterized by incongruous
juxtapositions. Art environments often may embody a sense of suspended animation, a
dynamic approach to creation that appears impulsive and spontaneous. Many of these sites
are densely packed with innumerable elements, generally including found objects whose
previous function may challenge or confuse the current function the piece is serving; por-
tions may be wildly (and perhaps jarringly) colorful, and the site as a whole may be situated

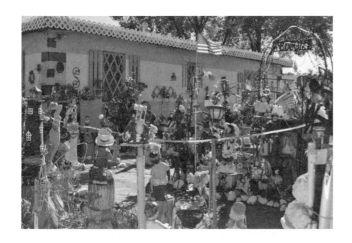

C. L. Sharpe (American, b. ca. 1931), Helen's Garden, *detail, Santa Fe, N.M., October 2009.*

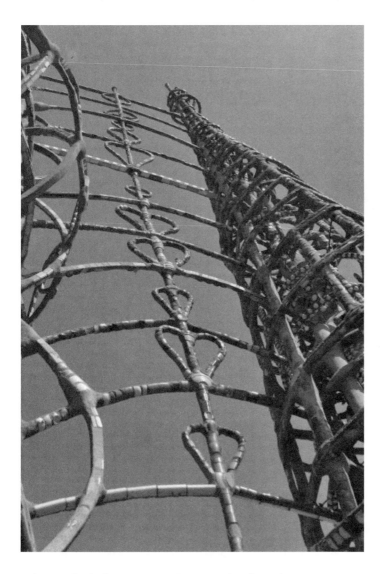

Sabato Rodia (Italian, 1879–1965), Towers, *detail, October 2009.*

on a variety of levels as it follows the natural topographical contours of the terrain. Finished fabricated works may share space with natural plant or mineral forms, works in progress, and raw materials (often considered by others to be junk or cast-off detritus) piled up to be used in future constructions; further, to add to the physical and formal intricacy, aesthetic meaning is typically not solely the unique intent but is often superimposed on historical, social, spiritual, and even cosmological references. (Some of the artists are so intent on ensuring the viewer's comprehension that they include numerous signs, lists, exhortations, and other written notices to overtly proclaim their motivations or points of view.) The sites were developed organically, without formal architectural or engineering plans—and often without even simple conceptual drawings—thus manifesting an additive process of creation without a preconception of the grandeur that they would ultimately attain.

Yet Rodia has been quoted as saying "I was going to do something big, and I did,"[14] thus suggesting that he had a grandiose preconception of the form and scale that his constructions would take from their inception. In a parallel vein, some scholars researching other environmental sites have assumed that those creators, too, began their decades of labor inspired from the beginning by similar visions of grandeur, partly due to such expansive artistic statements—which always were, of course, proclaimed after a lifetime of work had been achieved. I am skeptical, however. My deduction, after experiencing and studying literally hundreds of these sites and speaking to dozens of artists, is that the process is not merely additive but accumulative and accretive. Making art stimulates one to make more art: Successful completion of one sculpture tends to provoke the desire to make another, enabling one to learn from past methodological mistakes and branch out with greater conceptual confidence as well as with greater physical and technical prowess. Anecdotal descriptions from Rodia's neighbors as they watched him work recount his dismantling, rebuilding, refining, and experimenting, certainly suggesting that he was learning from each day's work and being motivated by the physical manipulation of the materials themselves.[15] So although an artist may, in effect, say that she or he always had planned it this way, a more accurate assessment is that in most instances the process was ongoing and improvisational and that the artist was inspired daily to continue to construct, to embellish, and to create by the very acts of constructing, embellishing, and creating.

The work of these artist-builders is typically discussed solely with reference to the "outsider art" field. However, many of them grapple with some of the same formalist, conceptual, and aesthetic issues that any academically trained artist confronts, despite their characteristic isolation from the contemporary art world. It is also noteworthy that although academically trained artists have long looked to the art of nonacademic creators for inspiration and stimulus—some produced work that may have even bordered on plagiarism, while numerous others appropriated media, technique, or subject[16]—the hierarchy of mainstream art movements continues to isolate those creators to whom some of the acknowledged masters of Western art history paid unrewarded homage. These two fields have historically been approached in radically different—if not oppositional—ways, yet a comprehensive look at art environments provides the opportunity to challenge the ideological art historical doctrine that delineates a chronological linear progression of stylistic logic, and to explore the convergence of contemporary and "outsider" art.

Although a thorough exploration of this topic far exceeds the scope of this essay, it is worth briefly noting several core congruencies. One can be drawn from examining the "peripheral" geographies of Western cultural histories. Early-twentieth-century Califor-

nia could hardly have been perceived as a cultural center vis-à-vis the powerhouses of Paris and, later, New York. Consequently, fully aware that they could not rely on the annals of historical learning—be those situated in august universities or resulting from genealogically based economic enterprises—California's greatest pioneers instead based their innovations on experiential discoveries. Learning by doing rather than by studying became the modern standard by which these formerly anonymous leaders broke new ground, forging a society markedly different from those in historically recognized capitals. In the commercial arts, the Hollywood studios are a prime example, wrenching film from its sentimental roots and catapulting it into the modern era; in a more personal vein, Rodia's Towers are equally exemplary. In each case, the creators riffed only tangentially on what had gone before to construct something completely new. Striving toward self-expression, discounting past manifestations and thoughtless conformity, and welcoming difference, distinction, and even defiance: These are all hallmarks of cultural and aesthetic modernism. And as much as the creators themselves, modernism's audiences—including those visiting and viewing art environments—likewise embrace the romantic edge of cultural rebellion that these works exude.

A second perspective in this regard is the oft-repeated assertion that the quintessential modernist work is the assemblage or montage.[17] The cultural and historical equilibrium provided by centuries of representational works describing life anchored by our views (or fears) of "nature, man, and God" (Seitz 1961: 74) is thoroughly destabilized by composite works that force the viewer to balance between the identification of the familiar prosaic fragments comprising the work and the conceptual and aesthetic transcendence that is pursued by considering the work as a whole. As we alternatively focus on this collision between our experiential expectation of the functions typically served by these objects and the perceptual evidence we are confronted with, our response to the work itself shifts, and we are more apt to layer our own personal histories and experiences on top of the totality of the varied expressions of the artist's arrangements. This thus destroys any "conceptual preconditioning," to quote Seitz, and ensures that there is no single univocal "reality" possible from such an assemblage, as there is no single comparable reality within modern society. Marcel Duchamp's "readymades" and the "junk aesthetic" of the 1950s and 1960s are classic examples of the "disequilibrious clash of expectations and perception," (Greenfield 1984: 136) but art environments reveal this modernist ideal equally as well as do the assemblages or collages of academically trained mainstream artists.

Art environments distinctively take this modernist quest even further, because although they are clearly most affiliated with the visual arts, they are often related to performance events as well, due to the time-based development that is so essential to their essence. Unlike a painting that is in process until it is finished and is then studied and understood solely on the basis of that final product, these sites are constantly evolving at the same time that they are constantly complete. This time-based element also promotes the intermingling of visual arts and performance events by way of the participatory and interactive dialogue that is set up with site visitors as they physically enter into and explore the creator's constructions. Because of the complexity of these sites, they are as a rule neither completely comprehensible nor clearly viewable from a single perspective. What may at first seem rather chaotic or disordered will often evolve, after multiple viewings from multiple perspectives, into a patterned, rhythmic milieu that is akin to those gestures found in improvisational jazz.

Taya Doro Mitchell (Dutch, b. 1934),
living room interior and ceiling,
Oakland, Calif., May 2009.

One example of this is the *Palais Idéal* of French postman Ferdinand Cheval, in Hauterives, outside of Lyon. While making his daily rounds, Cheval's foot caught on a stone that arrested his glance; later he returned to pick it up, along with many other such weathered and curiously shaped rocks. Thus began the creation of a monument on which the postman worked, in his "off" hours, for some thirty-three years. This discovery exemplifies the enormous power of the found object to motivate the visionary artist: A chance encounter with a fragment of stone or a piece of broken glass can become the incentive to a life's labor. The *Palais* is among the oldest surviving, most extensive, and most extraordinary of architectural sculptures and a virtual encyclopedia of the forms of visionary environments the world over: architecture, sculpture, grotto, temple, and garden. It is also an encyclopedia of oft-used themes: religion and patriotism, brotherhood and equality, individual freedom and self-motivated labor. Almost as important as the form and iconography of Cheval's monument, however, is the way it both inspired and validated the ideas of a later generation of artists; among the most significant is that his *Palais* confirmed core surrealist notions about automatic creativity.[18] This manifest link to one of the most important movements in twentieth-century art history should be sufficient, in and of itself, to argue for a greater inclusiveness in defining the entire artistic canon.[19]

Fundamental to this discussion, as noted above, is that most creators of art environments build on or within their own immediate and personal spaces: These are their own

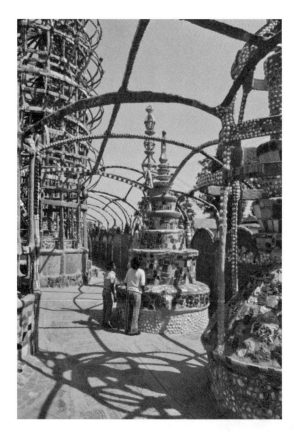

Sabato Rodia (Italian, 1879–1965),
Towers, *detail, interior with visitors,*
photograph by Seymour Rosen,
© SPACES, April 1972.

private homes, their gardens, their farms. This fusion of art with life becomes a total synthesis, generally unmatched in any other circumstances of making art, revealing not only complete commitment to the work and a blurring of divisions between art and daily living, but an open self-reflection of the maker's life and concerns. Indeed, they become self-portraits, as Cardinal has mused, "where every facet represents an entry in the curriculum vitae" (Cardinal 2000–1: 7).

Art Environments in Spain

Almost everyone who has ever worked with the Watts Towers has fielded questions about Catalan Antoni Gaudí (1852–1926), undoubtedly the most renowned of Spain's impressive roster of visionary architects.[20] His sumptuous, imaginative works cast a long shadow, not only for those contemporary disciples and students who worked with him during their original explorations of Catalan *modernisme*, but for any number of trained and untrained builders who have since utilized broken pieces of ceramic tiles on expansively constructed organic forms. The worldwide incidence of this type of sculptural or architectural assembly and ornamentation, however, suggests that it is more a universal response to "making do" with diverse and locally available materials than merely derivative reiterations of the master's techniques.

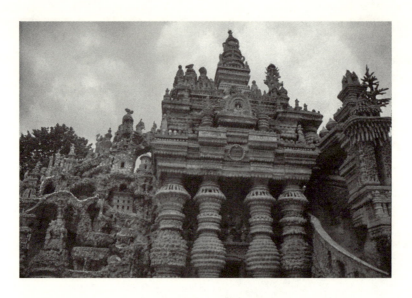

Ferdinand Cheval (French, 1836–1924), Palais Idéal, *detail, Hauterives, France, August 2004.*

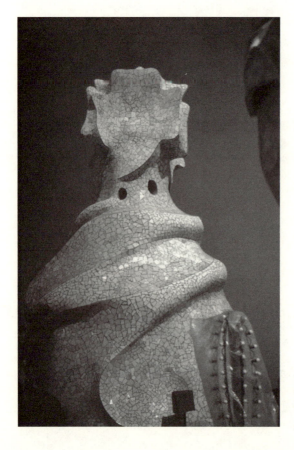

Antoni Gaudí (Catalan, 1852–1926),
La Pedrera, *rooftop detail, Barcelona,*
Spain, photograph by Sam Hernández,
July 1999.

There is no evidence that Rodia knew about Gaudí's works. There is, however, persuasive scholarship that suggests that traditional Italian garden ornaments featuring a similar bricolage aesthetic would have been well-known to him.[21] Yet as Gaudí moved beyond the stylish *modernisme* of his day, so too did Rodia refract and surpass the simpler expressions of the traditions of Mediterranean-style bricolage. And although Rodia's Towers are a masterpiece of the genre, they do not stand alone as a category of artistic expression; indeed, thousands of such constructions, each distinctive in its own way, have been documented around the globe.

My recent research on work of this genre has been in Spain,[22] so although I have researched, written about, and advocated on behalf of the Watts Towers, in acknowledgment of the breadth and depth of the work of this book's cowriters on that site, I will focus this essay on several Spanish art environment creators. To illustrate, I will provide cursory descriptions and images of the work of six of these artists out of a total of almost fifty that I have been studying in the last few years, to provide a sense of the range of imagery and aesthetic that informs the field, and to underscore the need for breaking down boundaries and categories with these personalized aesthetic expressions.

Of equal importance in this text is the recognition of the reality that despite the uniqueness and idiosyncrasies of each art environment site, many face similar predicaments in terms of community response and governmental pressure. It cannot be denied that the fame accorded Gaudí's works has affected general response to other nonstandard constructions within Spain. However, cognizance of his works has not necessarily been associated with the willingness of local building inspectors, municipal councils, or urban planning committees to bend regulations inscribed in local property ordinances or civic improvement strategies in order to preserve these extravagant sites and allow them to flourish. The appalling history of City of Los Angeles bureaucrats tilting against the Towers—which would be almost laughably absurd if it had not had such a severely negative impact on the long-term stability of one of the world's greatest works of public art—has, unfortunately, numerous replications, as the following synopses will show.

Francisco González Gragera (b. 1935)

When Francisco González Gragera began the construction of the *Capricho de Cotrina*[23] next to his stonework business in 1988, he envisioned the site as a new and extraordinary country home for himself and his family, an opportunity to explore his expanding interests in sculpting natural forms, and, ultimately, an attraction that could be added to the Ruta de la Plata (Silver Route), one of the newly designated itineraries promoted by Spain's national government to bring tourists to the interior of the country.[24] On the outskirts of the village of Los Santos de Maimona in the western province of Badajoz, the site is adjacent to a major thoroughfare and thus attracts a number of visitors who are drawn off the road by the organic crenellation of three towers, sheathed in bright tiles affixed in a random but formally balanced exemplar of *trencadís* (often described as *picassiette* mosaic) composition. Fronted by an undulating fence of vertical finials thrusting upward into the Extremaduran sun, the towers and accompanying domes melt down into asymmetrical cylindrical shapes, pierced with an assortment of abstractly shaped windows and limned by a curvilinear exterior staircase that provides fine views of the complexity and meticulous craftsmanship of González Gragera's artistry. In contrast to

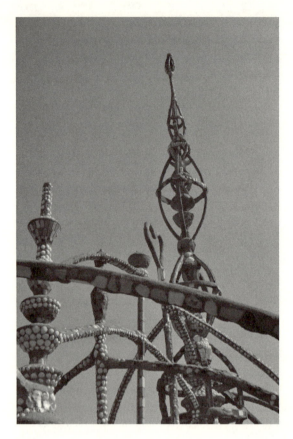

Sabato Rodia (Italian, 1879–1965),
Towers, *detail of finials, October 2009.*

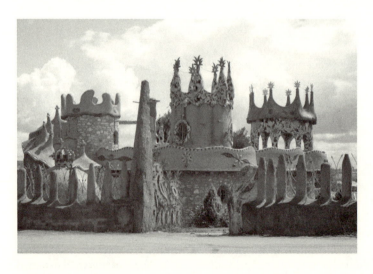

Francisco González Gragera (Spanish, b. 1935), Capricho de Cotrina, *western façade and entry fence,*
April 2008.

the products of his decades-long vocation—flat marble and granite floors, façades, and even sober geometrically rectilinear headstones—his architectural–sculptural *Capricho* flamboyantly celebrates the curve.

This site, immediately compelling with its fantastic forms, otherworldly plants, and imaginary animals, has become one of the most complex and interesting art environments in the entire country. However, a battle developed between the artist and the local municipal offices that called into question whether he would be able to complete his construction as he envisioned. After two decades of working on his *Capricho*, the city decided to require González Gragera to "requalify" himself as an architect or engineer, neither of which he pretends to be and for neither of which does he possess the kind of skills that would enable him to succeed in any kind of qualifying written examination.

So although the artist's site is on the outskirts of town, in 2006 he was slapped with a "stop work" order. At stake was the newest section of the home, which the artist began constructing in 2005. Conceptualized as taking the shape of a worm, with a rippling hallway rising and falling both vertically and horizontally, the "head" of the worm culminates

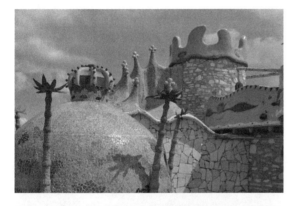
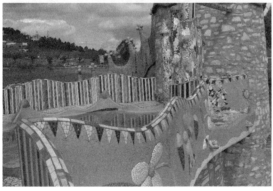
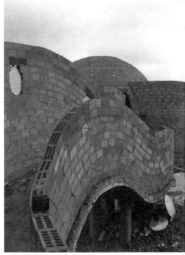

Francisco González Gragera (Spanish, b. 1935), Capricho de Cotrina. *Above left, detail, northwestern corner with cupola. Below left, detail, second-level bridge, reflecting pool and tower. Right, detail, "worm" hallway and master bedroom under construction, April 2008.*

in a two-story spherical building, the top floor of which will become the master bedroom and the bottom a garage. Yet the town architect updated the general plan to include a new thirty-foot-wide road to be routed through the portion of González Gragera's property that includes the new "worm" construction. Given that a road within one-eighth mile of the property already existed, this plan seemed designed solely to harass the artist and to force him to cease construction.

This deadlock was a fundamental power struggle about which entity has the dominant right to define the parameters of art within the community. González Gragera acted on an individual basis to design and develop his project, working quietly and privately without government support, spending little money, and not deferring to the laws or the regulations of the local authorities. His efforts have been wildly successful: He has attracted local and now international attention, and he welcomes visitors at his site almost every day. Although not deliberately, he has in this way excluded the city from exercising power in this realm. In response, refusing to submit to this gentle mutiny, the city took to other paths to wrest it back. Although city officials did not mandate demolition, neither would they allow the artist to advance with or enhance the site in any way.

González Gragera dutifully refrained from working on his *Capricho* for almost three years. But finally, in mid-2009, he quietly began to carry on with his plans to finish his vision, despite the nagging worry that he would be fined, punished, or forced to dismantle the new sections of the site. But then, in spring 2011, a "new administration" was elected, one that recognized the value of the work for the artist, for the village, and for a broader public. Finally, the *Capricho de Cotrina* is being included in the local publicity

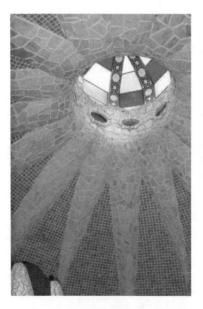
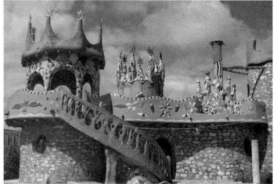

Francisco González Gragera (Spanish, b. 1935), Capricho de Cotrina. Left, *detail, cupola ceiling interior, bathroom.* Above right, *detail, eastern façade, April 2008.*

for the Ruta de la Plata tourist materials, and the authorities seem to have recognized the potential source of income González Gragera's site can serve locally, with tourists visiting and then stopping to eat or drink or purchase provisions among the local townspeople. But, more fundamentally, of course, the significant and direct hardship on the artist himself has been averted. As Karpel has commented, such visionary builders are "swept up by a grand vision, not just of what they can create *but of who they can become*" (Karpel 2009: 18, italics his). González Gragera looks forward to finishing his house and spending the rest of his life enjoying the fruits of his labors, opening the site for public visitation during the day, and closing it for the personal enjoyment of his family at night. He would never sell it, he says, unless, of course, someone gave him so much money that he could afford to quickly build a new one (Rosa 2010).

Justo Gallego Martínez (b. 1925)

Perhaps Spain's most famous example of work of this nature is the handmade cathedral being built just outside of Madrid.[25] Born into a family of farmers, Justo Gallego Martínez

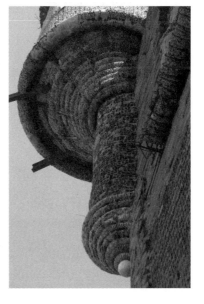

Justo Gallego Martínez (Spanish, b. 1925), Cathedral. Above left, *view from southwest.* Below left, *view to southwest.* Right, *detail, Tower, April 2008.*

dedicated himself to his religion and entered a Trappist monastery when very young. A small and (superficially) fragile man, the rigors of monastic life made him susceptible to disease; after he contracted tuberculosis in the early 1960s, before taking his final vows, he was asked by the ecclesiastic authorities to leave the monastery.

Faith in the administrators of his religion broken but not in his religion itself, Don Justo, as he is known, was left several hectares of farmland after the death of his parents. On this land, he began the construction of a cathedral dedicated to Nuestra Señora del Pilar, one of the most revered aspects of the Virgin Mary.[26] With no architectural, art, engineering, or even construction background, he sold off part of the farmland to purchase supplies to erect this monument, the plans for which exist only in his head. Once the money from the sale of the land was exhausted, he continued with recycled materials of all kinds as well as seconds donated by local building contractors. Ten stories high, with the top of the dome rising at least 130 feet, the cathedral has now been under construction for more than five decades.

During all this time, Don Justo has worked mostly alone, but now, in his mid-eighties, he occasionally hires young laborers to help with some of the heavy lifting (using such low-tech mechanisms as bicycle wheels for pulleys to bring cement and supplies to the higher levels). He has bequeathed the cathedral to the bishopric in a nearby town,

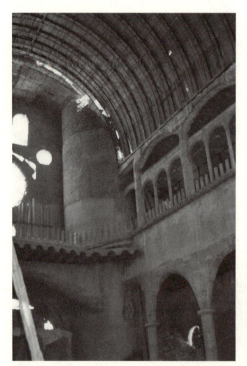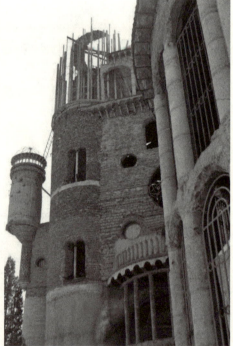

Justo Gallego Martínez (Spanish, b. 1925), Cathedral. Left, *detail, interior.* Right, *detail, frontage on Architect Gaudí Street, April 2008.*

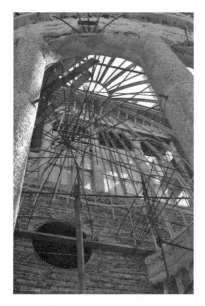 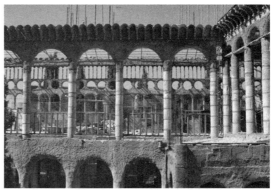

Justo Gallego Martínez (Spanish, b. 1925), Cathedral. Left, *detail, interior courtyard, construction details.* Above right, *detail, interior courtyard, April 2008.*

but they call it a "poisoned present,"[27] for despite the fact that the 24,000-square-foot structure has a cloister, a crypt, and a portico, besides the huge domes and myriad spiral staircases, it has no construction permit, no architectural or engineering plans of any kind, and no inspection clearance, all requirements for the necessary building and occupancy licenses that would be required for the cathedral to actually be used.

Although the municipal and ecclesiastic authorities have stopped fighting with Don Justo for the moment, given his advanced age and increasing fragility it is unlikely that he will finish his dream. If he does not, it is as yet unclear what will happen to the cathedral. Filling oil drums with cement and then stacking them on top of each other to extend the towers, using old tires in which to mold the window arches, building with bricks that were so overfired that they partially melted (so much so that looking up at the walls provokes vertiginous queasiness), obvious questions are raised about its foundations, supports, and overall stability. Despite its notoriety, no architect or contractor has been willing to undertake responsibility for helping Don Justo to modify his cathedral to meet standards of structural integrity. It is therefore very possible that immediately after his death, the entire structure will be razed to the ground by the municipal authorities.

Francisco del Río Cuenca (1926–2010)

The industrious young man Francisco del Río Cuenca held a variety of low-paying jobs, from working in a factory in Germany to working as a cook for a family in Ibiza, to cultivating his own small plot of land in a primitive process of subsistence farming.[28] Desperately poor, without asking permission from the municipality of Montoro, he made use of

an empty space within a small grouping of houses at the edge of town that had been bombed out during the Spanish Civil War. There, he began constructing a home. He, his wife, and three daughters lived in one room while his sister and eight others lived in a second room. The house, which he built all himself with the help of a single additional worker, was ultimately composed of two floors with four exterior patios at the rear.

As he was building, he worried about the time and money that he would have to spend annually to whitewash the lime on the façade of his home (the socially and culturally acceptable exterior surface treatment for local buildings). Serendipitously, a truck loaded with clams had an accident near his inland home near Córdoba, discharging its load. He thought that he could save himself the drudgery of the exterior painting if he covered the façade with the shells, so he mounted his motorcycle and rode back and forth from the accident site, bringing home hundreds of bags of shells from the time of the accident in 1957 until he finished the house itself in 1959. He began to apply the decoration in 1960 and continued until his death. There are now 115 million shells from all over the world adorning the interior and exterior of the house.

The initial idea of saving time turned out to be an absolute chimera, of course, something that became immediately clear as the work continued. Moving on from the

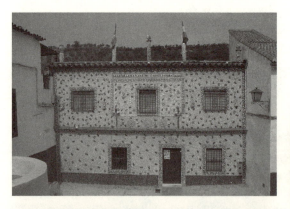
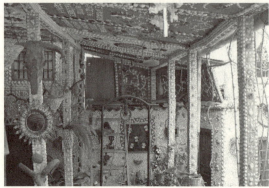
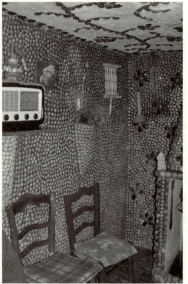

Francisco del Río Cuenca (Spanish, b. 1926), Casa de las Conchas. Above left, *front façade.* Below left, *detail, rear patio, March 2009.* Right, *detail, kitchen interior.*

façade, he continued with the interior hallway and garden patios, ultimately covering not only the walls but the floors, the ceiling, the stairs, the flowerpots and even the trees with shells. The result is an almost baroque bas-relief incrustation of movement and texture everywhere one looks. The artist's earnest and modest demeanor endeared him to his thousands of visitors over the years, who reciprocated his graciousness in letting them see his home by sending him shells from their own areas or countries of origin.

Functionally semi-illiterate despite his few years education with the local monks, Francisco del Río Cuenca sought help in composing written statements that he made part of his home's decoration to honor his daughters and their families, the areas of origin of some of his shells, his pride in his creation, and his appreciation of his visitors. His name and the

Francisco del Río Cuenca (Spanish, b. 1926), Casa de las Conchas. Above, *detail, west wall, third patio, rear of house.* Below, *detail, east wall, third patio, rear of house, with staircase to terrace over fourth patio, March 2009.*

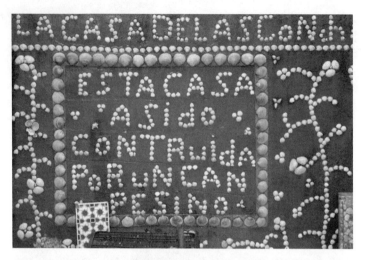

Francisco del Río Cuenca (Spanish, b. 1926), Casa de las Conchas. Above, *detail, north third patio, rear of house, "The House of Shells. This House was built by a Peasant."* Below, *detail, the artist in front of his home, April 2008.*

name of his village adorn many of the walls, as one proudly proclaims, with numerous spelling mistakes, that "this house was constructed by a peasant [*esta casa asido* (sic) *contruida* (sic) *por un canpesino* (sic)]." Although he never received help from the municipality in terms of funding, they do recognize his work as a tourist draw (apparently after it was informally deemed the seventh wonder of Córdoba, that city of so many wonders located less than twenty miles to the west) and did not seek to disturb his work. He worked on the house until he could work no longer, and now a grandson leads visitors through the house and grounds. However, the masterpiece is a burden for the family, and the site is up for sale.

José María Garrido Garciá (1925–ca. 2013)

Sanlúcar de Barrameda sits at the mouth of the Guadalquivir River where it empties into the Atlantic Ocean, mixing at the same time with the waters of the Mediterranean Sea.[29] Because of its location at the intersection of these three bodies of water, this region, though rich in fish, suffers from numerous currents, storms, and underwater tide pools that make fishing both unpredictable and dangerous. Located at the southwestern-most tip of Spain, this was the departure site for Christopher Columbus's third and fourth voyages to the Americas, Fernando Magellan's quest to circumnavigate the globe, and numerous other explorers', merchants', and mariners' trips to follow their dreams or make their fortunes. Many lost their lives and did not return.

Born to a fisherman's family, José María Garrido had only one real career option growing up: to follow his father to sea. During the final years of the Spanish Civil War, there was severe hunger and deprivation all over the country, and young boys had to go to work as early as they could to help their families survive. Without ever attending school, he taught himself to read and write, obtained his fisherman's license at the age of fifteen, and went to sea.

Garrido worked as a fisherman for twenty years, until the stormy day in 1959 that his close friend José Sánchez Pérez was dragged overboard by an anchor that grabbed his pant leg. Thirty-nine years old, Sánchez left behind five children and a pregnant wife who would not be sufficiently supported by survivor's benefits. From that moment on, not only did Garrido never again set sail, he never even put one foot in the sea that up until then had been his life as well as his livelihood.

Instead, he decided to pay homage to his friend, and to the sea that was such a part of his history and his very being, by creating a museum in a run-down building in an area close to the municipal market. Beginning in 1960, he worked every day on the Museo del Mar, covering the walls with more than 80,000 sea snail shells, as well as with photographs of old ships, signs on which he painted maritime proverbs, and innumerable other objects that he gathered from the beaches after storms. Because the building is so long and narrow, he easily adapted it to the shape of a boat, even adding a built-in sleeping bunk and a "treasure chest." He became an avid historian of the sea and of how it shaped his natal city, and was full of the legends and stories that provide such a sense of place to the old-timers.

Unfortunately, these old-timers are not those in power. Although the decrepit building dating from 1503 that now houses Garrido's museum had been in a less-than-desirable neighborhood when he purchased it—in fact, immediately prior it had been a house of prostitution, the last stop for sailors before they left the port—now the municipal council has designs on the property. They tried to buy the building from Garrido, but because he knew that their goal was to demolish it, he refused. His rejection of their deceitful offer was made more laudable because he was so poor that his only real source of income, uncertain though it may have been, was to collect shark heads from the market's refuse, clean off the rotten flesh, pry their mouths open with small pieces of wood, bleach them in the sun, and sell them for five euros to the few tourists who passed through town. Faced with his adamancy, the city purchased the building next door—in worse shape than his own, without even a roof—and made it official town policy to let it collapse from the effect of the weather, hoping that it would take Garrido's museum down at the same time.

José María Garrido (Spanish, 1925–ca. 2013), Museo del Mar "Las Caracolas." Left, *front façade.* Right, *detail, eastern façade with sailors' proverbs, March 2009.*

José María Garrido (Spanish, 1925–ca. 2013), Museo del Mar "Las Caracolas." Left, *detail, interior stairway.* Right, *detail, antechamber, March 2009.*

José María Garrido (Spanish, 1925–ca. 2013), Museo del Mar "Las Caracolas." Above, *detail, sleeping berth (demonstrated by artist).* Below, *detail, roof terrace, March 2009.*

Discouraged, by 2009 Garrido had stopped opening the museum to the public and even stopped going to the plaza to sell his sharks' jaws. He wanted to bequeath his vast knowledge and vast collection of materials to the city, but officials were not interested, despite the value of the numerous ancient Greek, Roman, and early Spanish coins and artifacts he had found,[30] and despite the value of the historical photos and important data about ships and shipwrecks he had recorded. As the sign on the top of his museum pleas, Garrido and his museum are only appealing for justice.

Julio Basanta López (b. 1933)

Perhaps the most immediately arresting site in Spain is the group of *castillicos*, little castles, created on the outskirts of a small village near Zaragoza in a rather desolate part of Aragón.[31] Julio Basanta, born into a family of ten brothers and sisters, was abandoned

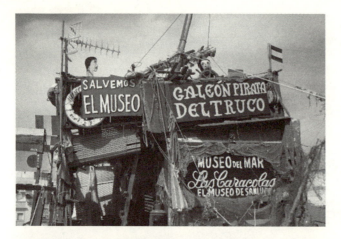

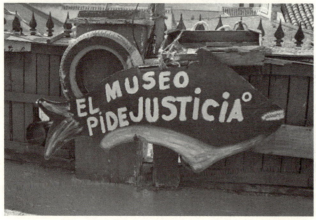

José María Garrido (Spanish, 1925–ca. 2013), Museo del Mar "Las Caracolas." Above, *detail, roof terrace with placards identifying the museum and urging people to save it.* Below, *detail, placard on roof:* "The Museum Pleads for Justice," *March 2009.*

with his siblings by their father soon after his birth; he was raised in an orphanage, where he received the basic (and brief) education common to those difficult times. He learned the basic skills of a construction worker and worked independently, doing small jobs; later, he married and had five children, four of them daughters.

Although Basanta protests that he is not religious, it can be assumed that his upbringing in the charitable children's home in Franco's Spain included some basic religious instruction, and although he has described his constructions as a House of God, in fact it appears to be populated to a greater extent by what he defines as demons. There are demons among all of us, he has said, and although they cannot penetrate everyone, they certainly live among us. His vehemence regarding this belief not only is underscored by the psychological stress of early abandonment by his father but was exacerbated by two

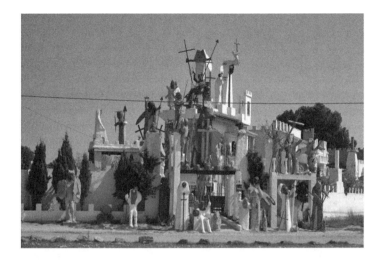

Julio Basanta (Spanish, b. 1933), La Casa de Dios, *front façade, March 2009.*

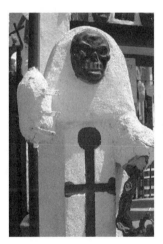 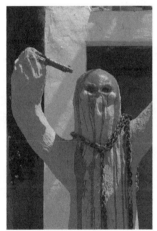 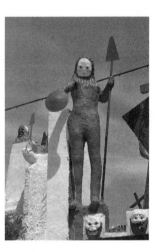

Julio Basanta (Spanish, b. 1933), La Casa de Dios. *Left and center, detail, demon. Right, detail, demon surmounting front façade, May 2008.*

deaths of close relatives: the first of his brother Vicente in 1977 and then that of his only son, Moises, in 2004, both in mysterious circumstances involving the police.

In an effort to identify—and possibly exorcise—some of these demons, he has surrounded his three little *castillicos* with them (distinguishing them from the gods by their red eyes). Larger than life, leaning imposingly toward the viewer as they tower over him or her, they are built on a fairly sloppy infrastructure of wood and iron rods or wires, then covered with cement and industrial paints of vivid colors. Most are created from scratch, but others are transformed garden gnomes or dwarves that have

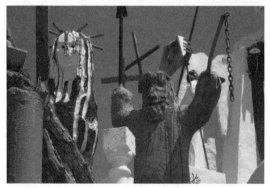

Julio Basanta (Spanish, b. 1933), La Casa de Dios. Above left and right, *detail, demon.* Below left, *detail, Christ and demons, May 2008.*

had their heads replaced with more expressionist and disturbing beings. They surround the exterior of the *castillicos* but are concentrated toward the front entrance and are clearly intended to be seen not only from the outside of the buildings themselves but from outside the fence that surrounds the property. Over the last several years, Basanta has repainted some of the existing figures, has glued some plastic reptiles to their bodies, has repositioned others, and has even created new figures with new and disturbing characteristics.

Working alone with help only from his wife, Basanta is both proud of his work and simultaneously dismissive of it. At times he has said that it should be maintained as a museum and given to the municipality; other times he had said that since his son's death, with his daughters terrorized by his work and therefore not interested in living there or maintaining the property, he expects that at some point he will douse it all with gasoline and blow it all up.

Josep Pujiula i Vila (b. 1937)

For some forty-five years, several different versions of a spectacular and arresting art environment rose and fell alongside a curve in the shallow Fluvià River in northwestern

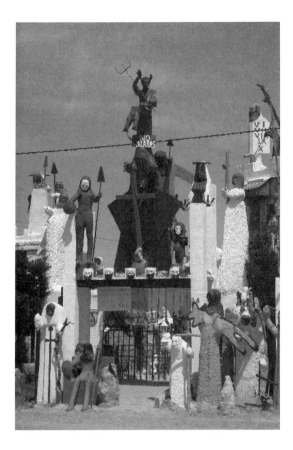

Detail, front façade and entry gate:
"Thou Shall Not Kill," May 2008.

Catalunya.[32] Nestled among the medieval villages, this fantastic, sprawling construction
at once harmonized and collided with the well-worn stones, deep valleys, and verdant dor-
mant volcanic cones of its surroundings. Locally known as a *parc salvatge* (wild park) or
poblat salvatge (wild village), seven soaring towers, innumerable bridges, shelters, walk-
ways, stairwells, and, above all, a labyrinth over 1.5 kilometers long comprised the most
extensive incarnation of the labors of Josep Pujiula i Vila. The entire intricate construction
covered just barely over one hectare of land, and the towers soared over thirty meters high,
jauntily capped by Catalan flags and banners. It was the world's best jungle gym, the most
unaffected open-air sanctuary, the most devilishly enjoyable maze, the "Sagrada Familia
of Art Brut" (Casasses 2001), in a Madrid newspaper's apt aesthetic and conceptual refer-
ence to one of Spain's most recognizable architectural treasures, the Barcelona temple de-
signed by Antoni Gaudí.

 Pujiula, born in a neighboring village fronting the river, attended school only until
age thirteen; later, he became a metal-turning machinist, married, and had a daughter.
Yet although working long hours and spending time with his wife and child would seem
to provide sufficient activity to fill a young man's days, Pujiula wanted to do something
that would be edifying for him and perhaps for his family, friends, and community as
well. Unlike certain other creators of art environments who have constructed their

monuments to retell local histories,[33] comment on social or political issues,[34] or glorify religious belief,[35] Pujiula had no initial intent other than to entertain himself and occupy his free time.[36]

I have recounted the complete story of Pujiula's early inspirations to construct what became one of the world's most impressive art environments in my 2005 book, *Forms of Tradition in Contemporary Spain*, continuing the narrative of the site's development through 2013 in my book of that same year, *Singular Spaces: From the Eccentric to the Extraordinary in Spanish Art Environments*. Suffice it to note here that he worked intuitively and quickly, moving from evading the view of the authorities—since he was working on land that was not his own—to a determined effort to ensure that the public knew about, visited, and physically participated in his constructions by climbing and walking within.

The most impressive components of the huge site were woven basket-like passageways created by the flexible, curved slender branches of saplings that he collected from the nearby river, each tightly wired to its neighbors and completely enclosing the pathways with ovoid arches. These pathways became a labyrinth complex with intertwined paths, yet the openness of the construction enabled visitors to see contiguous pathways as well as nearby bridges, stairs, and the towers. The convoluted and intricate nature of the construction, however, often prevented people from figuring out how to reach or approach even adjacent points. The cage-like warrens twisted and turned back on themselves, dead-ended, and forced people up and down ladders and through portals. It was easy to get disoriented and lost. Visitors loved the labyrinth, and Pujiula delighted when people asked whether they could enter, chuckling to himself that the real question was whether they would also be able to leave.

Despite the public enjoyment of this site and increasing visitation, in 2002 Pujiula was forced to demolish the entire structure, as the local authorities had decided to reroute the immediately adjacent thoroughfare in order to straighten out the dangerous curve in the road (a slight curve, actually, whose danger was exponentially increased by drivers craning to see Pujiula's roadside construction).[37] He took the construction apart, piece by piece, first working with his regular hand tools and then with a newly purchased chainsaw when it became apparent that a worldwide mobilization would not be of help.[38] I went every day in the summer of 2002 to watch him take it down; I was thoroughly depressed, but Pujiula was philosophical, saying that it had been an adventure putting the work up, and likewise it was an adventure taking it down. By the middle of that fall, he had removed it all, cleaned up all the debris, and lit the last of the bonfires that consumed decades of his work.

In 2003, with the roadwork plowing through the site, he convinced the men working on the highway above to give him their "extra" concrete and steel, enabling him to create a lyrical cascading fountain—on a slightly different location yet still on land that is not his own. Bucket by bucket, he smoothed out a wide albeit shallow swimming hole; he liberally ornamented the sides of the spillway leading from the large concrete drainage pipe that passes underneath the freeway with smoothed concrete rounds to facilitate access to all portions of the site, as well as with elaborate vertical concrete components and openwork steel sculptures, some of which kinetically move as the water from the pipe filters down.

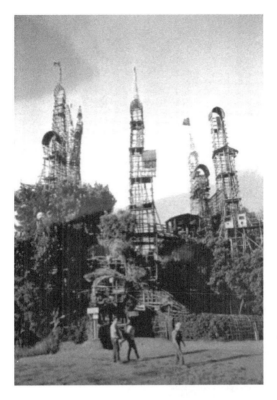

Josep Pujiula i Vila (Catalan, b. 1937),
Poblat Salvatge, *detail, western façade*
prior to beginning demolition, photograph
by Carlos Vila, June 16, 2002.

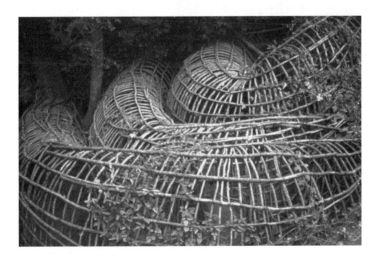

Josep Pujiula i Vila (Catalan, b. 1937), Poblat Salvatge, *detail, eastern side of original labyrinth,*
Summer 2000.

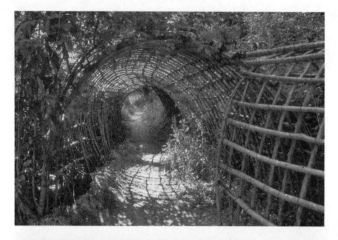

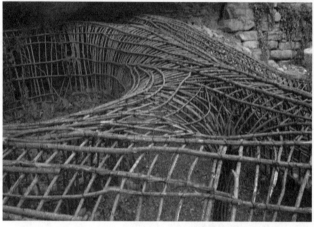

Josep Pujiula i Vila (Catalan, b. 1937), Poblat Salvatge. Above, *detail, tunnel interior.* Below, *detail, labyrinth section near "museum," August 2007.*

Markedly different from the labyrinthine tunnels and towers of its previous incarnation, this new fountain area is spectacularly innovative and dynamic. Pujiula is proud of it and clearly articulates that he never would have moved in this aesthetic direction—let alone to the change of medium—had it not been for the necessity to demolish the earlier construction and move away from that first site.

By spring 2009, since the highway workers had finished the road and disappeared, taking with them the possibility of scrounging their "extra" cement and steel—Pujiula returned to forming a new labyrinth to join the disparate parts of his constructions. Although not quite as large as the incarnation that was destroyed in 2002, this version, on which he worked until the end of 2011, became nevertheless extremely complex, with just one opening up above and one below, with steep climbs within and numerous dead-

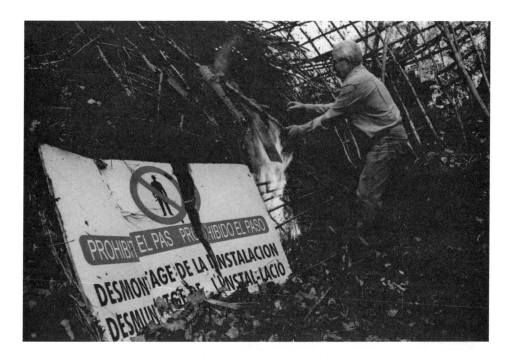

Josep Pujiula i Vila (Catalan, b. 1937), Poblat Salvatge, *detail, lighting the bonfire to demolish the structure, photograph by Carlos Vila, October 2002.*

ends and trick walkways. He added a three-story series of little houses for his young grandson, as well as a walkway across the nearby river, and eight tall towers flagged down passersby, encouraging visitation. Yet after he sustained a temporary injury in late 2011 to early 2012 and was unable to return to the site for some three months, the municipal authorities again became skittish at the possibility of danger to visitors: "It was a victim of its own success," Pujiula commented sadly. In April 2012, under orders from the municipality, he again began dismantling the huge environment, removing all of the tall towers and most of the sections of labyrinth. But then he stopped, hoping that at least some of the remaining wooden constructions would be able to be salvaged. In the meantime, he was reinspired to return to the fountain area, which he began to enlarge and expand, adding additional freestanding sculptures and engineering new paths for the water to follow. Yet although the order to destroy his works had originally focused only on the wooden structures, in early spring 2013 the agency in charge of water mandated that all of the concrete and steel sculptures and cascading ponds alongside the spillway also be removed. This time, however, Pujiula resolved to fight, assisted by my international petition drive and a newly energized community that had belatedly realized what a gap the removal of all of Pujiula's works would create in their village's very identity. Although the decision on whether to let the works remain has not yet been rendered as of this writing,[39] Pujiula is continuing to enhance the concrete sculptures and he has,

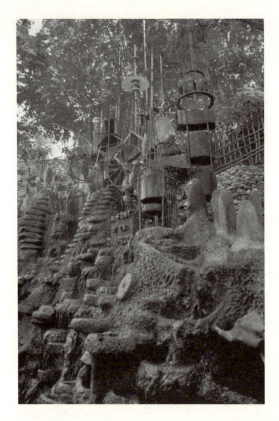

Josep Pujiula i Vila (Catalan, b. 1937), Poblat Salvatge, *detail, kinetic sculptures lining fountain spillway, August 2007.*

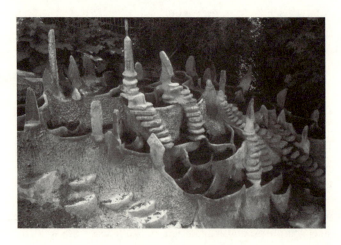

Josep Pujiula i Vila (Catalan, b. 1937), Poblat Salvatge, *detail, cascading fountain, August 2007.*

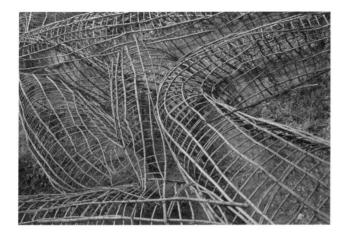

Josep Pujiula i Vila (Catalan, b. 1937), Poblat Salvatge, *detail, overview of labyrinth, March 2009.*

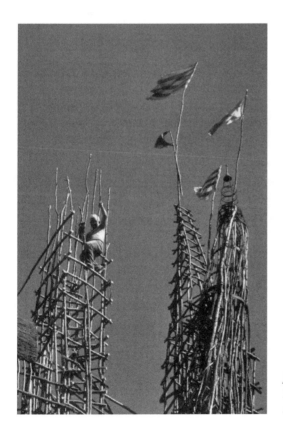

Josep Pujiula i Vila (Catalan, b. 1937),
Poblat Salvatge, *detail, construction*
of northern tower, August 2001.

secretly, also begun to build yet another labyrinth. This remarkable tenacity has driven his efforts over some forty-five years despite the repeated need to dismantle or demolish major components of his work and has made him, in my eyes at least, an icon of the irrepressible artist whose phenomenal intensity of effort and creative drive is rightly celebrated internationally.

Conclusion

Art environments such as those discussed here are personal, individual spaces that nevertheless reveal significant public ramifications on a variety of levels, not the least of which is that the creator-builder assumes a new social identity within the community as his or her visible works expand. Although their creative work may not fall within the parameters of what their neighbors think of as "Art," this does not inevitably imply their disconnection from their local community or their inability to function therein. It may be more disquieting that the sites may reveal built, written, or even implied critiques of or commentaries on general cultural, ethnic, historical, or political issues and that these judgments may challenge or confront superficial community accord. And perhaps most important, the formalist visual impact they have on neighbors and passersby often creates tensions between the society's recognition of the right of individuals to structure and adorn their living and working spaces as they see fit and that same society's right to social order and a certain aesthetic consensus. These tensions are rife within many aspects of our lives, and thus, despite their edge of audacity, art environments can be viewed on many levels as fitting within the traditional paradigm of art mirroring a culture's collective life. More often than not, neighbors ease these tensions by accommodating these constructions as a "hobby," a term often used by the creator artists as well.

Thus, although art environments do regularly incite community questioning, concern, and even, at the extreme, demands for demolition, their creators do, for the most part, remain very much part of their communities. In fact, it is often response to community issues that motivates construction—whether the term "community" is understood as referring to a local, regional, national, or even international identity. Their neighbors may look askance at the productions of these artists, may decry their works as "ugly" or scratch their heads over troubling or enigmatic components, but the creators are not "outsiders," and for the most part they are neither estranged nor outcasts. It is not insignificant, for example, that despite even Rodia's own acknowledgment that some of his neighbors thought he was "crazy,"[40] during the revolts of 1965 when so much of the Watts area in Los Angeles burned, the Towers were untouched by the violence. Surely this underscores the impact this monumental work carried—and continues to carry—for the local community.

Further, it is clear that—albeit some of these creators may be more welcoming than others of outside visitors—the very act of physical creation implies the desire to elicit response from viewers. Although certain of these sites are difficult to find, hidden away behind farm outbuildings or at the ends of country roads, many more are located where a drive-by audience is assured. Each artist has his or her own motivation for construction—and for all, without doubt, at the most primal level they are doing it because they "have" to—but every one is also trying to make a connection with other

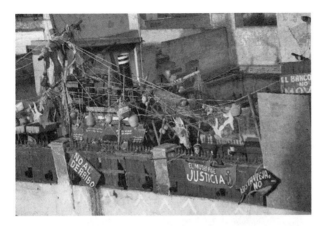

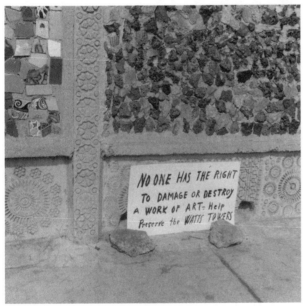

José María Garrido (Spanish, 1925–ca. 2013), El Museo del Mar "Las Caracolas." *Above, detail, roof terrace with signs, including "No to Demolition," "The Museum Pleads for Justice," and "The Ship Will Not Move," March 2009. Below, Sabato Rodia (Italian, 1879–1965),* Towers. *"No One has the Right to Damage or Destroy a Work of Art. Help Preserve the Watts Towers," photograph by Seymour Rosen, © SPACES, October 1959.*

people, some in a more spiritual sense, and others with a more worldly or secular bent. Although public viewing and response is rarely, if ever, the initial stimulus for beginning work evidenced by art environment builders, along the way it becomes an important component in communicating the artist's intent. In fact, it is assumed to be a given by certain scholars that the viewer is essential to the completion of the artwork

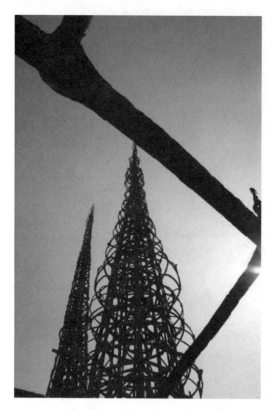

Sabato Rodia (Italian, 1879–1965), Towers, *detail, October 2009.*

in much the same way that an audience completes the intent and production of a work of theater.

Yet although the works of nonacademic artists such as Rodia and those Spanish builders that I've commented on here are beginning to be included in an expanded definition of art, these works still remain in a more tenuous and often precarious position. Academic art and folk arts are typically protected in some way, housed in galleries or museums, regarded as national treasures, or cared for by the community from which they were generated; even if they are in a private home and in use, they are relatively safe. In contrast, most if not all art environments are continuously at risk.

Even after fifty years of active, aggressive community work on behalf of the Watts Towers, for example, in 2001 the city of Los Angeles was considering tearing down Rodia's northeastern wall so as to provide an unobstructed view of the Towers from the city's newly constructed amphitheater,[41] and as of the present writing they are exploring the possibility of installing a skateboard park just east of the complex, a proposal that supporters thought had been buried years before (Boehm 2009a). The Watts Towers share National Historic Landmark status with such extraordinary sites as the White House, Abraham Lincoln's tomb, and the Manzanar Relocation Center; a similar dishonor for any of these spots would be unthinkable. Schemes for inappropriate construction adjacent to or demolition of components of the Towers are exacerbated by

recent official acknowledgments that corroborated citizen claims of long-term incompetence in conservation and repair (Boehm 2009b). And the litany of issues with the local authorities that I have touched on in the discussion of the work of several of these Spanish artists underscores the precarious nature of their continued existence. Artworks in other categories would not be subjected to such unethical destruction.[42] Art environments challenge our artistic and social norms, and because of this—not despite it—they should be welcomed as an indication of positive progress toward greater inclusivity in art historical definition.

Folklorists and anthropologists (although, typically, not art historians) have come to realize that "making special" is a universal human trait. Those genres typically defined and studied as "Art" are not, in fact, the most primary forms of aesthetic expression, for much of everyday human behavior is aesthetic, whether it be the arrangement of fruit on a table, the way we dress and fix our hair, or large-scale art environmental sites. Hans Prinzhorn, the fabled psychiatrist whose early studies on people with mental illness have become a basis for the field of outsider art, outlined six psychological traits fundamental to artistic creation: drives underlying self-expression, play, decoration, ordering and arranging, imitating, and reflecting symbolic meanings (Prinzhorn [1922] 1972). It is noteworthy that despite his predilection and area of study, Prinzhorn emphasized that these were universal—not psychopathological—human characteristics. Decades later, Ellen Dissanayake described such creative drives as so essential a "core tendency" of evolved behavior that she has rechristened our species "Homo Aestheticus" (Dissanayake 1995). By focusing on these universals—as we concomitantly study the specific differences and peculiarities of each artist's oeuvre—we can sidestep the tendency to create artificial distinctions between art genres, and open ourselves up to a much more expansive view of the range of influences on each creative act.

Works Cited

Aulahk, Malkiat Singh. 1986. *The Rock Garden*. Ludhiana: Tagore.

Boehm, Mike. 2009a. "Getting Rad at the Watts Towers." *Los Angeles Times*, December 9.

———. 2009b. "Strapped City Wants Donors for Watts Towers Conservation." *Los Angeles Times*, July 17, D8.

Bryan, Robert S. 1967. "Sam Rodia and the Children of Watts." *Westways* 59.8 (August).

Burger, Peter. 1984. *Theory of the Avant-Garde*. Minneapolis: University of Minnesota Press.

Cardinal, Roger. 2000–1. "The Vulnerability of Outsider Architecture." *Southern Quarterly Review* 39.1–2 (Fall–Winter): 7. http://vnweb.hwwilsonweb.com.libaccess.sjlibrary.org/hww/results/results_single _ftPES.jhtml

Casasses, Enric. 2001. "Bulliment del País." *El Mundo*, May 5. http://www.el-mundo.es/2001/05/05 /catalunya/990898.html

Conley, Katherine. 2006. "Surrealism and Outsider Art: From the 'Automatic Message' to André Breton's Collection." *Yale French Studies* 109, *Surrealism and Its Others*: 129–43.

Crease, Robert, and Charles Mann. 1983. "Backyard Creators of Art That Says: 'I Did It, I'm Here.'" *Smithsonian* 14.5 (August).

Cullum, Jerry. 1998. "Vernacular Art in the Age of Globalization." *Art Papers*, January/February, 14.

de Amores Carredano, Fernando, and Tomás Lloret Marín, 1995. "Un lote de Crisoles Triangulares Modernos en Sanlúcar de Barrameda." *SPAL-Revista de Prehistoria y Arqueología* 4: 265–72.

Dinsmoor, Samuel P. n.d. *Pictorial History of the Cabin Home in Garden of Eden*. Lucas, Kans. (self-published).

Dissanayake, Ellen. 1995. *Homo Aestheticus: Where Art Comes From and Why*. Seattle: University of Washington Press.

Doss, Erika. 2000. "Religious Dimensions of Work by Contemporary Self-Taught Artists: Speculations on New Methodologies and Perspectives." In *Negotiating Boundaries: Issues in the Study, Preservation, and Exhibition of the Works of Self-Taught Artists.* Sheboygan, Wisc.: John Michael Kohler Arts Center and Kohler Foundation.

Evans, Estyn E. 1972. "The Cultural Geographer and Folklife Research" In *Folklore and Folklife,* edited by Richard M. Dorson, 517–32. Chicago: University of Chicago Press.

Ferris, William. 1982. *Local Color: A Sense of Place in Folk Art.* New York: McGraw-Hill.

Friedman, Martin, et al. 1974. *Naives and Visionaries.* New York: E. P. Dutton.

Giles, Ciaran. 2006. "Hand-Built 'Cathedral' Headache for Town." *Associated Press,* December 23. http://AP/a/2006/12/23/international/i102439S33.DTL

Gisbourne, Mark. 1994. "Art of the Untrained Mentally Ill." In *The Artist Outsider: Creativity and the Boundaries of Culture,* edited by Michael D. Hall and Eugene W. Metcalf, Jr., 228–51. Washington, D.C.: Smithsonian Institution Press.

Greenfield, Verni. 1984. "Silk Purses from Sows' Ears: An Aesthetic Approach to Recycling." In *Personal Places: Perspectives on Informal Art Environments,* edited by Daniel Franklin Ward, 133–47. Bowling Green, Ohio: Bowling Green State University Popular Press.

Hall, Michael D., and Eugene W. Metcalf, Jr., eds. 1994. *The Artist Outsider: Creativity and the Boundaries of Culture.* Washington, D.C.: Smithsonian Institution Press.

Hernández, Jo Farb. 2001. "Watts Towers." *Raw Vision* 37 (Fall): 32–39.

———. 2005. *Forms of Tradition in Contemporary Spain.* Jackson: University of Mississippi Press.

———. 2013. *Singular Spaces: From the Eccentric to the Extraordinary in Spanish Art Environments.* London: Raw Vision.

Jones, Barbara. 1953. *Follies and Grottoes.* Glasgow: University Press.

Jouve, Jean-Pierre, Claude Prévost, and Clovis Prévost. 1981. *Le Palais Idéal du Facteur Cheval.* Paris: A.R.I.E. Éditions.

Karpel, Mark. 2009. "Swept Away." *The Outsider* 14.1 (Spring).

Lancaster, Clay. 1960. *Architectural Follies in America.* Rutland, Vt.: Charles E. Tuttle.

Laporte, Paul, et al. 1962. *Simon Rodia's Towers in Watts.* Los Angeles: Los Angeles County Museum of Art.

Maizels, John. 1999. *Fantasy Worlds.* Cologne: Benedikt Taschen.

———. 2009. *Outsider Art Sourcebook.* Hertfordshire, England: Raw Vision.

Mingus, Charles. 1991. *Beneath the Underdog: His World as Composed by Charles Mingus.* New York: Vintage Books.

Montpied, Bruno. 2000–1. "Outsider Art, the Situationist Utopia: A Parallel." *Southern Quarterly* 39.1–2 (Fall–Winter): 19–46.

Morgan, Jeanne. 1984. "Rodia's Towers: Nuestro Pueblo, A Gift to the World." In *Personal Places: Perspectives on Informal Art Environments,* edited by Daniel Franklin Ward, 72–82. Bowling Green, Ohio: Bowling Green State University Popular Press.

Peacock, Robert. 1996. *Paradise Garden: A Trip Through Howard Finster's Visionary World.* San Francisco: Chronicle Books.

Prinzhorn, Hans. [1922] 1972. *Artistry of the Mentally Ill: A Contribution to the Psychology and Psychopathology of Configuration.* Translated by Eric von Brockdorff from the 2nd German edition. New York: Springer-Verlag.

Relph, Edward. 1976. *Place and Placelessness.* London: Pion.

Rosa, Francisco. 2010. "Un castillo de azulejos, 'a lo Gaudí,' en el corazón de Extremadura." *El Mundo,* June 10. http://www.elmundo.es/elmundo/2010/06/09/suvivienda/1276108346.html?a=a44e03017ead3a11a58ad236a7c705be&t=1322507425. Accessed November 28, 2011.

Sciorra, Joseph. 1989. "Yard Shrines and Sidewalk Altars of New York's Italian-Americans." In *Perspectives in Vernacular Architecture* III, edited by Tom Carter and Bernard Herman, 185–98. Columbia: University of Missouri Press.

Seitz, William. 1961. *Art of the Assemblage.* New York: Museum of Modern Art.

Sheehy, Colleen. 1998. *The Flamingo in the Garden: American Yard Art and the Vernacular Landscape.* New York: Garland Publishing.

Stone, Lisa, and Jim Zanzi. 1991. *The Art of Fred Smith.* Phillips, Wisc.: Friends of Fred Smith.

————. 1993. *Sacred Spaces and Other Places: A Guide to Grottos and Sculptural Environments in the Upper Midwest*. Chicago: School of the Art Institute of Chicago Press.

Tuchman, Maurice, and Carol Eliel, eds. 1992. *Parallel Visions: Modern Artists and Outsider Art*. Princeton, N.J: Princeton University Press.

Unpublished documents, SPACES Archives, Aptos, Calif. www.spacesarchives.org

Ward, Daniel Franklin, and I. Sheldon Posen. 1985. "The Watts Towers and the Giglio Tradition." In *Folklife Annual*, edited by Alan Jabbour and James Hardin, 143–57. Washington D.C.: Library of Congress, American Folklife Center.

Yust, Larry, and Leonard Knight. 1998. *Salvation Mountain: The Art of Leonard Knight*. Los Angeles: New Leaf Press.

Everybody Knows This Is Nowhere: Structure and Performance in Rodia's Watts Towers

Guglielmo Bilancioni

Everybody seems to wonder
What it's like down here
I gotta get away from this day-to-day running around
Everybody knows this is nowhere.
—NEIL YOUNG

Built at the junction of the impossible and the available, or of the possible and the enchanting (but nonexistent), fantastic architecture is the serious game of projection between *iam* and *nondum*, of the *already* and the *not-yet*, between something that has always been here and something that, almost certainly, will never exist. Like myth: things which, according to Sallustius, "never have been and always are." Architecture is always fantastic, or else it never is—as it is brought into presence or *real*ized. Like all art, architecture draws its nourishment from its limits, attaining its standstill where matter encounters the spirit that informed it.

Esoteric geometries from the Watts Towers floor.

Visionaries, as Focillon (1926: 7) writes, "interpret more than they imitate, and trans-figure more than they interpret." "They show sometimes what is most daring and free in the creative genius, a power of divination concentrated on the most mysterious domains of the human *rêverie*." Their "peculiar vision deeply twists the light, the proportions, and even the density, of the sensible world." "They do not see objects, they view, and there-fore, examine them."

A masterpiece with a high psychic resonance, Sabatino Rodia's Towers, *Nuestro Pueblo*, embody a philosophy of freedom, an image of human labor, and the everlasting creative tension—a true *performance*—toward realization.

Two other authors contribute to an understanding of Rodia's work: Huizinga and Caillois. Johan Huizinga in *Homo Ludens* ([1938] 1949) wrote:

Game, in the formal point of view, could be defined as a free action, perceived as
fictitious and placed outside everyday life, but nevertheless able to completely absorb the

player; an action devoid of all material interest and utility, done in a time and space that are specifically circumscribed, developed with an order and with given rules, awakening group relationships in life, willingly surrounding itself with mystery, or accentuating through disguise its weirdness vis-à-vis the usual world. Huizinga [1938] 1949: 13

And Roger Caillois (1958: 43), in *Les Jeux et les Hommes*, would further elaborate these thoughts: "Game is a free activity, separated, uncertain and nonproductive, and fictitious.... Here, ordinary laws are suspended and a special awareness of a second reality, or a complete unreality, rises up."

Competition (*certamen*) or improvisational play (*alea*; the dice). "Simulation" and "vertigo" are key words in Caillois's study that perfectly encompass the enthusiastic motivation and deep endeavors of Rodia's venture. Anarchic and complex, mimetic and heroic, Rodia's gesture is a true *ludus metamorphicus*, a surreal brilliant disguise, and a fated symbol of one man's will. *In-lusio*, being-into-the-game, is the origin of any built form, and the game, as Eugen Fink (1960) points out in *The Game as World Symbol*, is the most solemn among many decisions. There are echoes of Nietzsche (1888) in the great paradox that gives nerve to every aphorism: "I know of no other way of coping with great tasks, than play." Hence, the Towers are serious play, inspired and mystical—a sacred drama. They are a "Theater of the World" and a "Praise of Folly."

And in such play were engaged Raymond Isidore, known as Picassiette, the dish breaker, at Chartres; the postman Ferdinand Cheval, *le Facteur*, in his *Palais Idéal* at Hauterives; and Pirro Ligorio at the Rometta, a miniature of ancient Rome, at Tivoli. As were many others: Vicino Orsini in the Holy Wood of Bomarzo; François Nicolas Henri Racine de Monville in the Désert de Retz; Tomaso Buzzi at La Scarzuola; Niki de Saint Phalle at the Giardino dei Tarocchi; and Tressa "Grandma" Prisbrey at Bottle Village in the Simi Valley: Castles made of sand.

Special mention is due Antoni Gaudì, even though Rodia scaled him down to size: somebody helped Gaudì, Rodia said, whereas he had worked alone. As with all the other follies, these works exalt the nonmaterial aspects of the art of building, overcoming the limits of so-called function. And while creating a disconcerting sense of confusion, they highlight the iconological program. Pathos here towers above Ethos, understood as usual dwelling. These quirky, droll, yet engaging masterpieces, with their calculated fusion of the archaic with the modern, their granular character, their aura of the never finished, their rusty folksy tracery, perform, in their plastic florescence, an insatiable craving for beauty. Bizarre and sublime secret places, where "the past is a foreign country," as Leslie Poles Hartley states: "they do things differently there." David Lowenthal (1985) drew on this sentence in the title of one of his books, adding: "they speak a different language there."

Sumptuous and nonproductive, anthropomorphic and theriomorphic, the Watts Towers are a building from Elsewhere, late-antique and nostalgic, transient and ephemeral, made out of enchantment and disenchantment, in the spires of which the feeling of the end is controlled by the modernity of bricolage. They are a bejeweled product of bricolage, a jewel box or a treasure chest of dreams, offered as a gift, free and gratuitous. Dal Lago and Giordano (2008) well explain this attitude as the noblest offering of an artist, in *Fuori Cornice* ("out of frame").

They are also magical more than naive—genuineness and ingenuity stem from the same root. Rodia courageously joins the *Opus Incertum*, assembling it into a new iconology,

Subtle eighteenth- or nineteenth-century echoes.

using *Spolia*, recycling and upcycling these broken parts into meaningful fragments, fractal geometries, and kaleidoscopic aesthetics, where symmetry and rhythm predominate.

When asked about the meaning of his Towers, Rodia asserted: "They mean lots of things, son." They could be a celebration of California highways (66, 99, 101, the height of the three Towers, as Rodia himself said); or a complicated and flamboyant sundial system, casting its shadows in triplicate *Stylus*, or *Gnomon*; they could also be a ship of fools or even an ark. Paul Harris (this volume) explains in a heuristic way that the Towers are the three masts of a ship, an ark actually, relating to Ronald Johnson's poem *Ark*, which has a Rodia Tower on its cover. There, the word-knots hearth–heart–earth, joining with the cosmogonic sense of *Clinamen* (in Epicurus and Lucretius), illuminate the free will of living things, the much in the little, and the whirling beauty of apparent randomness. Rodia behaves as a Rousseau le Douanier architect, or a new Ligabue with a slight Dubuffet flavor, as well as a forerunner of Ele d'Artagnan's psychedelic cosmography.

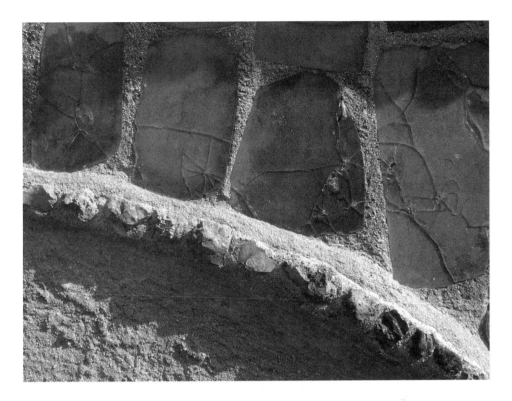

Fragments and colors, seemingly liquid stone, nestled in cement.

Clarence Schmidt's aluminum foil constructions, Jean Linard's mosaics, along with Posada's *Calaveras,* might also be recalled, in this unsettling context.

Many ideas and ideals are to be found in this spiral-like uproar: Rem Koolhaas's (2006) *Junkspace* (but Jon Madian [1968] reminds us: beautiful junk!), David Leatherbarrow's (2009) *Architecture Oriented Otherwise,* the Mediterranean vernacular and Buckminster Fuller, *Art Brut* and jazz, *débris* and *Muschelwerk,* Sophia and Phantasia (wisdom and fantasy) at their confluence. The ancients called this *Imaginatio Vera.* The Towers—Vortex of Noise and Cathedral of Jazz, as Don DeLillo (1997) defined them in *Underworld*—show very well that the difference between magic and technology depends only on historical variation. The same is true between the organic and the mechanical, perfectly modulated in the Towers and therefore perfectly interwoven. Magical matters and technical matters are here fused at very high temperature, in this sort of dream: "It's just a dream, I wanna keep on dreamin' it."

Visionary *machina* and silent *fabrica,* though ringing and flashing, is Rodia's double construction, equipped with a reinforced altitude connection, marking the supremacy of the skeleton over the work of art, like Tatlin's tower, a giddy topology of the hollow. It is pure structure: *machine à grimper* and pièce de résistance. Before Tatlin, the poetry of technique was found in Shukhov's Hyperboloid Lattice Shell structure: towers high and light as stellar baskets. The first *Mnimosti*—the imaginary—high-tech. A bit gothic pinnacle and

Sealing wax, Emmenthal cheese, and blue magnesia: mixing origins and outcomes.

a bit Hindu *sikhara*, the Towers had for their builder the characteristics of a Mandala: You have to compose it following the line of precision and you have to leave the result to the great law of the universe. In Thomas Harrison's essay on the Towers (this volume), this is very well explained: "Once the structures were finished, they lost their purpose."

Meanwhile, iron and mortar, spires encrusted with broken crockery, accumulation and inlay, produce an alchemical fusion. Iron is used whenever power and necessity are supposed to be manifest. Hence, the Towers provide a panorama, a *mirador*, different "points" of view, in order to see out and to be seen, much like Le Pont des Planètes by Jean-Ignace-Isidore Gérard, known as Grandville (1844). For, as Walter Benjamin ([1982] 2002: 152) explained, studying the origin of iron construction: "Technological production—at the beginning—was in the grip of dreams. Not architecture alone, but all technology is—at certain stages—evidence of a collective dream."

Sabato Rodia is a wonderworker, craftsman of the *Opus Magnum*. A producer of marvels, he built a miniature of the universe, a civic temple in perpetual disrepair. This poetic acrobatic gesture of a gothic glass master, which Bruno Zevi ([1953] 2001: 402); with characteristic descriptive precision) defined a "Tower of Babel made with iron wire, a Christmas tree, or a firework," is an "*Incunabulum* of informal architecture."

It is a cloud scraper or a lightning catcher, incorporating the essence of a nymph's grotto with its dome and apse; a gigantic antenna in the creative paradox of an experi-

mental utopia. It has the aesthetics of Jules Verne's flying machines and Albert Robida's *Cures d'Air*, whence a precise prophecy of the past produces monuments fit for the purpose of forgetting the future, for tempering the catastrophic and the apocalyptical, and for restoring joy into a vision, as in Finsterlin and the Archigram.

Rodia masters various techniques, as an avant-garde artist: *assemblage, collage, montage*, fusion, groovy joint, in a style that encloses truth. It is a mirage-like style made of unpredictable compressions, apparent randomness, and sharp sternness, a fantasy of innocence and artistic Titanism (more geomantic than geometric, more archaic than modern), where the Chaos of Proteus encounters the happy tangled weave of fate and cause, the order of entropy: *objets trouvés* and structural joint venture. The traces left by cookie cutters are the first evidence of a pyrotechnical extravaganza, mixed with an exquisite taste for color; an example among many is in the green of 7UP bottles harmoniously tangled up with the blue of Milk of Magnesia bottles, with an addition of red jelly plasticity, stirring in terra-cotta and steel. The spirit of patchwork quilts, along with the endless wire of the spiral—all this lives in the work of the artisan-artist whose only aim was a job well done, "un lavoro ben fatto," as Joseph Sciorra (this volume) points out: "Che bella insalata!" ("What a beautiful salad!"). Sabato smoothed all the rough edges off his Italian-African-Mexican mosaic work, in spiral layers, used as the small steps of

Green and blue as emblems of complementarity.

Lava's primordial breath transformed into enamelware.

a stairway, and stated with pride: "If you do something half good and half bad, then is no good."

The spiral has been defined, by Jakob Bernoulli (1744), *mutata resurgo,* "as curved, I straighten upright." And the curve is *Spira Mirabilis.* This metaphor could be the heraldic device for Rodia's behavior: curving pieces of steel, forcing them into the railway tracks and raising them up toward the lonely top. Dizziness of height, oddity of the meander, quizzical voluptuousness of danger, and fabulous distance: This is futurism, with an echo of Edward Bellamy's (1888) *Looking Backward* and of William Morris's (1891) *News from Nowhere.*

Rodia is the solitary aesthetic hero, a self-taught transformer, with his "no-pulley" thoughts and a subtle control over his results, staging a roller coaster vision in his vertical challenge, with a sweetly astonished serenity, primeval and sophisticated bravura, a mix of talent and courage, in the virtuosity of the one-man band: one man, alone, equipped with allegorical genius and a dizzying know-how. His dripping in height, as Jackson Pollock's dripping, is pure rhetoric, a figure of speech, an act of *Blindness and Insight*, as Paul de Man would say.

Rodia realizes, as Reyner Banham (1971) wrote, his "mechanical Satori"—as surfers, hot rodders, sky divers, and scuba divers do. California wouldn't really be the same without Neutra and without Rodia.

Again, it is Roger Caillois (1958: 52), who explains: "You must call vertigo every attraction whose effect surprises and disorients the self-preservation instinct." Here lies the deepest meaning of Rodia's strongest sentence: "You have to be good good or bad bad to be remembered."

In the alien attitude of Rodia's delirium lie grace and composure, wild features, pictorial enigmas, the hieroglyphs of pathos, and a respectful love for *Mater Materia*, our Mother-Matter, with its own form. In his work can be found the "sumptuousity of the modest," the glory of which has been described by Simone Weil (1947).

In the power of will, as grandiose as it is simple, the Superman—"I am a Steel Man"—overcomes and surpasses himself: In Rodia's endeavor is concealed a pure expression of the titanic in art. His will to art shows a state of mind where "the mountain is a cloud," as Leonardo "Diobello" Sileo, another talented pauper Italian, would say (quoted in Byrne-Severino 1991: 30): I work "Solo per lasciare il nome" (just to leave behind a name), *mano mano, mano mano* (little by little), with bare hands. Rodia's famous assessment is simple and ultimate: "I had in mind to do something big, and I did it."

It must be true: It takes a tough man to make a tender architect. Rodia's *Hypnerotomachìa* (a battle of love in dream), obstinate, patient, resistant, becomes *Technomachìa*, a battle between utility and revelation, inspiration and calculation. His delirious symphony is a hymn to endurance. This spurious yet beautiful construction, built with non-homogeneous building materials, is a triumph of structural form, inside of which (as in every work of art) psychic and physical forces cohabitate in a restless struggle.

Sabatino has fire inside, a yearning afflatus that becomes matter through inexhaustible labor—the epic of improvement. Tools, a cathedral builder's tools, are the loner's best friends. A poet sang: "Chisels are calling . . . Steely reminders of things left to do." Every night Rodia climbed his stairs and spent many days yonder, up with his lunchbox, Caruso playing on the gramophone, sparks flying all around, lamps mounted on a bicycle wheel, chisels, rasps, hammers, pliers and pincers, lucky horseshoes, and, of course, his window-washer's belt.

The mysterious path that led a pioneer from Ribottoli, *comune di* Serino, *provincia di* Avellino, on the River Sabato, to set a bowling ball among Canada Dry bottles, to spread around the mother-of-pearl of shells, records (imagine if he had had CDs), corncobs and mirrors, in Los Angeles, California, is illuminated by the light of uniqueness, in the delicacy of a butterfly and the toughness of a bone joint.

Walking alone down the middle of this path, Rodia demonstrated with proud humility that it is possible to recompose the shattered and that salvation is hidden in the Smallest.

Works Cited

Banham, Reyner. 1971. *Los Angeles: The Architecture of Four Ecologies*. London: Allen Lane.
Bellamy, Edward. 1888. *Looking Backward*. Boston: Ticknor and Company.
Benjamin, Walter. [1982] 2002. *Das Passagenwerk*, edited by R. Tiedemann, *Gesammelte Schriften*, Band V, 1 and 2, Frankfurt: Suhrkamp Verlag; English translation, *The Arcades Project*, translated by H. Eiland and K. McLaughlin. Cambridge, Mass.: The Belknap Press of Harvard University Press.
Bernoulli, Jakob. 1744. *Opera Jacobi Bernoullii*. 2 vols. Geneva.
Byrne-Severino, Moyra. 1991. "'Per lasciare il nome' Leonardo 'Diobello' Sileo, scultore lucano." *La Ricerca Folklorica* 24, (Artisti, icone, simulacri. Per una antropologia dell'arte popolare)(November): 27–35.
Caillois, Roger. 1958. *Les Jeux et les Hommes*.[Of Games and Men] Paris: Gallimard.

Dal Lago, Alessandro, and Serena Giordano. 2008. *Fuori cornice: L'arte oltre l'arte.*[Out of Frame: Art Beyond Art] Torino: Einaudi.

DeLillo, Don. 1997. *Underworld.* New York: Charles Scribner's Sons.

Fink, Eugen. 1960. *Spiel als Weltsymbol.* Stuttgart: Kohlhammer.

Focillon, Henri. 1926. "Esthétique des Visionnaires." *Journal de psychologie normale et patologique* 23 (Janvier–Mars); Italian translation in *Estetica dei visionari e altri scritti*, edited by Marco Biraghi, 1998. Bologna: Pendragon.

Grandville, Jean Ignace Isidore Gérard. 1844. *Un Autre Monde: Transformations, visions, incarnations, ascensions, locomotions, explorations, pérégrinations, excursions, stations, cosmogonies, fantasmagories, rêveries, folâtreries, facéties, lubies, métamorphoses, zoomorphoses, lithomorphoses, métempsycoses, apothéoses et autres choses.* Paris: Fournier. [Another World: transformations, visions, incarnations, ascensions, locomotions, explorations, pilgrimages, excursions, cosmogonies, fantasmagorias, dreams, delusions, mottos, fascinations, metamorphoses, zoomorphoses, lithomorphoses, metapshychoses, apotheoses, and other matters.]

Huizinga, Johan. [1938] 1949. *Homo Ludens.* London: Routledge & Kegan Paul.

Koolhaas, Rem. [2002] 2006. *Junkspace.* Macerata: Quodlibet.

Leatherbarrow, David. 2009. *Architecture Oriented Otherwise.* New York: Princeton Architectural Press.

Lowenthal, David. 1985. *The Past Is a Foreign Country.* Cambridge: Cambridge University Press.

Madian, Jon. 1968. *Beautiful Junk: A Story of the Watts Towers.* Boston: Little, Brown.

Morris, William. [1891] 1998. *News from Nowhere.* London: Penguin Books.

Nietzsche, Friedrich. [1888] 1908. *Ecce Homo.* Leipzig: C.G. Neumann.

Sallustius. 2000. *On the Gods and the World.* London: Edward Jeffery and Pall Mall. Italian edition: Sallustio. *Sugli déi e il mondo.* Ed. R. Di Giuseppe. Milan: Adelphi.

Weil, Simone. 1947. *La Pesanteur et la Grâce.* Paris: Plon.

Zevi, Bruno. [1953] 2001. *Storia dell'architettura moderna.* Torino: Einaudi.

Sam Rodia's Watts Towers in Six Sections in Succession

Paul A. Harris

This essay will not provide an art historical, social, historical, or political assessment of Rodia's Watts Towers. I leave that work to other experts. My interest in Rodia's work is conceptual and creative. For over twenty years, I have found that visits to the Watts Towers stimulate theoretical thinking, induce spiritual reflection, and inspire all manner of writing. This essay will replace critical analysis with what I call "creative synthesis." Combining conceptual and creative styles of thought and writing, I offer a multifaceted reflection on Rodia's work. To emulate the Watts Towers, which integrates heterogeneous materials into a coherent structure, I have composed six discrete sections that merge into a continuous whole, or so I hope. You have just finished reading the first one.

Assemblance

I have always been fascinated by the materiality of writing, by the shapes and patterns that letters make. The page is a surface where language takes on texture and springs into motion, as a reader traces markings left by the animating spirit of a writer. Italo Calvino, in his *Six Memos for the Next Millennium*, expresses this idea beautifully:

> The polymorphic visions of the eyes and the spirit are contained in uniform lines of
> small or capital letters, periods, commas, parentheses—pages of signs, packed as closely

together as grains of sand, representing the many-colored spectacle of the world on a surface that is always the same and always different, like dunes shifted by the desert wind. (Calvino 1988: 99)

I will refer to Calvino often, because his writing seems to capture the complexities of Rodia's work. Calvino is also appropriate here because he has written the most architectural of novels, *Invisible Cities*—a text I assign students to read when I send them to visit Rodia's Watts Towers.

Just as the page can be seen as a space of material arrangement and construction, certain works of architecture can be seen as a form of writing. This is certainly the case with Rodia's Watts Towers. Calvino's characterization of writing as a "many-colored spectacle . . . on a surface that is always the same and always different, like dunes shifted by the desert wind," fittingly describes the perplexities of Rodia's mosaic compositions. Indeed, the whole site is, like the written page, one continuous surface covered in signs, with Rodia's intricate ornamentations forming a kind of private language. Rodia explicitly invites us to see his work as writing by repeatedly signing his work. His initials, in mosaic, are found in many places: He inscribed his initials "SR," street address and name, and "Nuestro Pueblo" on the central tower and on the mail slots. Rodia's "signature" takes even more cryptic forms. In several panels, he impressed his tools into the cement, a signature in the hand of his hand tools that complements his initials, creating a set of signs that distinctly resemble hieroglyphs.

I often wonder whether Rodia's sign language, like some outsider art, amounts to some kind of glossolalia or if, rather, he composed numerous cryptograms. Walking through the Watts Towers, I find myself haunted by the feeling that myriad minute messages await discovery and decoding. Here there is writing on the walls; there signs appear that await deciphering. But unlike the writing on the wall in the book of Daniel, these signs portend playfulness rather than doom. For instance, in the northwest corner, there are three groups of corncobs, in sets of seven, seven, and twenty-one. Is this a biblical allusion of some kind? Or could it be a calendar date—July 7, 1921, perhaps marking the very day Rodia began building on the site?

What about the carefully juxtaposed concave and convex impressions of wheat motifs, made by pressing a bread-baking mold into the cement? The sheaf of wheat is adorned with grape bunches; certainly, the wheat and grapes evoke bread and wine, the body and blood of Christ (cf. Del Giudice, this volume). This conventional interpretation, though convincing, is not sufficient, for it does not address the significance of the juxtaposed convex and concave impressions. Rodia's iconography recalls Pharaoh's dream in the book of Genesis; the convex/concave imprints resemble the healthy/withered ears of grain, and the convex/concave wheat impressions evoke the seven years of plenty and seven years of famine, respectively. In fact, Joseph is associated with sheaves of wheat, from his first dream where his sheaf rises upright and those of his brothers bow to it, to his overseeing the Pharaoh's wheat harvest in Egypt. Joseph's dream readings provide a paradigm for the task Rodia leaves viewers of the site's writing—to decipher sets of symbols and convert them into coherent narratives. On the most general level, the raised and hollow impressions metaphorically resonate with the pattern of highs and lows that punctuate Joseph's life. And finally, the metonymic image of Joseph, his coat of many colors, is itself an apt metaphor for the Watts Towers in general.

Pursuing semiotic lines of interpreting Rodia's work presumes and plays off of the predominant art historical classification of the Watts Towers as a form of assemblage. The standard definition of assemblage is a three-dimensional constructed arrangement of found or scavenged objects that have been appropriated and recontextualized.[1] Assemblage may be taken as a fruitful model for pursuing this creative synthesis of Rodia's work in writing. Here I am using the Towers themselves as found material that can be arranged in many different ways, described in different conceptual vocabularies, and recreated through experimental writings. This is, emphatically, not to claim that this essay is itself an assemblage. With some self-irony, I call this venture an *assemblance*—a portmanteau that suggests that assemblance is a mere semblance of assemblage, a representation or trace of assemblage. Simultaneously, assemblance situates itself in the zone where writing and architecture meet in a complementary dance—architecture as writing that engenders architectural writing—as will be seen in the conclusion to this essay.

(W)hOles

The word *wholes*, as a homonym, articulates both *wholes* (complete things) and *holes* (punctured things). Considered architecturally, the word is a whole, a single grapheme or unit of language, punctured by a hole in the middle.

Any place you look at the Watts Towers, any way your gaze frames a view of it, what you see constitutes its own whole—any section of Rodia's assemblage is a unique composition all its own, a whole apart. Simultaneously, of course, any whole is only a part, because we can only ever have a partial view of the whole. Even if you could assemble every view you've ever had of the site, arrange each thing ever touched on by your eye, you would never be able to reconstitute Rodia's assemblage. You would end up with nothing but a whole full of holes—a whole punctured by things unnoticed, unnoted, views and perspectives never seen or even contemplated.

Rodia's assemblage is, formally or mathematically speaking, a fractal: a structure where each part is a whole and each whole a part, whose totality can never be viewed or exhausted. Rodia's work also displays fractal properties of repetition, iteration, and self-similarity across scale. For instance, the Ship of Marco Polo (part), is replicated by the three-masted ship (whole) of the entire composition. And one may see the three towers themselves as fractal iterations of a single form, which were generated by a process that builds on itself recursively, evolving in height and complexity.

Rodia's Towers are composed of concentric rings, a pattern which, once one looks for it, may be found in many forms throughout the site. A miniature signature of this pattern is the rosette, a shape Rodia imprinted with faucet handles. Rosettes are found in clusters throughout the site; the concentric markings made by gear patterns, often juxtaposed to rosettes, also replicate this general shape. Like the site as whole, the rosette is a whole composed of holes, a form forever hollowing itself out. Considered conceptually, this process of hollowing out expresses a physics, a model of matter, that may be derived from the site, while also defining it. The rosette expresses a physics of the alveolar; it models matter as a honeycomb, an infinitely porous texture.

Rodia's assemblage not only represents this view of reality; it teaches or, more pointedly, induces us to perceive reality this way. Confronted with an environment that yields more detail the closer we look, indeed, that provides us more to look at than we can actually

see, we end up in an infinitely regressive investigation of minute perceptions of a reality that continually escapes us. Calvino, in his novel *Palomar*, depicts this conundrum with great humor and finesse in the episode where Mr. Palomar discovers infinity in his lawn. Mr. Palomar realizes that "What we call 'seeing the lawn' is only an effect of our coarse and slapdash senses; a collection exists only because it is formed of discrete elements." Palomar then "tr[ies] to apply to the universe everything he has thought about the lawn. The universe as regular and ordered cosmos or as chaotic proliferation. The universe perhaps finite but countless, unstable within its borders, which discloses other universes within itself" (Calvino 1985: 33). Calvino's work helps us draw this conceptual conclusion: that to walk through Rodia's Towers is to navigate a finite space that presents a dizzying spectacle of an infinite universe.

Dioramas: The Watts Towers as Invisible City

Here, in the spirit of Calvino, let me reimagine Rodia's Towers as an invisible city called Dioramas. The name invokes the many re-creations that Rodia's work has inspired, including a scale-accurate replica by Larry Harris (no relation), and also pays homage to the builder of Nuestro Pueblo—Dioramas is an anagram of Sam Rodia.

All roads lead to Rome. Multiple media lead to Dioramas. You can get there by Googling or going to the library; you might, through a chance encounter, find yourself suddenly discovering an unanticipated tentacle of the city. Although not invisible, Dioramas persists only in traces, signs, and images dispersed all across the globe. Dioramas, a kind of collective brain, represents the sum total of all human experiences of the Watts Towers. It encompasses memories of visitors to the site, photos taken, drawings made, films produced, writings inspired, Web sites created. It also includes the site's guest appearances on television shows, in movies, or books, and its historical associations, such as the Watts Rebellion of 1965.

Dioramas, a sprawling assemblage, an intersection or nexus of countless individual lives, reminds us that we ourselves are, ultimately, just such an assembly of lived moments. As Calvino writes in *Six Memos for the Next Millennium*,

> Who are we, who is each of us, if not a combinatoria of experiences, information, books we have read, things imagined? Each life is an encyclopedia, a library, an inventory of objects, a series of styles, and everything can be constantly shuffled and reordered in every way conceivable. (1988: 124)

Nuestro Pueblo embodies such a life, being itself a compendium of styles, materials, designs, beliefs, impressions, and concepts.

The origin point of Dioramas is the vibrant city where Nuestro Pueblo is situated. The heart of Dioramas, its living pulse, is the vital community of Watts. If Rodia's physical Towers hearken back to the *Giglio* festival of Nola, the experienced Towers of Dioramas find renewal and continued inspiration in the annual festival of the Simon Rodia Day of the Drum and the Simon Rodia Jazz Festival held each September. And if Watts is the heart of Dioramas, the city's soul rests in the hands of its prophets, seers, and caretakers—those who maintain the Watts Art Center, the artists and writers of Watts, those who labor to preserve the structures, those who become guardians of the Towers, those who hold it in trust in the city of Los Angeles. Rooted in the local soil of Los Angeles,

Dioramas constitutes the global imaginary that Rodia's construction has stimulated humans to create.

Frozen Flow, Fluid Dynamics

Although it is a solid fixture in space, even taking on the permanence of a historic monument, Rodia's Towers may also be viewed dynamically, as something created in and persisting through time. Imagining the site this way, the Watts Towers suddenly take shape as a series of temporarily frozen flows, made up of many masses of solidified miasma. On reflection, one realizes that Rodia's constructive process repeatedly demanded that he transform flux or flow into fixture or stasis. Cleanly designed mosaics and crisp impressions embedded in or imprinted on wet mortar were created on a carefully controlled cusp where liquid merges with and into solid. Many ornamental materials themselves form in phases that move from wet to dry: Clay becomes pottery; clay, feldspar, and silica become porcelain; industrial slag resembles a lava flow. And glass is, from a technical or scientific standpoint, not actually a solid but a supercooled liquid. Rodia returned glass to its liquid state by melting it in the oven he built, experimenting with ways to fashion new ornaments out of found materials. Among the most eye-catching effects he created this way are seen in the bright blue-green and turquoise glass pieces embedded in the Ship of Marco Polo—colors that recall the southern Mediterranean culture and seas of his Italian homeland.

Rodia used many ornamental materials that evoke water in its ebb and flow. For instance, the thousands of shells decorating the site conjure up the sea or beach, and the lines on these shells record traces of the countless waves that formed them. Calvino (1988), in his *Six Memos for the Next Millennium*, cites this beautifully apt passage from *De Rerum Natura* by his compatriot Lucretius: "We see the multitude of shells painting the lap of the earth, where with soft waves the sea beats on the thirsty sand of the curving shore" (Lucretius 1982: 2.374–76). With Lucretius's image in mind, we may view Rodia's assemblage as a curvilinear, hardened mass, thirsty for the water that once coursed through it. Many structures on the site are containers or conduits of water: birdbaths, the fish pond or baptismal font, and the wedding cake fountain. Water flowing over Rodia's mosaics produces a dazzling chromatic display, explosions of light that generate myriad impressions of microscopic motion, transforming tile patchworks of color into mutually interfering, vibrating waves of light in Brownian motion.

A simple demonstration of how form and flow interact symbiotically on the site occurs if one pours water on the wedding cake fountain: We can watch water draw the imprinted forms in the floor adjacent to the fountain. This exquisite experiment entrains us to see spatial patterns as diagrams of liquid flow.

Rodia's overall design concept of the site as a ship sailing the seas articulates an aesthetic founded in fluid dynamics as much as architecture, and several of Rodia's favorite patterns in fact anticipate the mathematical morphologies of fluid dynamics and chaos theory that became popularly known in the 1980s. Impressions formed by steel chair backs and gears become the whorls within whorls peculiar to turbulent flow or evoke the intricate fractals called Julia Sets. Or, looking up a tower from the base, one feels sucked into powerful fluid vortices; the vortex pattern is also drawn by the Towers in shadow.

The dizzying array of dazzling detail found all over Rodia's site, combined with the fluidity it evokes, are enough to make one's brain swim. To visit the Watts Towers, you

better have your sea legs and be prepared to return to the ocean from which we emerged eons ago.

Sam's Ark: An LA Landmark

The Watts Towers are a monument of migration, a majestic ship that memorializes Rodia's journey to America, and they expresses the rejuvenation he experienced as he created it. I think of Rodia's ship as his ark: Like the biblical ark, the Watts Towers integrate images of both destruction (waste, debris, loss, ossification) and renewal (water, hearts and roses of love, plants, aspiration). And like Noah's ark, Rodia's site is packed with animals—strewn along the archway into his home, hidden in the cactus garden, and popping up in mosaics.

Rodia also resembles Noah in that he undertook a massive building project constructed under demanding conditions. One way to appreciate the magnitude of Rodia's accomplishment is to see it as something created within specific constraints—constraints that we reconstruct after the fact, of course. Here is at least a partial set of the constraints, listed as if God had given spoken orders to Rodia, in the manner that he called on Noah:

> You will assemble massive structures weighing well over 50 tons from scrap materials, using techniques that you have to invent.
>
> You will build the tallest structure ever made by one person alone.
>
> You will build by the sweat of your brow: no scaffolding, no machine tools, bolts, or nails allowed.
>
> You will collect discarded, forgotten fragments numbering about 50,000 and use them to decorate the work.
>
> You may work on your ark only in time left after your hard labor of eight hours a day.
>
> You have thirty-three years to complete the project.
>
> You may begin only midway in your life's journey.

This imaginary scenario reframes architecture as a practice of constraint-based construction. Constraint-based construction has also become popular in the world of writing and literature. Constraint-based writing is most famously associated with the Oulipo, or "workshop for contemporary literature," a group of writers based in Paris and still active today. Calvino was elected to the group in 1973, and many of Calvino's works are considered constraint-based creations, including *The Path to the Nest of Spiders*, *The Castle of Crossed Destinies*, *If on a Winter's Night a Traveler*, and *Invisible Cities*. Calvino's friend, Georges Perec, produced the most acrobatic constraint-based writings, including a novel without the letter *e* in it, entitled *La Disparition*, where a character named Anton Vowl disappears—there are twenty-six chapters in the book, but the fifth one is missing. In Perec's next novel, *Les Revenentes*, all the missing *e*'s from *La Disparition* return. In *Les Revenentes*, *e* is the only vowel used (which means that there is no single word that appears in both novels).

To conclude, I offer a tribute to Rodia's Watts Towers, written under the constraint that *a* is the only vowel used (and sometimes *y*). Why select *a* as the governing constraint? First, because the *a* allows me to match writing to architecture: Visually, capital *A*'s mirror

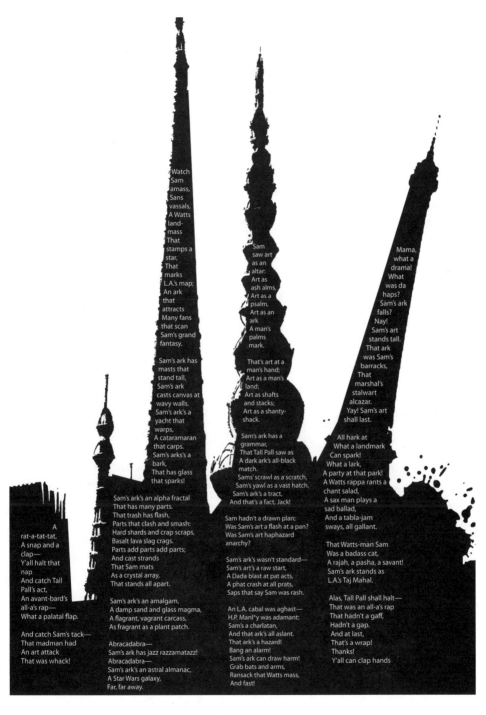

Watch
Sam
amass,
Sans
vassals,
A Watts
land-
mass
That
stamps a
star,
That
marks
L.A.'s map;
An ark
that
attracts
Many fans
that scan
Sam's grand
fantasy.

Sam's ark has
masts that
stand tall,
Sam's ark
casts canvas at
wavy walls.
Sam's ark's a
yacht that
warps,
A catamaran
that carps.
Sam's arks's a
bark,
That has glass
that sparks!

Sam
saw art
as an
altar:
Art as
ash alms,
Art as a
psalm,
Art as an
ark
A man's
palms
mark.

That's art at a
man's hand;
Art as a man's
land;
Art as shafts
and stacks;
Art as a shanty-
shack.

Sam's ark has a
grammar,
That Tall Pall saw as
A dark ark's all-black
match.
Sams' scrawl as a scratch,
Sam's yawl as a vast hatch.
Sam's ark's a tract,
And that's a fact, Jack!

Mama,
what a
drama!
What
was da
haps?
Sam's ark
falls?
Nay!
Sam's art
stands tall.
That ark
was Sam's
barracks,
That
marshal's
stalwart
alcazar.
Yay! Sam's art
shall last.

All hark at
What a landmark
Can spark!
What a lark,
A party at that park!
A Watts rappa rants a
chant salad,
A sax man plays a
sad ballad,
And a tabla-jam
sways, all gallant.

That Watts-man Sam
Was a badass cat,
A rajah, a pasha, a savant!
Sam's ark stands as
L.A.'s Taj Mahal.

Alas, Tall Pall shall halt—
That was an all-a's rap
That hadn't a gaff,
Hadn't a gap.
And at last,
That's a wrap!
Thanks!
Y'all can clap hands

A
rat-a-tat-tat,
A snap and a
clap—
Y'all halt that
nap
And catch Tall
Pall's act,
An avant-bard's
all-a's rap—
What a palatal flap.

And catch Sam's tack—
That madman had
An art attack
That was whack!

Sam's ark's an alpha fractal
That has many parts.
That trash has flash,
Parts that clash and smash:
Hard shards and crap scraps,
Basalt lava slag crags.
Parts add parts add parts;
And cast strands
That Sam mats
As a crystal array,
That stands all apart.

Sam's ark's an amalgam,
A damp sand and glass magma,
A flagrant, vagrant carcass,
As fragrant as a plant patch.

Abracadabra—
Sam's ark has jazz razzamatazz!
Abracadabra—
Sam's ark's an astral almanac,
A Star Wars galaxy,
Far, far away.

Sam hadn't a drawn plan;
Was Sam's art a flash at a pan?
Was Sam's art haphazard
anarchy?

Sam's ark's wasn't standard—
Sam's art's a raw start,
A Dada blast at pat acts,
A phat crash at all prats,
Saps that say Sam was rash.

An L.A. cabal was aghast—
H.P. Manl°y was adamant:
Sam's a charlatan,
And that ark's all aslant.
That ark's a hazard!
Bang an alarm!
Sam's ark can draw harm!
Grab bats and arms,
Ransack that Watts mass,
And fast!

"Sam's Ark: An LA Landmark," a creative tribute to Rodia's work, answers the question: "How can an architectural work like Rodia's Watts Towers dictate structural constraints for a written work?" This poem exclusively uses the vowel A and corresponds to the structural frame of Rodia's Towers.

the shape of Rodia's Towers, while small *a*'s, a hole with a tendril curving out to connect to other lines, evoke the site's spongy surface. Aurally, the harsh, assonant sound of the nasal *a* sonically mimics the gnarled, angular texture of Rodia's assemblage. This text is designed as an answer to the question: How can an architectural work like Rodia's Watts Towers dictate structural constraints for a written work?

Here, then, is an all-*a*'s text, which, naturally, I designate an "alpha rap," written by my only-*a*'s avatar, Tall Pall Harass. I have included a graphic version of the poem, where the words shape three *A*'s, to mimic Rodia's three Towers. The poem is a fractal, *A*'s made out of *a*'s.

SAM'S ARK,
AN L.A. LANDMARK
AN ALPHA RAP
BY TALL PALL HARASS
A rat-a-tat-tat,
A snap and a clap—
Y'all halt that nap
And catch Tall Pall's act,
An avant-bard's all-a's rap—
What a palatal flap.

And catch Sam's tack—
That madman had
An art attack
That was whack!

Watch Sam amass,
Sans vassals,
A Watts landmass
That stamps a star,
That marks L.A.'s map;
An ark that attracts
Many fans that scan
Sam's grand fantasy.

Sam's ark has masts that
stand tall,
Sam's ark casts canvas at
wavy walls.
Sam's ark's a yacht that
warps,
A cataramaran that carps.
Sam's arks's a bark,
That has glass that sparks!

Sam's ark's an alpha fractal
That has many parts.
That trash has flash,

Sam's ark's an amalgam,
A damp sand and glass
magma,
A flagrant, vagrant carcass,
As fragrant as a plant
patch.

Abracadabra—
Sam's ark has jazz
razzamatazz!
Abracadabra—
Sam's ark's an astral
almanac,
A Star Wars galaxy,
Far, far away.

Sam saw art as an altar:
Art as ash alms,
Art as a psalm,
Art as an ark
A man's palms mark.

That's art at a man's hand;
Art as a man's land;
Art as shafts and stacks;
Art as a shanty-shack.

Sam's ark has a grammar,
That Tall Pall saw as
A dark ark's all-black match.
Sam's scrawl as a scratch,
Sam's yawl as a vast hatch.
Sam's ark's a tract,
And that's a fact, Jack!

Sam hadn't a drawn plan;
Was Sam's art a flash at a
pan?

An L.A. cabal was aghast—
H. P. Manl*y was adamant:
Sam's a charlatan,
And that ark's all aslant.
That ark's a hazard!
Bang an alarm!
Sam's ark can draw harm!
Grab bats and arms,
Ransack that Watts mass,
And fast!

Mama, what a drama!
What was da haps?
Sam's ark falls?
Nay! Sam's art stands tall.
That ark was Sam's barracks,
That marshal's stalwart
alcazar.
Yay! Sam's art shall last.

All hark at
What a landmark
Can spark!
What a lark,
A party at that park!
A Watts rappa rants a chant
salad,
A sax man plays a sad ballad,
And a tabla-jam sways, all
gallant.

That Watts-man Sam
Was a badass cat,
A rajah, a pasha, a savant!
Sam's ark stands as
A jazz chantry,
L.A.'s Taj Mahal.

Parts that clash and smash:
Hard shards and crap scraps,
Basalt lava slag crags.
Parts add parts add parts;
And cast strands
That Sam mats
As a crystal array,
That stands all apart.

Was Sam's art haphazard
anarchy?

Sam's ark's wasn't standard—
Sam's art's a raw start,
A Dada blast at pat acts,
A phat crash at all prats,
Saps that say Sam was rash.

Alas, Tall Pall shall halt—
That was an all-a's rap
That hadn't a gaff,
Hadn't a gap.
And at last,
That's a wrap!
Thanks!
Y'all can clap hands.

A rat-a-tat-tat,
A snap and a
clap Y'all
halt that nap
And catch Tall Pall's
act, An avant-bard's
all-a's rap—
What a palatal flap!
And catch Sam's tack—
That madman had An
art attack That was
whack! Watch Sam amass, Sans vassals, A
Watts landmass That stamps a star, that marks
L.A.'s map; An ark that
attracts Many fans that
scan Sam's grand fantasy.
Sam's ark has masts that
stand tall, Sam's ark casts
canvas at wavy walls. Sam's ark's
a yacht that warps, A cataramaran
that carps Sam's arks's a bark,
That has glass that sparks!
Sam's ark's an alpha fractal That
has many parts. A trash fractal
That has flash, Parts that clash
and smash: Hard shards and
crap scraps, Basalt lava slag
crags. Parts add parts add parts;
And cast strands That Sam mats
As a crystal array, That stands all apart.

```
                        Sam's
                    ark's   an
                    amal-   gam,
                A damp    sand
                and           glass
                magma,   A flagrant,
                vagrant       carcass,
                As fragrant   as a plant
                patch.        Abracadabra
                Sam's ark         has jazz
                razzamatazz.      Abracadabra
        Sam's ark's an astral almanac, A Star
        Wars galaxy, Far, far away. Sam saw art
            as an                         altar:
            Art as                        ash alms,
            Art as                        a psalm,
            Art as                        an ark
            A man's                       palms mark.
            That's art at                 a man's hand;
            Art as                        a man's land;
            Art as                        shafts and stacks;
            Art as a                      shanty-shack.
            Sam's ark                     has a grammar,
            That Tall Pall                saw as A dark
            ark's all-black               match. Sam's
            scrawl as a                   scratch, Sam's
            yawl as a                     vast hatch.
            Sam's ark's                   a tract,
            And that's a                  fact, Jack!
            Sam hadn't                    a drawn plan.
            Was Sam's art a               flash at a pan?
            Was Sam's art             haphazard anarchy?
            Sam's ark's wasn't            standard—
            Sam's art's a raw start,      A Dada blast at
            pat acts, A phat              crash at all prats,
        Saps that say                     Sam was rash.
```

An L.A. cabal

was aghast—

H. P. Manl*y

was adamant:

Sam's a charlatan,

And that ark's all

aslant. That ark's a

hazard! Bang an

alarm! Sam's ark

draws harm! Grab bats

and arms, Ransack that

Watts mass, And fast! Mama, what a drama!

What was da haps? Sam's ark falls? Nay!

Sam's art stands tall.

That ark was Sam's barracks,

That marshal's stalwart alcazar.

Yay! Sam's art shall last. All

hark at What a landmark

Can spark! What a lark,

A party at that park!

A Watts rappa rants a chant salad,

A sax man plays a sad ballad,

And a tabla-jam sways, all gallant.

That Watts-man Sam Was a badass cat,

A rajah, a pasha, a savant! Sam's

ark stands as L.A.'s Taj Mahal.

Alas, Tall Pall shall halt—

That was an all-a's rap

That hadn't a gaff,

Hadn't a gap. And at last,

That's a wrap! Thanks!

Y'all can clap hands.

Works Cited

Calvino, Italo. 1985. *Mr. Palomar.* Translated by William Weaver. San Diego: Harcourt Brace Jovanovich.
———. 1988. *Six Memos for the Next Millennium.* Translated by Patrick Creagh. New York: Vintage International.

Goldstone, Bud, and Arloa Paquin Goldstone. 1977. *The Los Angeles Watts Towers (Conservation and Cultural Heritage.* Los Angeles: Getty Center for Education in the Arts.

Lucretius. *De Rerum Natura.* 1982. Translated by W. H. D. Rouse, revised by Martin Ferguson Smith. Cambridge, Mass.: Harvard University Press.

Seitz, William Chapin. 1961. *The Art of Assemblage.* New York: Museum of Modern Art.

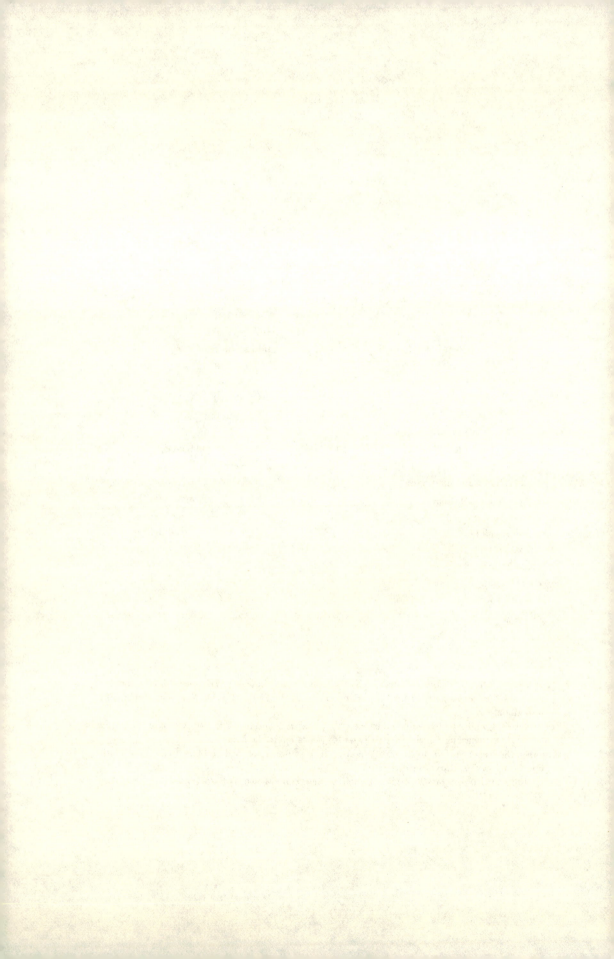

Without Precedent: The Watts Towers

Thomas Harrison

Italo Calvino, in the concluding tale of his *Cosmicomics*, tells the story of a mollusk that, though sightless, generated a beautiful spiral shell for beholders to admire. The mollusk is, of course, a metaphor for the artist, whose creation becomes one in a potentially endless series of images in the eyes of others. In fact, the "vocation of form" embraced by the blind mollusk explains how the murky sea was transformed into a "visual field" to begin with. All the eyes that would focus in on shells like its in the course of the coming millennia—those of passing cuttlefish and seals, of sea captains with lady friends looking through a spyglass—owe their activity to this first and literally blind act of creation, generated in the manner of a spontaneous exclamation or gesture of love.[1] "All these eyes were mine," says the mollusk, with some bitterness but an even greater sense of pride; "I had made them possible; I had had the active part; I furnished them the raw material, the image. . . . In other words, I had foreseen absolutely everything" (Calvino [1965] 1968: 152–53).

The parable of the mollusk suggests that each important first step, each beginning, entails a journey whose nature is unknowable until one reaches the destination and then turns back and discerns its shape. That is what some writers mean when they say that the first line of a poem is given to them automatically, while the rest of the work still remains in the dark. But such a line is enough for a start. As the destination draws near, the beginning progressively recedes, until it is finally lost—in finality itself, or in the completeness and enclosure of the work.

One day after working on his Towers in Watts for more than thirty years, the immigrant tile setter from Campania, Italy, called Sam Rodia decided he was through with them. He gifted them to a neighbor and left Los Angeles for good. To the day of his death, he remained reluctant to discuss this extraordinary creation on his private property, wishing never to see the Towers again, even though they had attracted the attention of art circles across the world. Once they were finished, they had lost their purpose; for they were all about the doing.

We know hardly anything more about Sam's motivation in building these Towers than this: "Why I build the towers?" he retorted to queries from his admirers. "Why a man make the pants? Why a man make the shoes?" ("Now, it's no use my piling up words, trying to explain the novelty of this intention I had," says Calvino's mollusk about the making of his shell; "the first word I said is more than enough: make, I wanted to make, and considering the fact that I had never made anything or thought you could make anything, this in itself was a big event. So I began to make the first thing that occurred to me, and it was a shell" [Calvino [1965] 1968: 146]). Some years earlier, when still in Watts, Rodia had said something slightly more revealing: "I wanted to do something. I wanted to do something big." And, finally, in his most eloquent explanation, he offered this: "You gotta do something they never got 'em in the world."[2]

Rodia's emphasis was consistently on the doing, on creating something not simply momentous, but momentous because it was unprecedented. In short, building these Towers was about making a beginning—envisioning something utterly new, and something that would always remain new insofar as its objective could not be clearly understood. Here a beginning was dilated and extended indefinitely. Only when Rodia decided to quit building them did the process of creation end. In fact, the Towers were never finished; they were only terminated.

Hence, what prompted Rodia to begin a thirty-year project, engaging him each night after work, not to mention each Saturday, Sunday, and holiday of the year, cannot be established with historical or psychological certainty. Yet the motivation of the work is already inscribed in the form that it took, or in the nature of what Sam decided to build: towers. Towers reach up. They engage in an act of ascension. They formalize a continuous, consecutive accretion, an unending beginning. This is especially the case with these open, agglutinative Towers of Watts, with their differing and improvised heights, built rod by rod and ring upon ring. Rodia did not operate like a professional architect, on the basis of drawings and designs. He worked one day at a time, often tearing down on Wednesday what he had built on Tuesday (as reported by his neighbor, the jazz great Charles Mingus [1971] 2002: 558–59). As the entire thing was built without the aid of external scaffolding, and Rodia was a slight man barely five feet tall, his Towers themselves created a ladder "upon which he climbed as he 'built'" (Linda White, as quoted in Morgan 1984: 74).

The Towers articulate and record this process of accretion—this "incremental aesthetics" (Doss 2007: 28)—that created the final result. At every stage of their progress, they show themselves distancing themselves from the earth, "taking off" in a manner reminiscent of the scene in Federico Fellini's $8^{1}/_{2}$ that shows a launching pad for a rocket to transport people away from the earth. The launching-pad tower, in that film, is virtually coextensive with the spaceship. And, for all we know, its potentially infinite, ascensional drive might even have been inspired by Rodia's Towers, completed eight years earlier (in 1954 or 1955) and conspicuously discussed in the press.[3]

In a different optic the Watts Towers could be seen as a kind of pier turned up-ward—a pier, which in a witticism of James Joyce (*Ulysses* [1922] 1998: 25) is "a disappointed bridge," insofar as its real desire is to reach across the water to the other shore. Such a pier is destined to remain no more than a beginning, even when terminated. It is a thrust, a motivation—and thus also a failed connection.

But a pier at least rests on the water, and boats can attach to it. An openwork tower, instead—constructed out of thin steel rods encased in concrete—is a pure act of reaching out, of grasping and clasping, but with no corresponding hand to come meet it from the sky. These Towers in Watts are the beginnings of a bridge that cannot be brought to completion. They figure the unending nature of beginnings themselves, whose end lies in achieving no end, or in embracing their nature as unfulfilled bridges.

This act of ascension and aspiration is reenacted by the material and cultural history of the Towers. Vis à vis matter, these towering, vertical deviations in the extended and flat horizon of urban Los Angeles sublimate various products of nature and consumer culture. Empty bottles of Milk of Magnesia and 7UP, seashells, pottery and cups, broken tiles, colanders, and wire baskets are incorporated into cement surfaces, used to make imprints, built into the constructive foundations of birdbaths, walls, and a sculpted ship.

In actual fact what we refer to as the Watts Towers are not mere towers at all. They are an extended, assembled composition on a plot of land that Rodia named Nuestro Pueblo: our town, our habitation, even our people or clan.[4] Whether you call it vernacular architecture, assembly art, or, as Sam's brother-in-law or the city's building inspector Manley declared, "a pile of junk" (*I Build the Tower;* Landler and Byer 2006), this complex amalgamate sculpture takes thousands of pieces of debris, bonds them with the highest grade steel and mortar (costing Rodia small fortunes of his own money), and submits them to an imponderable artistic purpose.

It makes new use of materials that once littered the earth, inertly, without life or function: empty bottles, found objects, dead shellfish, tile shards, the detritus of nature. A new beginning is made of these end points, transforming the "copious waste of an industrial society into structures of soaring magnificence" (Seitz 1961: 72–73).

This ostensible transmutation of "junk" into art (informed by a breathtaking structure of high-grade engineering) turned into a bone of contention—a veritable political and ideological debate—when the Los Angeles Department of Building and Safety decided to raze the Towers to the ground three years after Rodia left, in 1957.

The official reason given was that these unregulated towers, built with no permit, were a community hazard; a less vocalized reason was that they did not serve any appreciable interests on the urban horizon.[5] The man responsible for the demolition order, one Harold Manley, was all but explicit about this (Whiteson 1989: 27). In 1959, with Los Angeles reeling from the aftereffects of the House Un-American Activities Committee (denounced the same year by President Harry Truman as the "most un-American thing in the country today," quoted in Whitfield 1996: 124), the custodians of an image of the city (county and state officials) clashed with the defenders of an image of art. In 1957, two men from a more prosperous neighborhood than Watts—soon to organize themselves and others into the Committee for Simon Rodia's Towers in Watts—discovered the structures in a derelict and abandoned condition, purchased them for a few thousand dollars from a Watts resident, and proceeded to spend immeasurable energy trying to convince civic functionaries that Nuestro Pueblo was not a meaningless, useless, unsafe

THE WATTS TOWERS
SITE PLAN

1. Rodia's house
2. Chimney
3. Canopy
4. A Tower
5. B Tower
6. Gazebo
7. Oven/barbecue
8. Fish pond
9. West Tower
10. Garden Spire
11. Center Tower
12. East Tower
13. Ship of Marco Polo
14. Patio floor
15. North Wall
16. South Wall

Layout of "Nuestro Pueblo," as Rodia called his property. The rectangle on the left represents his house, and the circles outside the Towers. Courtesy of Goldstone and Paquin Goldstone 1997, p. 9.

pile of junk. Rather, it was a work of unique inspiration, made to the highest intuitive standards of design and engineering, even if with some poor materials and with no defined space in the art world; with no determinable market value, no clear and incontrovertible purpose, no relationship whatsoever to the economic structures of contemporary life, no beauty or order as conventionally associated with Art.

Beneath these issues, of course, lay the problem of the Towers' location, in a neighborhood thoroughly outside the economic and political power structures of Los Angeles. Here in Watts something both practically and symbolically dysfunctional seemed to be encroaching on the order of civic institutions; on clear and distinct conceptions of enterprise; on those immured bureaus of power that the 1960s would denounce as "the political establishment." The city's determination to destroy the Towers was in many ways a defense of the "high" against the threats of the "low," spurred less by material than ideo-

logical interests. Both literally and figuratively, the Towers suggested a rising up of the earth and the lowly, the humus and the materially unruly, against elites of various casts. The controversy surrounding Nuestro Pueblo was a harbinger of greater tensions to come in the Watts Riots in 1965.

In 1959 the call by a small group of college graduates, artists, intellectuals, engineers, writers, and museum curators to respect an unusual monument of land art called into question the beliefs and operational principles of an entirely different group of city councilmen, law enforcers, bureaucrats, urban planners, politicians, and businessmen. The only way to preserve the Towers, the two sides agreed, was to ensure that they were no threat to their surroundings. If they turned out to be strong enough to resist a 10,000-pound load of cables trying to pull them down then they would have earned a right to remain on the site. The Towers withstood the assault—on October 10, 1959—and in so doing achieved a victory for the entire category of folk art, vernacular architecture, and environmental art that they represented. Thus did the Towers bridge the art world and the ghetto, establishing common causes between them. To be sure, this was not the first case of *Art Brut* in modern art history; however, those were the years—the 1950s and 1960s—when *Art Brut* made permanent inroads into social consciousness, winning its place in the pantheon of the arts. In other words, what Rodia began in 1921 found its cultural and political development on the cusp of the 1960s. By contesting the civil authorities, the intellectually astute members of the Committee (a tower of power, an impressive work of social construction in its own right) successfully defended naive art and by proxy underprivileged culture: in this case, the labor of a penurious immigrant, who hardly spoke the language of his host country, inhabiting a community worse off than he.

The result of this fight was that the ignored inner city was thrust into the affairs of the polis. This was the beginning, in Watts, of forced attention. The six days of rampage following police brutality in the same district on August 11, 1965, were a more clamorous dramatization of the same principle, stressing that well-to-do Los Angeles could no longer afford to ignore what was happening on the other side of town. Rodia's was a symbolic gesture; that of the Watts community a political one; both were inaugural and universalized their locale. In this context, more answers must be sought to the question of exactly where Rodia chose to construct his Pueblo—namely, ten meters from the Watts railroad tracks on which nearly 100,000 commuters a week traveled between Long Beach and Los Angeles on their way to work (see Goldstone and Paquin Goldstone 1997: 35). These passengers, who could almost reach out and touch these Towers, could not avoid asking themselves what these strange structures were all about, why a man was hanging up in them with a bucket of cement, and what relation the Towers bore to other types of constructive work and practice. It is astonishing to think—as Rodia reported to an Italian American film student at the University of Southern California who helped produce a documentary on the craftsman called *The Towers* (Hale 1953)—that Rodia considered buying another triangular piece of property in Los Angeles before he settled on this $900 lot on 107th Street in Watts (the purchase price is cited in Umberger 2007: 112).[6] It was the property currently occupied by the Beverly Hilton Hotel, at the intersection of Wilshire and Santa Monica Boulevards in Beverly Hills.[7]

Had Rodia bought that triangular lot at the intersection of Santa Monica and Wilshire instead of the one in Watts, the Los Angeles community would have engaged in an even more heated debate about the future of these Towers—assuming such a debate would

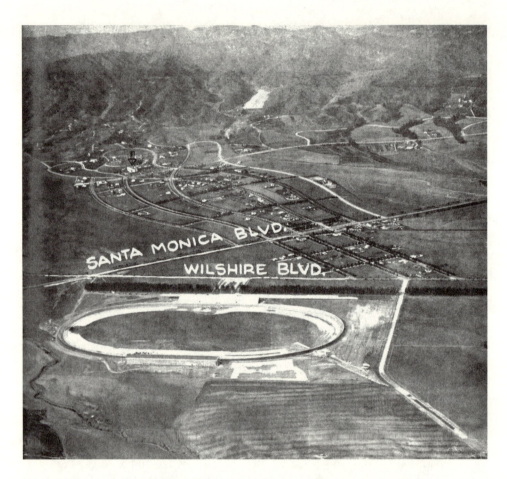

Beverly Hills in 1921–22. Rodia's lot would have been the triangular one at the far left. Courtesy of the Benjamin and Gladys Thomas Air Photo Archives (Spence Collection), UCLA.

have occurred at all. No doubt, the sculptures would have been dismantled even if they had been erected by Michelangelo himself. Or else, assuming a miracle, they would have become more visible a civic structure than the Roman Coliseum.

Yet the irony is that in 1921, as Rodia deliberated over which property to buy, there was no activity whatsoever at this barren intersection in Beverly Hills. The property next to the railroad track in Watts had much more to commend it. Watts was well developed, inhabited, and for ten years had been advertised as the very "Hub of the Universe," boasting an extraordinary, four-track electrical line connecting "Los Angeles and Long Beach, Los Angeles and San Pedro, Newport, Huntington Beach and Balboa" (Ray 1985: 26–27). So Rodia knew exactly what he was doing as far as public exposure went. He chose the location for his Towers with their visibility utmost in his mind: 107th Street in Watts, on which the lot lay, ran exactly east–west between the two main train tracks turning north to Los Angeles proper; and the Towers were also well in sight of the other two tracks

WATTS THE HUB

WHERE OPPORTUNITY AWAITS YOU

Watts, Calif.,

Watts Chamber of Commerce Letterhead, circa 1912
Los Angeles City Archives, Watts City Records, 1907-1926

Publicity campaign for Watts, 1912. Rodia's property is adjacent to the train tracks coming in from the south. Reprinted from Ray 1985, p. 27.

coming from Redondo and San Pedro. Outsider and marginalized immigrant though he may have been, Rodia wanted his Towers to be seen.

In this respect his construction was intrinsically related to the geodynamics of the train. It shifted the commuters' and workers' vector—the motion in which they were taken— from horizontal to vertical. The Towers offset the travelers' lateral movement, on tracks clinging to the earth, by way of a different set of tracks reaching up to the sky, converging up high at a pointless point. Not only did the sleepy commuters have to ask themselves what these Towers were all about. However subconsciously, they also had to confront the contrast between these static, inexplicable ascensions and their own plotted out, horizontal projects.[8]

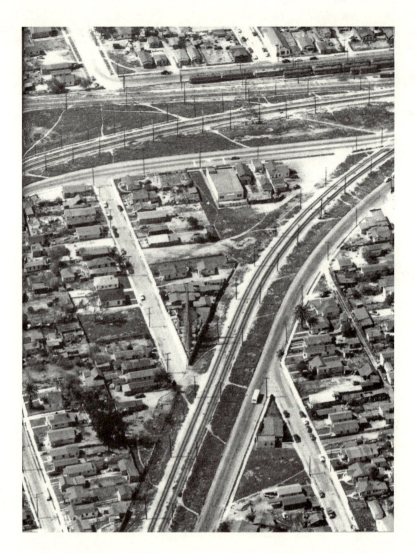

The Watts Towers are at center, between the two railroad tracks turning north to approach Watts' 103rd Street Station. Courtesy of the Benjamin and Gladys Thomas Air Photo Archives (Fairchild Collection), UCLA.

After 1975, when they were donated by the Committee to the City of Los Angeles, the Towers turned Watts into a permanent, if not altogether welcome, presence on the stage of the larger metropolis.[9] In them, the politically repressed—South Central LA—pierces the city's horizon. Despite the changes that this district has undergone since Rodia lived there from the 1920s to the mid-1950s, the Towers have remained Watts's abiding symbol. In the 1960s, they became the site of the first community art center in America, and currently they are the location of two annual music festivals; they are one of only a half-dozen National Historic Landmarks in Los Angeles. In short, the attention the Towers

have drawn to themselves over these years is simultaneously an attention to the broader precinct of Watts. And it is probably inevitable that the interests of the two should often be at odds, especially considering how few funds Los Angeles directs toward Watts and how a major portion of these funds is earmarked for the preservation and upkeep of the Towers. According to circumstance, the relationship between the Towers and the neighborhood varies from conflictual to fraternal. In any event, it is fatefully symbiotic, each element drawing attention toward or away from the other in a syndrome of codependence (Schrank 2009).

A prime function of the Towers is thus rhetorical. They are acts of invocation, calling from one place to another, perforating that place with their spires. They inaugurate discourse, continually and reiteratively. In the beginning, their interlocutor was not the greater city of Los Angeles but the immediate surroundings of Watts. When Rodia lived there in the 1920s and 1930s, the district had a different demographic. More multiethnic than it is now, it was inhabited by a solid working class made up predominantly of whites, but with a sizeable number of Mexicans and blacks and some Japanese. Hardly any of these immigrants were Italian like Rodia. Before and after the Towers began their symbiosis with the community of postwar Watts (which has changed once again, becoming as Latino as African American), Nuestro Pueblo was distinctly different from its neighborhood in form, style, intent, and meaning.[10] Put otherwise, these Towers have always enacted a gesture of otherness, in a prime instance of what, in the early 1970s, Roger Cardinal dubbed *outsider art.*[11]

From the start, the Towers marked a stylistic *écart,* a deviation, a difference within an environment already strongly marked by social and ethnic difference. Within the walls of Rodia's pueblo, one entered a recreated, imaginative, otherworldly space. We also cannot discount the fact that he built them with only his own hands and rudimentary tools; that he appeared to his neighbors as often curmudgeonly and even nuts; that by the 1950s, when the neighborhood had changed and Sam decided to leave, economic and social tensions had led boys to pelt his sculptures with rocks.

Giving free rein to his rants, Landler and Byer's (2006) film has the virtue of richly dramatizing the polemical, philosophical, and anarchic outsider that Rodia was. And the rants have an obsessively consistent theme: how America has degenerated. No attempt that I know of has been made to link Rodia's worldview, as it comes across in the 1950s and 1960s, to the Towers that he built (see Del Giudice's essay in this volume). Yet we are well aware that in the case of most so-called outsider artists (as in that of the nineteenth-century bohemians that preceded them), their strident anti-establishmentarianism of opinion is inextricable from the creative acts for which they are admired. There is no sense in dividing these autonomous and eccentric figures into two separate persons—the first an ingenious craftsman and the second an intellectual quack.[12]

The visions, obsessions, and manias by which characters like Rodia are driven are reinforced by their marginal relationship with the culture they inhabit, and are themselves the beginnings, motivators, or inaugurators of the work that they do. What is altogether clear from the Landler and Byer documentary is how disillusioned the post-Towers Rodia was about the political and economic straits of contemporary America. Short of dismissing him as a "cracker-barrel philosopher" (Langsner 1952: 25), we cannot help but reflect on how his points of view resonate with the prime concerns, both then and earlier in time, of anarchy, socialism, libertarianism, revolutionism, and sometimes even occult

thinking. There is little doubt that a sense of the principles and practices on which the United States were based, at least in the mind of this unassimilated immigrant—the degeneration of which so obsessed Rodia in his later years—were involved in his relation to the Towers to begin with. And also to end with, for Sam may have stopped working on his project precisely when he no longer believed in its productiveness, in its fruitfulness, in the concrete possibilities of the aspirations it expresses. The cultural dereliction against which Rodia inveighs in taped interviews is no less embodied than battled in the Towers themselves—in the manner, the materials, and the genealogy of their construction along with the historical and spiritual space they make their own.

Two minds of considerable distinction, Jacob Bronowski (in *The Ascent of Man,* 1974) and Buckminster Fuller (interviewed in *I Build the Tower*), have hailed Rodia's work as one of the world's least adulterated hymns to the dignity and freedom of pure human initiative. In their Promethean gesture, the gratuitous and ingenious Towers signal the endless capacity and nobility of our species' inventive spirit. As correct as this is, Rodia's work bears witness to more than the irrepressible *homo faber* at the heart of the humanistic ideal. His initiative inaugurates a series of material and cultural effects, beginning with the form that the work takes (towers) and its revitalization of abandoned and consumed materials. The initiative then focalizes an epochal debate about the very nature and worth of this kind of work. It bridges the art world and a forlorn urban space from which that world had so often strived to keep its distance. Many fortuitous and felicitous relations were forged by this bridge, including connections with a world of social hopes and exclusions and disappointments that the Towers themselves referenced by their position in Watts, to say nothing of the civic battles with which these structures were soon to be embroiled. There was no anticipating such beginnings from Sam Rodia's idea to build "something they never got 'em in the world." Blind though the mollusk may have been, an entire visual field was born from his decision to embrace a vocation of form.

Works Cited

Banham, Reyner. 1971. *Los Angeles: The Architecture of Four Ecologies*. New York: Harper and Row.

Beardsley, John. 1995. *Gardens of Revelation: Environments by Visionary Artists*. New York: Abbeville.

Bronowski, Jacob. 1974. *The Ascent of Man*. Boston: Little, Brown.

Calvino, Italo. [1965] 1968. *Cosmicomics*. Translated by William Weaver. San Diego: Harcourt Brace.

Cándida Smith, Richard. 1996. "The Elusive Quest of the Moderns." In *On the Edge of America: California Modernist Art, 1900–1950,* edited by Paul Karlstrom, 21–41. Berkeley: University of California Press.

Cardinal, Roger. 1972. *Outsider Art*. New York: Praeger.

———. 1978. *Primitive Painters*. London: Thames and Hudson.

Dal Lago, Alessandro, and Serena Giordano. 2008. *Fuori cornice: L'arte oltre l'arte*. Torino: Einaudi.

Doss, Erika. 2007. "Wandering the Old, Weird America: Poetic Musings and Pilgrimage Perspectives on Vernacular Art Environments." In Leslie Umberger, *Sublime Spaces and Visionary Worlds: Built Environments of Vernacular Artists,* 25–46. New York: Princeton Architectural Press.

Fiore, Teresa. 2002. *Pre-Occupied Spaces: Re-Configuring the Italian Nation Through Its Migrations*. PhD dissertation, University of California, San Diego. Available from http://www.proquest.com (Publication No. AAT 3064464).

———. 2004. "The Ship as a Pre-Occupied Space: A Comparative Approach to Migrant Cultures Between Italy and the United States." In *Sites of Ethnicity: Europe and the Americas,* edited by William Boelhower, Rocío G. Davis, and Carmen Birkle, 29–44. Heidelberg: Universitätsverlag Winter GmbH.

Goldstone, Bud, and Arloa Paquin Goldstone. 1997. *The Los Angeles Watts Towers*. Los Angeles: Getty Conservation Institute.

Hale, William, director. 1953. *The Towers*. Los Angeles: Creative Film Society.

Harris, Paul A. 2005. "To See with the Mind and Think Through the Eye: Deleuze, Folding Architecture, and Simon Rodia's Watts Towers." In *Deleuze and Space*, edited by Ian Buchanan and Gregg Lambert, 36–60. Edinburgh: Edinburgh University Press.

Hernández, Jo Farb. 2001. "Watts Towers." *Raw Visions* 37 (December): 32–39.

Joyce, James. [1922] 1998. *Ulysses*. Oxford: Oxford University Press.

Landler, Edward, and Brad Byer, writers, directors, and producers. 2006. *I Build the Tower*. Los Angeles: Bench Movies.

Langsner, Jules. 1951. "Sam of Watts." *Arts & Architecture* 68.7 (July 1951): 23–25.

Maizels, John. 1996. *Raw Creation: Outsider Art and Beyond*. London: Phaidon Press.

Mingus, Charles. [1971] 2002. "Excerpts from *Beneath the Underdog: His World as Composed by Mingus*." In *Writing Los Angeles: A Literary Anthology*, edited by David L. Ulin, 558–61. New York: Literary Classics of the United States.

Morgan, Jeanne. 1984. "Rodia's Towers: Nuestro Pueblo, a Gift to the World." In *Personal Places: Perspectives on Informal Art Environments*, edited by Daniel Franklin Ward, 72–82. Bowling Green, Ohio: Bowling Green State University Popular Press.

Posen, I. Sheldon, and Daniel Franklin Ward. 1985. "Watts Towers and the *Giglio* Tradition." In *Folklife Annual: 1985*, edited by Alan Jabbour and James Hardin, 143–57. Washington, D.C.: Library of Congress.

Ray, Mary Ellen Bell. 1985. *The City of Watts, California, 1907 to 1926*. Los Angeles: Rising Publishing.

Rose, Barbara. 1974. "Dubuffet: Seeing New York His Own Way." *Vogue Magazine*, September.

Rossellini, Roberto, director. 1950. *Francesco, giullare di Dio* [The Flowers of Saint Francis.]

Schrank, Sarah. 2000. "Picturing the Watts Towers: The Art and Politics of an Urban Landmark." In *Reading California: Art, Image, and Identity, 1900–2000*, edited by Stephanie Barron, Sheri Bernstein, and Ilene Susan Fort, 373–86. Berkeley: University of California Press.

———. 2008. "Nuestro Pueblo: The Spatial and Cultural Politics of Los Angeles' Watts Towers." In *The Spaces of the Modern City: Imaginaries, Politics, and Everyday Life*, edited by Gyan Prakash and Kevin M. Kruse, 275–308. Princeton, N.J.: Princeton University Press. Reprinted in the present volume.

———. 2009. *Art and the City: Civic Imagination and Cultural Authority in Los Angeles*. Philadelphia: University of Pennsylvania Press.

Seitz, William. 1961. *The Art of Assemblage*. New York: Museum of Modern Art.

Sides, Josh. 2004. *L.A. City Limits: African American Los Angeles from the Great Depression to the Present*. Berkeley: University of California Press.

Trillin, Calvin. 1965. "A Reporter at Large: I Know I Want to Do Something." *The New Yorker*, May 29, 72–120.

———. 1971. "U.S. Journal: The Towers of Watts." *The New Yorker*, December 4, 136–43.

Umberger, Leslie. 2007. *Sublime Spaces and Visionary Worlds: Built Environments of Vernacular Artists*. New York: Princeton Architectural Press.

Valéry, Paul. 1960. *Oeuvres*, vol. 2. Paris: Gallimard.

Whiteson, Leon. 1989. *The Watts Towers of Los Angeles*. Oakville, Ontario, Canada: Mosaic Press.

Whitfield, Stephen J. 1996. *The Culture of the Cold War*. Baltimore: Johns Hopkins University Press.

An Era of Grand Ambitions: Sam Rodia and California Modernism

Richard Cándida Smith

I have written about Sam Rodia on several occasions. In this short piece, I will explore the underlying conception I had formed about Rodia and the Watts Towers as I studied his work and his place in California cultural history: Sam Rodia is the quintessential modernist artist of California, an inspiration who exerted an influence on the state's cultural life fully equal to that of any other visual artist who has lived and worked in the state (Cándida Smith 1996, 2005, 2009a, and 2009b). For many in the generation of artists, of various social and racial backgrounds, who came of age during or after World War II, Rodia was indeed the equal of Pablo Picasso, Marcel Duchamp, Max Ernst, or Paul Klee in providing a model for what a great modern artist could accomplish. The reasons given for what made Rodia important are quite literally "all over the map." Nor was there a single interpretation of what the Watts Towers meant. The more important fact was that again and again, across communities, in the oral histories collected at the Archives of American Art, in Special Collections at UCLA, or at the University of California, Berkeley, artists spoke of Rodia as an important influence. He looms large in many of these documents and is repeatedly considered to be an exemplary example of a modern artist who engaged with his materials to make a critical interpretation of his world.

The recognition young artists gave him matched Rodia's own ambitions. He told William Hale in 1952, "I was going to do something big, and I did."[1] It was an ambition

that matched the times, that was consistent with the goals of state leaders to turn California into a new center of world culture. John Aubrey Douglass has shown in his superb study of "the California Ideal" developing at the beginning of the twentieth century that political, business, and social elites were committed to an ambitious program of creating a society where the best education and culture that the world had to offer would be available to all citizens. It was no idle ambition, as governors and legislatures, regardless of party affiliation, made sizable investments, decade after decade, in the institutions and infrastructure needed, and by 1930, university attendance in the state was already twice the national average. Such programs, with the University of California at the apex, were an important factor in the state developing into a center of scientific and technological innovation (see Douglass 2000).

As with many utopian goals or visions, the shadow side of the California Ideal was never hidden. "Universal" education did not mean that the children of farm laborers were imagined as participants, nor perhaps were the children from many other communities. In 1939, the World's Fair at Treasure Island proclaimed that California was a society well on its way to synthesizing the cultures of the world into a new culture that took the best of what every people had developed. At the time, this boast did not mean that people of African or Asian descent would be allowed to live in any neighborhood, or that children from Mexican families would necessarily be allowed in the schools or the swimming pools that white children used, but perhaps the imaginary claim played a role in the abolition of formal segregation in the state between 1940 and 1960.[2] Those who proclaim a grand ambition cannot control how others, within earshot but seldom perceived as even being present, will understand and act on these declarations. And were it not for those foolish enough to take grand ambitions seriously, despite the obvious hypocrisy surrounding them, the goals would never have moved closer to realization.

Sam Rodia became the quintessential California modern artist because he took these grand ambitions, articulated all around him, seriously, and he insisted on making himself an integral part of that mosaic of California excellence. For this reason, he helped artists of the postwar generation determine for themselves what was distinctive, though perhaps not unique, about the society in which they lived and worked. Presenting an ambitious vision of what art offered modern society was an important part of Rodia's appeal, but equally important was the example he provided of how to overcome the limitations of being an artist in a commercial, technology-centered society. Rodia inspired because he took artistic ambition seriously, and he relied on his own efforts to realize his vision in a way that would compel others to pay attention. He built the Watts Towers on a lot that was adjacent to the most important commuter railway line of his time in Los Angeles County. Thousands passed the Watts Towers day after day, week after week, for three decades, between 1921 (when Rodia began his project) and 1954, when he moved away shortly after the commuter rail line connecting downtown Los Angeles and Long Beach closed (see Harrison, this volume). His vision of a reconfigured city must have seemed wondrous to some and simply weird to others.

Because of his use of found materials and because of his critical revisioning of modern life, Rodia was particularly relevant to artists who worked in assemblage, and his example helped define what distinguished California assemblage from its East Coast and European variants. Rodia offered a locally grounded way of thinking about art practice that reshaped what assemblage artists could do. Critics in the 1950s and 1960s under-

stood that California assemblagists shared a need to comment on life in the United States and the conflicted, hypocritical nature of its social relationships. They needed to break down barriers between subject and object, between reality and fantasy, life and art, literature and the visual arts.[3] For those who saw modern art as requiring ever more formal purification and the exclusion of non-art messages, California assemblage was work to be excluded. California art in general was largely invisible in New York and barely known on the world stage. Prior to the post–Ferus Gallery explosion of the mid-1960s, any of those in the state who made modernist art had to think of themselves to some degree as an outsider, regardless of whether they had studied in Paris or New York or whether a vision of modern life to be expressed in visual terms had developed while working as an itinerant laborer going up and down the West Coast. An ambition to be an artist was particularly grand because so consistent with the ambitions of the state but also so at odds with the limited practical possibilities for doing it. The ambition was even grander if the art was committed to changing the way people felt about the world around them. Rodia's work demonstrated the ultimate validity of the proposition that "universal" education and culture would transform the world, even if those who proclaimed the goal as their ambition did not understand who "universal" necessarily includes or excludes.

The ideals that Rodia exemplified provided a model for intellectual and moral independence. He used his talent as an artist to create a place of respect for himself, something he could do only through the exercise of imaginative freedom, for in his aspect as a laborer in an industrial society, his thoughts and feelings, his personality, were of little significance. Art allowed him to change the world, if only by claiming the right to speak, and by finding a clever way to do it, relying on property rights and his skills as a tile setter, to force others to pay attention. The problem of establishing his presence as a contributor to his society paralleled that of every artist, even those securely within the guild. But it was particularly meaningful to many younger artists after World War II, as educational opportunities opened up for men and women who might otherwise never have explored their artistic capabilities, much less imagine that the arts offered them a profession.

Rodia's work is emblematic of an era when the isolation of California, its relative prosperity, and the ascendancy of middle-class democracy fostered widespread faith—objectively perhaps only an illusion but nonetheless powerful in its subjective consequences—that a new world culture could emerge here. It would be a culture that synthesized a broad variety of cultural traditions, and it would be a culture developed by both men and women. It would be a culture where the ideal of creating something new would take root. Isolated from but not ignorant of the main developments of world culture, California's modern artists provided a model for a creative synthesis that could lead to a new contemporary culture transcending modernism as it had developed in Europe.

It was indeed a period of grand ambitions, when problems defined might suggest the search for solutions—whether the problem involved culture, the environment, race relations, the roles women could play in modern life, or arbitrary controls on sexuality. The United States, with its plethora of problems, also contained a culture that fostered faith in both individual potential and large-scale social action. Belief in a can-do, problem-solving ability supported ambitious individual and national projects, indeed supported hubris and overreaching that finally encountered their limits in the brutalities of the Indochina wars. Conversely, the relative decline in public education during the last third of the twentieth century, matched by the increased prestige of private schools, is one institutional

correlative of the social conservatism of the United States since the 1960s that promotes fear of any but the narrowest of personal ambitions. A subjective correlative would be the pervasive pessimism over the possibilities of what either individuals or the nation can successfully accomplish, a negative cast that ought to be puzzling (given the immense wealth and resources our society still possesses), and the ability of individuals to accomplish amazing things once they commit themselves.

Sam Rodia proved to be the quintessential California modern artist because he provided an exemplary model for transcending the dual challenge of personal marginality and regional provinciality. He created a work that was original, even though there were no institutional resources available to support his project. Each of his limitations, whether of materials, real estate, finances, or his own education, passed through his creative imagination to become a positive element strengthening his statement. He had no fine arts training, so no preexisting standards of excellence constrained his imagination. Nor did the widely shared desires of many boosters and regional cultural leaders in the first half of the twentieth century to translate to the shores of California fantasy images of idealized Mediterranean heritage affect his work. The Mediterraneanity in the Towers refracted his memories of his birthplace through the prism of a life spent hard at work in the new world. His work conformed to the standard set by Frank Stella in 1959 for contemporary painting after abstract expressionism: "What you see is what you see."[4]

What Rodia had seen were the messy social conditions of his time, and he responded with a single site-specific work, clearly intended to attract attention and approval. Rodia provided a model for cultural production no longer defined through subordinate relationship to imaginary cultural capitals whose distance always marks the inadequacy of one's own immediate situation. Artists and others who think that an artwork can, or ought to, communicate directly with a broader public beyond curators, patrons, scholars, and the educated public that goes to museums must still confront the paucity of support available for alternative practices—despite rhetoric of inclusion in how arts institutions talk about what they do. In that sense, they find themselves in a position comparable to their predecessors in provincial places like California before the boom in the visual arts of the 1960s. If free expression is a precondition for any artist to make an original contribution, every generation of emergent artists still confronts the existential challenge that Rodia took on directly: how to break away from the institutional requirements particular to a historical moment without losing the ability to communicate to people who might see your work by accident, passing by the work while, say, commuting to and from work.

Works Cited

Brilliant, Mark. 2010. *The Color of America Has Changed: How Racial Diversity Shaped Civil Rights Reform in California, 1941–1978*. New York: Oxford University Press.

Cándida Smith, Richard. 1996. "The Elusive Quest of the Moderns." In *On the Edge of America: Modernist Art in California*, edited by Paul J. Karlstrom, 21–40. Berkeley: University of California Press.

———. 2005. "Reverencing the Mortal: Assemblage Art as Prophetic Protest in Post-World War II California." In *Betye Saar: Extending the Frozen Moment*, edited by Sean Ulmer, 38–51. Berkeley: University of California Press.

———. 2009a. "Learning from Watts Towers: Assemblage and Community-Based Art in California." *Oral History* (UK) 37.2: 51–58.

———. 2009b. *The Modern Moves West: California Artists and Democratic Culture in the Twentieth Century*. Philadelphia: University of Pennsylvania Press.

Cooper, Harry. 2006. *Frank Stella 1958*. New Haven, Conn.: Yale University Press.

Douglass, John Aubrey. 2000. *The California Idea and American Higher Education: 1850 to the 1960 Master Plan*. Stanford, Calif.: Stanford University Press.

Fried, Michael. 1965. *Three American Painters: Kenneth Noland, Jules Olitski, Frank Stella*. Cambridge, Mass.: Fogg Art Museum.

Glaser, Bruce. 1966. "Questions to Stella and Judd." *Art News* 65 (September): 58–59.

Los Angeles County Museum of Art. 1962. *Simon Rodia's Towers in Watts* (Exhibition catalogue). Los Angeles: Los Angeles County Museum of Art.

McWilliams, Carey. 1943. *Brothers Under the Skin*. Boston: Little, Brown.

———. 1949a. *California, the Great Exception*. New York: Current Books.

———. 1949b. *North from Mexico: The Spanish-Speaking People of the United States*. Philadelphia: Lippincott.

Rosenblum, Robert. 1971. *Frank Stella*. Harmondsworth, England: Penguin.

Rubin, William. 1970. *Frank Stella*. New York: Museum of Modern Art.

A California Detour on the Road to Italy: The Hubcap Ranch, the Napa Valley, and Italian American Identity

Laura E. Ruberto

The general perception of California as a place of escape or retreat, or simply as a place to experience everyday life differently, resonates in certain ways with a number of site-specific art constructions that lie within the state's borders.[1] Of these environments, at least a handful can be recognized as being the creative effort of Italian Americans. Considered together, these Italian American sites form a kind of mirrored mosaic that reflects not only an Italian immigrant experience but a particular West Coast variety of that experience. The focus of this study, the Hubcap Ranch, is one such cultural production; it rests in the heart of Pope Valley, not far from Napa, in the greater San Francisco Bay Area.

Constructed by Emanuele "Litto" Damonte, the Hubcap Ranch is one of at least four Italian American site-specific vernacular architecture constructions in California that still exists, at least in part, today.[2] Arguably the most well-known of the West Coast Italian site-specific creations (for good reason, as this collection attests) is by Sabato (or Simon or Sam) Rodia, the Watts Towers, a massive grouping of mosaic spirals, turrets, and other formations built out of broken tiles, dishes, bottles, and a variety of found objects. The colorful structures, which appear to push upward effortlessly toward the sun, were fabricated with a skill that amazes contemporary engineers and at the same time suggest to

folklorists, art historians, and other scholars Rodia's experiences both in his native southern Italy and in his adopted Southern California. Similarly, in the dry Central Valley, outside of Fresno, Baldassare Forestieri carved out of the ground a sprawling series of living spaces, grottoes, and gardens, collectively called the Underground Gardens. Evoking Forestieri's time spent digging subways on the East Coast as well as grottoes not unlike some found in his native Sicily, the garden complements his desire for fertile, cool ground, by creating an unexpected, otherworldly immigrant retreat. Less widely known is Romano Gabriel's Wooden Sculpture Garden in Eureka, at the very northern edge of California, a now-displaced mosaic installation built from reclaimed wood produce crates and found objects that (like both Rodia's work and Forestieri's) gesture toward the hybrid space between Italian and Californian migrant experiences.[3] (The remains of Gabriel's work are installed in a custom-built storefront structure in downtown Eureka.) In sometimes overlapping ways, these four Italian American expressions speak to a California way of experiencing and shaping immigrant life.[4]

Not far under the surface of this study is a critical desire to recognize further the regional differences inherent in any ethnic American experience.[5] In other words, a result of my focus on an obscure Italian American man's life and creative production in Northern California is a redirecting of the standard history of Italian American culture as funneled through New York City and the East more generally. To put it succinctly if not rather flippantly, I ask: What kind of scholarship would already exist about Rodia's Watts Towers if he had built them in the Brooklyn neighborhood of Bensonhurst, rather than the Los Angeles neighborhood of Watts? I contend that Rodia's ethnic ambiguity, that is, the fact that much of the general public (not to mention scholars) are ignorant of or ignore the fact of Rodia's Italian identity,[6] suggests a larger regional blind spot with regard to Italian Americans in the West rather than anything necessarily unique to Rodia or his creation.[7]

In turning to the Hubcap Ranch, with its explicit references to consumerism and mobility, I claim that it reveals a decidedly California Italian American culture and suggests how one man's approach to negotiating his immigrant identity intersects with a larger culture of immigrant-community place making. This complex relationship is further strengthened when considered in relation to Northern California's Italian-influenced wine-growing region, home to the Hubcap Ranch and to a myriad of intriguing cultural contradictions. For Damonte, the Hubcap Ranch seems to have functioned as what William Cronon (1992) in his *Nature's Metropolis* might call a middle-landscape, or retreat (both in personal and community terms) away from urban San Francisco and away from (and in a sense curiously also back to) rural Italy. As such, the Hubcap Ranch can be reread and thus understood as a creative process of Italian immigrant place making.

Finding the Hupcaps among the Grapes

An area known for its tranquil, rolling hills of vineyards, the Napa Valley is about a two-hour drive northeast of San Francisco. Along one of the valley's main thoroughfares, the Silverado Trail, lies Charles Krug Winery, the region's oldest winery (established in 1861), and shortly past Charles Krug lies a windy, two-lane road that splits off the main road. That road, thinly forested with an occasional vineyard, is relatively unspectacular, until a few miles down, one begins to realize that something is hanging, perhaps randomly, perhaps purposefully, on the chicken-wire fence that flanks the road. Indeed, the

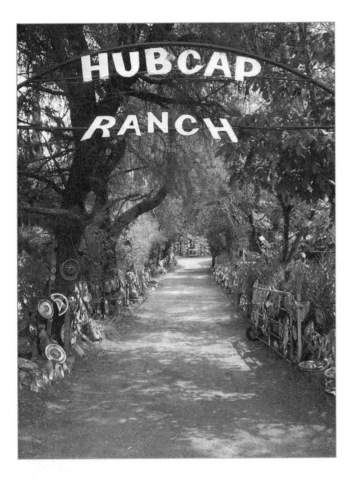

Driveway entrance, Hubcap Ranch, 2008. Photo by Laura E. Ruberto.

objects are hubcaps and they mark the beginning of California Historic Marker 939, the Hubcap Ranch.[8]

Litto Damonte's Hubcap Ranch is an assemblage of found everyday objects cemented in place and purposefully scattered within a sixty-two-acre enclosed ranch. The property is most notably decorated with hubcaps, estimated to number 5,000, but it is a much more diversely appointed space than its name suggests, with sections devoted to tools, toys, bottles, religious statuary, aluminum foil-wrapped gourds, ceramic tiles, and other everyday found objects. The open fields, grazing area, main house, barn, multiple sheds, converted chicken coop, outdoor patios, fences, and many surrounding trees are all adorned with hubcaps and floral-designed beer cans. Other objects line different areas: A row of overturned Michelob beer bottles create a quiet path to an outdoor sitting area; old beer-can pull-tabs create a decorative garland across the large covered patio.[9] In addition to the repetitive use of such bits and pieces, certain areas suggest focus and symbolic heightening, and we might even call these spaces modest shrines (mostly broken or in disarray now) to a variety of secular and sacred figures.

Garland, aluminium-wrapped gourds, outdoor patio, Hubcap Ranch, 2008. Photo by Laura E. Ruberto.

Fence, Hubcap Ranch, 2009. Photo by Laura E. Ruberto.

Floral-cut cans, detail, Hubcap Ranch, 2008. Photo by Laura E. Ruberto.

Overturned beer bottle path-edge, 2009. Photo by Laura E. Ruberto.

Assembled found pieces, Hubcap Ranch, 2008. Photo by Laura E. Ruberto.

Damonte began work on the Hubcap Ranch in the early 1930s, and today it is expanded upon by his grandson Mike Damonte and Mike's son, also named Emanuele ("Litto"). The elder Litto was born in 1892 in Arenzano (in the province of Genoa, in the region of Liguria) and emigrated to the United States first around 1914, on a contract to do the stone and marble work for the Stanford Chapel at Stanford University. He then returned to Italy and then emigrated permanently to the United States, arriving with an employment contract to do stone work on the pools at the Julia Morgan–designed Hearst Castle in San Simeon.

One can look at the Hubcap Ranch as a cultural relic, a symbol of immigrant Italian American space, practically unheard of, unseen, unfound in the developed, tourist-friendly valleys in and around Napa. The Napa Valley has long had a specific Italian style to it—a look and feel that developed first from the Italian Americans who populated the area but that over the last few decades has blossomed because of the many individuals and businesses capitalizing on fads about Italian wine and food. And yet with high-end Italian American spaces such as the Robert Mondavi Winery and Francis Ford Coppola's Rubicon Estate Winery within a short drive of the Hubcap Ranch, Litto Damonte's assembled clutter—with its similar potential for "feeling Italian," as Thomas Ferraro (2005) has used the phrase—seems out of place, practically unheard of, a mere speck of an older Italian American expressive vocabulary on an otherwise slow-food, artsy map of the greater San Francisco Bay Area. In great part this is true.[10]

Emmanuele "Litto" Damonte, early 1970s. Photo courtesy Philip Linhares, by Philip Linhares and John Turner.

Damonte's bricolage, surrounded by a broader Italian cultural presence in the region, represents a particular way of place making. It is simultaneously an individual man's desire to express himself within the confluence of the urban and the rural and a projection of an Italian American–instilled identity connected to masculinity, skilled labor, and everyday space.

In and of itself, the position of the Hubcap Ranch within a decidedly rural but urbanized (tourist-filled) space suggests a complex cultural site and a hybrid sense of home. When looked at in conjunction with its evocation of an immigrant perspective, the site becomes all the more dynamic, neither static nor unified in its meaning—either for the creators (because in fact there is more than one) or the visitors.

Constructing a Middle Landscape

Once his Hearst Castle mason contract was complete, Litto Damonte settled in the city of South San Francisco, where he soon opened the Golden Gate West Concrete business with his future brother-in-law. According to Mike Damonte, the two men won a substantial bid to pour most of the sidewalks and curbs for the Sunset District of San Francisco (from Golden Gate Park at Ninth Avenue to the Pacific Ocean at Forty-Eighth Avenue). In 1930, with the revenue of this lucrative business, he bought a large portion of land in Pope Valley.[11] The combination of an immigrant's focus on work, San Francisco's post–World War I

development, and the general entrepreneurial tenor that was present throughout California led to Damonte's economic stability allowing him to buy land in Pope Valley.

Pope Valley is a small, unincorporated community within Napa County, situated between more well-known areas (in 2012 its population stood at 623). It lies off of the famed Silverado Trail (a route that has been important to trade and tourism since at least the Gold Rush),[12] between various leisure and tourist attractions: from the small cities of Napa and St. Helena to the natural lakes of Lake County and the hot water springs of Calistoga. It is flanked on one side by Angwin, a Seventh-Day Adventist community. On the other side lies Aetna Springs, which was a celebrity resort spa from 1873 until 1976, when it was bought and used by the Reverend Sung Myung Moon and his Unification Church for a few years before being sold to redevelopers; since 2009 it has been renovated and reopened as a private resort area.

When Damonte bought land in Pope Valley, it was a remote, rural area, passed through occasionally by, first, stagecoaches and, later automobiles from San Francisco en route to vacation and entertainment venues in the valleys (see Callizo). While it may have seemed destined for full-fledged development, it remains a relatively unknown and unvisited town.

Pope Valley is also part of California's wine-growing region; the Pope Valley Winery, founded in 1897 by Swiss émigré Ed Haus, lies just down the road from the Hubcap Ranch. Wine has been made for large consumption in California since the Franciscan missionaries, led by Junipero Serra, started the San Diego Mission in 1769. By the time the Volstead Act was passed in 1919, California was producing the majority of U.S. "bulk" wine, and in the decades following World War II, California wines, particularly those from the Napa Valley, started to rival those of France and Italy (see Cinotto 2012; Siler 2007).

Take, for instance, the concept of boutique wineries in the Napa Valley, which exploded with Robert Mondavi's entrance into the business in the mid-twentieth century. Robert Mondavi, a second-generation Italian American, practically single-handedly made drinking wine a daily habit for Americans, not just of Italian immigrants, clergy, or the upper crust. Mondavi helped devalue the traditional Italian American aspects of the valley, by changing the pronunciation of his surname and therefore of his company's image back to the Italian MondAvEE instead of the Anglicized MondAYvEE that his immigrant father, Cesare, had begun. He also instituted the culture of wine tasting in the valley and ushered in an era still evident today where ornate Italian ceramics in bas-relief, not hubcaps, adorn Napa buildings (see Siler 2007).

Thus, while the Mondavi enterprise embodies the tourist, consumerist side of Italian Americana in the region, the Damontes' contribution remains a more personalized and community-oriented site. The ways in which individual immigrants refashion or preserve their pre-immigrant culture in relation to their adopted one is obviously varied—as this brief comparison between the Mondavis and the Damontes suggests—and is influenced by many factors, including different concepts of success and community.

For Damonte, the land he bought quickly became a hideaway and at the same time a place where his daily life could in some fashion resemble that of life in Italy. In abstract terms, the ranch simultaneously functioned as nostalgia, as spiritual retreat, and as both a personal and community place making. The potential conflict in such characterization of the ranch makes sense by recognizing it as an immigrant's space. In other words, what

might seem like Damonte's inward, reclusive identity is merely a facade to a more dynamic immigrant identity. Such an identity is not self-evident in any straightforward surface reading of the vernacular environment itself. Instead, such an interpretation requires other sources, other ways of experiencing and knowing the ranch—such as through the eyes and the words of people who have a locally grounded relationship to it.

One of Litto's grandsons, Mike Damonte, offers interpretations of the ranch as well as possible motivations behind its creation (interview, July 15, 2008). His perspective helps lead to broader ways of making sense of the vernacular environment. According to Mike, Litto had wanted to get back to farming, working the land and raising animals as was done in his village, Arenzano, in Italy (where even those who had a skilled trade, as he did, also led a life close to the land). He bought the land in 1930 but did not start visiting regularly until 1935, when he and his family would spend weekends and summers there. He moved there permanently after one of his sons was killed in the Second World War. (He brought his oldest son and daughter with him, leaving his other eight children and his wife, Elizabeth, in South San Francisco.) This move, as well as the beginning of his collecting and assembling of found objects, in fact might suggest a particular kind of grieving process that perhaps works itself out in solitary, creative activities. Such a possible motivation is in line with Daniel Wojcik's observation that many so-called outsider artists "began creating art in response to adversity, suffering, or personal crisis" (2008: 186). In relation specifically to Italian American creative environments in California, one can turn to John Giudici's *Capidro* as an example of art created as an act of grieving. As Phil Pasquini explains, the space was constructed after Giudici's son drowned, or nearly drowned[13] in a backyard pool:

> Despondent and upset Giudici decided to fill in the pond with cement. Before the cement had time to set, Giudici began decorating it by pressing rocks, shells and other broken bits of materials that he had at hand to embellish the otherwise bland surface. What started out as a simple project soon evolved into a huge backyard environment that eventually covered the entire property. (2008: 1)

Damonte's retreat to the countryside, in as much as it may be connected to his son's death as well as a desire for an urban-free space, could also be understood as an immigrant's version of the more mythical "pastoral retreat" historically associated with city dwellers, as William Cronon in his *Nature's Metropolis* describes with direct references to large city parks, like New York's Central Park:

> The pastoral retreat in its mythic form is a story in which someone becomes oppressed by the dehumanized ugliness of urban life and so seeks escape in a middle landscape that is halfway between the wild and the urban. (Cronon 1992: 380)

Damonte created this "middle landscape" both between California's cities and towns and also broadly between the cultural landscapes of Italy and the United States. Somewhere between a desire for his native home, a memory of a dead child, an attempt to create a new home, and a reflection of his adopted country, Damonte expressed his individual experiences and personal motivations. As Michael Owen Jones explains, individual creative constructions even when they may appear not to be motivated by outside factors, are an amalgam of experiences, motivations, and influences:

people without formal training in art do not necessarily work in isolation from others' inspiration, influence, or instruction, nor is their behavior wholly idiosyncratic. Typically they learn forms, designs, choices of materials, and standards of excellence and preferences from people with whom they interact and communicate as well as through systematic, purposeful observation of objects in their environment. (Jones 2001: 56–57)

Damonte assembled and reshaped discarded consumer items and other found objects filtered through his labor experiences, his environment, his family, and his immigrant positionality.

Collective Memories

The relationship Litto Damonte and his Hubcap Ranch had and has to the greater wine country and its Italian American tone is not straightforward. On the one hand, Litto had an engaged, public life and was especially connected to the Italian American community through his membership in Italian American associations such as the Sons of Italy and the Native Sons of St. Helena. At the same time, according to grandson Mike, "they thought he was crazy," specifically because of his penchant for collecting and organizing what most people thought of as garbage. He was a philanthropist, donating to the Pope Valley School their first school bus and buying a Quonset hut to serve as the town's general store. After selling his half of the concrete business, he took on occasional mason or concrete work—his signature design of stars and moons is noticeable throughout the area in front of houses and shops. But for the most part, he lived his life on his land, encountering people who came to him, creating a sense of place within a private, albeit outdoor, space.

Local lore says that Damonte immediately started tacking up hubcaps along the fence that lines the curved road when they fell off cars as people drove by and rarely would anyone ever come back to retrieve them (see, for instance, journalistic pieces by Garrett 2005, Jones 2009, Larson 2009, or Padova 2006). The hubcap—a symbol of industrialization and capitalism strongly associated with the United States—evokes mobility, itself a concept centrally connected with migration. That a symbol of modern human mobility comes to define Damonte's place is consistent with the general outline and development of California's cultural and economic reliance on cars that developed throughout the mid-twentieth century—a reliance that cuts across every ethnic and racial group, mobilizing (or not) everyone.

A serious car enthusiast can walk around the property and enter a living museum, an archive of hubcaps and indirectly to the California car culture that led to that chrome being in Pope Valley in the first place (see Garrett 2005). The outside patio shelf is lined with plaques given to Damonte from car clubs that have honored him through the years, recognizing the place as a pilgrimage site. Such recognition suggests that the ranch speaks to community in a targeted way.

In contradiction to the local origin narrative is that as a hubcap archive, Damonte's construction can be documented historically, by recognizing that the oldest part of the collection is actually not along the fence, as local lore suggests, but nearer to the house, on some trees, at the end of the driveway, as confirmed by Mike. In fact, according to Mike, Litto early on cemented in place a chair (no longer there), and it was Litto's favorite spot:

Litto used to have a chair cemented in place right here, he used to sit here and just watch people go by, drinking some wine, eating some cheese or salami, especially as he got on in years. (Interview, July 15, 2008)

So, although the space itself tells a different story (at least for a visitor who recognizes cars' makes and models through their hubcaps), the more public and indeed more community-focused origin narrative corresponds to particular views on how collective or public memories become formed and stabilized. As Steven Hoelscher reminds us, memories must be displayed, articulated, or in some fashion named in order to be memories:

in order to be believable—what good is cultural memory if it is seen as contrived?— selective versions of the past are often made concrete through material objects. The ephemeral and processual nature of memories means that their architects and guardians frequently ground them in physical form—in landscapes. (Hoelscher 2003: 661)

The site itself, those same concrete material objects, suggests a different story, a different narrative of development, one that brings to the surface its own set of myths.

Looking at the ranch today, on the one hand it can be understood as an example of personalizing one's space, while on the other it is equally so a reflection of a greater Italian American and no-doubt Californian consumerist culture. In fact, this connection has been recognized by others as well. In 2008, a New York–born, German American sculptor, Gordon Huether, won a design bid for an art installation to adorn a new public parking garage in Napa. His openly stated inspiration for the project was the Hubcap Ranch. Huether's polished hubcaps and ordered clutter extend Damonte's vision while remaining

Gordon Huether making hubcap installation for downtown Napa, 2009. Photo courtesy Gordon Huether.

similarly tied to symbolic California images of urban living, consumerism, and the mobility of a culture dominated by cars. The parking lot installation, whose hubcaps were all donated by the Damonte family (which refused Huether's money), caused some public concern of an aesthetic variety, precisely because of Huether's use of an immigrant, working-class, heterodox site as his artistic referent. As Napa supervisor Harold Moskowite claimed in disgust: "It [Huether's installation] looks pretty tacky to me. . . . If I wanted to see hubcaps, I can go to Pope Valley" (Courtney 2008).

The Ranch Today, a Living Site

Since Litto died in 1985, his grandson Mike and, more recently still, his great-grandson, Litto, have extended the vernacular environment. For one, they nail up around the property the hundreds of hubcaps that yearly continue to be left at the end of the driveway. The young Litto (age 12 when I interviewed him), in particular, seems to have his great-grandfather's talent for such creative expression. When I asked him how he decides where to put the hubcaps, he responded: "I think about what I think will look the best. If there's one that's kind of interesting looking, I'll try and hang it so I think more people will see it when they drive by" (Interview, July 15, 2008).

In addition, Mike and his son have taken the basic concept of the ranch's vernacular architecture environment and used the skills and materials available to them to broaden its look. Their interest lies more in expansion of the project rather than preservation, making the site alive, transmutable. In fact, earlier photos of the ranch show an order and brilliance to the assemblage missing in its current formation, since the elder Litto used to dust and polish consistently those parts of the installation closer to the house. Community memory of what the ranch used to look like further points to this change in style. As

The Hubcap Ranch, early 1970s. Note the painted lightbulbs, Madonna hanging on the tree, and Litto's chair, nailed in place. Photo courtesy Philip Linhares, by Philip Linhares and John Turner.

one Italian American woman, a Napa native, told me, referring to the 1970s: "There used to be beauty in the sparkle and order of the place. Now it's iconic, a shadow of its former self" (Bettina Cassayre Moore, Interview, October 20, 2008).

Even so, Mike and the young Litto have developed their own sense of place. Mike taught his son how to do plasma welding, and thus welded signs adorn much of the property. Young Litto today looks around the ranch and finds practical uses for materials that might otherwise be discarded—with a teenager's skilled hands, an old tire becomes a planter, and oak wine barrels become comfortably curved wooden benches. In so doing, he seems to have embraced fully his great-grandfather's recycling style, something the family connects to his Italian immigrant background, joking that "'Nonno Litto' was green well before it was hip." Josephine Gattuso Hendin, in a discussion of the Don DeLillo novel *Underworld* and references to Rodia's Watts Towers, argues similarly about Italian Americans' relationship to waste:

> Italian American art may serve as an inclusive discourse that reveals the impulse to reclaim and recycle as a primary creative drive and a major part of its innovative aesthetic. (Hendin 2003: 31)

Similarly, Mike, again and again, notes his grandfather's Italian and immigrant background, what he calls an "Italian work ethic," as giving rise to his grandfather's particular relationship to everyday objects, work, and environment. Damonte never threw anything away and always found a use for something: Mike explains: "Me? I think you're supposed to throw away an old lightbulb, but not him, you paint it and hang it up" (Interview, July 15, 2008). Damonte sought to bring beauty to his living space, using the things around him and his own skills to do so. Mike recalls of his grandfather that "he'd cement toys and our stuff in place, if we kids weren't careful, it'd get cemented in place. We learned to put our stuff away fast" (Interview, July 15, 2008).

In talking about his grandfather's creative efforts and his (and his son's) ongoing efforts, Mike actively participates in the re-production of the space itself and also, significantly enough, in the interpretation of the site for visitors. Through Mike's reading of the ranch, in relation to Litto's work history and ethnic background, he reaffirms certain Italian immigrant attributes for himself and for us as well. The bricolage process of collecting and preserving that Mike associates with his grandfather's history is in line with others who square such activities with an Italian American sensibility (a point reinforced in other essays in this collection with respect to Rodia's style; see, for instance, the contributions of Del Giudice, Scambray, and Sciorra). While creating mosaics out of broken glass, à la Rodia, may signify "Italian" more than cutting and arranging hubcaps do, both rely on a similar set of skilled labor and work ethos that can be linked to an Italian immigrant identity.

In different ways, Mike connects the tradition of collecting and assembling everyday found objects with what he calls "lost arts" (many of which are still practiced by the Damonte family), all of which he relates to his grandfather's Italian background, a way of living he carried with him from Arenzano. For Mike, these lost arts (which together also suggest a particular relationship to and experience with consumerism) include things like butchering livestock, basic carpentry, canning and drying fruits, distilling grappa, and, undoubtedly, the lost art of hubcap collecting. These creative activities as Mike himself explains them are examples of what Sciorra refers to as the "expressive culture" of

Italian immigrants; such material culture and activities are part of an immigrant identity that may even be "fraught with conflict, negotiation, and creative solutions often involving hybridic cultural forms" (Sciorra 2011: 4). The entire ranch environment consists of such "hybrid cultural forms" that, as I have been suggesting, reflect an Italian immigrant's identity in relation to his surroundings.

Although not as sublime a presence as either Forestieri's Underground Gardens or Rodia's Watts Towers, the Hubcap Ranch has many connections to these and other California Italian American vernacular architecture sites. As Kenneth Scambray notes in comparing the Underground Gardens with the Watts Towers, although the two creations are strikingly different visually (one constructed upwardly, the other downward) and their makers were ". . . influenced by their different geographical environments in Italy and California" both men "created sites that represent 'home' for the two immigrant wayfarers" who constructed them (2011: 81). It is this association with the construction of home that the Hubcap Ranch also shares with these grander sites. As Scambray summarizes with respect to Rodia's project, we could say that Damonte's Ranch is likewise an Italian immigrant expression of a "bicultural experience" (2011: 79).

Moreover, although Damonte's collection is informed by his Italian American identity, it does not comply with any sense of "Italian authenticity" that much of the wine-growing region in and around the Napa Valley today tries to convey. Damonte's project is far too urban, far too pop, and at the same time literally too trashy; it cannot be readily understood within this particular location, the tourist-friendly, Italianate Northern California area. Further, the working-class, Italian-immigrant subjectivity evoked by the ranch (i.e., the objects used, the Damontes' work on it, and Mike's observations about it) and the surrounding area's history of an older, working-class Italian American community are also erased by not recognizing the site as part of an immigrant's experience. To put it quite simply, when it comes down to ethnic identity, people tend to hold on to expected concepts about a particular group and often do not consider identity as something that is variable, transformable, or an integral part of cultural processes rather than in specific objects or art forms. As such, Damonte's art is in line with Sciorra's general conceptualization of an Italian American aesthetic position that is in flux and porous: "Italian American culture is not a static museum piece but dynamic and open to transition" (2011: 6).[14] The ranch is constantly being made and remade through an ongoing accumulation of and reorganization of material, everyday objects. The place does not signify readily with conventional ideas of Italian American identity, nor can it find a place alongside more upscale, Italian trends in the Napa Valley. As the wine region developed into a tourist-focused and urbanized area, Pope Valley took on more and more of a quirky, "off-the-grid" attitude, and the Hubcap Ranch is today representative of that quirkiness, embracing a particular alternative culture often stereotyped as emblematic of California.

Perhaps nothing better explains the way in which the Hubcap Ranch is about an immigrant sensibility toward place making than Mike Damonte's answer when asked directly: "Why do you keep doing what your grandfather did"? He responded: "You do it because that's what you do, it's tradition." It then can be recognized as an example of the physical transformation of the immigrant experience into an aesthetic experience, illustrating a dynamic, fluid identity informed by multiple intersections of work, home, family, community, and the continuity of culture.

Works Cited

Barron, Stephanie, Sheri Bernstein, and Ilene Susan Fort. 2000. *Made in California: Art, Image, and Identity, 1900–2000.* Berkeley: University of California Press.

Bishop, Greg, Joe Oesterle, Mike Marinacci, Mark Moran, and Mark Sceurman. 2006. *Weird California.* New York: Sterling Publishing.

Callizo, Joe, "Pope Valley memories: The stories of Joe Callizo, an oral history," March 31, 2012. *Napa Valley Register,* http://napavalleyregister.com/lifestyles/home-and-garden/pope-valley-memories-the-stories-of-joe-callizo-an-oral/article_f818507c-7ac4-11e1-910d-001a4bcf887a.html (accessed August 6, 2012).

Cándida Smith, Richard. 2009. *The Modern Moves West: California Artists and Democratic Culture in the Twentieth Century.* Philadelphia: University of Pennsylvania Press, 2009.

Cinotto, Simone. 2012. *Soft Soil, Black Grapes: The Birth of Italian Winemaking in California.* New York: New York University Press.

Cronon, William. 1992. *Nature's Metropolis: Chicago and the Great West.* New York: Norton.

Courtney, Kevin. 2008. "The Art of Garbage." *Napa Register,* November 22.

Di Leonardo, Micaela. 1984. *The Varieties of Ethnic Experience: Kinship, Class, and Gender among California Italian-Americans.* Ithaca, N.Y.: Cornell University Press.

Ferraro, Thomas J. 2005. *Feeling Italian: The Art of Ethnicity in America.* New York: New York University Press.

Garrett, Jerry. 2005. "Another Roadside Attraction." *New York Times,* April 18. http://www.nytimes.com/2005/04/18/automobiles/18CARS.html?ex=1271476800&en=7bdeee4afc9ab617&ei=5090&partner=rssuserland&emc=rss.

Hendin, Josephine Gattuso. 2003. "Social Constructions and Aesthetic Achievements: Italian American Writing as Ethnic Art." *Melus* 28.3 (Autumn): 13–39.

Hoelscher, Steven. 2003. "Making Place, Making Race: Performances of Whiteness in the Jim Crow South." *Annals of the Association of American Geographers* 93.3: 657–86.

Jones, Carolyn. 2009. "A Collection of 5000 Hubcaps Hard to Pass Up." *San Francisco Chronicle,* March 15. http://articles.sfgate.com/2009-03-15/bay-area/17212417_1_hubcaps-car-collectors-shiny.

Jones, Michael Owen. 2001. "The Aesthetics of Everyday Life." In *Self-Taught Art: The Culture and Aesthetics of American Vernacular Art,* edited by Charles Russell, 47–90. Jackson: University Press of Mississippi.

Landler, Edward, and Brad Byer. 2006. *I Build the Tower.* Los Angeles: Bench Movies.

Larson, Fredrich. 2009. "Mystical Photography: The Hubcap Ranch." *San Francisco Chronicle,* March 15. http://www.sfgate.com/cgi-bin/blogs/photoblogfl/detail?entry_id=36837.

Padova, Nino. 2006. "Chrome on the Range." *VIA Magazine,* March. http://www.viamagazine.com/weekenders/chrome_range06.asp.

Pasquini, Phil. "Capidro: A Garden of Concrete Ideas." http://www.grassrootsart.net/RestOfTheStory/RestOfStory-Capidro.htm 2008 (accessed various dates between August 2008 and January 2010).

———. "Menlo Park, White Cement Artichokes." http://www.roadsideamerica.com/tip/22710 (accessed January 13, 2010).

Rolle, Andrew. 1999. *Westward the Immigrants: Italian Adventurers and Colonists in an Expanding America.* Ninot: University Press of Colorado.

Ruberto, Laura E.. 2008. "Italian Americana, California Style." April 10. http://www.i-italy.org/bloggers/1605/italian-americana-california-style.

———. 2009. "Californians Sell Little Italy, One Crate at a Time." December 2. http://www.i-italy.org/bloggers/12016/californians-sell-little-italy-one-crate-time.

———. 2012. "The 'Naïve Wooden Sculptures' of Theodore Santoro." July 9. http://www.i-italy.org/bloggers/33894/naive-wooden-sculptures-theodore-santoro.

Scambray, Kenneth. 2011. "Creative Responses to the Italian Immigrant Experience in California: Baldassare Forestieri's 'Underground Gardens' and Simon Rodia's 'Watts Towers.'" In *Italian Folk: Vernacular Culture in Italian-American Lives,* edited by Joseph Sciorra, 63–82. New York: Fordham University Press.

Sciorra, Joseph. 2011. "Introduction: Listening with an Accent," In *Italian Folk: Vernacular Culture in Italian-American Lives,* edited by Joseph Sciorra, 1–10 New York: Fordham University Press.

Sensi-Isolani, Paola, and Phylis Martinelli. 1998. *Struggle and Success: An Anthology of the Italian Immigrant Experience in California*. Ann Arbor: University of Michigan.

Siler, Julia Flynn. 2007. *The House of Mondavi: The Rise and Fall of an American Wine Dynasty*. New York: Gotham Books.

Starr, Kevin. 1991. *Material Dreams: Southern California Through the 1920s*. Oxford: Oxford University Press.

———. 2007. *California: A History*. New York: Random House.

Stevenson, Robert Louis. 2005. *The Silverado Squatters*. North Hollywood, Calif.: Aegypan.

Wojcik, Daniel. 2008. "Outsider Art, Vernacular Traditions, Trauma, and Creativity." *Western Folklore* 67.2–3 (Spring/Summer): 178–80.

The *Gigli* of Nola During Rodia's Times

Felice Ceparano

This essay seeks to describe the *Gigli* of Nola in the late nineteenth century, account for their evolution in time, and support the thesis that Sabato Rodia likely had known of the *Gigli* and was inspired by them in the construction of his Towers in Watts.

The Feast

In the city of Nola (a few kilometers from Naples, near Caserta and Avellino), the Feast of the *Gigli* of Nola (*Festa dei Gigli di Nola*) is celebrated annually in honor of Saint Paulinus (San Paolino) on the 22nd of June (or the first Sunday thereafter). Eight obelisks, together with a boat, are carried through the streets of the city's historic center, lifted on many shoulders, and "danced" to the rhythm of music. Every June, the town Nola is transformed, as the entire population of the city—and points well beyond—is in the grips of a spectacle of imposing magnitude.

The *Giglio*'s Structure

Thanks to the skill and expertise of Nolan artisans who have transmitted their art from generation to generation, each *Giglio* embodies construction techniques that have remained virtually unchanged for over a century. The *Giglio* presents a wooden base sheathed in

Gigli *and boat in Piazza Duomo, Nola 2008 (Photo by Felice Ceparano, Museo etnomusicale* "*I Gigli di Nola"*).

papier-mâché. Eight wooden structures (pl. *Gigli*), all of equal size, and measuring approximately 25 meters in height, are constructed. Construction proceeds from the bottom up. Indeed, once the *borda* (constituting the main axis of the *Giglio*) has been raised, the base is mounted onto it and the remaining obelisk structure nailed to it. It is made of pine and held together by four to five stout poles in trenched joints (i.e., stepped in mortises; *giunture ad incastro*)—the first of which is known as the *pericino*. The base, or more precisely the foot *(piede)*, is a square section, measuring 3 meters in height, and 2.60 meters in width. Its four feet are linked together by crossbeams (*traversoni*), and on each of the four sides are two crews and two *croci* (crosses) made of *squadre incrociati*, or beams crossing at right angles. A structure known as a *portamusica* (music platform or band box), which carries the musical band, is placed on its rear side. On the base are mounted, all around the *borda*, six *pezzi* ("pieces" or frame members); the first (which is in the shape of a parallelepiped) on a squared base has sides each measuring 1.46 meters. It is composed of four pine wooden racks (or *stacchini* in local jargon), each measuring 6.50 meters in length, 10×10 centimeters thick, of which 2.50 is inserted in the base, while 4 meters stick out at the top. The two frames are joined by lateral (poplar-wood) beams and by crossed *squadri*. The other members or framing posts (the second to sixth *pezzi*) have a prismatic polygon shape, tapered at the top. Toward the back the spire is made of rectangular frames similar to the first piece and supports in vertical overlays of

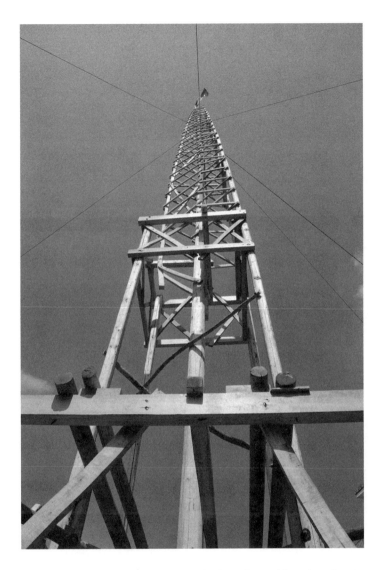

"Undressed" Giglio *structure (*spogliato*)—lateral view (Photo by Felice Ceparano, Museo etnomuiscale "I Gigli di Nola").*

diminishing size (both with respect to height and width). Each framework is made up of two pinewood *stacchini* joined together by two transverse beams, toward the top made of poplar wood. Further, it is joined to the *borda* with poplar beams laid out horizontally crossed by smaller transverse beams (again in poplar), joined to the *schine* or supports. The dimensions of the *pezzi* are 3.70 meters, 3.50 meters, 3.30 meters, 3.10 meters, and 3.00 meters for the second through sixth *pezzo,* respectively. Finishing the structure, on its rear and lateral sides, are the mounted *schine* or *scuoscino* (supports or bracing pads)

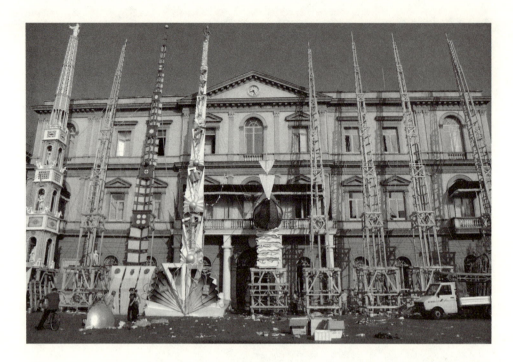

Papier-mâché sheathed Gigli, *together with "undressed"* Gigli *on Piazza Duomo, Nola 2009 (Photo by Felice Ceparano, Museo etnomusicale "I Gigli di Nola").*

joined to the *borda* and to the middle pieces by poplar-wood *traversine* (or smaller cross beams). On the day the *Giglio* is lifted, special poles of chestnut wood are used: *varre* each 5.85 meters long and *varrielli* (smaller poles) 1.80 meters in length (Russo 1995: 20–34). After the trial, the wooden structure is sheathed with papier-mâché *revêtement* according to the design chosen by the *maestro di festa* (master of the feast) to whom the organization of the feast has been entrusted (see also Ballacchino, this volume).

The introduction of papier-mâché into the Nola feast is attributable to the presence of artisans from the city of Lecce who happened to be in Nola (working on the ornamentation of the new cathedral) and who helped Nolan artisans refine their technique (Avella 2001: 28). Specifically, Nolan artists learned the clay and gesso technique that, once dried, provides the negative form for the sculpture. In the capable hands of such artisans, a positive form is then created, by applying to it paper soaked in glue. Through such a process, it is possible to create statues, ornamentation, and stuccos of varying (but limited) weight, accounting for the great success of using papier-mâché for the *Gigli* of Nola. All *Gigli*, with only a few exceptions, are adorned in their upper parts, by a papier-mâché statue of Saint Paulinus or of some other saint. Tradition dictates, during the weeks leading up to the procession, that the *Giglio* be placed in the vicinity of the residence of the *maestro di festa*. The entire festival apparatus of the *Giglio* is constituted of humble materials, almost always recycled from one year to the next. That is, not only is

*The foot (*piede*) or base of the* Giglio *structure. (Photo by Felice Ceparano, Museo etnomusicale "I Gigli di Nola").*

the wood recycled, but so too are the papier-mâché and the very nails that hold the structure together (see also Ballacchino, this volume).

The *Giglio* in Motion

Once the *Gigli* have been constructed, they are carried in procession through the streets of Nola on the feast day, according to a very precise and prescribed course, moving, thanks to a *paranza* (crew), to music.

The first piece (primo pezzo) *of the* Giglio. *(Photo by Felice Ceparano, Museo etnomusicale "I Gigli di Nola").*

Various pieces (pezzi) *of the* Giglio—*frontal view. (Photo by Felice Ceparano, Museo etnomusicale "I Gigli di Nola"). Dressing the* Giglio *in papier-mâché. (Photo by Felice Ceparano, Museo etnomusicale "I Gigli di Nola").*

Gesso matrix. (Photo by Felice Ceparano, Museo etnomusicale "I Gigli di Nola").

The *Paranza*

The *paranza* is a crew of about 120 participants distributed alongside the *Giglio*, who lift the structure on their shoulders and perform some truly acrobatic moves, under the co-ordinated guidance of the *capo paranza* (crew captain), to move the obelisks through the streets. Various *paranze*—not always from Nola—giving their best performance can often count on the strength of over 400 men. Two factors can determine the success of a crew: experience and strength. Experience and know-how are critical to overcoming the challenges of the course itself, composed of turns by the names of "the redhead turn" (*girata 'e caparossa*), "the prison turn" (*girata delle carceri*), "the Alpine lift" (*'o pesole alpino*), and "the Piciocchi Alley turn" (*'o vico 'e Piciocchi*). The physical strength of the *cullatori*, or lifters, allows them to exaggerate these turns and, through varying acrobatic moves, raise

The bas-relief positive in papier-mâché. (Photo by Felice Ceparano, Museo etnomusicale "I Gigli di Nola").

astonished cries of admiration from the public—as well as increase the challenge of competition from other *paranze.*

The Music

The music is provided by a band sitting on the foot (*piede*) of the *Giglio,* playing musical pieces whose purpose is to dictate the pace (*passo*) or rhythm of the *paranza* as it executes the *capo paranza*'s commands. A local song production exists for the purpose of the lifting of the *Gigli,* for each of the *Giglio* (and the boat), and the songs vary from year to year. For the various presentations of the *paranza* itself, well-known passages from a variety of musical genres are frequently adapted for the occasion. In recent years, there has been a band consisting of a rhythm section, a brass section (especially a saxophone), and a few electric instruments (such as bass and keyboard). A singer and amplification complete the musical ensemble of each *Giglio.* Behind the dance of the *Giglio* (and boat) stands a year's worth of preparation by the *maestro di festa,* the various *capo paranzas,* *cullatori,* singers, wordsmiths, composers, sound technicians, musicians, *Gigli* artisans, firework specials, designers, and an entire community besides.

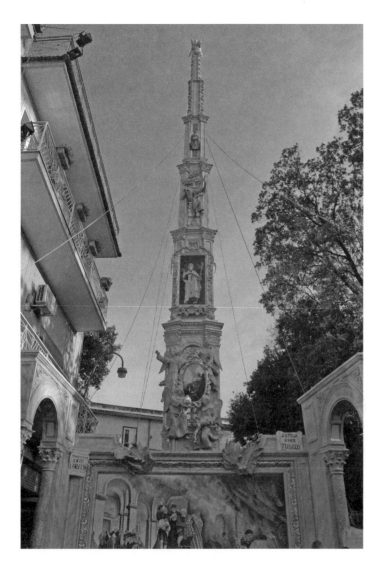

A Giglio *in the vicinity of the residence of the Blacksmiths' Giglio's master of the feast (*maestro di festa*), 2009. (Photo by Felice Ceparano, Museo etnomusicale "I Gigli di Nola").*

The *Giglio* and the Boat in Historical Perspective

There are numerous historical sources on the feast of the *Gigli* of Nola. The first document to speak of the Nolan tradition is found in the third book of Pope Gregory the Great's (540–604) *Dialogues*, where he recounts the legend of how Saint Paulinus (354–431), bishop of Nola, traveled to Africa to free some Nolans who had been taken into slavery by Barbarians. In 1514, Ambrogio Leone, in his *De Nola*, provided an elaborate description of the festivities; this was followed in 1644 by Andrea Ferraro, in *Del cemeterio nolano con*

After the feast, the Giglio *is disassembled (*abbattuto*), and workers set aside for recycling wood, papier-mâché and nails for the following year's* Giglio. *(Photo by Felice Ceparano, Museo etnomusicale "I Gigli di Nola").*

le vite di alcuni santi; and in 1744 by Gianstefano Remondini, in his ponderous opus, *Della nolana Ecclesiastica Storia*, where he provides a more current description of the feast (Remondini [1747] 2000: tome 1, 182 and 183; tome 2, 28 and 29). Among other things, Remondini tells of the existence of a boat symbolizing the return of Saint Paulinus from Africa with the freed Nolans. With regard to the boat (*barca*), we also note the testimony of Ferdinand Gregorovius, in *Passeggiate in Campania e in Puglia* (Gregorovius [1853] 1979: 23):

> Following later was a boat upon which a young man dressed as a Turk held a pomegranate blossom. Behind this boat followed a great war ship on waves supporting it.

> *Seguivano poi una nave sulla quale era un giovane vestito da turco con in mano un fiore di melograno. Dietro a questa nave veniva un gran bastimento da guerra su un lembo di mare che gli faceva da fondamento.* (Avella 1989: 36)

*A Giglio is "danced" through the streets of Nola on the shoulders of a crew to a musical rhythm. Detail of the crew (*paranza*). Photo by Felice Ceparano, Museo etnomusicale "I Gigli di Nola").*

Currently, there is only one boat, which, in similar fashion to the *Gigli*, is transported by the *cullatori* to the prescribed rhythm through the historic town center of Nola.

The *Gigli* During Sabato Rodia's Times

Here follow a few observations on the *Gigli* feast during Sam Rodia's time:

1. The *Gigli* were all of the same height, as evidenced in a rare print (dated 1887) in the ethnomusicological museum I Gigli di Nola that was taken on the occasion of a Vatican

A Giglio platform carries its musical band and singer. (Photo by Felice Ceparano, Museo etnomusicale "I Gigli di Nola").

Preexposure in the diocese of Nola (*Preesposizione Vaticana della Diocesi di Nola;* Autiero 2004).

2. We find a musical element on the structure's base: "on the lower level one sees a musical band which, among general jubilation, launches into a rousing march" (C. A. Mayer, quoted in Avella 1989; he is referring to the year 1840).

3. The *Gigli* as we know them probably appeared as of 1887 and were constructed by master carpenter Filippo Cantalupo (Russo 1995: 18).

A cullatore *(lifter) carrying/dancing a* Giglio. *(Photo by Felice Ceparano, Museo etnomusicale "I Gigli di Nola").*

Various cullatori *(lifters) bearing a* Giglio. *(Photo by Felice Ceparano, Museo etnomusicale "I Gigli di Nola").*

4. In the years 1861 and 1891, *Gigli* were danced on the Sunday following June 22, separate from the procession in the saint's honor. Two explanations might be offered here: that this deviation in the festival occurred because of the difficulty of transporting the *Gigli* in conjunction with the saint's procession; or to accommodate the needs of visitors and especially to (commercially) benefit the city, because the feast had become a magnet for tourists (Avella 1989: 70–72).

5. Between 1884 and 1885, the railway line connecting Naples to Nola and Baiano was completed, allowing for increased exchange between Nola and the capital of the region of Campania (Naples) but also between Nola and its provincial hinterland around Avellino.

6. In 1893, the waters of Serino were routed to Nola (*Corriere di Napoli*, December 22–23, 1893; Avella 2001: 57).

7. Finally, one should not ignore the long pilgrimage tradition, whereby pilgrims on their return from the sanctuary at Montevergine (also in the province of Avellino) paraded their carriages along the streets of Nola, to hear *a figliola* singing, as noted in contemporary newspaper accounts: "for two days now the city has been transformed into a general pandemonium" (*Corriere di Napoli*, May 21, 1902, in Avella 2001: 164). "The engaging folk festival of Montevergine, a feast where religion and mayhem go perfectly hand in hand, was very crowded" (*Il Mattino*, June 9–10, 1897, in Avella 2001: 125).

These last events are cited to demonstrate how Nola's notoriety in the communities around Avellino was well established by the mid- to late nineteenth century. Indeed, the feast was celebrated throughout the entire twentieth century, with the exception of 1911 (Avella 2001: 320), because of a cholera epidemic; as well as a few years during World War I (1915–18; Avella 2001: 484) and World War II (1941–43; Avella 2001: 1055). By limiting our period of research, as well as the source of documentation, to those found in the I Gigli di Nola museum,[1] we may here further note how the feast was perceived outside its city walls and answer the question: What was the scope of the *Gigli*'s notoriety during Sabato Rodia's lifespan? Already at the end of the nineteenth century, a significant movement of tourists to Nola occurred during the feast, testifying to its fame and its ability to attract. Various newspaper sources of this era attest to this fact:

> Toward nightfall yesterday, many carriages and carts, departed from the arch of Nola, overloaded with Neapolitans celebrating the Nolan patron saint.
>
> [*Sul tardi di ieri, partirono alla volta di Nola moltissime carrozze e biroccini carichi di napoletani a festeggiare il patrono nolano.*] (*Corriere di Napoli*, June 24, 1888; Avella 2001: 28)

> The feast in honor of St. Paulinus lasted two days and the flow of people was immense.
>
> [*La festa in onore di S.Paolino è durata due giorni e il concorso della gente è stato enorme.*] (*Corriere di Napoli*, June 27, 1895; Avella 2001: 67)

> The Duchess of Aosta was deeply moved by the grand spectacle on the piazza where 40,000 people jostled each other, applauding and yelling.
>
> [*La Duchessa d'Aosta restò profondamente colpita dallo spettacolo imponente che prest-ava la piazza ove quarantamila persone si pigiavano applaudendo e gridando.*] (*Il Giorno*, June 25, 1906; Avella 2001: 217)

We note a huge crowd already forming since this morning in the streets of Nola. In the Piazza del Duomo at 10:00 a.m. traffic has become extremely difficult. . . . Frequent trains on the Napoli–Nola–Baiano line arrive, brimming with people.

[*Una folla straordinaria si nota fin da questa mattina per le vie di Nola. Nella Piazza del Duomo alle ore 10 è difficilissima la circolazione. . . . Treni frequentissimi della ferrovia della Napoli-Nola-Baiano arrivano zeppi di persone.*] (*Il Giorno*, June 29, 1909; Avella 2001: 258–59)

Yesterday, tens of thousands of people converged upon Nola to attend and admire the beautiful feast.

[*Nella giornata di ieri si sono riversati in Nola, decine di migliaia di persone per assistere ed ammirare la bella festa.*] (*Il Giorno*, June 24–25, 1913; Avella 2001: 356)

Finally, Sunday already at 9:00 a.m., one could not make one's way across any street. . . . There was a veritable crush of humanity, jammed together, jostling, suffocating, in order to catch a glimpse up close of the initial and most dramatic "lift."

[*Finalmente domenica alle ore 9, già non si poteva attraversare nessuna strada. . . . Vi era una vera ressa di gente, che si pigia, si urta, si soffoca per vedere meglio da vicino la prima, caratteristica "aizata."*]. (*Roma*, July 3–4, 1927; Avella 2001: 670)

Their Most Royal Excellencies, the Princes of Piedmont, will attend the grand *gigli* feast.

[*Le LL.AA.RR. i Principi di Piemonte assisteranno alla grandiosa festa dei gigli.*] (*Corriere di Napoli*, June 24, 1933; Avella 2001: 708)

The Piedmontese Princes will attend the *Festa dei Gigli*.

[*I Principi di Piemonte assisteranno alla Festa dei Gigli.*] (*Roma*, June 27, 1936; Avella 2001: 720)

The Prince participated in the *Festa dei Gigli*.

[*Il Principe intervenne alla Festa dei Gigli.*] (*Il Mattino*, June 28, 1937; Avella 2001: 725)

The Piedmontese Princes will attend the traditional *Festa dei Gigli* next Sunday.

[*I Principi di Piemonte assisteranno domenica prossima alla tradizionale Festa dei Gigli.*] (*Il Mattino*, June 21, 1938; Avella 2001: 728)

70,000 people attend the *Festa dei Gigli di Nola*.

[*70 mila persone presenti alla Festa dei Gigli di Nola.*] (*Il Mattino*, June 24, 1957; Avella 2001)

The traditional *Festa dei Gigli* took place this year with great solemnity with approximately 100,000 in attendance, arriving in Nola from all parts of Italy, and with the participation of Nolans living in America.

[*La tradizionale Festa dei Gigli si è svolta quest'anno con grande solennità alla presenza di circa 100.000 persone, affluite a Nola da ogni parte d'Italia e con la partecipazione di Nolani residenti in America.*] (*Il Mattino*, June 23, 1958; Avella 2001: 1305)

We also must not ignore the relationships between the Nolan community and America:

> Not long from now the Villani brothers will leave again for America, promising to return in seven years to build another *Giglio*, even grander than the one built this year.
>
> [*Fra poco i fratelli Villani ripartiranno per l'America, colla promessa di ritornare fra sette anni per costruire un altro Giglio più grandioso di quello di quest'anno.*] (*Il Mattino*, June 29–30, 1902; Avella 2001: 166)

> Even in our own district, the rate of emigration has risen alarmingly. The sub-prefecture has issued, during the first two months of this year, approximately a thousand passports.
>
> [*Anche nel nostro Circondario l'emigrazione ha vissuto un aspetto allarmante. La sotto-prefettura ha rilasciato nei primi due mesi di quest'anno circa un migliaio di passaporti.*] (*Il Mattino*, March 8, 1903; Avella 2001: 170)

> Courtesy of the Nolan residents of Brooklyn, members of the St. Paulinus Club, a beautiful bronze eagle was fixed to the base of the Tommaso Vitale monument.
>
> [*A cura dei nolani residenti a Brooklyn, soci del Circolo San Paolino, fu apposta alla base del monumento a Tommaso Vitale, una bellissima aquila in bronzo.*] (*Roma*, August 25–26, 1927; Avella 2001: 671)

> The Fascist Vito Genovese, a member of the New York Fascist organization, contributed 5,000 liras to the construction of the children's summer camp of Nola.
>
> [*Il fascista Vito Genovese iscritto al Fascio di New York ha versato L. 5.000 per la costruzione della colonia Elioterapica di Nola.*] Il Mattino, July 8, 1930 (in Avella 2000. 728)

Vito Genovese, born in Risigliano, near Nola, had emigrated to the United States at sixteen years of age on November 21, 1897. Having become a "king of crime," he returned to Italy with the Allies. In 1944, he was arrested by the American police in Piazza Duomo (the public square) of Nola and was returned to America where he thereafter became the "boss of bosses" (*il capo di capi;* Avella 2001: 728–29).

At the beginning of the twentieth century, the *Giglio* was taking root in Barra and Brusciano but also in New York. In 1903, a few emigrants, originally from Nola, introduced the *Festa dei Gigli*, building and dancing an obelisk in Williamsburg, Brooklyn. In subsequent years, Nolans transplanted to Ravenswood or Astoria, Queens, similarly honored their patron Saint Paulinus, while emigrants originally from Brusciano instituted feasts in honor of Saint Anthony of Padua in East Harlem, Manhattan, and in Fairview-Cliffside, New Jersey. During the 1920s, the *Giglio* was danced in various neighborhoods of Long Island, with feasts organized by mutual aid societies. In Brooklyn, the feast was a powerful reenactment of the values the community held most dear, in support of the parish churches of their neighborhoods—witnessing to ongoing faith in the power of the saints and the continuity within an Italian past.[2] The strong ties between emigrants and the *Festa* continued throughout the following years. For example, in 1975, the *Giglio* of the Sausage Makers (*Giglio del Salumiere*) included various Italian Americans as masters of the feast: Gaetano Spampanato, Angelo Iorio, Angelo Meo, Gennaro Saccone, and

Vincenzo Santaniello. In 2005, the *Giglio* of the Green Grocers (*Giglio dell'Ortolano*) offi-cially paired with the *Giglio* Boys Club of New York.

The Variable *Gigli*

To conclude, I wish to offer a few observations on the *Gigli* of Nola, on the peculiar aspect of the festival's variability, both in its physical aspects and with regard to its function.

VARIABILITY OF FORM

The *Giglio* we know today did not always take its present form. Prior to 1887, the *Gigli* were not all of equal height. Today's structures, too, tend to vary. For example, during the past few years, the builders have attempted to reduce the weight of the components used for the construction of the *Giglio*. In America, specifically in Brooklyn, wood has even been completely substituted by an aluminum frame. And if we look to past centuries, we find that the *Giglio* had a completely different form and structure:

> An enormous torch in the shape of a column, lit and adorned with shafts of wheat . . . is called *cereo*. (1514)
>
> [*Una grandissima torcia a guisa di colonna, accesa e adorna di spighe di grano . . . la chiamano cereo.*]
>
> . . . solemn procession in which some artisans carry *Mai* or *Gigli*, and they are machines in the form of globes, pyramids, ships, all adorned with numerous carnations. (1747)
>
> [. . . *solenne processione, nella quale portano alcuni Artefici certi Mai, o Gigli, e sono certe macchine in forma di globi, di piramidi, di navi, tutte adorne d'innumerevoli garofani.*]
>
> I saw a very tall tower held up by porters, and sheathed in shimmering gold, silver and red; it was five stories high and elevated on columns adorned with friezes, niches, arches and figures. (1853)
>
> [*Vidi, retta da facchini, una altissima torre, rivestita di oro scintillante, di argento e di rosso; era alta cinque piani, elevata su colonne, adorna di fregi, nicchie, archi e Figure.*] (Avella 1989: 29–37)

VARIABILITY OF ROLES

The *Giglio* originated as an ex-voto for Saint Paulinus, but it hasn't remained such. The *Giglio* can be dedicated to another saint, for example, Saint Anthony of Padua, as is the case in Brusciano, or to the Virgin of Mount Carmel, in Brooklyn. The *Giglio* is related to seventeenth- and eighteenth-century Neapolitan Baroque spires, which in turn are linked to the earlier Roman practices of Pope Sisto V and the Christianization of pagan (Egyptian) obelisks, which radically transformed Naples during the Catholic Restoration. In the pub-lic squares of Naples, especially in the square of San Domenico or del Gesù, spires seemed to replace the saints' statues, thereby enhancing monumentality in these public places.

Undressed Gigli, *Nola. (Photo by Felice Ceparano, Museo etnomusicale "I Gigli di Nola").*

Further, there exists a relationship between spires (*guglie*), characterized by verticality and exuberant dimensions, their propagandistic function, and the wooden construc-tions of civic and religious festive apparatuses. These were frequently mounted on the occasion of nuptials and birthdays, during the period from the Spanish viceroys to the reign of Charles of the Bourbons (Salvatori and Menzione 1985: 15–30). Among the most accomplished designers of such festive apparatuses or machines during this time were Ferdinando Sanfelice (1675–1748; Avella 1997: 518–60), who also worked in Nola, on the construction of the new church of Santa Chiara; and Domenico Antonio Vaccaro, who designed various ornamental features of the basilica of the Santissimi Apostoli, also in

Gigli *seen from behind. Nola. (Photo by Felice Ceparano, Museo etnomusicale "I Gigli di Nola").*

Nola (Avella 1997: 77–88). Are these merely coincidences, or do these facts strengthen the ties between the festive apparatuses of Naples and the *Gigli* of Nola?

The *Giglio* does not always have a religious role but may fill a secular one as well. For example, on September 30, 2007, the city administration of Nola created a *Giglio* in Rome, in the vicinity of the Imperial Forum, to promote the candidature of the *Festa* of Nola into UNESCO's Intangible Heritage list, in support of the initiative taken by the Associazione Extra Moenia of Nola, beginning in 2000. Further, the city administration also took part in the recent *Sete Sòis Sete Luas* project, exporting a *Giglio* to Santa Maria da Feira, Portugal, in 2005, to Lisbon, Portugal, in 2006, and to Valencia, Spain, in 2007, as a totemic presence and as a means of promoting tourism to Nola and its vicinity.

When it is an actual person (a master of the feast or a crew captain) to be associated with the *Giglio*, beyond devotional motivation (*ex-voto*), other motivating factors may come into play: for example, social prestige, passion, pleasure, or the mere interest to become a crew captain "not merely by chance" (*non a caso se i' capo paranza*). Masters of the feast today almost exclusively derive from the business sector and have seen their prestige (and their earnings) increase dramatically in recent years (Lucarelli and Mazzacane 1999).

Today, therefore, beyond religious motivation, the height and size of the *Giglio* can signal other sentiments and even nostalgia toward one's native land. The predisposition of the *Giglio* to vary its function and its physical contours, its relationship to Nola (and the Irpinian community), the feast's fame in the diaspora (i.e., the *Giglio* in America), together with certain construction features (bottom-to-top construction, humble and recycled materials),

its placement near the master of the feast's home, the shape present in the working of the papier-mâché itself—all these are factors that suggest that Rodia did indeed know about the *Gigli* of Nola and was inspired by them in the making of his Towers.

Works Cited

Arbace, Luciana, ed. 2004. *Da Nola a Ottaviano: Restauri e recuperi di opere d'arte.* Naples: Istituto Grafico Editoriale Italiano, 2004.

Autiero, A. 2004. "La preposizione Vaticana della Diocesi di Nola." In *Da Nola a Ottaviano: Restauri e recuperi di opere d'arte,* edited by Luciana Arbace. Naples: Istituto Grafico Editoriale Italiano, 2004.

Avella, Leonardo, ed. 1979. *La festa dei gigli di Nola dalle origini ai nostri giorni.* Naples–Rome: Libreria Editrice Redenzione.

———. 1989. *Annali della festa dei gigli (1500–1950).* Naples: IGEI.

———. 1997. *Fototeca Nolana.* Vol. 3. Naples: Istituto Grafico Editoriale Italiano.

———. 2000. *La Festa dei Gigli.* Nola: Extra Moenia.

———, ed. 2001. *Cronaca Nolana: Dalla monarchia alla Repubblica.* 12 vols. Naples: Istituto Grafico Editoriale Italiano.

Ceparano, Felice. 2009. *Per una filmografia dei Gigli di Nola.* Nola: Extra Moenia.

Ferraro, Andrea. [1644] 2000. *Del cemeterio nolano con le vite di alcuni santi,* chap. 9. In *La Festa dei Gigli,* edited by Leonardo Avella. Naples: Di Tomaso.

Gregorovius, Ferdinand. [1853] 1979. *Passeggiate per l'Italia* ("Passeggiate in Campania e in Puglia"). In *La festa dei gigli di Nola dalle origini ai nostri giorni,* edited by Leonardo Avella, 59–70. Naples–Rome: Libreria Editrice Redenzione. (Translated from the German by Mario Corsi. Rome: Carboni, 1906.)

Gregory the Great, Pope. [1644] 2000. *Dialoghi,* book 3. In *La Festa dei Gigli,* edited by Leonardo Avella 2000. (Translation by A. Ferraro, *Del cemeterio nolano con le vite di alcuni santi,* chapter 11. Napoli: Di Tomaso, 1644.) http://it.wikipedia.org/wiki/ferrovia_Napoli-Nola-Baiano

Leone, Ambrogio. [1514] (2000). *De Nola,* book 3, chap. 7. In *La Festa dei Gigli,* edited by Leonardo Avella 2000. (Translation by P. Barbati. Naples: Torella, 1934.)

Lucarelli, F., and Lello Mazzacane. 1999. *L'UNESCO et la tutelle du patrimoine immateriel. Les fêtes traditionnelles. Les Gigli di Nola.* Nola: Extra Moenia.

Remondini, Gian Stefano. [1747] 2000. *Della Nolana Ecclesiastica Storia,* tome 1, book 1, chap. 279. In *La Festa dei Gigli,* edited by Leonardo Avella 2000.

Russo, Alfonso M. 1995. *Arte e tecnica nei Gigli di Nola.* Milan: Elio Sellino Editore.

Salvatori, Gaia, and Corrado Menzione. 1985. *Le guglie di Napoli: Storia e restauro.* Naples: Electa.

The Literary and Immigrant Contexts of Simon Rodia's Watts Towers

Kenneth Scambray

The story of the Watts Towers is as much about Italian immigrants in California as it is about Simon Rodia, the Italian immigrant who constructed the more than seventeen sculptures that compose the site. As Italian American immigrant novels and autobiographies of the era reveal, Rodia's life and Towers express the immigrant experience in Southern California and ultimately the experiences of many more Italian immigrants throughout America at midcentury. Although the immigrant quest for success was often presented as problematic in the works of such Italian American writers as Pascal D'Angelo, Antonia Pola, and Pietro Di Donato, Western Italian American writers such as Angelo Pellegrini, Dorothy Bryant, Steve Varni, Jo Pagano, John Fante, and Flavio Trettel generally expressed greater hope and optimism in their characters' quest to succeed in the New World. As these novels reveal, nearly all immigrants came seeking escape from their subaltern and historically conditioned lives in Italy. One common measure of that success was expressed in terms of how much wealth the immigrant could amass in the shortest amount of time. In the California novels of Milan-born Paolo Pallavicini (San Francisco newspaper editor and novelist), for example, his Italian immigrant characters travel to America and California solely "to make money" ("far denaro"; Pallavicini 1939: 30). As one of Pallavicini's characters says in *Tutto Il Dolore: Tutto L'Amore,* "in America you will not have one, but thousands of opportunities to make money" ("E in America con quello

145

che abbiamo avvrai non una, ma mille opportunita di far denaro"; Pallavicini 1937: 6). But as the Italian American autobiography and novel reveal, not all Italian immigrants came to America for the sole purpose of making money. As Rodia's experiences as a young man suggest, he certainly set out to succeed in America. But for us today, Rodia's s Towers in Watts are a sign of the creative fusion of the Italian immigrant experience with the Southern California environment that surrounded him during the first half of the twentieth century.

As Rodia's remarkable Watts Towers reveal to us, making money was not the sole objective of his life in Southern California. In fact, when he finished the Towers to his satisfaction, he simply gave them away. Rather, Rodia's life and Towers are to be located on that other side of the success story, transcending the mere pursuit of riches in the New World. Looking back to the pre–World War period, Tuscan-born Angelo Pellegrini wrote in *American Dream* that for many immigrants, "economic gain is no more than marginal relevance" in their struggle for success. For Pellegrini in Seattle, Washington, throughout the 1920s and 1930s, that dream was "the inalienable right to seek happiness in self-realization" (1986: 5–6). After years of grueling work as a pick and shovel laborer in the East, Abruzzo-born Pascal D'Angelo one day wrote, "Again I felt an urge to express myself, to cry out my hopes and dreams to this lovely unheeding world" (2003: 144). Similarly, first-generation Italian American writers such as Pagano and Fante would depict the problems of assimilation but ultimately celebrate the personal freedom and demo-cratization of life in Southern California for Italian immigrants and their offspring. For California Italian immigrant writers such as Trettel, Pagano, Varni, and Fante, California was not the terminus, geographical or otherwise, of the American Dream for the Italian immigrant, as it was so often depicted by other nonimmigrant writers of the period (Fine 2000: 7). Rather, in Fante's (2000) *The Brotherhood of the Grape,* Abruzzese immigrant Nick Molise is proud of his accomplishment as the town's mason, having built virtually all of his adopted northern California town's municipal buildings. At a time when Italian immigrants were viewed with suspicion and marginalized in towns throughout Amer-ica, Nick Molise views his brick public buildings as monuments to his skill and spirit, a heritage that stretches back generations in the Molise family (Scambray 2007: 183). Having made an indelible mark on his town's history and culture, Nick boasts that his buildings will "last a thousand years" (Fante 2000: 21).

In *Golden Wedding,* Pagano tells us that his characters' experiences were "a part of that glittering, reckless world of the future, a world whose history was a history of light" (1943: 284). What Pagano, a Hollywood scriptwriter, is referring to in his statement is that by 1915, the film industry had moved from the East to Los Angeles because of the omnipresence of sunlight, making it possible for filmmakers to film outdoors in natural light all year round (Mast 1986: 98). In fact, in the magazines and newspapers of the pe-riod, Southern California marketers and hucksters all promoted the region as a sun-drenched Mediterranean paradise (Rolle 1968: 292). Southern California's omnipresent sunlight is crucial to the understanding and appreciation of the Watt Towers' form and content, especially the selection of materials Rodia used to decorate his more than seven-teen sculptures and three towers.

Too often, the influence of Rodia's early life in the creation of his Towers is over-looked: his place of birth, his peasant family, the places of his settlement in America (Pennsylvania, Seattle, Oakland)—all locations with significant Italian immigrant com-

munities (Nicandri 1978; Reis 1993). At some point during this period, Rodia traveled the railroads, possibly seeking work, throughout the West, Southwest, and Northeast. It is also reported that he traveled to Canada and South America (Landler and Byer 2006). I believe that his travels on the railroad were an important influence on his life and ultimately his decision to build the Towers. His experiences took him physically and intellectually outside the ghettoized boundaries of the ethnic neighborhood. His peripatetic early life was not typical of that otherwise more common Italian immigrant neighborhood experience in North America (Lothrop 2000: 235). He was so impressed with what he saw throughout the West and Southwest that he often spoke of the cities he visited in his travels, from Berkeley and Cheyenne to Chicago, Denver, and El Paso (Haeseler 1971: 18; Goldstone and Paquin Goldstone 1997: 31). Even more important, although he never mentioned this to his interviewers, was his premature separation from Ribottoli. We cannot underestimate the influence this dislocation from family had on the construction of the Towers. This "exile" from his native land was an experience that Rodia surely shared with his generation of Italian immigrants.

In the earliest accounts of his life, Rodia was often characterized as an eccentric, living the life of a recluse, as he labored each night after work on his Towers. Although there were no Italian settlements in Watts, as there were in other nearby neighborhoods of Los Angeles, it is, nevertheless, essential to our understanding of Simon Rodia to see him within the context of the vast number of Italian immigrant settlements in Los Angeles, as well as throughout California. He was no different from all those other struggling immigrants who had settled California—from its rural valleys to its coasts. Like his immigrant compatriots, both men and women, Rodia intended to make his mark on the California landscape.

In California, Rodia was surrounded by a laboring Italian immigrant workforce that was making significant contributions to the state's developing economy, as well as to its culture (Palmer 1965: 212–95). In 1900, there were 22,777 foreign-born Italians in California, ranking this ethnic group fifth among American states (U.S. Census Bureau 1900). By 1920, there would be 88,502 Italian immigrants in California—first among all foreign born in the state (U.S. Census Bureau 1920). By 1940, in the western half of the United States—including regions designated as the West, West South Central, Mountain, and Pacific—there were more than 282,746 Italian immigrants engaged in a variety of occupations (Rolle 2000: 110–28; U.S. Census Bureau 1940). By 1940, that number had climbed to 100,911—second only to the Mexican foreign born (Helzer 1998: 42).[1]

Throughout California, Italian immigrants were, to borrow a phrase from novelist Garibaldi Lapolla, "making it" in American society. By 1940, there were over 45,000 Italian fishermen in California. In fact, Italians composed the largest percentage of fishermen on both the East and West Coasts (Fox 1990: 137). Along the California coast, Genovese and Sicilian fishermen virtually dominated California's fishing industry, from San Francisco, Pittsburg (California), Monterey, and Santa Cruz in the North, to San Pedro and San Diego in the South (Lothrop 2000: 236–40). There were thriving Italian immigrant communities in San Francisco, Oakland, and Sacramento in the North; Stockton and Fresno in the Great Central Valley; and nearby Los Angeles and San Diego in the South. All of these areas were an amalgam of many Italian dialect groups (including Italian-speaking Swiss immigrants who worked largely in the state's dairy industry; Perret 1950: 49–50, 74–77).

Before World War II, in both farming and winemaking, Italian immigrants became a dominant force in California agriculture throughout its coastal and interior valleys

(Palmer 1965: 212–95). In fact, Italian immigrants' influence was so great that their identity became synonymous with California agriculture (Miller 1995: 188). By 1910, more than 12,000 Italian immigrants resided in California's Central Valley, stretching from the Sacramento to the San Joaquin Valley. By the 1930s, 4,443 Italian immigrants would own or operate 60,000 acres of California farmland (Helzer 1998: 141; Maiello 2001: 164). As Flavio Trettel writes in *La Medaglia D'Oro*, set in the heart of the San Joaquin Valley, "Fresno was the garden of God: it had earth, water, and sun. The individual would be able to accomplish there whatever he wanted" (*Fresno era il giardino di Dio: c'era terra, acqua, e sole. L'uomo poteva farne quel che voleva*; Trettel 1993: 23).

Even though commercial winemaking began with the secularization of the Missions in 1833, the two greatest events that launched the wine industry in California were the Gold Rush and the Great Migration (Rosano 2000: 28). By midcentury, Italian immigrants dominated wine production throughout the state, north and south. Numbered among those early viniculture pioneers were Giuseppe Simi, Andrea Sbarbaro, Anthony Caminetti, Raffaelo Petri, and Giuseppe Di Giorgio, in Northern and Central California, and Secondo Guasti in Southern California (Rosano 2000: 27–43). When Di Giorgio died in 1951, he left to his heirs nearly fourteen square miles of vineyards in the San Joaquin Valley, near Delano—the largest family-owned operation in the world (Adams 1990: 457). Although the post-1970 period is often cited as the most important in California wine history, by the 1960s four California Italian immigrants—Gallo, Franzia, Di Giorgio, and Petri—already controlled more than 65 percent of all wine storage in the state (Helzer 1998: 141; Palmer 1965: 265; Rosano 2000: 27).

Long before the more famous Sonoma and Napa Valleys became the center of the wine industry in the post-1970s, the wine industry in California was centered around the old Plaza in what is now the historic center of downtown Los Angeles (Rosano 2000: 28). Secondo Guasti, an Italian immigrant from northern Italy, was among those early vintners. In October of 1900, Secondo Guasti and his partners expanded their Los Angeles–based winemaking enterprise by purchasing more than 5,000 acres of land in the Cucamonga Valley, not far from Watts. Cucamonga was a region that everyone thought at the time was a worthless desert landscape. Like Rodia, Guasti took what was believed to be of no value and, as one writer reported, made the "desert bloom as the rose" (Guinn 1915: 202–7).

Guasti planted 4,000 acres of grapes and established the Italian Vineyard Company. To nearly everyone's surprise, in just a few years the Italian Vineyard Company would become "the globe's largest vineyard" (Guinn 1915: 202; Lothrop 2000: 244.) In the decades before World War II, the Cucamonga label became the standard in the wine industry (Morra; Shiro). By 1940, in the wake of Prohibition, the Italian Vineyard Company shipped over 7,000,000 gallons of wine and tons of grapes to Canada and throughout the United States, the Southwest, Northeast, and East (Lothrop 2000: 245). Like those other Italian immigrants who made the Central Valley bloom into a garden of produce, vineyards, and orchards, Guasti's innovation in that semi-arid landscape is more the stuff of visionary imagination than it is mere economic success (Palmer 1965: 212).

When Rodia settled in nearby Watts, by 1930 there were 16,851 Italians in Los Angeles, ranking fifth among European-born immigrants (Helzer 1998: 54; Lothrop 2003: 274; U.S. Census Bureau 1930). Italians were concentrated throughout the northeastern part of the city. This wide area extended from the historic Plaza, along Spring Street and Broadway, to Exposition Park, surrounding Saint Peter's Italian Catholic Church. The

Italian settlement continued over the North Broadway Bridge to Lincoln Heights, where the final chapters of Jo Pagano's novel *Golden Wedding* are set. During this early period, La Società Garibaldina di Mutua Beneficenza (the Garibaldian Mutual Aid Society), among other groups, met in the Italian Hall, on the corner of what is now Cesar E. Chavez Avenue and North Main Street, where it serves as the Italian Hall Museum. As Rodia lived, traveled, and worked throughout Northern and Southern California, he witnessed Italian immigrants' extraordinary progress and accomplishments.

The Italian immigrant novel of the period has left a revealing record of the aspirations of Rodia's generation, as well as of first-generation Italian Americans of the era. For immigrants at the time in the West, opportunity would find itself firmly tethered to the immigrant work ethic. The Italian immigrant saw possibilities in the California landscape never before imagined (Rolle 1968: 16). Like Arturo Bandini, in John Fante's *The Road to Los Angeles*, Rodia no doubt was inspired by the "myriad possibilities" for the Italian immigrant in California and the West (Fante 2000: 38). As Pellegrini wrote of his family's experiences in the Northwest near Seattle, the undeveloped land and the abundant resources were theirs "at no cost other than the sweat of their brows" (Pellegrini 1986: 8).

Liberated from the shackles of his impoverished Italian past, Rodia was a free and independent spirit, not unlike Lapolla's Grand Gennaro and Fante's Nick Molise (Goldstone and Paquin Goldstone 1997: 27–35). Nineteenth-century Italian immigrant Antonio Gallenga wrote in his autobiography, *Episodes in My Life*, that the Italian immigrant in America should have "no [re]pining or hankering after things he left behind in the old one [country]. He must start with a stout determination to be a settler among settlers; to do in America as the Americans do" (Rolle 1968: 3). As Rodia's migration across America and his work illustrate, there is no doubt that he intended to renew his life in the New World. However, like Fante's Bandini or Pagano's Simone family in Los Angeles, while Rodia's migratory pattern indicates that he certainly set out to succeed, he would not do it at the expense of his Italian identity. For Italian immigrants and their offspring in America, social and economic mobility did not always override other cultural values (Di Leonardo 1984: 104–6). As Pellegrini wrote, the immigrant "should forget about economic gain and concentrate on becoming something—the best that is latent in us" (Pellegrini 1986: 6). Even Constantine Panunzio, in an autobiography dedicated to his own assimilation into American life, wrote that his book "depicts *the inner, the soul struggles* of the immigrant more than his outward success or failure. It tells the agonies and the Calvaries, of the bitter sorrows and the high joys of an immigrant soul" (1921: xi). As Robert Canzoneri wrote in *A Highly Ramified Tree*, he saw "roots and branches not only as a means of nourishment, but as what each of us diverges into" (1976: 1). As these writers demonstrate, assimilation was not a simple linear process; it was far more complex. Unavoidably, while immigrants struggled to succeed, they never could divest themselves of their heritage. Out of necessity, Rodia had abandoned his roots in the Old World, but he would make the past present in a timeless work of "grassroots art" that would be a fitting tribute, in Pellegrini's words, to the "immigrant's quest" for that less tangible side of the American Dream (Scambray 2001: 113).

Although Rodia did not live among other Italian immigrants, he was not isolated in suburban Watts. The Pacific Electric Red Car Line connected Rodia's neighborhood with the Watts Depot and Santa Ana (Goldstone and Paquin Goldstone 1997: 80). Throughout the thirty-four years he worked on the Towers in Watts, either by car or train, Rodia was

able to visit a diverse Southern California landscape, as he traveled to Santa Monica, where he worked as a laborer in a tile factory (Goldstone and Paquin Goldstone 1997: 68). His connection to the greater Los Angeles landscape, including its beaches, would prove important in the materials he used for his Towers.

Like all those other immigrants in California, this diminutive man from an obscure southern Italian village also began making himself visible in his community. As he labored each evening after work and on weekends, his three Towers rose by degrees over the rooftops of the single-story suburban houses that surrounded his site. Sunlight was a major influence in Rodia's selection of the materials he used to decorate his complex of sculptures and towers—including fragments of glass, pop bottles, automobile glass, window glass, and mirrors.

He organized his materials in bins and carefully selected his fragments for placement on his sculptures and towers. He kept a fire burning and melted glass into free forms before embedding them into the fresh cement (Goldstone and Paquin Goldstone 1997: 56). And he used many household and industrial objects, from the backs of ice cream parlor chairs, wire rug beaters, and faucet handles, to gears, iron gates, grills, baskets, and cooking utensils for design elements on wall panels surrounding his site, while on other surfaces he inscribed freehand designs. Into sections of his exterior wall, he pressed images of the hand tools, signs of his immigrant, working-class values.

Perhaps most important of all, however, as the viewer stands in the midst of the site, Southern California's very special "history of light" becomes evident. As the sunlight passes over the multicolored surfaces of his sculptures during the day, it creates a polyphonic luminosity. The combination of free-form glass and tile fragments reflect the Southern California light in harmonious tones and shades. And even more important, the elongated, arched buttresses that crisscross overhead (including the circular supports on the Towers) cast a network of changing shadows across the site. The sculptures are not static. They change with the movement and intensity of the sun, from sunrise to sunset. Although made of reinforced concrete, the giant towers appear light and airy, more celestial than earthbound.

Many of the soft drink bottles are placed with their labels showing and their fragmentary crockery and tiles represent a cross-section of 1920s and 1930s life (Goldstone and Paquin Goldstone 1997: 64), objects identifiable in the community and industries of Southern California. Nevertheless, Rodia's sculptures transcend their historic context and leave an indelible record of an immigrant mind that went beyond the parochial and the mundane. Aside from the placement of the three towers in the center of his space, there is seemingly no order to the layout of his sculptures or to the decorations that adorn the walls that surround his site. Rodia designed and decorated as he constructed each piece. Buckminster Fuller credited Rodia with making innovations in his structural engineering. But Fuller was quick to add that Rodia's innovations were "intuitive" and not technical (Goldstone and Paquin Goldstone 1997: 50). As that other Italian immigrant, Baldassare Forestieri, once said about the unplanned design of his Underground Gardens, in Fresno, California, "It takes no genius to make a straight line. . . . But to make something cooked and beautiful . . . that is a beautiful thing" (Scambray 2001: 13).

Finally, what is ultimately important about the Towers is that Rodia's site, like the over 100-year history of Italian American literature, expresses not only Italian immigrants' aspirations but conflicted recollections of their past in the Old World. The form of the three towers as they spire upward is a sign that has always been traditionally associated with

hope and aspiration, like the spirals of a Gothic cathedral reaching toward the heavens. Certainly, Rodia's site is his paean to the land that liberated him from his pre-migration poverty. However, his Towers are also a tribute to his past in southern Italy. As Jerre Mangione writes in *Mount Allegro,* although his relatives left their godforsaken villages in southern Italy, where they and their ancestors had lived for generations under the yoke of a hopeless poverty, they began in America to nostalgically recall their homeland (1981: 204). Like Sicilian immigrant Baldassare Forestieri's Underground Gardens, which he created during this same period, Rodia's Towers express that psychological, dislocating experience of immigration (Scambray 2001: 114) and recall aspects of an Italian past.

As folklorists I. Sheldon Posen and Daniel Ward have (in my opinion) established, Rodia's three towers were based on the ceremonial spires annually paraded through the town of Nola, not far from Rodia's native village, in honor of the local patron saint, Paulinus, for centuries (Posen and Ward 1985; Ballachino, Ceparano, this volume). Rodia named his ship the *Marco Polo* after the great Italian explorer who traveled the world beyond. And like other uneducated immigrants before him, the form and content of his Towers are also a sign of Rodia's awareness of his historical subaltern status (Albanese 1997: 37–49). In his many interviews [Editor's note: see Appendix A], Rodia expressed views on a wide variety of subjects, from labor and capital to religion and American cultural values, and gave voice to these complicated subjects as best he could in his broken English (Landler and Byer 2006). He was well aware of his peasant heritage and his place in modern industrial society. While common laborer Pascal D'Angelo and cobbler Frank Spiziri expressed themselves in prose and poetry, Rodia found self-expression through hand tools and the materials available to him, the detritus of industrial America in Southern California (Albanese 1997: 113–99; Scambray 2003: 168–79).

If we look at the immigrant literature of the period, what motivated Rodia becomes as transparent as the iconography of his work. It is remarkable that one man built the Towers without help from others or even assistance from machinery. The Italian immigrants who flooded America at the turn of the century were little more than beasts of burden—in D'Angelo's words in *Son of Italy,* "pick and shovel" laborers (2003: 72). Even so, in spite of their hardships in the New World, like Pagano's immigrants in *Golden Wedding,* they set out on another kind of voyage. As demonstrated throughout Italian American writings, once settled, immigrant men and women worked with a vengeance to reinvent themselves and overcome their historical subaltern status (Scambray 2007: 33–50). In Pagano's *Golden Wedding,* in the back of Marietta Simone's mind "was the driving urge to gain greater advantage for the children. . . . Her busy brain spun a million plans" (1943: 41). At one point, Lapolla's main character, the Grand Gennaro, pounds his chest and boasts: "I, I made America, and made it quick." Lapolla writes, "if one said of himself that he had made America, he said it with an air of rough boasting, implying 'I told you so' or 'Look at me'" (1935: 5).

It is often reported that Rodia wanted people to know how hard he had labored. He was emphatic about his accomplishment: "I'm gonna do something. I'm gonna do something. I'm gonna do something. This is a great country" (Landler and Byer 2006). He never failed to point out that he built his Towers *alone,* without help from anyone. For example, when asked if he had ever seen Antoni Gaudí's Church of the Sagrada Família in Barcelona, Rodia asked, "Did he have helpers?" Upon learning that a crew of workers who had helped the great artist, unimpressed, Rodia boasted, "I did it myself" (Goldstone

and Paquin Goldstone 1997: 60). Rodia's remark cannot be discounted merely as self-serving. Rather, his boast echoes the words of John Fante's quixotic Nick Molise and Garibaldi Lapolla's Grand Gennaro in their struggle to "make it" and be recognized in America. As Forestieri once said about the creation of his grottoes in Fresno, "The visions in my mind almost overwhelm me" (Scambray 2001: 13). Like the work of those other Italian immigrants in Southern California, and throughout the state, Rodia viewed his Towers as his contribution to California culture.

Like Forestieri's relatives and acquaintances during his work on the Underground Gardens, Rodia's neighbors thought that he was eccentric (Scambray 2001: 116). People sometimes called him crazy, and children even tormented him as he worked over the years. When asked why he built the Towers, he once answered whimsically that his wife was buried under the tallest tower (Goldstone and Paquin Goldstone 1997: 39). On another occasion, he answered the same question with, "Why does a man make shoes?" His apparent evasiveness is not surprising, any more than most artists' or writers' reluctance to divulge the meaning of their creative productions. When asked what the Towers (which he named *Nuestro Pueblo*) meant, Rodia answered, "Lotsa things, lotsa things" (Haeseler 1971: 18). His name for the Towers seems appropriate considering their public location in the middle of his suburban, ethnic neighborhood and his own attempt to redefine his peasant and immigrant self. That is, he was someone who had made a significant contribution to the Southern California cultural landscape, had indeed "made America"—succeeding beyond his wildest dreams.

There is yet another dimension to the complex sign that Rodia's site represents to us today. Rodia's sculptures are not merely an expression of a nostalgic recollection of his past (i.e., the *Gigli* of Nola) but also an expression of the profound and irremediable loss of that southern Italian heritage. Like Mangione's homesick relatives in *Monte Allegro* or the immigrant narrative that Baldassare Forestieri tells in the iconography of his Underground Gardens, in his Towers Rodia narrated his inner turmoil inspired by the dislocation of the immigrant experience (Scambray 2001: 29). He was yanked from his native village at a tender age and sent to America, never to return to his native village, never again to see his parents, his siblings, his extended family, his boyhood friends. They would all pass away without his ever participating in funerals, those formal moments so important to Italians, as collective rituals of grieving. Nor would he ever participate in other rituals, baptisms, marriages, and feast days (such as the *Giglio*), their collective rituals of joy. He would never be able to reconcile such loss in an appropriate way, and so the Towers also represent a legitimate place of cultural mourning. Rodia was not alone, for as contemporary literary sources poignantly attest, while many immigrants became "birds of passage," returning to their villages whenever they could, others spent a lifetime pining to return and lamenting their loss of family, friends, and culture (Bailey and Ramella 1988: 4–5, 15–17).

Rodia was able to reconcile in a creative and permanent way his past with his present life in Southern California. The Towers are not, in Steve Varni's words, a "junkshop of the past" but a recollection of a "sensible past," one that remains intrinsic to the present (Varni 2000: 233, 264). What is so fascinating about Rodia's site is that we can say that he merged the very regional elements of his Italian past into a narration created in his local Southern California "dialect." Surrounded by suburban and industrial America, Rodia merged the images from his Italian ceremonial spires with the found objects of modern industrial America collected from the Southern California landscape.

As both literary and historic sources on Italian migration demonstrate, work was a primary value that immigrant Italians brought with them as peasants to the New World. Considering his three and a half decades of laboring on the Towers (including the physical risks he took each day, scaling the three Towers alone and without help), we can say, without fear of hyperbole, that Rodia's was, indeed, a Herculean labor. And in his Towers, he expresses that universal bicultural conflict between the past and the present so fundamental to the Italian immigrant experience, for in their unique decoration and in their soaring heights, they merge both past and present. They recall those ceremonial towers of Nola but also speak eloquently, in their upward spiral, to that hope and dream of success that all immigrants brought with them to the New World. Ultimately, in his Watts Towers, Simon Rodia transcends his parochial, subaltern origins in Italy and inscribes a timeless message, not just about the Italian immigrant experience but also about the universal migration experience.

Works Cited

Adams, Leon. 1990. *The Wines of America.* 4th ed. New York: McGraw-Hill.

Albanese, Catherine L., ed. and trans. 1997. Introduction to *A Cobbler's Universe: Religion, Poetry, and Performance in the Life of a South Italian Immigrant, 21–102.* New York: Continuum.

Bailey, Samuel L., and Franco Ramella, eds. 1988. *One Family, Two Worlds: An Italian Family's Correspondence Across the Atlantic, 1901–1922.* Translated by John Lenaghan. New Brunswick, N.J.: Rutgers University Press.

Canzoneri, Robert. 1976. *A Highly Ramified Tree.* New York: Viking.

Crosby, Rosalind Giardina. 1993. "The Italians of Los Angeles, 1900." In *Struggle and Success: An Anthology of the Italian Immigrant Experience in California*, edited by Paola A. Sensi-Isolani and Phylis Cancilla Martinelli, 38–57. New York: Center for Migration Studies.

D'Angelo, Pascal. 2003. *Son of Italy.* Toronto: Guernica.

Di Leonardo, Micaela. 1984. *The Varieties of Ethnic Experiences: Kinship, Class, and Gender Among California Italian-Americans.* Ithaca, N.Y.: Cornell University Press.

Fante, John. 1988. *Brotherhood of the Grape.* Santa Rosa, Calif.: Black Sparrow.

———. 2000. *The Road to Los Angeles.* Santa Rosa, Calif.: Black Sparrow.

Fine, David. 2000. *Imagining Los Angeles: A City in Fiction.* Albuquerque: University of New Mexico Press.

Fox, Stephen. 1990. *The Unknown Internment: An Oral History of the Relocation of Italian Americans During World War II.* Boston: Twayne.

Goldstone, Bud, and Arloa Paquin Goldstone. 1997. *The Los Angeles Watts Towers.* Los Angeles: Getty Conservation Institute and the J. Paul Getty Museum.

Guinn, James Miller. 1915. *A History of California and an Extended History of Los Angeles and Environs.* Vol. 2. Los Angeles: Historical Record.

Haeseler, Rob. 1971. "The End of the Line." In *Dream Streets: The Big Book of Italian American Culture*, edited by Lawrence DiStasi, 17–20. New York: McGraw-Hill.

Helzer, Jennifer Hill. 1998. *The Italian Ethnic Substrate in Northern California: Cultural Transfer and Regional Identity.* PhD dissertation, University of Texas at Austin.

Landler, Edward, and Brad Byer. 2006. *I Build the Tower.* Los Angeles: Bench Movies.

Lapolla, Garibaldi. 1935. *The Grand Gennaro.* New York: Vanguard.

Lothrop, Gloria Ricci, ed. 2000. *Fulfilling the Promise: An Anthology of Essays on the Italian American Experience in California.* Spokane, Wash.: Arthur M. Clark.

———. 2003. "Italians of Los Angeles: An Historical Overview." *Southern California Quarterly* 85 (Fall): 249–300.

Maiello, Adele. 2001. "Italian Entrepreneurs in the Central Valley of California." In *Italian Americans: A Retrospective on the Twentieth Century: Proceedings from the American Italian Historical Association Conference, San Francisco (32nd: 1999)*, edited by Paola Alessandra Sensi-Isolani and Anthony Julian Tamburri, 151–65. Chicago Heights, Ill.: American Italian Historical Association.

Mangione, Jerre. 1981. *Mount Allegro: A Memoir of Italian Life.* New York: Harper and Row.

Mast, Gerald. 1986. *A Short History of the Movies.* 5th ed. Revised by Bruce F. Kawin. New York: Macmillan.

Miller, Sally M. 1995. "Changing Faces of the Central Valley: The Ethnic Presence." *California History* 74: 174–89.

Nicandri, David L. 1978. *Italians in Washington State: Emigration 1853–1924.* Seattle: Washington State American Revolution Bicentennial Commission.

Pagano, Jo. 1943. *Golden Wedding.* New York: Random House.

Palmer, Hans Christian. 1965. *Italian Immigration and the Development of California Agriculture.* PhD dissertation, University of California, Berkeley.

Panunzio, Constantine. 1921. *The Soul of an Immigrant.* New York: Macmillan.

Pallavicini, Paolo. 1937. *Tutto Il Dolore: Tutto L'Amore.* [*All The Pain: All The Love*] Milan: Sonzogno.

———. 1939. *La Carezza Divina: Romanzo.* Milan: Sonzogno.

Pellegrini, Angelo. 1986. *American Dream: An Immigrant's Quest.* San Francisco: North Point.

Perret, Maurice Edmond. 1950. *Les Colonies Tessinoises en Californie.* Lausanne: Librairie de L'Université.

Posen, I. Sheldon, and Daniel F. Ward. 1985. "Watts Towers and the *Giglio* Tradition." In *Folklife Annual 1985,* edited by Alan Jabbour and James Hardin, 143–57. Washington, D.C.: Library of Congress.

Reis, Elizabeth. 1993. "The AFL, the IWW and Bay Area Cannery Workers." In *Struggle and Success: An Anthology of the Italian Immigrant Experience in California,* edited by Paola A. Sensi-Isolani and Phylis Cancilla Martinelli, 124–45. New York: Center for Migration Studies.

Rolle, Andrew. 1968. *The Immigrant Upraised: Italian Adventurers and Colonists in an Expanding America.* Norman: University of Oklahoma Press. (Reprinted as *Westward the Immigrants: Italian Adventurers and Colonists in an Expanding America.* Ninot: University Press of Colorado, 1999.)

———. 1980. *The Italian Americans.* Norman: University of Oklahoma Press.

———. 2000. Introduction to *Fulfilling the Promise: An Anthology of Essays on the Italian American Experience in California,* edited by Gloria Ricci Lothrop. Spokane, Wash.: Arthur M. Clark.

Rosano, Dick. 2000. *Wine Heritage: The Story of Italian American Vintners.* San Francisco: Wine Appreciation Guild.

Scambray, Kenneth. 2001. "Creative Responses to the Italian Immigrant Experience in California: Baldassare Forestieri's 'Underground Gardens' and Simon Rodia's 'Watts Towers.'" In *Italian Folk. Vernacular Culture in Italian American Lives,* edited by Joe Sciorra, 169–79. New York: Fordham University Press, 2011.

———. 2003: "Son of Abruzzi, Afterword." In *Son of Italy,* by Pascal D'Angelo. Toronto: Guernica.

———. 2007. *Queen Calafia's Paradise: California and the Italian American Novel.* Madison, N.J.: Fairleigh Dickinson University Press.

Trettel, Flavio. 1993. *La Medaglia D'Oro.* Firenze: Reverdito.

United States Census Bureau. 1900. *Twelfth Census of the United States.* Agriculture. Part 2, Crops and Irrigation, Section 7, Fruits, Nuts and Forest Products, Table 34: 738–39.

———. 1920. *Fourteenth Census of the United States.* Vol. 3. Section 2, Table 5, Population: 1920, p. 109.

———. 1940. *Sixteenth Census: Sixteenth Census of the United States.* Vol. 2. Characteristics of the Population, Part 1, United States Summary, Part 1, Section 2, Table 36: 88.

Varni, Steve. 2000. *The Inland Sea,* New York: William Morrow.

Sabato Rodia's Towers in Watts: Art, Migration, and Italian Imaginaries

Luisa Del Giudice

On seeing Sabato Rodia's portrait (see the volume back cover) for the first time, his face looked very familiar.[1] I was peering into the eyes of an entire community of hardworking Italian immigrants I had known all my life. I searched for acoustic echoes in the contours of his own words, as he narrated the details of his life history, as well as in the testimonies of those who had known him—found in myriad archival reports, films, and correspondence (see Appendices A through C).

I was especially mesmerized by Rodia's voice. It was like listening to an old phonograph record of Enrico Caruso—a little scratchy but still full of conviction. I listened avidly to the intonation, cadence, and turn of phrase in his Italian-inflected English. And I nodded at his adamant opinions on topics of such great concern to him. Yes, I had heard those, too, and knew them all too well. But I also found myself wishing that his interlocutors had better understood what the man was trying to say, the cultural context from which his ideas arose. Why hadn't they asked the more nuanced questions I wanted answered? Indeed, in Rodia's pointed responses and raised voice, one senses the frustration resulting from his interlocutors' incomprehension.[2]

We find therein many of the observations typical of an Italian immigrant reflecting on the strange ways and values of American society while in the same breath marveling at others (see notes 9 and 34). Many of his discourses and opinions were firmly rooted in

a southern Italian peasant and immigrant worldview, and in the Towers themselves were decipherable many elements of an Italian imaginary. Along with other scholars, I concluded that for all the ways in which he might appear a solitary artistic genius, Sabato Rodia was also an Italian immigrant with a recognizable collective past. How was it that five decades after his death, only the barest of facts had been provided about Rodia's cultural background and immigrant experience? Signage at the Towers (until quite recently) told visitors almost nothing about this past. In other words, a curious silence had settled around the Italianness of Rodia and the Watts Towers, despite the fact that the artist himself was conscious of, and vocal about, working within a tradition of builders that spanned millennia.

I began my public journey with Rodia's Towers in 2003. It has taken me through festival and conference organization, publications, and presentations on both sides of the Atlantic. One of my primary concerns was to add to the historic record from my own disciplinary perspectives of oral history and ethnography, enhanced by a personal experience of migrations. On the scholarly front, I add to the work begun by folklorists, Daniel Ward and I. Sheldon Posen in the 1980s, by Joseph Sciorra, and later by Katia Ballacchino and Felice Ceparano (in this volume) on the cultural links between the Watts Towers and the *Gigli* of Nola; as well as recent enquiries vis-à-vis Rodia's Italian American Experience by literary scholars such as Kenneth Scambray, and Teresa Fiore (2002).

This two-part essay addresses, first, Rodia's life and worldview as an Italian immigrant and, second, the Italian cultural practices and imagery embedded in his art. That is, it examines Rodia's life and the Towers in Watts through the prism of Italian diaspora history and southern Italian peasant cultural practices, imaginaries, and worldviews seemingly adapted by Rodia in California. It listens for Rodia's expressions of personal longing and enduring cultural myths and seeks to identify his hidden landscapes of memory. As such, it is canted in the direction of the artist's premigration past, while not ignoring his life and times in the United States. This essay's second half is especially concerned with identifying possible sources of Rodia's topographies—both mythic and physical. It focuses on the symbolic culture embedded therein—for example, bell towers, ships, gardens, hearths, treasure—and explores cultural practices of devotion, such as village celebrations (e.g., the *Gigli* of Nola) and ex-votos, to consider how the Towers might be considered a street festival or conversely a tangible expression of gratitude for "graces received."

Highlighting Migration

Paradoxically, among the various discourses that have enveloped the Watts Towers over the decades, the Italian (and diaspora) historical and ethnographic perspectives have been largely absent. There are several possible reasons for this silence, some involving complex intersecting currents and contradictions. It may highlight the divide between Italian American and Italian scholarship, neither of which has shown any significant appreciation of Italian peasant culture (see Introduction to Del Giudice 2009b); or it may highlight the divergent foci of the Watts Towers Arts Center vis-à-vis the Watts Towers (see Introduction). A dismissive comment about the Watts Towers being patronized as "folk art" (made by Mike Davis in *I Build the Tower* and by others) may also have contributed to stifling further investigation about the "folk" in this "folk art" environment. I contend instead that without investigating Rodia's ethnographic and sociohistorical origins, we

cannot fully understand the artist or the Watts Towers themselves. It is not enough to merely note, in passing, that he was an "Italian immigrant." What are the many implications and ramifications of this statement?

I do not seek to capture the Watts Towers in some restrictive Italian frame, however, first, because such a narrow perspective would do harm to the magnitude of the work—decidedly a "world heritage site" (whether officially so designated or not)—and, second, because it would not correspond to the reality of Rodia's life, in which many and varied cultural and geographic experiences across the Americas were conjoined. My goal is to enrich our understanding of the Italian cultural histories and imaginaries at play in his life and work and to encourage more nuanced and culturally informed interpretation.

Of Names, Language, and Place of Origin

Let us begin with names because they are such a critical marker of immigrant life. His birth certificate indicates his name to be *Sabato Rodia* (pronounced Sábato Rodìa). *Sabatino* is the more familiar form of the name in Italy, and the generational peers within his Italian family indeed used this diminutive variant (Appendix A.6, Segre Letter). Rodia's first name is rooted in the local topography of Serino, recalling the Sabato River. (Thus, whatever its remote biblical origins ["Sabbath" in the Hebrew is *Shabbat*], Rodia was not likely destined for the priesthood, as some have creatively asserted.[3]) His name therefore is most likely toponymic, echoing down the Sabato Valley (*Valle del Sabato*). The history of verdant Serino is replete with references to its abundant and much coveted waters—such a critical part of the regional economy (see De Biase 2006). Indeed, Serino functioned as conduit across the millennia, moving this precious natural resource and directly linking

A local map, showing Rivottoli di Serino, in relation to the region of Campania, of which Naples is the capital city.

158 Luisa Del Giudice

Cognome: RODIA

Presente in 82 comuni

Copyright 2000 LABO
http://www.labo.net/

The distribution of the surname Rodia *on the Italian peninsula (*L'Italia dei cognomi: *http://www*
.gens.labo.net/it/cognomi/). Reproduced with permission.

the entire area from Benevento down to the sea at Naples,[4] confirming an ongoing historic relationship between the coast and the hinterland (including Serino and Nola: see *Gigli* of Nola infra). As far as Sabato Rodia's surname is concerned, its distribution on a map of Italian surnames (the indispensable *L'italia dei cognomi* site) reveals Rodìa to be found in various central and southern regions of Italy, with its highest concentration in Campania. In this region, it is pronounced *Rodia* (confirmed by Hispanic orthography

The distribution of the surname Rodia *in the United States (*L'Italia dei cognomi:
http://www.gens.labo.net/it/cognomi/). Reproduced with permission.*

Rodilla), whereas in the southeastern region of Puglia, it is pronounced *Ròdia* (variant
Ròdio). Ellis Island's Port of New York passenger records counts many nineteenth-century
immigrants with both *Rodia* and *Rodio* as surnames.[5]

The fluctuations in Sabato Rodia's name, referenced in print and orally (Sam, Simon,
Don Simón, Sabatino, Samuele, Rodia, Rodilla) are not trivial but rather emblematic of
the migration process whereby people and names struggle to maintain or redefine cul-
tural identity, perhaps achieving some stable form in time. Immigrants have all, more or
less, encountered personal naming traumas (e.g., Del Giudice 2001a: 45–56). Foreign names
(and people) literally cannot belong as such, for they are unpronounceable on native
tongues—contributing to an immigrant's heightened sense of invisibility and dissonance.
Frequently, therefore, surnames were Anglicized. The translation of one's name was not
always a result of personal choice but rather of acquiescence[6] to late nineteenth-century
assimilationist America.[7]

"Sam" was a customary Anglicization of Italian male names beginning in "S"—for
example, "Sabato," "Salvatore," "Santi," and "Saverio." (Rodia and his nemesis brother-in-law,
Saverio Colacurcio [Sam Calicura], were both rechristened "Sam"; see Appendix A.6, Segre
Letter). Indeed, Rodia was most widely known as "Sam," he signed by this name, and "Sam"
is the name found on his grave marker. A generic "Sam" may have suited Rodia just fine.
In his eighties, he may even have enjoyed the irony of the situation, having acquired
through a blending of names and family geometries the ultimate and hyper-Americanized
moniker "Uncle Sam" (the personification of the U.S. Treasury). Uncle Sam Rodia him-
self became a public benefactor as he stood outside Saint Catherine Catholic Church in

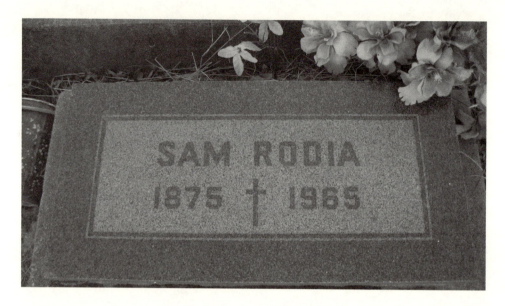

Sam Rodia's simple grave marker at Saint Catherine of Siena Cemetery, Martinez, California, giving 1875, rather than 1879, as his date of birth.

Martinez on Sunday mornings handing out coins to children (see Virginia Sullivan, in *I Build the Tower;* Landler and Byer 2006).

Closely related to this interplay of names are the related linguistic hybridities arising from Rodia's migrant experience. Rodia was, even after so many decades of living in America (and despite the fact that he had arrived as a still linguistically malleable adolescent), a nonstandard English speaker. His language was still heavily freighted with Italianisms (e.g., "machine" < *macchina*, "car"; "windship" < *barca a vela;* "sailing ship"); or outright loan words (e.g., *Babilonia* "chaos"; "*media* class" < *classe media*, "middle class"). But neither was he at home with Italian. When interviewed in (standard) Italian by Claudio Segre (Appendix A.6), Rodia preferred to revert back to the macaronic immigrant English (e.g., *Itagliese*)[8] to which he had become accustomed. He, too, lived in this linguistic "land between" as a largely unlettered speaker of English and Italian.[9]

Consider the historic reasons for this linguistic state. Given the low literacy rates of citizens of the newly unified Italian nation (1861), the majority of emigrants were illiterate dialect speakers. In Rodia's case, he had apparently refused to attend school as a boy in Rivottoli; and in the United States, his personal proclivities caused him to live apart from any recognizable Italian enclave (after his time in Oakland). Hence, even his oral Italian dialect proficiency likely diminished. He seems instead to have found a foster home in Spanish, a kindred Romance language (most likely of some Central or South American variety). But we have no sound recording of Rodia speaking Spanish to compare levels of fluency among the three languages he spoke, Italian, English, and Spanish. Although the full extent of his links to Hispanic culture remain largely unexplored[10] (*a fortiori* for his relationship with his own ethno-linguistic community, see note 17), they

must nonetheless have been significant since he was twice married to Mexican women;[11] preached in Spanish in a 1930s evangelical group, "The Cry of Christian Freedom"; and gave his Towers a Spanish name, *Nuestro Pueblo*. Rodia functions on the perimeters of so many languages, cultures, and places, however, that no one of these seems to contain him. Rodia himself is a hybrid.

A Peasant Worldview

Sabato Rodia's worldview was shaped by, and deeply rooted in, southern Italian peasant culture. He expressed well-worn ideas shared by many Italian peasants-turned-immigrants, keen observers, always ready to compare, debate (*ragionare*), and critique the merits of Italian vis-à-vis American society, politics, and the human condition. Rodia overcame the barrier of imperfect English to express his opinions with clarity and vehemence on a variety of topics, including the aged (that they should receive adequate pensions, be cared for by family, and not be left to die alone "like a dog" [*come un cane*], a horror for any Italian); thrift (Rodia was fond of stock-taking, reviewing and comparing precise quantities and rising costs of materials)[12] and the need to budget resources ("I no have anybody help me out. I was a poor man. Had to do a little at a time"; the quality of food (he purchased only good quality olive oil; he believed one could not trust bottled milk and that mothers should nurse their children);[13] and proper attire (men should wear hats). From the macro- to the microeconomy, Rodia held strong views on everything that touched the life of the working man. Working-class immigrant philosophers such as Rodia frequently commented on the overriding American obsession with money, unbridled consumerism, the increasing cost of living, and excessive taxation. He carefully monitored the evolving urban and rural landscapes around him, concerned with the effect the economic recession was having on the working man (e.g., he noted the number of stores and restaurants closing in Los Angeles or in Martinez, see Ashley-David and King interviews in Appendices A.10 and A.12). His egalitarian ideals nonetheless were accompanied by an inertial sense of social deference and lack of ease in the presence of those he perceived as socially superior (e.g., he declined sharing a meal in a San Francisco restaurant with his Committee for Simon Rodia's Towers in Watts hosts; would not take flowers from Nicholas King, because someone who "lived like a dog" did not need such niceties; and his dialogue contained frequent terms of social politesse: "dear lady" [*cara signora*] "kind sir" [*gentile signore*]). At the same time, he keenly felt the moral imperative to never betray his humble class of origin.[14] Many of his discourses were studded with small gems of wisdom and moral pronouncements ("God made man wrong") and practical advice on how to live one's life ("don't trust anyone, son"). The world as perceived by the aging Rodia was generally felt to be going to hell.

He held rigid ideas about gender roles ("Woman is a woman, a man is a man. Mother raise the children") and seemed especially fixated on the scourge of modern womanhood: Women who smoked, drank, wore makeup, and worked, in his opinion, provided a poor model for children.[15] He delighted in children (e.g., Appendix A.10, Ashley-David interview). He valued modesty and harbored a highly traditional ideal of womanhood (e.g., dutiful, loyal, long-suffering wives and nursing mothers). This rigidity likely contributed to his conflicted relationships with women.[16] On the other hand, he made a note to inform his interviewer Ashley-David that he cooked all his meals, cleaned, and mended

for himself—perhaps to impress on her what an unnatural thing this was for an elderly (Italian) man or, conversely, to underscore the fact of his utter autonomy vis-à-vis women. By this time, though, he must also have noticed with private regret that such a solitary life was also unnatural—especially for family-oriented Italians. As an old man facing his own demise, he seemed to yearn for some form of return to a mother's (or sister's) embrace—now both long gone (Appendix A.6, Segre Letter). Although he did return to family in Martinez, he eventually also returned to living alone in a boarding house, and he died in a convalescent home.

Contextualizing Rodia's Migration Experience

Rodia belonged to an early migratory flux (1880 to 1917) that brought waves of economic refugees to the Americas—many with direct experience of class oppression. Some came as political exiles and shared their ideologies with urban immigrant communities in places like New York, San Francisco, and Chicago. "[They] were the most proletarian-ized of any European nationality," when they arrived, and more than a few expressed socialist leanings: "[Italian immigrants] did not leave their vision of a radically-reordered society behind them," notes Italian American historian Phillip Cannistraro (Introduction to Cannistraro and Meyer 2003, on Italian radicalism). On the other hand, some (e.g., Nicola Sacco and Bartolomeo Vanzetti) "were radicalized by their experiences in the United States." Jews and Italians, as highly stigmatized ethnic groups, suffered the highest unemployment rates of any European group during the Great Depression. They also displayed the greatest degree of residential segregation of any foreign-born nationality.

It may be significant in this regard that in 1921, Rodia did not choose to live in an Italian enclave. Was this attributable to the so-called more tolerant social landscape of California? Or was Rodia by now something of an outsider even with respect to his own ethnic group? (Although Rodia must have had occasion to interact with local Italians in Los Angeles and Long Beach—if only to purchase olive oil and other Italian food staples.[17]) Instead, he purchased the future Towers site where there was no color line ("covenants" or exclusionary residential laws), in multiethnic "Watts Junction" (Pitt and Pitt 1997: 537), where African Americans, Japanese, Mexicans, Jews, Italians, Germans, Scots, and Greeks lived. Perhaps he felt most at ease among non-mainstream, working-class peers.[18] Or perhaps he knew it was a place where he would most likely be left alone to carry out his unusual project.

But the 1920s and 1930s were hard times for swarthy Italians (among others) in an America rife with prejudice and repression (e.g., the resurgence of the Ku Klux Klan circa 1915, the wrongful execution of Sacco and Vanzetti in 1927). The situation worsened with the outbreak of World War II and, after the attack on Pearl Harbor (December 7, 1942), culminated in internment and relocation camps for Japanese and Italians, as "enemy aliens" and co-belligerents (see Di Stasi 2001). During those war years, conspiracy theories enveloped the Watts Towers, too, imagined to harbor a signaling platform to covertly assist the enemy. Rodia was careful to propitiate those questioning his motives and remove any suspicion that his intentions were in any way un-American. When asked why he had built the Towers—perhaps abetting a discourse of American patriotism—Rodia spoke about wanting to do something for the "nice people" of the United States and of repaying

a debt. He may have been treading a fine line between deflecting hostile antiethnic American sentiments and expressing grateful relief at having been largely left in peace to do his work—even though acts of vandalism and theft did increasingly occur. (Patriotic rhetoric was later harnessed during the CSRTW's Campaign to Save the Watts Towers: Shouldn't the authorities applaud and support, rather than callously destroy, such heartfelt contributions of immigrants to American society? Indeed, this "Watts Towers as tribute to new country" theme became a leitmotif, echoed in the media.)

"A Natural Anarchist": Rodia's Political Ideology

Such were the times in which Italian immigrant Rodia lived and worked. And he had opinions about them. Indeed, according to his interlocutors, Rodia would harangue anyone who cared to listen (see Appendix A.1). His discourses included concepts of egalitarianism, class consciousness, and anticlericalism. According to fellow Serinese Colacurcio, the Rodias were a landowning peasant family[19] and "troublemakers" who opposed the Church (Appendix A.6, Segre Letter). Most likely, they were socialist and/ or anarchist sympathizers (with or without radical tendencies), although we do not know if they participated in organized action. Rodia appeared to be a "natural anarchist" (Appendix C.2, Byer interview), but while he likely derived many of his social and political ideas from his earliest years in Italy, his working-class consciousness was surely honed on U.S. soil, as a working family man and as a single, transient manual laborer with direct experience in the occupational settings where the labor movement was to fight its most bitter battles.[20] Rodia, for example, credited his brother, a Pennsylvania miner, for teaching him: "He tell me many things. From him I learn many, many things" (see Appendix A.3). I would venture that some of the "things" this miner taught his younger brother were political. A keen class consciousness and the rhetoric of workers versus powerful "bosses" (the American equivalent of the proverbial Italian *signori* [overlords] or *padroni* [landowners]) were also key points in the worldview and culture of the "hobo"—in which Rodia surely participated during his many years spent traveling the freight trains for free.[21]

Rodia persisted in expressing anticlerical tendencies and socialist political ideas in the United States. Much to his sister and brother-in-law's horror, he sang Italian anticlerical songs with friends in his Oakland home. Antichurch sentiments were (and still are) widespread among southern Italian men. In fact, Rodia reiterates some of the key points in this criticism, for example, the venality of priests, with their hand perpetually reaching out for donations, their laziness, and their complicity in the exploitation of workers (see "Hypocrisy," Appendix A.1). He was also keenly aware of the structural injustices in the class system ("We got three class of people all over the world. Millionaire class, media class, and poor class. Poor class of people all over the world, they no free"). After reflecting on the rising cost of living, low wages, and the impossibility of the worker's condition, Rodia wondered: "How do you feed your children? Tell me!?" (*I Build the Tower;* Landler and Byer 2006). He is also recorded talking about the betrayed ideals of the Constitution ("Thomas Jefferson, he write the Constitution in the United States and they don't use") and about race ("Abraham Lincoln, he want to free the colored people. They shot him on the back"; "Don't blame the colored people; blame the government"; Appendix A.12, Nicholas King interview).

Rodia's Song Culture

Rodia participated in a predominant component of traditional Italian expressive culture—its orality, as an ardent and opinionated debater of politics, as a raconteur, and as someone deeply attuned to music and song (he sang as he worked; he sang socially in his own home; he loved opera). Song was perhaps one of the most notable expressions of traditional peasant culture, integral to all parts of life, from lulling children to sleep, to working in the fields, serenading one's sweetheart, or accompanying the dead to their place of rest (Introduction to Del Giudice [1989] 1995), and Italian immigrants brought these songs to the United States, even though the retention of this cultural heritage proved uneven.

In Watts, we know Rodia listened to phonograph recordings, especially to great tenors such as Enrico Caruso, so popular among fellow Italians (and mainstream America: He was a star at the New York Metropolitan Opera), whose repertoire drew on operatic as well as Neapolitan song traditions. Opera, of course, had been a widely popular musical genre in Italy during and after Unification, partly as a vehicle for nationalist sentiment. Arias of grand opera, as well as a popular Neapolitan (immigrant) repertoire (replete with tearful farewells to one's native land and nostalgia for return: e.g., "Addio a Napoli"), were almost certainly known to Rodia. Rodia was likely familiar with songs from the Serino-based oral tradition and even sang a lullaby in an interview conducted late in his life, while recalling young children in his own extended family (see Appendix A.3).[22] Highly localized song traditions were not generally sustainable nor were they shareable outside a group of fellow Campanians. Opera instead, with its broader appeal, could be blared from Rodia's gramophone. Indeed, it was a skipping record (and lights that remained on for three full days) that alerted his eighteen-year-old neighbor, "Mexican girl, Marguerite," that something was amiss. When she checked in on him, she discovered Rodia unconscious, having suffered a stroke (see *I Build the Tower;* Landler and Byer, 2006).

In his testimony, Colacurcio (patently wanting to discredit the Rodias as violent rabble-rousers[23]) informs us of Sam Rodia's earlier repertoire of anticlerical, anarchist songs:

> All the time, night after night, Sam he sits in the kitchen with his gang and they sing
> anarchist songs. They sing terrible songs and they laugh and say bad things about
> the church and about mother and God and they make a racket all the night. My wife
> [Angelina, Rodia's sister] she cry and feel bad. I feel bad. Sam he betray the church, all
> the time, all his life, he betray God. (Appendix A.6)

Rodia either learned those songs in America[24] or in Serino, where they might have been shared at political rallies or in a village tavern. We wonder who his fellow Italian sympathizers in Oakland might have been (see Sensi Isolani 2003) and which of these songs he might have known. Of the fourteen anticlerical anarchist songs dating from the Unification to World War I (1870–1914) in the archival source "Il Deposito: Canti di protesta politica e sociale: Archivio di testi, accordi, e musica" (The Warehouse: Songs of political and social protest: Archive of songs, song sheets, music www.ildeposito.org), we find several candidates. Some explicitly denounce the Church; others deride its clergy; a few incite violence: for example, "Bruceremo le chiese" (We'll burn down the churches);[25] "I 365 primi maggio dei preti" (The 365 May days of priests); "Non esiste Gesù" (Christ doesn't exist); "Quando che more un prete" (When a priest dies); and "Si chiama Papa" (They call him Pope). We can only surmise that Rodia was familiar with songs in a similar vein or

at least with this better known of *stornelli* (found in Leftist song tradition to this day) with the refrain:

E quando muoio io non voglio preti,	(And when I die I want no priests,
non voglio avemarie nè paternostri,	want no "Hail Marys" nor "Paternosters,"
non voglio avemarie nè paternostri	want no "Hail Marys" nor "Paternosters,
ma la bandiera rossa dei socialisti.	but [only] the red flag of the Socialists.)
(from "Nuovi stornelli socialisti")	

"The Church of True Freedom"

Despite his traditional anticlericalism, Rodia nonetheless had his own "religious" notions. His participation in a theology or religion of "True Freedom," and his radical political ideas appear to be noncontradictory, even mutually enforcing. We infer his to be a left-leaning progressive reiteration of Christianity, expressed in the idea that "Cristo fu il primo socialista" (Christ was the first socialist; see note 25) and a vehicle of social upheaval and radical realignment (i.e., where the "last shall be first"). He seems to have experimented with varieties of nonmainstream (evangelical) Christianity. Indeed, alternative, protestant Christianities may have naturally appealed to an anti-Catholic Italian such as Rodia.[26] The "Church of True Freedom" may even have provided a vehicle for his expression of his spiritual and social ideals in a language (Spanish) he could more easily manage, for a community with which he shared an immigrant's experience of America.

Rodia was not hostile to the values of Christianity nor to God ("If you no believe in a God that's another thing. . . . I no say we ain't got any God, I can't prove it. But I'm no against a God, I told you before"; Appendix A.4), but he was definitely antiestablishment in that he disliked the institution of the Roman Catholic Church and detested its priests. As a sermonizer himself albeit of the freewheeling, tent-revival variety, see handbill with the title of Rodia's sermon, "True Freedom: Freedom of Spirit and Soul" in *I Build the Tower* Landler and Byer 2006),[27] Rodia was a man of contradictions (or perhaps evolutions). He was conversant with the Bible, or at least the Bible in oral tradition, frequently referring to it (e.g., "Christ was a Jew. That's in the Bible"). He also seems to have included (or alluded) to Christianizing symbolism in the Towers (e.g., the sheaves of wheat and vines, perhaps a representation of Eucharistic bread and wine. On his deathbed, he made his confession and took communion. Four Catholic prayer cards commemorate Rodia's funeral.[28] His connection with "organized religion," though, seems to have been fluid and short-lived, perhaps because the Towers themselves became his more compelling and truer "church." His path toward (spiritual) freedom through the soul work of manual labor and artistic self-expression likely allowed him to directly experience and thereby achieve true freedom.

The "Great Men" Narrative

Opera was the music of epic emotions, and "Great Men" fed a similar aggrandizing historic narrative among Italian immigrants. The grand and the monumental appealed to Rodia, too—in building style, in musical genre, and in historic discourse. He was especially fascinated by Great Civilizations and Great Men and was conscious of belonging to a civilization of antiquity and stature. He spoke of the ancient Romans ("Civilization,"

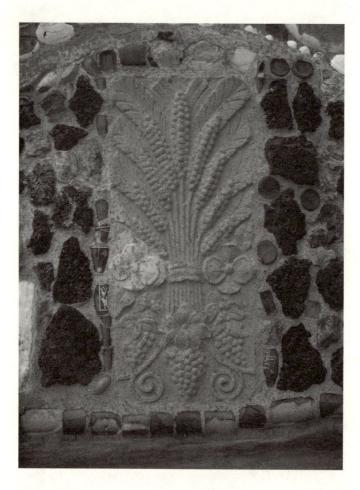

Vine and wheat, detail Watts Towers, perhaps a Christian symbol of the Eucharist.

Appendix A.1), of Christopher Columbus, Giovanni Cabotto (John Cabot), Marco Polo, and Galileo Galilei (another visionary linked to a tower—the Tower of Pisa). Perhaps Rodia was exposed to the "Great Men" rhetoric of his nation's history as it was promoted by Mussolini (with his Fascist grand Romanist schemes) and targeted at Italian communities abroad.

He seemed particularly fond of martyred heroes, those misunderstood and shackled men who held true to some cultural or scientific truth but who were persecuted by cultural "bosses" (such as the Catholic Church). He even invented a narrative of decapitation for Galileo: "Galileo Galileo [*sic*], he said the earth movin'. . . . they cut 'em the neck off"; in contrast, "Christopher Columbus, he die with a chain on the leg, a chain on the arm." We must remember that as he shared these reflections with interviewers, Rodia was often himself literally shackled to his bed by the nursing staff of his Martinez convalescent home; hence, this story might have been particularly poignant (see Appendix A.9, "Last Conversation," Jeanne Morgan). He even constructed a tower lineage that connected

his Towers in Watts with the Tower of Pisa and to Galileo (to whom he attributed construction of the Pisan monument). We can infer that Rodia envisioned his own life and work to be contained within such a tradition.

The Great Men rhetoric proved a boon to any beleaguered immigrant needing to validate himself by sharing the part of his cultural heritage that was so incontrovertibly great (Del Giudice 1994). Rodia reviewed the grand sweep of civilizations, comparing, contrasting, and tallying the relative merits of the Egyptians, the Chinese, and the ancient Romans[29] ("Civilizations," Appendix A.1, Hale-Wisniewsky interview with Rodia). In the grand tally of great men, Rodia could note, for instance, that among the millions of American citizens (many of whom were from foreign lands—but "they don't want to tell us that"),[30] the United States at that time could count only three (George Washington, Abraham Lincoln, and Thomas Jefferson); while other civilizations (his own, for example) counted many more.

To my mind, a more nuanced exploration of the name Rodia assigned to the Towers may also be informed by the "Great Civilizations" narrative. Let us consider how Rodia may suggest that "Nuestro Pueblo" represents more than just a village or town but perhaps an entire people—the Italians. First, we note a linguistic curiosity: Rodia refers to his assemblage of obelisks and other structures in the singular, "I build *the* tower," as if a lone tower-as-symbol bears a special significance in his psyche. We note other linguistic ambiguities in "Nuestro Pueblo" both with regard to adjective (*nuestro*) and noun (*pueblo*). It is not entirely clear whom to include in the possessive adjective *nuestro*, nor to which meaning of *pueblo* he refers ("village/town" or "people"). Given Rodia's linguistic hybridity, some linguistic interference from the Italian "nostro popolo" (or "our people"; cf. *nostra gente*) could have played some role therein. Further, does *nuestro* refer to Rodia's immediate (Watts) or more distant (Italian) collective? In other words, might *Nuestro Pueblo* refer to "our/my Italian town," and/or "we Italians" rather than to "our Watts/Los Angeles"? Further, if the Towers do indeed represent an act of Italian cultural remembrance (as many maintain), then metonymically "the tower" may represent something larger than the geographically local "village" (Watts), an entity more intangible and remote (a "people," a "heritage")—not unlikely, given Rodia's keen interest in comparative grand narratives, civilizations, and peoples (*popoli*). Rodia's very decision to build *towers* (or *a tower*)—the ultimate symbolic architectural representation of Italy and an expression of Italian localism (see the discussion of *campanilismo* below)—is highly significant in this regard.

Why did he use the Spanish? It was more widely understood. And perhaps to create some verbal echo with a better known Los Angeles "pueblo" at the heart of the city. I suggest that the Watts Towers were to be considered in a distant dialogue with "El Pueblo de Los Angeles"—although we cannot know precisely what relationship Rodia may have envisioned between Nuestro Pueblo in Watts and El Pueblo de Los Angeles Historic Monument in downtown Los Angeles (the historic nucleus of the city, developed during the 1930s as a romantic reinvention of a Mexican village). We note that Italians, too, had had a long commercial and social presence there (e.g., Italian Hall). Rodia was well acquainted with the area, specifically mentioning Main Street and N. Broadway, and even suggested that the "pueblo" inspired his naming of the Towers.[31] Could his Towers be a response to *El* Pueblo, "the" representation of the city's historic core with a more inclusive (and decentered) immigrant's ("our") representation of the city? After considering

these many threads woven into its name, we must seriously conclude that Nuestro Pueblo may be a symbolic representation of his Italianness as well as a reflection on the city's identity (i.e., a representation of "our people" [*nostro popolo*], or Italians; and of "our town" [*nuestro pueblo*], or OUR Los Angeles).

Rodia's aim was to do something great in order to be remembered. He knew one had to be extraordinarily bad or extraordinarily good ("good, good, good or bad, bad, bad") to leave one's mark on the world. He decided to turn away from a life of "bad" to lead a life of "good," to transform it by achieving his own act of greatness: "I had in my mind to do something big and I did it." As "something big," the Towers were indeed meant to be seen and admired (see Harrison's and Sciorra's essays in this volume) and to affirm his historic presence in the world through an artistic legacy.[32] He even signed and dated his work, marking his name and place in time.

Experts in the field of art environments, such as Seymour Rosen, corroborate that such endeavors typically represent "extemporaneous individual acts of people declaring their existence" (SPACES brochure, UCLA Library Special Collections No. 1388), thereby rescuing themselves from anonymity. Ernesto de Martino, an Italian anthropologist, identified the many ritual practices of southern Italian peasants (e.g., funeral laments, magic, tarantism) as a response of the disenfranchised to a psychological *crisi di presenza* (crisis of presence)—the ever-present danger of invisibility, noncommunicability, and alienation. The existential need to be seen and to be (re)integrated into community, one might add, seems especially critical to migrants (as outsiders). In fact, Rodia seems interested in some form of integration, of embracing (and, to some degree, being embraced by) the collective (i.e., *Nuestro* Pueblo)—despite the wall he built around his structures. I believe Rodia struggled with the opposing pulls of American individualism (the lone artistic genius) and an Italian's strong collective identity throughout his life, embodying this unresolved contradiction until the end.

His plan of creating or representing community may have gone awry. As the neighborhood changed and as Rodia aged, he appears to have felt increasingly alienated and even threatened by his neighbors.[33] Post–World War II Watts was, by all accounts, changing, as rising unemployment and crime transformed the relatively quiet and semirural community to which he had moved in the early 1920s. His stroke (in 1954) also may have contributed to his sense of isolation and vulnerability (as it took three days for his neighbors to even notice that something was wrong). Finally, he was convinced that he must leave his three-decades-long beautiful obsession behind and move on. His project was complete enough. And as he admitted to his friend Pete Teti, he was tired and ready to return to family.

During the final half decade of his life, as the stream of visitors became steadier, all incessantly asking him why he had built the Towers and why he had left them behind, Rodia asserted that "people were different then" (as they frequently seem to be from an elder's perspective) and that mores had changed for the worse. Rodia's mood was dark. But he was taken to task for this social pessimism: "there were good people then, there are good people now" (Appendix A.10, Ashley-David interview). (By way of contrast, during these same years, the younger [and sunnier] Leo Politi [1910–1996; see Stalcup 2004] was painting an idealized, pre-1965 street scene around the Watts Towers: a happy and tranquil place with black children riding bicycles and playing around them; see Introduction, this volume.) But by then, Rodia was recalling the Towers from afar, tinged with a deep

sadness, as something deeply cherished and now gone: "If your mother's died and you have loved her very much, maybe you don't want to speak of her" (p.); "I give my heart, break my heart down there" (Appendix C.1, interview with Jeanne Morgan). He desired neither to evoke painful memories nor to return to a closed chapter of his life ("I'm done with that, 'scusa me!"). What the precise source of that pain was, he never fully articulated. But the project that had literally rooted and inspired him for the largest portion of life was now a memory. The gas station attendant in Martinez observed of Rodia, who wandered the streets and along the railways of town, day after day: "I think he's the lonesomest man in town." Yet Rodia merely continued to do what he had done all his life: wander. As a fundamentally restless soul, he had strayed from the well-trodden path of family and community to find work, new adventure, and freedom. And during his years of tower construction, he had spent hours walking in search of usable (free) treasure.[34] It may have been natural that in his old age he continued to spend entire days walking—perhaps as a continuing expression of the immigrant's abiding sense of rootlessness.

Rodia, though, ended his days also knowing that he had achieved greatness in his own lifetime, that his name had been added to the list of Great Men. A year before his death in 1964, with a smile on his face, he bowed before a standing ovation of an audience at the University of California, Berkeley. Perhaps more important, according to Nicholas King (*I Build the Tower*; Landler and Byer 2006), he had achieved status among his peers (e.g., the railway station captain, the nursing staff). Such signs of approval must have partly healed his sad heart vis-à-vis the Towers.

Italian Imaginaries and Forms of Popular Devotion

Having considered Rodia's various personal and historic life experiences, I turn in the second half of this essay to an iconographic ethnography of the Watts Towers, exploring elements of an Italian imaginary (motifs and images—some of which Rodia may not have been consciously aware, nor which he verbally articulated) discernible in the Watts Towers themselves, as well as cultural practices of devotion. My few offerings focus on bell towers, ships, treasure, and cultural practices that suggest forms and attitudes of Italian popular devotion—even though the Towers do not present the iconography typical of that tradition (i.e., saint's niches, yard shrines, *presepi*)[35]—although Rodia did produce them elsewhere.[36] Perhaps he deemed such forms too referentially narrow for this grander visual narrative, choosing instead more universally communicative motifs (ships, towers, hearts) that could stir admiration and wonder across ethnic, social, religious, or geographic boundaries. Despite such conspicuous iconographic absences, however, the entire paved complex may be considered to be a large-scale yard shrine. He transformed his entire adjacent environment into an expression of secular and sacred space.

Italian Imaginaries: Patron Saint's Days, the *Gigli* of Nola,[37] and Street Festivals

While Rodia's iconography may not overtly recall Italian religious tradition, the Towers nonetheless display features of devotional practice and symbols (e.g., votive hearts, Eucharistic vine and wheat) that powerfully recall such a cultural matrix—aspects of which we consider here.

A grave marker in the form of a cross, with vase and heart, made approximately in 1924, for an Italian neighbor who had died in a car accident.

What the *onomastico* (or "name day") is to the individual, the patron saint's feast day is to the village. In peasant village life, the *festa* or *sagra* represented the ultimate expression of community celebration. Just as medieval guilds and lay confraternities organized patron saint day celebrations, Italians continued to do so even in diaspora contexts. One of the first and most common forms of association among immigrants were mutual aid societies, whose express goal was also replicating the patron saint feast day of their towns of origin.[38] These have been, for over a century, the most highly visible form of cultural expressivity for Italians in the United States, such as, for example, the feast of the *Gigli* of Nola, replicated in the *Giglio* festival of New York.

The first scholars to have posited a cultural link or lineage between the *Gigli* of Nola (a town situated only about 44.5 kilometers or 27 miles from Sabato Rodia's birthplace of Rivottoli di Serino, by its most direct route) and the Watts Towers were Daniel Ward (1984) and later Ward and Posen (1985). Their highly original proposal nonetheless still calls forth skepticism: Had Rodia ever seen the *Gigli*? If he had, why had he never mentioned them? Is this evidence even meaningful to an understanding of the Towers? The cultural links between *Giglio* and tower (see essays by Sciorra, Ballacchino, and Ceparano in this volume) included the custom of *Giglio* construction next to the home of the *maestro di festa* (the master of the feast) in honor of his patronage and physical similari-

Detail of grave marker with delicate shell inlay.

ties (decorated "open" frame, use of recycled materials,[39] built from the bottom up, a frame on which decorative elements are placed, embedded objects for the Towers, papier-mâché for *Gigli*, and their similar relative height: 82-feet *Giglio* versus 66- to 99.5-feet towers). There are many more cultural and geographic considerations to support the hypothesis. Given that the *Gigli* have been one of the most spectacular and widely known celebrations of the entire region, it seems unlikely that Rodia had not seen the *Giglio* festival or had not seen them in other Campanian towns where *Gigli* were also danced through the streets.[40]

But to my mind, the most compelling evidence that Rodia had in fact seen or known of the *Gigli* is the strange and unique juxtaposition of obelisks and ship: Saint Paulinus's ship in the case of Nola, the ship of Marco Polo in the Watts Towers. I suggest further that Rodia may even have learned of, or had seen, Nolan *Gigli* in a diaspora context from fellow Campanians. As a fairly well-traveled migrant laborer, part of that late-nineteenth-century massive flux that half-emptied the Region, it is likely Rodia met many other Campanians (including Serinesi and Nolani) along the way. A commonality of dialect and custom and a network of *paesani* likely linked these regional immigrants. And *Gigli* migrated with Nolans wherever they went. They soon began re-creating large-scale *Gigli* in New York as early as 1903. They even marked the feast while in POW camps.[41]

Rodia may have encountered images of *Gigli* on broadsides, postcards, and objects of memorabilia or heard oral descriptions of the festivity—in a narrative likely beginning

with "where I come from" (*nel mio paese*). Several late nineteenth- and twentieth-century Nolan broadsides (*fogli volanti*) of the "penny press" variety (a staple of itinerant performers at village markets) may have been purchased in Nola and found their way back to Serino via market route. Or they may have been carried to wherever in the diaspora Nolans (and other Campanians) emigrated, as a precious souvenir of the beloved feast. Indeed, a reproduction of such a broadside prominently hangs in the American-Nolan *Giglio* Boys' Club in Nola. A similar case may be made for postcards of the *Gigli*, already being mass-produced at the end of the nineteenth century ("Storia e diffusione della cartolina tra i Gigli di Nola" 2010).

Any such sources might have been available to Rodia prior to 1921, when he began to build. Can we make a conclusive case for the *Giglio*–Tower connection? There are no definitive answers to these questions: only the high probability that physical echoes, geographic proximities, as well as historic and cultural synchronicities, corroborate the likelihood that Rodia had seen the *Gigli* of Nola in person or had learned of them via oral or visual tradition. In the final analysis, we can bring only circumstantial evidence to bear on the issue because Rodia himself never spoke of the matter (perhaps because none of his interlocutors would have known what he was talking about).[42] Given the strong probability that Rodia did know of the *Gigli*, the more compelling question becomes: What are the deeper implications of this iconic echo? How does the feast of obelisks inform Rodia's Towers?

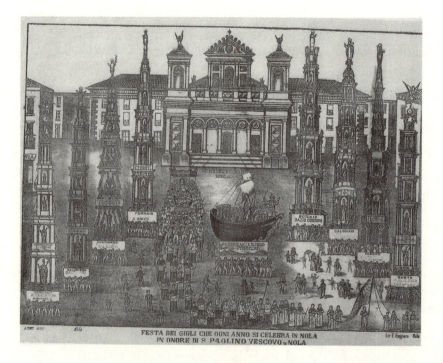

*A popular broadside (*foglio volante*) found in the National Ethnographic Museum in Rome (MNATP) and printed in Nola (1900).*

Among the many names the Watts Towers have acquired over the decades, one of the more felicitous is that of "Jazz Cathedral" (Don DeLillo, in his novel, *Underworld*). The Italian American writer here beautifully captures both the play of improvisational solo riffs made by jazz musicians and Rodia's process of art making, while noting something of the sacred symmetries of its structure (cathedral), all resonating within the African American cultural context in which the Watts Towers came to such prominence. That is, DeLillo used an African American musical genre to capture an essence of the art work and thereby define it. Were we to consider instead inherently Italian cultural resonances within the structures, we might also be persuaded to look at the Watts Towers as a form of public celebration, a village street festival. That is, not only do the Watts Towers recall the *Gigli* festival tradition (here in a fixed and permanent rather than danced permutation), they display an attitude of festive community celebration. Rodia's village reference is found in their very name: *Nuestro Pueblo*. Some have considered the entire complex to itself represent a microcosm of a "village," with public square, streets, fountain, bell tower, and so forth (see Whiteson 1989: 25ff).[43] Significantly, in the Landler and Byer (2006) film, we see Rodia as a sort of "master of the feast," with open arms inviting all to enter and enjoy: "I build the tower. People like. Everybody come." Rodia is throwing a street party (an ongoing state of celebration), and everyone is invited to join in. He appears, in fact, to be expressing a deeply embedded value of hospitality (perhaps expressing a gesture he might have wished for himself) as well as the spirit of the *festa* (a festive impulse) widespread among Italian immigrants.[44] As Morgan (1984) noted, Rodia created his artwork because he needed to express himself through art but also as a generous gift to the community.

ACTS OF DEVOTION, REDEMPTION, GRATITUDE: THE *EX-VOTO*

Rodia had lost his way in life: He had lost his family (through his own "failure to provide"; Landler and Byer 2006), had divorced, had faced the death of a young daughter, Bel (while his other children ended up in a relief home), and had became an alcoholic. He appears to have inherited a legacy of family brokenness: He did not have much affection for his own father, who sent him away to America ("I have no father," he said). He repudiated his own children ("I have no sons"). At Rodia's funeral, they, in turn, would say: "we are his sons, but he was not our father" (Seymour Rosen, quoted in *I Build the Tower;* Landler and Byer 2006). The diametrically opposed brothers-in-law ("the bourgeois and the rebel artist," according to Segre, Appendix A.6), Sam and Saverio, hated each other—or perhaps the symbol of each another. Colacurcio represented the *paterfamilias* to the extreme: a "work-till-you-drop," self-reliant, old-style patriarch, dutifully providing for his large family, tending to property, and never missing a day of work in forty years ("this guy was the real deal!"; Appendix A.13, Byer interview). According to Byer (Colacurcio's grandson), Rodia hated his brother-in-law because he had turned Rodia's beloved sister, Angiolina, into a "brood mare" (she produced seventeen children). Conversely, Colacurcio shunned Rodia because he had turned his back on his manly duty to raise a proper family and had instead dedicated his shiftless life to a "good for nothing" artistic folly. (Especially galling was the charismatic artist's[45] increasing fame: "that was really hard for him [Saverio]"; Appendix A.13, Byer interview). Rodia did not conform to Colacurcio's (normative) immigrant narrative. He left an enduring legacy of heated family debate around the question of whether he was a genius or a bum, "splitting the family down the middle."

The grave of Angiolina Rodia Colacurcio, Sam's beloved sister, next to his at Saint Catherine of Siena Cemetery, Martinez, California.

Rodia expressed remorse—"we all make mistakes"—and referred to himself as "a bad man of the United States." What buried shame might Rodia have experienced as an Italian man for whom care of family was the ultimate duty (Sciorra, this volume)?[46] He proved to be a man of extremes, even contradictions, and a Manichean in his moral judgments, stating that in life one must be "good, good, good or bad, bad, bad" (subtext: in order to be remembered). He had been both: a wastrel and a drunk who turned his life into an ascetic and aesthetic pursuit, one filled with creativity and beauty. The Towers are a perfect metaphor for his own life. As a locus of transformation and self-healing (Sciorra, this volume; and Wojcik) Rodia achieved in the Towers something beautiful from broken and discarded things. How could he express his deepest gratitude for this blessing? He filled his Towers with hearts, brilliant colors, achieving breathtaking heights. They are an expression of love, joy, and gratitude, which merge the beautiful with the good.

I don't believe Rodia's anticlericalism precluded deeply embedded cultural modes of relating to the sacred. Although Rodia never spoke of his own acts of devotion, the psychological dynamics informing specific Italian devotional practices of petition, of grati-

tude, suggest that the Towers, too, could be considered a form of *ex-voto* in the broadest sense—as a form of kataphatic (or manifested) prayer. His hearts are a symbol of love and longing in both secular and sacred tradition—as well as a common icon for the *ex-voto* in Italian and Mexican folk Catholic iconography. The Towers may represent an expression of gratitude for a "grace received" (*per grazia ricevuta*). Such acts of devotion frequently required the personal expenditure of great physical and financial resources and produced objects of beauty, from paintings on metal or wood (see Briscese and Sciorra 2012, to yard shrines and *presepi* (see Sciorra 2015) and even food altars (Del Giudice 2009a). Rodia, too, pursued his soulful artwork, using his own earnings and the strength of his own arms, and with unwavering creative spirit, alone over three long decades, he completed his opus. His was indeed an extraordinary feat of devotion—as well as a manifestation and celebration of the creative life force and of the true (spiritual) freedom he had sought (and found) in the very process of building the Towers. In at least one photo, Rodia literally "towers above," suspended by his slender window-washer's belt, commanding a vista from the top of the world. From such heights, he likely tasted that soaring sense of freedom and triumph.

Yet for all the exuberant life and color in the Towers, at its foundation is something of death or death defeated. Rodia was once quoted as saying that he literally "buried the bottle" in the Towers ("I wouldn't drink if you paid me a hundred dollars"). Many broken bottles, of course, form an integral part of this artwork—although none originally containing alcohol. Yet if a sonar scan were taken of the Towers' foundation, I would not be surprised if a wine or whiskey bottle were to be found buried there, like some foundational relic in this open air "cathedral" (cf. saints' bones vis-à-vis ecclesiastic buildings). Rodia once stated that he himself wanted to be buried at the Towers. Were the Towers therefore also to have been envisioned as a mausoleum or monument to his own life?[47] In some symbolic sense, Rodia is immured in those structures,[48] for he poured his life (earnings, energy, and time) into his work, as though it were cement.

The Towers represent an apotheosis of sorts—of objects, images, and memories. Each seems to acquire a transcendent metaphorical second life: For example, the ship is not only an Italian explorer's vessel but a synthesis of personal, cultural, and spiritual journeys. A fountain may be a bird bath, a village fountain, or it may represent a baptismal font flowing with the waters of life. Hearts may be those of romantic, communal, or sacred love. His many ovens may recall his mother's kitchen or home fires or evoke ancestral *lares*. The Towers embody topographies of Rodia's physical, emotional, and cultural worlds and present a dense forest of symbols (or "signs" according to Harris, this volume). They embrace domestic and public spaces (intimately known in his youth and evidently still with him) as well as idealized fertile landscapes filled with flora and fauna.[49] The second half of this essay seeks to explore Rodia's intimate iconography, through historic and ethnographic exegeses of a few significant topoi in his monumental work. Let us begin with the most immediate: towers.

BELL TOWERS, OBELISKS, AND *CAMPANILISMO*

The bell tower dominated the Italian village landscape and hence also towered in the popular imaginary. Towers were ubiquitous in the form of church bell towers or fortified castle towers. They were built big for military defense, for religious aspiration, or as a

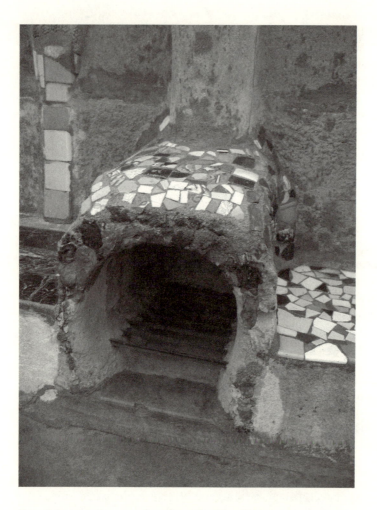

One of the several ovens or hearths at the Watts Towers.

statement of secular power and social dominance. Those who built them—but especially those who lived in their shadows—defined themselves and their collective identity in relation to adjacent towers. Consequently, the term *campanilismo* (literally "belltower-ism") is the concept by which Italians designate a local sense of place (i.e., close association with one's bell tower and thence toward a progressively pejorative connotation of "provincialism" or "parochialism"). Hailing largely from such rural villages, it is not surprising therefore that immigrants continued to seek shelter in the shadow of remembered bell towers. A fierce sense of localism, transferred directly to the Italian American diaspora, persisted for generations beyond the first. (Nolani literally carried and reproduced their obelisks wherever they went.) The Watts Towers, by definition, may be framed by this strongly embedded cultural tendency. As an Italian, when Rodia decided to build "something big," it is natural that he might have turned to constructing towers. For Rodia, too, towers and village sentiment and representation (i.e., *pueblo*, town) went hand in hand.

Interestingly enough, so dominant is this allegiance to the local bell tower that Serinesi even today assume that it was their own *campanile* in Rivottoli that inspired their compatriot Rodia to construct his Towers in Watts—despite the evident lack of resemblance between the two (one rectangular, the other tapered). Conversely, they almost uniformly disavow any possibility of Rodia having visited the *Gigli* in Nola—despite their uncanny resemblance to his Towers. (Serinesi also attribute his affection for steel—"I'm a steel man"—to his local heritage).[50]

Treasure

The concept of treasure is another identifiable generative motif in Rodia's artwork (and one especially poignant to immigrants). American streets were rumored to be "paved with gold," as every aspiring Italian emigrant seeking fortune in the Americas knew. Indeed, the Watts Towers might be viewed as a visual pun on (or embodiment of) this myth. Rodia collected treasure on the streets, along railway tracks, and by the oceanside and from these created his masterwork. Indeed, Rodia demonstrated how even the mundane could be spun into gold. "One man's trash is another man's treasure." In the Watts Towers, trash and treasure are one and the same. Furthermore, once abandoned by Rodia, the Towers themselves (as other archaeological sites attest: Del Giudice 2006) became the site of treasure hunts. As they entered into the oral narrative process, the Towers in turn became the subject of treasure tales, in a curious circular trajectory. Purported to contain buried treasure, alas, parts of the Towers were smashed by neighborhood youth in their attempts to find it. On the other hand, such recycled folk narrative motifs sometimes come to coincide with the facts, for it was later revealed (or is this too part of legend?) that Rodia had hidden cash under a brick in one of his ovens—in his peasant-derived, pre-banking ways.[51]

Ships

Rodia builds a ship alongside his towers. Outterbridge (in *I Build the Tower;* Landler and Byer 2006) maintains that the entire triangular Watts Towers campus represents a ship headed eastward and that the Towers stand as its many masts. Ships evoke journeys of various historic and mythic moment. In Italian popular imagination, and in Rodia's, ships conjure up explorers, many of whom were indeed Italian.[52] In Rodia's panoply of historic and mythic seafaring Italians sailing to unknown lands, we find Christopher Columbus, Marco Polo, Giovanni Cabotto (John Cabot), and Amerigo Vespucci. For Italian immigrants, ships recall Colombus's great three-masted ships sailing to America as well as lived personal experience.

For immigrants, this journeying to far-flung continents represented a search for modest riches (*cercar* or *cattar fortuna, fare l'America*), a decent life, a safe haven, and perhaps a place of belonging (Del Giudice 2009a). Italy had made socioeconomic refugees and exiles of millions of citizens. Many had undertaken such voyages with bitterness, vowing never to return. As late as the 1960s, immigrants have ships' tales to tell: of interminable, difficult, crowded voyages fraught with hope and fear, ending in various ports on several continents. Sometimes tales of shipwreck are told by kin or sung in songs, as warnings of the dangers of migration (e.g., "E da Genova il Sirio partiva" or "Mamma, dammi cento lire"). Although Rodia, to some extent, placed himself within a historical narrative of adventurers and rule breakers, he also felt he had been unjustly launched on

those seas, and he reproached his parents for this enforced journey: "I no need to come in America. That's my mother's, my father's fault." He had been ripped away from home through an emigration imposed by his parents. Rodia's trauma of displacement at such a young age was surely a key factor in his continuing experience of living outside the boundaries of family, social conventions, and art (Dal Lago and Giordano refer to Rodia's state of being as "out of frame").

For Rodia, there were also ships closer at hand, the fishing boats of fellow Italians who dominated the Southern California fishing industry, which in San Pedro included fishermen from the island of Ischia (co-regionals from Campania; Del Giudice 2007), as well as from Palermo (especially Trappeto), Sicily. He had surely seen these in Los Angeles's port city or in Long Beach, where he had lived and to which he returned by commuter train or walked, to gather seashells. Traditional fishermen's festivals with decorated purse seiners were a major public celebration in pre- and postwar Italian Southern California.

And of course, there is Saint Paulinus's Nolan ship, commemorating the bishop's safe return from captivity in foreign lands, greeted by grateful Nolani at the seashore with lilies (*gigli*) in hand. What other nuanced meanings might this (figurative) ship add to our understanding of the Watts Towers? To which ship—sacred or profane, historical or fantastic—does Rodia's ship allude?[53] An immigrant's ocean liner? An early explorer's masted ship? A triumphant Nolan's vessel of return and embrace? Or a "ship of fools," a

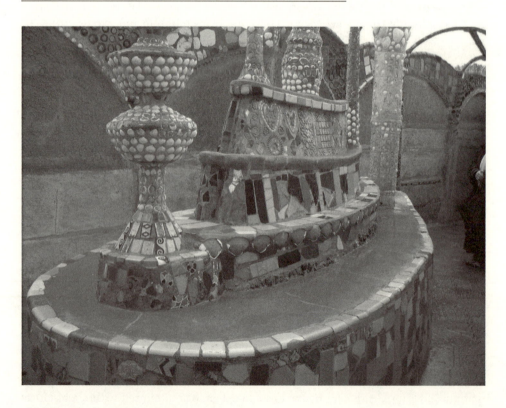

The "Ship of Marco Polo" at the Watts Towers.

dreamer's artistic folly: "'What is he doin'?' Some of the people, they thinkin' I was crazy" (as quoted in *I Build the Tower*; Landler and Byer 2006)? Was this the ultimate journey of a wandering man, homeward bound? It seems inconceivable that Rodia was immune to the pangs of longing, typically acute as immigrants age, as they reflect on the life journey and remember affections and landscapes long past.

Conclusion

The Watts Towers are a site of stirring beauty and spiritual transcendence—something of a wayfarer's chapel, lacy and open to sky, with sunlight casting through brightly colored stained-glass (bottle) work. Here the artist created a contemplative setting. We recognize Rodia's deeply soulful Towers as visionary art. They are full of imagery that speaks to the spirit: a seafaring voyage of the soul, the spirit's soaring to towering heights, geometric symmetries of divine order, nature's creation in flora and fauna, hearts of divine love. Rodia transformed the ordinary into the transcendent, and the culturally specific (e.g., Italian festive apparatus, bell towers, and ships) into the universally accessible. Many intuit this to be sacred space. And some witness to this: "the Watts Towers are my church" (Paul Harris in McNamara 2005); "they are my cathedral" (Zuleyma Aguirre, former conservator, in Catania 2005; cf. DeLillo's "Jazz Cathedral"); "It's such a spiritual experience just walking around . . . coming to work and looking at those Towers every day" (Rosie Lee Hooks, Appendix C.4). Davis and Rauner (2006) specifically place them in a sacred and visionary landscape of California. It is not an accident that baptisms, weddings, and other life-cycle celebrations have been ritualized here over the years. The Towers have indeed become both a sacred and "secular pilgrimage site" (see Margry 2008) to those initiated in the cult of Sam Rodia ("He was their god!" says Nick King in *I Build the Tower*; Landler and Byer 2006).[54] But they may represent yet another sort of pilgrimage site for Italians and for others who have experienced migration at a close remove—as a site of collective commemoration.

Let us consider the many historic sites of collective human suffering (e.g., the slave emporia of Ghana for African Americans; the Holocaust camps of death for Jews), sites where so much suffering began or horrifically ended, most with little redeeming sense of transcendence, only numbing sorrow. It is unlikely that any African American can visit such a place as a Middle Passage slave site and not have a personal response of revulsion. I suggest that migration sites such as the Watts Towers might also evoke (obviously, to a far lesser degree) unsettling emotional responses for migrants, as they remember struggles in their own personal and family histories, some little known and others perhaps long buried. Such sites help shake us from the stupor of cultural amnesia or denial induced by standardized "immigrant makes good" narratives.

According to Tower tour guides, Italian visitors not infrequently have an intensely emotional response to the site and to the Watts Towers narrative: They cry. I surmise that for others, like me, in the Watts Towers we are confronted with the raw truth of historic suffering: Immigration for so many was a traumatic event of forced displacement, alienation, and sometimes personal tragedy. By no means did all immigrants achieve the elusive American Dream. Some discovered that it was flawed; that it was not always lavish in its rewards or equally accessible to all; and that hearts, families, and communities could be broken struggling to achieve it. ("How many tears this America has cost us . . . how

bitter is this bread," to cite but one song in the immigrant's repertoire.[55]) Frequently, it simply cost too much. Some became loners and drifters, unable to properly fit in. Others became workaholics feverishly working until their dying breath (or they returned to Italy). The exceptional, calling on deep inner resources, cultural memory, and manual skills (both old and newly acquired), not only overcame suffering but somehow prevailed, expressing the best of themselves in rare, magnificent works of art dazzling the world with their gifts. Sabato Rodia was all of these.

Even for the casual tourist, art student, or seeker after curiosities, the Watts Towers have the potential to tell critical parts of our repeating human history of local and global migrations, of transience and permanence, of redemption and transcendence, of exclusion and belonging—above and beyond Sabato Rodia's artistic genius and the hard work embedded therein.

But we cannot fully appreciate the heights of this achievement, the depths of his longing, or all he wished to communicate through this singular work of art, without first intimately understanding the artist's own cultural points of reference or his life experiences as an Italian immigrant. It is through explorations of the historic and ethnographic contexts of the Watts Towers, and of the man who built them, that we may more fully understand what they are and why he built them, at least partly correcting the more fanciful and obfuscating responses to these fundamental questions. In Sabato Rodia's very familiar face, I am looking into the eyes of an entire community of the hardworking Italian immigrants I have known all my life—as well as into the soul of an artist of acute and rare genius.

Works Cited

Avella, Leonardo. 1999. *La festa dei Gigli: The Traditional Festivity of Nola.* Translated by Anna Giuseppina Ronga and Antonietta Bianca. Nola: Extra Moenia.

Briscese, Rosangela and Joseph Sciorra, ed. 2012. *Graces Received : Painted and Metal Ex-votos from Italy : the Collection of Leonard Norman Primiano* New York: John D. Calandra Italian American Institute Queens College, City University of New York. Studies in Italian Americana, Volume 4.

Byrne-Severino, Moyra, 1991. "'Per lasciare il nome' Leonardo 'Diobello' Sileo, scultore lucano." *La Ricerca Folklorica* 24 (November): 27–35.

Cannistraro, Philip V., and Gerald Meyer, eds. 2003. *The Lost World of Italian American Radicalism: Politics, Labor, and Culture.* Westport, Conn.: Greenwood.

Catania, Sara. 2005. "Towers of Power." *Los Angeles Times,* October 23.

Ceparano, Felice, director. 2000. *I Gigli di Nola.* (The Gigli of Nola) Naples: Assessorato al Turismo dell'Amministrazione Provinciale.

Concorso: L'Unesco per l'infanzia: La festa dei Gigli di Nola (Contest: UNESCO for Children: the Feast of the Gigli of Nola), con la collaborazione dei maestri di festa del Giglio de Sarto, 2000.

Dal Lago, Alessandro, and Serena Giordano. 2008. *Fuori cornice: L'arte oltre l'arte.* Torino: Einaudi.

Davis, Erik, and Michael Rauner. 2006. *Visionary State: A Journey Through California's Spiritual Landscape.* San Francisco: Chronicle Books.

De Biase, Ottaviano. 2003. "La famiglia di Rivottoli nel Settecento attraverso il Catasto Onciario." ('The Rivottoli Family in 18th-century Land Registries') In *Chiesa di Sant'Antonio di Padova e antica gente di Rivottoli* ('The Church of Saint Anthony of Padova and the Ancient Peoples of Rivottoli'). Serino: Parrocchia di Rivottoli.

―――. 2006: *L'Acqua del Serino: Sorgenti e aquedotti* ('The Waters of Serino: Springs and Acquaducts'). Solofrana: Comunità Montana Serinese.

Del Giudice, Luisa. 1994. "Italian Traditional Song in Toronto: From Autobiography to Advocacy." *Journal of Canadian Studies* 29 (Spring: special issue on folklore, edited by Pauline Greenhill and Gary Butler): 74–89.

————. [1989] 1995. *Italian Traditional Song* (2 audio cassettes + 135 pp. booklet), for the Italian Heritage Culture Foundation and the Italian Cultural Institute. 2nd revised edition, Los Angeles: Istituto Italiano di Cultura.

————. 2001a. "Cursed Flesh: Faith Healers, Black Magic, and Death in a Central Italian Town." *Italian American Review* 8.2: 45–46. Reprinted in *Italian Folk: Vernacular Culture in Italian American Lives*, edited by Joseph Sciorra. New York: Fordham University Press, 2010.

————. 2001b. "*Paesi di Cuccagna* and Other Gastronomic Utopias." In *Imagined States: National Identity, Utopia, and Longing in Oral Cultures*, edited by Luisa Del Giudice and Gerald Porter, 11–63. Logan: Utah State University Press.

————. 2001c. "'Wine Makes Good Blood': Wine Culture Among Toronto Italians." *Ethnologies* 23.1: 1–27.

————. 2006. "Interpreting Treasure: Oral Tradition, Archaeology and Horace's Villa." In *The "Horace's Villa" Project: 1997–2003*, 2 vols., edited by Bernard Frischer, Monica De Simone, and Jane Crawford, 1:345–64; illustrations, 2:951–56. Oxford: Archaeopress.

————. 2007. "Ischian Cultural Sites on the San Pedro, California Map" [Siti culturali ischitani sulla mappa di San Pedro, California]. In *Pe' terre assaje luntane: L'emigrazione ischitana verso le Americhe*. Domenico Iacono, Maria Lauro, Salvatore Ronga, Mina Scotto, ed. Ischia: Associazione Ischitani Nel Mondo.

————. 2009a. "Ethnography and Spiritual Direction: Varieties of Listening." In *Rethinking the Sacred*, Proceedings of the Ninth SIEF Conference in Derry, 2008, edited by Ulrika Wolf-Knuts, 9–23. Turku: Department of Comparative Religion, Åbo Akademi University, Religionsvetenskapliga skrifter.

————, ed. 2009b. *Oral History, Oral Culture, and Italian Americans*. New York: Palgrave Macmillan.

————. 2009c. "Rituals of Charity and Abundance: Sicilian St. Joseph's Tables and Feeding the Poor in Los Angeles." *California Italian Studies* 1.2. http://escholarship.org/uc/item/56h4b2s2?query=del%20giudice.

————. 2011. "Sabato Rodia e le Torri di Watts a Los Angeles: Arte, migrazione, e l'immaginario italiano." ['Sabato Rodia's Towers in Watts, Los Angeles: Art, Migration, and the Italian Immaginary'] In *Costruttori di Babele: Sulle tracce di architetture fantastiche e universi irregolari in Italia ['Builders of Babel: On the Trail of Fantastic Architecture and Irregular Universes in Italy']*, edited by Gabriele Mina, 121–132. Milan: Elèuthera, 2011.

Di Donato, Pietro. 1939. *Christ in Concrete*. Indianapolis: Bobbs-Merrill.

Di Stasi, Lawrence. 2001. *Una storia segreta: Secret History of Italian American Evacuation and Internment During World War II*. Berkeley: Heyday Books.

Ferraiuolo, Augusto. 2009. *Religious Festive Practices in Boston's North End Ephemeral Identities in an Italian American Community*. Albany: State University of New York Press.

Fiore, Teresa. 2002. *Pre-Occupied Spaces: Re-Configuring the Italian Nation Through Its Migration*. PhD dissertation, University of California San Diego University.

Gatto, Mariann. 2009. *Los Angeles's Little Italy (Images of America)*. Mount Pleasant, S.C.: Arcadia Publishing.

Grillo, Lucia, director. 2010. *Terra Sogna Terra* (Earth Dream Earth). New York: Calabrisella Films.

Guglielmo, Jennifer, and Salvatore Salerno, eds. 2003. *Are Italians White? How Race Is Made in America*. New York: Routledge.

Gulla, Katherine, producer and director. 1986. *My Town—Mio Paese* (film). Berkeley: New Video Documentaries.

Harrington, Beth, producer and director. 1986. *Ave Maria: The Story of the Fisherman's Feast* (film). Berkeley: New Video Documentaries.

Klindienst, Patricia. 2007. *The Earth Knows My Name: Food, Culture, and Sustainability in the Gardens of Ethnic Americans*. Boston: Beacon Press.

Landler, Edward, and Brad Byer. 2006. *I Build the Tower* (film). Los Angeles: Bench Movies.

Lucarelli, Francesco, and Lello Mazzacane. 1999. *L'Unesco et la tutelle du patrimoine immateriel: Les fêtes traditonnelles: Les Gigli de Nola*. (UNESCO and Intangible World Heritage: Traditional Festivals: The Gigli of Nola), Nola: Edizioni Extra Moenia.

McNamara, Michael. 2005. *The Watts Towers* (film). Toronto: Markham Street Films.

Margry, Peter Jan, ed. 2008. *Shrines and Pilgrimage in the Modern World: New Itineraries into the Sacred.* Amsterdam: Amsterdam University Press.

Mencken, Henry L. [1919] 1938. *The American Language: An Inquiry into the Development of English in the United States.* 4th ed. New York: Knopf.

Morgan, Jeanne. 1984. "Rodia's Towers: Nuestro Pueblo, a Gift to the World." In *Personal Places: Perspectives on Informal Art Environments,* by Daniel Franklin Ward, 1–11. Bowling Green, Ohio: Bowling Green State University Popular Press.

Orsi, Robert. [1985] 2002. *The Madonna of 115th Street: Faith and Community in Italian Harlem, 1880–1950.* New Haven, Conn.: Yale University Press, 2002 (3rd edition).

Pitt Leonard, and Dale Pitt. 1997. *Los Angeles A to Z: An Encyclopedia of the City and County.* Los Angeles: University of California Press.

Posen, I. Sheldon, Joseph Sciorra, and Martha Cooper. 1983. "Brooklyn's Dancing Tower: Brought to America by Immigrants from an Italian Town, the Feast of Saint Paulinus Celebrates Religious Devotion, Community Ties, and the Ideals of Manhood." *Natural History* 92.6: 30–37.

Ricci Lothrop, Gloria. 2003. *Italians of Los Angeles.* Los Angeles: Historical Society of Southern California.

Rolle, Andrew. [1968] 1999. *Westward the Immigrants: Italian Adventurers and Colonists in an Expanding America* (Originally published as *The Immigrant Upraised.* Norman: University of Oklahoma Press, 1968). Ninot: University Press of Colorado.

Scambray, Kenneth. 2001. "Creative Responses to the Italian Immigrant Experience in California: Baldassare Forestieri's 'Underground Gardens' and Simon Rodia's 'Watts Towers.'" 8 (Autumn/Winter): 113–140. Reprinted in *Italian Folk: Vernacular Culture in Italian-American Lives.* Ed. by Joseph Sciorra. New York: Fordham Univ. Press. 2011.

Sciorra, Joseph. 1989. "Yard Shrines and Sidewalk Altars of New York's Italian Americans." In *Perspectives in Vernacular Architecture,* Vol. 3, edited by Thomas Carter and Bernard L. Herman, 185–98. Columbia: University of Missouri Press.

———. 1993. "Multivocality and Vernacular Architecture: The Our Lady of Mount Carmel Grotto in Rosebank, Staten Island." In *Studies in Italian American Folklore,* edited by Luisa Del Giudice, 203–43. Logan: Utah State University Press.

———. 2001. "Imagined Places, Fragile Landscapes: Italian American *Presepi* (Nativity Crèches) in New York City." *Italian American Review* 8 (Autumn/Winter): 141–73.

———. 2015. *Built with Faith: Italian American Imagination and Catholic Material Culture in New York City,* Knoxville: University of Tennessee Press.

Sensi Isolani, Paola. 2003. "Italian Radicals and Union Activists in San Francisco, 1900–1920." In *The Lost World of Italian American Radicalism: Politics, Labor, and Culture,* edited by Philip V. Cannistraro and Gerald Meyer, 189–201. Westport, Conn.: Greenwood.

Stalcup, Ann. 2004. *Leo Politi: Artist of the Angeles.* New York: Silver Moon Press.

"Storia e diffusione della cartolina tra i Gigli di Nola." ('History and Diffusion of the Postcards of the Gigli of Nola') 2010. In program booklet of the *Festa dei Gigli di Nola.* Nola: Associazione "La Contea Nolana."

Ward, Daniel Franklin. 1984. *Personal Places: Perspectives on Informal Art Environments.* Bowling Green, Ohio: Bowling Green State University Popular Press.

Ward, Daniel Franklin, and I. Sheldon Posen. 1985. "Watts Towers and the Giglio Tradition." In *Folklife Annual* 1985: A Publication of the American Folklife Center at the Library, 142–57. Washington, D.C.: Library of Congress.

Whiteson, Leon. 1989. *The Watts Towers of Los Angeles.* Oakville, Ontario, Canada: Mosaic Press.

Wojcik, Daniel. Forthcoming. *Outsider Art Realms: Visionary Worlds, Trauma, and Transformation.* Jackson: University Press of Mississippi.

"Why a Man Makes the Shoes?": Italian American Art and Philosophy in Sabato Rodia's Watts Towers

Joseph Sciorra

No genius, however eccentric, exists isolated from the conditions of his or her milieu.
—HENRY GLASSIE[1]

That's what the Italians did.
—JOYCE JEFFERS SPEAKING ABOUT THE TOWERS[2]

In 1985, folklorists I. Sheldon Posen and Daniel Franklin Ward published their speculative essay "Watts Towers and the *Giglio* Tradition" that proposed a relationship between Sabato "Sam" Rodia's Watts Towers and the wood and papier-mâché spires constructed annually for *La Festa dei Gigli* (the feast of the lilies) in Nola (Naples province, in the region of Campania), in honor of the canonized bishop Paulinus (ca. 353–431).[3] The Italian feast consists primarily of competing teams of able-bodied men who, organized by different professional associations, transport on their shoulders eight tapered towers and a ceremonial "boat" manned by a costumed "Turk" through the town streets.[4] Posen and Ward suggested that Rodia witnessed this spectacular celebration as a boy and that the

spires served as models for him in California decades later. The authors' intriguing contention does not rest solely with their discovery of a one-to-one *Gigli*–Watts Towers correspondence but extends the discussion of Rodia's work to include the creative process itself. While Rodia certainly was not trained in the *Gigli* building tradition of wood lattice carpentry and papier-mâché form molds (Avella 1979: 45–51; Meazza and Bertolotti 1985: 492–99; see also Ballacchino, Ceparano, this volume), Posen and Ward concluded that "Sam Rodia worked all those years within a tradition—of form, of construction—and far from being a simple 'naïf' or nut, was one end of a relationship which individuals can be said to have with their community, however far or isolated they appear to be from them" (Posen and Ward 1985: 156–57).

Expanding on the pioneering work of Posen and Ward, I propose that Rodia's architectural fantasy emerges in relationship to a larger set of interrelated sociocultural precepts immersed in southern Italian peasant and Italian American immigrant laborer perspectives. I contend that Rodia worked within and against a set of aesthetic and philosophical elements involving survival and achievement, frugality and practicality, craft and building prowess, masculinity, beauty, Catholic aesthetics, and the spectacle, as well as a host of vernacular art traditions, that are part of the historically specific conditions of his proletarian, immigrant experience in the United States. I am proposing that it was a "habitus" of ideas, what Pierre Bourdieu identified as "a system of lasting, transposable dispositions which, integrating past experiences, functions at every moment as a *matrix of perceptions, appreciations, and actions* and makes possible the achievement of infinitely diversified tasks" (Bourdieu 1991: 82–83), that informed Rodia's reimagining and reconfiguration of cultural elements.[5] Rodia and his hybridic creation were works in progress as he "made America" (*fatto l'America*; Lapolla 2009: 8–9; see also Scambray 2011: 79) by refashioning himself and the world around him.

This essay is grounded in folklore and folklife studies, which have historically examined the expressive culture of nonacademically trained individuals operating within community-based aesthetic practices learned and nurtured in face-to-face interactions (Glassie 1989; Yoder 1990). Folklorists specializing in material culture and folklife studies, whether needlework and fiber arts, furniture building, sculpture, or architecture, approach these art forms from a contextual position that pays close attention to the maker's training, beliefs, and life history, as well as the creative process, and interpretations and use of the finished object (e.g., Briggs 1989; Bronner 1996; MacAulay 2000; Vlach 1981). Folklorists, as well as art historians and other scholars, question the purely aesthetic approach to nonacademic artists, whether traditionally trained or idiosyncratic ones like Rodia, that relies on the tastes and concerns of the art world membership (dealers, collectors, museum curators, etc.), as opposed to those of the artists. Scholars also point out that the focus on the creative work of recluses, the mentally ill, and criminals ultimately decontextualizes individuals to the extreme, thereby transforming the latter into decultured "outsiders" embedded in pathologies or psychoses (Ames 1994: 252–72; Cubbs 1994: 76–93; Metcalf 1994: 212–27; Wojcik 2008: 179–97).[6] Folklorist Michael Owen Jones's corrective to these romantic, elitist, and ultimately dehumanizing tendencies is a "material behavior" approach that focuses on the individual and "encompasses matters of personality, psychological states and processes, and social interaction in relation to artifacts," including "the processes of conceptualizing, constructing, using, and responding to them" (Jones 2001: 59; see also Jones 1989; Jones 1994: 312–30). In keep-

ing with this methodology, I explore the Watts Towers as the elucidation of, and resolution to, a turbulent life of displacement, death, alcoholism, and abandonment that was part of Rodia's Italian American subjectivity. I am interested in the social context of Rodia's life and artistic venture, as opposed to the biography that perpetuates the shopworn "outsider" narrative (Fine 2004: 73). To this end, I aim to locate his unique vision, individual drive, and innovative technology as emerging from a set of cultural practices that were part of a willful act of reinvention.

The recorded interviews of Rodia conducted by an assortment of inquisitive visitors echo with the booming dissonance of cultural disconnect.[7] None of them spoke Italian let alone Rodia's Campanian dialect.[8] Rodia's frustration is palpable as the curious insisted on knowing why he had built the Towers as he repeatedly turned the conversation to other matters of concern. These recordings, for the most part, came late in life when he had already walked away from the Towers (see Appendix A.1, "Conversations with Rodia"). This essay relies on those somewhat problematic interviews, as well as the body of literature dedicated to Rodia and his Towers up to the present. We no longer can sit and talk with Rodia the man, but we can look a little more closely at his life and his work as the evolving nature of beauty and knowledge in the passage from one state of being to another.[9]

As a folklorist researching Italian American material culture in New York City and the Northeast for thirty years, I cannot help but see the similarities between Rodia's Watts Towers and other objects and architecture crafted by Italian Americans. I agree with Laura Ruberto (see Ruberto, this volume) that the Towers' California location, as well as the lack of an Italian American community in Watts, has resulted in the erasure of Rodia and the Towers' *italianità* (Italianness). It is only recently that scholars of Italian American cultural expressions, in particular literary critics, have begun to tease out Italian aspects of the Watts Towers, without invoking dogmatic or essentialist arguments (D'Acierno 1999b: 537–40; Fiore 2002; Hendin 2003: 13–39; and Scambray 2001: 63–81). As Teresa Fiore observes, "Such an idiosyncratic work . . . cannot be simplistically celebrated as a one-man majestic creation" (Fiore 2002: 47) in keeping with the archetypical Western studio-trained, "modern" artist. My essay does not claim that any discussed element is unique to Rodia or Italian Americans but instead that there are aspects of his cultural makeup that cannot be ignored simply because he acted alone, that his work is unique, or that the Watts Towers share traits with other vernacular art environments.[10] To do so is to deprive Rodia and his transgressive creation a full and complete consideration. A culturally informed investigation such as mine, modeled on the work of others (Jones 1989; Thompson 1984; Wojcik 2008: 178–97), attempts to relocate Rodia within a matrix of cultural practices while rejecting the romantic portrait of Rodia as an eccentric, "crazy" genius operating in a vacuum.

I Gigli Reconsidered

There are those who remain doubtful of Posen and Ward's premise or at the very least have not considered the magnitude of their happenstance discovery. I was struck by comments Edward Landler, co-director of the documentary *I Build the Tower* (Landler and Byer 2006), made to me first in Los Angeles (November 2, 2005) and then in New York (September 18, 2007) in which he argued against the possibility of Rodia traveling from Ribottoli, a hamlet of Serino (Avellino province, in the region of Campania) to

Nola, the distance of some thirty-eight kilometers (approximately twenty-three miles), because of what Landler claimed were the poor conditions of Italian roads at the end of the nineteenth century. Landler's stated position (which he retracted after hearing a version of this essay I presented at the 2009 University of Genova conference) fails to take into account the historical fact that during the late nineteenth and early twentieth centuries, Italian laborers traveled back and forth between their *paesi* (hometowns) not only to France and England but also to Argentina and Brazil for seasonal agricultural work. Between 1908 and 1912, some 30,000–35,000 Italian agricultural laborers took advantage of inexpensive steerage steamship fares to bring in the harvest in Latin America and then return to Italy to do the very same there (Gabaccia 2000: 58–105; Solberg 1987: 95–96). The Argentines referred to the Italian laborers as *golondrinas*, or swallows, because of their migratory existence. This transnational commuting, which also included travel between Italy and the United States, created what Donna Gabaccia called a "proletarian cosmopolitism" for these Italian workers.

It is also important to note that Nola was not a mere village but a township (*comune*) that was a significant node in a network of economic, social, and religious import. Between 1861 and 1901, the period that included Rodia's birth in 1879 and his emigration around 1893, Nola's population fluctuated between 12,030 and 14,622 inhabitants ("Nola" 1931: 887).[11] Since the first century c.e., the town has been the seat of a Catholic diocese with its own cathedral. Situated between the city of Naples and surrounding mountain towns and villages, Nola was historically an important agricultural center and market town (Manganelli 1973: 109–14). The religious feast in honor of Saint Paulinus was celebrated in conjunction with a major market event that attracted people from far and wide to buy and sell agricultural goods and other products. Historian Ferdinand Gregorovius witnessed the feast in 1853 and described the "swarming city" in this way:

> The whole of Campania, it was said, collected here. . . . [T]he throng was immense; the
> roads crowded with carriages of every kind, hastening from the country to Nola. . . .
> Arrived at the gates of Nola, I beheld an endless stream of humanity pouring towards the
> town. A fair had been opened at the entrance. . . . Indescribable was the varied throng of
> wares that were proclaimed at the stalls, the noise of the incoming tide of people, and the
> glaring colours to be found in materials and clothes and in the innumerable little flags.
> (Gregorovius 1914: 111–14)

It is not improbable that a land-owning *contadino* like Rodia's father (Landler and Byer, 2006; Ward 1990: 162–63) would have ventured, along with family members, to this major event at least once before the young and impressionable Sabato emigrated at age fourteen.

Landler and Brad Byer's film *I Build the Tower* is deceptive in its treatment of Rodia's possible connection to the *Gigli*. In a scene dealing with Rodia's life in Italy, literary scholar Giovanni Cecchetti states, "Rodia certainly saw religious processions in his town. In these processions, the men of the towns carried the *Gigli*. The *Gigli* were ornamental towers built of wood. They were transferred by ox cart from one town to another for different rituals." Yet the religious processions in Ribottoli and Serino for Saint Anthony of Padua and Saint Francis of Assisi, respectively, do not include ceremonial towers or structures reminiscent of the *Gigli*. The thirty-second scene is further complicated by the fact that the viewer is shown footage from the feast of the *Gigli* in Nola, but it is unidentified as such. The film creates the impression that multistoried spires like the *Gigli* are

generic Italian religious objects and as a result effectively undermines the possibility of a Nola–Watts connection.

Making America

Rodia began his life in the United States as an unskilled laborer who moved not only from job to job but from occupation to occupation, like countless other Italian immigrants who were known simply as the *millemestieri* ("thousand jobs"; La Sorte 1985: 66–69).[12] The fourteen-year-old greenhorn joined his brother Riccardo in the Pennsylvania coal mines and traveled with him to arduous and perilous mining, quarry, and construction jobs until Riccardo died in a mining accident (Ward 1990: 165–70). After his brother's untimely death, the young Rodia traveled west, moving to Washington, California, Texas, and possibly Canada, Brazil, and Guatemala, as he later claimed, in search of work (Ibid.; see Appendix A.11). It was through these various jobs that Rodia garnered the building skills, especially the ability to work reinforced concrete, he would call on to create his Towers in Watts.[13] Rodia's working experience was part of a widespread practice for millions of Italian laborers:

> By far the most important Italian occupational niche world-wide was that of the male construction workers. . . . On five continents, Italian men were earthmovers, masons, and hod carriers—veritable human steam shovels who built the transportation and urban infrastructures of modern capitalism. (Gabaccia 2000: 74–75)

These jobs were consonant with "the immemorial Italian affection for wet cement" (A. Miller 1995: 168) that can be seen with other Italian American vernacular art projects like John Greco's *Holyland USA* in Waterbury, Connecticut; John Giudici's *Capidro* in Palo Alto, California; and Silvio Barile's *Italian-American Museum* in Redford, Michigan (Cicala n.d.; Skee 2008b).[14]

The refashioning of oneself through the acquisition of knowledge and skills in the face of rising opportunities is part and parcel of the immigrant experience. Casual and scholarly observers of Italian cultural practices have noted that this figuring out of how to survive on the fly, overcoming life's obstacles, has been raised to an "art" form known as *arrangiarsi*. In his "Cultural Lexicon: Italian American Key Terms," Pellegrino D'Acierno glosses the concept as "to improvise; to get out of a fix as best one can; to fend for oneself" (1999a: 753). Italian American "adhocism" has historically involved the "pragmatic aesthetics of making the most out of the least" (D'Acierno 1999b: 540; see also Jencks and Silver 1973), and it informs oral and written accounts of family history and ultimately identity formation. The Italian American enactment of *arrangiarsi* within the context of immigrant labor is illustrated in a passage from Karen Tintori's narrative *Unto the Daughters*, in which the author imagines her Sicilian grandfather, Nino Mazzarino, in 1909 Detroit:

> The boss sized up the young man—he was five feet five inches tall and slight—and told him he wasn't hiring. Nino nodded, but he didn't leave. He had no other job prospects to investigate that day, so he decided to stick around and watch his friends work. He came back the following morning, and then the day after that, watching and studying the technique of neatly sandwiching cement between bricks. On the fourth day, the boss again told Nino that he wasn't hiring. On the fifth day, Nino picked up a trowel, fell in

beside his friend, and began laying brick. The boss watched Nino that morning with practiced indifference on his face. The young Italian's work was neater and faster than that of other men who'd spent years in the building trades. Without a word, the boss watched again on the sixth day and the seventh, as the young man put in more than an honest day's work for nothing but experience. The next morning, when Nino again silently set to work beside his friend, the boss walked over and told Nino what an impression he had made with both his work and his moxie. With a handshake, he told Nino he was putting him on the payroll, retroactive to the first day. (Tintori 2007: 41)

Like the bricolage of the Watts Towers, this cultural prescript of taking advantage of situations and materials at hand is in keeping with Rodia's survival strategy in the United States.

Around 1919, Rodia's pre-Watts work with reinforced concrete and *pique assiette* situates the Towers within a continuum of Italian American vernacular material culture. In the yard of his Long Beach, California, home, Rodia made five structures, including planters, a fish pond, and what has been called a "merry-go-around" but what Ward suggests was more like a gazebo (Ward 1990: 169; see also Goldstone and Paquin Goldstone 1997: 32). These objects are analogous to others I have found constructed by Italian Americans

Planter inlayed with quartz beach pebbles and cobbles, 1609 81st Street, Dyker Heights, Brooklyn, 2012. Photograph by Joseph Sciorra.

in New York City and the larger metropolitan area. They range from the humblest of recycled work, such as the glass shards embedded in a cement and cinder-block barrier wall on 218 Frost Street, Williamsburg, Brooklyn, made by an unknown Italian immigrant during the 1930s, to the once pervasive porch planters inlayed with quartz beach pebbles and cobbles whose proliferation in the former Italian American neighborhoods of Brooklyn, Queens, and the Bronx leaves the informal viewer with the impression that these individually handcrafted items were mass-produced (Skee 2012). Broken colored glass and ceramic ware, seashells, smooth, oblong stones, and other reclaimed objects are pressed into wet cement for flowerpots, fountains, and towers of various shapes in yards throughout the city. This common Italian American practice on the East Coast is referenced by Queens-born author Barbara Grizzuti Harrison who recalls "all those basins I grew up (embarrassed) among in Brooklyn, shells and colored glass embedded in stucco, remarkable for the principle of accretion they exemplify" (1989, 266).[15] Such ornamentation is

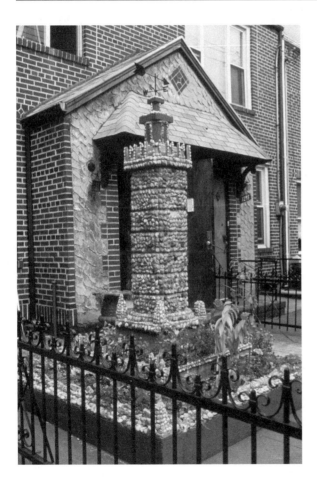

Tower with weather vane (nonextant) embedded with pebbles and stones, 1235 78th Street, Dyker Heights, Brooklyn, 1985. Photograph by Martha Cooper.

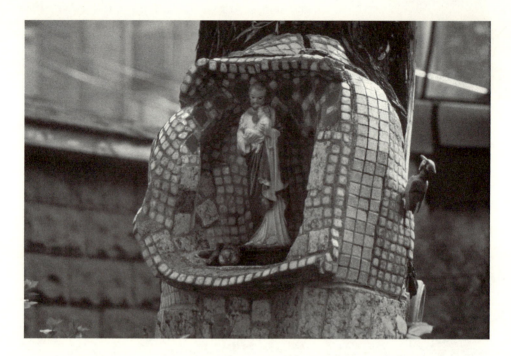

Joseph Furnari's backyard tree shrine to Saint Joseph, Jackson Heights, Queens, 1985. Photograph by Martha Cooper.

most evident in the countless shrines housing statues of Catholic saints found in front yards all over Italian New York (Sciorra 1989: 185–98).

During the same period, Rodia was working on his Towers in California, Italian Americans in the East Coast were using similar decorative techniques for various large-scale projects.[16] During the 1930s, Gaetano "Guy" Merenda, a "mason, artisan, craftsman," bought property on 489 Cooke Street in Waterbury, Connecticut, and promptly began to decorate his home and other properties with yard decorations and facade work that in time became "like a folk landmark" according to his stepson Carl Rosa (December 23, 2008, telephone conversation). Shards of mirror, ceramic, and glass are embedded in the mail box, the circle-head transom above the entrance door, and pathway walls that are part of Merenda's overall design.[17] In Williamsburg, Brooklyn, Ferdinando Lauria, a painter and plasterer, covered the facade of his four-story apartment building at 610 Metropolitan Avenue with broken crockery of mosaic trim.[18] The front yard includes an oversized flowerpot, a bench, and a chair decorated in a similar fashion. Lauria began his work to commemorate the 1939–40 New York World's Fair and, after returning from military service during World War II, continued his enterprise up until the 1960s. Current neighborhood resident Louis Bascetta, Sr., recalled, "He would always say, *'È tutto lavoro mio'* [It's all my own work]. He would have covered the whole block if he didn't get sick [with cancer]" (July 14, 2009).

By far the most impressive structure employing this technique is the Our Lady of Mount Carmel Grotto in Rosebank, Staten Island (Sciorra 1993: 203–43). This monumental

Decorated wall and flowerpot created by Gaetano Merenda during the 1930s, Waterbury, Connecticut, 2012. Photograph by Joseph Sciorra.

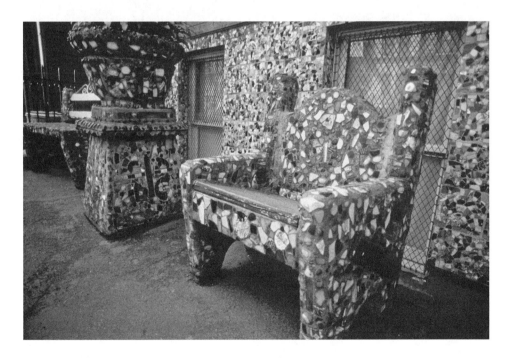

Detail of Ferdinando Lauria's pique assiette *work, 610 Metropolitan Avenue, Williamsburg, Brooklyn, 1985. Photograph by Martha Cooper.*

structure was begun in 1937–39 by members of the lay religious Mount Carmel Society on land owned by the organization and continues to serve as a religious site. The approximately thirty-foot-high shrine consists of a central chamber built with fieldstones, flanked by two adjoining sections stretching out in serpentine fashion. The central apse contains a linen-draped altar with a padded kneeler and an alcove housing a statue of Our Lady of Mount Carmel holding the infant Jesus. Rising from the grotto are a series of towers and crown-like protrusions, many topped by crosses. The surface of the grotto walls is decorated with smooth round stones, as well as glass marbles, shells, translucent plastic flowers, and bicycle reflectors inlaid into cement in various shapes that include crosses, triangles, ovals, stars, and diamonds. A freestanding shrine to Saint Anthony and a crucifix are decorated in similar fashion.[19]

Creative parsimony is not an indelible Italian American trait but part of a working-class aesthetic of thrift that exploits the vast waste of mass-produced products (Seriff 1996: 8–45; see also Greenfield 1986). The recontextualization of objects culled from nature and industrial detritus was an integral part of Italian American immigrant life in

Apse of the Our Lady of Mount Carmel Grotto, Rosebank, Staten Island, 1999. Photograph by Larry Racioppo.

general and artistic production in particular (Hendin 2003: 31). Bricolage is at the center of numerous vernacular art projects created by Italian Americans, such as Joe Milone's *Shoe Shine Stand* in New York City, Emanuele Damonte's *Hubcap Ranch* (see Ruberto, this volume), John Giudici's *Capidro*, and Romano Gabriel's *Wooden Garden* in California, as well as Angelo Nardone's *Villa Capri* in Nutley, New Jersey, and Salvatore Verdirome's *Sanctuary of Love* in Norwich, Connecticut, among others (Dillon 2008; Karpel 2008: 4–7; Metz and Foster 1989: 30–32; Pasquini 2008; Skee 2008a). Italian American idiosyncratic artists of frugality and reclamation salvaged bottles, crockery, wood crates, hubcaps, bathtubs, and architectural decorations to create unique artworks, often with strong religious connotations. Rodia's creation shares elements such as thrift and recycling with other idiosyncratic environmental works. (This is no less significant given Rodia's reported savings of $10,000, which he carried on his person in latter years.) The fact that Rodia may have been inspired by and learned directly from the German American priest Mathias Wernerus's *Dickeyville Grotto* in Wisconsin (Ward 1990: 162–63; see also Niles 1997) does not detract from the Italian predilection for such decorative work, especially given that the German grotto tradition, with its baroque and rococo encrusted walls, was influenced by Italian models (N. Miller 1982: 101–18).

This aesthetic of layering and accretion can also be seen in Italian American domestic altars and *presepi* (nativity landscapes), which grow and change over time (Sciorra 2001: 141–73; Sciorra 2013: 109–21). This Catholic-inspired aesthetic is part of Rodia's cultural heritage, despite his position on organized religion or his faith in general. The multiplicity of religious imagery and analogies is at the heart of what Andrew Greeley calls the "Catholic imagination" (modeled on David Tracy's [1987] notion of a Catholic "analogical imagination"). According to Greeley, Catholics' "enchanted" sacramental vision of the world, that is, the belief in the immanence of God and the presence of grace in the universe, engenders a sensibility and appreciation for sacred representation and the tangible (see McDannell 1995). Catholicism's "verdant rainforest of metaphors" (Greeley 2001: 9) has resulted in a plethora of imagery and symbols in which the "great Catholic churches of the world . . . have always been crowded with chapels, altars, statues, shrines, paintings, votive candles, and stained glass" (33). Writing about the Gothic cathedral in Köln, Germany, he observers that it "is no more cluttered than St. Peter's or your local Italian parish church" (33–34), a backhanded acknowledgment of the redundancy of sacred images historically found among Italian American Catholics. The predisposition to repetition and redundancy in the Catholic art tradition of sacramentality informs Rodia's six Towers, as well as the various decorative elements found among the inlaid objects and pressed patterning.

Rodia's Towers are in keeping with an attention to artistry in everyday life that has historically been a discernible element in Italian and Italian American working-class cultures. Folklorist Alan Lomax observed this attention to and appreciation of artistic competency during his experience recording Italian folk music during the mid-1950s:

Italians, no matter who they are or how they live, are concerned about aesthetic matters. They may have only a rocky hillside and their bare hands to work with, but on that hillside they will build a house or a whole village whose lines superbly fit its setting. So, too, a community may have a folk tradition confined to just one or two melodies, but there is passionate concern that these be sung in exactly the right way. (Lomax 1960).

This "expression of Italian everyday aesthetics" (D'Acierno 1999a: 708) is most evident in the simple yet common declaration "Che bello!" or "How beautiful!" that is used to articulate an appreciation for the most common objects such as freshly baked bread or a perfectly formed fruit. Mario Puzo captures vividly this quintessential trait in a scene from his 1964 debut novel *The Fortunate Pilgrim*:

> *"Che bella insalata"*—what a beautiful salad—the words rose up to the sleeping children at their moment of awakening. They all sprang out of bed, and Gino looked out the window. Below was the hawker, standing on the seat of his wagon as he held up to the sky and the watching windows a pearly green lettuce in each outstretched hand. *"Che bella insalata"* he said again, not asking anyone to buy, only asking the world to look at beauty. Pride, not cajolement, in his voice, he repeated his cry each time his horse took a mincing step along the Avenue. In his wagon were boxes of onions dazzling white, great brown potatoes, bushels of apples, bouquets of scallions, leeks, and parsley sprigs. His voice rose rich with helpless admiration, disinterested, a call for lovers. "What beautiful salad." (Puzo 1985: 48)

The world made beautiful through attention and detail permeates Rodia's artistic project.

Lomax's elucidation points to a key element in Italian everyday aesthetics, that is, a pervasive and deeply felt sentiment regarding the well-crafted object. This discerning awareness to craftsmanship, the mastering, execution, and discussion of acquired skills—for men constructing a brick wall or women preparing a meal—is summed up in the widespread phrase "lavoro ben fatto," or "work well done." In an interview with Philip Roth, Primo Levi spoke of his time in Auschwitz and the need for order in coping with the horrors of the concentration camp by pointing to this very concept: "The Italian bricklayer who saved my life by bringing me food on the sly for six months, hated Germans, their food, their language, their war, but when they set him to erect walls, he built them straight and solid, not out of obedience but out of a professional dignity" (Roth 1996: 179). Rodia referenced the artisanal trades of the tailor and cobbler to answer rhetorically the question he was often asked: "Why I build it? I can't tell you. Why a man makes the pants? Why a man makes the shoes?" (Landler and Byer 2006). Historically, working-class Italian Americans associated self-esteem with the fruit of one's labor and solutions of intellect (Gambino 1975: 87–88). Cinematic examples of Italian American concern with "professional dignity" include *Mac* (Turturro 1992) and *Big Night* (Scott and Tucci 1996), in which *lavoro ben fatto* becomes an obsession for perfection that drives a wedge between family members, whether housing contractors or restaurateurs. Rodia's attention to getting things "right" involved his repeated razing of towers and other elements that did not meet his vision or high standards and constructing them anew to produce his version of the Italian "hymn of proud and beloved building making" (Ferraro 2005: 62).

The admiration and pleasure of craftsmanship within Italian and Italian American cultural contexts are not the exclusive domain of the maker but are contingent on a discerning and knowledgeable audience. The finished product is not merely an object but a performance, an enactment of values and aesthetics to be judged by others (Hunt 1999: 8). On the page in Don DeLillo's 1997 novel *Underworld* in which he describes the Watts Towers as "a kind of swirling free-souled noise, a jazz cathedral," the main character, Nick (Costanza) Shay, recalls his Italian American father taking a trowel from an inept mason in order to properly set mortar to brick: "I went across the street and felt a shy

kind of pride, surrounded by middle-aged men and older, the fresh-air inspectors, they were called, and you've never seen happier people, watching a man in a white shirt and tie do a skillful brickwork bond" (DeLillo 1997: 277). As we know, Rodia was cut off, by design or chance, from Los Angeles's relatively small and dispersed Italian Americans grounded in these cultural precepts, despite having been inculcated with them (Crosby 1993: 38–57; see also Gonzalez 1993: 219–30).

Remaking Rodia

Pride in one's work has been historically associated with notions of masculinity and honor among southern Italians and Italian Americans. Anthropologist David Gilmore observes that in Mediterranean societies, a "conflation of masculinity and efficaciousness into a theatrical image of performing" (Gilmore 1990: 35) shapes a man's self-image as defined by the concept of honor. "Honor is about being good at being a man, which means building up and buttressing the family or kindred—the basic building blocks of society—no matter what the personal cost" (43). In his early years, circa 1905, Rodia saved money to buy a house for his wife Lucia Uzzi and three children in Oakland's Italian community and financed his sister Angelina and brother-in-law's voyage first from Italy and then, with their two children, from Pennsylvania to California (Goldstone and Paquin Goldstone 1997: 29; Landler and Byer, 2006). Yet ultimately, Rodia's self-image as a worker, as a maker, was not tied to the southern Italian ideal of masculinity linked to providing for a family, male honor derived from domestic duty. At this, he was a failure.

According to divorce papers filed by his wife, Rodia repeatedly beat Lucia, neglected the children, and was a drunk. The 1912 divorce was granted on grounds of "failure to provide" (Landler and Byer, 2006). And then, like Nick Shay's father in *Underworld*, Rodia committed "the unthinkable Italian crime. He walked out on his family. They don't even have a name for this" (DeLillo 1997: 203). Rodia's behavior at this time counters sociologist Richard Gambino's ideal (idealistic, some might venture to say) notion of Italian American masculinity, "*l'uomo di pazienza*," the man of patience who exhibits "cultivation and control of his capacities and special skills . . . and the seriousness and probity characteristic of maturity" (Gambino 1975: 130). This principle was not always the lived experience of numerous Italian American women and children who dealt daily with the abuse and violence of patriarchal power as did Lucia and her family. Lorenzo Carcaterra (1992), Rachel Guido deVries (1986), Annie Rachele Lanzillotto (2013), Gianna Patriarca (1994), Vittoria Repetto (2006), Karen Tintori (2007), and other writers have penned verse, novels, and memoirs to expose, purge, and heal the psychological and physical damage of patriarchal brutality.

It is evident from all accounts that Rodia was one of those numerous immigrant men "who crumbled under the glories of the new land" (Puzo 1985: 100) as the cumulative effects of abandonment, untimely death, and a general sense of disempowerment exacted a devastating psychological toll.[20] As an old man, he still expressed the pain of his parents' decision for him to emigrate: "I no need to come in America. That's my mother, my father's fault. They sendin' a boy like me, fourteen-years-old, to the United States" (Landler and Byer, 2006). As a teenager, he worked deep in the frightening and hazardous anthracite coal mines doing the same oppressive jobs as adult men. What must it have been like for young Rodia in a strange and estranging land to experience the horrific death

of his older brother in a mining accident? Even after beginning a new life in California, Rodia faced the untimely death of his daughter, Bel. "[H]e may have started his heavy drinking after her death, neglecting Lucy and the two boys," Bud Goldstone and Arloa Paquin Goldstone recount (1997: 31). At this critical moment in his life, Rodia can be said to have suffered what anthropologist Ernesto de Martino dubbed a "crisis of presence" (*crisi di presenza*), a passive psychological state "in which one is 'absorbed in the world' in a way that one loses control of one's own existence," a negation that ultimately results in an individual's "loss of a place in history" (Saunders 1993: 882–83). Yet this ontological emergency, according to de Martino, offers the possibility for reevaluation, self-knowledge, and transcendence (Saunders 1993: 883). Rodia's willful act of creative engagement saved him from the fate of other Italian immigrants, of whom journalist Giuseppe Prezzolini observed, when they "did not end up in an insane asylum or become a criminal, it was a miracle" ("che quando un emigrato italiano non è andato a finire in manicomio, o non è diventato un gangster, è un miracolo"; Prezzolini 1963: 14, my translation). Rodia's thaumaturgy was his transformation of self and his local landscape to become a great man like those he so often referenced (Landler and Byer, 2006; Mingus 1980: 30–31).[21]

Daniel Wojcik writes that Rodia, like other idiosyncratic artists, "began creating art in response [to] adversity, suffering, or personal crisis" (Wojcik 2008: 186). As Rodia stated: "'I was one of the bad men in the United States. I was drunken, all the time a drinkin'. . . . That's why I built the Tower for, I quit the drinkin'" (Landler and Byer, 2006). I suggest that, in building the Towers, Rodia grieved and exorcised the loss of his childhood, his parents, his hometown, his brother, his daughter, his marriage, and his honor through a herculean exercise in "overcoming the negation of presence" (Saunders 1993: 882; see also Jones 1989). Paul Harris writes about the Towers, "As a means and place of redeeming lost materials, the site also seems like a work of mourning and penance" (Harris, n.d.; see also Greenfield 1986: 71–72; and Wojcik 2008: 188–89). Rodia's work on the Towers was a vehicle for healing, self-knowledge, and redemption, not unlike the alcoholic and abusive character Nick Molise in John Fante's novel *The Brotherhood of the Grape*, for whom creative, manual labor was both a palliative from perceived domestic constraints and his inner demons (the "great contempt for himself") and a source of self-worth:

> He had a terrifying lust for work and bitter squint at the sun which, in his view, moved too fast across the sky. To finish a job brought him deep sadness. His love for stone was a pleasure more fulfilling than his passion for gambling, or wine, women. He usually worked far beyond quitting time, even into darkness. . . . He wanted a wall to build—that was it. He didn't care what wall it was, but let it be a wall that brought respect from his friends, who know he was abroad in the world, a workingman, a builder. (Fante 1988: 18–19, 114)

Thomas Ferraro's observation about Pietro di Donato's *Christ in Concrete* (1937), a novel concerning the aftermath of the job-related death of an Italian immigrant laborer, is applicable to Rodia as well: "Physical duress is the lot of these immigrants, but it is also their pleasure, their cohesiveness, their art, and, explicitly in this tale, the felt intimation of their redemption" (Ferraro 2005: 42). Despite the glory of his artistry and ingenuity and the pleasure of hard work and problem solving, the Towers remained forever tainted with a lingering pain. "I broke my heart there," Rodia stated (Trillin 1965: 104).[22]

If the Watts Towers can be said to represent "a language" for this semiliterate immigrant laborer (Fiore 2002: 47), then they can be read, in part, as an autobiographic articulation of a "history of the insulted world" (*la storia del mondo offeso*; Vittorini 1961: 117; Vittorini 1968: 136).[23] The outrages Rodia expressed through his jubilant work and in numerous invectives recorded by inquisitive visitors were tied to a subaltern critique of larger economic, political, and societal issues that he experienced body and soul. Rodia's triumphant creation was ultimately an engagement with his own subjectivity and place in a historical moment that "allowed him to change the world by claiming the right to narrate, and thus interpret, his own experiences and traditions" (Cándida Smith 1996: 28).

The Watts Towers as Spectacle

The extravagant and celebratory spires soaring over the streets of Watts are in keeping with the grand statement of the Italian spectacle. Journalist Luigi Barzini, in his popular 1964 book *The Italians*, suggested that copiousness, outward display, and, in particular, an appreciation for spectacle are traits that Italians have historically cultivated and relished. Although problematic for its essentialist characterization of an Italian "national character," Barzini offers insight to Italians' historic love for the theatrical in everyday life:

> This reliance on symbols and spectacles must be clearly grasped if one wants to understand Italy, Italian history, manners, civilization, habits, and to foresee the future. It helps people to solve most of their problems. It governs public and private life. It is, incidentally, one of the reasons why Italians have always excelled in all activities in which appearance is predominant: architecture, decoration, landscape gardening, the figurative arts, pageantry, fireworks, ceremonies, opera, and now industrial design, stage jewelry, fashions, and the cinema. (Barzini 1965: 94–95)

The notion of the spectacle in Italy is closely associated with a baroque sensibility, and thus we find ourselves returning to the *Gigli* of Nola. Those fantastic spires developed in the 1600s and 1700s, at the time of the Counter-Reformation, when the Catholic Church took a new interest in the staging of massive public religious spectacles that employed ephemeral architectural props such as towers, arches, fountains, and gigantic statuary, as well as illuminations and fireworks. The city became the stage on which the church's and the state's monumental power were displayed through extravagant pageants in the styling of the baroque (Mancini 1984: 24–31; Plattus 1981: 48–52). Italy, and Naples in particular, was a significant site for these colossal and orchestrated urban public displays (Del Giudice 2001: 11–63; Dell'Arco and Carandini 1978; Meazza and Bertolotti 1985: 487–552). The baroque aesthetic, once the language of state power vis-à-vis these colossal events, eventually became popularized and highly prized for religious life throughout southern Italy. The ephemeral spires are not unique to Nola but common in other Italian feasts, as seen in contemporary religious *feste* in Fontanarosa, Gubbio Messina, Mirabella Eclano, Viterbo, and many other townships and by extension the Italian diaspora (Napolitano et al. 1994). It is with Rodia's "jazz cathedral" that we see the baroque's "search for the unexpected and the stupefying" so splendidly manifested.[24]

These ceremonial towers hold an extraordinarily evocative power, especially for migrant communities, whether in New York or Milan, where *La Festa dei Gigli* has been duplicated (Ballacchino 2008: 275–89; Meazza and Bertolotti 1985: 487–552; Posen

1986: 171–91). For those who left their home, the *Gigli* are ambulatory bell towers that festivalize the Italian notion of *campanilismo*, a term referring to the attachment to place, in particular one's hometown, as encompassed by all within the aural space of the church bells.[25] The *Gigli*–Watts Towers connection allows us to discern the conflated Old World symbols of community—the bell tower and festival spires—reimagined for a New World community that was the multiracial, working-class neighborhood of pre–World War II Watts (Sides 2006: 19). The man who would be characterized as a recluse by those who discovered him late in life was seen by some in his community as "usually cheerful and friendly," recounting stories of the great men of history to his child collaborators who gleaned the streets for decorative material (Mingus 1980: 30–31; see also Landler and Byer, 2006). During his time in Watts, Rodia encouraged his neighbors to use the site, celebrating weddings and baptisms there (Cándida Smith: 1996, 31). In this spirit of community refashioning, Rodia christened his Towers "NUESTRO PUEBLO," Spanish for "OUR TOWN" and "OUR PEOPLE." The seventy-six-year-old Rodia abandoned Watts in 1955 after a stroke, a time in which the neighborhood was experiencing a demographic shift and becoming increasingly ghettoized with soaring unemployment, rising crime, and physical deterioration (Sides 2006: 95–130, 182).

While some youth hurled stones, vandalizing the site's ceramic and bottle decorations, other Watts residents claimed the site as their own, locating it on an emotional and psychological cartography of personal and collective identities. Community and cultural activist Cecil Fergerson, whose family moved to Watts in 1938, stated, "[When] we had people coming here to visit us from another state or someplace else, you would tell them once they were on the red car and they see the Tower, 'You're nearing home.' And the Towers really stood out, I guess like Sam wanted them to" (Landler and Byer 2006). The community's embrace of the Towers was made evident during the 1965 Watts Riots/ Rebellion when African American residents protected "old man Rodia's" Towers from conflagration. It was Tramell Turner who, as site docent during my 2005 visit, made explicit the idea that the spires Rodia bequeathed are seen today as beacons of community identity, inspiring residents to aspire to new possibilities. That sense of place is made visible in images of the Watts Towers that young neighborhood men, many of them Latino, have tattooed on their bodies (Cappello 2008; Russo 2011: 67; "Watts Towers Tattooed on Brian Portillo" 2006).

For some Watts Towers admirers, Rodia's cryptic attributions about himself and his work make for an alluring and fetishizing trope of the "outsider" artist that seemingly resists attempts at historically based assessments. Yet the *Gigli* correlation provides a pivotal entry into the cultural context of Rodia's southern Italian and Italian American immigrant subjectivity, allowing us to better comprehend the man and his creativity in ways that were unavailable during his lifetime. New information and fresh perspectives that contradict established narratives can only enhance a deeper appreciation for the Towers' artistic, architectural, and technological wonder.

Acknowledgments

I wish to thank Luisa Del Giudice for inviting me to address the topic of my essay for the 2009 conference in Genova and Anthony Julian Tamburri, dean of the John D. Calandra Italian American Institute at Queens College (City University of New York), for financially

making my participation possible. I am grateful to Rosangela Briscese, Paul D'Ambrosio, Joseph J. Inguanti, and Laura E. Ruberto for reading an earlier version of this article and offering their astute comments. And *mille grazie* to traveling partner Kenneth Scambray, who negotiated the Los Angeles freeway system to drive me to the Towers.

Works Cited

Ames, Kenneth L. 1994. "Outside Outsider Art." In *The Artist Outsider: Creativity and the Boundaries of Culture,* edited by Michael D. Hall and Eugene W. Metcalf, Jr., 252–72. Washington, D.C.: Smithsonian Institution Press.

Appadurai, Arjun. 2003. *Modernity at Large: Cultural Dimensions of Globalization.* Minneapolis: University of Minnesota Press.

Avella, Leonardo. 1979. *La festa dei gigli.* Naples: LER.

Ballacchino, Katia. 2008. "Il *Gigli* di Nola a New York: Uno squardo etnografico sulla festa e I suoi protagonist." *Altreitalie* 36–37: 275–89.

Barzini, Luigi. 1965. *The Italians.* New York: Bantam Books.

Bianco, Carla. 1974. *The Two Rosetos.* Bloomington: Indiana University Press.

Bourdieu, Pierre. 1991. *Outline of a Theory of Practice.* New York: Cambridge University Press.

Briggs, Charles L. 1989. *The Wood Carvers of Córdova, New Mexico: Social Dimensions of an Artistic 'Revival .'"* Albuquerque: University of New Mexico Press.

Bronner, Simon J. 1996. *The Carver's Arts: Crafting Meaning from Wood.* Lexington: University Press of Kentucky.

Cándida Smith, Richard. 1996. "The Elusive Quest of the Moderns." In *On the Edge of America: California Modernist Art, 1900–1950,* edited by Paul J. Karlstrom, 21–40. Berkeley: University of California.

Cappello, Kenneth. 2008. "Watts Towers." March 14. http://kennethcappelloblog.blogspot.com/2008/03/watts-towers.html (accessed January 16, 2013).

Carcaterra, Lorenzo. 1992. *A Safe Place.* New York: Ballantine Books.

Cicala, John. n.d. "Silvio Barile Shows off His Cement Sculptures." http:///www-personal.umich.edu/-acicala/silvio.html (accessed January 14, 2010).

Crosby, Rosalind Giardina. 1993. "The Italians of Los Angeles, 1900." In *Struggles and Success: An Anthology of the Italian Immigrant Experience in California,* edited by Paola A. Sensi-Isolani and Phylis Cancilla Martinelli, 38–57. New York: Center for Migration Studies.

Cubbs, Joanne. 1994. "Rebels, Mystics, and Outcasts: The Romantic Artist Outsider." In *The Artist Outsider: Creativity and the Boundaries of Culture,* edited by Michael D. Hall and Eugene W. Metcalf, Jr., 76–93. Washington, D.C.: Smithsonian Institution Press.

D'Acierno, Pellegrino. 1999a. "Cultural Lexicon: Italian American Key Terms." In *The Italian America Heritage,* edited by Pellegrino D'Acierno, 703–66. New York: Garland Publishing.

———. 1999b. "From Stella to Stella: Italian American Visual Culture and Its Contribution to the Arts in America." In *The Italian America Heritage,* edited by Pellegrino D'Acierno, 499–552. New York: Garland Publishing.

D'Ambrosio, Paul. 2010. "Placido Tobasso, Utica's Forgotten Folk Artist." September 8. http://folkartcooperstown.blogspot.com/2010/09/placido-tobasso-uticas-forgotten-folk.html (accessed January 16, 2013).

DeLillo, Don. 1997. *Underworld.* New York: Scribner.

Del Giudice, Luisa. 1993. "Introduction." In *Studies in Italian American Folklore,* edited by Luisa Del Giudice, 1–9. Logan: Utah State University Press.

———. 2001. "Mountains of Cheese and Rivers of Wine: Paesi di Cuccagn and Other Gastronomic Utopias." In *Imagined States Nationalism, Utopia and Longing in Oral Cultures,* edited by Luisa Del Giudice and Gerald Porter, 11–63. Logan: Utah State University Press.

Dell'Arco, Maurizio Fagiolo, and Silvia Carandini. 1978. *L'effimero barocco: Strutture della festa nella Roma del '600,* vols. 1–2. Rome: Bulzoni Editore.

deVries, Rachel Guido. 1986. *Tender Warriors.* Ithaca, N.Y.: Firebrand Books.

Dillon, Kathy. 2008. "Roman Gabriel's Folk Art Triumph." *Times-Standard,* December 21. http://www.times-standard.com/ci_11282862?source=most-viewed.

Fante, John. 1988. *The Brotherhood of the Grape.* Santa Rosa, Calif.: Black Scarecrow Press.

Ferraro, Thomas J. 2005. *Feeling Italian: The Art of Ethnicity in America.* New York: New York University Press.

Fine, Gary Alan. 2004. *Everyday Genius: Self-Taught Art and the Culture of Authenticity.* Chicago: University of Chicago Press.

Fiore, Teresa. 2002. *Pre-Occupied Spaces: Re-Configuring the Italian Nation Through Its Migration.* PhD dissertation, University of California, San Diego.

Gabaccia, Donna R. 2000. *Italy's Many Diaspora.* Seattle: University of Washington Press.

Gambino, Richard. 1975. *Blood of My Blood: The Dilemma Of The Italian-Americans.* New York: Anchor Press.

Gilmore, David D. 1990. *Manhood in the Making: Cultural Concepts of Masculinity.* New Haven. Conn.: Yale University Press.

Glassie, Henry. 1988. "Meaningful Things and Appropriate Myths: The Artifact's Place in American Studies." In *Material Life in America, 1600–1860,* edited by Robert Blair St. George, 63–92. Boston: Northeastern University Press.

———. 1989. *The Spirit of Folk Art. The Girard Collection at the Museum of International Folk Art.* Santa Fe: Museum of International Folk Art.

Goldstone, Bud, and Arloa Paquin Goldstone. 1997. *The Los Angeles Watts Towers.* Los Angeles: J. Paul Getty Trust.

Gonzalez, Gilbert G. 1993. "Factors Relating to Property Ownership of Mexican Americans and Italian Americans in Lincoln Heights, Los Angeles." In *Struggles and Success: An Anthology of the Italian Immigrant Experience in California,* edited by Paola A. Sensi-Isolani and Phylis Cancilla Martinelli, 219–30. New York: Center for Migration Studies.

Greeley, Andrew. 2001. *The Catholic Imagination.* Berkeley: University of California Press.

Greenfield, Verni. 1986. *Making Do or Making Art: A Study of American Recycling.* Ann Arbor, Mich.: UMI Research Press.

Gregorovius, Ferdinand. 1914. *Siciliana Sketches of Naples and Sicily in the Nineteenth Century.* London: G. Bell & Sons.

Grizzuti Harrison, Barbara. 1989, *Italian Days.* (New York: Ticknor & Fields).

Grossutti, Javier. 2007. "Italian Mosaicists and Terrazzo Workers in New York City: Estimating the Size, Characteristic and Structure of a High-Skill Building Trade." Columbia University Academic Commons. http://www.italianacademy.columbia.edu/publications/working_papers/2007_2008/paper_fa07 _Grossutti.pdf (accessed December 20, 2013).

Harney, Robert F. 1993. "Caboto and Other *Parentela*: The Uses of the Italian Canadian Past." In *From the Shores of Hardship: Italians in Canada. Essays by Robert F. Harney,* edited by Nicholas De Maria Harney, 1–27. Welland: Soleil.

Harris, Paul A. n.d. "To See with the Mind and Think Through the Eye: Simon Rodia's Watts Towers of Los Angeles." http://myweb.lmu.edu/pharris/Wattspaper.html (accessed June 22, 2009).

Hendin, Josephine Gattuso. 2003. "Social Constructions and Aesthetic Achievements: Italian American Writing as Art." *MELUS* 28 (Fall): 13–39.

Hernandez, Jo Farb. 2001. "Watts Towers." *Raw Vision* 37 (Winter): 32–39.

Howard, Robert Glenn. 2008. "Electronic Hybridity: The Persistent Processes of the Vernacular Web." *Journal of American Folklore* 121.480: 192–218.

Hunt, Marjorie. 1999. *The Stone Carvers: Master Craftsmen of Washington National Cathedral.* Washington, D.C.: Smithsonian Institution Press.

Jencks, Charles, and Nathan Silver. 1973. *Adhocism: The Case for Improvisation.* New York: Anchor Books.

Jones, Michael Owen. 1989. *Craftsman of the Cumberlands: Tradition and Creativity.* Lexington: University Press of Kentucky.

———. 1994. "How Do You Get Inside the Art of Outsiders?" In *The Artist Outsider: Creativity and the Boundaries of Culture,* edited by Michael D. Hall and Eugene W. Metcalf, Jr., 312–30. Washington, D.C.: Smithsonian Institution Press.

———. 2001. "The Aesthetics of Everyday Life." In *Self-Taught Art: The Culture and Aesthetics of American Vernacular Art,* edited by Charles Russell, 47–90. Jackson: University Press of Mississippi.

Kapchan, Deborah A., and Pauline Turner Strong. 1999. "Theorizing the Hybrid. *Journal of American Folklore* 112.445: 239–53.

Karpel, Mark. 2008. "Love's Labor Lost: Salvatore Verirome and the Sanctuary of Love." *Folk Art Messenger* (Winter): 4–7.

Landler, Edward, and Brad Byer. 2006. *I Build the Tower*. Los Angeles: Bench Movies.

Lanzillotto, Annie Rachele. 2013. *L is for Lion: An Italian Bronx Butch Freedom Memoir*. Albany: State University of New York Press.

Lapolla, Garibaldi M. 2009. *The Grand Gennaro*. New Brunswick, N.J.: Rutgers University Press.

La Sorte, Michael. 1985. *La Merica: Images of Italian Greenhorn Experience*. Philadelphia: Temple University Press.

Lomax, Alan. 1960. "Saga of a Folksong Hunter—A Twenty-Year Odyssey with Cylinder, Disc and Tape." *HiFi Stereo Review*, May. Reprinted online at http://www.culturalequity.org/alanlomax/ce_alanlomax_saga.jsp (accessed December 21, 2009).

MacAulay, Suzanne P. 2000. *Stitching Rites: Colcha Embroidery Along the Northern Rio Grande*. Tucson: University of Arizona Press.

McDannell, Collen. 1995. *Material Christianity: Religion and Popular Culture in America*. New Haven, Conn.: Yale University Press.

Mancini, Franco. 1984. "Piazze, feste ed apparati." *Campo* 18.1 (April–September): 24–31.

Manganelli, Franco. 1973. *La festa infelice*. Naples: Libreria Editrice Redenzione.

Meazza, Renata, and Guido Bertolotti. 1985. "La macchina rituale. I gigli di Nola al Lorenteggio." In *Mondo Popolare in Lombardia* (Milano e il suo territorio) 13, edited by Franco Della Peruta, Roberto Leydi, and Angelo Stella, 487–552. Milan: Amilcare Pizzi.

Metcalf, Eugene W., Jr. 1994. "From Domination to Desire: Insiders and Outsider Art." In *The Artist Outsider: Creativity and the Boundaries of Culture*, edited by Michael D. Hall and Eugene W. Metcalf, Jr., 212–27. Washington, D.C.: Smithsonian Institution Press.

Metz, Holly, and Robert Foster. 1989. *Two Arks, a Palace, Some Robots, & Mr. Freedom's Fabulous Fifty Acres* (Exhibition catalog). Newark, N.J.: City Without Walls Gallery.

Miller, Arthur. 1995. *Timebends: A Life*. New York: Penguin.

Miller, Naomi. 1982. *Heavenly Caves: Reflection on the Garden Grotto*. New York: George Braziller.

Mina, Gabriele. 2011. *Costruttori di babele: Sulle trace di archiettture fantastiche e universi irregolari in Italia*. Milan: Elèuthera.

Mingus, Charles. 1980. *Beneath the Underdog*. New York: Penguin Books, 1980.

Napolitano, Antonio, Vittorio Avella, Gaetano Peluso, Silvio Stefanile, and Vincenzo Vecchione. 1994. *Macchine da festa, rituali ed artigianato* (Exhibition catalog). Terzigno: Artegram.

Niles, Susan A. 1997. *Dickeyville Grotto: The Vision of Father Mathias Wernerus*. Jackson: University of Mississippi Press.

"Nola," *Enciclopedia Italiana di Scienze, Lettere ed Arti,* Giovanni Gentile, director, Vol. 24 (Rome: Rizzoli & Co., 1934), 887–88.

Pasquini, Phil. 2008. "Capidro." http://www.grassrootsart.net/index2.htm (accessed January 14, 2010).

Patriarca, Gianna. 1994. *Italian Women and Other Tragedies*. Toronto: Guernica.

Plattus, Alan J. 1981. "Emblems of the City: Civic Pageantry and the Rhetoric of Urbanism." *Artforum* 20.1 (September): 48–52.

Posen, Sheldon I. 1986. "Storing Contexts: The Brooklyn *Giglio* as Folk Art." In *Folk Art and Art Worlds,* edited by John Michael Vlach and Simon J. Bronner, 171–91. Ann Arbor, Mich.: UMI Research Press.

Posen, Sheldon I., and Daniel Franklin Ward. 1985. "Watts Towers and the *Giglio* Tradition." In *Folklife Annual 1985,* edited by Alan Jabbour Alan and James Hardin, 142–57. Washington, D.C.: Library of Congress, American Folklife Center.

Prezzolini, Giuseppe. 1963. *I trapiantati*. Milan: Longanesi.

Puzo, Mario. 1985. *The Fortunate Pilgrim*. New York: Bantam Books.

Quimby, Ian M. G., and Scott T. Swank. 1980. *Perspectives on American Folk Art*. New York: Norton.

Repetto, Vittoria. 2006. *Not Just a Personal Ad*. Toronto: Guernica.

Roth, Philip. 1996. "A Conversation with Primo Levi." In *Survival in Auschwitz,* by Primo Levi, 175–87. New York: Touchstone.

Rubini, Irene. 2006. *La Fradaie dai Teracîs e Mosaiciscj Furlans inte Americhe dal Nord/The Fraternity of Friulian Terrazzieri and Mosaicists in North America*, DVD (Arba, Italy: Commune di Arba).

Russo, Alexander. 2001. *Stray Dogs, Saints, and Saviors: Fighting for the Soul of America's Toughest High School*. San Francisco: Jossey-Bass.

Saunders, George R. 1993. "'Critical Ethnocentrism' and the Ethnology of Ernesto de Martino." *American Anthropologist* 95.4: 875–93.

Scambray, Kenneth. 2011. "Creative Responses to the Italian Immigrant Experience in California: Baldassare Forestieri's Underground Gardens and Simon Rodia's Watts Towers." *Italian Folk: Vernacular Culture in Italian-American Lives*, edited by Joseph Sciorra, 63–81. (New York: Fordham University Press).

Sciorra, Joseph. 1989. "Yard Shrines and Sidewalk Altars of New York's Italian Americans." In *Perspectives in Vernacular Architecture, III*, edited by Thomas Carter and Bernard L. Herman, 185–98. Columbia: University of Missouri Press.

———. 1993. "Multivocality and Vernacular Architecture: The Our Lady of Mount Carmel Grotto in Rosebank, Staten Island." In *Studies in Italian American Folklore*, edited by Luisa Del Giudice, 203–43. Logan: Utah State University Press.

———. 2001. "Imagined Places, Fragile Landscapes: Italian American *Presepi* (Nativity Crèches) in New York City." *Italian American Review* 8.2 (Autumn/Winter): 141–73.

———. "Introduction: Listening with an Accent." *Italian Folk: Vernacular Culture in Italian-American Lives*, edited by Joseph Sciorra, 1–10. (New York: Fordham University Press).

———. 2013. "Remembering and Imagining: Italian American Presepi in New York City." *Ethnologie française* 42.1: 109–21.

Scott, Campbell and Stanley Tucci, directors. 1996. *Big Night*. Rysher Entertainment.

Seriff, Suzanne. 1996. "Folk Art from the Global Scrap Heap: The Place of Irony in the Politics of Poverty." In *Recycled, Re-Seen: Folk Art from the Global Scrap Heap Folk*, edited by Charlene Cerney, 8–45. New York: Harry N. Abrams.

Sides, Josh. 2004. *L.A. City Limits: African American Los Angeles from the Great Depression to the Present*. Berkeley: University of California Press.

Skee, Joey (aka Joseph Sciorra). 2008a. "An Epic of Mediterranean Culture." December 23. http://www-i-italy.org/bloggers/5832/epic-mediterranean-culture (accessed February 23, 2009).

———. 2008b. "Holy Land, USA, a Religious Vision in Ruins." May 1. http://www.iitaly.org/bloggers/1897/holy-land-usa-religious-vision-ruins (accessed July 30, 2008).

———. 2012. "The Decorated Flowerpots of Brooklyn." October 17. http://www.i-italy.org/bloggers/34673/decorated-flowerpots-brooklyn (accessed January 16, 2013).

Solberg, Carl E. 1987. *The Prairies and the Pampas: Agrarian Policy in Canada and Argentina, 1880–1930*. Stanford, Calif.: Stanford University Press.

Thompson, Robert Farris. 1984. *Flash of the Spirit: African and Afro-American Art and Philosophy*. New York: Vintage Books.

Tintori, Karen. 2007. *Unto the Daughters*. New York: St. Martin's Griffin.

Tracy, David. 1987. *The Analogical Imagination: Christian Theology and the Culture of Pluralism*. New York: Crossroad.

Trillin, Calvin, 1965. "A Reporter at Large: I Know I Want to Do Something." *The New Yorker*, May 29, 72–120.

Trout, Dennis E. 1999. *Paulinus of Nola: Life, Letters and Poems*. Berkeley: University of California Press.

Turturro, John, director. 1992. *Mac*. Macfilm production.

Vittorini, Elio. 1961. *Conversation in Sicily*. London: Penguin Books.

———. 1968. *Conversazione in Sicilia*. Turin: Giulio Einaudi.

Vlach, John Michael. 1981. *Charleston Blacksmith: The Work of Philip Simmons*. Athens: University of Georgia Press.

Vlach, John Michael, and Simon J. Bronner. 1986. *Folk Art and Art Worlds*. Ann Arbor, Mich.: UMI Research Press.

Ward, Daniel Franklin. 1990. *Authenticity in the Cultural Hybrid: A Critique of the Community Paradigm in Folk Studies*. PhD dissertation, Bowling Green State University (ATT: 9034139). Ann Arbor, Mich.: UMI.

"Watts Towers Tattooed on Brian Portillo." 2006. *Cool Tattoos,* November 13. http://www.cool-tattoos
.com/item/86299 (accessed January 16, 2013).

Wojcik, Daniel. 2008. "Outsider Art, Vernacular Traditions, Trauma, and Creativity." *Western Folklore*
67 (Spring/Summer): 178–80.

Yoder, Don. 1990. *Discovering American Folklife: Studies in Ethnic, Religious, and Regional Culture.* Ann
Arbor, Mich.: UMI Research Press.

Parallel Expressions: Artistic Contributions of Italian Immigrants in the Río de la Plata Basin of South America at the Time of Simon Rodia

George Epolito

The call for papers for the Genova conference "Art and Migration: Sabato Rodia's Watts Towers in Los Angeles" acknowledged that "other Italian workers left the economic wasteland and rigid social hierarchies of their Italian homes during [the] 19th and 20th centuries to risk all in the Americas. Their contributions to New World societies remain vastly under-appreciated." This essay reveals the artistic contributions of these other Italian immigrants in the Río de la Plata Basin of South America—Argentina, Uruguay, and southern Brazil—which ran parallel to the lifetime of Simon Rodia in the Untied States.

As Italian émigrés, Rodia and the future South Americans would share these realities upon departing Italy. Upon arrival in the Americas, however, their experiences as Italian immigrants would become subject to the attitudes and motives of the receiving nations. Initially, more receptive attitudes by the nations in the Basin would eventually serve to propel the Italians and their offspring from the margins of society into the center of zeitgeist debates regarding the development of national cultural identities. As these South American nations were searching to identify themselves individually in the late nineteenth

and early twentieth centuries, artistic expression would intertwine with political aspirations. Italy would experience a similar search for a national cultural identity contemporaneously, thus prompting a fluid cross-Atlantic dialogue with the Italian immigrants of the Basin, a dialogue that Fascist cultural promoters would eventually try to appropriate for their own political gains.

This essay outlines how, through the eyes of Italian immigrants, the common value of the everyday became manifest in hybridized expressions. It also points to the differences in modes of expression of two major groups of contributors in South America. Each Italian immigrant artist ardently searched for a personal means of bridging Mediterranean techniques and aesthetics with South American content. The first grouping of artists concentrated more on social themes through pictorial narratives that were often poignant critiques of everyday life in their countries as experienced by the working-class natives, former slaves, and immigrants. The second major grouping, with some overlap, included avant-garde artists whose works were far less narrative and more abstract in aesthetic expression.

Interwoven into these narratives are questions regarding issues of marginality and displacement: When does an individual, a group of people, or a work of art make the transition from the margins to the center of society? Perhaps more important: What are the factors that allow such a radical change? Who determines when and under what terms this transition may happen?

Displacements, Hyphenated Existences, and Parallel Expressions

The Genova conference placed Simon Rodia and his Watts Towers into contexts of varying scale, ranging from the global to the local, thus unleashing an array of polemical situations and prompting diverse discourses regarding the work's impact. The scales discussed ranged from the immediate neighborhood of the predominantly African American community of Watts to the conflicting cultural establishments of the city of Los Angeles and the state of California, from contributions of Italian American immigrants on the state and national levels to the works of folk artists in a broader context. This essay expands the scope of the discourse by placing Rodia's work within the context of Italian culture and history vis-à-vis other peoples of Latin and African descent, but on an intercontinental level. That is, it examines the artistic contributions of Italian immigrants and their offspring[1] in the South American context during Simon Rodia's lifetime.

While many of the conference debates revolved around issues of historical accuracy regarding the work of Rodia, its symbolic influences and cultural references, its meaning to the local community and to various ethnic groups, how and by whom it should be maintained or preserved, and the subtle meanings of folk or naive art in relation to cultural production, this essay considers such issues only tangentially. The focus of this investigation, instead, emphasizes the commonalities and differences in the experiences of both Rodia and his Italian South American counterparts. It reveals how the act of displacement affected the formation of their hybridized artistic expressions. These expressions reflected the dual nature of a hyphenated existence continually calling into question the degree to which one chose to retain or reject Old World Italian values while venturing forth toward New World identities in the Americas.

Such acts of expressing hybridization were not always well received, nor were they tolerated. Those in control sought to maintain a continuum in societal values by applying

constant pressure on those who had no control but who nonetheless attempted to challenge conventional thought with an outsider's perspective—a flaneur with a critical eye, one might say. Hidden just beneath the surface raged a battle between those at the center of society and those inevitably confined to its margins. Both the Italians in South America and Rodia in North America would share this battle, albeit in very different ways.

In cities such as Buenos Aires, Montevideo and São Paulo, large numbers of people from Italy . . .
began arriving at the end of the nineteenth century. They made healthy contributions to the
developing arts in these capitals.[2]
(SULLIVAN 1996: 11)

Recruitment of Italians into the Americas: The Río de la Plata Basin in South America and the United States in North America

As Italian émigrés, Rodia and the future South Americans would share the struggles of leaving behind the "economic wasteland and rigid social hierarchies of Italy . . . to risk all in the Americas," as previously stated. Yet the story of Italian immigration into the Americas, of course, preceded Rodia's birth.

Italians could be found in the Río de la Plata Basin of South America as far back as the seventeenth century, but their first major impact, one could argue, occurred when Argentina became a republic in the 1820s. Contrary to typical immigration stories that tend to be dominated by the proletariat, this initial impact in Argentina involved the recruitment of Italian intellectuals, both academic and professional, by the founding president of the Argentine Republic. President Bernardino Rivadavia traveled to Europe specifically to establish bonds with universities as a means of strengthening and transforming the image and substance of the country from a former colony into a modern nation (Clemente 1998). Placing Italians in key positions in the academic establishment gave them access to influencing the production of art as a cultural means of expressing national identity. Italians also established the main art academies of Argentina, an act that eventually spilled over into Uruguay. The Brazilians, by contrast, looked to the French to establish their academies.

Beyond this initial recruitment of the intelligentsia from Italy in the 1820s, long before the time of Rodia's departure, massive waves of immigrants went into plantation societies of both North and South America. In rural parts, such as the Deep South of the United States, the Pampas region of Argentina, and the state of São Paulo of Brazil, Italians were set up in agricultural colonies with deplorable living conditions that the American, Argentine, Brazilian, and Italian governments promoted. Italian immigrants were frequently regarded as replacements for the newly emancipated slaves in these various plantation societies, including Uruguay. In time, Italians moved into more urban contexts in the Americas and took on other forms of labor, increasingly required as these societies were modernizing from agriculturally based economies to rapidly expanding industrially based ones.

Unlike the industrializing nations of North America . . . , the Creole political elites of Argentina and
Brazil actively recruited and welcomed Italian migrants as settlers of their rural lands in order to
Europeanize, civilize, and "whiten" their new multi-racial nations.[3]
(GABACCIA AND OTTANELLI 2001: 8)

Diverging Italian Immigrant Experiences in North and South America

In the Americas, however, the experiences of Italian immigrants diverged as they were subjected to the attitudes and goals of their host nations. Success and influence, the speed and extent of transitioning from the margins into the mainstream, were more easily attained, I argue, for immigrants whose host nation initially respected the Italians' skills vis-à-vis their Italianness, as well as their broader traditions of Latinity.

NORTH AMERICA: THE UNITED STATES

The U.S. southern plantation owners also saw the potential of Italians as replacement farm workers for the newly emancipated slaves (Nelli 1983: 50). Italians entered the former Confederacy but did not fit neatly into the existing social and religious order of the region's black–white divide (Nelli 1983: 51). For numerous reasons, Italians began venturing into other parts of the United States (Mangione and Morreale 1992: 213).[4]

Regardless of their point of entry, all Italian immigrants, including Rodia, were commonly subjected to the pressures of assimilation into Anglo-American society. The United States "demanded the complete renunciation of the immigrant's ancestral culture in favor of the behavior and values of the Anglo-Saxon Group" (Mangione and Morreale 1992: 216), a concept that was further reinforced by influential Anglo-Americans such as historian Robert E. Foerster, who in 1919 warned that "In order to be happy in America one must have . . . above all . . . 'a great interest in whatever is American and a high disdain for all that is Latin or that glorifies Latin life'" (Mangione and Morreale 1992: 215).

For the many Italian immigrants who favored assimilation, their preference for Anglo-American values such as individualism often led to the rejection of many aspects of Italianness. Consequently, this Anglicized group, firmly planted on its new soil, I argue, experienced a less fluid relationship with Italy. With his embrace of American individualism, Rodia, it could be argued, fit somewhat into this group, but not totally. He did venture into various parts of the Americas, never returned to Italy, and lived among his Latin (and other) American immigrant neighbors in relative harmony.[5]

SOUTH AMERICA: RÍO DE LA PLATA BASIN

Generally speaking, Italian immigrants in South America did not have to worry about the religious prejudice and/or any anti-Latin bias that occurred in the United States. Many of the Italians who initially landed in the Pampas region of Argentina, known as the Pampa Gringa, took advantage of the alternating harvest seasons of two lands on opposite sides of the equator as seasonal migrant workers. Because of their mobility, as Donna Gabaccia (2001) points out, they were referred to as "birds of passage" or by the Spanish word for swallows, *golondrinas,* and as a result, they felt no allegiance or national affiliation to any one country. This seemingly innocuous sense of mobility and the resulting lack of national allegiance it produced, I argue, set the foundations for a modus operandi of mobility that later generations of artists would also emulate.

This lack of national allegiance also took an unforeseen turn, much to the dismay of the Creole elite. Instead of fulfilling the Creole elite's desires of whitening and civilizing the countryside, many Italians sided with the working classes in rebellion against hege-

monic rule, as Italian exile Giuseppe Garibaldi and many Italian anarchists infiltrated the staunchly conservative political landscape of the region. As Gabaccia illustrates:

> By 1836, [Garibaldi] had organized troops from Italy to support the revolt of the Rio Grande do Sul against what he called the Portuguese imperialism of Brazil. Garibaldi subsequently organized an Italian legion in Montevideo that fought with the rebel "colorados" against the forces of the Argentine dictator General Juan de Rosas. (Gabaccia 2001: 33)

Although the nations that formed the Basin shared with the United States the experiences of being former colonies composed mostly of European elites and commoners, natives, and African (former) slaves, their struggles for independence linked the former more intimately with political struggles in Italy. The political boundaries and identities that define these Latin-based cultures today resulted in part from the battles won under the leadership of Garibaldi and the Italian legions he first organized in South America. Many of these freedom fighters subsequently followed him into battle back in Italy in hopes of unifying the *patria*. Because the United States had gained its independence in the previous century, prior to its absorption of waves of Italian immigrants, Italians had not shared the experience of patriotic bloodshed with North Americans as they instead had done with South Americans.[6] These violent experiences of rebellion that Italians shared with locally disenfranchised peoples created a bond that, when coupled with the political support of Italophiles such as Argentine statesman Domingo Faustino Sarmiento, paved the way for Italianness to seep into the psyche of the newly independent nations of Argentina, Uruguay, and Brazil—regardless of whether it was welcomed.

In the following century, however, large segments of society in the Basin were unwilling to welcome a new wave of Italianness, one that was now associated with Fascism. Mussolini was well aware of the high concentrations of people of Italian descent in the Basin and thus targeted them in hopes that they would play a crucial role in elevating his Fascist Italy to the rank of a global imperial Italy.[7]

Consequences of Recruitment in the Americas and Their Effects on Artistic Expression

The consequences of recruiting Italians into the Americas, it seems, formed the foundation for the hybridized artistic expressions that later emerged. In the Basin, the establishment of fluid relationships with the Old World through mobility, the development of profound bonds resulting from shared struggles in nation building, and the formation of critical masses in important cultural capitals provided an opportunity for the more collectively oriented aspects of Italianness to substantially affect artistic expression in these societies. These critical masses eventually attracted events orchestrated to (in)directly promote Italianness as an (artistic) expression of Fascism.

In the case of Rodia, his relentless sense of individualism, which was a quality often associated with Anglo-American values promoted by Foerster at the time, I argue, influenced his mode of operation in executing an artistic work that firmly expressed itself as a hybridized product of its time and place. Rodia eventually developed masonry artisan skills that he most likely observed while in Italy to passionately create the Towers in Los Angeles during a period in his life that found him operating staunchly alone, even devoid of family.

While these traits may seem fundamentally antithetical to the Italian mores that emphasize family and community they seem to be common features of "naive" artists. As Samuel Becker states, naive artists such as Rodia "carry on their activities quite alone, supported neither by an organized art world or any other organized area of social activity" (Becker 1984: 227; cf. Hernández, this volume). Rodia's Towers were started in the physical margins of a city that was not yet nationally influential as a center of culture but rather was a place that still bore the experimental "final frontier" spirit of the West. While certainly possible, it is hard to imagine Rodia constructing his work in the same manner amid the more collectively conscious-oriented societies populated by large Italian communities in the cultural capitals of Buenos Aires, Montevideo, or São Paulo. At the same time, this does not mean that Rodia's very visible expression of individualism in Los Angeles was well received. Rodia may have embraced many aspects of Anglo-American culture as other coethnics of his generation had done, but Anglo-Americans had not necessarily embraced him. As Becker also points out:

> During World War II neighborhood kids, for whom an eccentric like Simon Rodia was fair game, decided that he was using the Watts Towers to send radio messages to Italian submarines lying offshore and began harassing him in earnest, vandalizing the work extensively.[8] (Becker 1984: 268)

Sharing experiences of struggle for acceptance perhaps led Italian immigrants in North and South America to highlight a common interest in the everyday conditions of their lives through various means of artistic expression. For Rodia, this aspect was realized in the materiality of the Towers, where broken pieces of ceramics and shards of glass were taken from everyday objects and applied using Mediterranean masonry techniques commonly found in Italy. In the Basin, though, there were two contrasting trends that the Italian South American artists investigated, albeit with varying degrees of overlap.

The first group, while generally focusing on themes with direct social content, wished to transcend the subject of "the everyday" by revealing the harsh reality of life in their (or their parents') adopted countries, employing the sophisticated techniques learned from Old World masters, particularly from Italy. These artists found communication essential to their work, absorbing knowledge from European masters through travel, through collaborative efforts with other Latin Americans, and from each other, by forming subgroups such as the Taller Mural and the Família Artística Paulista. This value of communication, favoring the collective, was in stark contrast to Rodia's intensely individualistic approach.

For the South Americans, the plight of the working classes—be they of native, African, mixed race (mestizo), or other immigrant descent—became a compassionate focus in their work. These artists—such as Antonio Berni, Reinaldo Gíudici, Lorenzo Gigli, and Eduardo Sívori in Argentina; Pedro Figari, Alfredo de Simone, and Carlo Prevosti in Uruguay; Alfredo Volpi, Fulivio Pennachi, Cândido Portinari, Jose Pancetti, and Emiliano di Calvacanti in Brazil—could all be likened to the flaneurs in French painting, in the sense that they acted as out-of-frame observers, positioned at the margins—an ambiguous zone similarly experienced by Italians in the Deep South of the United States. Yet they were not casting their gaze on the romantic scenes of genteel Parisian park settings; instead, as foreigners, they were critically observing the relationship between the central figure of the colonizer and his former slave, native, or mestizo. Sometimes it was the simple admiration of Afro-Uruguayan or Afro-Brazilian dance scenes, workers in the

countryside, or ordinary street life in urban contexts. Utilizing a peripheral strategy, they were viewing the destiny of the proletariat by stepping outside the context into which they had been originally forced to serve as "whitening" tools by the Creole elite.

The second grouping rejected the descriptive qualities of realism, preferring to express aspects of the everyday through the more abstract methods of modernism that were evolving in Europe at the time. They placed a higher demand on exploring aesthetic value, thus finding similarities with metaphysical and futurist painters in Italy. Some merged local conditions with surrealistic compositions in such a way as to transform them into magical realism, a regionally shared cultural value found in Latin America in other creative genres as well. In this vein, one could argue that the South Americans and Rodia mystically combined European techniques with unrelated fragments from everyday life into abstract artistic expressions, and although articulated very differently, the resulting works may be interpreted as critical reflections of the very societies in which they were produced.

It is a language in which contemporary lessons and historical inheritance—especially from Italian art—are united in the search for an identity. There is a union of apparent opposites—critical discourse and formal abstraction; the social theme and the immobility of the destiny of men of the soil; and realism of popular types and the category of the marvelous that resides within Latin American reality.

(PACHECO 1992: 141)

Social Themes in Río de la Plata: Buenos Aires, Argentina

The symbiotic condition resulting from the arrival in Argentina of Italian masters, the influx of immigrants in great numbers from Italy, the founding of art institutions with strong academic Italian roots such as the Academia de la Sociedad Estímulo de Bellas Artes, an official center of learning (Pacheco 1996: 284), and the establishment of scholarships to study abroad in places such as Italy allowed artists to freely exchange ideas and skills. They achieved this at home and abroad by continuing the tradition of return travel to the Old World, particularly Italy and France, as modern-day birds of passage, reflecting the times of their migrant worker forebears from the Pampa Gringa.[9]

For Italian Argentine artists, the act of mobility during the years 1875 until 1945 exposed them to the shared pangs encountered in the building of national identities and institutions stemming back to the times of Garibaldi to the age of industrialization and through the world wars on both sides of the Atlantic. A keen social conscience arose through their experiences of viewing firsthand the rigors of everyday urban and rural life in the Italian and Argentine political and social landscapes, which, in turn, inspired these artists to explore themes of hardship in their artistic expressions. They were highly influenced by the academic training they received from Italian maestros in the fine arts both at home in Argentina and on their visits to Italy. As Argentine art historian Marcelo Pacheco explains:

> Travel in Italy, and the influence of teachers from northern Italy, were keys to the theme of social realism in this generation. The artists lived their formative years in a country, namely Italy, that was convulsed by social struggles, and those struggles were reflected in the works of the naturalist painters. (Pacheco 1992: 141)

These works did not romanticize the struggles but instead were used as means of criti-cally exposing an undesirable condition within society. The artists, now thrust into the political arena, thought their exposé would serve as a means of educating all peoples re-garding the plight of those suffering at the margins, thus triggering social transforma-tion. (Pacheco 1992: 123)

Through the lessons learned from such a critique, these painters were able to create hybridized expressions of art by adapting Old World techniques with Argentine content. In this case, the resulting works were executed with a greater level of academic sophisti-cation than the more intuitively derived technical achievement of Rodia's work. His steadfastly independent manner, years removed from his time spent in Italy, produced an artistic work that can be interpreted as a very personal critique at a localized scale of many of the aspects he disdained about American life, but it does not seem that he har-bored any grand desire to use his artistic expression as a communicative tool on a national scale of critiquing life in the United States, nor back in the *patria*, as the Argentines did.

As a consequence of consciously conceiving their works as integral parts of their immediate lives in Argentina, the Italian Argentines suffered economically. Patrons of the arts with the financial means to purchase the works preferred not to support those who were criticizing the way in which their wealth had been accumulated. The marriage of Old World professional expertise with the unpleasant dark side of prosperity in the New World was of no interest to those who controlled the cultural production of art.

It is important to note that these hybridized artistic expressions of the everyday were in and of themselves fluid. The works did not become the mere transference of Italian-ness to a New World context, subjecting them to a fate of stagnation. On the contrary, they evolved over time by paying homage to other epics in Italian art. Pacheco explains how during the 1920s and 1930s, artists transformed "daily reality into magical reality, with the suspension of time and space, together with a constructive trend in their draw-ing and color. One of the reasonable explanations for this phenomenon," he argues, "is the strong influence that Italian art of the 1300s, the 1400s, and [the] early twentieth century had on them" (Pacheco 1992: 141).

During the 1930s and 1940s, politically and socially conservative Argentine circles continued to look unfavorably on such works and their creators, confining the expression of social realism to large-scale easel paintings. In contrast, a more liberal Mexican society allowed social themes to enter into the public realm by way of the large-scale mural paint-ings by iconic figures such as Diego Rivera. For progressive Argentine artists, the less permanent form of display was a compromise at best, but they still used it in order to ex-ploit art as a communicative act. The son of an Italian immigrant, Antonio Berni, together with Lino Edeas Spilimbergo and Juan Carlos Castagnino were instrumental in forming the Taller de Arte Mural (Mural Art Workshop) in 1943, a group that sought to fight against the limitations imposed on them by the conservative establishment. This group of artists had not only searched for dialogue with other artists and maestros in the Old World, they had created a venue for themselves to do so at home on a daily basis.

Montevideo, Uruguay

As with many aspects of life that often spilled over from Argentina into Uruguay, so too did the influence of Italian immigrants from the freedom-fighting legions of Garibaldi to

later artistic expressions. Participants in defining a national character of Uruguayan art included Pedro Figari, Alfredo De Simone, and Carlo Prevosti. Like the Argentines, Pedro Figari strove to be a champion of social justice but not initially through artistic expression. Born the son of an Italian immigrant father, he was self-taught in the arts. As a skillful lawyer and writer for the major part of his life, Figari was credited with rectifying many social injustices. He took up painting seriously at the age of sixty, but unlike his neighbors, he painted scenes not from his daily reality but rather from the memories of his youth. Like many Argentine and Brazilian painters of Italian origin, he depicted the everyday lives of people of African descent in favorable ways not typically seen in the 1920s, given that racism was rampant in this part of the world. Mobility also played an important role in his art but not as we have typically seen with Italian Argentines. His physical and intellectual fluidity took place between the artist circles of Buenos Aires and Montevideo, as he spent only a very brief time in Italy studying art.

Born in Italy and raised in Uruguay from the age of three, Alfredo De Simone also had a great impact on the national character of Uruguayan art. In the 1920s, his works were more reminiscent of the times in Montevideo, where he found a passion for scenes of everyday life, neighborhoods streets lined with tenement houses.

São Paulo, Brazil

Social themes that focused on the everyday emerged in Brazil as well, albeit a bit later than they had in Argentina. In the latter part of the 1930s, a group of artists formed the Família Artística Paulista. They were also associated with the Grupo Santa Helena, which was composed of countless painters of proletarian Italian origins. The Família had much in common with the artists of Argentine social realism in that they were both composed of members whose humble origins led many to explore nationalistic themes with a social agenda. In contrast to the Argentines' pictorial realism, the Família preferred more experimental modes of expression. Some of the first members whose works focused on themes of the working classes included Aldo Bonadei, Alfredo Volpi, Mario Zanini, Fulivio Pennachi, Anita Malfatti, Hugo Adami, Paulo Rossi Osir, and Cândido Portinari.

Cândido Portinari was born in abject poverty to an Italian immigrant family that worked the fields of the coffee and cotton plantations in the state of São Paulo. In the late 1930s, many of his compassionate works drew favorable comparisons with the works of Antonio Berni in neighboring Argentina. Portinari's enthusiasm for social themes also extended to Brazil's former African slaves, as did Figari's in Uruguay, except that Portinari's works empathetically portrayed their specific human situation in such a bold way as to transform the works into a social surrealism.[10] By the end of the decade, he was known in the United States, having painted three murals for the Brazilian pavilion at the New York World's Fair. Today, in comparison to the iconic figure of Mexican muralist Diego Rivera, Portinari remains relatively obscure, decidedly marginalized. His interior wall murals with their local agricultural and working man themes of the late 1940s, together with his mural entitled *War and Peace* in the headquarters of the United Nations in New York in the early 1950s, should have placed him on an equally iconic platform, but they have not.

Born in 1896 in Lucca, Italy, and raised by Italian immigrant parents in São Paulo, Alfredo Volpi was a self-taught painter. His socially themed works were initially more pictorial in expression, which he modified over time. It was his inventive compositions and a

penchant for the craft of painting, however, that distinguished his works enough to move Volpi to the center of the art establishment of Brazil. At the 1953 São Paulo Bienal, he was awarded (with fellow Italian Brazilian Di Cavalcanti) the prize for the Best National Painter.

At first glance, these socially thematic works manifest a materially different form of expression to that of Rodia's, but they all were commonly influenced by the everyday life in which they lived, involving people of the Iberian peninsula, albeit powerful oligarchs in South America, people of African descent, and the Italian immigrant artist as the flaneur.

Argentina owes its priority and prestige in the modern art movement of Latin America largely to the pioneer work of Emilio Pettoruti in painting.
(CHASE 1970: 128)

The Rise of the Avant-Garde: Buenos Aires, Argentina

Contemporaneously, but often seen in opposition to social realism, there were artists seeking to introduce modern art principles into Argentina. First-generation Argentines of Italian descent became the central figures in defining it. A key contributor to the exploration of modern trends with a localized character was Italian Argentine Emilio Pettoruti (b. 1892). Gilbert Chase, in his *Contemporary Art in Latin America*, credits Pettoruti for being "the first abstract painter of Latin America to develop a consistently modern style that was both personal and contemporary" (Chase 1970: 128).

After being awarded a grant to study in Europe, Pettoruti ventured to Florence in 1913, where he intellectually immersed himself in progressive Florentine circles (Chase 1970: 128). He was soon meeting regularly with many avant-garde futurist artists and writers. While in Italy, Pettoruti met such influential figures as futurism's founder, Filippo Tommaso Marinetti; Mussolini's cultural promoter and cofounder of *il Novecento Italiano* art movement, Margherita Sarfatti; Florentine futurist painter Ardengo Soffici; and *il Novecento* painter Giorgio de Chirico.[11]

Futurism and social realism as movements were similar in intent in that they both sought to criticize the social status quo, but their means of execution were starkly different, with the former steering away from overtly pictorial scenes and favoring the more obscure, abstract forms of expression, as did many other avant-garde movements of the time. Pettoruti returned to Argentina in 1924 to the derogatory label of "futurist painter" and was shunned by social realist painters. Nonetheless, he planted himself in his native country for the next twenty-eight years, until 1952, when he yielded to the allure of returning to Italy, in true bird-of-passage form.

While in Argentina, Pettoruti contributed to the cross-Atlantic dialogue between Italian masters and artists in the Basin, by organizing at the bequest of Sarfatti the *il Novecento Italiano* art exhibition.[12] The 1930 exhibition, which took place in Buenos Aires and Montevideo, collectively presented the works of metaphysical painters such as Carrà, Morandi, De Chirico, and Soffici. Argentine scholar Diana Wechsler pointed out that the works of the exhibition influenced many artists in the Basin, including Italian Argentine artists such as Antonio Berni, Victor Cunsolo, Fortunato Lacámera, and Onofrio Pacenza, as well as Italian Uruguayan Carlo Prevosti. Wechsler also explained that there was a political dimension to the project: "Sarfatti intended to present *il Novecento* in Buenos Aires as an art of the State, born from the emotion of war and the redemptive work of Fas-

cism" (Wechsler 2003: 27).[13] Although the South American artists may have been influenced aesthetically, they distanced themselves politically from the Italians.

Joining Pettoruti on his initial voyage to Italy was a fellow Argentine adventurer–artist, Xul Solar. Born Oscar Agustín Schulz Solari (1887–1963) to German and Italian parents who migrated to Argentina, Solar also exhibited his work in Italy, first in Florence in 1920. Like Pettoruti, he returned to Argentina in 1924, where he joined the avant-garde group Martin Fierro and exhibited in the Salon Libre. Having no formal training as an artist, as was the case with Figari, Volpi, and Rodia, the free-spirited Solar felt no need to limit his creative expressions to any one genre. This eccentric personality became a noted figure within the various artistic communities of Argentina. The internationally acclaimed Argentine author Jorge Borges wrote of Solar:

> His paintings are documents of the ultraterrestrial world, of the metaphysical world in which the gods take on the imaginative forms of dreams. The passionate architecture, the felicitous colors, the numerous circumstantial details, the labyrinths, the angels and the homunculi, unforgettably define this delicate and monumental art. (Svanascini 1962: 7)

In viewing the works of Solar, there is something peculiarly reminiscent of Rodia's Towers. Their works of bricolage, fancifully created out of colorful fragments, form other-world environments that provide the observer with spiritual experiences that vary with each encounter. Perhaps a certain level of freedom or naïveté that is afforded untrained artists allows for such magical expressions to flourish.

Of the artistic expressions of Italian Argentines recognized in the Americas and Italy, most remained relatively marginalized compared with the works of Lucio Fontana (1899–1968), who ascended in the international art scene by founding spatialism *(Spazialismo)* in 1946. Fontana, like so many other Italian Argentine birds of passage, spent long periods of time alternating between Italy and Argentina. Upon returning to Buenos Aires from his latest stint in Italy in the 1940s, he and some of his students founded the Escuela Altamira, which became a place to exchange ideas. In 1946, he published his acclaimed *Manifesto Blanco* (The White Manifesto).

His signature paintings, however, were created while working again in Italy in 1958, roughly around the same time that Los Angeles authorities sought to demolish Rodia's Towers. Completely devoid of any figural reference to social themes, Fontana began his revolutionary treatment of slashing and puncturing the canvas itself. As Pacheco explains: "The conceptual and plastic tension of Fontana's 'cut' canvases, which he had completed in Milan, explored issues of density and space" (Pacheco 1996: 293). Fontana eventually went on to be associated with the well-known Italian movement *Arte Povera*, which focused on critiquing established institutions. His illustrious career thrust him beyond the artistic mainstream of any one nation and into the elite world of international art. While Pettoruti and Solar rubbed elbows with the likes of futurists and great avant-garde thinkers of the time, Fontana actually became one in his own right.

[São Paulo's] elite aristocratic landowners visited Europe annually, bringing back contemporary art and the latest aesthetic ideas which were circulated with unparalleled speed. The lack of artistic and cultural institutions in a city undergoing rapid urban transformation fostered a new aesthetic, in reaction to the conservative tendencies of Brazilian art.

(MESQUITA 1996: 203)

It was the art of Anita Malfatti (1889–1964), exhibited in 1917 in São Paulo, that unleashed the modernist movement in Brazil.
(MESQUITA 1996: 203)

São Paulo, Brazil

There was a fundamental difference separating the Italians who entered Brazil from those who ventured to the Spanish-speaking countries of the Basin. In Argentina and Uruguay, Italians could be found in great numbers in the cities that were the centers of politics, economics, and culture—Buenos Aires and Montevideo, respectively. At the time of Italian immigration, however, Brazil boasted of two major cities, with Rio de Janeiro holding the prominent position as its political and cultural center, while São Paulo was emerging as its economic center, a magnet for opportunity-seeking groups such as Italian immigrants. This seemingly trivial difference of settling in São Paulo rather than the cultural capital of Rio had profound consequences on the role Italians would or would not play in constructing a national cultural identity of Brazilianness, *brasilidade*.

Another crucial difference was that Argentina had invited Italian intellectuals to found its art academies, while Brazilians, under the guidance of Dom João VI, displaced from Portugal, invited the French Lebreton Artistic Mission to establish the Royal Academy in Rio in 1816. Thus, during the early 1800s, with Rio serving as the cultural and political capital of the entire Portuguese Empire, French aesthetic influences gladly satisfied the traditionalist appetites of the Creole elite and relocated European royalty.

Even as Brazil entered the twentieth century as a republic, Rio retained its position as the cultural and political heart of the country. However, with the economic center of the country now firmly displaced to São Paulo, Rio found itself in serious competition for national dominance (Mesquita 1996: 202). This shift caused a schism between the two cities, raising the question of whether one could lay claim to being the authentic representative of the national cultural identity of *brasilidade*. Rio represented the establishment and its traditional aesthetic tastes, while the more entrepreneurially spirited São Paulo, with its largely diverse populations of nouveau riche immigrants, represented a potentially more progressive image. São Paulo was, as Andrea Giunta points out,

> a landscape ripe for Futurism that, in opposition to the substitutional break with the past beloved of the Italian movement, would propose a new image charged with localisms. It would vindicate invention and surprise from a culture that already existed, in fact a complex reality, superimposed and impossible to abandon.[14] (Giunta 1996: 56)

As a means of advancing their emerging national cultural identity, one that was undeniably set within the localized conditions of Latin America, Brazilians also traveled to the Old World for inspiration—however, more often to countries other than Italy. This act of mobility could falsely be viewed as an acknowledgment of the superiority of the Old World with the implication that Latin American cultures were inherently inferior.[15] On the contrary, it might be conceptually interpreted as a modern-day implementation, found commonly in the former Roman Empire, of the medieval act of recycling or reappropriating, known as *Spolia*. As the impoverished people scavenged the former Roman works of architecture for fragments to reconstruct their new churches, Brazilians similarly scavenged ideas from the European masters in order to merge them with local con-

ditions in imaginative ways, creating hybridized expressions, or bricolage, that defined *brasilidade*. As art historian Edward Sullivan has noted, Brazilian critic and philosopher Oswald de Andrade

> wrote about the need to "cannibalize" from Europe in his Anthropophagite Manifesto (1928), in which he emphasized the necessity to appropriate and reconstruct, in a revolutionary way, both ideas and images from elsewhere. This notion has little to do with eclecticism. (Sullivan 1996: 14)

The appropriated or cannibalized products of this modern example of *Spolia* stood in contrast to erudite forms of eclecticism created by artists and architects who were typically educated at professional academies. The works of Italian Brazilians and Rodia are linked in that they each employed this modern version of creation that was based on the reassemblage of appropriated or cannibalized materials and ideas and that they were made possible in the culturally experimental environments fostered by the rapidly growing cities of São Paulo and Los Angeles.

Aspects of the Anthropophagite Manifesto could already be found in 1917 in the works of an Italian Brazilian from São Paulo, Anita Malfatti. After studying abroad, she returned home and created a stir in the Brazilian art world with her fusion of various European modernist trends and techniques with Brazilian content. Although widely recognized as the person who introduced modernism in art to Brazil—quite an accomplishment for a woman and a child of Italian immigrants—she was not always well received by the art establishment, with one critic in particular, Monteiro Lobato, writing a scathing article denouncing her work. Yet she did have her supporters in the important art figures Oswald de Andrade and Mario de Andrade (no relation), who saw the importance of her work in establishing a localized interpretation of European modernism. The nonestablishment orientation of 1920s São Paulo provided ideal conditions for the city to become the center of avant-garde activities for artists such as Malfatti. In 1922, to mark the centennial anniversary of Brazil's independence from Portugal, a symbolically liberating art exhibition was launched, the *Semana de Arte Moderna*. Malfatti participated in the event, but her works appeared tame compared with her earlier ones.

In the 1930s, as a result of the Great Depression and the collapse of the world economy, São Paulo's position as Brazil's capital of avant-garde culture was weakened as its coffee industry suffered greatly. Consequently, Rio and São Paulo continued their regional battle for cultural authority of *brasilidade*, with avant-garde activities being dealt a further blow with the rise to power of conservative Getulio Vargas, a man who held the Italian Fascist dictator Benito Mussolini in great esteem. As both leaders struggled to define their national cultural identities of *brasilidade* and *italianità*,[16] respectively, the latter crept its way into the Brazilian debate. São Paulo still provided a forum for deliberation for groups of artists such as the Família Artística Paulista and an opposing avant-garde group, Salão de Maio.

The Família group expanded to include artists such as Italian Brazilians Ernesto de Fiori, Paulo Sangiuliano, Vicente Mecozzi, and Bruno Giorgi, who were not necessarily focused on social themes but perhaps more interested in pushing boundaries by investigating experimental modes of expression. As a whole, the work of the Família group received both derision and praise, as had Malfatti's previously. Their Italian connections, both in terms of heritage and passion for the Italian masters, subjected them to scornful

criticism by Geraldo Ferraz, a steadfast defender of the Salão de Maio group. He mocked the Família group as "traditionalists, defenders of *carcamanismo* art of *Paulista* culture, who loved to death the processes of Giotto and Cimabue."[17] In an era when international artists were seeking avant-garde languages, the Família group was more interested in refining the craft of painting through the development of "a vocabulary using regional colours and based on the teaching of the great masters in art history, above all the Italians and Cézanne" (Mesquita 1996: 209). Mario de Andrade found merit in this type of exploration by praising the ability of its members "to carry on a conversation about the differences in the brush strokes of a Rafaello and of a Tiziano, knowing what it means to link one color to another."[18] As a group, they refused to be confined by the dogma of any particular movement, choosing instead, I would argue, to emulate Oswald de Andrade's philosophy of appropriation and reconstruction of ideas, images, and techniques from any of the trends of the era, such as fauvism, cubism, futurism, and surrealism. Their travels in Europe, as mobile Brazilian variants of artistic birds of passage, exposed members of the Família to such movements.

Politics is how they array power, how winners and losers in a society are determined.
(MITCHELL 2001: 13)

Conclusion

Historic events, of course, affected the artistic expressions of Italian immigrants and their offspring who migrated to the Basin. The initial welcome that the ruling Creole elite expressed toward the immigrants placed the latter group in varying roles: from founders of educational and professional institutions to mere tools of whitening and civilizing of the rural masses. Much to the dismay of these elite, Italians formed strong bonds with the disenfranchised proletariats made up of locals and other immigrant groups. Consequently, they first fought for freedom against hegemonic rule in the Basin and later returned home as experienced freedom fighters, as Garibaldi's birds of passages, who battled for the unification of Italy.

This act of transience, together with Italian influence in many academic institutions, I have argued, formed the basis for formulating cross-Atlantic artistic voyages more frequently for South Americans than for North Americans. These factors lent themselves to cross-cultural dialogues based on mutual respect between the emerging nations of the Basin and a recently unified Italy.

Because large Italian immigrant populations lived in key cultural capitals in the Basin, they had easy access to the debates regarding national cultural identity in the arts. This seemingly meaningless coincidence actually provided opportunities that, in turn, allowed many Italian immigrants and their offspring to often become central figures in the establishment of these emerging national cultural identities.

Yet because these cultural capitals were also imbued with political significance, their Italian expatriate communities eventually became susceptible targets of Fascist ideologues. In the minds of the Fascists, these communities were composed of Italian citizens merely displaced in South American colonies but eager to participate in the rebirth of a global imperial Italy. In order to accomplish their transatlantic vision, the Fascists

employed a strategy of intertwining artistic expression with political aspiration. An example of this strategy may be found in Sarfatti's *il Novecento Italiano* exhibition in Buenos Aires and Montevideo, where she tried to link Italian artistic expression with Fascist political achievements in hopes that (Italian) Argentine and Uruguayan artists would do the same. Many of these South American artists did, in fact, appropriate trends and skills from European countries such as Italy, but they also innovatively embedded their artistic works with localized meanings representative of new nation states in the Basin, not of a global imperial Italy. In other words, these artists chose to appropriate or cannibalize what they deemed fit from the Italians but not Italian politics.

The works of artists of Italian descent in the Basin and Rodia shared this common spirit of cannibalizing ideas, materials, and methods in order to reconstruct new forms of hybridized artistic expressions. Rodia cannibalized materials in a manner similar to the Italian medieval act of *Spolia*. Yet Rodia differed from his Italian South American counterparts, in that he had no interest in contributing to a discourse that may have placed his creation within a collective national identity. He also did not suffer from being targeted by Fascist ideologues (cf. Del Giudice, this volume). Much to the dismay of the Watts neighborhood kids, his Towers were not used to transmit messages as part of a global Fascist strategy of Mussolini or his Axis partners.

Another common factor shared among the artists of Italian descent in the Americas was that they occupied the margins of society, albeit in different ways. Those who represented the cultural establishment in the highly influential United States, as well as the Creole elites in Argentina and Brazil, often determined that immigrants of Italian origins were not authentic representatives of American national cultural production. Some artists, such as Pettoruti, Solar(i), and Fontana in Argentina, Figari, De Simone, and Prevosti in Uruguay, and Portinari in Brazil, were able to escape the confines of the cultural margins. Yet others, such as Antonio Berni and the members of his Taller de Arte Mural struggled against the conservative nature of Argentine society, while in Brazil, Anita Malfatti and her colleagues of the Família Artística Paulista suffered the wrath of acerbic criticism. Regardless of their battles with the cultural establishments in their respective countries, these artists were eventually nationally recognized for their accomplishments. Within the broader international context, however, one must ask whether these artists are, with the exception of Lucio Fontana, destined to remain in the margins to which all Latin American artists have been relegated, as they continue to endure the pejorative labels of "exotic" and "primitive" that powerful Eurocentric and North American art establishments continue to use (Sullivan 1996: 14).

Perhaps we may draw a parallel here within the context of the heated debates that (inadvertently) dealt with identity politics at our Genova conference. The Watts Towers were originally conceived on a site that was at the margins of a sparsely populated Los Angeles at a time when the city itself was at the margins of American cultural production. Few cared what this eccentric Italian immigrant was doing until Los Angeles grew to absorb the area geographically, while also rising in importance as a center of cultural production in its own right. As the context of the Watts Towers transformed from the margins to the center, debates arose in Los Angeles regarding whether the Towers should be maintained or destroyed. With the first battle won against city bureaucrats who advocated demolition, current debates such as those at the conference have also been transformed. In

a world-class city that still lacks an iconic identifying structure such as an Eiffel Tower or a Statue of Liberty, some argue that the Watts Towers should represent that iconic image for the city. Others identify with the Towers as a neighborhood landmark that continues to act as a catalyst for local activities and is a locus of art and festivals. Still others identify with the work as a representation of an immigrant narrative that risks being forgotten in time, as generations continue to assimilate into the American mainstream.

As the meaning and value of Rodia's work continue to fluctuate between the social margins and the center, as did the works of Italian South Americans (albeit for different reasons), a couple questions remain pertinent today: Who in any society is deemed worthy of deciding which cultural productions shift from the margins to the mainstream? What are the determining factors that allow such a shift to occur? How and when, if ever, does this shift take place?

Works Cited

Barnitz, Jacqueline. 2001. *Twentieth-Century Art of Latin America*. Austin: University of Texas Press.

Becker, Howard Saul. 1984. *Art Worlds*. Berkeley: University of California Press.

Chase, Gilbert. 1970. *Contemporary Art in Latin America*. New York: Free Press.

Clemente, Hebe. 1998. "Las Artes y La Arquitectura Italiana en la Argentina Siglos XVIII y XIX." Translated by Maria Carrión Georges and author. http://www.proa.org/exhibiciones/pasadas/italianos /exhibi-fr5.html (Accessed June 10, 2002).

Devoto, Fernando J. 2001. "Programs and Politics of the First Italian Elites of Buenos Aires, 1852–80." Translated by Amy Ferlazzo. In *Italian Workers of the World: Labor Migration and the Formation of Multiethnic States*. Urbana: University of Illinois Press.

"Família Artística Paulista." 2002: "Família Artística Paulista." Translated by Federico Ramos Domingues. http://www.pitoresco.com.br/brasil/grupos/fam_artrist.htm (Accessed July 15, 2002).

Finchelstein, Federico. 2010. *Transatlantic Fascism: Ideology, Violence, and the Sacred in Argentina and Italy, 1919–1945*. Durham, N.C.: Duke University Press.

Gabaccia, Donna R. 2001. "Class, Exile and Nationalism." In *Italian Workers of the World: Labor Migration and the Formation of Multiethnic States*, edited by Donna R. Gabaccia and Fraser M. Ottanelli. Urbana: University of Illinois Press.

Gabaccia, Donna R., and Fraser M. Ottanelli, eds. 2001. "Introduction." In *Italian Workers of the World: Labor Migration and the Formation of Multiethnic States*. Urbana: University of Illinois Press.

Goebel, Michael. 2010. "Gauchos, Gringos, and Gallegos: The Assimilation of Italian and Spanish Immigrants in the Making of Modern Uruguay 1880–1930." http://past.oxfordjournals.org /content /208/1.to (Accessed May 29, 2012).

Giunta, Andrea. 1996. "Strategies in Modernity in Latin America." In *Beyond the Fantastic, Contemporary Art Criticism from Latin America.*, edited by Gerald Mosquera. Cambridge, Mass.: MIT Press. 52–66.

Harrison, Lawrence. 1997. *The Pan-American Dream*. New York: Basic Books.

Mangione, Jerre, and Ben Morreale. 1992. *La Storia: Five Centuries of the Italian American Experience*. New York: Harper Collins.

Mesquita, Ivo. 1996. "Brazil." In *Latin American Art in the Twentieth Century*, edited by Edward Sullivan. London: Phaidon Press. 201–32.

Mitchell, Don. 2001. *Cultural Geography: A Critical Introduction*. Oxford: Blackwell Publishers.

Nelli, Humbert S. 1983. *From Immigrants to Ethnics: the Italian Americans*. Oxford: Oxford University Press.

Pacheco, Marcelo. 1992. "An Approach to Social Realism in Argentine Art 1875–1945." *Journal of Decorative and Propaganda Arts, 18: Argentine Theme Issue*. Miami: The Wolfson Foundation of the Decorative and Propaganda Arts. 122–53.

———. 1996. "Argentina." In *Latin American Art in the Twentieth Century*, edited by Edward Sullivan. London: Phaidon Press. 283–99.

Sullivan, Edward. 1996. "Introduction." In *Latin American Art in the Twentieth Century*, edited by Edward Sullivan. London: Phaidon Press. 8–15.

Svanascini, Osvaldo. 1962. *Xul Solar*. Buenos Aires: Ediciones Culturales Argentinas.

Wechsler, Diana B. 2003. "Da una estetica del silenzio a una silenziosa declamazione. Incontri e appropriazioni di una tradizione nelle metropoli del Ro de la Plata." [From an aesthetics of silence to a silent rhetoric. A tradition of encounters and appropriations in the metropolitan cities of the Rio de la Plata]In *Novecento sudamericano: Relazioni artistiche tra Italia, e Argentina, Brasile, Uruguay,* [In the South American twentieth century: Artistic relations between Italy, Argentina, Brazil, and Uruguay] translated by author. Milan: Skira editore.

The Watts Towers Contested: Conservation, Guardianship, and Cultural Heritage

Fifty Years of Guardianship: The Committee for Simon Rodia's Towers in Watts (CSRTW)

Jeanne S. Morgan

Early History of CSRTW

Over fifty years ago, in 1958, William Cartwright and Nicholas King purchased the abandoned Watts Towers site and founded the guardianship group called the Committee for Simon Rodia's Towers in Watts (CSRTW). Only four of the original fifty charter members are alive today [2013]: Erica Kahn, Lucille Krasne, Jody Farrell, and myself. Membership, however, has always waxed and waned and has thus proven a challenge because CSRTW is committed to contesting, when necessary, city or state treatment of the Towers—not an entirely easy or popular activity.

In 1961, Cartwright and King deeded the Towers to CSRTW, believing that the group's oversight could provide stronger guardianship than they, alone, could personally achieve.[1] Almost immediately the Committee met a seemingly overwhelming problem that threatened to cancel their plans to maintain and exhibit the Towers. The city's Department of Building and Safety had issued a demolition order against the Towers site. The great sculptures had been condemned to destruction as a public hazard.

The group overcame its consternation and began organizing a protest against this barbarous city order. Engineers and architects offered opinions, and thousands of signatures were gathered on a petition to cancel the demolition order. But the Building and Safety Department was adamant. Then, a young engineer with an aerospace background,

Bud Goldstone, appeared with a remarkable plan based on his perception that the big towers exhibited the use of aerospace principles. He convinced CSRTW leadership that a load test of 10,000 pounds could be successfully performed on the largest structure, the center tower, proving the stability and strength of the sculptures and thus canceling the city's demolition order. CSRTW's distraught and conflicted Board of Directors approved this plan by only one vote. The Committee lawyer convinced the city that this was a workable plan, the test was set up to stress the center tower with a load equivalent to an eighty-mile-per-hour gale.

This stress test was successful, fortunately, on October 10, 1959. The head of Building and Safety acknowledged the test's success, the demolition order was canceled, the Towers were saved. With the nightmare and drama of the test gone, CSRTW began its management of the Towers by setting up full-time public exhibition. A small entry fee was charged, and the site was kept open every day of the year, with gatemen hired from the neighborhood.

Maintenance of the Towers began with a process of filling the many cracks with cement mortar. At that time the very term "conservation" had not been applied to such work. CSRTW archivist, Kate Steinitz, launched a vigorous campaign to increase national and international connoisseurship for Rodia's work. An accolade for the Towers' merit came from the Eleventh International Congress of Art Historians, meeting in New York, in 1959. The resolution of delegates representing thirteen countries, read: "The Towers are a unique combination of architecture and sculpture and the paramount work of twentieth century folk art in the United States."

CSRTW's architects built a wooden platform over the footprint of Rodia's house, which had burned down years before. This modest facility became a stage where the first free art classes for Watts children were held, led by volunteer, Lucille Krasne, a children's art instructor from the Pasadena Museum of Art. She gathered children for the classes by going door to door in the neighborhood, inviting one and all.

Rodia Builds the Towers

Nearly 100 years ago, about 1920, when Rodia moved from Long Beach to Watts, he settled among windmills, dirt roads, and fields of yellow wild mustard stretching into the distance. In the middle of the country community, the hub of the great Pacific Electric Car terminal (opened in 1904) spread its tracks outward in all directions: to the beaches, the downtown city, the mountains. Was this splendid transportation system, called "the Big Red Cars," a factor in Rodia's choice of a small triangular lot at the eastern dead-end of 107th Street, next to the Pacific Electric railroad tracks? Certainly, the location guaranteed a daily audience of thousands. The railroad line also became his primary tool for building the Towers; he bent steel rebar under the tracks using only his body weight. This technique provided all the arcs in the many smaller pinnacles and the three huge towers.

That Rodia may have contemplated building something in Watts with reinforced cement seems possible since he had already built a tremendous merry-go-round structure on his Long Beach property for the neighborhood children. When a CSRTW member visited the Long Beach site in 1959, Rodia's structures had just been destroyed. Neighbors described a cement construction so heavy that a week's work with the wrecking ball was required to demolish it.

When Rodia began to build the Watts Towers in 1921, his property was near a village area that had been part of a Spanish land grant called El Rancho Tajuata. As late as 1907, it became a new city named after Charles H. Watts, a Pasadena realtor who had an interest in the growing community. When Rodia arrived, Watts was a farming village with a mixed population that was one-third Anglo, one-third Latino, and one-third black (Whiteson 1989).

Rodia's rural life was altered by the World War II, for a large number of new black residents arrived from the South to work in the war plants and to live in the new little houses constructed everywhere. Some of those small frame dwellings can still be seen on 107th Street across from the Towers, where twenty-five-foot frontages were sold for a dollar down and a dollar a week. Soon Rodia's view of fields and farms became a neighborhood of Latino and black families.

Rodia's constant day and night work on the Towers (except when he was on a job to make a living) raised questions in the community. While 10,000 travelers on the Big Red Cars watched Rodia build, some were undoubtedly confused by his tenacity and "useless" effort, but some carried Rodia's sensibility into their far-flung lives and found meaning in it. One such observer, Princeton artist, Linda White, has detailed her own observations:

> The Big Red Car ride from Long Beach to Los Angeles could be an endless journey for a child . . . but one event along the way was reassuring, never failing: the glimpse of "the crazy man" building his towers near the tracks at exactly the halfway point in the little town of Watts. The fascination of the glittering Towers included the certainty that he used no ladders but the structure itself was a ladder upon which he climbed as he built.
>
> When the Red Car gave way to the freeway [and Watts consequently became an isolated ghetto,] our trips to L.A. changed and I forgot about the Towers. But when I was old enough to drive I began searching for the Towers and found them, to wander on the paths of Rodia's strange man-made gardens. I was immediately aware that he was a man who loved the sea. The materials he used, which as a child I had thought to be jewels glittering in the sun, were the familiar materials I took for granted as merely debris washed up by the tides on unkempt beaches of my Long Beach childhood. To my amazement it was all there: the broken shards of 7up bottles, cockle shells, bits of broken crockery and a forgotten miscellany used and abandoned, found again and pushed, piece by piece into the sandy surfaces of the cement foundations and walls. Even the patterns of his tools were imprinted in the cement, like footprints in wet sand, but he had assured their permanence as a record of his presence.
>
> Looking upward through the spidery structures I knew that he had climbed the Towers as he built them, as one would climb the rigging of a ship. But unlike a sailor leaning out and yearning for the sight of land, Rodia was looking across the sea and across the years. (Quoted in Morgan 1984: 74)

In the early 1950s, when the Pacific Electric Red Car was gradually eliminated in favor of freeways, Watts became more isolated. But Rodia's isolation began to end. Lost in Watts, he had been free of official attention for three decades, but now a local building commission began to notice and to criticize his structures. "The Labyrinth of Watts," in the September 3, 1951 issue of *Time Magazine*, records the first press account of official interference in the artist's work:

Even Californians blink unbelievingly at the architectural labyrinth in Sam Rodilla's [sic] backyard in the modest little Los Angeles suburb of Watts. It is a steel and concrete lacework of fountains, arches and pinnacles that would be far more at home among the temples of Bangkok than in bungalow-land. The current *Arts and Architecture* tells how it got there. It is Sam Rodilla's [sic] tribute to his adopted country.

Sam was born in Italy 72 years ago, emigrated in 1888, settled down happily to his work as a tile setter. The U.S. was good to him. Thirty years ago he told himself, "Before I die I'm going to do something for the U.S." Sam said, "I had it in mind to do something big and I did."

He began his labyrinth without a long range plan, improvised as he went along. He set up steel rigging, plastered the rigging with concrete, encrusted the concrete with sea shells, broken glass, tiles and pottery. So far he has used 7,000 sacks of cement, 75,000 sea shells, several truck loads of broken bottles from the city dump. When the local building commission objected to Sam's project as dangerous, Sam made a trip to Sacramento, got the State's OK. Since then he has spent his spare time pushing his Towers skyward.

At first he topped them off at 25 feet but the highest now rises 104 feet [sic]. Neighbors who once looked on Sam as a hopeless eccentric have developed neighborly pride in his work. Other Californians, visiting Watts to inspect the Towers, bring along offerings of broken glass and pottery. Sam promptly chips the shards to shape and size and builds them into his masterpiece. According to critic, Jules Langsner, in *Art and Architecture*, Sam's work "lacks the discipline of genuine folk art but still is bizarre . . . pleasant and even disturbing. Sam himself has little time to think about artistic theories. 'I'm worried to death to get this work done before I leave,' he says, 'But I'm a pretty happy guy.'"

The statement "Sam made a trip to Sacramento" a story that Rodia continued to repeat for years, was most likely a vivid dream.

Without the Red Cars, the community of Watts began to suffer more isolation. Anyone without a car was doomed to stay in the little town. Watts had no market with uptown goods and services, only small "mom and pop" stores, while 103rd Street was a pulsing artery of street life and a place where a sense of community was generated in liquor stores and a pool hall. The wartime immigrants to Watts were left high and dry when war plants closed and there was no other work. Of course, this was the basis of the town's disadvantaged status.

The Watts Towers Arts Center

As soon as they could do so, CSRTW bought a tiny white house down the street from the Towers and moved the children's free art classes indoors. This was the first Watts Towers Arts Center, in 1961. The Committee realized that they needed a director from the community itself, and this was accomplished. An underlying motive was to create community goodwill and familiarity with the Towers. Thus, the Committee began to perform its commitment to exhibit and preserve Rodia's Towers in Watts.

However, the Arts Center also became a destination for people in need who thought it was a social service agency. Mothers came pleading for help to get sons out of jail; for children who had no clothes for school; to keep a telephone working, to find a doctor.

Children who came to the Arts Center told of their problems:, having no bed to sleep in, no place to keep their homework safe from the younger kids, no breakfast. In the face of such profound human needs, the Committee had to strengthen its motives in order to renew its belief in its mission as a cultural resource. People in the community said, "Who needs art when the kids don't have enough to eat?" The wounds of the community were brought to CSRTW's executive director in the little white house.

The Board of Directors was challenged to define the Arts Center's goals. It was difficult for the Board to realize that the Committee should not mislead the community by appearing to function as a social service agency for, in fact, it was incapable of carrying out this role. Thus a wave of disappointment and possible hostility was sure to result. But the pressure to help with welfare issues was enormous.

In the early 1960s, the outside world began to pay attention to the Towers and particularly to the Arts Center, which became a drop-off point for excess clothing and "do-good" operations, with mixed results. For instance, a well-intentioned but misguided donation was made by an uptown woman who drove up to the center with two large brown shopping bags. She said, "We wanted to share our shoes with the children." Unfortunately, the bags were filled with used pink ballet slippers.

The Committee was in a difficult position, for the only other white faces seen in Watts were police or social workers. As the "War on Poverty" advanced, CSRTW set up the Watts Towers Teen Post and offered not only free art classes but also improvisational theater led by a drama professor and assistant from the University of Southern California, Andrew Doe and Steve Kent.

Professors from various campuses contacted the Arts Center to develop grant applications for projects involving Watts youth. The Watts Towers Arts Center (WTAC) became a safe landing pad for outside dignitaries visiting Watts, such as Robert Kennedy. Activity at the Towers site itself was overshadowed by constant and vivid events at the Arts Center.

In August of 1965, the Watts Rebellion filled the skies with smoke and ashes. Thirty-four people were killed and hundreds injured in the street fighting that continued for days. The army cordoned off Watts and the Committee had no way to protect the Towers, which were only four blocks from 103rd Street where fires blazed for days. Yet phone calls to the Arts Center inquiring about the Towers' welfare brought good news. A little neighborhood girl's voice would answer, saying, "Oh, the Towers is just fine. We having a good time here."

In fact, the Towers were not touched during the riots. They became, for the TV and press reporters, the symbol of Watts and were shown around the world as a landmark feature of the social disturbance. After the rebellion had ended and 103rd Street lay in cinders, the city demolished the commercial area and built houses there. Four blocks away, the Arts Center and the Watts Towers experienced a decline in visitors, for the rebellion had made Watts a feared locality.

After the violence of 1965, CSRTW built a large new Arts Center much grander than the little white house: the Watts Towers Arts Center. At the new Center, a fresh interest in its possibilities arose in the community, and new, local leadership of programming began. Under the direction of John Outterbridge, full-time activities were developed and local personalities became the center of the operation. While attendance at the Towers declined, the WTAC expanded its influence between 1965 and 1975.

In 1975, the Board determined that the Towers required major treatment for deterioration, but CSRTW was not financially able to undertake the work. Towers tour income had continued to decline. The Towers were the only source of CSRTW income. The Arts Center attracted much local interest and brought more continuous activity for adults as well as children. Arts Center events, such as an annual Watts Towers Jazz Festival, brought important national and international contacts but no reliable funding for the Towers.

The Board faced a crisis, for delaying Towers' repairs could result in structural damage. The Los Angeles Municipal Art Department's director, Kenneth Ross, offered to finance a complete Towers restoration if CSRTW would donate the sculptures to the city. The Board reluctantly approved the plan to give away the Towers but refused to simply drop their responsibilities and concern for Rodia's masterwork.

A contract deed was written and signed by the city, which granted to CSRTW the right of approval over any action that would affect the Towers' surfaces. Thus, CSRTW pledged its ongoing attention to the sculptures' welfare and undertook monitoring to keep in touch with the city's activity at the Towers site. CSRTW's continuing legal responsibility for the sculptures is well expressed in the text of this contract, which states, in part:

> 4. Should the City desire to perform any major structural work upon the structures constituting the Watts Towers, or change or impact the external appearance thereof, it shall first request the majority approval of the Board of Directors of the Committee . . . said Board shall be charged with determining whether such work is necessary and whether it is being performed in a manner which will promote the artistic and cultural values of the tower structures and which will minimize any change in the structures or the external appearances of the Towers . . .

> 5. Should the City cease to operate the Watts Towers for the purposes for which it is granted, or should it not keep the Towers open to visitors, or should the City determine in its sole discretion, that it is no longer desirable or physically or practically feasible to operate the Towers for the purposes for which it is granted to the City, the City shall have no obligation to continue to do so. In such event, title to said Lot 385, on which the Towers are located, and the Towers themselves, and all improvements erected on the said real property shall revert to the Committee or a successor thereto . . .

> 6. Should any governmental agency having jurisdiction thereof, including the City or any department thereof, order the destruction or removal of the Tower structures or the maintenance of the structures in a manner not approved by the Committee pursuant to the right of approval retained in paragraph 4, then this grant shall immediately terminate and the ownership of said lot 385, the Towers and any improvements thereon, shall immediately revert to the Committee or any successor or appointee in the same manner as if the Towers cease to be used for the purposes of this grant.[2]

This contract deed is the document providing the basis for CSRTW's intervention, questioning, and monitoring of city and state treatment of the Towers. Although the city's promise of immediate repair work was made by the Municipal Art Department in 1975, control of the sculptures was given to the Department of Public Works (DPW), because the city charter required, inappropriately, that any building attached to the land must be under the aegis of DPW. However, the DPW ignored the Towers' need for immediate repair, and CSRTW's contention that the sculptures were not a building.

Three years late, in 1977, the city traded the Towers with the state for $207,000 and got an immediate leaseback to control management of the site for fifty years, to 2027. The lease repeats the directives of the deed contract: the Agreement and Conveyance:

> 2. For the period of this lease, City agrees that except as herein otherwise provided, that it shall be solely responsible for the care, maintenance, development, operation and the control of the above-described real property (hereinafter sometimes referred to as "Watts Towers Property") for the purpose of the State Park System but particularly for the preservation of the Watts Towers as a part of the State Park System in its present visual condition, as an historical resource (including artistic and cultural monument) and to keep the Watts Towers Property open to visitors at reasonable hours. . . . City agrees that it shall not commit any act which shall violate the terms and conditions of the deed(s) by which the City acquired said property.[3]

The word "deed(s)" refers to two actions: the deed of 1961 which gave the Towers from King and Cartwright to CSRTW and also to the gift to the city, the contract deed of 1975, "Agreement and Conveyance: Transfer of Watts Towers and Community Arts Center to the City of Los Angeles." In other words, the state's lease to the city continues all the points in the contract deed that donated the Towers to the city in 1975.

From 1975 to 1978, despite all the legal documents and promises, the city did nothing to repair the Towers, while cracks widened significantly and threatened to cause structural changes. At last, in 1978, the city began repairs of the Towers—or so CSRTW believed. However, the city granted a fund of $207,000 to an unlicensed contractor for "refurbishment" of the Watts Towers (terminology alien to preservationists).

In August, members of CSRTW visiting the Towers to monitor the new contractor's work found a fearsome situation. Ralph Vaughn, the city's contractor, with a crew of local teenagers, was prying off the mosaic surface of the Towers. It was his intention, in Phase 5 of his contract, to replace the gouged-off shells and tiles with a design of his own invention. The Towers floors were covered with what the contractor called "the rubble," which was the mosaic integument of the gazebo, the west tower, and part of the center tower. Boxes and barrels of "the rubble" were found lying among fifty-gallon drums of a chemical not approved by the Getty Museum's Committee on Restoration Standards for the job. Five or six of these heavy metal drums were placed not in a storage area but directly on the floor of the sculpture itself. The labels contained a warning against sparks or open flame. I remembered that the requirement for fire insurance in Mr. Vaughn's contract had been waived by the city.

Scattered among the sculptures and on the floor, I observed about a dozen large pieces of disassembled struts and braces from the body of the Towers, lying randomly, with no written tags or codes. These large fragments were well covered with their original mosaic integument, intact, but their ends (where rust appeared) were shattered, cracked, or broken. It was evident that they had been removed by great force rather than by any technical cutting process.

Many gaps and losses were seen throughout the west tower and the first thirty feet of the center tower. I found long rivulets of an unknown black liquid, which had run randomly down the columns and collected at the base. In the gazebo, on the inner face of the vault arches, streams of an unknown white chemical ran down the body of the arches; crust-like formations had developed along these wide rivulets. Throughout the

sculptures, mosaic areas were seen to be missing and the marks of gouging and prying were evident. This demolished integument was "the rubble" in boxes on the site. Additional "rubble" was stored in Mr. Vaughn's trailer at the job site, and it was this material that he was going to replace on the Towers in "Phase 5, necessary art restoration." In other words, "the rubble" was to be put back up according to the contractor's personal design ideas.[4]

With artist, June Wayne's help, CSRTW found a pro bono law firm, the Center for Law in the Public Interest (CLIPI), which went to court for CSRTW and canceled the city contract! The Towers were saved from destruction. The court ultimately took the Towers' ultimately repair work away from the city and gave it to the state, which then worked fourteen years (1979–1993) to repair the badly damaged sculptures before returning them to the city in 1993.

From 1978 to 1985, CLIPI continued in court with a "breach of contract" suit against the city. CSRTW's successful lawsuit resulted in stipulations from the court that included a requirement that the Towers be provided with full-time security:

STIPULATIONS [from Case #C259603]

[All contracts are reaffirmed and full-time security is designated for the Towers site.]

III MISCELLANEOUS PROVISIONS

A. Existing contracts or agreements

Nothing in this Stipulation of Settlement shall obviate, impair or in any way alter the rights or obligations of the parties under existing contracts, deeds or agreements relating to the Watts Towers between the City, State and the Committee.

B. Watts Towers Security

City, State and Committee agree that Watts Towers must be secure from vandalism 24 hours per day, and further, that the City is responsible for maintaining adequate security . . . the City shall deploy a security guard at the Towers site up to 24 hours per day[5] but, as a minimum, between 9:00 a.m. and midnight each day.

Superior Court of the State of California for the County of Los Angeles

Civ. No. C259603 STIPULATION OF SETTLEMENT: Committee for Simon Rodia's Towers in Watts v. The City of Los Angeles.

The judge required the city to pay $1,00,000 to the state owner for repair of the savage restoration[6] performed by the unlicensed contractor. (Ultimately, the city negotiated this down to $800,000.) The state added another million to this money in order to adequately fund repair of the city contractor's severely damaging work.

CSRTW's Demise and Renewal

After the drama of the court case had subsided in 1985 CSRTW gradually disintegrated. Leadership of the board changed. As the chair, I stepped down for badly needed rest. The new board chair, Seymour Rosen, allowed our nonprofit, educational, California corporation (holding legal contracts) to dissolve, by failing to file essential forms and by

ignoring the Board of Directors, some of whom simply disappeared while others melded into Rosen's new nonprofit, S.P.A.C.E.S. No entity enforced CSRTW's protective Towers' contracts with the city and state. For fifteen years, CSRTW was in suspension or non-existent.

In 2000, under my renewed leadership as CSRTW charter member, I undertook to rebuild the Committee and the Board of Directors. An immediate, essential goal was to gain the city's agreement that Los Angeles was financially responsible for the mainte-nance of the Towers. The city had ignored the Towers, failed to maintain the state's enor-mous repair effort completed in 1993. By 2000, the need for maintenance was again obvious, as cracks appeared throughout the site. The city affirmed that it was not finan-cially responsible for the Towers' maintenance.

CSRTW asked Attorney Carlyle W. Hall, Jr., of CLIPI for his opinion. He replied: "The City's contractual maintenance obligation is more than a vague 'best efforts' obligation . . . it is also specifically obligated to maintain the Towers in accord with the 'specifications, standards and recommendations of the Ehrenkrantz Report, including any updates thereto.' This specific obligation is expressly estimated in the 1985 Stipulation to cost $120,000 to $150,000 annually."[7]

I addressed a letter of inquiry to the assistant city attorney Francisco Orozco, who clarified city policy as follows:

September 19, 2001

Dear Jeanne Morgan,

On this day I advised the General Manager of the Cultural Affairs Department and Cultural Heritage Commission that the City of Los Angeles has a continuing obligation to operate, maintain and repair the Watts Towers. The basis for this obligation are [sic] the terms and conditions set forth in the Lease Agreement between the City and the State of California's Department of Recreation and Parks executed in 1978.

We disagree with your contention that the City's obligation is based on the 1985 Settlement of Committee for Simon Rodia's Towers in Watts v. City of Los Angeles et. al., Los Angeles Superior Court Case No. C 259603. The terms of that settlement agreement were expressed very specifically. It is our belief that the City has fulfilled all of its obligations under the Settlement Agreement.[8]

We believe that the Cultural Affairs Department management and staff agree with our position and have expressed their intention to seek annual allocations through the City's budget for the continued necessary maintenance and repair of the Watts Towers.

With this most important question sufficiently settled, we began the reconstruction of a Board of Directors and the revival of the Committee.

Watts Towers Requirement List

At the same time, it was necessary to bring the city's attention to the conclusions of the Towers preservation engineer, Bud Goldstone. On April 30, 2001, we addressed Jay Oren of the Cultural Affairs Department who was assigned to primary city responsibility for the Towers on issues of funding and required work at the site:

Dear Jay Oren,

We've recently researched the 1985 Superior Court order which requires the City to provide an annual payment to fund continual maintenance of the Watts Towers. Here's the stipulation that makes the City legally bound to fund perpetual maintenance: "City was ordered to provide . . . between $120,000 and $150,000 annually [1983 dollars] for maintenance of the monument as estimated by the Ehrenkrantz Group's report to the State."

You'll find attached an outline of the immediate needs for remediation developed by Towers engineer Bud Goldstone, listing the deficits at the time his City contract was cancelled in 2000. Other deficits have developed since.

Here is Goldstone's list of current requirements for the Towers' welfare:

April 26, 2001

Dear Jeanne,

At your request, here is the current Watts Towers Requirement List . . . I believe suitable actions are required to satisfy these requirements by either the City or State as a minimum program to safeguard and preserve the Watts Towers. My work for the State and City from September 1977 to July 2000 enables me to feel confident [that] these needs are critical to the survival of Rodia's work.

I) ANNUAL MAINTENANCE BUDGET of $125,000 to $150,000 is critical. Immediately. The funds may be used now for the sculptures listed in (item A) below that have not received maintenance for (number of years).

(Item A) Chimney (8 years), Ship (10 years), Gazebo (7 years), "A" Tower (9 years), "B" Tower (8 years), House facade and posts (7 years), House steps (7 years), Garage at west end of South Wall (more than 20 years) and elsewhere.

II) CONSERVATION DOCUMENTATION REPORTS are of historical significance and are either not done at all or are out of date. Under contract to Cultural Affairs between 1986 and 1994 I prepared eight final conservation reports and preliminary unfinished versions of some of the others. My personal estimate for preparing the reports would be about one to one and a half year's work. Nine (9) new reports are needed: both walls and three tallest towers, floor, oven, barbeque and overheads. The nine reports needing updates are:

1) *The Watts Towers Conservation Handbook* (this is the controlling conservation document initiated by the State of California in 1980) and conservation reports with photo documentation on 2) the Ship, 3) "A" Tower, 4) "B" Tower, 5) Garden Spire, 6) Gazebo, 7) Chimney, 8) House; and 9) Canopy.

III) EMERGENCY CONSERVATION WORK is needed to seal all the cracks now present with approved sealants (there are plenty as of April, 2001) and do quarterly inspections for cracks and other failures in the South Wall and North Wall and also in the Chimney, Ship, Gazebo, "A" and "B" Towers, House facade and posts, House steps, Garage at west end of South Wall and elsewhere to keep out moisture and slow the rusting.

IV) MONITORING MAJOR MOVEMENTS of the tall sculptures was done up to 1994. A new survey is now needed to serve as a baseline for periodic checks to identify lateral

movement of the six (6) tallest towers. The original survey sites were disturbed by [construction of] the amphitheater and no steps to remedy this deficiency have been taken for two (2) years.

Sincerely,

Bud Goldstone

Five years later, in 2006, CSRTW said it was questionable whether these Towers requirements had been correctly performed by the city.

CSRTW, City, Museums

In 2001, CSRTW asked the Getty Conservation Institute if it might fund a complete restoration of the Towers. The answer was positive, and the Getty sent grant application papers to the Cultural Affairs Department. Unfortunately (as the Getty reported to me), no response was forthcoming from the city. Here was an enormously valuable opportunity for Towers restoration, which was ignored. Today the city has corrected this oversight and is collaborating with the Los Angeles County Museum of Art, which contracted in 2011, to develop a preservation plan for the Towers.

While the Agreement and Conveyance lease-contract assigns CSRTW the right of approval on any work that affects the Towers, the city has practiced an entrenched policy of ignoring CSRTW. This results, in our opinion, in a number of unacceptable, unapproved city actions.

One example is the eight-foot chain-link fence surrounding the walled Towers which reduces visibility of the south wall exterior. The city has even added an additional, more fine-meshed fence to cover the chain-link along the south wall. Thus photographs of the south wall or the lower portions of the Towers, are not possible. These fences are a cheap substitute for the security teams that should be serving the Towers twenty-four hours a day.

The city provides, for each shift, a single guard who must walk a very long distance to protect Rodia's Towers, the Watts Towers Arts Center and the Mingus Youth Arts Center. Such security service cannot devote full-time surveillance to the Towers, since he must cover the entire area. Dedicated full-time two-man security service is needed at the Watts Towers site! Removal of the obscuring fences surrounding the site should follow funding of correct Towers security.

Stingy Towers' funding seems unreasonable since all the Towers' tour income goes directly to the city's General Fund. None goes to the Towers.

As another example: the city has attached ten huge signs to the fences covering the south wall. They obscure all of that wall and make it impossible to observe Rodia's designed wall as a whole. These signs should be placed on the west wall, at the margin of the site, where they could be studied but would not obtrude on the artist's work.

Furthermore, the enormous cement pad called "the amphitheater," has not been evaluated for its weight, its drainage, or heat radiation effects on the Towers. The city's big cement pad was installed with no notice to the Committee—a contract violation. In the first version of the city plans for the amphitheater the Towers' north wall was removed and the amphitheater cement merged with the floor of the Towers. The city's

explanation given for this outrage was that the Towers would be the scenic backdrop for concerts in the amphitheater.

Towers engineer, Bud Goldstone, was able to persuade the city contractor that the north wall was a structural part of the Towers complex and that a safety zone was essential between the north wall and the cement pad. A six-foot clearance zone between the north wall and the cement pad may be seen today. The effect on the Towers of the amphitheater's many tons of cement could be significant; no one knows. The big Towers are set in socket-like cement bases that measure less than twenty inches deep. The underlying soil is sand. An engineer's evaluation of the amphitheater's effect on the Towers' site is needed.

The amphitheater, of course, should be removed, but the jackhammers probably needed to do so would disturb the stability of the Towers. These are some examples that demonstrate in our opinion, the city's poor management of the Towers.

Reassessing Conservation Efforts

In February 2003, a historic meeting of three principals was held to discuss issues related to the care and maintenance of the Towers. Several recommendations emerged from this meeting of the California Department of Parks (the Towers owner), the city of Los Angeles Cultural Affairs Department (the leaseholder), and the Getty Conservation Institute. As a result, the state hired two consultants (Frank Preusser and John Kariotis) whose recommendations were sent to the city on October 15, 2003:

> Recommendations of Frank Preusser and John Kariotis: "Updating the *Conservation Handbook* to include the current approved materials and methods for conservation; Developing a plan for the long-term maintenance of the Towers; Revising the current documentation process, including updating the computer database system; and Improving the visitor experience through removal of the work area from the State Historic Park site and better signage."[9]

Six years later, in 2009, the work area's big trailer still sat inside the Towers site. Had any of the other recommendations been fulfilled? Evidently not, for a new round of recommendations in 2006 contained repetitions of some points.

Damage in Process

On March 11, 2006, CSRTW's revived Board of Directors met inside the Towers, where they found, to their dismay, that the city's current work of "maintenance" was actually degrading Rodia's artistry. Cracks were, indeed, being filled, but the crack-fill substance ran over the sides of the cracks and formed gross edges covering an inch or more of the surrounding integument. The impression was that the workmanship was so unprofessional that the crack fill could not be contained inside the cracks. In addition, a strange three-dimensional effect was seen in some applications, which built up surrounding material and inappropriately dramatized the cracks.

Further, the east facade of the chimney had been "restored" with alien designs in a pattern degrading the original Rodia design. The damage throughout the ground level was so extensive that the original ambience of beauty in the site's interior was altered and coarsened. CSRTW proceeded to produce a sixteen-page color booklet of photographs

of the degraded areas, titled "Damage in Process," showing visual proof of substandard work, The booklet discloses, in the opinion of CSRTW, the city's improper performance of its "maintenance" work. The city has imitated Rodia's designs, performed "artistic interpretations," and colored with geometric designs, the entire exterior of the north wall (although Rodia finished it in plain gray mortar). Throughout the ground level area the city conservator replaced lost mosaic with randomly chosen tile pieces, filled cracks with the same substandard work that smeared crackfill over the margins, and created several other alien effects.[10]

Following distribution of "Damage in Process," the state historic preservation officer performed an inspection of the Towers on May 15, 2006, and subsequently produced a new set of recommendations, which was sent to Ruth Coleman, chief of state parks and recreation on July 7, 2006

> Recommendations:
>
> Furthermore, for several years there have been disagreements as to the proper approach to conserve the Towers. Several qualified individuals, agencies and professional organizations have participated in formulating opinions, processes, studies, and in some in-situ experiments to address the challenges of conservation.
>
> More recently, Ms. Jeanne S. Morgan, Chair of the Committee for Simon Rodia's Towers in Watts/Guardians since 1958 (Watts Committee), issued a 16-page color document entitled "Damage in Process," dated May 10, 2006 . . . [which] has been widely distributed to several agencies and individuals, including the Advisory Council on Historic Preservation, the National Park Service, the National Trust for Historic Preservation, the American Institute for Conservation, the American Institute of Architects, The Getty Conservation Institute, the California Preservation Foundation, the Los Angeles Conservancy, the City of Los Angeles Department of Cultural Affairs, UCLA Archives/ CSRTW, and Mike Boehm of the *Los Angeles Times* as well as the OHP [Office of Historic Preservation] and California State Parks.
>
> At your request, on May 15, 2006, I met with representatives of the conservation project. . . . [A]n overview of the long-term, complicated and controversial challenges of the conservation efforts on the Towers was briefly reviewed at the site. . . . Based upon my site visit, my review of applicable documents and my discussions with interested individuals, I recommend the following . . .
>
> RECOMMENDATIONS
>
> 1. Preparation of a General Plan . . .
> 2. Preparation of a new Conservation Handbook/Plan . . .
> 3. Implement 3-D model with linked database . . .
> 4. Suspend Artistic Interpretation of Rodia's Work
>
> Rather than stopping the work, I recommend only minor repair work and structural stabilization, as defined in a written agreement between California State Parks and City of Los Angeles, should be accomplished at this time. The artistic interpretation of Rodia's missing artwork should be placed on hold. This time period would permit concurrent completion of the General Plan and the new Conservation Plan. Once the new Conservation Plan has been completed the City's conservation team can be trained in the recommended treatment methodologies. The conservation team should also be trained in the

use of the database system and be required to add any on-going conservation documentation such as the minor work to the database.

5. Establish an Advisory Conservation Committee[11]

The Role of Museum Professionals

Establishing an Advisory Conservation Committee has been an issue discussed for many years. CSRTW has believed that museums, not individuals, should constitute such a consortium. This point of view was publicized in the editorial section of the *Los Angeles Times* on October 8, 1983:

CONSORTIUM FOR TOWERS

Our major contemporary art treasure, Rodia's Towers in Watts, an internationally-valued sculptural assembly, deserves recognition and responsible concern from Los Angeles' new, powerful museums, both of which are free from the fluctuations of city, county and state funds.

The special interests of both the Museum of Contemporary Art and the Getty Museum suggest that the Towers should come within their purview, both esthetically and physically.

The international luster and modern innovation of the sculptures should arouse the concern of the Museum of Contemporary Art to promote esthetic connoisseurship while the physical existence of Rodia's message should be guaranteed by the powerful Getty Conservation Institute.

A museum consortium should be formed to explore means to bring museum guardianship and ongoing conservation to Rodia's sculptures, thereby protecting this treasure from the impact of political, social and commercial forces.

At this moment the future of the Towers remains unclear. Their physical immensity, disadvantaged site and a residue of political mishandling are factors creating challenges which citizen groups or even the Municipal Art Department itself cannot easily meet.

While the sculptures are owned by the people of the State of California, responsibility for their ongoing exhibition and maintenance lies with the City. Rodney Punt, a Municipal Art Department spokesman, has questioned the City's financial ability to carry out these responsibilities.

Assuming tandem responsibility for explication and conservation of our greatest contemporary art masterwork would surely be of benefit to our new museums, now seeking an authentic relationship with the Los Angeles community.

Jeanne S. Morgan
Santa Barbara
[Morgan was board chair (1977–1980) of the Committee for Simon Rodia's Towers in Watts.]

While many approve the idea of an Advisory Conservation Committee or a consortium of museums, not everyone agrees that committee action will help the Towers. In a letter addressed to Jeanne Morgan as CSRTW chair, Tim Whalen, director of the Getty Conservation Institute, offered a different view:

14 August 2006

. . . Finally, you mention engaging the Los Angeles County Museum of Art in a larger Watts Towers Conservation Consortium. Indeed, LACMA, and I am sure all cultural organizations in Los Angeles, are committed in principle to the long-term preservation of the towers. While I cannot speak for LACMA, I am not sure that involving more external organizations in your efforts will advance the Towers' conservation. My own observation is that the creation of yet another body could have the potential to dilute your efforts. Indeed, I would continue to focus on improving the management context for the Towers—that is working to make the State and City increasingly effective stewards of this important cultural resource. It's hard work, but over the years I have come to realize that management context is the starting place for the well being of any site. The Committee's work is contributing to this.

With best regards,

Tim Whalen

Timothy Whalen
Director
The Getty Conservation Institute

The fragility of the sculptures was noted by a Getty conservator in a 2001 note to CSRTW:

The towers, and other components of the site, are fragile structures and are susceptible to both sudden and more gradual changes that can lead to destabilization and possibly catastrophic issues.

William S. Ginell, Senior Conservation Scientist
Getty Conservation Institute
August 1, 2001

CSRTW and Advocacy

The Committee for Simon Rodia's Towers in Watts has steadily monitored the city and state treatments of the Towers and tried to improve their management by the Cultural Affairs Department. Some of the Committee's efforts include a request for a stop-work order addressed to Ruth Coleman, chief of the State Department of Parks:

OPEN LETTER TO STATE OWNER OF WATTS TOWERS

TO: Ruth Coleman, Chief, State Department of Parks

FROM: Committee for Simon Rodia's Towers in Watts/Guardians since 1958

Dear Ms. Coleman,

The Watts Towers, your property federally honored as the Watts Towers National Historic Landmark, is being systematically robbed of the design work created by the artist, Sabato Rodia.

We have sent requests for a stopwork order to Virginia Kazor, Historic Sites Curator in the L.A. Cultural Affairs Department and to Margie Reese, General Manager of

Cultural Affairs. Neither has stopped the barbaric work now defacing and damaging Rodia's masterwork.

Thus we appeal to you to do so, for we have discovered threats to the Towers' federal status, as authenticity is compromised.

1. IMITATIONS OF RODIA DESIGN MOTIFS appear as false Rodia designs, random impressions in new mortar (light color). Location: 3/4 of the east facade of the Rodia Fireplace. This is a violation of the Codes of Ethical Conservation for Historic and Artistic Works adopted by the American Institute for Conservation.

2. DAMAGE AND DEFACEMENT OF RODIA TOOL PANEL DESIGNS and other surfaces. Stains from unknown liquids and smeared cement are seen. Location: South Wall Interior. Board observers on 4-22-06 found the panel "cleaned" or "restored" evidently with some type of grinding tool, for the original form of Rodia's artistic statement is altered, his tool impressions more shallow, their crisp 90-degree edges now softened. Many Tool Panels now exhibit such changes along the margins where substandard crack filling has smeared cement into the impressions. Such smeared areas appear to have been ground down, often degrading Rodia's impressions of tools or dates.

3. SMEARED CEMENT appears pervasively applied on Wall Panels by grossly sub-standard work. It magnifies and dramatizes crack repair.

4. ORIGINAL NORTH WALL EXTERIOR, finished by Rodia as plain gray cement, has been replaced by City "restoration" with many colors.

5. GROTESQUE CRACK REPAIR WORK is seen on walls at each side of the steps into Rodia's house and in many other areas. There is no qualified Towers oversight from staff with, minimally, an AIC Second Level Professional Associate status. There is no written workplan but only daily improvisation. The city "conservator" has been given, for five years, the personal authority to ad lib decisions as one might do when fixing your own patio's cement birdbath.

The Towers Committee calls for an immediate stopwork order from the State owner, to end the false restoration now destroying areas of the Rodia Towers National Historic Landmark, now potentially under threat of removal from that honor by the City's barbaric work, perhaps deemed by City authorities to be "good enough for Watts."

Because the Towers National Landmark is a State property, its ultimate owners are the citizens of California. The Board recommends that citizen-owners inform the Governor of the urgent need for a stopwork order by the State Parks-owner, to immediately end City damage to Rodia's unique, inspiring sculptures.

(*Los Angeles Free Press*, June 30, 2006: 8)

CSRTW Accomplishments

During its short life span, the renewed CSRTW Board of Directors has achieved an impressive record of accomplishment:

1. We revived our 501(c)(3) nonprofit California corporation, which holds legally enforceable deeds and contracts with the city and state.

2. We began formal renewal of CSRTW with the revival board meeting of March 11, 2006.

3. We prevented installation by the city of a huge 100-foot-long metal canopy over the amphitheater, which would have half obscured the visibility of the northern aspect of the Towers.

4. We prevented "restoration" of Rodia's burned house, planned without authoritative historic documents.

5. We prevented construction of a "kiosk for a more welcoming entry" inappropriately affecting the southwest corner of the Towers site.

6. We caused the city to reverse its policy of no financial responsibility for the Towers, to providing $150,000 for annual maintenance.

7. We renewed exhibition of the Towers by proposing a system of multicultural tour guides, well trained and well paid. (The Towers had been closed to the public for decades until this plan's adoption.)

8. We studied and produced "Damage in Process," a sixteen-page photo book showing degrading treatment of the Towers and circulated it to crucial authorities in 2006.

9. This led to a state inspection that resulted in a state order to stop work on "artistic interpretations" (i.e., the "false restoration" under way) and limited city work to minor repairs and structural stabilization, neither of which have been performed to date (in 2010).

10. We succeeded in getting the city to remove, from the south wall area, the fine wire mesh (attached to the chain-link fence), which prevented photos of the south wall exterior and blurred the view of the Towers. (The chain-link fence, however, remains.)

When the board designed the restrictive condition of CSRTW's right of approval in the 1975 contract deed, members believed they were thoroughly protecting the Towers. But recent events that are bringing proposals for encroachments on the Towers' visual area suggest otherwise. The board should have been more prescient and designated a 300-foot permanent safety zone around the eastern side of the Towers, where vacant land owned by the city permits a view of the site from a favorable distance. Today that distance is under pressure from the Wasserman Group Sports Management to build, within 120 feet of the eastern side of the Towers, a "hardcore skateboard park." Negotiations and discussions now under way disclose the community's desire to maintain the educational and cultural atmosphere of the Towers area as opposed to the Wasserman skateboard plans. Both groups have developed considerable support. However, the skateboard group's pressure may be declining since their main local support came from Janice Hahn, who has moved up to congressional ambitions, dropping her former role as the Watts representative to the L.A. City Council.[12]

A further encroachment has come from artist Edgar Arceneaux, who has organized strong support for his concept of the "Watts House Project," a plan to repaint and decorate the historic houses across the street from the Towers. One house, which has already been painted and decorated, is covered with large, Disney-style flower images to rival the Towers. Here too, opposing groups have formed differing opinions on another "outsider's" proposed plan to ride along on the Towers' fame. Recently, Arceneaux's plan seems to be disintegrating, for the press, in 2012, brought news of the artist's resignation as head of this project.[13]

The Committee has always tried to present the Towers in a curatorial fashion, using terms such as "sculptures," instead of the more common form, "constructions." In Los Angeles, where the perceived character of Watts as a disrespected ghetto is projected onto Rodia's unique sculptural environment, the Towers' nature, as a world-class work of Art which should be honored as a World Heritage Site, is not fully valued and will not be, until a strong museum undertakes development of connoisseurship for Rodia's mindprint. The small voice of CSRTW cannot achieve this desired level of public consciousness. However, good progress has been made since the days in 1965, when the chief of the Conservation Bureau of the Los Angeles Department of Building and Safety said:

> I haven't changed my feeling about the Towers. They're remarkable, but they're not a work of art. I have no feelings one way or the other about that business when we condemned them. It was my job. I did what I thought my job called me to do.

> H. L. Manley
> Conservation Bureau Chief
> Los Angeles Dept. of Building and Safety[14]

In contrast to Mr. Manley's dismissal of the sculptures as non-art, here instead are two professionals who have lauded the artist and his work:

> I first experienced Rodia's stunning Towers in 1969. I felt then, as I do today, that they are one of the most inspiring and beautiful examples of the heroic determination that divides the truly great artist from the merely accomplished. With little or no means and humble materials, Rodia created a sculptural monument that rivals the Getty as a Los Angeles icon.

> JAMES M. WOOD
> President and CEO
> The J. Paul Getty Trust

> The Towers are a remarkable achievement which has always meant different things to different people. Sam's work is such an unusual object that it has crystallized much attention on a social level, as well as on an artistic level. We have wanted to help these fantastic and wonderful objects find their place in art history and reach the broadest audience. They are worthy of the widest attention. Rodia's achievement is a work of deeply intuitive order and of the first importance. He is an artist, above and beyond his status as a craftsman.

> WILLIAM OSMUN
> Senior Curator
> Los Angeles County Museum of Art[15]

In 2010, the Los Angeles County Museum of Art undertook responsibility to develop plans for the conservation and preservation of Rodia's masterwork in a contract signed with the city of Los Angeles Department of Cultural Affairs. The museum's Scope of Work document for the first year 2011 includes the following:

> The Contractor [LACMA] shall be responsible for the day to day oversight and monitoring of conservation and preservation of the Watts Towers and for the implementation of

minor repairs and restoration under the direction of the Contractor's Conservation Center and in consultation with the [city's] Department of Cultural Affairs.

Thus, for the first time in fifty years, since the artist finished his work, a major museum has recognized the merit of Rodia's cultural statement. We look forward to a new day of rising connoisseurship by the international public and increased respect for the Towers in Los Angeles itself. The Towers are the property of the state and thus are owned by the people of the state of California. LACMA conservation plans, if followed by the city's dedicated management and exhibition, could make the huge sculptures available to their admirers throughout the world, as long as our culture wishes to conserve and care for them.

Works Cited

Morgan, Jeanne S. 1984. "Rodia's Towers: Nuestro Pueblo, a Gift to the World." In *Perspectives on Informal Art Environments*, edited by Daniel Franklin Ward, 72–82. Bowling Green, Ohio: Popular Press.
Whiteson, Leon. 1989. *The Watts Towers of Los Angeles*. Oakville, Ontario, Canada: Mosaic Press.

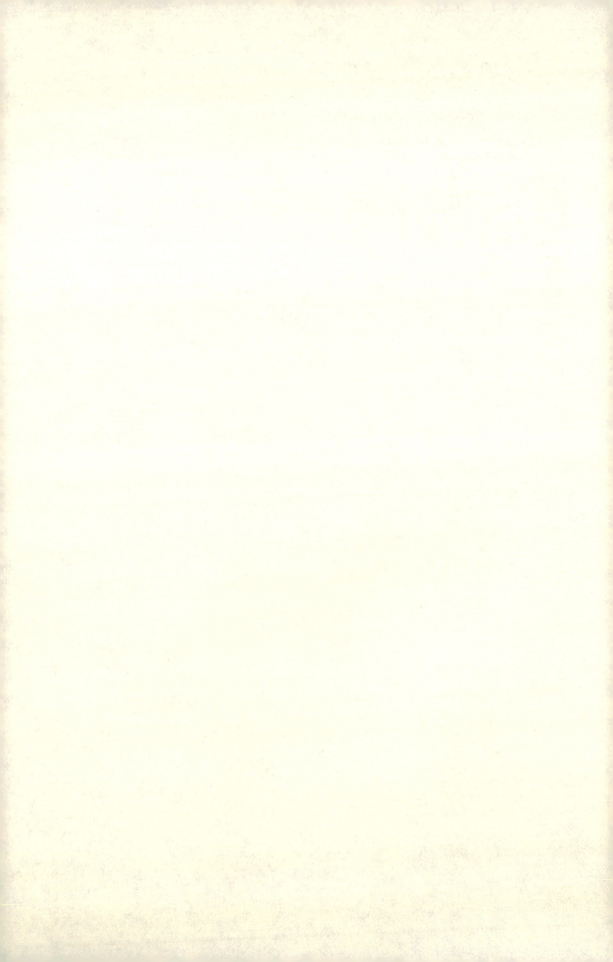

A Custody Case: Ownership of Rodia's Towers

Jeffrey Herr

What do we mean by applying the term "custody" to the Watts Towers? The structures Simon Rodia began constructing in 1921 were a personal undertaking and remained so until he ended it in 1954. During that thirty-three-year period, this developing site was a personal endeavor executed on private land and not subject to review or public scrutiny.

However, when Mr. Rodia ceded the deed to the property, a chain of ownership ensued that has had consequences for the welfare of this site. By terminating his work on the Towers, he stopped the sequence of build and rebuild—a period of constant and consistent care—to begin a sequence of neglect and vandalism, intermittent care, and, finally, preservation. In the process, as the structures commonly referred to as the Watts Towers gained notoriety as one immigrant's obsession, a parallel appreciation of their value as a work of art began to emerge.

This recognition of aesthetic significance added perceived value to the site, thrusting on subsequent owners a greater responsibility. This is where the notion of "custody" enters the picture. In the art historical world, provenance defines this chain of ownership. Custody, at its core definition, is the care and keeping of property. However, custody is more than mere possession of something or someone. There is a connotative emphasis on guardianship, which in itself connotes responsibility and protection. The custodian (e.g., owner) is responsible for the care and supervision and, in this instance, the preservation and conservation of a work of art. In that light, what I would like to do here is not

only outline the chain of ownership or custody of the Towers but also comment on the impact of each custodian on this artwork.

Simon Rodia: 1921–1954

Rodia bought his triangular plot of land in Watts in 1921.[1] He was forty-two years of age. He began to "improve" his property immediately and worked on it continually for the next thirty-three years. The initial years and up to the late 1940s were spent in construction as the project expanded. Additional layers increased the height of the three tallest towers, walls enclosed the site, and ornamentation embellished every surface.

Under the formation and care of the creator, a continuous process of building and repair ensued. Rodia's methods, modes, and aesthetic judgment were unassailable. Because it was his idea, land, materials, and labor, everything he executed was indisputable. In this sense, Rodia was not the first custodian of the Towers. He was the creator.

However, from the moment Rodia relinquished his owner–creator status of the Towers, a traditional chain of custody began that, because of the extraordinary nature of the property, launched an idiosyncratic tale replete with idealism, neglect, heroism, litigation, and redemption. This story defies the ordinary seller-to-buyer chain of possession, making the provenance of Rodia's Towers not only an inspiring preservation success story but also an affirmative reminder of the indefatigable immigrant labor force that fueled the industrialization of the United States.

Louis H. Sauceda: 1955

The first custodian was Simon Rodia's neighbor, Louis H. Sauceda. At age seventy-six, Rodia simply gave the deed to his property to his next-door neighbor.[2] That act is as extraordinary as the site itself. It is practically incomprehensible that he could simply give away his property and life's work and leave it all behind—an extraordinary gesture from an extraordinary man. Sauceda was, by all accounts, more of a disinterested placeholder— that is, owner but not a custodian. Unoccupied, the property and the "improvements" began to deteriorate, as a result of normal environmental conditions and vandalism.

Joseph Montoya: 1956

The next custodian was also a neighbor. In 1956, Joseph Montoya bought the Towers from Sauceda for a reported $500.[3] He had the entrepreneurial aspiration of turning them into a taco stand. But Montoya's custodianship was as derelict as Sauceda's.

It was during this period that Rodia's house was destroyed by arson, and by 1957 the city's Building and Safety Department had investigated the site and declared the Towers unsafe. However, they were unable to locate Montoya throughout two years of repeated attempts to serve the demolition order—not an unlikely failure, as the property was virtually abandoned. It could be argued that Montoya's absentee owner status, while abetting vandalism, ironically prevented the city of Los Angeles from demolishing Rodia's Towers.

William Cartwright and Nicholas King: 1959

Joseph Montoya never realized his desire of building a taco stand on the site, nor was he ever served the demolition order. Instead, two inventive and enterprising young men, William Cartwright, a filmmaker, and Nicholas King, an actor, who were devotees of the neglected and vandalized Towers, succeeded where city officials had failed.

They located Montoya and persuaded him to sell them the Towers. In conversation, Cartwright related how the transaction took place with the assistance of Montoya's young daughter as translator. There was no negotiation. Montoya said he would sell the Towers for $3,000, and Cartwright and King consented to the deal. However, when Cartwright and King went to City Hall to pull a permit to build a cottage on the site, the specter of demolition reared its ugly head. As the current owners, they were served with the order.

It is at this point that a custody battle ensued between these two young men and the city of Los Angeles—Goliath bent on protecting public safety pitted against two Davids fighting to preserve a work of art. The Davids began to raise money and public awareness. To help in their endeavor, they formed the Committee for Simon Rodia's Towers in Watts (CSRTW). They also mobilized citizens and experts in the fields of art and engineering.

It proved necessary to go to court if they were to prevent the demolition order from being executed. The argument that the Towers were more a sculpture and that, therefore, building codes were not applicable was dismissed by the judge. During the course of the hearing, Kenneth Ross, general manager of the Municipal Art Department of the city of Los Angeles, asked an unnamed building department official, "If we had the Leaning Tower of Pisa here, what would you do with it? 'We'd tear it down,' Ross said he was told."[4]

The proverbial rabbit was finally pulled out of the hat by the Davids. As a last resort, they offered to attempt to pull down the tallest tower. If the effort failed and the tower stood, the proof of the tower's structural integrity would be validated, disproving city engineers' claim that they were dangerous. On the other hand—well, that was the chance they apparently would have to take, but public opinion was on their side.

An aeronautics engineer named Bud Goldstone became the CSRTW's engineer. He, with the help of friends and colleagues, devised a way to apply pressure to one tower, no mean feat as variable contingencies required countless calculations to produce a valid test and minimize the risk of irreparable damage. With the calculations done, the day of the test arrived. Pressure amounting to 10,000 pounds was applied to the tallest tower, but nothing happened. The tower stood and the crowd cheered when the representative of the Department of Building and Safety removed the demolition order sign. That test remains the basis for recognizing the stability of the structures to this day and underscores the natural genius of Rodia's intuitive understanding of engineering.

Nevertheless, there were those for whom such questioning and potentially destructive testing was heresy, like "art historian, Kate Steinitz, who denounced the test as, 'a barbaric measure comparable to a witch trial in the Middle Ages.'"[5] One newspaper headline read, "Torture Test Due for Watts Towers."[6]

Now that the Towers were no longer an "official" threat to public safety, the CSRTW began raising funds for restoration. In 1963, the Towers were listed on the National Register

of Historic Places and declared a City of Los Angeles Historic-Cultural Monument. However, by 1975, the rate of deterioration in the aging concrete-encased structures had accelerated, and they were in need of extensive repairs. Although vandalism during this period abated and repairs were effected, the cumulative result of the environmental degradation of the structures had not been alleviated. The CSRTW, custodian for the sixteen years following Cartwright and King's purchase, was faced with huge restoration costs, was unable to raise sufficient dollars, and desperately needed a solution to their dilemma if the Towers were to be preserved.

City of Los Angeles (Department of Public Works): 1975

That solution introduced the Towers' first public custodian. In 1975, the CSRTW gave the Towers to the city of Los Angeles. To the surprise of all involved, the Towers were placed under the aegis of the Department of Public Works and not the Municipal Art Department, whose general manager, Kenneth Ross, had been a staunch advocate in the fight to prevent demolition.[7] Unequipped to address preservation needs, the next two years under the Department of Public Works were a low point in the Towers' history. Ralph Vaughn, Department of Public Works contractor, was executing heavy-handed repairs, and there was little or no preservation of artifacts that had delaminated from the structure. This compromised the historical and aesthetic integrity of the Towers and outraged those who had worked so hard to preserve them. It is difficult to be precise about all the details at this point in the story. It is certain that the CSRTW noted the ill treatment, was appalled, and began to advocate for more sympathetic conservation treatment.

State of California Department of Parks and Recreation: 1977

Funding to support the preservation of the Towers has always been at issue. In 1974, California voters approved the State Beach, Park, Recreational and Historical Facilities Bond Act. In it was a $207,000 appropriation for Watts Towers. The condition for activating this appropriation was that "the City of Los Angeles shall transfer to the State the land and property designated as the 'Watts Towers, Simon Rodia Park,'" introducing the second and current public custodian.[8] Ordinance number 150,100 transferred ownership to the state while also providing for "the lease of the 'Watts Towers' to the city of Los Angeles for its exclusive control."[9] The site was renamed the Watts Towers of Simon Rodia State Historic Park.

Using state funds, the city of Los Angeles began repair and restoration on the Towers. Ever vigilant, the CSRTW protested the unprofessional work of Ralph Vaughn, and in 1978 he was enjoined from further work on the Towers. In 1979, the city agreed to return the unused portion of the $207,000 dollars to the state, who then began repair and restoration on the three tallest towers. Subsequent litigation instigated by CSRTW resulted in a settlement in 1985. It obligated the city of Los Angeles to establish a Watts Towers Restoration, Maintenance and Preservation Trust Fund in the amount of $800,000; place $50,000 in a Watts Towers Community and Conservation Fund (for administrative purposes); and pay the plaintiffs costs, attorney's fees, and out-of-pocket expenses of $360,050.[10]

State of California Department of Parks and Recreation, and City of Los Angeles (Department of Cultural Affairs): 1985

The nature of the materials Rodia used and both the ordinary and extraordinary effects of environment have demonstrated that conservation work on his Towers needs to be constant and consistent if they are to be preserved. In the years since signing the fifty-year lease agreement—this time with the city's Department of Cultural Affairs, the successor of the Municipal Art Department—the Towers have managed to withstand earthquake, weather, and controversy. Disasters such as the 1994 Northridge earthquake have not destroyed the Towers but have brought federal assistance to aid in their conservation. The degradation of the concrete-encased structures as a result of normal weathering is a daily concern that is part of the ongoing preservation effort. The way in which the current custodian has dealt with the disasters and the daily preservation issues has often put the department at odds with the remaining members of the CSRTW, the group responsible for preventing their demolition. The state of California has given these various allegations the benefit of hearings resulting in both formal and informal studies and evaluations from a variety of experts. The state's conclusion was that it was "confident the Cultural Affairs staff is doing everything possible (given the current fiscal environment) to follow the correct conservation standards and procedures in all their work at the Towers."[11] This conclusion has not met with universal satisfaction.

The Towers, like their creator, have had a checkered history. I don't find that at all out of character. In fact, it would be remarkable if their history had avoided controversy. The care and stewardship of this unique monument—it gained National Historic Landmark status (in 1990), the most prestigious designation awarded by the United States government—has been rather benign, except for the attempt to demolish them. I say this cautiously. Early custodians did little or nothing and allowed vandalism to occur. But these people were not preservationists, nor did they see themselves as public stewards. Even when stewardship passed to the city of Los Angeles and the Department of Public Works, the damage incurred happened not necessarily from maliciousness but from ignorance. It is helpful to maintain a perspective on preservation history in the United States by remembering that the preservation standards for historic structures that we observe today did not begin to be formulated until 1965—a consequence of the demolition of Pennsylvania Station in New York City. On the West Coast, Los Angeles created its Cultural Heritage Commission in 1962. Watts Towers was the fifteenth Historic-Cultural Monument designated by the Cultural Heritage Commission in 1963.

The battle early custodians faced—preventing Rodia's Towers from being demolished—on the legal front has been won, and we owe them a debt of gratitude. Today's joint custodians face additional challenges: The aging cased concrete structures respond to environmental conditions that both cause and accelerate their degradation. The challenge is complex. The multiplicity of materials Rodia used require individual conservation treatments. Raising funds to maintain the conservation program is time-consuming. Finding consensus among those most passionately concerned for the future of the Towers is a considerable challenge. And as structural engineer Melvin Green has noted, "Permanent solutions are elusive because of structural indeterminacy."[12]

In 1985, at the conclusion of a seven-year legal battle and a $1.2 million restoration effected by the state of California, the Los Angeles City Council, "voting unanimously

without discussion,"[13] agreed to take responsibility for the care of the aging monument. Carlyle W. Hall, one of the attorneys instrumental in persuading the City Council, said that the action left him "very optimistic"[14] about the Towers' future. That was over twenty-five years ago. In spite of subsequent earthquakes, wind, hail, and the perennial shortage of adequate funding, the Towers continue to be preserved—proving not only that Carlyle's optimism was justified but also, I think, validating the optimism of their creator, Simon Rodia.

Nuestro Pueblo: The Spatial and Cultural Politics of Los Angeles's Watts Towers

Sarah Schrank

In exploring the spaces of the modern city, Los Angeles provides as rich a venue as any for asking important questions about the relationships between culture and identity, history and society, politics and community, and the power dynamics inherent in those couplings.[1] Phil Ethington reminds us that this is a city of high modernist conceit, with its freeways and archetypal modernist buildings, yet is a city replete with "the spontaneous profusion of the unique and the particular—those unplanned social relations that people form in the everyday."[2] It is a city that has produced its own field of inquiry, the so-called LA School, which managed to hang itself on a rhetorical split between hyperbolic exceptionalism and paradigmatic normalcy.[3] Volumes of new historical work, however, have moved us out of this knot by avoiding regional sunshine/noir mythologies, with no disrespect to Mike Davis who articulated them but never intended us to create historiographical bedrock out of them.[4]

Los Angeles is also a city whose political economy is embedded in what David Harvey has called a dialectical relationship between the human body and the effects of globalization.[5] It is a city where a global economy has helped mark ever-sharpening divisions between rich and poor, white and nonwhite, citizen and noncitizen, while continuously selling images of the black gangster body, the Latino laborer body, the porn star body, and the white Hollywood Barbie body to the world. Bodies themselves, and the concomitant

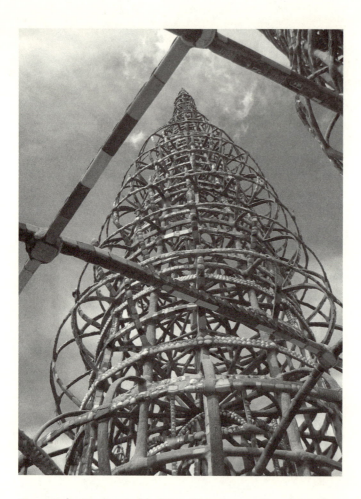

Simon Rodia, Nuestro Pueblo *(Watts Towers), 1921–1954, detail. Photograph by the author.*

images of them, do important cultural and economic work in Southern California: building a local economy while naturalizing exploitative social relations in racialized and sexualized forms. At the same time that Los Angeles has deployed the body as the key to its cultural and economic development, the city, historically, has also invested in an art-based civic culture in its bid for prominence as a global cosmopolitan entity. Nowhere does the body, the city, and the artistic merge more completely into a complex symbol of the civic than at the Watts Towers.

Watts Towers: The Making of a Modern City Space

While Los Angeles sought for decades to project the self-image of a modern city with an internationally significant art center, far on the margins of civic officialdom an unassimilated and self-educated Italian laborer worked alone in his backyard building the city its best-known artwork. Using nothing more than premodern tools and the weight

and strength of his less than five-foot-tall body, Sabato Rodia bent steel, broke glass gathered in a wheelbarrow pushed through the streets of Watts, and hauled tons of cement up and down the towers he built to 100 feet and from which he could see far into downtown, the Hollywood Hills, perhaps even the ocean. So often did Rodia work with the detritus of the growing city that journalists and students who interviewed him in the 1960s reported that tiny glass shards were embedded in the skin of his hands and arms. Rodia literally embodied the modern city while the towers, with their artful beauty born of immense human labor, bore lengthy witness to the historic urban shifts from multiracial integration to segregation and violence that have plagued Los Angeles's southern neighborhoods. Together, Rodia and his towers exemplified the creative vision and brutalizing physicality of the modern urban experience.

From 1921 to 1954, on an awkwardly shaped triangular space on East 107th Street, Rodia lived and worked until the day he deeded his property to a neighbor and abruptly moved to Martinez, in Northern California.[6] During his thirty-three years in this historically multiracial neighborhood notorious for its ghetto and its race riot, Rodia hand-built his fantasy city of seven towers, a gazebo, two fountains, two cactus gardens, and a boat. Embedded in tile on one of the towers is "Nuestro Pueblo," Spanish for "Our Town," but the structures remain best known as the Watts Towers. They have received international acclaim as a masterpiece of engineering, folk art, junk sculpture, and mosaic tiling while recent scholarly interest in outsider art has led to their appearance in hundreds of catalogs and guidebooks.[7]

In part because Rodia preferred not to specify what they meant (or explained and was misunderstood) and in part because their sheer size and eccentricity lend them to the imagination, the Watts Towers have become a modern urban space laden with shifting cultural and political meanings. Whether portrayed in newspapers as a public safety hazard, in art journals as an important international artwork, appearing as a metaphor for African American community in movies and music videos, adorning the cover of municipal financial reports as a symbol of urban redevelopment, or showing up in guidebooks as a tourist destination, the towers exist as an ever-increasing collection of images.[8] Because the Watts Towers are irrevocably linked to the racial politics of Los Angeles, the meanings of these images slip and change depending on the prominence of Watts, or matters of race in general, in the American popular imagination. This point is underscored by the fact that while some Angelenos know of the towers, most people who visit them are not from Los Angeles, or even California, at all. Nuestro Pueblo's geographical location in South Central has proven a deterrent for local visitors. The Towers' fame as an artwork juxtaposed with their physical presence in Watts has led them to become a convenient stand-in for Los Angeles and an emblematic symbol of postwar American blackness; they have served as cultural place markers in hundreds of literary pieces, movies, music videos, and television shows, from Don DeLillo's *Underworld* to HBO's *Six Feet Under.* As such, political efforts to claim, preserve, and celebrate the Towers have been tightly connected to postwar struggles for space and power in the city. Reading the startling varied interpretations of Rodia's work one reads contested meanings of Los Angeles's promise and limitations for diverse people in the city.

This representational layering of an urban-based spatial idiom is certainly visual, but it also emerges from the language surrounding Rodia's creation. He called it "Nuestro Pueblo," but few know the work by this name, a provocative take on Los Angeles's original

name, "El Pueblo de Nuestra Señora la Reina de los Angeles de Porciúncula." By inscrib-
ing his Towers in Spanish, Rodia honored his Mexican neighbors, the pre-American his-
tory of Los Angeles, and claimed the Towers and the city for others than he alone. The
Italian origins of Rodia's inspiration and his conscientious effort to incorporate the
language of his Mexican neighbors have largely been obscured by "Watts Towers," a
name that stuck during the 1959 Building and Safety hearings involving their imminent
demolition.

As a landmark placed historically and geographically at the nexus of Los Angeles's
suburban promise and socioeconomic failure, the history of the Watts Towers also offers
a unique commentary on American postwar urban policy. Once seen by thousands of
daily train commuters, the Towers faded from the landscape as new freeway routes and
rapid economic decline in the 1950s contributed to what Norman Klein has called Los
Angeles's "urban erasure."[9] As private automobiles replaced trains and trolleys, the Towers
and the neighborhood disappeared from the city's popular consciousness. In the his-
torical struggle to render them visible to a local as well as an international public, the
Towers have become important for understanding how Los Angeles's struggles over civic
identity are connected to the city's politics of race and representation. In Los Angeles, a
city that has sought recognition as a reputed artistic center on a par with New York and
other world cities, the Watts Towers have proven a political challenge and a cultural irony.
At once symbolic of the city's failure to ensure social equality, the Towers have also served
as a testament to Los Angeles's indigenous creative merits. The city of Los Angeles has
always had a conflicted relationship with the Towers, working almost as hard to destroy
them as to harness their cultural value. The Towers have evolved into a political space in
which the meanings of the modern city are negotiated, contested, and inscribed.

Watts and Los Angeles's Postwar Urban Policy

In the early 1900s, Watts, originally a Mexican land grant named Tajuata, grew into a
multiethnic, working-class transportation hub (known as the "crossroads of Los Ange-
les") as Mexican, African, and Asian Americans joined Anglos working on the railroad
tracks. Processes of segregation combined with the black migration of the World War II
era made Watts, and the surrounding area known as South Central Los Angeles, a largely
African American neighborhood. Known for its high rates of black home ownership and
solid middle class, Watts would, by the late 1950s, suffer the effects of white and middle-
class black flight, the early erosion of a heavy manufacturing base, and the dissolution of
public housing. Restrictive housing covenants and Federal Housing Authority redlining
policies meant black residents were limited by where they could go in Los Angeles, and
Watts residents who found access to new suburban areas left as quickly as they could. A
once stable community, Watts in 1959 was an early example of what American ghettos
would look like later in the century as regional, national, and global economic restructur-
ing widened class disparities among African Americans and between African Americans
and other ethnic groups. Growing unemployment, decreased rates of home ownership, and
a loss of a once superb public transportation system in favor of private automobiles
and freeways that cut across the residential area meant that Rodia's old neighborhood
was in rapid decline. Josh Sides, in his excellent history of black Los Angeles, points out
that these social changes also "encouraged many of South Central's remaining white

residents to abandon their efforts at 'neighborhood preservation' and simply move out [while] well-employed black families … sought to flee the rising crime and poverty, and the declining schools, of South Central."[10]

Watts was not the only community in postwar Los Angeles to struggle with urban restructuring, nor were redlining and freeways the only factors contributing to increased racial segregation. George Sánchez demonstrates in his work on Boyle Heights that the 1950s represented a difficult time for multiethnic communities like Watts as right-wing politics pressured Jews, among other white ethnics, to leave peacefully integrated neighborhoods for white suburbs. Even when dedicated to civil rights, the combination of racialized housing policies, increasing economic pressures, and fears of voicing political opposition in the censorious early 1950s pushed even progressive Angelenos out of their communities, leaving behind the more impoverished and less assimilated.[11]

As Sánchez, Eric Avila, Josh Sides, and others have argued, the postwar period in Los Angeles is best characterized as one of urban relocation, rarely at the behest of city residents. In one of its most egregious examples, the Los Angeles City Council gave its final approval to the Bunker Hill Renewal Project in March of 1959. The 136-acre downtown project razed nineteenth-century mansions that were home to pensioners and the poor and replaced them with financial and civic buildings that became Los Angeles's downtown civic center. The "substandard rooming houses and cheap hotels" were removed by city authorities because of their "inevitable earmarks of crime, disease, fire, and excessive public housing costs."[12] This was followed by the eviction of the last residents of Chavez Ravine, the Arechiga family, to make way for the building of Dodger Stadium.[13] As Angelenos ate lunch and watched on television, the family members were led (or carried) to waiting police cars.

Los Angeles also enacted the slum clearance policies trumpeted by New York's chairman of the Committee on Slum Clearance, Robert Moses, whereby "blighted" areas, often hosting thousands of private residences, were razed to the ground. Rather than building new and affordable housing units, commercial districts, or sometimes nothing at all, replaced long established working-class neighborhoods. Watts was such a target of postwar slum clearance. In the fall of 1959, at precisely the same time that Los Angeles's Building and Safety Committee reissued the order to demolish the Towers, the *Los Angeles Examiner* reported that the area east of Central Avenue, on 103rd Street, was the subject of municipal "housing rehabilitation." About two blocks from where Nuestro Pueblo stood, almost 3,000 properties, mostly African American residences, were to be cleared away as part of Building and Safety's bid "to clean up slum and blight conditions."[14]

A critical part of urban renewal was the freeway system that allowed suburbanites rapid access to and from commercial and leisure districts. As part of postwar urban renewal programs instituted in Los Angeles, freeway construction was symptomatic of nationwide federal support of white suburbs at the expense of minority neighborhoods. The freeways built under the auspices of the 1956 Interstate Highway Act (many of which were begun earlier as WPA projects) often cut through poor areas, destroying limited low-income housing, obliterating public space, and forcing property values to plummet.[15] Freeways like Los Angeles's Harbor Freeway (110) and the Santa Monica/San Bernardino (10) were especially damaging to minority communities in Los Angeles by creating a geography of ethnic invisibility as commuters drove over and past neighborhoods like Compton, Watts, and East Los Angeles without ever seeing the segregated consequences

of Southern California suburban growth. The loss of the "Red Cars" (Henry Huntington's electric trolley line) that followed the embrace of freeways meant that Watts, the former transportation hub, had grown obsolete. Rodia's Towers, which for thirty years had been seen by thousands of daily passengers on their way to work, were no longer a prominent feature of the Los Angeles landscape. Like so many minority residents, the Towers, too, disappeared in the shadow of the freeway system. Bud Goldstone has astutely pointed out that "this sudden lack of an audience and the increasing urbanization of his neighborhood probably influenced [Rodia's] decision to leave."[16] Like Bunker Hill's residents and Chavez Ravine's Arechiga family, the Watts Towers were simply in the way.

Sabato Rodia and the Building of the Towers

The Towers, and the surrounding smaller structures, are built from steel rebar that Rodia bent into his desired shapes by placing it under the nearby railroad tracks and bending it with his body.[17] The shaped rebar was overlapped with heavy wire and wrapped with another layer of chicken wire to secure the joint. Rodia then created his own unique mixture of durable cement (currently unmatched by preservationists) with which he encased the wire-wrapped joint and pressed broken glass, dishes, tiles, shells, found objects, and tools into the mortar. Most of the objects were left to stick permanently while others, like tools and household objects such as faucet knobs, fire screens, and baking tins, were used to create imprints and removed, leaving Rodia's signature heart and floral designs in the 140-foot wall and along the cement floor.

The physical feat of Rodia's accomplishment is usually the first quality to impress the novice viewer. Not only did he bend steel with his body, Rodia built his Towers without scaffolding, blowtorch, or power tools. Instead he used a window washer's belt and devised a system of pulleys that he used to haul himself, and thousands of pounds of cement, up and down the metal towers as he wrapped the joints and stabilized each level before moving on to the next. Rodia built ladders into the Towers' form to facilitate his movement, possibly in foresight of the maintenance the structures would constantly require.

When Rodia was not working on Nuestro Pueblo, he labored for a tile company, collecting the leftovers of expensive tile used in homes in more affluent parts of the city, or gathered broken glass, shells, and miscellaneous objects from the neighborhood and the beach. To have envisioned the project at all is remarkable, but to have tenaciously stuck to it for over thirty years is what makes the Watts Towers so impressive. Having completed his project, Rodia gave the property away and left Los Angeles, never to see his handiwork again. Located by art history students from the University of California in 1961, Rodia granted interviews and made a warmly received appearance at a discussion of his work at Berkeley.[18] He died at eighty-six, on July 16, 1965, less than a month before Watts would erupt in violent civil protest.[19]

Why Rodia built Nuestro Pueblo has been a source of great speculation ever since he began work on it in 1921. A native of Ribottoli, a village twenty miles east of Naples, who came to the United States in the 1890s to work in the Pennsylvania coal mines, Rodia kept most details of his personal history vague.[20] Reasons for why he might dedicate his adult life to such a solitary endeavor also remained obscure. Local newspapers interpreted the Towers as an immigrant's homage to his adopted homeland, a gift to Amer-

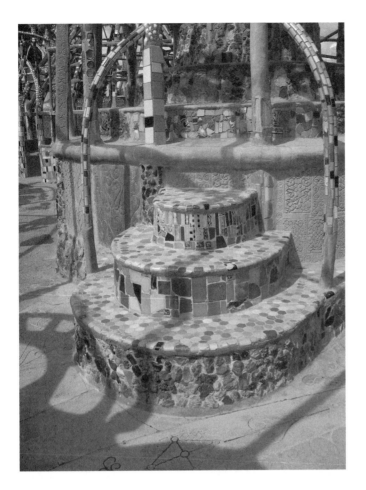

Simon Rodia, Nuestro Pueblo *(Watts Towers), 1921–1954, detail of steps. Photograph by the author.*

ica.[21] A 1939 *Los Angeles Times* piece reported that the project helped Rodia through his alcoholism, his new sobriety meaning he no longer used his own bottles but those of other drinkers.[22] In 1952, the papers reported that neighbors who once found the Towers eccentric now took pride in their local landmark.[23] Those who lived with the Towers as part of their daily urban experience also speculated that Rodia had built a radio tower, possibly one transmitting the wartime propaganda messages of Ikuko Toguri (Tokyo Rose), who grew up in Watts. Student filmmaker William Hale documented Rodia working in 1953, arguing that "inner necessity" caused the craftsman to obsessively "build toward the sun."[24] Richard Cándida Smith has noted how art critics have deemed Rodia an outsider artist, spontaneously spinning his steel and cement like a spider, arms encrusted with broken glass like the very sculpture he was building.[25] In 1971, Reyner Banham declared the Watts Towers "almost too well known to need description" and Rodia himself as "very much at one with the surfers, hot-rodders, sky-divers, and scuba-divers

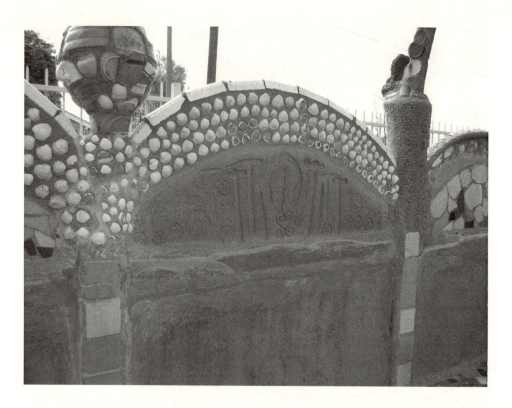

Simon Rodia, Nuestro Pueblo *(Watts Towers), 1921–1954, detail of tool impressions and tile work. Photograph by the author.*

who personify the tradition of private, mechanistic *satori*-seeking in California."[26] Rodia himself was recorded saying, "I want to do something big."[27]

There is another compelling explanation. In 1985 two folklore scholars, I. Sheldon Posen and Daniel Franklin Ward, published the findings of a lengthy investigation into the Feast of Saint Paulinas, an Italian American festival that took place each June in Brooklyn, New York. The highlight of the festivities was the carrying of a three-ton, six-story tower called a *giglio* through the streets on the shoulders of over 100 men. Other festival participants carried a giant galleon. Atop both the tower and the boat stood a statue of Saint Paulinas. What Posen learned while conducting his research was that the festival originated in Nola, near Naples, in southern Italy. Paulinas had been a fifth-century bishop of Nola captured by invading Vandal marauders and taken to north Africa. There he was made a slave but through divine gifts was able to interpret the future for the Vandal king. As a reward, the king set Paulinas and his fellow captives free. They returned to Italy by ship and were greeted by villagers bearing mounds of lilies (or *gigli*). The contemporary annual festival celebrated the miraculous return of Paulinas to his village. Ward realized that Los Angeles's Watts Towers, the topic of his own doctoral research, bore a startling resemblance to these *gigli* ceremonial towers.[28] Adding together Rodia's own origins in a town not far from Nola and his inclusion of a boat in his complex of

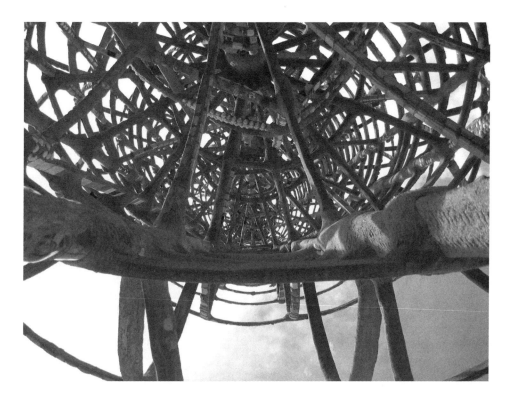

Simon Rodia, Nuestro Pueblo *(Watts Towers), 1921–1954, inside view of spire. Photograph by the author.*

structures lends credibility to their argument that he was recreating the *gigli* of his youth in his backyard. The Committee for Simon Rodia's Towers in Watts argues that this plausible explanation was long overlooked because a reporter misunderstood Rodia as pointing to his boat and saying the "Ship of Marco Polo," obscuring any obvious connection to Nola or Saint Paulinas. Given the strength of the *Gigli* festival evidence, the Committee believes Rodia actually told the reporter that the sculpture was "il barca di Paolo" or "the boat of Paulie, Paulinas."[29] A 1937 *Times* article did state that the structures were "modeled after quaint towers which Rodilla remembered from his native Italy" but did not elaborate on what those "quaint towers" might be.[30] Someone early in the Towers' construction had part of the story, but years of reinterpretation and misunderstandings have rendered the Towers' meanings elusive, infinite, and deeply personal to those engaged with them.

No one is certain why he left Los Angeles although surviving interviews imply that Rodia left because of aging and his deteriorating relationship with the neighborhood, as teenagers tossed garbage over the fence or threw rocks, breaking his carefully placed tiles and bottles.[31] After he moved north, Rodia's next-door neighbors tried to turn Nuestro Pueblo into a taco stand ("Tower Tacos"), but the city refused to grant them the building permit. The Towers stood in vandalized disrepair until the Committee for Simon

Rodia's Towers in Watts fought to protect the Towers from the city's demolition order, beginning work to permanently conserve and exhibit them to the public.[32]

The Politics of Art in Los Angeles

Art preservationists first invested the Towers with symbolic and political meaning in 1958 when the Committee for Simon Rodia's Towers in Watts—composed of mostly middle-class art students, teachers, artists, architects, and engineers—led the grassroots effort to save Rodia's Towers from demolition by the city's Building and Safety Department. The Committee had serendipitous origins in Los Angeles's civil rights movement as one of its original members, Jeanne Morgan, an Otis art student, took a wrong turn and came across the Towers accidentally while driving to an activists' meeting. Amazed by the Towers' size, workmanship, and beauty and disturbed by their neglect, Morgan organized a student "Committee for the Watts Towers."[33] Together with other students from the city's leading art schools, Morgan led a delegation to the downtown office of *Los Angeles Times* publisher Norman Chandler, to draw attention to the Towers but was ignored.[34] That same year, film student William Cartwright and his friend, actor Nicholas King, formed a second, larger organization, which they named the "Committee for the Preservation of Simon Rodia's Towers in Watts." At a meeting held at the Frank Lloyd Wright Pavilion in Barnsdall Park, the two organizations merged to ensure effective and permanent guardianship of Rodia's work.[35] Shortly thereafter, Cartwright and King sought out the Towers' owner, Rodia's former neighbor, Joseph Montoya, and bought the property for about $3,000.

It quickly became clear that caring for the Towers would be more complicated than any of the students involved had thought. When the Committee (whose name was shortened to the Committee for Simon Rodia's Towers in Watts) applied for a permit to construct a caretaker's cottage on the site, their request was refused.[36] Unsure about what the Towers were and finding no building permit, in 1957 the Building and Safety Department had issued a demolition order for their removal. Because of the vandalism occurring after Rodia's departure from Los Angeles, Building and Safety also declared the property unsafe and a public hazard. Neighbors reported to investigating students that local teens made sport of throwing rocks and chipping away at the bottles and tiles pressed into the Towers' mortar, probably searching for treasure rumored to be hidden within. At the subsequent July 1959 public hearing regarding the Towers' future, Deputy City Attorney W. E. Wilder argued that their "workmanship was of poor quality [and that] the towers have begun to deteriorate rapidly in recent years," adding that "the structures are broken in places and in danger of collapsing."[37] Assured of the Towers' strength, the Committee challenged the city to test them. The Committee's engineer, Bud Goldstone, whose expertise in aeronautical structures convinced him that Rodia's skilled craftsmanship would withstand a 10,000-pound-pull stress test, persuaded the Committee's volunteer attorney, Jack Levine, to put forth the stress test challenge. The city accepted, agreeing that if the Towers survived, Building and Safety would withdraw the demolition order. On October 10, 1959, the widely publicized test was held, and with hundreds watching, the Towers survived a truck's 10,000-pound pull intact.[38] The next day, H. L. Manley, chief of the Building and Safety Department, announced that the city would drop its efforts to have the Towers torn down. For the moment, the Towers were saved.[39]

In preparation for the 1959 demolition hearings, the Committee for Simon Rodia's Towers in Watts launched an international campaign of letters and petitions to define the Towers not as an eccentric local curiosity but as a significant artwork. The Committee hoped that if the Towers could be understood as art, rather than an unusual novelty, then perhaps the city of Los Angeles would grant them civic landmark status, ensuring their protection. This was a risky strategy given the city's general campaign to restrict, remove, and even destroy artworks and art spaces throughout the city. As the Committee phrased it later in 1966, "in spite of dramatic changes during the last decades, there is still a strong backlog of sentiment against the arts as useless if not outright corrupting."[40] In Los Angeles this was an especially dubious legacy as the 1950s had been marked by nasty public art controversies.

For a brief period from 1948 to 1951, Los Angeles had hosted a remarkable art program of festivals, community centers, galleries, and children's classes all sponsored by the publicly funded Municipal Art Department. Kenneth Ross, the department's dynamic director, placed emphasis on community art projects and local cultural centers.[41] In the spring of 1951, the *Los Angeles Times* announced Ross's introduction of a new program that promised "to give art exhibits, lectures, films, forums, painting demonstrations, and instructions in arts and crafts in community buildings . . . in every community area."[42]

Buoyed by public sponsorship, the Municipal Art Department encouraged a decentralized civic culture that annually brought art and music festivals to public parks in diverse neighborhoods, from Beverly Hills to Compton. Ross so believed in the social benefits of public art in public space that, as early as 1950, he secretly funded festivals in Compton and Watts, appointing Beulah Woodard, the first African American to exhibit at the County Museum, director of the art shows.[43]

Working in the long shadow of the 1947 Hollywood blacklist, a conservative attack on the Municipal Art Department undermined the new art program. Together with the anti–public housing real estate lobby, the Building and Safety Committee accused Ross of permitting a "heavy Communist infiltration" of the All-City Outdoor Art Show, the cornerstone of Ross's program.[44] After weeks of public hearings, the council refused to authorize funds for the city's art department unless Kenneth Ross banned abstract modernist art from all future public art exhibits.[45] This, combined with an internal audit, meant by the mid-1950s, Ross could no longer count on public funding in order to offer free exhibits, inexpensive art classes, and art festivals.[46]

With public art spaces closed and modernist art suspect, many artists were pushed out of the city completely or into the cultural margins. Some went to Venice Beach, which since the early 1950s had been a reprieve for artists and bohemians. By 1959, however, publicity generated by Beat literature, movies, and popular magazines made Venice an attraction for both tourists and young, stylish beatniks, pitting artists against homeowners in disputes over coffeehouses like the Venice West Café and the Gas House, both of which were private businesses hosting poetry readings and exhibiting artwork. Stories of the economic threat to bar and nightclub owners and tales of thousands of teenagers flocking to late-night racially integrated dens of iniquity made the newspapers frequently enough to pressure both city and county authorities to look into the "coffeehouse problem."[47] In the fall of 1959, the Los Angeles City Council passed an ordinance requiring all coffeehouses to have entertainment licenses, giving the Los Angeles Police Department

the power to grant permits at its own discretion.[48] As a result, local police had the power to control sites of cultural activity, usually by making arrests, orchestrating drug searches, planting spies, and through general surveillance.

It was artwork, however, that fell under the greatest suspicion. Coffeehouses displaying paintings and sculptures attracted the most attention from the Los Angeles Police Department and the County Sheriff's office. An anonymous coffeehouse owner reported in the *Los Angeles Times*, "the average cop thinks there is something subversive about any place with paintings on its wall. He thinks an artist is a suspicious character partly because of the way he may dress and partly because the officer holds art itself suspect."[49] The Watts Towers thus came under municipal scrutiny at precisely the same time that Building and Safety and the Los Angeles Police Department were shutting down alternative art spaces in other parts of the city.

Once Building and Safety declared the Towers safe to stand, the city cautiously (and briefly) tried to parlay the Towers into a tourist attraction. Following a 1960 fundraiser by Kenneth Ross and the Municipal Art Department, entitled "The Significance of the Watts Towers in the Community Landscape," a number of articles appeared in the *Los Angeles Times* arguing for the Towers as a site to be included in guidebooks along with the Rose Bowl, Forest Lawn, Grauman's Chinese Theater, and the recently opened attraction Disneyland. As one piece put it, "Watts Towers is the one local landmark guaranteed to raise a few eyebrows, whether in approval, awe, or amazement."[50] Professional claims that the Watts Towers were indeed art combined with Ross's support were successful in achieving some municipal recognition. In March 1963, the city of Los Angeles recognized the site as a cultural heritage monument.[51]

Racial Politics and the Watts Towers Arts Center

The troubled relationship between Watts and broader Los Angeles led the Towers' protectors to try to separate them symbolically from the neighborhood in which they stood. Images promoting the Towers' artfulness were usually shot from the ground up, obliterating their surrounding urban environment. Photographs exhibited by the Museum of Modern Art (1961) and the Los Angeles County Museum of Art (1962) show the Towers in a rural setting with barely a hint of the city that has always surrounded them.[52] Photographed from peculiar angles, the Towers were shorn from Watts and recontextualized in the discourse of postwar modernism. Conversely, neighborhood activists and community leaders historically have tightly linked the neighborhood to the Towers. Once saved from the municipal wrecking ball, they have served as an uneasy liaison between white liberals invested in their artistic merits and predominantly black community activists hoping to parlay the Towers into federal and state funding for local cultural and commercial facilities. The Watts Towers Arts Center (WTAC), a separate building originally purchased by the Committee in 1959 and serving community youth as a space for free arts and music education since 1961, has competed with preservation efforts for state funding. The quality of this codependent relationship between the Towers' preservationists and the community center has ebbed and flowed through the decades, depending greatly on the broader political and socioeconomic context.

Neither the push to make the Towers a tourist attraction nor their granting of official monument status was done with much municipal enthusiasm, and the city made no

move to support the WTAC. The second part of the Committee's preservation campaign, in fact, was the maintenance of this community center. Committee member Eve Echelman recruited African American artists Noah Purifoy and Judson Powell and teacher Sue Welsh to set up and run the center. Purifoy, who had a background in social work, ran the WTAC with a powerful sense of community activism and a commitment to art education. While much of the Towers' publicity had focused on preservation and aesthetics, he insisted that the WTAC function as a material connection between the Towers and the community of Watts, with art the medium through which a child could learn "he is part of the community of man, and that he is no more and no less than any other."[53] With two full-time teachers on staff, Debbie Brewer and Lucille Krasne, the center offered drawing and painting classes everyday for children aged four to eighteen. The community role of the WTAC would attract significantly more state and municipal attention after the Watts Riot, but in the years prior there was little support beyond 1964's Teen Post, a program funded through Lyndon Johnson's War on Poverty.[54] Some federal funding also came through a research project entitled "The Aesthetic Eye" to study black youth and the connections between the learning process and art education.[55]

As early as 1963, the Committee began work to propose an ambitious expansion of the WTAC. The new cultural facility would be better staffed, offer a broader range of classes, and host a social services office. Hoping that the unification of art attraction and community-at-large would help build much needed cultural, social, and commercial facilities in Watts, the Committee thought that the state of California would be instrumental in supporting to such a project. This strategy was articulated in a Committee publication: "After removing the demolition danger, [the Committee] has turned its attention to larger purposes—long-range preservation of the towers as a cultural monument; development as a community facility."[56] In the spring of 1965, the architecture firm of Kahn, Farrel, and Associates, on behalf of the Committee, submitted to the California Department of Parks and Recreation a proposal to build the "Simon Rodia Community Arts Center," which included a teen center, social services office, food facility, exhibition spaces, outdoor amphitheater, dance studios, a theater seating 200, and a parking lot for 400 cars. If adopted, the plan would have overhauled one square block of Watts.

The expansion was overly ambitious and some Committee members had voiced doubts whether it was even appropriate for "a small, self constituted committee to have control of something like the towers," let alone create and run an entire arts and culture center.[57] The new, Simon Rodia Community Arts Center, dropped any immediate association with Watts, and its size and scope spoke to some Committee members' loss of perspective in their preservationist zeal. Noah Purifoy, the original director of the WTAC, stated in interviews that the planned expansion was a mistake, that such a program would weaken the relationship between the community and the art center. Purifoy felt an expansion designed to draw people from outside Watts to what was hoped would eventually become a credential-granting art school was too sophisticated an art program for the focused goals of the WTAC.[58] Purifoy feared that such a project would alienate Watts residents and defeat the original goal of the WTAC, which was to provide a safe place for black youth to learn about the creative process. In addition, he disliked the proposed new name because he had always been reluctant to identify the art center as a community center, recognizing that neighbors would see it as one more government agency making an intrusion akin to urban renewal and redevelopment.

Judson Powell shared Purifoy's concern that they not pose as an agency. He remembers Watts residents often came to the WTAC asking for money, bail bonds, medical assistance, and other aid far beyond the abilities of a community art facility. The WTAC and the Committee found that they were in the situation of offering a cultural site that was useful to an impoverished urban neighborhood but neither equipped nor prepared to provide the basic facilities and infrastructure residents needed. Powell felt that the role of the WTAC was to tie art to public education by creating outreach programs with the Los Angeles Unified School Board. The Watts community felt it ought to play a greater role, creating further tension between the art center and the neighborhood.[59]

The tension over the expansion was for naught as the state rejected the plan outright and refused the Towers both state park and landmark status. The California Department of Parks and Recreation concluded, "the Simon Rodia towers are definitely a sort of bizarre art form. . . . However, their preservation is not a matter of statewide concern."[60] In its report, the state encouraged private ownership and maintenance of the Towers and helpfully recommended "that the proper local agency enlarge and develop the area into a Community Art Center," thereby kicking financial responsibility back to the Committee, which was surviving from grant to grant without any secure fiscal base.[61]

The Towers and the 1965 Watts Uprising

The summer California rejected the Watts Towers as a state park and crushed hopes of a permanent source of funding was the same summer that Los Angeles hosted the so-called Watts Riot, one of the largest civil uprisings in U.S. history. The event began on Wednesday, August 11, 1965, during a scuffle between police and onlookers after twenty-one-year-old Marquette Frye's arrest for drunk driving at 116st Street and Avalon, several blocks south of Watts. Violence escalated after Marquette was bloodily struck in the head by a cop's nightstick and rocks were thrown at the departing police car. As remaining police called for backup, growing numbers of young men took to the streets lighting fires and throwing stones, moving on to overturn cars and break windows of white-owned shops and businesses. By Thursday, the Los Angeles Police Department and the County Sheriff were outnumbered, and on Friday, August 13, Governor Pat Brown called in the National Guard. It was on Friday that the uprising moved north into Watts, burning two full blocks of 103rd Street near Central Avenue. Throughout the day, Noah Purifoy maintained considerable calm over the WTAC as crowds of kids gathered for their regularly scheduled art classes. According to Jeanne Morgan, the phone rang off the hook as admirers from all over the world called to find out whether the Towers were surviving the violence outside. Purifoy stationed children at the phones so callers would hear their small voices telling them all was well but also reminding them that there were people there, too, who might be cause for concern.[62]

At 3 a.m. on Saturday morning, 3,356 National Guardsmen were in the streets of South Central. At 8 p.m., Governor Brown instituted a curfew and by midnight on Saturday there were thousands of National Guardsmen on active duty in Los Angeles. The curfew was finally lifted on Tuesday, August 17. A frustrated response to high unemployment, a dire education system, a lack of social services, a history of police violence, and a dearth of public transportation in a neighborhood where less than 14 percent of residents owned cars, the riot left thirty-four people dead, 1,032 injured, and approximately 4,000 arrested,

500 of whom were under 18 years of age. The McCone Commission estimated damage to stores and automobiles to be over $40 million, and the numbers of dead, wounded, and arrested in Los Angeles far outnumbered the total numbers for all of the uprisings combined in New York, Rochester, Jersey City, Paterson, Elizabeth, Chicago, and Philadelphia during the bloody summer of 1964.[63] As shocking as the televised images were to Americans from all over the country, black Los Angelenos knew trouble had been brewing for a long time. As Chester Himes put it, "the only thing that surprised me about the race riots in Watts in 1965 was that they waited so long to happen. We are a very patient people."[64]

The Watts Riot forever changed national perceptions of American urban race relations, dulled Los Angeles's sunshine booster image, and reoriented how Rodia's Towers would be publicly represented as the city was catapulted into the American popular consciousness as an emblem of urban blight and black revolution. With the national spotlight on Los Angeles, Watts, and anything associated with it, was too charged a place for lighthearted editorials about an eccentric Italian tile setter and too dangerous to attract art-loving tourists. Rodia's grateful immigrant gift to America seemed more appropriate as an emblem of urban failure. In a radical contrast to the art discourse surrounding the Towers prior to 1965, post-riot mentions of the Towers did so in direct conversation with recent events, emphasizing their unavoidable geography. The year 1966 proved a pivotal one for the city of Los Angeles's renewed interest in Watts, art production in the community, and publicity for the city and the Towers.

The Community Redevelopment Agency and Spatial Politics, Post–1965

Noah Purifoy's fears that outside interests in Watts could do more damage than good were realized when, less than six months after the riot, in January 1966, headlines splashed across the *Los Angeles Times* promising that "Visions Point to Park-Like Future for Watts."[65] While residents voiced anxiety that the burning of South Central facilitated urban renewal (or "Negro removal"), city planners began work to transform the neighborhood into "the concrete and trees of pedestrian malls, sparkling new commercial structures and even garden apartments." The city's Community Redevelopment Agency (CRA) proposed long-term plans for new housing but suggested that commercial development was the most important strategy in rebuilding the area.[66] The most dramatic component of the CRA plan for Watts was its appropriation of the Committee's 1965 plan for an expanded community center. In this new, post-riot rendition, the burned-out 103rd Street business district was transformed "into a tree-lined pedestrian mall with a park corridor connecting it to the Watts Towers as a cultural monument."[67] The CRA plan kept the originally proposed name "The Simon Rodia Community Arts Center," removing direct associations with Watts, black Los Angeles, or the original goal of the center to create a safe cultural space for black and Latino kids.[68] In fact, CRA drawings of the center show a safe cultural space for *white* middle-class Angelenos. Appalled, the Committee insisted that the WTAC be black-run, arguing that "federal or local support cannot be expected unless greater Negro participation is achieved."[69]

CRA money did not come through for the new WTAC, and it is unclear what happened to $3 million earmarked for Watts redevelopment. Instead, the Committee regrouped and launched a campaign to raise $75,000 for a new building. Jack Levine, the

attorney for the Committee since the 1959 Building and Safety hearings, stated at a press conference that they only wanted to sponsor an expanded art center and leave its operation to the community.[70] Despite millions of federal dollars being pumped into the neighborhood through the U.S. Department of Housing and Urban Development (HUD), the War on Poverty, and other offices such as the Economic Youth Opportunity Agency, Teen Post, and Job Corps, the Committee was unable to raise the necessary funds and, almost a year later, staged a "dig-in" whereby 200 people, mostly Watts residents, worked in shifts to dig the twelve-inch trench needed to lay the building foundation. Unable to afford the necessary heavy equipment, neighbors and Committee members put in the concrete foundation by hand. Plans for the new center were donated by sympathetic architects in the Los Angeles area. Though the Committee hoped to open the center in August 1967, the new building would not be dedicated until March 1, 1970.[71] By surviving for at least forty-seven years (1959–2006), the WTAC may be the oldest nonprofit community art space in the country and certainly the model for the radical Los Angeles arts centers of the 1960s and 1970s, such as the Studio Watts Workshop, Watts Happening House, the Performing Arts Society of Los Angeles, the Compton Communicative Arts Academy, as well as Chicano centers found mostly on the other side of town: Mechecona Arts Center, the Mexican American Center for the Creative Arts, and Plaza de la Raza.[72]

Community Politics and Community Arts, Post–1965

If flawed commercial redevelopment plans represented Los Angeles's approach to addressing the "Watts problem," a focus on the arts represented the neighborhood's. In the spring of 1966, representatives from the WTAC and local high schools planned the "Watts Festival of Arts" to be held at Markham Junior High with the intention of exposing "Watts artists to the general community and expose the general community to Watts."[73] The festival included theatrical productions, a parade, and various workshops on painting, dance, music, and sculpture. The big draw, however, was the exhibit, "66 Signs of Neon," organized by Noah Purifoy and Judson Powell. While still running the WTAC in 1964, Purifoy and Powell had thought of creating a sculpture garden around the Towers made of found objects from the neighborhood. The one thing the Watts Revolt produced in unlimited quantities were piles of burned and trashed materials that those with a creative eye could gather and mold into sculpture. Thus the exhibition was born. "The riot," explained Powell to the newspapers, "was the first thing this community ever did together."[74] After collecting three tons of charred riot detritus, the artists invited four friends to join them in their project named for the drippings and casings from broken neon signs.[75] The artworks also included assemblages of shattered windshields, torn sheet metal, and ghoulish montages of children's shoes and broken dolls. The exhibit at Markham Junior High attracted an enormous amount of attention, traveled to Washington, D.C., and onward to Germany in an ironic twist as bloody American ruins were shipped abroad.[76] In the accompanying catalog, "Junk," Purifoy tied the exhibit, the riot, and his goals as the director of the WTAC together. Basically agreeing with the findings of the McCone Commission, the governor's report that blamed unemployment and a lack of educational resources for the revolt, Purifoy felt that art and culture should also have been emphasized. By having few outlets for artistic creativity, education in South

Central was further failing its youth. "66 Signs of Neon" was shown again at the 1967 and 1968 Watts Arts Festivals but, by 1969, had been dismantled with the individual pieces scattered and lost.[77]

Purifoy's dark vision was echoed in a widely read account of post-revolt Watts, "A Journey into the Mind of Watts," Thomas Pynchon's 1966 *New York Times* exposé. Pynchon described a neighborhood that went from national obscurity to national obsession and yet remained virtually unchanged as an impoverished neighborhood in which government intervention was resented, the police feared, and communication between black activists and white liberals poor. It was a place ("Raceriotland," a dark play on Disneyland) that America wanted to forget: "Somehow it occurs to very few of them [white Americans] to leave at the Imperial Highway exit for a change, go east instead of west only a few blocks, and take a look at Watts. A quick look. The simplest kind of beginning. But Watts is country which lies, psychologically, uncounted miles further than most whites seem at present willing to travel."[78] Pynchon knew, however, that the one thing that had historically drawn white visitors to black Los Angeles was Simon Rodia's backyard fantasy. But Pynchon was not willing to let a curious, art-loving public off so easily. No pat on the head for *Times* readers on June 12, 1966. Instead, Pynchon foregrounded Rodia and the Watts Towers as more evidence of Los Angeles's urban decay. Pynchon respected Rodia, admiring his "dream of how things should have been: a fantasy of fountains, boats, tall openwork spires," but also saw the mortared broken glass as a specter of failure: "A kid could come along in his bare feet and step on this glass—not that they'd ever know. These kids are so tough you can pull slivers of it out of them and never get a whimper. It's part of their landscape, both the real and the emotional one: busted glass, busted crockery, nails, tin cans, all kinds of scrap and waste. Traditionally Watts. Next to the Towers, along the old Pacific Electric tracks, kids are busy every day busting more bottles on the street rails. But Simon Rodia is dead, and now the junk just accumulates."[79]

Little publicity for the Towers followed the Pynchon article or Purifoy exhibition of 1966, with a few exceptions. One was a children's book written in 1968 by Jon Madian depicting a kindly old gent schooling a black kid on the artistic value of garbage. Distributed to elementary schools around the United States, Madian's picture book shows an actor playing Rodia (the real Rodia already dead three years) in a romanticism of the relationship between an elderly white man and a racially charged neighborhood. A second public image of the Towers in the post-riot years was their appearance on the cover of *Time* in 1969 in celebration of California's population explosion. Two years later Reyner Banham celebrated the architectural landscape of Los Angeles, featuring the Towers as one of the few orienting emblematics in his maps of the city.

Political Backlash: Damaged City, Damaged Towers

With a general lack of publicity and the stigma of 1965 preventing the fundraising campaigns possible in 1959, the Committee could no longer afford to keep the Towers or the WTAC. After sixteen years of maintaining them on private donations, in 1975 the Committee turned the Towers over to the municipal government. The city promised to care for them and repair weather damage and hired a contractor to do so. Untrained in the skilled work needed to reinforce Rodia's unique structure, the contractor and his associates badly damaged the Towers, performing what is known as a "savage restoration" whereby a

work of art or historical landmark is "preserved" in such a way as to purposely destroy or irreparably damage the original work. What the 10,000-pound stress test could not do in 1959 was achieved sixteen years later by chipping away the mosaics, ripping apart the foundation, attempting to pour plastic onto the face of the Towers, and leaving flammable waste in barrels within the Towers' base. Fortunately, the Towers did not explode, and the Center for Law in the Public Interest sued the city, on behalf of the Committee, to stop the damaging restoration and force the city to pay reparations. In a complex lawsuit that would finally end in 1985, the Committee donated the Watts Towers to the state of California with the stipulation that $207,000 of state funds would go to the city for their preservation and upkeep. As part of the settlement, Watts Towers was finally proclaimed a California Historic Park while responsibility for restoration was assigned to Los Angeles's Cultural Affairs Department.[80]

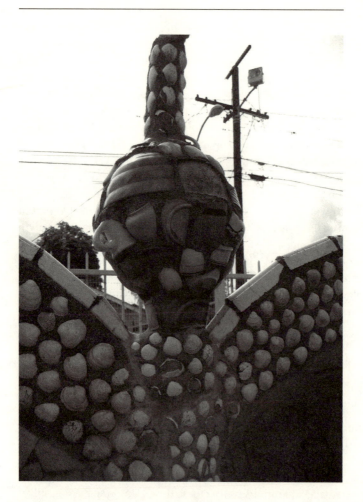

Simon Rodia, Nuestro Pueblo *(Watts Towers), 1921–1954, detail of chipped shell and dinnerware. Photograph by the author.*

The municipal government's neglect of the Towers reflected the national attitude toward the inner city in the 1970s—a lack of empathy combined with diminished financial support. The conservative backlash against the social upheaval of the 1960s was pronounced in California as exemplified by the passage of Proposition 13. In 1978, landlord lobbyist Howard Jarvis gathered over a million signatures to put the proposition limiting property taxes for suburban homeowners on the state ballot. The passage of Proposition 13 severely limited the funding of schools, public services, and urban infrastructure in inner-city neighborhoods and had an immediate effect on the Watts Towers. [81] In a letter to a concerned resident of Watts, the Office of the Mayor wrote, "all of us in [in the city government] share your concerns regarding the safety of the Watts Towers. However we cannot give any assurances for 24 hour security. . . . With the passage of Proposition 13 it may be necessary for the city to have fewer security officers than we had before to guard all of our public facilities."[82]

The Towers in the Age of Civic Renewal

The 1970s and 1980s represented a shift in the political infrastructure of the city. Conservative mayor Sam Yorty lost in 1973 to the first (and, to date, only) African American mayor of Los Angeles, Tom Bradley, who would win four consecutive terms before his retirement in 1993. Properly criticized for copping to corporate land grabs, susceptibility to foreign payoffs, and not supporting affordable housing, Bradley was also responsible for putting Los Angeles on the international map as a financial center, with the 1984 Summer Olympics his career's major coup. As Roger Keil argues in his work on Los Angeles as global city, downtown Los Angeles would undergo an immense transformation during the Bradley years, becoming dominated by skyscrapers and the symbols of global capitalism: "Bradley's ability to smooth out the waves of social unrest in Los Angeles during [the 1970s and 1980s] enabled new concepts of an urban future to surface, and opened the space of the city to the fantasies of developers who had their eyes on the downtown prize."[83]

Bradley's vision of a rejuvenated Los Angeles, with racial and economic distress behind it, included an emphasis on the arts as part of a new, invigorated civic identity. In anticipation of the 1984 Olympics, Bradley commissioned forty-seven murals, painted along major stretches of the 110, 101, and 10 freeways. Often showing runners or other sports participants, the murals "officially" resurrected an art form that the city of Los Angeles had destroyed in the 1930s as communistic and overly critical of racial and class inequities. David Siqueiros's *Tropical America,* whitewashed in the 1930s, is the most famous of the city's Mexican murals. By the 1960s and 1970s, of course, murals had become a major visual component of the Chicano movement and of radical social movements in Los Angeles and other cities throughout the United States. The irony of Los Angeles's Cultural Affairs Department adopting a highly politicized and historically marginalized art form to represent the new global Los Angeles as a seat of international financial prowess was not lost on local artists. To this day, the Bradley-era murals are a favorite target of graffiti artists and taggers who see these freeway wall paintings as unwelcome marks of the "civic official."[84]

This strange separation of art and history in the name of a new civic identity continued through the 1980s when the Los Angeles papers, the *Herald Examiner* in particular, sponsored a fundraising campaign in support of the Towers. Pulling together an impressive

roster including representatives from the Committee, local art critics and commentators, museum curators, newspaper editors, state assemblymen, prominent American architects, and a couple of Watts activists, the *Herald Examiner* hosted "The International Forum for the Future of Sam Rodia's Towers in Watts," which ran for three days in June 1985 at the Davidson Conference Center at the University of Southern California. Avoiding the 1965 revolt and the social history of Watts, the press instead used the Towers to obscure racist power relations that defined living conditions in South Central and promote Bradley's civic campaign of "community affirmation." The *Herald Examiner* adopted the language of the 1950s preservation campaign, writing, "No symbol in Los Angeles carries more meaning than these sparkling spires. A testimony to immigrants' dreams . . . Today that vision towers over Watts, high above the railroad tracks, the little houses and the human struggle—a tribute to a community's inner strength."[85] This commentary, combined with photographs that rarely showed the neighborhood, served to separate the "Towers as community" symbol from the history of Watts. Moreover, the romantic mythology surrounding the narrative of an immigrant building such a monument obscured Watts's new Latin American immigrants from view. With all the trappings of an official and possibly productive meeting, little came of the campaign other than plans to host an international design competition to commercially redevelop the area surrounding the Towers. Mike Davis has pointed out that at the very moment that Los Angeles came into its own as a global city, with the trappings of shiny buildings and plans for new museums, "such vital generators of community self-definition as the Watts Towers Arts Center . . . had to make drastic cutbacks to survive the 'age of arts affluence.'"[86]

The Cultural Politics of the Towers

While Los Angeles's municipal government and the newspapers deployed the Towers as a deracialized, deracinated, and depoliticized symbol of community, popular culture increasingly adopted the Towers as a symbol of American blackness in the 1980s and 1990s. Pop cultural appropriations of the Towers were not new. Musicians who lived or performed in postwar Watts, for example, often had close affiliation and nostalgia for Nuestro Pueblo. Jazz and rhythm and blues greats, respectively, Charles Mingus and Johnny Otis, have commented in their autobiographies on the Towers' significance as a neighborhood landmark and a testament to artistic endeavor. Visual artists have been captivated, too; Jann Haworth and Peter Blake featured Simon Rodia amid the crowd of faces assembled on the Beatles' 1967 *Sgt. Pepper* album cover.

What changed in the 1980s was the infusion of hip-hop into mainstream American popular culture with graffiti, urban dance moves, and rap music together articulating "a black cultural expression that prioritizes black voices from the margins of urban America."[87] The social effects of neglecting the inner city increasingly played out in movies, with Los Angeles emerging as the filmic trope of black urban unrest in the late twentieth century in much the same way that New York served as the symbol of American ethnic conflict and urban blight in 1970s films like *Taxi Driver, Mean Streets, Serpico,* and *Saturday Night Fever.* And with the Watts Towers physically located in Watts, ground zero for gang warfare and a historical touchstone for popular conceptions of Los Angeles's "South Central," Rodia's life work became a common spatial reference for Hollywood. In *Colors* (1988), Dennis Hopper deployed the Towers to metaphorically show how a black neigh-

borhood is torn apart by gang warfare, police violence, and drugs.[88] *Ricochet* (1991), starring Denzel Washington and John Lithgow, encodes the Towers as symbols of "blackness," black community, and Black Power.[89] In the 1992 cheeseball buddy film *White Men Can't Jump,* the Towers signal a white man's arrival in the ghetto while the 1996 movie *Courage Under Fire* deploys the Towers to new effect. Displayed as a black and white print hanging on a bedroom wall, the Towers serve, for a middle-class black family functioning in the upper echelon of white Washington, D.C., political culture, as an ambiguous marker of black authenticity, one's roots in the hood, or perhaps a sign of a finely tuned aesthetic sensibility.

The Towers have increasing, and significantly embodied, resonance in hip-hop. Since the Los Angeles gang wars of the 1980s (and possibly before), the thrown hand sign for Watts is three fingers of the right hand pointed down symbolizing Rodia's three main towers. In very recent years, they have been featured in advertisements, music videos, and computer games. R&B performer Tyrese appears gleaming, well-sculpted, with his body placed in geometrical alignment with the towers on the cover of his 2001 CD release, commenting in the liner notes, "I use the Watts Towers as a symbol of freedom, history, struggle, independence, strength and a high level of confidence."[90] LA hip-hop artist The Game prominently features the Towers in several of his videos. In 1999, the Towers appeared in a Levi's print ad in which a young hipster sits on a stool in the lot behind the Towers holding a sign that says "Restoration, Rejuvenation."[91] The Levi's appropriation of the Watts Towers helps render them an icon of popular culture while a multinational corporation profits by cashing in on a real social and political history. Globalization and the denim-clothed youthful body emphasize the growing socioeconomic space between those living near the Towers and those able to buy the latest offerings from Levi's. Removed from their urban context in high art discourse, popular representations of the Towers in the hyperviolent video game "Grand Theft Auto-San Andreas" and Boost Mobile's ubiquitous "Where you at?" advertising campaign exploit the Towers for their authenticating street credentials. As hip-hop has become mainstream through our broader popular culture, representational icons like the Towers have become increasingly part of an urban vernacular landscape whose meanings are loosely tied to pop notions of black cultural identity and tightly secured to commercial products. Far beyond any intention of Simon Rodia, the Watts Towers increasingly embody the globalized process whereby an urban space's commercial value makes a profit for those well outside the reach of the social ills originally rendering that space its consumerist marketability.

Conclusion: *Nuestro Pueblo* as Political Space

Representations of the Watts Towers in artwork, advertising, municipal reports, art journals, and popular culture are inscribed with the contrasts between high art and community art, black public space and white safe space, art removed from its urban context and art made of urban debris, towers of power and towers of poverty. Underlying much of the "officially civic" language surrounding the Towers is an inarticulate but obvious discomfort with the evolution of the Towers into a nationally recognized civic landmark in a city with a long history of painting over, literally and figuratively, representations of nonwhite and poor people.

The political climate of the 1990s helped formulate new uses for the Towers. In 1990, Arloa Paquin Goldstone successfully applied for the Towers' National Landmark status. One the heels of this achievement, the city of Los Angeles Watts Redevelopment Project used the Towers to decorate its cover in the fall of 1991.[92] It is yet another ironic twist that proponents of urban renewal would use the Towers as a symbol of a rejuvenated neighborhood when so much more energy has gone into preserving the Towers than rectifying social and economic inequities. This irony is especially pronounced since urban renewal helped destroy Watts as an economically viable neighborhood and led to the early efforts to tear down the Towers in the first place.

The 1991 CRA project evaporated first with the brutal beating of Rodney King by officers of the Los Angeles Police Department, then with the "not guilty" verdict that sparked looting and violence across a wide band of southern Los Angeles. With riots focusing

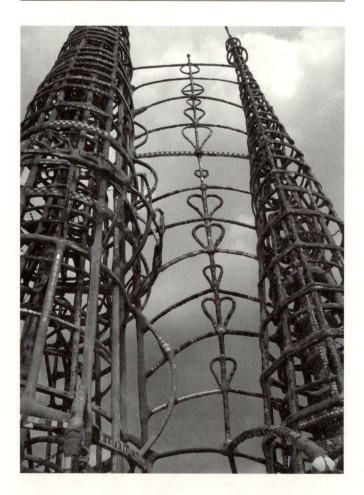

Simon Rodia, Nuestro Pueblo *(Watts Towers), 1921–1954, detail of heart-laced earthquake reinforcement bridge. Photograph by the author.*

national attention again on Los Angeles's black neighborhoods, the failure of programs, grants, and contracts that followed the aftermath of 1965 were shown in stark relief. James Woods, founder of the Studio Watts Workshop, has said: "If funding had concentrated on establishing institutions rather than temporary programs, we could have accomplished much more."[93] Short-term funding of community art could not maintain such programs anymore than fixing Watts Towers could fix Watts.

Since the summer of 1999, Watts and the Towers have become state-recognized tourist attractions. Through the nonprofit Watts Labor Community Action Committee and the California Council for the Humanities, local activists have organized bus tours of Watts with an extended stop at Rodia's Towers. The hope of tour organizers is that by educating outsiders on the cultural merits of Watts, commercial interests might start investing in the area. In July 1999, President Clinton visited the neighborhood as part of a national tour of economically depressed areas. Work on the large Watts Towers community art center, proposed and rejected by the state in 1965, began in 1998, but the project is riddled with design problems and moves slowly. The new building, begun in 2006, has obliterated the parking lot and WTAC staff fear few will visit if they have to park on the street. The WTAC continues to offer classes, mount exhibitions, and host art and music festivals, now under the direction of Rosie Lee Hooks.[94] Watts faces new challenges as its Latino population has overtaken the African American population. The new residents of Watts are also poor and the social services that exist in the area are ill-equipped to handle Spanish-speaking clients.[95] In 2001, the Cultural Affairs Department's eight-year, $2 million renovation ended, with help from the Getty Conservation Institute, and the Towers' scaffolding was removed to great fanfare in the local media.[96] Today the Committee for Simon Rodia's Towers in Watts is trying to get either the city or the state to issue a "stop work" order to end another bout of damaging restoration practices that have inalterably erased unique examples of Rodia's handiwork.

Midway through Rodia's construction of Nuestro Pueblo, in 1938, Lewis Mumford published his epic history of the origins of the modern city, *The Culture of Cities.* He wrote in his introduction, "the city, as one finds it in history, is the point of maximum concentration for the power and culture of a community. . . . With language itself, it remains man's greatest work of art."[97] Nuestro Pueblo has proven such a point, an art-based space that acts as a galvanizing force for a politics grounded in cultural identity and loud claims to social equity. Nuestro Pueblo's towers have been both generative of community and symbols of community in political fights over funding and territory. Nuestro Pueblo represents the penultimate modern city as it embodies premodern labor while holding the multitudinous meanings, multilingual names, and commercial promises of the postmodern world city.

Reading the Watts Towers, Teaching Los Angeles: Storytelling and Public Art

Monica Barra

Pathways

"Sculpture isn't simply an object in space. It lives through the processional or returning views" (Assmann 1995: 125–33). Built environments deploy their own ethos of reading, wrapped up in urban form and the rhythms of everyday life. I had finished rereading Italo Calvino's *Invisible Cities* (1974) for the third time the day before I traveled to the Watts Towers in 2006. Like many monuments and the cities of the world that Calvino's Marco Polo speaks of to the Kublai Khan in *Invisible Cities*, the Watts Towers, before I knew them, were a work of great imagining. When I finally arrived, my eyes were racing along portals, walls, and masts of the frenetic hodgepodge of materials that composed the piece. The infinite networks of cement scaffolding and mosaic tiling were overwhelming, at once overshadowing and encompassing me. The compulsion to simultaneously look up at the Towers' peaks and step back to see the whole piece, only to move in closer again to view the details of green soda-bottle glass and cement engravings, made me acutely aware of the in-between space I occupied, as a viewer, between the expansiveness of the Towers and their nuanced detail. The Towers were less an object, as the quote above suggests, but an experience produced through the collection of vantages and second looks, participatory despite their seeming monumentality.

Urban processes, the individual and collective actions that are the pathways through which an urban space comes to life, function in a similar vein: solid, yet frenetic and multiple, existing somewhere between concrete form and social–spatial fluidity. Like the bits and pieces of the Towers and infinite cities within Marco Polo's Venice in Calvino's book, to engage with a place is to become involved in the ever-emergent patterns and formations that tenuously await the viewer's gaze. In this regard, the stubborn details and expansiveness of Los Angeles is reflected in the composition of Rodia's work existing, like a city (or any place rural or urban for that matter), in disparate, shape-shifting forms that resist totalizing images or narratives.

To this end, I would like to consider the Towers within a convergence of several disparate, yet interconnected, discourses about cities, history, monumentality, and public art as a way to demonstrate how Simon Rodia's artwork gestures toward a particular production of space that is distinctly of a place, in general, and particularly Los Angeles. I do this first by considering how narratives about cities and art circulate and interact in a fluid process of becoming within space and through time. Using the Italian writer Italo Calvino's work *Invisible Cities*, I use the dialogic conversations about cities between the two main characters, Marco Polo and Kublai Khan, to begin to open up the possibility of reimagining how a place is collaboratively created through the stories told about it. From here I consider how storytelling—invoking oral historian Alessandro Portelli—as a form of history making that is always between, wherein meaning is always co-produced within the interstitial space between the speaker and her audience, is a salient way to think about how we teach and engage the politics of place. I end by considering how embracing a more collaborative and processual approach to understanding urban environments based on narratives and storytelling interfaces with more specific theoretical engagements with the question of urban space. In particular, I turn to Henri Lefebvre's notion of the urban phenomenon, whereby urban space is always in contradiction and flux, and how this notion of social and material space challenges the ways we think about the Towers as a monumental space and instead asks us to think of how a place—a public art piece in particular—comes into and out of being within the various practices, histories, environments, and futures that produce a place and give it meaning.

The desire to memorialize, to read the city and monuments and art pieces like the Watts Towers as consistent and static signs, obscures the dynamic processes through which the mnemonic of a place or piece of art comes to signify a particular historical moment or group of people. Especially in a city like Los Angeles that is prone to popular narrative maskings of "other Los Angeleses,"[1] it is important to consider not only how local narratives and memories bring the city into existence within (perhaps in contrast to) popular narratives but also how the Towers and their history in the Watts community, as a continually collaborative piece, eschew any one narrative, forcing us to confront the city and the Towers on the terms of their participatory and emergent nature. I chose this approach in order to ascertain a sense of a whole that can be cultivated and presented, not as an artifact, but more as a means toward better understanding how public art and urban space can simultaneously stage and represent a city like Los Angeles.

Collaborative Cities

It is for a good reason that Italo Calvino's slim novella *Invisible Cities* is invoked consistently among urbanists to frame their work on the complexity and delicacy of the "urban fabric."[2] The novel is told between three voices: a third-person narrator and a dialogue between the famously reimagined Kublai Khan and Marco Polo, divided into a series of vignettes that consist of Marco Polo's tales of various cities he has explored in the great expanses of Kublai Khan's kingdom. Each section is thematically framed, exploring a phenomenon within the context of built and imagined urban environments, for example, "cities and desire," "trading cities," "cities and signs," and "cities and the dead."

While standing in front of the Towers for the first time, I recalled a moment in *Invisible Cities* where the narrator comments on Kublai Khan's struggle to make sense out of the seemingly disparate stories that Marco Polo tells him. Communication between the two is strained because they do not speak the same language. Instead, Marco Polo and Kublai Khan always speak in gestures, relying on objects and signs to communicate with each other:

> The connections between one element of the story and another were not always obvious
> to the emperor; the objects could have various meanings [the reader is told] but what
> enhanced for Kublai every event or piece of news reported by his inarticulate informer
> was the space that remained around it, a void not filled with words. (Calvino 1974: 38)

The spaces around the stories are where the imagination flourishes and the city begins to exist, for these men do not have the benefit of speaking the same language. They do, however, manage to craft and imagine a language of cities through which to speak. The narrator's insight into the residue of actions, the spaces between storytelling—the possibility of the uncharted, unnarrated void—this is the site where the work of creating cities, the signs and their meaning, develops. This particular excerpt highlights the participation and collaboration of the audience (Kublai Khan) and the greater audiences and authors (the narrator and the reader) in the production of the novel (as well as through the vignettes through which Polo speaks of Venice). Beyond the fascinatingly rich and imaginative language at the sentence level, Marco Polo and the narrator deploy an architectonic narration technique that embodies the dialogic and metamorphic that the cities undergo as they are transposed through memory, language, time, and anticipation. The cities explicitly function symbolically and literally: At no point does Marco Polo indicate that his cities are fictive, in the traditional sense of the word that implies they are a work of imagination. Instead, it is understood that what constitutes reality is itself imagining, potentiality and temporality.

As a dialogue between storyteller and listener, the relationship between Marco Polo and Kublai Khan is pedagogic as well as collaborative. Kublai questions, listens, questions, attempts to interpret and undermine the stories, or lessons, told by Marco Polo. The two men engage in a dialogue about the stories told, their possibilities, and their interpretive value. At one point in the novel, Kublai attempts to invert the pedagogical relationship to Marco Polo by proposing to describe an imagined city to him and then asking him whether he has visited such a place. "Of course," Polo replies and launches into the story of the city of Kublai Khan's imagination. It is a city imagined into reality

that breaks through an ideology of binary oppositions between myth and reality (a process Kublai Khan challenges throughout the novel), turning a myth in the present of one man into a memory in the past of another. This impossibility becomes reality in the world of the novel, yet it extends beyond the narrative of *Invisible Cities*, for it reflects a process of memory making for the present that a highly vulnerable collective memory is constantly exposed to. In short, Kublai Khan's exercise (albeit in a novel) draws attention to the effect of memorialization in the present on a collectively remembered past: how singular pasts are carved out of cacophonous memories that are distinct in their substance but universal in their collective representation. Beyond this, Khan and Polo's conversations demonstrate how places change through the stories we tell about them—imagined, remembered, or forgotten. Polo challenges his listeners to think of Venice not as a singular place on a map but as a confluence of imaginings and practices emanating from different bodies (both people and bodies of knowledge) across time, space, and form. What is Venice but the memories one has of it, or the stories one tells to a foreign listener?

Between Stories Told

"It is not the voice that commands the story: it is the ear" (Calvino 1974: 135). I here wish to bring insights from the field of oral history to bear on this emerging dialogue. Navigating the spaces around stories brings into context the work of Italian oral historian Alessandro Portelli, whose work has been central in transforming the field of oral history from one concerned with historical accuracy to one that recognizes the salience of memory as a scholarly aspect of historical study. Meaning rests, for Portelli, in the accumulation of in-between and indistinct spaces, tied to highly personalized perceptions, interacting with and continually forging the meaning of pasts, against a sense of historicity and historical fact. For Portelli, the relationship between oral historian and informant is a collaborative one: The history collected, the story disseminated, is created "between spaces" in the perceptions and conversations *between* parties. Value lies in the personally remembered as opposed to the officially documented truths of history. The "departure from fact," according to Portelli, reveals more about the "imagination, desire, and symbolism" of events or historical moments, entities far more revealing about a group of people than any kind of accurate depiction of what did or did not happen to them or what they witnessed or remember being told (Portelli 1988: 37). In this vein, the question for the oral historian focuses on the meaning of an event (or moment) as understood through the narratives—accurate or false—of witnesses (or those who remember) themselves. Memory, then, moves to the forefront of what is valuable to historians (at least oral historians). The substance of what makes an event or moment important is not the event itself but rather how it is remembered, disseminated, or narrativized. Such attention to remembering, as opposed to history, acknowledges that memory does not function as a fixed historical document but acts on and through historical narratives and everyday practices. As Portelli elegantly puts it: "memory is not a passive repository of facts but an active process of creating meanings" (Portelli 1988: 37). Memory, as such, comes out of the archive or shadows to speak as an unconventional participant: one that cannot claim a historical existence or innocent impartiality but is the imperfect witness that is subject to desire, forgetting, and re-membering, as much as the individual who

houses memory is at the mercy of uncontrollable internal forces and external circum-
stances.

The mnemonic value of the Watts Towers is their ability to facilitate, if not instigate,
the exchange of stories and stand in as the material sign that represents against the ebb
and flow of history and memory: They are a catalyst for memory. "The Watts Towers is
overwhelmingly a history of its representations," Californian art historian Sarah Schrank
remarks, and those representations are mined from incredibly localized experiences and
deployed through the Towers' monumentalization into a collective memory and history
of Los Angeles (Schrank 2000: 374). Beyond Watts, they are a foundational element of
the Angeleno imagining of the city (for those who know about them). Their value was
socially constructed before they were ever incorporated into an official discourse of value
bestowed on them by the city of Los Angeles and the state of California. Their social
value is the epitome of an *other* city, a significance derived from their particular history
of artistic production and designation of a community space apart from typical, every-
day working and living spaces. They are a bricolage sign of Italian immigrant influence
(quite singular in itself), folk-art style, and a history of alternative practices of making
place, unique histories and urban landmarks that participate at a very local level in the
production of a distinct neighborhood identity apart from the rest of Los Angeles.

While questions of production certainly dominate the critical study of the Towers,
questions of reception, especially for public art, illuminate the Towers' social and urban
function. When thinking about the Watts Towers, the move toward community, toward
the *how* as opposed to the *what* of a history, shifts their importance onto the groups who
tell, live, and relive them at the everyday level and the perpetual processes of making,
breaking, and rewriting history—processes that create a history all their own. As a pub-
lic space, one designated a public landmark by the city of Los Angeles, it is even more
important to consider how they relate to the various publics that they are beholden to.
There is an authorship, a network of interrelationships that is implied in work that is in
the public sphere. The very notion of *public*, particularly in a contemporary urban land-
use context, implies a connection to residents and their lineages within a certain space.
There is a public ownership of the Towers, or at least a sense of ownership, that has been
expressed over the past sixty years in community battles to have the Towers designated
as a public landmark and/or park, thus saving them from being torn down or condemned
by the city of Los Angeles. When the city attempted to tear down the Towers, because it
deemed them unsafe, residents in the neighboring blocks were the ones to call attention
to the space as one of significance to the community. As the story goes, the Towers with-
stood the stress test, achieving validity in the eyes of the city of Los Angeles that allowed
the authorities to begin the process of turning them into a preserved space. The civic
recognition of the Towers as worthy of saving reflects the efforts of the Committee for
Simon Rodia's Towers in Watts, together with a wider community, to guard them against
the forces of destruction (embodied in the city of Los Angeles). It is a modern-day David
and Goliath story. The Towers stand as a material reminder, a *lieu de memoire* (collabora-
tive site of memory) as French historian Pierre Nora would call it, reminders to residents
of their own assertion of power in that space (Nora 1989). With a recent history of urban
poverty and violence that perpetuates public narratives about disempowerment and the
failures of this particular inner-city community, their preservation becomes an important

counternarrative in the public sphere. Not only do the Towers function in the physical context of the urban environment, but they function symbolically in the terrain of the social milieu of Watts, serving as a site through which to channel a kind of material and discursive authority in the neighborhood.

The Urban Phenomenon

Its representations, and myriad imaginings, illuminate the pedagogical work that the Towers can do for reading and producing knowledge about the city. There is no established field of "urban pedagogy," yet "urban" can be an incredibly powerful heuristic through which to consider the relationships between what, how, and where we teach about the city, or the urban. "Environment" also functions here as both subject and mechanism of urban pedagogy beyond context. The fabric of the city is the nexus through which distinctions between myth, history, reality, perception, and representation are constructed and mediated, infusing lived space with meaning through both their content and form.

It is significant at this point to distinguish what I mean by the adjective "urban" because it carries a significant connotation here. I invoke "urban" in the spirit of French urban theorist Henri Lefebvre's use of the term, as one that designates a type of exchange that happens in city spaces, specifically economic, social, and political. It is indicative of a philosophy of sorts about networks and the production—more in the sense of performance and less in economic exchange—that are suspended in motion in the urban environment that is a conductor of dialectical relationships. This observation can be extended to how we think about the social production of space in general, not just urban space (even though the bulk of Lefebvre's arguments about social space are generated from thinking about cities specifically). Such relationships are indicative of Lefebvre's theory of "dialectical materialism," a mode of "dialectical thinking" that potentially opens up—if not completely rejecting—an empirical system of binaries for analyzing space, instead "bringing together the conflictual and contradictory [that would be] both homogeneous and fragmented, ephemeral and durable [which] would not deny one or other term nor transcend them, but reveal the continual movement between them" (Lefebvre 1996: 10). His linking of theory and practice is less about a closed discourse shuttling back and forth between two fixed points but rather about a synergy that happens as said discourses and knowledges[3] are staged through the urban environment. The oeuvre that is the urban, "closer to a work of art than to a simple material product," is the iteration of the expansion that emanates from the contradictory moments and movements within urban space (Lefebvre 1996: 101). Urban is a performance, a dance of double binds made possible by the urban material and social environment that is an open totality where exchange and use values produce meaning within the urban milieu, or "fabric" as Lefebvre states, beyond the limits of binary systems.

Within the built environment, one can encounter what Lefebvre calls the "urban phenomenon," the urban as a space of *passage* and *exchange* that is perpetually caught up in a process of signification that gives meaning in fluctuating contexts. The urban exposes the problems of how to maintain specificity without separation—unity without mixture. Such challenges highlight core dissolutions in epistemic disciplinary models (especially those that pertain to the study of cities), calling our attention away from the objects of

study—urban facts and artifacts—and toward the ideologies we use to construct such objects, such as our imaginations, collective memories, or discourses of "art value." Recasting the urban environment as an open totality enables us to understand that the "real" object is an image and ideology within an ostensibly concrete space: that to be a place, and this urban site in particular, is to negotiate its realities while inhabiting its ideologies, an antinomy that resolves simultaneously in harmony and discord within a continuous urban concerto of the built (or any) environment. The "urban phenomenon" and urban space are particular terrains where social relationships come into contact and sometimes clash. Thus, an "urban pedagogy" is not a unilateral model of the "urban" per se but rather a pathway within and toward which to seriously consider physical forms and discursive practices shape and alter what we see when we look at a city and how we see it (Lefebvre [1970] 2003).

In the City

My relationship with the Watts Towers is heavily mediated by the pedagogical potential infused in and through the Towers' dual role as image–object that symbolizes narratives of Los Angeles and as ideology that produces and reproduces the images and narratives of the Towers. Italo Calvino and Alessandro Portelli, in their respective fields, examine and engage the processes of storytelling in order to illuminate the dialectical construction of memory and meaning, especially in cities. They are figurative interlocutors of the Watts Towers, as is Lefebvre, who embark on the dialogic analysis of "concrete contradictions" of the city (Lefebvre [1970] 2003: 39). *Invisible Cities* gives us an iteration of the "urban palimpsest" through which to read how places are continually and cumulatively constructed and reconstructed, layered upon and through one another by storytellers. The character of Marco Polo in Calvino's book dissolves boundaries between illusion and truth to reveal the influence imagination, memory, and context have on our perceptions and constructions of realities and experiences. Calvino's story draws our attention to the limitation of the audience (characterized in Kublai Khan) to be able to envision the worlds narrated by Marco Polo's stories of Venice. Indeed, how do we begin to see everything all at once and at the same time? How can all these cities, characters, and plots be of one place? We can ask the same questions of the Watts Towers and, moreover, of Los Angeles and other cities.

As a public art piece that lives simultaneously as a timeless and continually evolving site, the Towers are a powerful space through which to engage the "concrete contradiction" of the form and content of urban space, to "study the city through a dialectical analysis [and experience] of its contradictions" (Lefebvre [1970] 2003: 39). The transference of meaning and the process of making public art and public spaces were central themes of discussions I have had with students and other Angelenos. The efforts of groups over the years to give meaning to the Towers is, in many ways, a struggle with greater cultural questions about art without intention. Rodia's refusal to give one coherent story of the structures reminds researchers, community activists, or anyone seeking to tell a story about the Towers of the hypersubjectivity of their own work. His words forces his interlocutors to confront their role as authors of another Towers, which is really the only story that exists for the Towers—since there is no original, documented reason for them being there—a problem of historicity and authenticity that confronts writers, civic leaders,

and community leaders at every turn as they attempt justifications for their myriad actions on a space and story that have no fixed origin nor space through which to assess value. Rodia's tendency to "prevaricate," as Leslie Umberger notes in her book *Sublime Spaces and Visionary Worlds*, is indicative of the pleasure Rodia received from eluding definition and meaning, relishing, if you will, in the self-proclaimed nonartist–nonartwork status of himself and the Towers. As Umberger relates of Rodia, "he enjoyed creating an aura of mystery (of himself and the Towers) giving deliberately conflicting accounts" (Umberger 2007: 116).

The function of the Towers as a public art piece and a monument conjures significant dissonance. As an art piece, the Towers inhabit and create an *active* space, like Marco Polo's storytelling, a product and process of imagining. As a public landmark and monument, they extend outward, encompassing a fullness of space that overflows its material boundaries, distancing it, as such, from a timeless authenticity that stands apart from their creator. They become *receptive* objects through which to speak about Simon Rodia, the Watts Riots, the legacy of folk art in Los Angeles, migration and the city, and any other number of narratives through which the Towers have become a *lieu de memoire*.

Public Art and Monument

When considering the cultural and political resonance of a work of art or public landmark, local communities rarely have the luxury of a sustained background in aesthetics or architectural studies through which to comment on such a work, nor on the social functions of public art. Within the limited reaches of language and experience, as I stated earlier, rest many subjectivities in the dialogues around public art spaces. Conversely, there remains a need to incorporate other informed critical, and perhaps more distant, perspectives for inquiry into a public art piece beyond its immediate context. As a particularly keen distant reader of sculpture and public environments, American minimalist sculpture Richard Serra's comments on the place-making capabilities of an artwork casts an interesting light on reading the Watts Towers' function as public art piece in an urban environment:

> I think that if a work is substantial, in terms of its context, then it does not embellish, decorate, or point to specific buildings, nor does it add on to a syntax that already exists. I think that sculpture, if it has any potential at all, has the potential to create its own place and space, and to work in contradiction to the spaces and places where it is created in this sense. I am interested in work where the artist is a maker of "anti-environment" which takes its own place or makes its own situation, or divides or declares its own area.... I am interested in sculpture which is non-utilitarian, nonfunctional ... any use is a misuse. I am not interested in culture that conventionalizes metaphors of content or assimilates architectonic spiritual structures, for there is no socially shared metaphysic. (Serra 1994: 101)

The first part of this excerpt is an echo of the documented comments of Simon Rodia himself, a sculptor/artist/Italian/man who had no real plan or intention in the construction of the Towers. They are certainly decorative pieces, but they do not "add on to a syntax that already exists." In other words, they were not an intentional response to anything or built for any reason other that of Rodia's own willful desire (at least to our knowl-

edge). Much of the context for the Towers' construction has been assembled after the fact (a process in which this essay is guilty of participating). As they were built, almost destroyed, and "saved," they become grafted onto contexts and histories (and even futures, one could argue) that existed outside the initial context of their creation. The second part of Serra's comments, subtly contradicting the first, further state that sculpture "has the potential to create its own place and space, and to work in contradiction to the spaces and places where it is created." There is significance in the function, be it complementary or contradictory to, the environment that a piece occupies. Even if the artist creates an "anti-environment" the piece is still *affective*, resting in a resolving or evolving antinomy that does not resolve or implicate any particular perspective but conducts contradictions as anti-environment within the greater totality of the (urban) environment. Especially if we understand the urban environment within the theories of Lefebvre's urban oeuvre and monument within the context of architectural historian Mark Wigley's "anti-monumental monumentality"—a demarcation of time that still operates within the ideology of monumentality—there is still a totality that acts as a means of organizing and distinguishing memory and past events (even in its seeming contradictory anti-form; Lefebvre 1996: 101; Wigley 2000: 41). Thus, the artist as maker of the "anti-environment" still operates and participates within the fabric of space, even in its "nonutilitarian" uses and misuses. And while Serra is correct in his assertion that there is no "socially shared metaphysic" as such, there is a process of socially produced and shared metaphysics staged in and through public spaces and, in particular, any art that is in that space—with, without, or against—which makes a work substantial.

Caught between art and monument, *public* is the powerful qualifier that problematizes the politics of this space: Who does it represent, who has the right to imagine it and sustain its future, and why? In art perhaps, but moreover in cities, intentionality, or rather the reification of an object that is pure, is a perceptual fallacy. The sense of "public" I am invoking here is of a quotidian nature, defined by the civic (and very American) sense of a space designated as public (a kind of privatization to be sure). I am also using the term in a sense of openness, that is, without permanent borders: a porous and accessible space, physically and imaginatively. Any perception of an authenticity of intention, use, or future is a product of systems of elaborate production conducted by and through urban space that is hopelessly *processual*, simultaneously accumulating and dismantling—temporally, materially, and socially alive. If anything, the chorus of voices speaking for and against, laying claim to and relinquishing responsibility to, is indicative of the collaborative production of this public art space. The opinions and stories are a veritable building of the Towers.

Do monuments (or public art and space) function only when they are contested? Can contradiction save the Watts Towers from indifference? Perhaps it has been the multiple stories of the Towers, Watts, and Rodia that have enabled the Watts Towers campus to remain an active site of meaning making in a city all too often prone to quick metanarratives about the American West and the entertainment industry that, though an aspect of Los Angeles's history, tend to obscure the experience of everyday Los Angeles—an everyday that builds, little by little, and takes shape as an evolving oeuvre. It is less about meaning and content and more about the process of building. The Watts Towers have been a resistant monument since the city first attempted to make it a state park. This process has consistently been one about interpretation and identity at the local and civic

level. The struggle between groups who define or who are defined by the Towers has been one fought between the city of Los Angeles as it has attempted to make the Towers a depoliticized and deracialized space, separating art and history in the name of civic identity, as Sarah Schrank indicates, and that of locals who fight to recuperate local and personal meanings of the Towers (Schrank 2009: 159).

Building and Forgetting

> "Memory's images, once they are fixed in words, are erased," Polo said. "Perhaps I am afraid of losing Venice all at once, if I speak of it. Or perhaps, speaking of other cities,
> I have already lost it, little by little. (Calvino 1974: 87)

Marco Polo's response to Kublai Khan's question of why he never speaks of Venice marks a turning point in the narrative, one where the reader is first introduced to the multivalent nature of Marco Polo's stories—the double inscription inherent in each of his stories. " 'There is still one city of which you never speak,' Kublai Khan says. 'Venice' [to which Marco Polo replies] 'What else do you believe I have been talking to you about? . . . Every time I describe a city I am saying something about Venice' " (Calvino 1974: 86). Polo states quite simply the problem of monumentalizing and erasure: how efforts of preservation participate in the destruction of the very things one wishes to preserve, for monumentalizing is a function of inscribing time with meaning, but it does not stop the flow of time from gently and continually erasing the substance of memory. We build against forgetting; it is the basis of architecture in a traditional sense and the unconventional architecture of a community through its vernacular memorial processes. The building constructs a sense of time, as Mark Wigley reminds us, but the mechanisms we use are ephemeral because forgetting is the shadowy double of memory, the two do not exist apart, and both contain qualities of erosion that societies continually build through and against.

Memory and monument inscribe spatial and temporal meaning in their conceptual and ideological functions. They are means of organizing and distinguishing historical memory and past events through naturalizing discourse that author "pastness" as a foundational stage on and through which meanings of past, present, and future are inscribed. The crisis of forgetting within the discourse and practice of memory is not unique to the Watts Towers. Like many public spaces and objects into which local communities interweave meaning, it appears as the emergence of a dualistic consciousness of the process of remembering and the substance of what is remembered. The dissonant space with the potential of forgetting—tenuous spaces and memories—could be the dynamic intersection and tension that activates memory, dehistoricizing it, and saving it from ruin (even if in that process it must become a ruin, as the Watts Towers may one day become). Memory is not the object of cultural identity making but rather the staging grounds, the necessary foundation, in its fractured states, that enables and fuels the ruptures that cause us to consistently demand how, what, and why we remember or monumentalize. These questions are encompassed in a greater discourse of identity.

As a landmark, public space, and art piece, the Watts Towers sit at the crux of numerous discourses about memory and memorialization that can be in radical dissonance at times. Making harmony out of the discord is the implied and underscored goal of writing, collecting, historicizing, and teaching about them, but in these processes we some-

times risk rendering all the histories and memories associated with them invisible along with the social relations and power imbalances that have made the site memorable to those who have lived in the Towers' spindly shadows.

Our conversations about memory and our practices of telling stories in the language of preservation and monumentalization hold the potential to tamper with and endanger the political value of the Towers as a topos for investigation into the matrix of their mnemonic function. As Katia Ballacchino suggests, perhaps the Towers were meant for disintegration, and by insisting on their uncommon ground, they can they be distinguished from the expansive and destitute landscape of Watts and the greater collective memory of Los Angeles (Ballacchino 2010). As Ballacchino's comment suggests, the dynamism conjured by this contested space—a dynamism harbored in the multiple tellings, interpretations, and reappropriations of them—is the value of Rodia's work. We should be wary of conflating meaning and history, taking a lesson from the challenging contradictions of the urban environment. Terms like "space" and "environment" imply a deference to the process of creating, one that participates as well as recognizes how knowledge about a place, community, or art piece is based both on "facts" or "events" as much as on *how* we have come to know, articulate, and trace a community and their experiences.

Los Angeles and the Watts Towers

> What he [Marco Polo] sought was always something lying ahead, and even if it was a matter of the past it was a past that changed gradually as he advanced on his journey, because the traveler's past changes according to the route he has followed: not the immediate past, that is, to which each day that goes by adds a day, but the more remote past. Arriving at each new city, the traveler finds a past of his that he did not know he had: the foreignness of what you no longer are or no longer possess lies in wait for you in foreign, unpossessed places. (Calvino 1974: 28)

The Towers are a vessel of the urban phenomenon, an entity of and through Los Angeles. Thus, the Towers orient us toward an urban pedagogy that is a double helix of sorts between urban spaces and urban processes that encompass pasts and presents, histories and memories, immigrants and Angelenos. This art, in this public space, holds a political power mined from its multilateral participation in the creation and definition of a community both near and far. What the Towers mean and how they represent, and are representative of, is a collaboration between the residents of Watts, immigration to Southern California, and public representations of Los Angeles. They embody and symbolize stories of survival through urban unrest, the struggles of immigrant communities, and the great imagining of "visionary architecture." The Towers are emotionally charged because they are a confluence of histories and contingencies (Goldstone and Paquin Goldstone 1997). The elusive nature of the Towers and their meanings reflects their resistance to being a monument to any one event, community, or interpretation (Schrank 2009). Their transience among and between the worlds of Watts make them the quintessential space and symbol through which to grasp the rootlessness and mobility that is representative of twentieth-century America and, specifically, the varied and ever-changing history of Los Angeles.

Urban environments are not passive repositories of history, people, and events but processual, always becoming. Integrating the collaborative and dynamic nature of the city unhinges the Towers (as the Towers do for the city) from a monumental or singularly representative function, unfolding their ability to inhabit and demonstrate that places are continually produced and between the narratives they engender. The Towers might be a story of representations, but as public art they participate in a process of meaning making in the Watts community. To be "Nuestro Pueblo" implies a multiplicity of authorship, a vernacularization of their meaning, in the Los Angeles community. They are public art that invites the community to participate in their construction. The Towers have been read along the lines of the Watts community's struggles through riot and restoration and endure as a history of migrations of peoples, economies, and landscapes that coalesce in different layers of the city.

The Towers are a powerful way to speak about Los Angeles. The historical fact of them representing Simon Rodia's story—a man of many stories to be sure—is the foundation, but their meaning migrates outward in time and space as Los Angeles grows and the communities around the Towers change. As a public art and historical space, they become a way to speak about immigration, urban rebellion and reconciliation, and the role of art in the evolution of urban communities. The Towers participate in a dialogue emblematic of the constellation of networks that arrive and populate the city. The spaces between the pieces of ceramic and glass, the vessel the sculpture becomes when put together, shows us what and how Los Angeles becomes a city. As a public space, anyone can (and does) inhabit the Towers. We weave our eyes and hands in and out of the sculpture's scaffolding, its details and its vision. To imagine the function of them like this is to refract and recontextualize how they engage a space that complicates hard and fast barriers between objectivity and subjectivity. No one event or person, not even Simon Rodia, is embodied in the Towers; their power is in their gesture toward and through the urban fabric. As such, the Towers are no longer solely of Rodia, folk art, or the Watts community but a site of the collaborative work that composes a place. They literally and symbolically embody how the phenomenon of the global city is firmly rooted in individualized and collective practices, histories, and imaginings.

Works Cited

Assmann, Jan. 1995. "Collective Memory and Cultural Identity." *New German Critique* 65 (Spring–Summer): 125–33.

Ballacchino, Katia. 2010. "Towers of Memory: Images and Visual Community Symbols Between Italy and the United States." Paper presented at the Watts Towers Common Ground Initiative Conference, Los Angeles, October 21–23.

Calvino, Italo. 1974. *Invisible Cities.* Translated by William Weaver. San Diego: Harcourt.

Foucault, Michel. 1977. *Language, Counter-Memory, Practice: Selected Essays and Interviews.* Translated by Donald F. Bouchard and Sherry Simon. Edited Donald F. Bouchard. Ithaca: Cornell University Press.

———. 1980. *Power/Knowledge: Selected Interviews and Other Writings.* Translated by Colin Gordon, Leo Marshall, John Mepham, and Kate Soper. Edited by Colin Gordon. New York: Pantheon.

Goldstone, Bud, and Arloa Paquin Goldstone. 1997. *The Los Angeles Watts Towers.* Los Angeles: Getty Conservation Institute.

Lefebvre, Henri. [1974] 1991. *The Social Production of Urban Space.* Translated by Donald Nicholson-Smith. Oxford: Blackwell.

———. 1996. *Writings on Cities.* Translated and edited by Eleonore Kofman and Elizabeth Lebas. Oxford: Blackwell.

———. [1970] 2003. *The Urban Revolution.* Translated by Robert Bononno. Minneapolis: University of Minnesota.

Nora, Pierre. 1989. "Between Memory and History: Les Lieuxs de Memoire." *Representations* 26: 7–25.

Portelli, Alessandro. 1988. "What Makes Oral History Different." In *The Oral History Reader,* edited by Robert Perks and Alistar Thomson, 2nd ed., 37–42. New York: Routledge, 1998.

Sawhney, Deepak Narang. 2002. *Unmasking L.A: Third Worlds and the City.* New York: Palgrave.

Schrank, Sarah. 2000. "Picturing the Watts Towers: The Art and Politics of an Urban Landmark." In *Reading California: Art, Image, and Identity, 1900–2000,* edited by Stephanie Barron, Shari Berstein, and Ilene Susan Fort, 373–388. Berkeley: University of California Press.

———. 2009. *Art in the City: Civic Imagination and Cultural Authority in Los Angeles.* Philadelphia: University of Pennsylvania Press, 2009.

Serra, Richard. 1994. *Writings and Interviews.* Chicago: University of Chicago Press.

Umberger, Leslie. 2007. *Sublime Spaces and Visionary Worlds: Built Environments of Vernacular Artists.* New York: Princeton Architectural Press.

Wigley, Mark. 2000. "The Architectural Cult of Synchronization." *October* 94 (Autumn): 31–61.

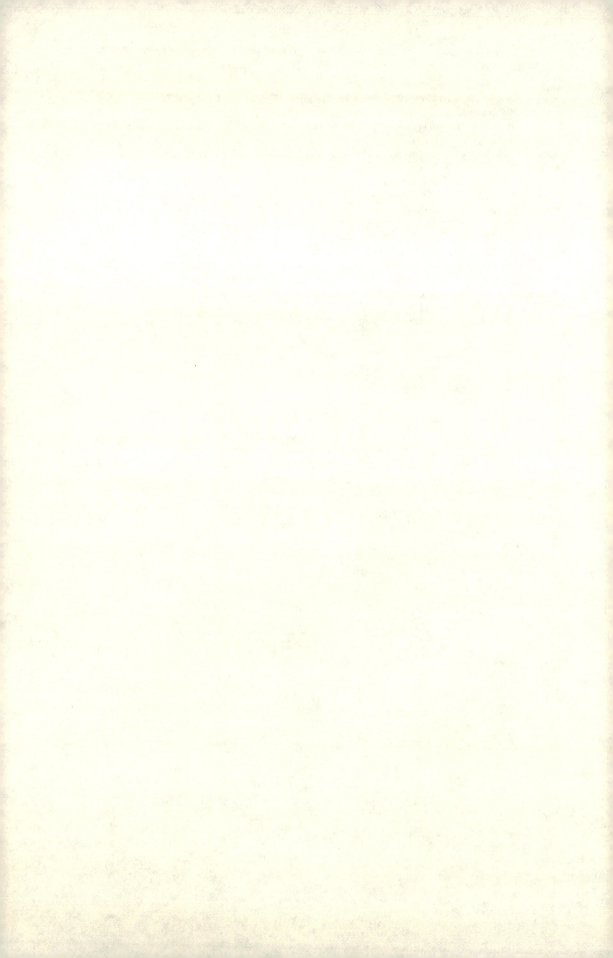

Spires and Towers Between Tangible, Intangible, and Contested Transnational Cultural Heritage

Katia Ballacchino

To have culture and history is not enough: the affirmation of ownership on the part of the collective must be acknowledged by others.
—RICHARD HANDLER 2000: 284

Premise for a Hypothesis of Comparison

This essay emerges from reflections on the international conference "Art and Migration: Sabato (Simon) Rodia and the Watts Towers of Los Angeles," together with those developed during my own research of the past few years.[1] This ethnographic work focused on the *Festa dei Gigli*,[2] a festival that has been celebrated for centuries in Nola, a Vesuvian town in the Italian region of Campania. It is one of the most complex, intense, and notable festive institutions in all of southern Italy—both as spectacle and from the perspective of the highest levels of public participation. It is this high visibility and intensity that has caused such a high degree of competition between its thousands of participants, while at the same time ensuring the ceremony's continual renewal and evolution. The exploration

and description of the complex universe of festive space and time, its relational dynamics, and the sociopolitical issues it engenders and which I have personally experienced during my long ethnographic journey with this Nolan festivity are, however, beyond the scope of this article (Ballacchino 2009). While unable to address such complexities here (or the many symbolic features and sensory nodes that feed the feast), this essay will instead focus on the more "material" aspects of the ritual, namely, the nine "festive machines"*(macchine da festa)* that comprise the processional ceremony. I will limit my discussion to a mere few of the many possible anthropological interpretations regarding the feast's meaning and focus on the features that might hypothetically connect the *Gigli* of Nola to Sabato Rodia's Towers in Watts. These reflections must be considered within the context of ongoing debate around Rodia's Towers. I frame the discussion by reviewing current academic and nonacademic debates around the *Festa dei Gigli* in Nola—debates much like those swirling around the Watts Towers—focusing on "valorization" through a complex and highly articulated system of "patrimonialization," on "museification," on the *Gigli* UNESCO proposal, on my recent visits to other European festivals, and finally on tourism marketing and "mediatization" (Ballacchino 2013b).

This contribution will especially reflect on the concept of tangible and intangible "heritage" as it specifically relates to the *Gigli*. Political strategies of defining cultural identity as it relates to place is here investigated by analyzing various manipulations and controversies, as they relate to the territory's cultural heritage and its transnational (or migratory) contexts, as employed by researchers, politicians, and the community itself (Ballacchino 2008, 2012b). Through a multisituated ethnography (Marcus 1995), we address transnational sites united by imagery that stimulates similar practices and passions (Freedberg 1989).

We note, of course, that the Watts Towers were constructed by Sabato (or Simon) Rodia, who was born in 1879 in Campania, emigrated to the United States alone at the age of about fourteen, and died there in 1965.[3] It is critical to note that Serino, Rodia's birthplace, in the province of Avellino, is not far from Nola[4]—a fact that in and of itself might induce us to imagine that the two phenomena are, in some inescapable way, connected (see Calabria 1989; Posen and Ward 1985). But more significant than geography is the structure itself, the tallest of the three main towers (and the most spectacular part of the complex), reflecting the style of the "arches of light," which provides the strongest link, given that they are typical of many southern Italian festival machines and of the Galleria Umberto I of Naples besides (Landler and Byer 2006). These structures, built of steel-reinforced cement and decorated with brightly colored recycled household materials, the tallest of which measures approximately $99^{1}/_{2}$ feet, are of a very similar size to the *Gigli* of Nola, which traditionally rise to a height of 82 feet. Further, their shape and positioning seem to harken back to the traditional Nolan festival apparatus and ceremony. The practices of "recycling" and "assemblage" that Rodia used in his work are also reminiscent of the Nolan art of *Giglio* construction, which use partially recycled wood and papier-mâché, a technique that in turn has much earlier origins (Bauman 1978; Cerny and Seriff 1996; Seitz 1961). We might also consider the fact that the Towers were constructed in front of their maker's own home, in the same way that the *Gigli* are constructed as closely as possible to the home of the *maestro di festa* (the master of the feast),[5] so that he might daily admire the obelisk at close quarters as it is being constructed.

From one of the photographs that portrays their construction, Rodia seems to be "hanging" from his Towers, without the benefit of scaffolding or other protective equipment, holding only his tools in hand, in much the same way Nolan artisans and carpenters work to construct *Gigli*.

The final element in support of the hypothesis of a connection between *Gigli* and Towers is the presence of a boat, constructed in the same style as the rest of the work, which rather incontrovertibly recalls the ninth festive machine, the queen of the Nolan procession—a boat—surrounded by the eight *Gigli*, anchoring its religious symbolism, in accordance with the maritime legend of the ritual's foundation.[6] This element has even caused some to hypothesize Rodia's connection to Catholicism, a fact often denied by pointing to tales of his evangelizing verve, considered by some to be "heretical."[7]

All of this raises the question of how a traditional Italian festival can be compared to an American artwork, from an anthropological perspective, despite these many correspondences. The aim of this essay is to address this question by tracing possible threads linking these two geographically distant, complex, and widely debated realities together. Let us now turn, therefore, to a consideration of these material and immaterial objects from the point of view of their ritual, structural, and aesthetic dimensions, together with their cultural meanings.

The literature regarding Rodia's Towers[8] demonstrates that the Watts Towers have become a topic of fierce debate, bringing various disciplines and diverse interests into play. Given the uniqueness of the extraordinary work (but at the same time its apparent link to other artworks and architectural styles) and the debates regarding the author's origins, the Towers are open to numerous creative interpretations, including the most extravagant theoretical suggestions proposed by scholars of art, architecture, social science, psychology, and migration history.[9] In fact, we find forms of scientific interpretation and speculation ranging from semiotics to symbolic readings, from analyses of the work's spiritual and material dimensions, but above all with patrimonies that are in part contested and in other parts objects of manipulation. This essay hopes to make a contribution to the debate from an anthropological perspective, from Italy and about Italy, but also following its research flow to the United States.

It was at the fundamental moment that the Towers survived the threat to their physical integrity and long-term survival was assured (by the stress test of 1959) that they embarked on their path to becoming "tangible heritage." And it is at the very moment that an artwork becomes "monumentalized" that it may be considered shared *and* contested heritage, often provoking a revaluation of the site on which it is found.[10] (In 1959, the Towers were deemed secure and in 1990 were "patrimonialized," becoming the fifteenth National Historic Landmark in the state of California.) Having said this, a latent conflict exists relating to the economic development of the area in which the Towers are situated and its adjacent Arts Center. The schisms witnessed between local administrators, working groups, heritage conservationists, art critics, and conservators have forced an interesting debate about the methods and means of conservation and management of the monument. These factors bring into play the question of who can claim "cultural ownership" (and therefore of the power relations that develop around the monument) and whose disputes constitute, and become representative of, its cultural identity.[11]

Origins and Mutations of a Heartfelt Image of Migrations

In Italian, the term *giglio* refers to a flower (the lily), but in Nola, it is the name given to each of the eight festive obelisks created for a *Gigli* of Nola festival. As noted earlier, the *Gigli* are wooden structures dressed in papier-mâché, on a platform, on which a band sits, playing traditional festive music during the procession. On the first Sunday after the 22nd of June, the obelisks are made to dance to the band's music for up to twenty hours through the streets of Nola's historic town center.[12] The shape of these obelisks is reminiscent of the marble "needles" or spires (*guglie*) that decorate the squares of Naples, for example, San Domenico Maggiore, Gesù Nuovo, or Trinità Maggiore (see Pellet 1894). The origins of the structure of the *Gigli* and the feast itself continue to be debated, but it is clear that the modern-day festive apparati *(macchine)* are the result of a centuries-old process of modifications (Ammirati 1969; Malagnino 1961; 1995; "Per un museo delle macchine festive" 2002).

According to the feast's foundational legend, the Nolans' gifts of devotion to San Paolino (or Saint Paulinus, to whom the ritual is dedicated) were initially flowers (lilies, *gigli*), then *ceri* (candles), *mai* (maypoles), *carri* (carts), and finally *macchine* (machines) transported on wheels and growing in size as Nolans' devotion grew, eventually becoming the enormous structures we see today. It appears that the obelisk shape was established at the end of the eighteenth century, although various functional modifications have been made to the structures as recently as decades ago, in order to allow them to be danced through the streets on the patron's feast day.

For more than a century, the *macchine* had a single facet, whereas earlier they were constructed *a quattro facce* (with four facets or "faces"). The *Giglio* with four "faces" was built until around the second half of the nineteenth century. The structure has also become narrower over the years, due to modifications in the dance movements the structure must execute. Today, more thought is given to transport technique. Indeed, there is a true "philosophy" of how to *collare* or *cullare* (the local term referring to the act of carrying the obelisk on one's shoulders and moving it to the sound of music). The machine has to be of a weight and structure that allows the *collatori* or *cullatori* (carrier or dancers) to create a great performance, in order to dramatize competition between the dance groups and to enhance the spectacular aspects of the dance. The holding structure of the entire obelisk must be flexible, dynamic, and light, even though its weight will in any case be somewhere in the region of four tons. Over recent decades, these needs have led to the introduction of polystyrene, a much lighter material, used alongside papier-mâché made from recycled paper. As well as its lighter weight, the advantage of polystyrene is that it makes the constructors' work less complicated, reducing labor time while still providing a comparably high aesthetic finished product. Here we see that the choice of construction materials is affected by the principle characteristic of this feast, namely, its constant mutation, in terms of generational change with regard both to the protagonists themselves and to the social contexts in which they live (see Ceparano, this volume).

I support the hypothesis that the scenery used during the public feast throughout the baroque period represents the best point of reference for the modern *Gigli* structure.[13] Following the evolution of festive scenery, we note that the sixteenth- and seventeenth-century *addobbo* (ornamentation) was initially very modest but later became dominant. Numerous local master artisans were involved in the construction of this imposing

"ephemeral architecture," and their skills are recounted in many written and illustrated testimonies, thanks to which the production of this art, generally considered to be of lower class or folk art *(arte popolare),* has been reevaluated. Among the many examples analyzed in *Capolavori in festa* ("Festive masterworks") (Zampino 1997) is an image of a baroque scenery machine that gives testimony to a direct link between that and the modern structure of the *Giglio*.[14]

As is well established, the baroque feast was based on the astounding play of artifice, in which art, nature, and the universe are commingled and where the boundaries between reality and illusion become blurred, creating a single multiform theater variously described as *ephemeral* and *memorable* (see Chastel [1959] 1966; and Zampino 1997).[15] The predominant baroque idea was the temporariness of its apparati, a concept that is intrinsic to the Nolan *Giglio* as an artform. Indeed, *Giglio* forms and decorations vary from year to year. Each is knocked down at the end of the feast, its principal components destroyed, and some of its elements recycled the following year.[16] The seventeenth-century artworks did not last long either, for these "ephemeral apparati" were periodically recycled and remade. These objects often had interchangeable functions, and their decorative images hosted a variety of narratives. The papier-mâché used in the construction of the *Gigli* was considered the last rung of the decorative art hierarchy, for as "poor art" it was used only on these festive occasions.[17] We can imagine, therefore, how an art described as ephemeral corresponds in ethno-anthropological terms (and beyond) with *immaterial* or *intangible*. We speak of a collection of *immaterial* meanings but of *material* and therefore *tangible* artworks, while at the same time, they may be *ephemeral* only because they are continuously destroyed and reproduced, linking this practice to the cyclical nature of the feast and community life.[18]

The structural complexity of the *Gigli* is possible thanks to the skills and expertise of local Nolan artisans. However, the main problem here regards the seasonality of work (and hence earnings), given that *Gigli* employment is available only in June. Many of the artisans sustain themselves throughout the year by offering low-cost services to other cities in the region that also require the construction of numerous *Gigli* for a variety of events (e.g., a local saint's day or Mother's Day). Investment in high-quality artistic production, with its guaranteed income throughout the year, would probably not only ensure higher income for these artisans, thanks to the unique nature of their work, but would preclude the real danger of Nolans witnessing their feast being reproduced throughout the region of Campania, due to competing cut-price obelisks constructed on commission.[19] Income needs constrain artisans to accept assembly-line jobs outside Nola, with all of the consequences that such a choice entails. At the end of the day, on the one hand, *una mazza all'erta* (a straight bar) is enough to reignite the Nolans' passion for the *Gigli*, and so more often than not, neither the place nor the context in which the obelisk is constructed is all that important.[20] On the other hand, the existence of so many "splinter" feasts creates constant and often deeplyfelt local animosity regarding cultural ownership of the obelisk, the ceremony in general, and the need to safeguard this cultural property.

It would here be useful to highlight how some interesting images published in the annals of the feast by Leonardo Avella[21] demonstrate that the papier-mâché covering known as *addobbatura* (ornament) has, over time, almost represented a "visual memory" (Ballacchino 2013a) of the social texture as well as the political and cultural representations of Nola at specific moments in its history.[22] The festive machines often become a

temporary space where Nolan ideas and symbols of belonging and of memory are performed. It is in the very nature of the *Festa dei Gigli* to incorporate change, dynamism, and especially movement. The *Giglio* may be considered to be inherently *migratory*, given that all its components are designed to allow for constant movement, and the musical and collective organization of its transportation is fine-tuned to produce the best dance performance. Because the obelisk can be conceived only in movement, the feast also lends itself to concepts of migration, mutation, and dynamic change.

Part of my research has been directed toward the more or less modern "migrations," as well as the real and virtual displacements, of the *Giglio*. For some time now, the *Giglio* has been an object of celebration for communities in both Campania and other regions of Italy. In recent years, the *Giglio* has also travelled to other European cities. Its migration has also been virtual, due to its recent mediafication and hyperdocumentation on the World Wide Web (cf. Bindi 2008). Further, my research also investigates its Italian American context in Williamsburg, Brooklyn,[23] where a *Giglio* (and boat) has been danced for close to a century.

Returning briefly to the structural evolutions of the *Giglio*, it should be noted that in its migratory context (during the 1970s), the priest of the Our Lady of Mount Carmel Church[24] in Williamsburg introduced a mountable aluminum structure, rebuilt each year for the feast without the need to employ artisans and spend large sums of money and

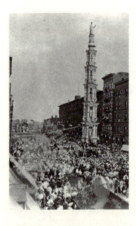

Giglio *festival in Harlem, Manhattan, 1920s–1930s. (Archivio Contea Nolana).*

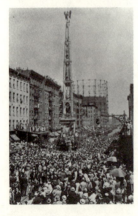

Giglio *festival in Harlem, Manhattan, 1920s–1930s. (Archivio Contea Nolana).*

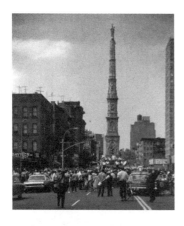

Dancing the Giglio *in Harlem, Manhattan, 1950s. (Archivio Contea Nolana).*

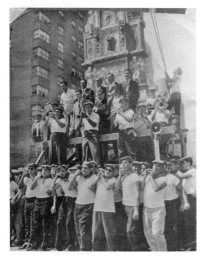

Dancing the Giglio *in Harlem, Manhattan, 1960. (Archivio Contea Nolana).*

energies. This fact alone has radically changed both the movement and performance style of the dance. Every June in Nola and in a similar way in July in Williamsburg, both towns are completely overtaken by the feast. For example, cables for the street lights are even temporarily removed in order to allow the *Gigli* to dance down various prescribed streets in the historic town centers. The community becomes the feast completely, as Posen (1986) also maintains for the *Giglio*'s festivalization of space in its American context.[25]

It is significant to note that those who organize the *Festa dei Gigli* in Williamsburg, Brooklyn, do not, generally speaking, share a common birthplace or place of origin. Most come from Campania or southern Italy more generally, but very few today are descendants of Nolan families. Having said this, however, their nonshared "local" origins do not affect their belief in the "correctness" of maintaining this tradition.[26] As far as ethnicity as a sociocultural construct, the *Giglio* feast in Williamsburg has, indeed, acquired broader meaning over time.[27] That is, from a feast that celebrated a sense of local belonging linked specifically to Nola, it has become a ritual that brings people with a broader common identity together, linked to their nation of origin, Italy. In this way, the feast functions as a litmus test of the transformation of identity that Italian migrants and their

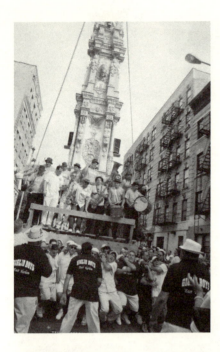

Dancing the Giglio *in Harlem, Manhattan, 2004.*
Photograph by Aldo Mari (Archivio Contea Nolana).

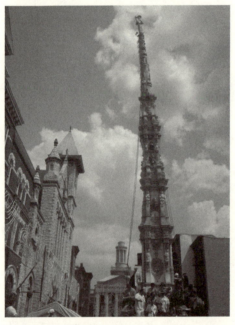

Giglio *in Harlem, Manhattan, 2004. Photograph*
by Aldo Mari (Archivio Contea Nolana).

children have undergone in the United States. The feast therefore becomes a place of in-
clusion encompassing all Italian Americans, not only those from Nola.[28] As I have ar-
gued elsewhere (Ballacchino 2008, 2012b), it could be said that the transformation of the
legend of the bishop Saint Paulinus, to whom the feast is dedicated, could lend itself to a
reading in terms of cultural juxtapositions.[29]

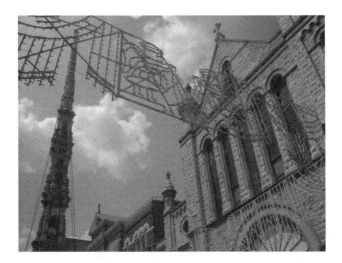

Giglio *between monuments in Harlem, Manhattan, 2004. Photograph by Aldo Mari (Archivio Contea Nolana).*

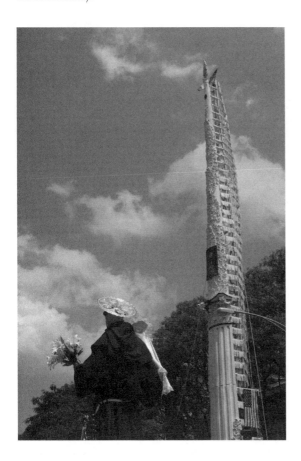

Giglio *in honor of Saint Anthony, Harlem, Manhattan, 2010. Photograph by Cono Corvino.*

Whether built of wood or aluminum, the *Giglio* takes on a multitude of intertwined roles, including preservation, construction of cultural identity, integration into a diaspora context, and the enhancement of Italian origins through this time-honored tradition. It bridges and reinforces transnational links between its place of origin, Nola, and diverse nodes in the migratory flux—not dissimilar to Rodia as migrant and the case of the Watts Towers. Indeed, images of the *Giglio* multiply in the diaspora. Italian American parents reproduce them for their children as a sign of great affection. By way of notable examples, a baby's tomb in the form of a *Giglio* may be found in the Bronx cemetery, and *Giglio* murals have been painted on the walls of a newborn's nursery. Further, children in Williamsburg, Nola, and other parts of Campania also have the privilege of dancing a miniature *Giglio* in imitation of the one danced by adults.

Both the American and especially the Nolan *Giglio* feast have received a great deal of media attention in recent decades, thanks to the creation of numerous Web sites describing and promoting the *Giglio*, its history, and the city of Nola (including virtual dance sites, video channels, YouTube, Facebook, and Second Life). These discussion forums have become virtual public squares where the feast is subject to daily discussion, helping to create a network of fans well beyond territorial borders and thereby also contributing to change in the feast itself.[30]

Contested Symbols of Identity in the New Era of Patrimonialization

Many examples exist of the reproduction of the *Giglio* (not the entire feast), taking place throughout the region of Campania, as my own research has shown. We find, for example, multiple requests for the purchase—and opportunities for the appropriation—of the festive machines often made by small groups of Nolan emigrants who seem unable to live without their *Giglio*.

For decades, *Gigli* have been exported from Nola within the context of various sister-city relationships with other Italian cities. In March 2007, I witnessed firsthand a Nolan delegation that had organized the dancing of a *Giglio* in Valencia, Spain, for the *Fiesta de Las Fallas*.[31] This was the third in a series of events that hosted the *Giglio*: in Santa Maria da Feira, Portugal, in 2005, Lisbon in 2006, and Valencia in 2007.[32] Such migrations are often promoted by political and academic institutions (among others). They introduce, however, a series of thorny issues relating to the fact that they use only a part of an entire ritual and, further, within a context to which they do not belong (see Faeta 2008; Freedberg 2008), thereby subverting the ceremony's symbolic order and restricting its meaning to an aesthetic and performative dimension.[33] Frequently, such actions serve to support "Mediterranean identity" by way of pairing some of the region's salient symbols with engaging aspects of Italian folklore. As previously noted, however, the migratory context of Williamsburg's *Giglio* is quite different. Field research reveals that numerous groups have created multiple and complex uses for the *Festa dei Gigli*, where varying power mechanisms are brought into play, on various levels, and by competing parties—all riding the crest of the spectacular performative possibilities offered by dancing *Gigli*. Perhaps this state of affairs even contributed to the three failed candidature attempts (advanced by the Extra Moenia Association and the Gigli di Nola Ethnomusicological Museum) between 2000 and 2005, to have the feast registered (respectively, Lucarelli and Mazzacane 1999; Ballacchino 2009 and D'Uva 2010) on UNESCO's[34] list of Intangible

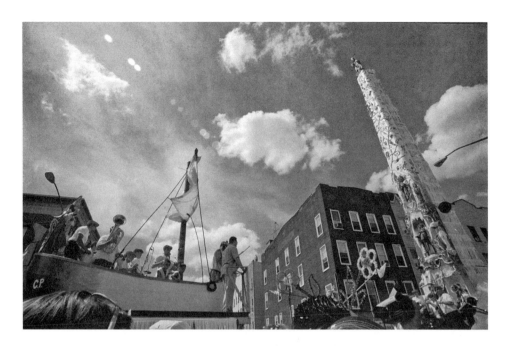

Ritual encounter between Giglio *and "boat," Williamsburg, Brooklyn, 2003. Photograph by Cono Corvino.*

Children's Giglio *in Williamsburg, Brooklyn, 2007. Photograph by Aldo Mari (Archivio Contea Nolana).*

Cultural Heritage.[35] The negative outcome of these legitimate petitions to garner such prestigious recognition led to a gradual awareness, on the part of the Nolan community, that it was necessary to rethink UNESCO's very notion of a static "tradition" anchored to the past and its lack of appreciation for the continual renewal that a tradition such as that of the *Gigli* often expresses.

Further, I monitored and analyzed other *Giglio* migration events tied to its UNESCO candidature. For example, in July of 2007, immediately following the celebration of the Nolan feast, a *Giglio* was constructed and danced at the University of Fisciano, in Salerno, Campania, for the *Campus in festa*[36] event. The promoters presented yet another reenactment of the tradition[37]—this time dancing the *Giglio* in conjunction with a variety of other traditions, such as Sicilian *pupi* (puppets), Sardinian *tenores* singers,[38] and the *pizzica* from the Salento. This reenactment took place along the ancient imperial Via dei Fori Imperiali in Rome, running alongside archaeological sites that have, for some time, been defined as Tangible Cultural Heritage.

The present debate around intangible heritage and the *Giglio*'s UNESCO candidature contains an extremely interesting tangle of issues critical to modern anthropology, as it analyzes heritage and intersects power relations criss-crossing political, intellectual, and academic worlds, as well as local communities and international institutions (Ballacchino 2009; Bindi 2009). My ethnographic work demonstrates how, in many instances, the *Giglio* has become an instrument manipulated through its varied and disparate contexts and events. Without a doubt and due to its fame, its performative characteristics, and related art forms, the *Giglio* is worthy of being the guest of honor at any event. This fact, however, also creates divisions and raises conflicts within the Nolan community regarding the organization of the feast, as well as its political and economic effects on the territory (Ballacchino 2013b). At the end of 2013, however, the Gigli feast, within a network of Italian celebrations of big shoulder-borne processional structures, was inscribed on the UNESCO Representative List of the Intangible Cultural Heritage of Humanity (Ballacchino 2012a).

Finally, to return to Rodia's Towers, their recognition as a National Historic Monument has, similar to the *Gigli* case in Italy, reignited interest and debate in and around them. As instruments on a path toward patrimonialization (Palumbo 2009), the Towers, too, have radically turned the spotlight on heritage, dividing the academic world, politicians, and the community, in a way that had not been seen in Italy since the 1970s. The same is true of the papier-mâché-covered aluminium *Giglio* of Brooklyn, representing an important point of reference for Italian Americans in the surrounding area.

A fundamental characteristic of the *Festa dei Gigli* in Nola is its music, thanks to which each *Giglio* is *cullato* (carried, or "lulled" back and forth) on the shoulders of 128 men, a feature that turns the obelisk into a dancing belltower—a feature that the Watts Towers do not share, fixed as they are to the ground. On the other hand, the Towers, too, have become a gathering point for music, where many can share a common sense of belonging and unity around this emblematic obelisk or belltower, including, for example, the annual Simon Rodia Watts Towers Jazz Festival and a percussion festival, which promote peace and cultural integration.

The ingenious Nolan *Giglio,* therefore, regardless of its construction materials, place of construction, and uses, seems to give the idea of a belltower drawing people toward it, united in Nolan citizenship, common national origins, or shared religious belief. It seems to demonstrate that *Giglio* migrations are the fruit of a community of practice whereby

diverse individuals recognize themselves to be part of a group through common real and symbolic practices, an interpretation supported in recent anthropological literature(e.g., Lave and Wenger [1991] 2006). Here we might recall a well-known passage of the Italian anthropologist Ernesto de Martino:

> He [an Italian shepherd] got into the car with apprehension, as if he thought it were a trap, his wariness slowly turning into anguish, because now, from the car window that he constantly stared through, he had lost sight of the belltower of Marcellinara, his point of reference in his extremely circumscribed domestic space. With the disappearance of that belltower, the poor old man felt completely lost. With great difficulty we managed to drive him to the junction and obtain the information we wanted. We took him back quickly, as agreed. He kept his head out of the car window, scrutinizing the horizon, waiting to see the belltower of Marcellinara reappear. Finally he saw it, his face relaxed, and his old heart stopped racing, as if having reconquered "the lost land." (de Martino 1977, 480–81; my translation)

In this instance, the belltower of Marcellinara, both known and familiar, conveys a sense of geographic orientation and equilibrium to the Calabrian shepherd who suffered a keen disorientation at the moment in which he lost sight of his village belltower. This scene allowed de Martino to explain the complex notion of the "crisis of presence," an existential malaise causing an inability to live and function in the world. In the same way, the image of an obelisk, especially in an American context, can become a "tangible" sign, to which one may anchor oneself in an attempt to find one's identity—however reinvented.

As Del Giudice has noted (in this volume), with his very probable love for Italian village belltowers (and perhaps even for the dancing *Gigli* of his Campania region), Rodia likely felt the need to build reminders of those childhood images. And as Sciorra has shown (also in this volume), Rodia also wished to construct something that could be admired according to an aesthetic sense that so characterized Italy (Del Giudice 1993), expressing his manual skills and typically southern expertise in a thrifty assemblage, a recycling of disparate materials (Cosentino 1996).[39] To use a typical Nolan turn of phrase, perhaps Rodia also wanted to "construct something that is considered great,"[40] a phrase repeated with each *Giglio* construction cycle, year after year. In fact, a song entitled "O' Paese de Gigante" ("The Village of Giants"), written in 2003 by the Nolan *paranza* La Fantastic Team, refers to the enormous size of the obelisks, which create so much passion as to make the village incredible, fantastical.

The debates around the patrimonialization process of the Watts Towers,[41] as has been amply demonstrated (see Morgan, Herr, Schrank, this volume), caused great rifts over issues of safeguarding,[42] conservation, and function. A monument such as this could, in fact, help monumentalize the site and therefore give value to the territory, converting the idea of the area's degradation as a periphery, by giving it centrality and dignity.

In conclusion, the *Giglio* tradition, on the one hand, and the history of the Rodia's Towers, on the other, might be linked in more ways than one. They seem to share a milieu of turbulent politics and strategies of patrimonialization, as well as historical links and structural similarities. An analysis that focuses on the process of valorization and patrimonialization has been overlooked in the multiple and varied interpretations of the two sites and might warrant further investigation. Without a shadow of a doubt, we are dealing with two ingenious expressions of material, artisan, and artistic culture, constantly

being reinvented within the debate around cultural ownership. These are sites of great symbolic strength, both in the local and transnational contexts of cultural heritage, as they come to figure in the inevitable modern global movements of those who produce and constantly reinvent them.

If Boas argued that a vast area of thought cannot be expressed by an object "because that particular aspect of life can only consist of ideas" (Boas 1907: 928), we might also argue the opposite, that in some cases *only* an object can express an idea and become "a privileged symbol of the idea of culture" (Handler 2000: 286).

Works Cited

AA.VV. [various authors] 2002. "Per un museo delle macchine festive." Messenion D'oro, Anno I, Messina, 39–48.

Aglialoro, Giorgio. [1971] 1996. "Paesi Vesuviani." In *Santi streghe e diavoli. Il patrimonio delle tradizioni popolari nella società meridionale e in Sardegna*, edited by Lombardi Satriani, Luigi M., 169–70. Rome: Ei Editori.

Ammirati, Luigi. 1969. *Il "cereo" quattrocentesco della Cattedrale di Nola*. Acerra.

Amselle, Jean-Loup. 2007. *L'arte africana contemporanea*. Turin: Bollati Boringhieri.

Avella, Leonardo. 1989. *Annali della festa dei gigli (1500–1950)*. Parts 1 and 2. Naples: Istituto Grafico Editoriale Italiano.

———. 1993. *La festa dei gigli*. Nola: Scala.

Ballacchino, Katia. 2008. "Il *Giglio* di Nola a New York. Uno sguardo etnografico sulla festa e i suoi protagonisti." In *Atti del Convegno internazionale Con gli occhi della globalizzazione. I nuovi studiosi e la ricerca delle migrazioni italiane. Altreitalie. Rivista Internazionale di studi sulle migrazioni italiane nel mondo*, edited by Maddalena Tirabassi, 36–37, 275–89. Turin: Centro Altreitalie, Edizioni della Fondazione Giovanni Agnelli.

———, ed. 2009. *La festa. Dinamiche socio-culturali e patrimonio immateriale*. Nola: L'arcael'arco.

———. 2011. "Embodying Devotion, Embodying Passion. The Italian Tradition of the Festa dei Gigli in Nola." In *Encounters of Body and Soul in Contemporary Religiosity. Anthropological Reflections*, edited by Anna Fedele and Ruy Llera Blanes, 43–66. Oxford, UK and New York: Berghahn Books.

———. 2012a. "Unity Makes . . . Intangible Heritage: Italy and Network Nomination." In *Heritage Regimes and the State*, edited by Regina F. Bendix, Aditya Eggert and Arnika Peselmann, 121–40, Göttingen Studies on Cultural Property, Vol. 6. Göttingen: Göttingen University Press.

———. 2012b. "An Ethnography of Migratory Heritage. The Gigli Feast in Nola." In *Patrimoine Culturel et Désirs de Territoire*, edited by L.S. Fournier, D. Crozat, C. Bernié-Boissard, C. Chastagner, 91–97. Paris: L'Harmattan.

———. 2012c. "Dalle Watts Towers di Los Angeles ai Gigli di Nola. Processi di patrimonializzazione tra arte e migrazione," AM-Antropologia Museale, anno 11, n. 32–33, 26–34.

———. 2013a. (Electronic Online Journal) "Is watching the feast making the feast? Visual language and practice in an ethnography," Anthrovision. Vaneasa Online Journal (Visual Anthropology Network of the European Association of Social Anthropologists - VANEASA), 1.2 | 2013, Online since August 1, 2013 (accessed October 24, 2013). http://anthrovision.revues.org/586

———. 2013b. "Mettere in valore una comunità in 'questua.'Patrimonio immateriale e cortocircuiti glocali," Voci. Annuale di Scienze Umane, Anno X/2013, 21–35.

Battista, Piero. 1973. Vita di antiche tradizioni campane. La sagra dei "Gigli." Firenze: Olschki.

Bauman, Richard. 1978. "Simon Rodia: The Original Recycler." *Glass* 6(2): 51–54.

Bindi, Letizia. 2008. "Folklore virtuale. Note preliminari a un'etnografia delle tradizioni sul web." *La Ricerca folklorica. Contributi allo studio della cultura delle classi popolari* 57: 87–94.

———. 2009. *Volatili Misteri. Festa e città a Campobasso e altre divagazioni immateriali*. Rome: Armando.

Boas, Franz. 1907. "Some Principles of Museum Administration." *Science* 25: 921–33.

Bortolotto, Chiara,ed. 2008. *Il patrimonio immateriale secondo l'Unesco: Analisi e prospettive*. Rome: Istituto Poligrafico e Zecca dello Stato.

Calabria, Giada. 1989. *Le torri di Simon Rodia*. Rome: Paolo Soffiantini. Centro di Cultura del Molise. Ed. 1997. *Uomini e Santi. Macchine da festa, rituali e artigianato*. Nola: Il Laboratorio.

Cerny, Charlene and Seriff, Suzanne. eds. 1996. *Recycled, Re-Seen: Folk Art from the Global Scrap Heap*. New York: Harry N. Abrams in association with the Museum of International Folk Art, Santa Fe.

Chastel, André. [1959] 1966. "Architettura, festa utopia." In *La grande officina: Arte Italiana 1460–1500*, Milan: Feltrinelli.

Cirese, Alberto M. 2002. "Beni immateriali o beni inoggettuali?," AM-Antropologia Museale 1,: 66–69.

Cosentino, Donald J. 1996. "Madonna's Earrings, Catholic Icons as Ethnic Chic." In *Recycled Re-Seen: Folk Art from the Global Scrap Heap*, edited by Charlene Cerny and Suzanne Seriff, 166–79. New York: Abrams.

Dal Lago, Alessandro, and Serena Giordano. 2008. *Fuori cornice. L'arte oltre l'arte*. Turin: Einaudi.

de Martino, Ernesto. 1977. *La fine del mondo. Contributo all'analisi delle apocalissi culturali*, edited by Clara Gallini. Turin: Einaudi.

Del Giudice, Luisa. 1993. "The Archvilla: An Italian Canadian Architectural Archetype." In *Studies in Italian American Folklore*, edited by Luisa Del Giudice, 53–105. Logan: Utah State University Press.

———. 2001. "Mountains of Cheese and Rivers of Wine: *Paesi di Cuccagna* and Other Gastronomic Utopias." In *Imagined States: National Identity, Utopia, and Longing in Oral Cultures*, edited by Luisa Del Giudice and Gerald Porter, 11–63. Logan: Utah State University Press.

D'Uva, Francesco. 2010. I Gigli di Nola e l'UNESCO. *Il patrimonio culturale immateriale tra politiche internazionali e realtà territoriali*. Nola: Extra Moenia.

Fabre, Daniel. 2000. *Domestiquer l'histoire. Ethnologie des monuments historiques*. Paris: Editions de la Maison des Sciences de l'Homme ("Ethnologie de la France").

———. 2006. *Les monuments sont habités*. Paris: Maison des Sciences de l'Homme.

Faeta, Francesco. 2008. "'Creare un oggetto nuovo, che non appartenga a nessuno': Riflessioni sull'antropologia e il campo artistico." *Ricerche di Storia dell'arte* 94: 41–48.

Fagiolo dell'Arco, Maurizio, and Silvia Carandini. 1977–78. *L'effimero barocco, strutture della festa nella Roma del 600*. Rome: Bulzoni.

Freedberg, David. l989. *The Power of Images: Studies in the History and Theory of Response*. Chicago: University of Chicago Press.

———. 2008. "Antropologia e storia dell'arte: La fine delle discipline?" *Ricerche di Storia dell'arte* 94: 5–18.

Goldstone, Bud, and Arloa Paquin Goldstone. 1997. *The Los Angeles Watts Towers*. Los Angeles: J. Paul Getty Trust.

Greaves, Brendan. n.d. *The Watts Towers*. Los Angeles: Committee for Simon Rodia's Towers in Watts.

Hale, William, director. 1952. *The Towers*. Los Angeles: Creative Film Society.

Handler, Richard. 2000. "Avere una cultura. Nazionalismo e preservazione del Patrimoine del Quebec." In *Gli oggetti e gli altri. Saggi sui musei e sulla cultura materiale*, edited by George W. Stocking, Jr., 261–89. Rome: Ei Editori.

Harris, Paul A. 2005. "To See with the Mind and Think Through the Eye: Deleuze, Folding Architecture and Simon Rodia's Watts Towers." In *Deleuze and Space*, edited by Ian Buchana and Gregg Lambert, 36–60. Edinburgh: Edinburgh University Press.

Hernández, Jo Farb. 2001. "Watts Towers." *Raw Vision* 37 (December): 32–39.

Isnenghi, Mario. 1996–97. *I luoghi della memoria*. Vols. 1–3. Roma-Bari: Laterza.

Kurin, Richard. 2004. "Safeguarding Intangible Cultural Heritage in the 2003 UNESCO Convention: A Critical Appraisal." *Museum International*, vol. 56, 66–76.

Landler, Edward, and Brad Byer, directors, writers, and producers. 2006. *I Build the Tower*. Los Angeles: Bench Movies.

Lave, Jean, and Wenger Etienne [1991] 2006. *L'apprendimento situato. Dall'osservazione alla partecipazione attiva nei contesti sociali*. Milan: Erickson.

Lombardi Satriani, Luigi M. 1999. *La sacra città. Itinerari antropologico-religiosi nella Roma di fine millennio*. Rome: Meltemi.

Lucarelli, Francesco, and Lello Mazzacane. 1999. *L'UNESCO et la tutelle du patrimoine immatérielle. Les fetes traditinelles Les Gigli de Nola*. Nola: Extra Moenia.

Madian, Jon. 1968. *Beautiful Junk: A Story of the Watts Towers*. Boston: Little, Brown.

Malagnino, Biagio. 1961. "Arte e tecnica nella costruzione dei Gigli." *Opinione* 7.

Manganelli, Franco. 1973. *La Festa infelice*. Naples: LER.

Marcus, E. George. 1995. "Ethnography in/of the World System: The Emergence of Multi-Sited Ethnography." *Annual Review of Anthropology* 24: 95–117.

Mariotti, Luciana. 2008. "Prospettive italiane della Convenzione per la salvaguardia del patrimonio culturale immateriale. Ipotesi di analisi tra antropologia e norme giuridiche." In *Il patrimonio immateriale secondo l'Unesco: analisi e prospettive,* edited by Chiara Bortolotto, 67–83. Rome: Istituto Poligrafico e Zecca dello Stato.

Mazzacane, Lello. 2000. "La festa di Nola: Conoscenza, rispetto e tutela di una festa come immagine riflessa della cultura folklorica." In *La forza dei simboli. Studi sulla religiosità popolare*, edited by I. E. Buttitta and R. Perricone, 207–17. Palermo: Folkstudio.

Minar, Rena. 1994. *Case Studies of Folk Art Environments: Simon Rodia's Watts Towers and Reverend Howard Finster's Paradise Garden*. Master's thesis, Rice University.

Monaco, Filippo. 2003. *Paolino, i gigli di Nola e le macchine da festa,* edited by Mario Podda. Nola: Arti Grafiche "G. Scala."

Orsi, Robert A. 2002. *The Madonna of 115th Street: Faith and Community in Italian Harlem, 1880–1950.* 2nd ed. New Haven, Conn.: Yale University Press.

Palumbo, Berardino. 2003. *L'Unesco e il Campanile. Antropologia, politica e beni culturali in Sicilia orientale*. Rome: Meltemi.

Palumbo, Berardino. 2009. "Patrimonializzazione," AM-Antropologia museale, 22, XXXVIII-XLV.

Pellet, Marcelin. 1894. *Naples Contemporaine*. Paris: Charpentier-Fasquelle.

Posen, I. Sheldon. 1986. "Storing Contexts: The Brooklyn *Giglio* as Folk Art." In *Folk Art and Art Worlds*, edited by John Michael Vlack and Simon J. Bronner, 171–91. Ann Arbor, Mich.: UMI Research Press.

Posen, Sheldon I., Joseph Sciorra, and Martha Cooper. 1983. "Brooklyn's Dancing Tower: Brought to America by Immigrants from an Italian Town, the Feast of Saint Paulinus Celebrates Religious Devotion, Community Ties, and the Ideals of Manhood." *Natural History* 92, no. 6 (June): 30–37.

Posen, I. Sheldon, and Daniel Franklin Ward. 1985. "Watts Towers and the *Giglio* Tradition." In *Folklife Annual,* edited by Alan Jabbour and James Hardin, 142–57. Washington, D.C.: Library of Congress.

Primeggia, Salvatore, and Pamela Primeggia. 1983. "Every Year, the Feast."*Italian Americana*7, no. 2 (Spring–Summer): 5–12.

Primeggia, Salvatore, and Joseph Varacalli. 1996. "The Sacred and Profane Among Italian American Catholics: The *Giglio* Feast." *International Journal of Politics, Culture and Society* 9(3): 423–49.

"Produrre culture ai tempi dell'Unesco." 2011. AM Antropologia Museale, anno 10, n. 28-29. Imola: La Mandragola.

Ray, Mary Ellen Bell. 1985. *The City of Watts, 1907 to 1926*. Los Angeles: Rising Publishing.

Remondini, Gianstefano. 1747. *Della nolana ecclesiastica storia*. Vol. III. Naples: Stamperia Giovanni Di Simone.

———. 1995. *Arte e tecnica nei Gigli di Nola. Forme ed espressioni dell'attività artigianale campana*. Pratola Serra: Sellino.

Scambray, Kenneth. 2001. "Creative Responses to the Italian Immigrant Experience in California: Baldassare Forestieri's 'Underground Gardens' and Simon Rodia's 'Watts Towers.'" *Italian American Review* 8, no. 2 (Autumn–Winter): 131–32.

Sciorra, Joseph. 1985. "Religious Processions in Italian Williamsburg." *Drama Review* 29 (3): 65–81.

———. 1989. "*O' Giglio e Paradiso*: Celebration and Identity in an Urban Ethnic Community." *Celebrating the City: Urban Resources* 5, no. 3 (Spring): 15–20, 44–46.

———. 1999. "'We Go Where the Italians Live.' Religious Processions as Ethnic and Territorial Markers in a Multi-Ethnic Brooklyn Neighborhood." In *Gods of the City: Religion and the American Urban Landscape*, edited by Robert Orsi, 310–40. Bloomington: Indiana University Press.

Seewerker, Joseph, and Charles H. Owens. 1940. *Nuestro Pueblo: Los Angeles, City of Romance*. Boston: Houghton Mifflin.

Seitz, William C. 1961. *The Art of Assemblage*. New York: Museum of Modern Art.

Sponsler, Claire. 2004. *Ritual Imports: Performing Medieval Drama in America*. Ithaca: Cornell University Press.

Varacalli, Joseph A., Salvatore Primeggia, Salvatore J. LaGumina, and Donald J. D'Elia, eds. 2004. *Models and Images of Catholicism in Italian Americana: Academy and Society*. Stony Brook, N.Y.: Forum Italicum Publishing.

Ward, Daniel Franklin. 1986. *Simon Rodia and His Towers in Watts: An Introduction and a Bibliography*. Monticello, Ill: Vance Bibliographies.

Watts Towers of Simon Rodia. 1983. Los Angeles, California: Sacramento: State of California, Department of Parks and Recreation.

Whiteson, Leon. 1989. *The Watts Towers of Los Angeles*.Oakville, Ontario, Canada: Mosaic Press.

Zampino, Giuseppe, ed. 1997. *Capolavori in festa. Effimero barocco a Largo di Palazzo (1683–1759)*. Naples: Electa.

Zelver, Patricia, and Franeì Lessac. 1994. *The Wonderful Towers of Watts*. New York: Tambourine Books.

Zevi, Bruno. 2004. *Storia dell'architettura moderna*. Vol. 2, *Da Frank Lloyd Wright a Frank O. Gehry: L'itinerario organico*. Turin: Einaudi.

PART 3

The Watts Towers and Community Development

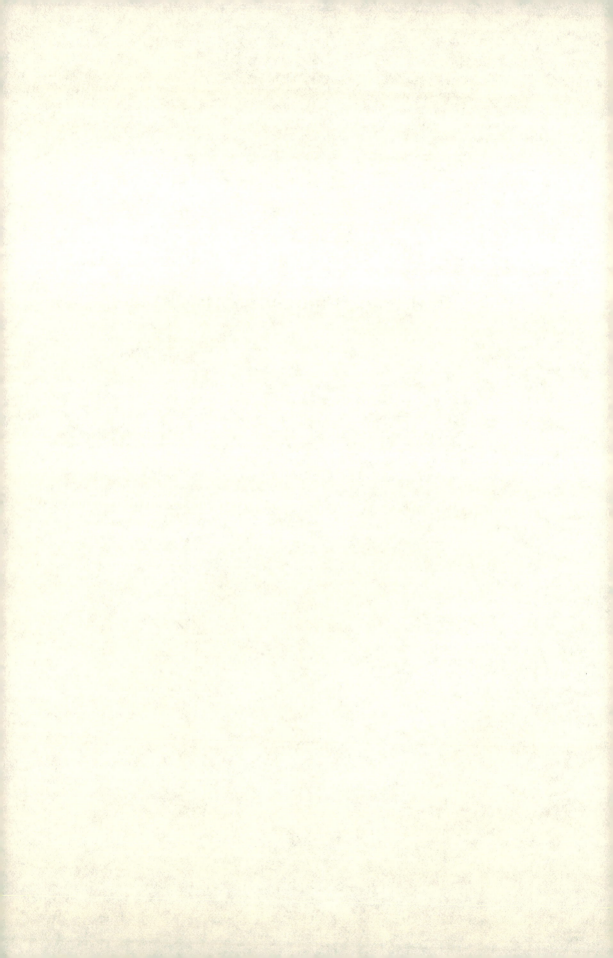

Artists in Conversation

R. JUDSON POWELL, JOHN OUTTERBRIDGE, CHARLES DICKSON, BETYE SAAR,
KENZI SHIOKAVA, AUGUSTINE AGUIRRE. ARTIST'S PANEL MODERATED BY ROSIE LEE HOOKS
(SATURDAY, OCTOBER 23, 2010, UNIVERSITY OF CALIFORNIA, LOS ANGELES, 121 DODD HALL)

[Transcribed by Claire Lavagnino]

Luisa Del Giudice: We have a very special panel. . . . There are some people in the audience [to whom] it's my pleasure to call to your attention. . . . Mark Ridley-Thomas, supervisor of Los Angeles County (the Watts Towers are in his district), [who] is very interested in this Initiative and [in] what can come of this meeting of partners. Thank you for honoring us here [applause]. Melody Kanschat, president of LACMA [Los Angeles County Museum of Art]. And of course, Olga Garay, director of the Department of Cultural Affairs, a very important member in the Watts Towers Common Ground Initiative. Now it's my pleasure to introduce someone who has really been key, my sister in Watts. Without Rosie Lee Hooks, none of this could have been constructed. I'm really grateful to Rosie. [here follows her curriculum]

Rosie Lee Hooks: Thank you Luisa. I'm also known as—and Tom Harrison can attest—Rosa Parks. With Rosa in mind, I do say: Don't give up your seat, and if they make you give up your seat, don't get back on the bus until they give you your seat. This conference actually started September 25th . The opening was at the Twenty-Ninth Annual Watts Towers Day of the Drum Festival and the Thirty-Fourth Annual Simon Rodia Watts Towers Jazz Festival. We also opened an exhibition, *Migrating Towers: the Gigli of Nola and Beyond* (we had Musicàntica there

John Outterbridge, Rosie Lee Hooks, Judson Powell, Charles Dickson.

at that opening). The next event was at [the Italian Cultural Institute] in West-wood, where we opened *Simon Rodia's Towers in Watts,* curated by Jo Farb Hernán-dez and myself. And we had a screening of the film *Fertile Ground,* which gives a history of the Watts Towers Arts Center. When I came to Watts, there was not a lot of information on the WTAC, and I thought that it needed to be documented as history, and also it needed marketing. Also, at the Italian Cultural Institute [IIC] the other night, the 18th, other artists from Watts came to support the opening of the exhibition, including a third-grader from one of our schools that actually did the model of the Watts Towers, which is absolutely phenomenal. She even included the designs on the floor. So we were very happy about Justine's work, along with the professional exhibitors. That night also concluded with a phenome-nal trio playing Niccolò Paganini's music. It was a beautiful evening.

After Bill Cartwright bought the Towers, they started restoration on the Towers, and the community said to Bill Cartwright and the Committee [i.e., the Commit-tee for Simon Rodia's Towers in Watts (CSRTW)]: "You care about those Towers, but what about this community?" Immediately, the Committee started art classes at the Center, which was on the foundation of the burned-out house of Simon Rodia. So, from the beginning, the community had input in that campus, not only to protect those Towers but also to take part in the resources of those Towers. Bill tells me the story of his wife being pregnant when he bought the Towers. And his son, who was with him last night ([with whom] she was pregnant); Bill went to the hospital and told her: "I bought the Watts Towers for you." [Audience laughs.] And

she was not excited about that, needless to say. "What Watts Towers? Who cares about the Watts Towers!" was her response. So he got a good laugh out of that. But it was good to see Bill, his son—who just being born at the time—there with us last night . . . a lot of history there.

I want to read a little something about the Watts Towers Arts Center before we talk about the artists who came through the Center. The Watts Towers Arts Center is not just an arts center. It's a community arts center. It's a social institution. People know that they can come to the Watts Towers Arts Center and get assistance with papers they need to fill out. They know that they can send their children there any time and get a snack. The children know that also. They also know that there are other resources there [as] a beacon to the community. The Tapias, a family of seven who live in their truck outside the Center, know that when I open up at 8:00 in the morning, they can come in and get some water and use the bathroom. So, we function not only as an art center teaching art classes, but we are a social institution, too. That needs to be understood.

The campus itself is, has been, neutral territory over these years. When I first came to the Watts Towers Arts Center years ago, it was at a meeting of the Bloods and the Crips. That was a place [where] gangs could come together and talk about issues when they couldn't get along any place else. That's one of the reasons that the Watts Towers Arts Center was neutral territory. All the young people know that they can come to that Center and [find a] safe, creative environment . . . a refuge to our children and to the community. And it always has been. And Mr. Powell even told me of the days when they were open at night to facilitate people in the community.

The Watts Towers Arts Center is the only functioning entity on this campus for fifty years. That's a long time providing arts education to the community—not just to the community of Watts but to Los Angeles and the world at large. Sometimes we have more foreign visitors than domestic visitors. That's a problem. We gotta pay more attention to marketing us in Los Angeles. Some people, the other night, got us confused with the Twin Towers! I said, "No, we're not quite the Twin Towers. We're still there. We didn't get pulled down, you know. We're still there." There's a lot of education that has to go on to [tell] Los Angeles about these treasures. Everybody knows about Disneyland, but the Watts Towers Arts Center [is] not as well known as [it] can be, as [it] should be, and as [it] will be. The artists that you see sitting up here have made a foundation for this Center. They have been there all these years. Once you are a part of that Center you don't leave. You keep coming back to see how you can enrich this Center. All of these people do that on a daily basis.

I'm just gonna read a little something very important on this day. Our classes began informally in 1961. In 1964, the Committee purchased a house where the Watts Towers Arts Center now stands and initiated programs for youth. Then came the events of August 1965, the Watts Riots, Rebellion, or Uprising, triggered as they were by years of poverty, neglect, racism, and unfair treatment by the establishment. But for individuals like Noah Purifoy and R. Judson Powell and many more, they were called to find ways to continue to instill value and hope in the young people in the community of Watts. A quote from Noah Purifoy: "Out of the

ashes we can create something new." When the current Watts Towers Arts Center was opened in 1970, several professional artists contributed their work to the face of the building, including Elliot Pinkney and Alonzo Davis.

Through the years, literally thousands of children, teachers, seniors, and special needs individuals have come to the Center for classes in art, music, drama, and, most recently, community gardening. Like the thousands who visit the Watts campus each year, they have also toured the Towers and viewed the permanent collections and changing exhibitions. Through our artists-in-residence program, the community arts program with Cal Arts, the jazz mentorship program, and others, young people are guided in their classes by professional artists. We don't expose our young people to mediocrity. All of our teachers are masters. More importantly, they are exposed to creative self-expression and to the belief that they too may aspire to have a productive and fulfilling life. In the art and photography exhibitions, they see that people of color, of every color and background, can and do triumph.

And in the solitary work of Simon Rodia, a man of limited resources, they have a living testament to the power of perseverance and self-realization. It is impossible to separate the spirit of Simon Rodia and his determination from the spirit that drives all those who contribute to the work of the Watts Towers Arts Center. Simon Rodia took the garbage of civilization—broken glass, broken plates—and used them, saw them as shapes and colors. That is the kind of vision of innocence. In the thousands of comments collected over the years from the visitors of every age, race, culture from around the world, one word is repeated most often: inspiring. The Watts Towers are a powerful source of energy and inspiration as they rise like a phoenix from the earth, leading us to embrace the courage to believe in ourselves and to follow our hearts.

The phenomenal artists that we have at this table . . . [are] just an example of about . . . 400 visual artists and about 500 master musicians that have been through that Center. We had the fifty-year celebration in 2009. October [2009] was the fifty-year celebration of not pulling the Towers down. So we had an exhibition at the Center, and we started with ten artists, but we ended up, somehow, with fifty. I have no idea how that happened. But when we started with those ten, word got out that we were doing this exhibition. And they started to call me to say, "Look, I've been there over this time. I need to be a part of this." We had phenomenal artists. All of the artists at this table were involved, including Bill Pajaud, Betye Saar who is here, Mae Babitz, Seymour Rosen. I brought along a commemorative that we did . . . documenting a timeline of the Watts Towers and the Watts Towers Arts Center [*The Watts Towers: 50 Years of Inspiring Art, 1959–2009*. Los Angeles: Watts Towers Arts Center and Los Angeles Department of Cultural Affairs]. You can also see those 400, 500 visual artists and musicians. Their names are recorded in this book. We think documentation is very, very important. We've . . . done about seven films that deal specifically with the Watts Towers and that community.

I'd like to start with the earliest participant at the Watts Towers Arts Center and that is R. Judson Powell, who came there with Noah Purifoy (as the first Arts Center director), and teachers, after Lucille Krasne and her art classes. So, I'd like

to introduce R. Judson Powell, who remains with us at the Center. He does tours on occasion. He teaches. We have a fundraising project called "The Heart of Watts," and this is a Heart of Watts [holds up heart]. You'll see some in Watts when you go there. You can see some at the [Italian Cultural Institute in Westwood] when you go to see that exhibition. That's a fundraising project for us that Mr. Powell has spearheaded. So Mr. Powell, I'd like for you to just talk a little bit about coming to Watts and your experience during those times.

Judson Powell: Good morning everyone. I . . . migrated to Los Angeles with my father in the year 1958, I believe it was. I had been involved in the arts. I'm from an artistic family. My father was a violinist and my mother engaged in graphics. So I was born into the arts and introduced at a very early age. I became a pianist. I understood the piano keyboard by the time I was two years old. I played piano by ear. I understood every note and where they were in relationship to each other. I gave my first public concert when I was four. I was in music most of my life. When I came to LA, I took up vocal study and became a troubadour, and I was billed for a period of time in Los Angeles as an "international troubadour," specializing in Yiddish folk songs. [Audience laughs.] I became quite popular and I received an audition at RCA Records. I had two managers at the time and they arranged for me to have an audition. After the audition, they called me into this little office and said, "We're considering signing you on, young man. You're unusual for

Judson Powell.

your abilities. But there's one thing you must understand. If we do put you under contract, you must be willing to put yourself in our hands because we intend to invest money behind you, and your life can no longer be your own." And then he looked at me and said, "Are you willing to put yourself in our hands?" I had a problem. [Audience laughs.] I didn't answer them immediately. I hesitated. And after a while, just looking at my expression, he said, "I didn't think so." He said, "But we are the entertainment industry and we represent you here, this is the way to the entertainment world. The only choice you have is to go back out into the community and continue and perhaps one day, maybe, we'll come and find you. But it's strictly business that we run here and this is the way we operate. If you're not willing to [follow our] guidance, we can't use you."

So, I said, if I can go back to the community, then that's what I'll do. So I went to Watts. I said, "Let's see how I can apply my talents to the community of Watts." That was in . . . 1960 or 1961. I came to Watts. I was invited by a friend of mine, Noah Purifoy, whom I had met through another artist friend, Claudine Myers (who was an actress). And he was having a week's cleanup campaign of a two-bedroom house, and they invited me to help, so I did. I became so involved that that week turned into about fifty years. But I was particularly fascinated by the skills of Noah Purifoy. He to me represented the essence of Dr. Carver, utilizing materials that were generally considered to be thrown away or castaways, and turning them into viable new products. Noah was an amazing man. He could transform something before your very eyes, just sit there and weave something out of nothing. And I thought that was a fantastic skill. I wanted to learn more about that skill, so that's one of the reasons I stayed—to study Noah.

But I soon found out that most of Noah's . . . recycling concepts were from Dr. George Washington Carver—this is a man who gave the world a new formula by which they can convert things. The science is predicated primarily on three propositions. . . . The act of finding [is] number one; adapting, number two; and creating, number three. I found that formula to be applicable in so many other forms: finding, adapting, and creating. . . .

But what to me makes the Towers such a unique structure is that it's not a building; it's a molded work. This man created this structure from the ground up, one layer at a time. We usually think of building as going up in a linear fashion—a frame going up first, and then something being applied to that frame. This is not constructed that way. It's constructed in a lateral fashion—one rung at a time. Hence, he's developing his own ladder as he climbs. The neighbors say they saw the fence go up first and then suddenly from behind the fence things started to rise. And the concept of lateral construction is consistent with stretching out into the community also—by collecting from all the community and involving them on his finished work. So, everybody living in the city of Watts from 1920 through 1940 has something from their personal families embedded in the structure. That's why they all feel that they are a part of it; it belongs to them because they are indeed represented on it. So, he involved the whole community in his act. That's one of the things that makes it so viable.

But most specifically, I was attracted to the Towers because I understood the science of it. And I still relate strictly to the science surrounding the Watts Towers:

the science of recycling. It also conforms to the science called the "power of intention." That's being still [discussed?] by Wayne Dyer on public radio. That science states that when you change the way you look at things, the things you look at actually change. I am firstly a scientist, and then an artist.... That gave me another identification with Simon Rodia.... Which part comes first, the science or the art? We don't know because we engage in both science and art, and we can't distinguish the difference ourselves. But I consider myself a scientist first. That's what I've been involved in all of my life. So I'm still connected with the Towers as a scientist, folks. And I have many, many materials relating to that (too much to pass around here). I've written a great deal of material to explain the actual science of the arts. [applause]

RLH: Mr. Powell happens to have been at the Towers during the time of the first Rebellion. And there was an art activity that actually came out of those burned-out buildings and melted neon. Mr. Powell, can you tell us a little about that exhibition?

JP: Yes, that's *66 Signs of Neon*. We had started the Arts Center in April of 1965, and the Revolt occurred in August of 1965. It's interesting also that Simon Rodia passed away, I believe it was, in July of 1965, and a few weeks after his passing, the town exploded. So we don't think that had much to do with his passing, but this is a factual occurrence.... But in 1965, soon after the Revolt, Noah and I were wandering the neighborhood, just taking a view of what all had happened, and we noticed these little drippings, shining in the sunlight. [end of DVD segment] [. . .] [We went to the] public schools, the elementary schools, the middle schools, the senior high schools, and the professional artists who [took] this opportunity to exhibit some of their works. Feeling that there was so much negative publicity about Watts, we thought this would be an excellent opportunity to show a creative side to the community. All of the works that people were involved in, creating out of a need to do something positive. So we put the community on display for a total week. It was a total success—kids hanging their paintings in the schools. All of their relatives came. So, we had this delightful community activity. It gave the opportunity to exhibit some of the culinary arts. The community had a chance to make their particular dishes. And so we had a ball for a whole week on the grounds of Markham Junior High School. We hope to do that again, because this gave the people an opportunity to meet each other. "I didn't know you did that!" We're really glad about people meeting [each other] for the first time. And we think we have a need for such a festival again because people still know too little about each other, and people around them.

RLH: Thank you. We're gonna pass around a catalogue of the *Junk* exhibition. That exhibition traveled for a number of years around the United States. I think it even went to Washington, D.C. However, as it traveled, it got a little battered and worn. And actually, what they did with it is put it back where it came from. It eventually went back to trash. I don't think there's one piece left. I think Sir Watts was the longest-lasting piece. It was said that it was somewhere in Germany, but I don't think it even exists any longer. And it's very interesting that all those phenomenal pieces of art were materials taken from that Rebellion. And it went back to where it came from. That's why it's called *Junk*. Thank you, Mr. Powell. And along came John. [laughter]

John Outterbridge: Rosie, thank you very much. I'm really embarrassed for scuffling to get here. I was at the wrong site [laughs]. I'm John Outterbridge. I had a great experience at the Watts Towers site—one of the most important works in the world. One of the phenomenal experiences in any person's being, once you come into contact with it. I fortunately discovered the Watts Towers by being lost in Los Angeles. I'm not from Los Angeles. I came to Los Angeles in 1963. And the best way for me to find out what a city is all about is to find out what streets separate north from south, and east from west. From that point I can go, you know, around. I was in the process of doing that one Sunday afternoon, after being in Los Angeles for just a few months. And I was going south on a very popular old street then— Alameda Street. I loved Alameda Street because it had too many junkyards, beautiful junkyards. Collector pieces. Saved them. And I also fell in love with Alameda because it reminded me of age, dignity, and sophistication and went from Los Angeles all the way south. I was driving along, Sunday afternoon, lost and loving it, and very excited in being just that—lost.

I came to 103rd Street south, and for some reason I decided, at that point, that maybe I'll turn left and head west and see what that's all about. So I came into a community that was very familiar. It smelled right. It looked right. It had picket fences. It was well manicured. And we're talking about the Sixties, very much intact. And I drove for a few blocks west and there was a shopping center then, before 1965, before the Revolt. And so, it was beautiful. So wonderful.. And I saw this thing. I didn't know what it was. I had heard of the Watts Towers, but I had not experienced seeing them. I saw something growing up out of the trees, literally. I said, "What is that?" And all of a sudden, I said: "That's not an oil well . . . What is that?" It was beautiful, whatever it was. And I drove west and I found out that the closest left turn led into whatever that was, that beautiful thing, was Graham Street. I turned left and went down Graham Street and I came to 107th Street and there it was.

That was my first experience with the Watts Towers. A few months after the Revolt, I went to visit the Watts Towers and the community itself, just to get a feeling of what had happened. And the first people I met [were] Judson Powell and Noah Purifoy. And they were preparing for the show that Judson spoke of earlier, the show at Markham. And I sort of indicated to both of them how much I was fascinated with the structure of the Watts Towers. And I also had some work from Chicago that I had done—very much like what Noah Purifoy was thinking and doing in his narrative—and so, we became fast friends. And through Judson Powell, Noah Purifoy, Curtis Tann, [who] I had met already, Ethelyn Tann (Curtis's wife), I was introduced to a whole tapestry of very, very creative individuals.

And . . . so, I would say that my home in Los Angeles has always been Watts. I would say that I can't spell love any better. I can't say anything more about humanity itself than my relationship to the site. And it started a long time ago. My entry to Los Angeles was the Watts Towers.

I would also say how important assemblage as a discipline is. We don't just live in the world. We don't just live in the universe. We are select[ive] about how we live as human beings. We assemble who we are over a long period of time. So assemblage, to me, has been none other than a way of life, *the* way of life. Any

time you encounter human growth, dignity, our need to know, you start to think of assemblage, and what has been described as a discipline.

I was fortunate enough to grow up in the South, with works of art all around me, and with people who had no names, and decided not to have names, and who didn't apply a signature to an expression. They decorated old fences. Eggshells were very important elements. Everything around you was beautiful. The aesthetics of the environment was a way of speaking. . . . [I] later went to school in North Carolina, at Black Mountain College, and this stuff was all around me. It was everywhere. And so what we call "vernacular art" today, what we called "folk art" then, and what we call "assemblage" now are very much the language of humanity. But in the South, where I grew up, it was very important also to recycle everything, and to live by that. So I grew up with assemblage [as] just a way of being, a language. And it told me very clearly that human beings are extremely creative as organisms. And that what we refer to as assemblage, what we refer to as art—the most important thing that pulsates in us—belongs to everyone. That's how we save humanity. It's not just art, but it's the way that we live. It gives us a lot of guidance.

I'm not going to say all the things that I could say about the site, the Rodia site, which helped me grow up, and which opened a lot of windows and doors for my sensibility. I've always been a very creative person and an artist. And I'm grateful for that. But I feel that humanity at large is very much indeed expressive. And if we do nothing else, we should always dig deep within ourselves and come out with something, *something.* Thank you very much, Rosie. [applause]

RLH: Thank you, John. I think we're all here because of that crazy man, Simon Rodia. You know, he chose Watts to build his Towers. He had a choice of two pieces of land that he was looking at. One is at the corner of Wilshire and Santa Monica, and the other was down in Watts. We know if he had chosen the piece at Wilshire and Santa Monica, those Towers would have come down because that hotel needed to go up. So we're pretty glad that he chose Watts. He chose it also because that railroad ran right by this piece of land, because he wanted many people to see his work. And it also proved to be a source of items to use on the Towers.

It's amazing this spirit that Simon evokes in artists and in people who come [to see them]. You will see that when you go into the Towers tomorrow [i.e., "Day in Watts" program], the feeling that you get, the spirits that are there. When you come into the Watts Towers Arts Center, there's a lot of positive energy also. We are literally the heart of Watts, geographically—and it pulsates. You will feel that. While John was at the Watts Towers Arts Center (he, of course, is my mentor), I started there in 1993, in an interim position, with transition going on. And I was also able to produce, for the first time, the Day of the Drum Festival and the Jazz Festival, under John's tutelage. So I learned a lot from him. I still learn a lot from him. He's still available to us. He gives advice to us continuously. . . . And I could not do what I do without John's support, and without the support of these artists on this panel, and other artists.

So now I'm going to take you over to Charles Dickson, who is very involved at the Arts Center. . . . I realized that, when you go to Paris you can get the Eiffel Tower. When you go to New York you can get the Statue of Liberty. We wanted

you to come to Watts and get the Watts Towers! So, I went to Charles Dickson and said, "Charles, what do you think about this? How can we make these Towers?" We've been working on that Watts Towers project for a number of years. We're still working on the formula for developing it and reproducing it, but you can get them now, thanks to Charles Dickson. All I have to do is have an idea, and go to one of the artists, and they're ready to create. [applause]

Charles Dickson: Thank you. . . . I'd like to thank . . . Rosie Lee and John Outter-bridge, and the entire panel, [for] inviting me to be a part of this historical union of remembrance of the Watts Towers, and also the creativity within the commu-nity. My relationship to the Watts area: I was born in Los Angeles and I was raised on 121st and Avalon. And much of my early life was going back and forth on the Red Car to Hollywood, because I was very ill. I was going to Hollywood to Children's Hospital when it was first being developed. And . . . we would pass that space all the time. Of course, I was too young and too ill to really be familiar with what was going on there.

But later on in life, I remember my father trying to bring my attention to— "And there's the Watts Towers and there—." I said, "I don't see anything dad." So as time went on, it was interesting. I graduated from high school in '66, so . . . there was activity at the Watts Towers well before that. But I'm looking at my relationship with that community because actually, I went to Watts Markham Ju-nior High School for summer school. And they had busses in and busses out, because we weren't from the area and they knew that. But I always had like, *pass* to go, because I always had my little art in my hand. And they'd say, "Yeah man, let him go. Let him go on the bus." [laughs] So, I always had a creative pass within

Charles Dickson, Augustine Aguirre.

the area, in respect to the gang leaders and people like that. They enjoyed that creative spirit within our community.

Again, as time went on, I graduated from high school. I had the opportunity to go to many institutions, such as UCLA and Long Beach State, Otis Art Institute and Chouinard, through mentors like Danny Johnson and Charles White, who encouraged me to be an artist.... I did not need to go to the institution. Danny Johnson was into "learn the politics of art, go to Chouinard." So that didn't come to light until many, many years after I had become a professional artist.

But, onto the story of Watts. When I graduated and I became a practicing artist, I practiced art but I didn't know where to put it, how to apply it in the real world. I had an opportunity to see a program at Studio Watts. I carried my art, as I usually do—my portfolio—and I got my first art job [in the] Masters Apprentice Program, directly across the street, well across the tracks from the Watts Towers. A good friend of mine, Gwen Buckley, was also teaching hair design, fashion, and other things at the Studio Watts location. She was also at the Watts Towers working with Curtis Tann.... Well, she was a very interesting and driven person, to teach and to expose people to the creative processes. She's very much into African culture. She was into sharing these wonderful possibilities that were in our community. She even introduced me to Frank Cummings, who was a phenomenal artist of this time.

I was introduced to the Watts Towers just at the time they were constructing *Mother Watts*. Gwen Buckley saw me making some wooden beads, and she wanted me to teach that at the little bungalow that was there. So I said yeah. I'm always willing to share technology and whatever I know. So I went there and saw them building the piece. I thought: that's interesting; they're making that from concrete. And I asked a couple [of] questions about it, watching them do what they do.From that I met Curtis Tann, Bill Watts. And just found the Towers—and still, you know, looking at the Watts Towers actually in a distance . . . [there's] a very creative energy there. I was more into wood carving at the time. I'm looking at concrete and these various construction things in a very distant way, but seeing that there is a definite energy there, that creative energy that is in all of us.... [I] became more interested as time [went] by.

And eventually, a good friend of mine, that I met in trying to get an application at Parks and Rec[reation], John Outterbridge, was up for directorship at the Watts Towers. So, I became part of the staff. And I think an important part of that development of John being at the Watts Towers as a director was his flexibility, his creativity, and sensibilities of the artists—the way that artists think. I mean, as you have seen, it's a way of life, it's an expression of soul.... That being said, he was flexible enough to enable me to teach there and also not teach there. Their space was small, and at the same time I had a space over at another location in Compton (I'm still there today). So, John enabled us to kind of satellite with the Watts Towers.

People signed waivers. The walls and the construction around the Watts Towers [were going up and] people said, "You can't do that." . . . And before you know it, things start popping up. Things you couldn't do, were suddenly there.... Very much the pulse beat of John's administration at the Watts Towers.... A lot

of other things [like] that happened. . . . He developed his fluidness through the directorship. . . . Again, this creativity with the Watts Towers also had to do with our own creativity and developing the things that we wanted to do all the time, with the multimedia of assemblage, and doing what we normally do.

Eventually, I was the one—and I have to say this, because it seems as though whatever administration or whatever programs were going on at the Watts Towers . . . —I was the guy that had the truck. If anything happened (Curtis Tann gave me a call as well), if the Watts Towers were gonna be closed down for budget purposes, "What can you salvage, what can you gather . . . to keep things going on a creative level?" So that's my input within the community, and also with the [Compton] Communicative Art Academy which John was involved in. . . . We taught from my location, many people. We traveled all over Westwood, and where have you, to gather information and share information with various people. I'm jumping around because pretty much my creative life has been jumped around like that. . . .

I try to share what I practice with everyone that's interested. And the Watts Towers is one of those places that I could go and always have that dialogue and conversation with young people. As Rosie Lee was saying, because of my affiliation with the Watts Towers, I thought that it's very important that . . . we enable the young people, and whoever, [with] the knowledge of how to produce these small Towers within our community. Always, with me, it's important not to import the art but to create the art out of the community, because that is where the soul of that ownership lies. So basically, I'm just sharing my abilities to reproduce. I have a natural gift to do that.

Recently, the efforts to close the Towers [for] various reasons—for me many political reasons—provoked again this same closed down fear. You know, I was totally taken by surprise when I was in a conversation and actually broke down. I mean, I went to tears. Where did that come from? Then it suddenly occurred to me, through a lot of examination, that I have real invested energies in the Watts Towers and in the people within the community. And so it's a hurtful thing to me to see . . . politics over people, monies over people, and creativity not understood, because of [district politics?] and things like that. . . . For me, it was always a God-given talent, and I would always be taken care of. But how many people in that community needed to see and needed to know that they were okay and that these were the processes of creating, of being more of their creative self, and knowing that that's okay to do that.

That's what Simon Rodia did when he built the Watts Towers. He just said, "I'm okay. It's okay. Do you want to be a part of that? This is what I'm doing and I'm gonna do that." He walked away from that. He was totally satisfied, totally cool with what he had done. You know, "I did a good thing. It was good. I had fun." And so, I think that that's what all creative people need to know. And I think that that's what the Watts Towers provides in conjunction with the community— this is part of the creative energy that we all have. We all have to make something. But we can always do the administrative work in a creative way, do the writings in a creative way. There's many ways. . . . [applause]

RLH: Thank you, Charles. Charles is speaking of breaking down when we were challenged with the possibility of being partnered out. And that possibility absolutely

frightened everybody in the community. The thought of losing control of the community Arts Center was just unheard of. This community Arts Center has always belonged to the community.... There were marches down at the Center in support of the Arts Center staying in the community and being controlled and run by the city of Los Angeles. We had a rough time this year just staying alive. We managed to do that solely because of the support of the community.

The Watts community is very vocal. And when they see something like this being taken away, they don't sit quietly about it. They express themselves. And they came out [in] full force.... So, we thank the community for standing up for us and ensuring that we're still existing and providing arts education to an underserved community that would not get arts education if we were not there. They cannot afford to pay for piano classes or animation classes or graphic art classes or photography classes.... They hold us accountable to it. When things are going on, they come over. They wanna know what's going on, and ... I have to have the answers....

The next artist that I'd like to introduce is one who grew up in the community, who actually saw Simon building the Towers, and that's one of our mentors and phenomenal artists, Betye Saar. [applause]

Betye Saar: Thank you. Sometimes things happen in your childhood that last throughout your life. My paternal grandparents left Louisiana in the early 1900s and settled in Watts. My siblings and I were the only grandchildren, and after our father passed, we spent many, many weeks with my grandparents. In the 1930s (a long time ago for many of you people!), when I was about six or seven, we would make a weekly journey up to the shopping center in Watts, where my grandmother would do her marketing and pay her bills, and so forth. My grandmother's house was on 113th Street, near the railroad tracks for the Red Car. And we would hold hands, walking along the railroad tracks on 113th Street, up to the shopping area.

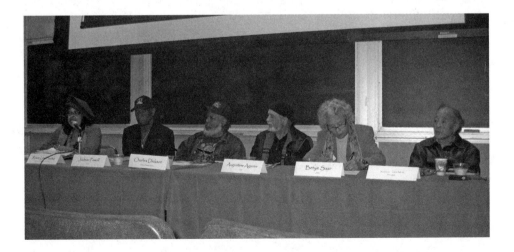

Rosie Lee Hooks, Judson Powell, Charles Dickson, Augustine Aguirre, Betye Saar, Kenzi Shiokava.

Simon Rodia's property, a corner that intersected the railroad tracks and his construction of the Towers, were visible to us as children. As a kid with a really big imagination, the spires inflamed that imagination, and I'm sure had something to do with my becoming an artist at a later time. I would ask my grandmother, "What are these strange things? What's that guy doing over there?" "Oh, he's just doing something, you know." She was intent on getting where we were going. Then about six or seven years later, when my grandfather had passed away, I went to spend some time with my widowed grandmother and attended an elementary school in Watts. I would frequently take detours on my way home from school, searching for the Watts Towers. Needless to say, I got lost. I could see them, but I couldn't find out how to get there. As an adult, I was able to find it, with somebody taking me by the Towers, to really look at them. But there was that longing to find out what was going on there, what was happening.

I went to school at UCLA and graduated in design, so I had a formal art training. And later, when I was married with my children, I think it was maybe in 1959, with my daughters Lesley and Allison (they were maybe seven and three or something like that), we went to visit the Watts Towers. And we have some photographs of us at that place, so we can examine what he was doing with the cement and what I call free fall, making art, that interpreting and reusing and recycling materials. And I think that that was probably an important part of my development as an artist, of really having a firsthand experience of mixed media and what you could do with art, what you could do with materials.

And from what John has told me about how he worked, how Simon Rodia worked, he would spend much of his time before he went to work, gathering broken crockery, shards, broken dishes. And when I look at the work, you can see the cement was sinking . . . settling, and you have to put something here before it gets hard. So he was drawing in it, he was making imprints, he was using corncobs, he was using anything. And that kind of rapid-fire way of creating made an impression on me. And later, when I got into assemblage art myself, I could sort of feel what the essence is of creating and being inspired by the materials that you find. I think that it also made an impression on my daughters, as it does with any young artist going to visit there. And also, it formed my concept of what being an artist was, of being a recycling artist—that you could make art out of anything. That really has been always part of my art making and still holds true today. Thank you. [applause]

RLH: Thank you, Betye. We're next going to go to Kenzi Shiokava. Kenzi actually grew up in Brazil and was very influenced by his mother [in] his art. Kenzi was also gardener to Marlon Brando for twenty years and worked with him on a number of projects. We're very, very fortunate to have Kenzi in our community and always at the Watts Towers Arts Center, looking to see what he can do and how he can support us in our efforts. And I'd like to say thank you to Kenzi for being here to help us out today. [applause]

Kenzi Shiokava: Thank you. I'm not a speaker, but I'm going to try to say as little as I can, but make the essence. You know, to me, the Watts Towers is a hub, a cultural hub of the United States. Right now it's not, but spiritually, it always has been. Even the process of building, because everything works to be there. . . . We

always see the monuments in the world as [identifying?] with . . . the whole community [and its] belief[s]—the pyramids, the French cathedral, the gothic cathedral. We see that with awe The process [has] passed and now it's recognized, but we don't realize the treasure, the cultural treasure that the United States has here. . . . We came here because of the freedom to do, the opportunity [f]or endless creativeness. . . . I'm getting older. . . . The Watts Towers is amazing . . . , you know [for]everybody that goes there: if they're an artist, they will be a better artist; if they're a doctor, they're gonna be a better doctor. . . . I think the United States should put the Watts Center in the center of a big, big space, so that people go there from all over the world.

. . . Also it's very important the Watts Center be there, because it's there . . . in an area [where they] could . . . survive. . . . The Arts Center is very important because it's [in] a community that needs some kind of . . . image to boost the creativeness of the person. That's the thing—the Watts Towers is very, very important, but also the consciousness of the nation, of the world, because we need to make the cultural Arts Center, to bring [it to] the grassroots, [and] permit that creativeness. . . . Simon Rodia . . . ha[d] that drive that nothing could stop. He could move mountains. He put[s] all the energy there. And after he finished he . . . literally accomplished something extraordinary. . . . When you see even the pyramids was only a hundred years, . . . that was society that would do something, and we realize how they were built, it's impossible. That was an extraordinary energy that Rodia ha[d]. . . . I'm a sculptor and I cannot figure out myself how to get a bucket of cement like ten feet high. And I get awe with his accomplishment. It's the essence of America to come here and do something like that, also [as] the symbol of the person that came here and what they can accomplish. . . . America is so wonderful. Now we have an African American president. Imagine, something unthinkable. The whole world is astounded. The sight of the whole world is changed just for that. . . . Thank you very much.

RLH: Kenzi reminds us that the Watts Towers are more a symbol of the United States than the Statue of Liberty because it was built by an immigrant himself. It wasn't floated over. It was built here. And he keeps reminding us . . . what the possibilities are, of why some people came here. You can see this in the Towers, in what Simon did. [applause]

Our next artist is Augustine Aguirre. Mr. Aguirre lives in Watts. He lives not too far from the Center. . . . He started out in our gardening program. We were in the process of waiting for a parking lot, and because we had to wait so long, we decided to use the land and make a garden. And with that garden we employ and work with young people in all of the schools surrounding us. They walk over and they work in the garden, plant, and they bring the fruit and vegetables to fruition. But while Mr. Aguirre was there, he decided to build towers. So he has small towers out in our garden area. You'll see that tomorrow when you go. And as he was building those towers—and the kids learned to tile at our Center—one of the neighbors got really involved. He came over and made some pots with Mr. Aguirre. And then he decided he wanted us to tile his wall. So tomorrow, you'll see a beautiful wall that was tiled under the supervision of Mr. Aguirre and our young people. . . . There's some other places on campus that we'd like to tile also. The

amphitheater is pretty gray. But our young people can come . . . see [what] they did, and have pride in that wall. And that's one of the things we want to extend to our community schools, . . . so when they have community service, they come over and work with us and they are more invested in . . . taking care of the community. That's what Mr. Aguirre has inspired in us. Mr. Aguirre. [applause]

Augustine Aguirre: Thank you, Rosie. Thank you for your support and your dedication, and for being a mentor. I've always been an artist. As a young man growing up, I watched my mother create quilts out of old Levi's and things that had gotten worn, old dresses. I was one of ten siblings. . . . My dad was a cook and my mother was a homemaker. But she used everything. Everything that was available was usable. And she always taught us . . . to utilize everything that you have, whether it was hand-me-downs or whatever. . . . I got out of my home very early because, well, as a young man, instead of paying attention to things they were doing, I decided that girls were more interesting. So at seventeen, I wound up getting my wife pregnant . . . —not my wife—[she] was my girlfriend.

So I went into the navy. When I came out of the navy, I went to Colorado for a couple of years. But in 1963 I came back to California. And in '64 I came to the Towers. They had no fence around 'em. I had two boys and they said, "Can we climb up dad?" I said, "Sure." So they climbed up and they went up quite a ways. I only went up about twenty feet and came down. But that was the first experience that I had with the Towers. In 1963 I was part of a group of artists that had gathered in Compton and they were planning a big artists' mall. It was gonna be called "Whole Earth Marketplace." But Compton had other ideas. They decided to tear down the building that we were involved in. I think John was part of that event and Mr. Powell was part of that event. So, I didn't know 'em then, but I probably saw 'em.

About . . . twenty or thirty years ago, I got hurt and I went into some depression, and I decided that I'm gonna do some art. So for two years I painted. I didn't go anywhere to look at anybody's art. I painted in my own studio, used whatever was available—discards of every kind, paint that I had used as a contractor. . . . (I was an independent contractor that had already built all kinds of houses and room additions . . . in the Watts, Los Angeles, area.) And when I got finished, after those three years, I called up to the Watts Towers and Mark Greenfield was the director at that time. And he had had to take down an exhibition—that we saw also documentation [of] this week—about the police and gangsters, you know, and it was taken down. . . . I asked him to come out and take a look at my work. And as he goes through the house, he's looking at my watercolors and he's saying, "Frames, frames, frames." And I know what he's meaning—you know they're just frames, the work is nonchalant. But when I get him out to the backyard, and I've got—my studio was a large canvas over an area (it was a blue canvas, it was very large), and in there, that's where I worked. And I let him go in first. . . . On the outside I had done a great big sculpture of hands, and I had one sculpture (quite large) of a lady [with] flowing hair that's made out of a root of a big avocado tree. And so I had taken the root and turned it upside down and did the face and the flowing hair. And so he was interested in all of that. But when he walks in . . . the first thing he says, "Do you want to sell all of this?" And I said, "That would be fantastic."

But then he started finding: "Well, why did you use discarded material? Why didn't you use quality?" Well, the thing is, I was out of work, had no money, under depression because, for all my life I've worked for myself, and then all of a sudden, I'm not able to work. So, he was very cordial and he said, "Look, come up to Barnsdall. That's where it's happening."

But I didn't have any money, and my van didn't have insurance, and I didn't have any gas. So I stayed in Watts and I continued on. . . . Kenzi happened to tell me about an event that was happening and that was the *Eye Speak* (2000). And I was asked by Joseph Beckles to be part of that group. I helped him set up as well. I was the first one who started the work, and my work was right after the towers—Twin Towers—were knocked down, so my interpretation was of the event. . . . I was constantly talking with Kenzi, because he was my mentor.

You know, I had no formal training in arts. Well, I went to two years at Cerritos, but they were part-time. It was art history and drawing. I had to work to support my family, but for thirty-six years, thirty-seven years, I was an independent contractor. I didn't have to write out applications for jobs because the jobs came to me. I made a lot of money. So I wasn't really too much into the art because it wasn't making any money. But after I got hurt, of course . . . , I decided well, this is what I love to do. And about four years ago, I had taken pictures of some of my sculptures and . . . I was going to go see Kenzi, but I stopped by the Towers and I asked Rosie . . . (we didn't know each other yet), "would you mind giving me about ten minutes?" She said, "Oh, that much?" I said, "Well, If you don't like what you see, within a minute you'll know." So she looked at my work and then she began to call, "Hey come over here." . . . And from there it happened.

She asked me to be in an exhibit there with them. And also to be part of *Trading Dirt*, which is a film that she produced. And in the process, because I am an artist that is very spiritual (I sought direction in that way), and I was given the go to be part of the Towers. . . . They had just torn down some properties that were on the Cultural Crescent, and I had told Rogelio[1] about putting up a garden. So he didn't say too much about it because they just didn't have the time. But the next year he said, "We're going to put up the garden." I said, "Okay, I'd like to be a part of it." So I've been there for almost four years.

And in the process . . . they had a Call for Artists to go to the Los Angeles Fair, to put up towers, build them on site, and then they were gonna be transported, to see if they would stand up. I had my group together, but all of a sudden, again, the finance. There's no money, it's forty miles to Pomona, forty miles back. And some of the partners—they had to have at least a four-man crew for this building—weren't available until the evenings or on weekends. So again, I asked Rogelio and Rosie, would they allow me to build the towers in the garden. And they did. In the process, I had the children help with the embellishment. The designs were my own. Then after I built the towers, I started having classes on these large concrete planters. And all of a sudden, we had six, seven artists—artists, not students, but artists.

. . . The neighbor across the street . . . has two properties and a big fence that another organization wanted to tear down. This is a concrete fence or a block wall. They wanted to put [up] more wrought iron. And I told them: "We have a lot of

children in jails where there's a lot of wrought iron. So why tear down this block wall, that this gentleman has put up by his own labor, and put up these wrought irons?" And he said, "Well I have my ways." So I said, "Okay." So, I went behind him and I talked to the gentleman, Mr. Garcia, and I said, "Let me have the wall." And he said, "Well, I'm with you, but let me talk to my wife." And last year I wanted to be done with it by Christmas, but it took all the way till after Easter before we were given permission. I put up, with collaborative effort, seventy-two feet of block wall, five-foot tall, and mosaics in tile. And I had cooperation with about seven artists from the Center, as well as the neighbor. And that was on the first two panels that I did. It's thirty-six feet on the front one, another sixteen feet on another one. The first panel is called *Metamorphic Experience*; the second one is *Mi Tierra* (My Land), and that's because of the neighbor; and the third one is *The Duck Farm*. So when you get a chance tomorrow, come in and see it.

Again, there's a lot of energy there, around the Towers. As I was building the towers, I was working on a ladder because it's only a twelve-foot ladder, but it weighs 850 pounds, and that's a lot of concrete. But as I was up there for a few minutes, that day it was all sunny, I had an out-of-body experience. . . . All of a sudden, I was higher, and I'm feeling all kinds of joy, all kinds of exhilaration, and a voice (an inner voice) that says: "come up higher." When I came back down, I'm holding onto the ladder because I'm thinking: I'm falling. And I thought, "Well, if Rodia felt this, then I can understand what he was going through," because of the energy. Unless you felt it, I think it's difficult to explain, because I get chills just thinking about it. For me, it's a spiritual thing. I have to be there. And I continue to work wherever I'm needed. I tell Rosie the same thing: "Rosie wherever you need me, I'm available," because to me, the Towers represent creativity. And all of us have that ability within us, but it's only when we let ourselves go and absorb that higher power, that gives us the ability to be as he is—creative and objective. There's also a lot of love there. Love is one of those things that moves mountains. It's one of those things that the Scriptures say is above all things. If you love one another, you've accomplished what needed to be accomplished. So I thank you. I thank you. [applause]

RLH: To round off the conversation—we know that there is a lot of love in those Towers, as is evident by all the hearts that are around there. You can feel and you can see all the love here on this panel. [The] artists are absolutely committed and in love with the experience of being around those Towers and being inspired by those Towers. We actually feed the soul with art. Our soul gets treated with art. I think that's why it's valued so much in our community. You can always go around those Towers and be rejuvenated, no matter what the issues, trials, and tribulations. Once you walk in those Towers, you are empowered to do what you have to do. It's a hard row to hoe, but if you have the strength to hang in there—which we seem to have . . . —it is a sentence.

Building Community Through Self-Awareness and Self-Expression

Gail Brown

Rodney King has died, and his untimely death, in June of 2012 at the age of 47, brings full circle events that began in 1992—set in motion by a high-speed freeway chase in which King, an African American male who was driving while intoxicated, attempted to evade Los Angeles police. When he was eventually apprehended, he was viciously beaten. What made this event unique was not the police beating of a black man but that it was the first time such an event had been captured on video and played repeatedly on television. The horrific video captured public imagination worldwide, providing seemingly indisputable proof for what the African American community had been claiming for years: that black males were routinely targeted and brutalized by police. To any ordinary observer, the video evidenced a clear case of police brutality. At the end of a lengthy court trial, the officers involved were acquitted of any wrongdoing, and in April and May of 1992, the city of Los Angeles erupted in the worst civil violence since the Watts urban uprising of 1965.

I am an artist, photographer, and educator. For me, ultimately, art is a search for meaning. In July of 1990, I packed my belongings into a truck, left my native upstate New York behind, and headed west to Los Angeles, as many have done before me, to find myself as an artist and to venture into a new life. To pay my bills, I took a job substitute

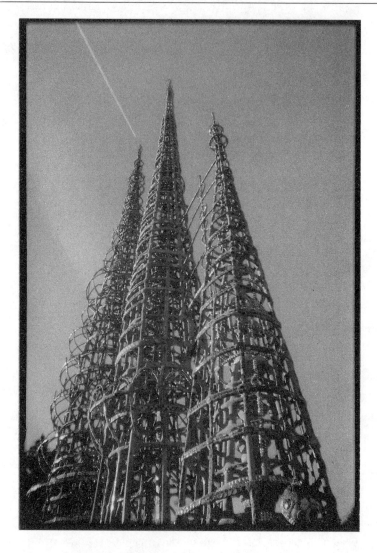

Photo and text 2007 by Maria Meza, b. 1992. Courtesy From Where I'm Standing *Photo-Documentary Archive,* © *2012 Gail Brown.*

teaching for Los Angeles Unified School District. In this role, I had a unique window through which to observe high school and middle school campuses throughout the city of Los Angeles. It was, to put it mildly, an eye-opener. It is one thing to have intellectual knowledge of something and quite another to be immersed in it. I experienced school campuses with widely divergent access to resources as I traveled from north to south and east to west. I witnessed conditions in some south and eastside schools that I couldn't integrate with my own experience of a high-quality public school education. I felt a disconnect between what I was witnessing and the American values of "liberty

When I first came to live here in watts, the 1st thing I noticed were the watts Towers. I used to think they were made out of metal and that they were boring. But I changed my mind when I came to see them close up for the 1st time. I saw that they were made out of cement, recycled glass, shells, and rocks. These towers were finished in 1954, by Simon Rodia. I think it is really cool that he took other people's trash and made it into beautiful art. The towers are very cool, colorful, and big. When I heard the history about the towers, I saw that Rodia had put a lot of heart and effort to them, to make them the best of all, and I think he succeeded.

and justice for all," with which I had been instilled as a child, and in which I had believed wholeheartedly. I witnessed students without desks, math and science classes without textbooks, art classes without materials or teachers, buildings with leaking roofs and busted bathrooms. I spent days, weeks, and months at treeless, blacktopped campuses enclosed by chain-link fences topped with razor wire. I taught children in classrooms where no permanent teacher was on hire.

In 1992, I was deeply shaken by the Rodney King riots, and I experienced a jolt of recognition—my students, people who I knew and *liked*, were among the rioters and

some people think my community is
a dead-end. I don't think it is,
not really anyway. I don't want to
end up with a dead-end job or
a dead-end life choice.

Photo and text 2011 by David Reyes, b. 1993. Courtesy From Where I'm Standing
Photo-Documentary Archive, © 2012 Gail Brown.

looters. I am a photographer, but photographic documentation alone seemed insufficient to gain understanding of these urgent social events and the underlying conditions that kindled them. To gain insight, I felt an imperative to delve below the surface; to see the world through the eyes of the participants; to explore and document their concerns as they saw and experienced them. To this end, I set about creating the *From Where I'm Standing* photo-documentary workshops (the workshop). In 1995, I received funding from the California Arts Council to conduct the first pilot workshop in East Los Angeles.

IF somebody asked me to join a gang, I think
I would, because I would have another
family on my side to back me up, but I would
really have to think about it. People have
asked me already to join their gang.
Right now I am thinking about joining their
gang but I just don't know. In ways I am
scared because innocent people might
get hurt. I would feel like it's my fault,
and I don't want my family in danger.

Photo and text 2006 by Melecia Gonzalez, b. 1990. Courtesy From Where I'm Standing
Photo-Documentary Archive, © *2012 Gail Brown.*

I have conducted the workshop for more than fifteen years, documenting three Los
Angeles communities: seven years in East Los Angeles, seven years in Northeast Los
Angeles, and since 2005, I have been providing in-depth photography and writing work-
shops in Watts at the Watts Towers Arts Center (the Arts Center) to people in the commu-
nity ranging in age from ten through sixty-nine years of age. Each year, approximately
twenty volunteers participate in creating photographic and written documentaries about
their lives. The workshop is free. Young and old work together and independently in a
supportive community environment, exploring their core values and issues of identity,
as well as their concerns about the world around them.

FRom WheRe I'm standing I see violence
most people who live in violent neighborHoods Don't like it.

FRom where I'm standing I See Gang life,
killing People over colors, man, It's not Right,

FRom where I'm standing I see people Doing DRugs.
we Got to tRy to Get the people to stop selling Bud.

FRom where I'm standing It's RaRe to see people HAPPy,
Because They Have to walk ARound In A neighborHood
So TRASHy.

FRom where I'm standing I look Back at the
2006 watts life. 2007 Is Going to be better
AlRight.

Photo and text 2007 by Walter Finnie, B. 1994. Courtesy From Where I'm Standing
Photo-Documentary Archive, © *2012 Gail Brown.*

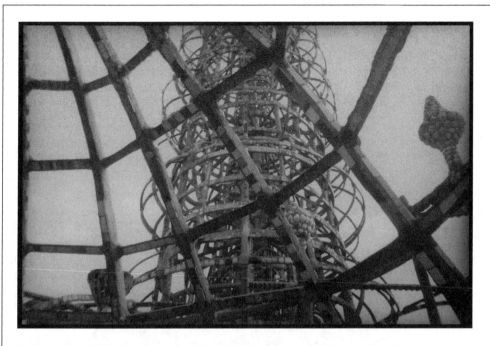

From where Im standing, I can see the Watts Towers. The Towers make me want to come to my class. They make me want to come to my class Because I can see them again, and I can learn more About photography. When I look At the towers they make me Feel Good. They make me Feel Good because A man made something that He would be Remembered For, And He got Remembered By leaving His mark, and that mark He left now Represents our City.

Photo and text 2007 by Walter Finnie, B. 1994. Courtesy From Where I'm Standing
Photo-Documentary Archive, © *2012 Gail Brown.*

Photograph of Marisol Manzano by Gail Brown, 2012. Courtesy From Where I'm Standing *Photo-Documentary Archive,* © *2012 Gail Brown.*

From Where I'm Standing is an experiential, film-based, black and white photography workshop. Participants are lent inexpensive 35mm cameras, which they have access to twenty-four hours a day, seven days a week, for the duration of a fourteen-week series of classes. The program begins in late September, is repeated again in the spring, and culminates in June with an all-inclusive participant exhibition. All materials are provided.

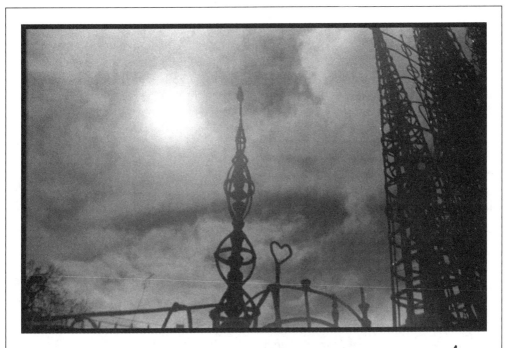

I want my life to be full of light, color, and flavor. I want to read, write, and build for myself a world where anything and everything is possible.

*Photo and text 2011 by Marisol Manzano, b. 1989, (*From Where I'm Standing *workshop participant 2006– 2012). Courtesy* From Where I'm Standing *Photo-Documentary Archive, © 2012 Gail Brown.*

Students photograph, process film, and make enlargements in the Arts Center darkroom. They also write and learn to share their writing within the support of the group. In conclusion, each workshop participant produces a high-quality, handmade accordion-format artist book that is expanded out for wall display during the June exhibition. The books belong to the participants. Their writings and negatives are incorporated into a growing historic photo-documentary archive.

The objective of the workshop in Watts is the creation of an in-depth photo-documentary by and about the Watts community. In the process, the workshop builds community. People young and old participate in discussions about their photographs and writing and experience the dynamic and vital relationship between the individual (artist) and the community (society) at large. Visitors from all over the world come to see the Watts Towers and the Arts Center. *From Where I'm Standing* serves to increase worldwide recognition, understanding, and respect for the Watts community.

The workshop takes participants on a journey into themselves. Integrating creative disciplines that demand equal measures of reflection and expression, the program helps individuals to articulate and manifest their personal truths and unique destinies. They experience the power of their words and images to affect others. Children and adults who live in Watts need, aspire, and deserve to identify with something other than the poverty and violence around them; to recognize themselves and be recognized by others as the heroic individuals they truly are—in the Joseph Campbell sense of heroism—constructing beauty and meaning from the raw material of their lives.

There are resonances between the workshop, the Arts Center, and Simon Rodia's Watts Towers. Classroom and darkroom space for the workshop, are nestled in the Arts Center's main building, under the shadow of the Towers. During the very first week of class, workshop participants are introduced to Rodia's Towers with a VIP tour, and they interface on a weekly basis with the art exhibitions in the Arts Center gallery. Moreover, Arts Center staff cultivates an environment of inclusion for *FWIS* students. They learn about Simon Rodia, the artistry of the Watts Towers, and the history of Watts, and many become involved in other Arts Center programs, including volunteering for art openings, working in the community gardens, and taking music lessons. In all of these ways, workshop participants and their families develop a more expansive and positive view of themselves and their community. People recognize in Simon Rodia a piece of themselves, a true man of the people, of humble origin and with limited resources, and yet one who made a monumental work of art that endures and inspires.

As human beings, belonging is essential to our physical survival. A sense of belonging is hardwired into our psyche. We must make a difference to somebody, count for something. We long to be recognized, valued, loved, or respected, yet very few of us are destined to be rich or famous. How much greater is the sense of demoralization for a teenager in Watts, when *going* to school is in itself an act of unacknowledged courage; a teen who is aware of the fact that his or her school offers no music, art, civics, horticulture, philosophy, or any of the unquantifiable pursuits that inspire us all in the search for personal meaning and beauty in life; a teen who comes from a community whose very name, "Watts," causes an outsider to shudder and shrink with prejudgment. In Watts, the dangers of the street are real, not in the ways an outsider might imagine it but in that there is no money in the bank to act as a buffer from the street. Yet, in spite of monotonous, grinding poverty, there is also joy and abundant interior life. I defer to the workshop participants themselves, who tell you themselves, in just a few words and images, more than I can say.

Simon Rodia's Watts Towers: Sociopolitical Realities, Economic Underdevelopment, and Renaissance: Yesterday and Today

Shirmel Hayden

Did you hear about the rose that grew from a crack in the concrete? Provide nature's law is wrong it learned to walk without having feet. Funny it seems, but by keeping its dreams; it learned to breathe fresh air. Long live the rose that grew from concrete when no one else cared.
—TUPAC SHAKUR, *THE ROSE THAT GREW FROM CONCRETE*

What do we know about great men? A few words come to mind: inexplicable, brilliant, innovative, and ingenious. What we know about Simon Rodia is that he was all of these and more. As Copernicus ("Nicolaus Copernicus" 2005) and Galileo were revolutionary in science, mathematics, and medicine, Columbus in exploration, Rodia joins their ranks as a skilled master builder and visionary artist. His area of expertise was constructing towers out of steel rods and cement. He designed and decorated surfaces with mosaics made from tile shards, glass, marble, broken dishes, rocks, seashells, and pieces of bottle,

while using impressions made from hand tools, automotive parts, corncobs, wheat stalks, and various types of fruit, as a method of covering these surfaces with many images (O'Donovan 2008).

As Simon Rodia worked to "do something big," he was not timid about expressing his concerns about politics and social change. Using the Watts Towers as a statement to express his unique talent, building one of the world's most unique artworks of the twentieth century, he also expressed his socioeconomic and political ideals through this work. During Simon Rodia's journey from Old Italy to New America, we see through the Watts Towers how he was able to "fight back" against social paradigms that governed societies, stereotyped people, and allowed inequality to exist. With these challenges, he began to create and express a vision that spoke silently against preconceived notions about America. As we travel from the past to present, from Old Italy to New America, we see similar struggles against economic underdevelopment and cultural politics. Today, instead, we add the dimension of community activism and, more important, the understanding of community leaders in Watts who have been at its forefront—as proponents of change.

Upon Rodia's departure from Italy in the late 1890s, the country was experiencing social unrest due to entrenched hierarchies, change in government as a newly unified nation, and severe underdevelopment—all factors in mass migrations from the South of Italy (Trueman 2000). Soon after his arrival, California's population increased over 20 percent, the country was undergoing massive industrialization, and racial division was systemic. During the World War II era, however, a timeline of economic expansion, reform, and political shift was sparked in Southern California (Bean 1968).

During the 1920s, Rodia saw Watts through many different lenses. While the majority of the local residents worked in manufacturing, building maintenance, or food services or were small business entrepreneurs, there were very few professionals in the community (e.g., doctors, lawyers, or bankers). According to the Automotive Club of California (*Intersections of South Central: People and Places in Historic and Contemporary Photographs* 2006), "this caused a geographically *discontinuous and socially fractured community*, much of what Rodia believed to be true." Several of the major concerns Rodia expressed were his displeasure with the way elected officials governed American society, how local law enforcement treated immigrants, and the strained relationships within families. Coming from Italy, it was an eye-opener for Rodia to witness for the second time around injustice, unfairness, and inequality (*Intersections of South Central* 2006). Those same factors still exist today in the Watts community.

Much like Simon Rodia, I, too, journeyed (or migrated) from my home in Atlanta, Georgia, to Southern California. To me it seemed like a dream. Traveling over 2,000 miles to a city, sight unseen, proved an economical, political, and social shift from my normal life, and I arrived in Los Angeles on August 17, 2003, to a city famous for cultural diversity, movie stars, beautiful scenery, and beaches. After stepping off the airplane into the new city I would now call home, it took me a while to adjust to the climate, the people, and a new way of life. For the first couple of years, I worked and went to school. I had little time for socializing with friends, and besides, I really did not have any friends. I knew only the people I worked with at the time. Like Rodia, I came to Los Angeles to do "something big," although I did not know the extent of it until a couple of years down the road. My first year in Los Angeles was difficult. It wasn't until 2005 that I actually started feeling somewhat better about being in the city. At that time, I worked for the University of

California, Los Angeles, as an AmeriCorps VISTA volunteer in the Watts community. The organization I worked for was called the City of Los Angeles Youth Opportunity Movement (YO! Watts), and it was located in the heart of Watts, about one mile from the Watts Towers. It wasn't until I began working there that I got a sense of local socioeconomic and political realities. Before setting foot in Watts, I, like many other people in the South, had a preconceived notion of what Watts was. I thought Watts was the thriving community that existed in the 1960s. It never occurred to me that it had changed. I guess I never made the transition in my own mind, from the stories I had heard about the community prior to the Watts Riots of 1965, and I did not really believe films that depicted Watts as a low-income, high-crime, and drug-ridden area.

The community I came to know and love was struggling, not only with its image, but with its past. The Watts I saw (and still see) is one that fights every day for equality with regard to food, housing, education, health, and employment. According to statistics from the Advancement Project, the "Great Migration" of African Americans to the city greatly changed the racial composition of Watts (Nicolas 2002). This is probably what Simon Rodia saw when he settled in the city during the 1920s. The growth of the African American population in and around the Watts area coincided with the expansion of the manufacturing industry directly northeast of Watts along Alameda Boulevard. Between the 1920s and 1940s, the African American population in Watts grew from 14.4 percent to 35 percent (Sides 2003). African American workers were largely excluded from higher-paying industrial jobs and were relegated to janitorial and other low-skilled positions within factories. While racial discrimination and segregation existed in the workplace and in the surrounding communities, Watts remained a racially heterogeneous community into the 1940s (Advancement Project 2007).

When I begin working with YO! Watts, I thought it was going to be fairly easy. My goal was to recruit as many students into postsecondary education as possible. I began organizing a college center, college field trips, and college events for students at David Starr Jordan High School and around the community. Little did I know that organizing the college center was not going to be easy. Like building the Watts Towers, this, too, was going to take much patience, effort, and dedication to finish. The project's evolution became a story in itself. Jordan High School was one of the lowest-performing high schools in the city of Los Angeles, with a high dropout rate; it was located next to one of the largest housing projects in the United States. I did not think I was prepared to handle the frustrations of the job, similar to the frustrations Rodia might have experienced in his building project. In the mornings before school started, while walking or catching the bus to work, I would see middle school students handcuffed outside the school yard being questioned by the police. Working at Jordan High School, I saw shortages of textbooks, high substitute teacher rates, and high dropout rates. One parent commented:

> I see my community as a sleeper. It's got potential, but trying to bring that potential
> out gets difficult. . . . People don't look at this community as having potential because
> of its violence. A majority of the potential doesn't get developed because of the lack of
> resources. (Advancement Project 2007).

Many of the students I worked with had failing grades, low SAT scores, overcrowded classrooms, and problems at home, but they continued to fight against adversity, graduated, and continued on to college. I believe they took refuge in coming to tutorial sessions,

college trips, and weekend educational seminars. Successfully reaching students was not an easy task. Once the students began to believe in what they could accomplish, that college *was* attainable, their focus, minds, and motivation changed.

Even though the statistics stacked up against the students, I did not stop trying to reach as many as I could. According to socioeconomic environmental research on the Watts community by the Advancement Project, Watts had a high unemployment rate, minimum unemployment training opportunities, low levels of educational attainment, low performance, unsafe schools, and general poverty (Advancement Project 2007). The statistics did not scare me, because like Rodia, I had a mission to do "something big," and I believed that each student I worked with could do the same. Some of the challenges included students not speaking English; lack of financial resources to pay for college; noncitizen parents and/or students; first-generation students try to attend college; parents not wanting them to go to college; parents not wanting to fill out the financial aid forms; and schools being ill equipped with counselors to effectively manage their caseload. Charting unfamiliar territory was a challenge, but once again, it did not scare me. I had a passion for education and wanted to see each and every senior get the same opportunity I had, which was to attend a four-year college or university. I felt that my goals were positive, but getting "buy-in" was a challenge. In the beginning, students would not listen to me until I came up with the idea of providing lunch. I noticed that the typical student lunch was a can of soda and some type of chips or nothing at all. I decided to go to the local grocery store (Food for Less) on my way to Jordan and pick up bread, ham, cheese, turkey, chicken, a couple of bags of potato chips, water, and fruit drinks. This drew attention, and when I hosted the various college workshops during lunch and after school, the students actually ate lunch and listened attentively to my presentation.

During the first week of school in 2005, I presented a workshop on postsecondary education twice a week from mid-August until Christmas break. In addition to the workshop, college recruiters came to the school, weekly college trips were planned, and the parents were offered workshops. Once students and parents began believing that these high schoolers could go to college, have it paid for, and in most cases become the first generation to attend a postsecondary college, the real work began. Students began going to tutoring before and after school, taking an interest in all their classes, attending SAT and ACT preparatory courses, as well as filling out admission, financial aid, and scholarships applications online.

The reward was over 150 college and university acceptance letters for the spring of 2005. This was one for the history books at Jordan High School. I knew my passion was education, and I always loved working in this field, but I could not have anticipated the number of students who would be motivated to attend college. The most amazing part about that particular school year was that students were also motivated to "do something big." They really fought the odds. If you know the Watts community and its history, struggle is not a stranger. From the days of Rodia, this was evident in his dream to build the Watts Towers, *here* in the Watts community. It took many long hours, patience, commitment, dedication, and the will to achieve—all in spite of adversity.

The beauty of the Watts community is that the fight has never ended. From my own experience, the students are proof of that fact. Every day, people are signing petitions in local shopping centers, organizing community meetings, encouraging youth to finish school, and advocating on behalf of civic and civil rights, to ensure that the community

of Watts and its people are not forgotten. When I first saw the Watts Towers, I was amazed by the dedication, strength, courage, and persistence Rodia must have had to build them. It is not something that happened over night: It took him over 30 years. Today, I am reminded instead of the students I have worked with in the Watts community and their dedication, strength, courage, and persistence, despite the great odds stacked against them. One particular student I have worked with, and continue to work with, I met as a result of advertising for free tutoring in 2004. He stopped by after school and introduced himself by saying, "I am Eduardo, I am 12 years old, I want to go to Yale University, and I want to be a jazz musician." I was speechless for a moment, but answered: OK. Another student had a mother who would not let her finish school. She was encouraged instead to stay home and watch her younger brothers and sisters. At the time she told me this story, her grade point average dropped from a C to D. She would often have to fight her mother to get out of the house in the morning in order to go to school. One thing that motivated her was the belief that graduating from high school and continuing her education was the right path for her. It was a long road, but she ended up graduating and attending college in New Orleans. She currently has one year left before completing her bachelor's degree in marketing and communications. It was the idea of "doing something big" that carried both students along their path toward success. Sure, they could have not hoped nor dreamed and just accepted what life threw their way; but instead they decided to create their own individual reality, fulfill their own vision, following Rodia's example. This speaks volumes to evidence-based research that says otherwise.

Artist Gordan Wagner called the Watts Towers "an expression of freedom" (Goldstone and Paquin Goldstone 1997). Although considered unskilled and uneducated and often mocked as a crazy man by his peers, Rodia, idealistic and focused, silently contributed to change in Watts. Through the construction of the Watts Towers, he not only proved he was capable of achieving great work, but he did it outside the normal scope of what greatness was considered to be. He was neither an oil tycoon nor a celebrity, and he was not a manufacturing entrepreneur. From the moment he began building the Towers, Rodia showed how common perception could often be mistaken. A poor and uneducated immigrant, he nonetheless had great dreams. The Towers represent his legacy of hard work, dedication, strategic planning, and, more important, a vision of change. Regardless of his circumstances, Rodia proceeded to achieve "something big," setting the tone for others to follow, such as the Committee for Simon Rodia's Towers in Watts, whose understanding of the greatness of his work motivated it to save the Towers for us all, and the Watts Labor Community Action Committee (WLCAC), which set out to develop Watts on many fronts.

The Watts Labor Community Action Committee is a community-based, nonprofit public benefit organization, with a primary mission of improving the quality of life for the residents of Watts and South Central Los Angeles. WLCAC was founded on the philosophy "Don't Move, Improve" and has worked diligently to engage low-income residents in self-determining the vision for their community. For over forty years, WLCAC has consistently served community residents and in the process established itself as a leading social service organization in Watts.

Whether Rodia built the Watts Towers to be seen from the highways of Southern California, to remember the eight craft guilds of Nola, or to speak to economic underdevelopment, cultural politics, and community activism, he was an extraordinary man.

The climate of poverty against which Simon Rodia struggled in the 1920s still exists today in Watts—as do injustice and inequality. Currently, community activists seek to redirect many misconceptions about this place, promote education, and stand as a vision of change. The "rose that grew from concrete" is Simon Rodia's Watts Towers. They represent change, hard work, and dedication. More important, however, it is the very people of Watts who represent change, commitment, and community. Taken together, they represent *Nuestro Pueblo*—Our Town.

Works Cited

Goldstone, Bud, and Arloa Paquin Goldstone. 1997. *The Los Angeles Watts Towers*. Los Angeles: Getty Conservation Institute.
Intersections of South Central: People and Placed in Historic and Contemporary Photographs. Los Angeles: Automobile Club of Southern California.
Nicolas, Betty. 2002. *My Blue Heaven*. Chicago: University of Chicago Press.
"Nicolaus Copernicus." 2005. In *Stanford Encyclopedia of Philosophy*. http://www.plato.stanford.edu (accessed January 22, 2009).
O'Donovan, Donald. 2008. "Simon Rodia, Architect of Dreams." http://plato.stanford.edu/search/searcher .py?query=nicolaus+copernicus (accessed December 23, 2008).
The Advancement Project 2007: *Gang Reduction and Youth Development Watts Southeast GRYD Needs Assessment Final Report*. City of Los Angeles, www.lacity.org/major/stellent/groups/ . . . /lacity _004912.pdf (accessed May 22, 2008).
Bean, Walter (1968). California: An interpretive history. Journal of American History, Vol. 55 (3), pp. 662–663.
Shakur, Tupac. 1999. *The Rose That Grew from Concrete*. New York: MTV Books/Pocket Books.
Sides, Josh. 2003. *L.A. City Limits*. Berkeley: University of California Press.
Trueman, Chris. 2000. "Italy in 1900." http://www.historyofnations.net/europe/italy.htm (accessed February 11, 2009),

Personal Reflections on the Watts Towers Common Ground Initiative

Luisa Del Giudice

This afterword is best read as a codicil to both the volume's introduction and to my own essay, "Sabato Rodia's Towers in Watts: Art, Migration, and Italian Imaginaries," allowing me to share some personal reflections on the past decade of involvement with the Watts Towers and its Arts Center. This decade of activity has included both archival and oral research, public programming and academic conference organization (both the conference held at the University of Genova and especially the Watts Towers Common Ground Initiative in Los Angeles 2010–11), as well as the editing of this volume. In reviewing this recent history, I sought to further understand its challenges, goals, and accomplishments and achieve some form of closure in my own mind. Where had my early encounters with the Watts Towers led? What have I learned?

In the late 1980s, I had mapped the Italian community for the city's Cultural Affairs Department Traditional Arts Program (Del Giudice 1990), exploring Los Angeles's many sites, celebrations, and associations, and began presenting its culture and history in public programs throughout the city. This survey eventually formed the basis of an Italian Oral History Institute (the nonprofit I founded and directed for over a decade) collaborative research project and Web site, *Italian Los Angeles: The Italian Resource Guide to Greater Los Angeles* (www.ItalianLosAngeles.org), which went live in 2005 (but is now out of date). Building on these efforts was our simultaneous festival, *Italian Los Angeles: Celebrating Italian Life, Local History, and the Arts in Southern California* (October 19 - December 9, 2005). When in 2003 I began exploring sites and programs for the festival, I vaguely remembered the Watts Towers (a site I had visited decades before as a recently arrived graduate student from Florence, Italy) and proposed a Leo Politi exhibition at the Watts Towers Arts Center, thereby including two iconic Italian cultural "sites" (Politi and Rodia) on the Italian Los Angeles map. It seemed appropriate that so significant a

monument might figure prominently in this context—despite the fact that the Italian community had barely noted it on its own map of the city.

As an oral historian, folklorist, and ethnographer, I was used to making the hidden visible and voicing the unspoken. This festival accompanied the first annual conference of the scholarly organization the American Italian Historical Association (now the Italian American Studies Association) to be held in Southern California: *Speaking Memory: Oral History, Oral Culture, and Italians in America* (cf. Del Giudice 2009b) which the IOHI organized in collaboration with other sponsors. Based on the Los Angeles I was increasingly discovering, it seemed that two "must-haves" were Sabato Rodia (1879–1965) and Leo Politi (1908–1996), a much-loved urban artist and children's book author–illustrator. In the exhibition *Leo Politi: Artist of the Angels* (curated by Ann Stalcup, Paul Politi, and Don Short; see Stalcup 2004), ideally conceived to take place at the Watts Towers Arts Center (WTAC) itself, I especially enjoyed the idea of celebrating two open-hearted local Italian Americans who had embraced a multiethnic and egalitarian society. Politi had actually made multiethnicity a focus of his art (before it became the norm) and showed a penchant for expressions of ethnically costumed festive celebration in a simple, even semi-naïf vein (appropriate to children's literature). Rodia, instead, expressed his open-minded and egalitarian attitudes by choosing to live in Watts and in his expressed notions of social justice and concern for the working man. Both had an especially close rapport with Mexican culture, spoke Spanish, and married Mexican women.[1] Both seemed to show affection for the wider community beyond their own, for a *Nuestro Pueblo* in the broadest sense. Rodia had made this the very name of his artwork. Politi, instead, lived in the historic heart of the city, on Bunker Hill, for thirty years and spent much time on the El Pueblo de Los Angeles Historic Monument plaza (Olvera Street), painting its street scenes in vignettes and murals. Rodia's verbal echo was not likely a casual one, as the name of his monument refers back to the historic Spanish colonial pueblo at the heart of the city (see Appendix A.1, this volume).

It was a revelation—unknown even to Paul Politi, Leo's son—to discover (only *after* the exhibition proposal had been approved) that Leo Politi had himself painted the Towers (see Introduction). We used the Politi Towers painting on the *Italian Los Angeles* festival brochure (see Introduction). Politi had also been directly involved in the Watts Towers Arts Center, early on, helping to paint its exterior wall with brightly colored flowers, together with Lucille Krasne and her art students. The circle seemed complete.[2] The festival also offered the opportunity to begin bringing the ethnographic component back into view, with Joseph Sciorra's lecture on the *Gigli* of Nola and on the cultural connection few, even on the Watts Towers campus itself, seemed to suspect.

My initial engagement with the Towers therefore was ethnically motivated and deeply in tune with my own disciplinary foci. But alongside this professional activity, and intimately entwined with it, was an evolving sense that my life's activities and direction were expanding well beyond, to encompass larger goals of compassionate social action— hence part of my unrelenting pursuit of the goals of the Watts Towers Common Ground Initiative. In retrospect, I realize that I was seeking to tell a fuller story of Rodia's cultural past; focus on the spiritual dimensions of creativity and life purpose (in Rodia, in myself); and work on behalf of a common good. That is, Rodia's face and voice had become very familiar, indeed. But what made him of even greater interest was reconstructing his personal search for a life purpose, meaning, and self-expression, as he put his own

ethnic past and immigrant experiences to work for a greater good, in the service of his immediate community and those well beyond it. The Watts Towers have been used to tell many life stories in its five-decade history, and now mine too was included. Indeed, the Watts Towers came to tell even more of my own peculiar narrative than I could have first imagined: that of a twice-displaced South-Central-Italian immigrant of peasant stock (first to Canada as a post–World War II "economic refugee," later as a graduate student to Los Angeles), as a (first-generation) scholar coming to grips with the oral history and culture of Italian immigrant lives, retelling these personal and collective narratives, and as someone increasingly in tune with "spiritual direction" and the discernment process (Del Giudice 2009a). I suppose I too was seeking to accomplish "something big" in the Watts Towers Common Ground Initiative, which I conceived as an act of peacemaking.

As coordinator of the Common Ground Initiative, in fact, my efforts coincided with an ever increasing alignment of head and heart, which sought to combine academic work and social advocacy efforts, creatively and judiciously. (I would argue that our best work results when following this path.) Thus, facing exposure to all the potential criticism such a stance might invite (e.g., parachuting, patronizing, do-good-ism), I pursued these goals nonetheless, with trepidation at first, trying not to step on too many of the land mines that seemed to go with the territory, but increasingly with confidence, as I listened deeply and learned as I went along. And there was much to learn (e.g., about Los Angeles identity politics, cross-cultural dialogue, and trust). The fact is that while I had always included cross-cultural dialogue in previous Italian Oral History Institute programs, holding it in high esteem, I had never before experienced firsthand a strong black community gathering place such as the WTAC. This context required more careful and deeper listening.[3] I am learning more about the historic roots of this guardedness, as well as how and how *not* to "help." I have also learned, of course, that long-term shared goals and relationships begin with the experience of personal trust—rooted in honesty, respect, fair play, and action—not merely vague intentions. The ice eventually began to thaw. (No less critical, I needed to learn about the sometimes even more bitter *intra*cultural, historically entrenched divides, between Italians and Italian Americans.) I made many discoveries, friends, colleagues (and perhaps some enemies) along that journey. But inspired by Rodia's own obsessive sense of purpose, I, too, felt it was important to persevere—however modest my knowledge, however many my blind spots, however limited my means, however long it took.

What creative contribution was I hoping to make? First, I wanted the Watts Towers recognized and embraced as an important site on an Italian cartography of Los Angeles and as a significant monument built by an immigrant worker's hands. (Currently, I am exploring its candicacy as a UNESCO world heritage site.) Beyond this, I hoped to accomplish some small local act of peacemaking and justice. My form of social action entailed creating a space for speaking and listening hard across many boundaries, to move beyond oppositional rhetoric and entrenched barricades, and to achieve common ground. With the new words of a 2004 UN Commission on the Status of Women meeting in my ears and heart, I also felt compelled to help "repair the world" by "sweeping at our feet" (that is, by acting right here, right now).[4] When the prospect of the 2009 Genova conference appeared on the horizon and I was asked to become involved, a propitious moment of action seemed to have presented itself. I worked relentlessly to make it an occasion for high

synergy combining many local and global concerns—rather than merely a conference of limited academic interest.

One approach was to treat the international Genova conference as a preliminary step toward a longer-term goal of refocusing local (and global) attention back onto the Towers, its Arts Center, and the community. That envisioned larger project was the Watts Towers Common Ground Initiative.[5] Alongside the history of Sabato Rodia, the Towers, and the Arts Center lay the opportunity to address broader social issues and perhaps even contribute something to the fierce debates raging around the issue of migration, social equity, and justice, for example, here and abroad. That is, as economic and political refugees were continuing to migrate in search of hospitable places, we were also witnessing a rising tide of xenophobia—in Europe (which was increasingly becoming a migration destination), no less than in the United States.

Further, pressing issues of the increasing social divides in the city were of equal interest to me, as were the concerns specific to Watts as it continued its own local development efforts. Didn't we all have a stake in protecting the many Watts neighborhoods (with high unemployment and social problems) in our very midst—even those without a monument like the Watts Towers? And to better achieve basic human needs and rights, such as education, health care, employment, and housing—as well as the opportunity to engage in creative self-expression through community arts? How were we nurturing our hidden human treasures and facilitating their emergence? The financial crisis, beginning in 2008, was revealing uglier truths about the growing imbalance between the interests of the few over those of the many, and how the gap between rich and poor was widening. The recession was threatening to destroy communities already out on the outer edges of economic viability, further frustrating their efforts, further marginalizing their participation in civic discourse. In Watts, all of this seemed to be painfully evident. But in great evidence was also the community's marvelous historic resistance, its creative spirit, its ability to overcome.

From the initial meeting around our family's dinner table, where many Watts Towers "stakeholders" gathered to discuss the prospect of the Watts Towers Common Ground Initiative, we waited with bated breath to hear especially from Watts community "insiders" whether this was a feasible or even desirable proposal. When both Timothy and Janine Watkins, bold advocates for development in Watts, helped those assembled around the table face the fears and obstacles that must attend such collaborative efforts, and yet responded "yes," we knew we might be on the right path and could at least try to achieve something together.

The Watts Towers Common Ground Initiative sought to address multiple goals all along the Watts Towers–Watts Towers Arts Center–Watts community continuum. Divergent goals, cultural models, even language, threatened definitive breaks (even among organizers) at times, but we worked beyond these fault lines. The Initiative culminated with a Communal Table that wove a circle around all three, while underscoring the combined needs of body, soul, and mind (or food, community, and art). A beautiful Saint Joseph's Day altar and table, in the Sicilian American tradition (adorned with ritual braided breads, flowers, and art), was created between communities (and with Watts artists) in the African and Latino parish of Saint Lawrence of Brindisi Church in Watts. It was followed by a pageant of "saints" (actual migrants themselves), highlighting the ideals of welcoming the stranger, practicing hospitality, and caring for one another. The Communal

Table also focused on food sustainability through Mudtown Farms and its future community gardening project.

I have been asked, pointedly at times, over the past few years: What was the ultimate goal of the Watts Towers Common Ground Initiative? I knew I disappointed many when I said I did not exactly know. Partly, it was to refocus our attention on Rodia's story and to increasingly promote the Watts Towers as a symbol of transformation, achievement, and generosity, so that they might continue to inspire many. Partly, it was to share a vision of unity and common purpose. I did not know what would come of these efforts. If the Initiative had any merit at all, our elaborately constructed partnerships would withstand our own "stress test." If none of our discussions and programs had true merit, the edifice would crumble, and the idea would have been a minor "blip" in the almost century-long Watts Towers saga, which began in 1921. Ours was, after all, a community-building endeavor, and to be successful, there needed to be those who wanted to remain a part of an expanding community. It is not entirely clear to me what part of this hope will prove to be wishful thinking and what part will prove true.

It would be impossible to ignore the many continental divides within Los Angeles: those determined by socioeconomics, geography, ethnicity, and migration status (Rosie Lee Hooks calls Watts Los Angeles "Mason-Dixon Line"), which stand to be exacerbated during hard financial times. One hopes, however, that adversity may also offer a moment for civic reengagement and compassion, binding us in partnerships within communities and across the city—even as we remain vigilant to imbalances of power and to how we engage across divides of such great poverty (see Appendix D.4, Timothy Watkins's conference paper: " 'Don't Move, Improve!' Watts Labor Community Action Committee, Past and Present"). It appears wisest to listen to and help those in the community already doing the work well and assisting them to accomplish their goals.

In rallying around an icon such as Nuestro Pueblo—one which Mike Davis (author of *Ecology of Fear* and *City of Quartz*) affirms that "ordinary people in the city have embraced as its kind of most profound, most poignant symbol" (Landler and Byer 2006)—we also promote a symbol embedded with many positive values of freedom, trust in our capacity to build, and in community.

From the first moment I heard Rosie Lee Hook's admonition, back in 2005, that "everybody wants a piece of the Watts Towers but few have left anything behind," I began pondering how best to respond. I want to believe that conferences, festivals, and programs to Italy, to promote the Watts Towers and its Arts Center—as well as this publication—might be considered worthy gifts to leave behind. I also wish to believe that we form a continuing part of a historic community, one first rallied by the Committee for Simon Rodia's Towers in Watts. I am heartened in this regard, by the words of Bud Goldstone (*buon'anima*—rest his soul), who addressed the UCLA conference opening session via videotape and who affirmed what we had come together to accomplish in the Watts Towers Common Ground Initiative. Indeed, perhaps we should consider our new "band" of participants to be following in the footsteps of our heroes, as we, a new generation, continue to create community around the Watts Towers. We leave the last word to Bud Goldstone:

> The founders of the initial 1959 group recognized the importance of Sabato Rodia's artwork, but we vastly underestimated the costs for preserving them! When Jeanne Morgan helped the CSRTW sue the city for their earlier neglect, she won a court

judgement of $800,000! But that was about $3M short of what was needed! The original CSRTW members were a great bunch of people, most gave large sums of money and months of their time. Only a few were actually from Rodia's part of town. But they were there, Museum curators, architects, engineers, photographers, musicians, artists, entertainers, writers, poets, singers and more. Thanks to Sam and his team of saviors. Bud Goldstone thanks you for supporting this valuable action by Luisa Del Giudice and her UCLA group for historic preservation!

[Signing off as Bud always ended his emails: Bud Goldstone; OSU, Purdue Aero Engr; AIC Pro. Assoc.-retired; Apollo Engineering, The Los Angeles Watts Towers, publ. by Getty Museum & Conservation Institute; "Secrets of Watts Towers"; SPACES Archives]

Works Cited

Bryan, Robert S. 1967. "Sam Rodia and the Children of Watts." *Westways*, August.

Del Giudice, Luisa. 1990. *Preliminary Survey of Italian Folklife in Los Angeles*. Los Angeles: Folk and Traditional Arts Program, Department of Cultural Affairs. www.ItalianLosAngeles.org

———. 2009a. "Ethnography and Spiritual Direction: Varieties of Listening." In *Rethinking the Sacred*, Proceedings of the Ninth SIEF Conference in Derry 2008, edited by Ulrika Wolf-Knuts, 9–23. Department of Comparative Religion, Åbo Akademi University, Religionsvetenskapliga skrifter.

———, ed. 2009b. *Oral History, Oral Culture, and Italian Americans* (selected papers from the 38th AIHA annual meeting, Los Angeles, 2005). New York: Palgrave Macmillan.

Landler, Edward, and Brad Byer. 2006. *I Build the Tower.* Los Angeles: Bench Movies.

Stalcup, Ann. 2004. *Leo Politi: Artist of the Angeles*. New York, N.Y.: Silver Moon Press.

Conversations with Rodia 1953–1964

A.1. Interview of S. Rodia, with Bill Hale and Ray Wisniewsky

Watts Towers, Watts, California [1953]

Transcription by Mae Babitz and Kate Steinitz. Transcribers' note: "read like prose poetry in Sam's original 'lingo!'; so far unpublished." [I have eliminated quotation marks found in the original transcription.]

Sound recording not found. UCLA Library Special Collections, No. 1388, Box 5, File 5.

[p. 1]

The Towers

Hale: People say peculiar things about the Towers.
They say you drink. They speak of pictures of half nude
girls and of the Towers in the same article.
I want to write the true article about the towers.
I want to get my story straight.
And from where else can I get it, but from you, Sam.

Sam: Yes my Son. What do you mean, They don't like the towers or what?/
Well people could do what they believe/
That is not my business/
What I am talking about/
People are bad or we live long, why the hell . . .

You have got to be hungry . . .[1] I will sing you a song, Son . . .

(Hale interrupts Sam in order to make him answer the reporter's questions)

Hale: Did important people come see Towers?

Sam: Well yes, What's the difference/
All people is the same combination, a collar . . .
catholic . . . no catholic . . . / send in catholic school . . . /

Hale: asks whether he noticed for the first time that all his work look[s]
like ships, when the Lieutenant said it.

Sam: Never thought of it before . . . Schoolteacher said the same thing . . .
(Women['s] voices interfere)

Well when you go . . . (mumbling) you go down
There you are watching / you go down
There you are watching / you go down
You go w[h]ichy [?] / you go /
I bet you go to Hollywood once a week with the machine/
Why don't you look there / You see the tower / line sticking op [up]/

[p. 2]

STEEL/
They get a cable / hold/

One wire here / one wire there / the RADIO TOWER/
Marcon[i]2 inventch [invented]
Marcon inventch [invented] wire Radio, wire telegraph/
No, they no use in Marcon any more / they got a differentche radio/

Girl: Did you name your Towers?

Sam: Yes Maam—it is a name up there—its PIEBLO [PUEBLO]

Girl: All of them?

[p. 3]

Similar to the Towers

... Rome ... He never saw Rome ... Luscher (Luther)
He was German / ... He changed the Bible / ... from Latin/
Seven days they had: / the years, the months they had . . . /
... same in Rome / ... same in England . . . / in New York buildings square . . . /
The Shinesh (Chinese) something like my towers/
Now you see Chinese / look at the Chinese Main Street/
North Broadway Chinese town / small but like my towers/
Eshiptic (Egypt) the same thing . . . they all [mold] it outside . . . /
They take the windows out/
That is because I call them "P[I]EBLO (publo)" [sic] [PUEBLO]

They ask me questions, the people, look around.
My child they know It's all right?

[p. 4]

Down Town Los Angeles

Femal[e] voice asks: What is the name of the Towers?

Sam (mumbling): Well, I told you ... everything on the ground you've got to read/
 When you ... when you ...
 That's the Towers / That's new / One thing that's new
 Lady: you know one thing/
 We had no machines [cars]/3
 When you drive you got to look, Lady/
 Had no horse no buggy one time/
 They had a horse / they had chunk wood tree got off/
 No wheel / It was no wheel on that chunkwood/
 On the buggy no iron on the end/
 That took a people 1,000 miles 18 months/
 Now you go thousand miles / why don't you look around/
 On the side, the stores, business / where they go/
 When I go to city Los Angeles / I no watch a city/
 I no watch a people / all got a same face, some white, some black/

I watche [*sic*] something else / I watch[e] when the business close up/
That means/
That hard time is to come/
It's a seventy 5 businesses hadda close up on Maine Street/
From four weeks ago today / from fifth and Main—fo[u]rth and Main/
From four saloons close up / and two saloons close up a here once/
That means enorme [no one?] come down / No people come/
I don't mean a Robinson store / Sear Roeboek [Roebuck]/
I mean the small potato / That's on the Main street/
They close up/
I go there alo[o]k[e] [to look]/ is no light in there / no more/ [p. 5]
No more light, in the dark/
Business close up/
Two four three months ago / there was light/
Smoke, people a' dancing / throw the cigarette down a' fighting/
That mean they are coming down/

 [p. 6]

Civilization

Well . . . you . . . they people chivilize you:/
Why don't you fixit? why don't you?/
Why you read English / you read Italian/
You read in Piazza/
Who chivilize you? / In / English they tell you/
Why the Greek book, you . . . /

The Greek got chivillized [civilized] from [by] the ETCHIPTESSE (Egyptians)/
You want to say this / In Italian they say Roman took Chivilyzs [civilization] from the Greek/

. . . Why don't you . . . No . . . no . . . /
England took Chivilize from Roman . . . /
50 or 70 years before Christ was born, my son/
That's in English ENTCHICOPEDIA[4] / it's the one printed/
They don't call 'em English people then/
Franch civilized from Roman / Spain chivilized . . . /
They don't call 'em French, / Roman gave name/
They call 'em . . . Spain was called Castille/
Julius Caesar gave 'em this name.

 [p. 7]

The Duke sleeps with the Surf [Serf]

Hale: Surf?

Sam: The Serf, the woman

washing the dishes / scrubbin' the house/
And the cook sleepin' with the Duke's wife/

They had children all mixed up /
The Hell / why you gotta 40% here in Los Angeles/

Babies don't belong to hosbands/
The baby belongs another man/
And the hosband know . . . /
He knows that / but he gotta Baby from another woman/
Another man's wife.

The owner of the bank's wife/
She wants to go to work for the lawyer/
And Lawyer's wife she wants to go to work for the Real Estate man/
And Real estate's wife wants to work for the doc/
They don't need no job/
They have a million dollar home a [Italian: in] Beverly Hill[s]/
They gotta man there working in the garden / all day/
They gotta housekeeper, why the hell she wants to go to work/
—She wants to work, why she not work for the hosband?/

That's the same as the Romans . . . /
And the baby come, some of them throw away/
The *animali* [It.: animals] don't do that / You take a hog/
A dog, horses and mules/ [p. 8]
He never throw away/
And a cat, no matter if she get a dozen/
He want to keep 'em all/
He don't throw away any of 'em/
You go over there—you take a little dog from a female/
You the boss he wants a bite you/

And the human race / the human race/
Civilize people—we through [throw] [a]way baby . . .

 [p. 9]

There is no difference my boy . . .

Sam: There is no difference, my boy/
 It's no difference / if you want a reason/
 No it's no difference from [between]
 Roman / When Roma fell down [i.e., the Fall of Rome]/
 And the United States today./

 I don't know another country/
 If I was there I talk about / 'em / too/
 But I don't know them / There is no difference . . . /

You see when the Romans fell down/
And that's in the United States Library/
It's no bigger books/ . . .

[p. 10]

Hypocrisy

A fellow one time he worked in a church/
Catholic Church / He worked one week/
Then he met the Priest / Then he says:/
(Stuttering) "Please, Father you know I work on[e] week/
Won't you going to pay me?"/
"You no working for me / You working for [the] Jesus . . ."/

He went into a saloon / He gotta bottle of wine/
He gotta half drunk/
Then he shot his hatchet on the floor/
Then said: "My God, he no going to pay me/
I'm gonna, I'm gonna [to] cut his neck off."/

The Priest he was hipocrisy / you know/
Smart man/[5]
He put the bigger . . . bigger Jesus away/
He put the little one, you know / On top of the Platform/
And he went . . . he . . . said:/
Ahh, you smart, sint [since?] you/
You sent your son in there/
No; I can't kill your son/
YOU / the one—gotta—pay me./

You, the father . . . and he went away./
He don't kill 'im, because this was his son./
. . . that's like a monkey,/
I told you / The Brazilian monkey, [p. 11]
Look, when the monkey rests them,
He sent the male / he sent three female/
The monkey . . . on the arm . . . you know/
He could kill 'em, like that . . . /

[p. 12]

I don't blame no younger people . . .

I don't care what younger people are doing / No/
You no wear no hat / you wear no hat / you see/
Why a' hell you see an old man seventy-five/
If I'm no wearing no hat / how the hell/
I blame <u>you</u> no wear, no wear no hat/

I told you again other day:/
Mother iron cloth/
She stand 'a little girl/
Says "Mama I wont [want] 'a iron a cloth too."/
She starts a brooming [sweeping][6] a house/
Little girl say: "Mamma, buy me self lille [little] broom too."/

She start a' play Poker, drink Beer, Wishky, Wine/
Lill 'a girl start too.
Sit down on a table / both o 'em drunk/
Mother and father drink, talk dirty/
Lill 'a girl, lill'e boy he talks dirty/

You go home on a Sunday and Saturday/
Nail [fix] your house, geth a brosh, paint a' windows/
Lill 'a boy says: "Hoo Pappa, paint a' windows/
I want a hammer a nail too./

WHATEVER YOU DO, THE CHILDREN WILL [DO] IT/
I canno' blame the children,/
I canno' blame grand young lady painted [with makeup],/
I blame [on] the mother— /

[p. 13]

Great Men

Luscher [Luther], Martın Luscher,
Rome

Ray's voice:* Marco Polo is the one.

Sam: That's the Man.

Hale: Where was he born? In Genova?

Sam: No, in Venice, (Fenish), All America is discovered from Italian people.
 England . . . He had Giovanni Cabbots (John Cabot) . . .
 was born in Venice . . . discovered New York . . .
 They got York in England, they called it NEW YORK.
 Emilio Gerrio he discovered Canada . . . Amerigo Vespucci he discovered Brasil.
 The Chinese *Montagna* Cicino [?] . . . feet high, biggest mountain
 in the world; 34,000 feet high/
 Then what he is called, / Chile has the second mountain
 18,000 and United States the third Mount Rainier/
 Look at the Chinese / 24,000 high/[7]

Hale: The Chinese were great architects?

Sam: Sure they built the things well, . . . they got the machine . . .
 Minaret (?) I took it off.

*Ray Wisniewsky who was Hale's collaborator at that time.

[p. 14]

Civilization

You call 'em in French / you know what 'at means:/
French people / When Julius Caesar went to Franch / no chivilize/
But they fight like dickens / one of a hardes' battle ever had/
These people they are free / you know what Frank means: FREE,/
That means in Latin Free/
And there you are, my son.

(Mumbling . . .)

I wan' to remember / I wonder when . . . when . . .
Look at the opera in New York / the big opera in New York/
That was Italian man composer / English man writin'/
Shekespeare/
But AIDA, its Etschiptian/
They wan' to respect for that / a good nation/
Bum Nation, they wan' to hyde / They don't wan' to tell-us/
The people in the United States / they don't wan' to tell George Washington
Englishman/
The liberty dishiplin/
They don't want to say that/
They say we are free . . . /

[p. 15]

The Hell of a Joke

She was 28 years old/
she stand on my backyard/
she was lieutenant/
It was Easter morning/
raining too . . . /
looking at them/
All your jobs look like ship./
I have not to go down she said/
Look at the ship/
All she said to me/
"How do you get up there?"/
And I went up on top/
When I stood at the top/
She talked to me./
I don't understand what she said/
Too high up./

Why not come back./
When I come down back to the bottom/
I found 10 . . . 5$ bill
And a little rock on top of the 5$ bill/
"Jesus Christ . . . that's the Hell of a joke"
(this is said in amazement, almost in reverence, the voice lowers
at "hell of a joke")

A.2. Interview with Simon Rodia, by William Hale and Ray Wisniewsky "at the Towers Site, Standing Outside Rodia's House," 1953

Paraphrased Transcription (Excerpts), by Mae Babitz.

Sound recording not found. Jeanne Morgan CSRTW Archives [Also in UCLA Special Collections, No. 1388, Box 5, File 5]

Transcriber's note on Rodia's voice and manner of speaking:

> Sam speaks in a very expressive, expansive voice, dramatizing the word "England" and "all" to denote respect and vastness. Also Sam repeats sounds, like ornamentation on the flow of his thoughts. Bits of sounds and syllables become like mosaics adding pleasing graces to his otherwise very forceful way of speaking.
>
> He is somewhat of an actor and he mimics, becomes sarcastic, sardonic, indignant, wheedling, unctuous, caressing, furious, at times affectionate and sometimes very impatient but always gracious and sociable.
>
> He speaks with a sonorous, rhythmic Italian accent and in the flow of conversation each word has its vowel ending or the singing emphasis of his native tongue. Sam is an artist in his speech, composer of sounds, volumes of texture, color and intensity—palimpsest of his life.

Rodia shows his tools, trowels, jacks, the bars he bends into shape (reinforcing rods), a bedstead he plastered over with tile but had to tear down because it rusts. Used galvanized iron wire after that; saved broken tile he tore off the bedstead. Shows a knife, plumbs (plumb bobs probably).

Says he never used the little plumb bobs, used window sash weights instead. Got the idea from watching workmen at City Hall at time it was built.[1] Philosophizes on little things holding up the work. Couldn't find the little plumb bobs. Sash weights bigger.

Clothes. More clothes than any man in L.A. Some you can't patch. Including the one he has on, patched in several places. Some practically new, but never wears them. Because you can't patch. Demonstrates on Bill's clothes. Tore off buttons on one coat because *that's* what costs. Dusts off chair for Julie.

Never throws anything away. Sells it. Sash weights, jacks, etc. Sells to junkman. No more use for them.

Twenty years ago used to have 30 people here every night. Now nobody. Why? They get high class. Shows dishes for 30 and many chairs.

Inside the house a postcard on the wall captioned "Patriotism in Stone. Dickeyville, Wisconsin. 2—31." A photo of Sam's work. Catholic monument,[2] in typical Rodia technique: stone, cement and tile.

Rodia says: "Jobs I did in Wisconsin: Was a Catholic but not now. To tell you the truth I don't believe in no religion. Material free. Designed it himself. Used to design flower pots at home with wire around and shells (only for presents, never sold) and used to bring to boss's wife for present." Thus he got the Dickeyville monument job.

Used to make cement tables with concealed money vault—"a hider." Fireproof. At Long Beach. Look for hider here. No took it off. I used to have a hider here. To hide my

money. Make it, throw it away, what the hell I want (with money?). [Lived in Long Beach for 3[–]5 years before he came to Watts.]

Look, my son, I don't care if I die. Pope, he don't believe in a God. Because he know when he die he gonna go to Heaven. Heaven. Why does he call doctor, if he believe in Heaven? Why he should be happen (happy?) when he die. (Compares Pope to leader of Army who is happy to die first.)

Hale: Do you believe you'll go to Heaven?

Rodia: I can't tell about that. When you go, you go in a different way. (Refers to story of "God, why don't you defend me?")

Rodia speaks about a recent article about the towers which used the name, "Nuestro Pueblo." "I told him I want to do something for the United States. Invite people, notify. I drank, sure, but no wino. I no told him that. They not put in what you want. Only what they want."

Bill recalls: 1. brother killed. 2. doesn't hate millionaires. They provide jobs. Hates the middle class that does its own work. 3. Invites Hale to come in back gate now. "You don't have to come in front. Just reach over. You my friends. 4. Big themes. Religion. War and peace. Jobs. People in past. Rejections.

"Giordano Bruno. He told the world we got millions, millions biggest (than the) earth. You see the stars . . ."

"This lumber they don't sell 'em by the foot; they sell 'em by the pound—red cedar, come from Wisconsin."

"General foreman in Poland [?] Plane Mille[r] in West Long Beach, near seaside. Hospital. 1914–15–16–17. While in Army. McClune's (?) son went broke. Was a farmer once. Contracted big. 1892. Went broke on job."

"New style sidewalk. Someday people will be walking on 'em all over world. New York, no. San Francisco, no. Ask your mother, father."

Brother's death, killed in mine. Minnesota? Minor arsonist. Burned 3 homes during depression. Collect insurance? Kind of joking reference by Sam.

State refunds his money sunk into Towers. $3,600. Also power, etc. given free. Working arrangements to bend on railroad tracks. Walks with a wheelbarrow about two miles to Firestone (auto supplies, like Sears) to buy cement to avoid a delivery charge, exorbitant.

How Rodia colors selected? He doesn't understand himself. Tile-setters do it that way. Tries to use the best materials. He wants it to last.

Outside the house the interviewers ask about the bowling ball, but Rodia doesn't remember who gave it to him. Design of peacock, etc. [at the entry to the house] given completely by a man from San Francisco. No foliage was planted near there so the tiles could be easily seen, in case the man ever came back. Once had a tree in the center of "patio" part of the architecture. Too much trouble to maintain. Also it disturbed him because some people came to look at the foliage, not at the towers.

He shuts himself up in his room and listens to his records for hours sometimes. He used to read a lot, but the doctor says no. He read the *Encyclopedia Britannica* from beginning to end. Once preacher.

[It is not certain that Rodia can read. He said to Mae Babitz in an interview when she visited him in Martinez, "Yes, lady, you can read and read but somebody got to 'splain it to you . . ." —Jeanne Morgan]

Question from a couple [articles] from the *Times-Picayune,* New Orleans: You say slavery is still here. Any hope of change?

Rodia: I think the world always be that way. Sometimes the nation will change but always come back. (Refers to Rome again.) Tom Paine, Franklin, Jack London, Buffalo Bill [and great Americans]. He got 6 states for the United States. For me, for you, for the United States: Idaho, Iowa, Nebraska, Montana, Utah, Nevada. He got 'em while General Sherman sat on a chair in Washington. I know Buffalo Bill. I talk to him. I'm in Denver. In Seattle. He was [one of the great men of the United States.] He got you 6 states. Seven days after Buffalo Bill got Wyoming there was a little river back of Cheyenne. Indians there. We don't want Indians to dress up like that, General Sherman says. Buffalo Bill says let them dress the way they want. Buffalo Bill died of syphilis. Poor. A Good Man. Great. That man shoulda had a billion dollars in gold. You only got 6 great men in the United States. You had a lotta great men in this country. But not now.

Rodia never bathes; he washes with rubbing alcohol every other day. He is scared of water; says his sister died four days after taking a bath.

He grins with a pleased smile after a point is well made. Sam is all pointed: ears, nose, corners of his mouth.

Rodia says it's OK for young unmarried girls to paint their lips to get a husband. But not OK for the married woman; They already got theirs.

He describes the towers as being 104, 102 and 52 feet high. The 102 tower was made to lean like the Leaning Tower of Pisa. It leans both ways, inside the tower. But it didn't work. So he made the outside layers straight. Was going to build the largest tower in the world, but he didn't have enough dough to do it.

In Lansing, Michigan, 1906 he worked in a stone quarry. First time to church (Nazareth). He only knew 15 words of English. Girl took him, met her in a boardinghouse. He looked at the pages, opened his mouth, but didn't sing. She turned the pages for him.

"Young nation she's a children. Old nation she's a [?]. Bible says something about put away childish things. When a child speak as a child, when a man speak as a man."

Rodia says materials here in America are cheap. He resents that. Rome quality is his quality. Spaghetti, glass, [marble,] cheese.

On the ship of Marco Polo, lady watching. Sat, never asked questions. She made him nervous. Told her to go see Marco Polo ship. She said the whole thing is like a ship. I don't have to go see it. In pointing out the resemblance she said highest towers in rear, smallest in front, middle widest.

She asked how he got up. He showed her. When he came down she was gone. She had left a five dollar bill under a rock. Made him mad. Didn't want to take it. Felt bad. Arabia, contribution of people in past.

Towers as representative of all the cultures; "all the people." All who contribute to our whole world. All his work is in dedication to people—Chinese ceramics are a bow to the Chinese. Japanese things to the Japanese. Italian marble. Roman symbols. Lot of this he dedicates to the Romans. But some of this is bad. Good and bad in all.

Chose the site for a reason: not so much to live, but where the towers could be seen, and since industry couldn't very well build there (didn't say exactly why) this was it.

MUSSOLINI: (Another one, not *the* Mussolini) who killed 30 of his relatives. One during a game of mat[t]o (fingers) [*morra*].

Lived in Long Beach for 3–5 years before coming here.

At first didn't like the English / who didn't / But does now. Called them Johnnie Bulls. Killed them like dogs. Though then even he saw the cruelty. Didn't say exactly why the English were resented. Liked England now because it keeps the US from getting too big, strong, imperialistic.

Everybody hoarded during the war: shoes, soap. Because during the war some big shot executive asked him to carry two cans of gas out to his car. Contraband. Rationed. Warned to be real careful. Says this situation was bad. Rationing only for poor people. People with money got anything.

A.3. Conversation with Sam Rodia, by Mae Babitz and Jeanne Morgan

Martinez, California, September, 1960

Six-page report. Handwritten note: "For Bill [Cartwright] who made this possible" [signed] Jeanne Morgan

[This text integrates the report from the Jeanne Morgan Archive with a variant in UCLA Library Special Collections, No. 1388, Box 1, File 1.]

Visit to Simon Rodia in Martinez, Calif. During September, 1960

TO: Committee for Simon Rodia's Towers in Watts
FROM: Jeanne Morgan
RE: Report of conversation with Rodia, September, 1960, Martinez, CA

We flew up to San Francisco from Los Angeles, got a rented car and drove through the freeway mazes toward Rodia's town, Martinez, carrying our messages and gifts from the Committee for L.A.'s prodigal artist. Rodia has lived up here near his relatives for six years; the Committee has only recently found him and made contact. Martinez seems to be a semi-rural enclave in the perimeter of San Francisco, about 30 miles northeast of Oakland. The Benicia Ferry and the old John Muir House represent its sole distinctions. Its quietness and village-like character was emphasized by a young lady riding a palomino mare casually down a main street in mid-afternoon on this Saturday.

With no address for Rodia we drove around the wrong side of the tracks looking for him in the streets. We knew that he might be walking about, as his daily habit had been described to us. And we did, in fact, first see him on a corner, standing in the sunshine hatless, wearing a ragged gray sweater. From a distance we both said, "That must be Sam." I had never seen him and found myself remarking, "Maybe it isn't. That's not such an old man. He's standing up awfully straight." I was not prepared for such vigor in a man who is evidently 83 years old.

We pulled our rented car around the corner, hoping he would not see its embarrassingly red, 1960 contours. We had been told how much Rodia dislikes ostentation, commercialism, modern values. Mae got out and walked across the streets and spoke to Sam while I completed the necessary wardrobe changes. We removed our lipstick and put on our flat shoes which we had brought along, because Sam doesn't care for the American custom of decorated women.

Carrying my serigraph called, "Rodia's Front Wall," I joined Mae and Sam; with this print as an opener we were able to offer him a gift and initiate a warm beginning. Standing in the street we talked to this short, wiry man with his baggy pants, brown canvas shoes, old gray sweater with the pockets cut off and evidences of crude mending with twine around the buttonholes. Sam's hair is sparse and upstanding on the top of his head where it is cut short in a manner suggesting a homemade haircut. Sam's face is brownly weather beaten and his smile reveals a row of bottom teeth very greatly deteriorated. His eyes must be dimming, for the milky white rings of age appear around the iris. In spite of all this, Sam's vivid, smiling face suggests a man of 65 not 83.

Sam's hands are remarkable: huge, tough, brown, thick. The ends of the fingers are tapered, while the length of the fingers is actually muscular; something I have never

seen before. Sam appears to be only a vivid, mobile face and a pair of giant brown hands attached to a ragged little body. As we gave him our gifts he turned to us insistently, saying, "Come with me. Come with me, I have something to give you." He led us to a two-storey frame building, very old in its basic parts but newly fronted with a stone facade for two dental offices. As he opened a side door we followed him up a rather wide, shallow flight of old wooden stairs, through a dark hallway with an old fashioned bureau and mirror at the top of the stairs. Down the hall we passed the clean barren community kitchen of the home for old men.

Sam said the house was old and rickety. He led us down the hall and said, "Watch." He began jumping up and down as energetically as a teenager, making the walls and floors, the whole building, shake and shudder.

Sam showed us his two rooms, across the hall from each other, one for sleeping, the other a kitchen. The kitchen he opened and entered, inviting us to join him. He set a chair, brought another, and ran across the hall to return with a clean dish towel and a piece of fine, spotless, ragged white linen. These white cloths he spread carefully on the chair seats and invited us to be seated. He stood between us by his bureau, with his back to the bare curtainless window.

The narrowness of the room was clearly evidenced by our positions. Both Mae and I were sitting against opposite walls, yet had we extended our hands we could have clasped them.

The room contained a hot plate (the open flame burning), a table, 3 or 4 well seasoned pots, a sink, the bureau and our two chairs. On the floor a cardboard box held 9 cans of lima beans and chile con carne.

With a little amusement Sam pointed out the overhead light fixture on a rather high ceiling. He had lowered the bulb by the novel device of interlocking sockets (probably from the hardware store). In this way the bulb was perhaps as much as 18 inches lower than originally.

On the south wall were hung in a careful pattern, four hats. On the west wall, two hats. On the east wall, carefully nailed with 4 or 5 nails on each side, was Mae's print of the Towers.

As we sat in our careful chairs Sam, the host, now repeated that he had something to give us. He opened the top bureau drawer and revealed a loose scatter of pennies, three or four dollar bills and a five dollar bill. He thrust the five dollar bill into our hands and insisted vehemently that we take it. We, of course, refused, and the flurry of conversation was transformed into other avenues while we quietly put the money on the table under a page of paper.

Sam's conversation I cannot record in sequence. Let me merely try to reconstruct as many points as possible, without regard to sequence or coherence.

Sam is obsessed with a sense of decadence and corruption in contemporary life. Although he does not use these terms, this is the substance of his feelings. It is as though his mind refuses to release the significances he has built for the things he has observed. His mind is like a rat terrier, biting and shaking its victim to death. And Sam has many areas of bitter feeling.

Sam speaks of "the grandmother with the painted mouth, the painted toenails, the short pants, the women who laugh at the husband, the girl who smokes a cigarette, the television looker who sends the little kid out for a hotdog."

Sam speaks of the unions and having to pay $75 to get a union card. He quotes amounts of taxes: four cents here, seventeen cents there. Sam like Charles the Fifth ("Carlos Five" candy bars) and seems to think that those were the good old days in history. He says, "People came to the New World and took it away from the copper people." He spoke of Alexander the Great, and Marco Polo and the Greeks, saying the Greeks were the first civilized people. Sam ranted on the decadence, "dancing, drinking, falling down of Greece and Rome" and insisted that "this country is going that way."

He describes his family as his niece (Virginia Calicura Sullivan) and her husband; other relatives in Guatemala, in Vermont (perhaps), in Green River, Wyoming. Someone in his family has a nine-year-old son who was born in Japan. As he talked about this child, Sam sang a fragment of a lullaby in a quick and supple melody.

Sam loved and admired his older brother, Frank (?), who was killed by dynamite long ago, perhaps in New York or Pennsylvania. Of this beloved brother Sam said, "He tell me many things. From him I learn many, many things." He was born in a village in Italy called Serena [Serino]. Sam knows about the Leaning Tower of Pisa and said that he had planned to make one of his towers lean like that but he changed his mind [...] after he got it partly finished.

He must have been in California in the early nineteen-hundreds, for he speaks of "working with Jack London, over there, (gesturing toward San Francisco) on the brick buildings at the school over in Berkeley." When we asked if he has anyone with whom he can speak Italian, Sam said, in effect: They don't want to speak it anymore and if they did they would have nothing to say.

Sam tells, with pain and anger, how everybody insists that it's a new world. He seems to be quoting his niece or nephew. He says it is "not a new world. Not new." Man is the same. Man has steel and trains and movie pictures but man is still the same. One could almost hear the family arguments clashing against his stubborn, thinking mind.

Sam is thinking of death. He described the death of an old man in the neighborhood— "died like an animal on the street. They come with a canvas and roll him up and take him away. No friend. Nobody. Used to be the child died in its mother's arms. Sam made a tender cradling gesture looking down into the hollow of his roundly bent arms. Here he said a word or two about being alone. Dying alone. I felt a sense of unspoken, desperate clinging to a town where at least a niece is aware of his life and his being-ness. It occurs to me only now that Sam gave us an opening to ask about his past personal life. At one point he said, "Cannot marry more, right? Can marry only one. Is not true? Once you marry, only once, no?" We agreed, but failed to ask about his own marriage, if any. Sam talks in a most animated way with his emotional face and his great hands gesturing and dancing. He cries, "Read a history book! Get a book, read about the history of the world!"

Rodia says this country is lost. People used to be good, but in the last 10, 15 years it's "bad everywhere." Left Los Angeles because it was nothing but no good people. Now up here it's the same thing. Same thing all over the country—all over the world. He said: Think about what Abraham Lincoln did for the colored people. And Lincoln was killed in the last. Killed for nothing. This theme of the great man persecuted and unappreciated was offered as a response when we spoke about the Towers. Sam spoke of Christopher Columbus dying in chains, of Galileo brought to nothing—and one felt a sense of Sam's image of himself as a man whose life has been for naught, a man who will die

alone, unappreciated. A man who has accomplished something of the greatest merit, but he alone knows this. When we explained in every way that we could that the Towers are loved and appreciated by thousands of people all over the world, that Bill Cartwright and Nick King had bought them and fought bravely against the City, and saved them, Rodia seemed genuinely impressed. When we told him that a hundred people go to the Towers every week to enjoy and admire them, he seemed surprised and pleased. When we explained that the Towers would stand, would not be torn down, he showed cautious pleasure, even though he then spoke of "the bombs, tear down everything."

We felt that the information we were trying to convey to him offered his first chance to understand the new situation with the Towers. He seemed surprised and very pleased with the idea that the Towers were going to endure and his life's work was becoming known and loved. Yet when we asked Sam to come to Los Angeles for a visit he became quite excited and distressed: "No, I won't go back there. I break my heart there. Walking, 20, 40 miles from Redondo Beach, walking everywhere getting things . . . No Sunday, no holiday, no Christmas for 25 years! One week I buy cement, next week I buy iron, every week use all my money buy things to keep working, keep working!" As though he had wasted his manhood. "Better to take the money and go to travel. Go to Canada. Go to Guatemala, back to old country. Enjoy."

Evidently before he started the Towers (before 1921?) Sam worked for MacNeil Construction Company. It seems he knew MacNeil personally and he went to talk with MacNeil. The reason for this was not clear, but somehow this incident was connected with Sam's remarks on the way he began building the Towers. He spoke of the time before he began the Towers as a time of violence and unhappiness: "lot of drinking, go to bars, have fights . . ." He seemed to imply that this stopped when he began building the Towers. Surely the energy Sam expended on the Towers must have been evident in some form before he began directing it to the construction of Nuestro Pueblo. Sam said, when we spoke of the Towers, "People go through life, make many mistakes. I make a very big mistake. Bad mistake." We asked about this. It was shrouded. Sam's pale eyes looked into the distance at something invisible and he said softly, "Cannot say, cannot say."

This same phenomenon occurred when he talked about his money situation. At first he wouldn't tell us about how he lived. He spoke of having moved from some place across town where he paid $48 a month for "two little rooms, little shack." He said "hard to live on $77 a month." He mentioned being in "the war 1918" and implied that his income comes to him as a veteran. We asked about a pension, using the term, "old age pension." Sam was hostile to this and said, "No, don't want it. Not take any money like that. No government money like that." "When we asked why, he again paused with a faraway look, and said, "Cannot say, cannot say," as though he were really talking to an inner self, really did not understand that self, and did not know why it felt this way.

When we asked Sam if he would like some materials to work with, some means to make something again, he was quick to insist that he had the right to NOT work. "Over 65, don't have to work." We're not certain that he understood that we meant creative work. But then, why should he distinguish between the hard physical labor or hod-carrying and the hard labor of architectural sculpture. He also spoke of physical infirmities: "hand shakes. Sometimes in night wake up and can't get breath."

When Sam looked at Clarence John Laughlin's photographs of the Towers brought by Mae, we pointed out the words Nuestro Pueblo, where Sam had tiled them on the Center

Tower. Sam said, "Meansa many things, means lots of different things." The word "pueblo," as a matter of fact, is used in the Chicano community to mean group, clan, people, community as well as town.

Looking at the photo of the "fountain" inside the Towers, Sam said that he had put a copper pipe inside and that it once truly "was a fountain, had water yes." Sam would not expatiate on the Towers themselves. All his comments were brief and fragmentary on this subject. His expression and tone of voice at these moments seemed gentle, tender, more quiet than at any other time in our discussion. For example, we offered the money from the Committee, saying it was a gift to the artist, Rodia, a present from the Towers. Sam said he didn't make the Towers for money. "No money. Let it be for a sentimental."

In the end we realized that this feeling and the courtesies and manners of Sam's culture made it impossible for him to extend his hand and say any words of agreement to take the Committee's gift of money. Through warmth and expressions of love and regard we finally established enough confidence so that Mae could actually place the money in his hand and close his fingers around it. At this point he said, "What I do with it? What I do?" We said that he should do anything at all that he wished—buy ice cream for the children, use it as he pleased.

Sam embraced us, kissed us on the cheeks, hugged us and shook our hands and then Mae and I left, quickly.

<p style="text-align:center">* * * * *</p>

We spent the next two hours in the streets of Martinez trying to think of, and trying to find, a few gifts which would be particularly appropriate for Sam. We returned and took him some picture postcards of historical events he had referred to: Columbus' first landing, the Pilgrim fathers, Abraham Lincoln splitting logs. We took a harmonica so that he might make a bit of music in his lonely evenings. We took a green potted plant so that he could see something living and growing in his bleak room. Mae had brought along a black Oaxaca bird and a series of little Mexican cards with birds made from brilliant feathers. When we returned with these gifts Sam had gone out, but the manager of this old men's rooming house opened the door for us. This manager was a sort of alcohol-dried man of perhaps 40.

We placed our gifts in a kind of Christmas tree arrangement around the green plant and then we left. As we passed the manager's door he told us Sam "always eats supper in his room" and that most of the men there were sick a lot. But not Sam. Sam was "a cantankerous old coot."

<p style="text-align:center">* * * * *</p>

We wanted to find some local aesthetic force or authority capable of comprehending Rodia's achievement and providing some admiration and support directly to him by occasional visits more frequent than we could make from Los Angeles. We also needed such a person to link with the Committee in L.A. so we might "keep in touch" with Sam's welfare from afar. Without the possibility of phoning Rodia or exchanging letters we were too isolated and could not exercise our concern for him.

Therefore we left Martinez only after asking the teenagers on the streets for the name of their local high school art teacher. With great good luck we found her name in one of the many regional phone books and we were invited to visit her. Fortunately, she had read about the Towers in *Arts and Architecture*. She was very friendly, agreeing to be a kind of local liaison between the Committee and Rodia, if we should need a person to take food or money to him.

[JSM's NOTE: At this time we did not know that Rodia's niece and nephew ran a grocery store where Rodia could pick up whatever food he wished, if his pride permitted him to do so. We urge the Committee's Board of Directors to develop more ways of informing Rodia of his international fame and appreciation and reassuring him that his work is standing in Watts, guarded and monitored by the Committee formed to preserve his aesthetic message to the world. He is not long for this world and deserves as much satisfaction as we can give him.]

Jeanne S. Morgan
October 17, 1960

A.4. Interviews with S. Rodia, by Ed Farrell, Jody Farrell, Bud Goldstone, and Seymour Rosen

Part A: Martinez, California, October 17, 1961
Part B: Berkeley, California, October 17, 1961

Digitized recording (Part 2 of 1:13:27; for Part 1, see Appendix A.11). Part A, 55:28 made from Irish 3″ magnetic tape. Part B, 12:51, made from Brand Five 5″ magnetic tape. UCLA Library Special Collections, No. 1388, Box 5, File 1. Transcription by Luisa Del Giudice.

Part A (55:28)

... [Knock on Rodia's door, man's voice] Sam ... Sam, they want to see ya'.

Ed Farrell: Hello, we came from Los Angeles to see you. We're from [SR: sit down ...] My name is Ed Farrell, and this is Seymour Rosen.

Sam Rodia: I'm glad to meet you.

EF: Uh huh. We're very grateful. We're from the Towers Committee down there, you know, and other people have come to see you, Mrs. Babitz. You remember talking with her. [SR: yes] And other people from time to time. So, whenever we get up this way we like to come in and say hello, and to see you. Hey, Tiny, was here a couple of months ago, a short woman ...

SR: Yes, well ... it's a hard, it's a hard. You see, the United States change, like Roman and Greek. You see we got one of the old ... nation in the world, that'sa Greek. I'm no Greek. [... uh huh]

EF: They were great people, the Greeks.

SR: Well, no, I mean the United States in the danger. Maybe no gonna be United States ten years from [now] ... if a people keep a goin' like this. Maybe hundred years. There ain't goin' be United States, son. I been every[where in] ... America. You've got to call it. See, I came ... you see, when the Roman went on, they don't call them Italians in the Bible.

EF: What did they call them?

SR: You know what they call 'em, if you read the Bible. They call 'em Roman. [EF: They were from Rome, yeah]. They no say: Italian Catholic, they say Roman Catholic, if you believe on a God. And how they goin' to believe a God when people of today, when you go to church [up here, the nails painted].

Seymour Rosen: Don't you think it's getting better now, Sam? Is it getting any better?

SR: No, that's all right. It's OK for me. Because. Dear son, life no made the right.

EF: You know, Sam, we saw a beautiful film about your Towers at the university over here and Seymour has also made some color pictures of your Towers which will be shown on the screen there and we wonder if you would like to come over there. Would you be interested in seeing them tonight?

SR: Yes, son.

EF: Would you? Wonderful. Would you like to come?

SR: Come on Los Angeles?

EF: No, over at the school, the university in Berkeley. There will be a showing of these things there.

SR: Today?

EF: I wonder if you would like to come tonight?

SR: Tonight?

EF: Uh huh. Wonderful. Good.

Seymour Rosen: Sam, would you mind if I took some pictures? Thank you very much.

EF: I'd also, if you don't mind, put on a record some of your talking, is that OK? . . . That's my wife, Jody and Bud Goldstone . . . We were just talking to Sam about coming. [Bud: Wonderful, that's wonderful.] Did we interrupt your lunch? Were you eating your lunch?

SR: Oh, that's OK.

EF: I saw a picture of you a long time ago.

[Break]

SR: Panama, Columbia, Argentina, I mean, I been a workin' . . . Colored people; I been to Canada, no colored people in Canada. [US] Closed to white people, open to Japanese people [referring to immigration quotas?]. Mixed marriages, why don't they stop it. . . . Today the United States in danger, watch out. . . . You can't find a room to sleep in Los Angeles . . . They got money to buy car, but no money to buy a home . . . baby girl, baby boy . . . $5,000 for a car: how does a working man afford that? You've got 18,000 machines [cars], only 19,700 people in the town, and you pay rent.

EF: Birdbaths . . . in Martinez, long ago, do you remember doing that? What year?

SR: Don't know.

EF: Did you make other things in other places?

SR: Well, I'll tell you what I build the towers for . . . I never lost one day work; all in spare time . . . I read a book . . . Today, people no read no book anymore.

EF: What was this book, on Vienna? . . .

SR: Machines for mailmen?! Who's going to pay for that? That's what the taxes . . . too many! Why don't they buy machine for policemen . . . how they supposed to? . . . 64 years ago, for a policeman . . . Who's going to pay that? People's fault, because people [is] the government. . . . He made women goin' on the saloon and maybe they bring children, baby girl, baby boy—on the saloon—7, 8, 10 years old! She's talkin' dirty, whatever the mother and father do, the children do it. . . . 1,800 men here in Martinez out of work . . . puttin' woman on the work. Woman no made for workin'. She made for home.

Seymour Rosen: Most of them do now, they work, yeah.

SR: Well, the government doin' that! Then she lay off, and he's got to hire another woman to teach 'em how to do the work, all over . . . I don't blame the people what they do. I blame a government. . . . When I came, 11,000,000 in the U.S.; in New York 400,000. We had no free[way], no machine, no highway, roads. Now someone built the railway. . . .

We all make mistake, you know. . . . Abraham Lincoln, he want to free the colored people. . . . 64 years old, shot 'em on the back. Christopher Columbus, he die with a chain on the leg, chain on the arm, 66. . . . New land, new land . . . we all make mistake.

Poor class people today, they blind. When the man lookin' for the job, he no free, and they thinkin' they free. Working for company, everyone has a $100, $150 watch—clock. You can't go eat before they blow the whistle; in the night you can't quit . . . Paying rent . . .

Seymour Rosen: Why [are] rents so high, Sam?

SR: To buy machines ... government ... policeman supposed to walkin', mailman walkin' ... and teachers have 3 months vacation, and who's going to pay? One time you was free in the United States. Look my dear child, I like people be wise. Today, you can't park your machine on your own property ... you own sidewalk! One time you were free. I had a machine in Alameda, Long Beach. You no need ... you can park wherever you want. LA different—you got to have a license for dog ... for everything! You park your machine, you find a ticket! ... won't sell house to the colored people!

Jody Farrell: That's wrong.

SR: You've got lotsa places like that! And they thinkin' they free! ... When man lookin' for job, he no free.

[Bud Goldstone arranges to pick Rodia up at 7:30 p.m. Offers dinner before that. Rodia says that he will wash up and will wait for Goldstone at corner. Bud explains how he, as engineer, saved the towers, by proving they were safe, and that they were all so very interested in keeping them.]

SR: Government won't give you no pension! People supporting government. You are paying pension ... taxes ... It's not the government giving pension! Country is no more free! [mentions all the presidents: Roosevelt, Wilson, etc.] Three classes: $60,000 [break-off point] and up to get out of poor.

BG: We're in the poor class ... not even close!

SR: [Talks about taxes] U.S. didn't have millionaires; Germany, England yes. We have poor classes, can't send kids to college; they go to the army, before President Wilson. Why don't college boys don't go to army? Why do you want to send to college [he tells his family]? Well, I don't want my grandson to go to the army. Because college costs money. Wilson started 10% income tax, stopped immigration, stopped white people, but not Japanese, Chinese people. Hollywood, different: poor, no car almost 100%. Been there ... rich man and poor man.

When I was in army, General Miller ... I no went in army. [In] 1917, they sent me to Texas ... Spanish flu ... run elevator, shovel coal (I got a license for that). I used to go out at night, and he say: [until] 9:00 or 10:00. I needed to get up at 4:00 or 5:00 [a.m.] to shovel coal in boiler room. Hundreds of soldiers died every day. [Miller said:] "What you go out for? Look, you're not making much. If you go out and have one dollar on your pocket, you spend ten cents here ten there, you put your hand in your pocket, and your dollar's gone." Today, people are crazy. Work hard and throw money away, poor ... money's ... wife has no business with pants, and the dress ... she wants pants ... has no business to spend five cents here and there. I don't care what the people say.

When you're looking for job, you have to say: "Please, you got a job for me [pleading voice]"? Painters, truck drivers, carpenters ... got to join: $74 to join, $5/month. You have children, got to buy milk for children. You ain't got $74 [for union dues], you can't get the job. Tell me what you gonna do? Boss can't hire you.

[Seymour Rosen wants Rodia to look through his pictures and explain details, for example, "fish ... water"]

SR: A little book, *LA Times*, $2.80! Called the "Pieblo" [Pueblo] book ... book about the Towers, Los Angeles. I buy 'em. [He bought five of them, to give away, then they stopped printing them.]

BG: I have that book.

[SR is especially impressed that it says "the tower a build without a scaffold"]

BG: When they did the test they had to *build* scaffolding!"

SR: They thought I was crazy because I built the tower without a scaffold. You can't build a *house* without a scaffold.

One of the interviewers: [Note that there is no decoration on back wall.] Were you going to decorate it by railway?

SR: No [no decoration], not on the back. Steel under the cement, no foundation, but with rail . . . U.S. law don't lend any money . . . Bank of United States pay for land, but not for house, if you don't got foundation—got to have foundation.

[Likes picture.] Hundred pictures in there . . . I wasn't drinkin' . . . I don't blame what you do, what I'ma doing. I don't care, but I mean the old people, they change . . . 80, 90 year old; woman she change. A young lady, I doubt she change [but] old man 75, change.

[Talks about Charles Darwin] Canadian, born in Canada, says: whatever the mother and father do, the children do it.

There's no more artist in the United States. I just went a picture show Los Angeles, every night. The night time when I so busy, I no go no more . . . Don't make 'em anymore . . . [BD: dirty, yeah] We've got children, 'scusa me! . . . Man lookin' for a job and he think he free. He no free. [repeating himself]. $5,000 for a machine, they comin' in . . . 5 radios . . . an old lady, everyone has their own radio. Too baby girl radio. Too baby boy radio. They poor, son . . . Because . . . 10 year-old girl smokin' a cigarette . . . learned from grandma, grandpa. Grandma throw it down, money: eat, home, sleep. . . . The book say I build the tower because I quit drinkin' and smokin— all money thrown away. . . .

[Laments nudity in films] Once they didn't allow that! They want to ruin the people. I don't blame a people. I blame the government. He's doin' it. [repeats complaint about hiring women, training them, then having to hire and train another.]

[They offer him all the photographs, "we took them so you could have them," but he says: "no, no, no"; he just wants one.]

SR: God or no God can't prove it. I'm no against God. I told you before . . . Mary, Christ . . . no steel no haircut . . . had a blanket [headscarf] on the head. . . . Copper, steel, glasses—no light, no automobile, no picture, no machine, no astronomy. Goin' to be a *tor[re]* [Italian, "tower"] of Babel. . . . United States, I don't care. It's a regular Babel. . . .

[Tells that when he was 22 years old, he smoked cigarettes, and his older brother smoked a pipe. He hid the fact that he smoked from his brother—that is, even though he was of age, he still thought it wrong.] And now, 10-year-old girls smokin' with grandma . . . and no more nothing.

Picture show . . . people were good. I saw Jesus a million time. They don't make [movies like] that no more. Every picture they make is dirty. They want to dirty the people. Government's fault; he done it. You go Los Angeles, workin' class people, it's too dangerous. It's too dangerous here now. . . .

Thank you, young lady, happy to see you. Goodbye, son.

[Bud invites others to come along at 7:30 that night, while Sam continues his laments: "7–8 men share one restroom." Goodbyes.]

SR: Oh, I like children!

Jody Farrell: I got five.

SR: You got five? Good! [JF gives Rodia a picture of her children, and he is very happy to have it.]

* * * * *

Part B (12:51)

[Poor sound. In car returning from the program at the University of California, Berkeley.]

SR: . . . Sister lives in the family way . . . they don't do that anymore [i.e., living with one's family in old age]. I pay $29/month, nearly $2,000 . . . why not . . . In 1949, when you die, you die on your daughter arm, on son arm: "goodbye son, goodbye." Now, put him in the hospital! What do you know if they choke him? We don't want that! Nobody say nothing.

EF: Would you like to stay here or would you like to come down to Los Angeles?

SR: Well, no . . . I no go no place anymore.

EF: Wouldn't you like to visit some of your friends in LA?

SR: I told you before. I like Canada better than the United States. Canada took 'em away from the French. Canada was French. French Canadian. Never make any . . . Never make any change. United States make thousand change.

EF: Have you been to Canada?

SR: Oh yes, all over. I been . . . Porto Filippo,[1] Brazil, Guatemala. Brazil bigger than the United States. . . . This no big a land. Canada: 170,000 square miles, is bigger than the United States. But never change. Same thing what he had. . . . And the United States change every 15 years. [Speaks of Jefferson, income tax, shoes, pants, etc.] Nine war made in my time: Puerto Rico war, China war . . . Leave them alone, that's their land.

EF: Did you like Italy, Rome?

SR: [Waves question aside.] What does it matter? . . . What did he write Constitution for? Jefferson, you see him everywhere on the money . . . lots of presidents. Wrote it at midnight, wrote that they have to be volunteer [not conscription]. You can't go to college. If you going to send them, send them all—college or no college! King's son, duke's son, doesn't matter. Millionaire: you got to go, just like the poor man. Man send them to college; grandfather send the grandson to college: why?! But that's the constitution!

Income tax . . . got to have a number. [Taxes at] all the levels: truck have to have another; freight another level; factory, to bring—six levels. One man in Martinez, he make a mistake . . . they goin' to put him in jail. Seven license for everything . . . for selling bread, driving, [etc.]. Tax, tax.

[Rodia did service for the military, but was not in the army. He was sent to Texas, to help with the Spanish flu pandemic: "People dying every day. Sometime makin' me cry. . . . Shoveling coal . . . elevator . . . cost money. Thousands dying . . . somebody have to clean it up."]

EF: Someone should take you home now. The fellow who will drive you home is the guy in green shirt. We're going to the San Francisco Museum night after next. Want to come?

SR: Yes, I'll come. Pick up a little earlier.

EF: Would you have dinner with us somewhere?

SR: Yeah.

EF: Not tomorrow, Tuesday, but on Thursday.

SR: Lots of nice people here tonight. I never see people like that.

A.5. Report on Visits to Simon Rodia, Made to CSRTW, from Jody Farrell (November, 1961), Re: A.4. Interview with Rodia, by Bud Goldstone, Seymour Rosen, Ed Farrell, and Jody Farrell

October 17, 1961, in Martinez and Berkeley
October 19, 1961, at San Francisco Museum of Art

UCLA Library Special Collections, No. 1388, Box 5

VISIT WITH SIMON RODIA

TO: Committee for Simon Rodia's Towers in Watts
FROM: Jody Farrell [written in November, 1961]
RE: Visit with Simon Rodia, October 17, 1961 in Martinez
 Visit with Simon Rodia, October 17, 1961 in Berkeley
 Visit with Simon Rodia, October 19, San Francisco Museum of Art

We looked for Simon Rodia on a hot day in Martinez. Four of us, feeling like a posse with our cameras and recording equipment slung against our hips, tramped the streets in search of him. We had none of us ever seen him but we knew the figure to look for and some of the places to look.

The attendant at the filling station said, "Yeah, he comes by every day. Likes to hang around and talk. No, I never seen his towers . . ." The men at the depot were willing to talk about him. "Oh, he's always hanging around. Just last week here he picked up a little kid about two years old, the mother she ran and grabbed the kid and told him: 'You dirty old bum, keep your hands off her.' I don't know about that artist stuff, but it would be easier to believe if the old guy'd wash his hands once in a while."

The man in the record store where we stopped to buy a Caruso recording as a gift had never heard of Simon Rodia, or Caruso either. He told us there was little call for that sort of thing in Martinez.

Finally we went to Sam's lodgings and there were directed by the casual thumb of a lounger on the sidewalk up dingy linoleum carpeted stairs and down a narrow hall to Sam's door. The face that greeted us with an inquiring smile we knew from still photos and the voice that asked us in the rising and falling Italian cadence familiar to us from tape recordings but I think we were all unprepared for the vitality of this little old man. We sat on chairs, waving us back until he had dusted the seats, and gesticulating, apologized for the tight quarters of his little kitchen where we all crowded together. It was a well organized room: spoons, a ladle and a sieve hung from nails over a tin sink; three felt hats hung in a row over a mirror, almost on display. In cardboard cartons along the wall were folded shirts and assorted shoes. You had the feeling that Sam could put his hand instantly on anything he needed.

He turned down the pot of beans simmering on the burner and pushed the cellophane package of sweet rolls out of sight, ignoring our protests that we were interrupting his lunch. Once primed with a question or two he carried the conversation alone, his tough old hands pounding, pointing; his eyes now fixed on a face, now with a malevolent

glare, now crinkling in a smile, oblivious to the click of the camera and the whirr of the tape recorder.

He talked about his favorite subjects: how can the police do a good job driving cars around the streets instead of walking among the people? How can women be good wives if they work in the supermarket when they should be home "sewing the pretty curtains and taking care of the children."

When asked a pointed question about the Towers he grew vague and managed to climb back promptly only to his preferred conversational track. This we had expected but we were taken completely by surprise when he accepted our invitation to attend the lecture at Berkeley. His "Ya-aa, I wash mysel up and be ready," was unhesitating. When we left it was with a feeling of having found gold. We could think of no reason for his sudden willingness to "emerge" from Martinez unless it was that the repeated gentle onslaught of so many Towers friends had at last broken through. Maybe he was curious, or flattered, or just not through talking. Anyway, a few hours later when we came back to pick him up he was waiting on the curb, neatly dressed in a tieless white shirt, black serge suit, brown canvas shoes and the inevitable fedora.

He talked freely all the way to the university, turning to look out the windows as we crossed the long bridge, pointing to lights on the far hills. His talk now was punctuated by many a "dear young lady," or "my son." His conversation seems less of a tirade, more expansive.

Long before we entered the auditorium it felt like a big night. When Sam was introduced before the program began, the applause was tremendous and people spontaneously rose to their feet. Sam stood facing them with his hat held against his chest in two hands and made little nodding bows. His smile grew and grew and I felt my own cheeks crack with smiling. I'm sure that was the response of the whole audience, to reflect his delight like a mirror.

During the lecture he sat quietly. When the film began he nudged his neighbor and pointed to the screen when the first shot of the Towers appeared. When the program was over and the audience again applauded, Sam stood of his own accord and said, "Thank you, thank you," nodding and bowing.

When the crowd thinned Sam held court with about 30 people who remained. They asked questions mainly about the construction of the Towers and he answered readily, showing in excellent pantomime how he crushed the glass or bent the steel or pressed grillwork into the soft cement. He managed to digress at times and get in a few licks at the government and bad women, but his heart wasn't really in it.

Someone asked if he knew the work of Gaudi and showed him a color print in a book of Gaudi's work. Sam looked closely and with interest, then shook his head and said, "No, I never see this." Then he asked quickly, his finger tapping the page, "This man, he had helpers?" At the answering nod he shut the book and said, with obvious satisfaction, "I never had no help at all."

There was another lecture two nights later at the San Francisco Museum of Art (October 19, 1961) and Sam came to that one too. We took him to dinner at a restaurant in Martinez, hoping to bolster his image a little in the eyes of the townspeople. He refused to order anything except a cup of coffee and seemed ill at ease, not relaxing much until we were in the car again and on our way to town. Here the pattern of the

first evening was repeated. It was the night before we were to leave for home and our goodbyes were warm with smiles and handshakes. I gave Sam a picture of our five children and he held it in both hands saying, "Thank you dear lady. I will keep this. I get a frame to put around to keep nice." I like to think he did keep it and that it reminds him of our visit.

A.6. Letter to the CSRTW, by Claudio Segre [Segrè], January 26, 1962, Re: Visit in Martinez, California, January 25, 1962

[Nine-page typescript, UCLA Library Special Collections, No. 1388, Box 1, File 1]

January 26, 1962

36 Crest Road
Lafayette, California

Mr. N. J. Goldstone
Committee for Simon Rodia's Towers in Watts
P.O. Box 1461
Los Angeles 26, California

Dear Bud,

First, let me properly thank you for your hospitality and the excellent steaks. Fortunately I'm currently on my mother's cooking. Otherwise I would come over and take lessons from you.

Second, could you please *rush* me some 8 × 11" glossies of the Towers and details, and if you have any good ones of Rodia you might send them too. The *Contra Costa Gazette* of Martinez finally seems to have discovered that it has a celebrity in its territory and would like me to do a write up on him. If you can send me 4–5 good shots I think that would do it. I'll see to it that the photographers get their credit.

* * * * *

I made the pilgrimage to Martinez yesterday and met the Master walking along the sidewalk of Main Street, che[e]rfully saying good morning to all the passersby. Most people recognized him, but no one seemed to know who he was.

I caught up with him and then talked to him for nearly three hours on a street corner in the bright sunshine. New autos were driving by and pregnant women in pants passed on their way to market. Uniformed policemen made their rounds and rich landlords who extracted rents went about their business. He seemed to be in the middle of the topic just as the living illustration walked by.

Like all old people, he's something of a record. Eventually the same topic will come up again. I let this happen two or three times to get a definite notion of just what his views were.

I don't think he said much that was new. His obsessions have probably set well by now: They're heavily colored (understandably) by his personal situation.

- he's obsessed with dying alone and forgotten.
- he's obsessed with the defilement of women.
- he's obsessed with the corruption of the United States.

You know about the death thing. To me he said a man "should die cradled on his mother's arm" and he made the gesture of a head lying in the crook of his arm. He also spoke of his fellow roomers in that little house who were found dead in the morning and carried out to who-knows-where. He spoke of several great men who "died like dogs." One was Buffalo Bill whom Simon claimed to have seen. He said Buffalo Bill died as a member of a circus and that seemed to be the ultimate indignity. Of all the great American presidents only Lincoln and Washington were remembered on national holidays. All the rest apparently met obscure ends to his way of thinking.

This fear of not being remembered gave me the leverage to pry about the Towers, but he was like a real clam. You would get him open for a few moments and then he would work off the topic again.

He said he built the Towers because "a man has to do something big in his life."

He also claims—and maybe this is new—that he built them to help him break the drinking habit. He said he had been drinking too much. Then he was laid off for awhile and to keep himself occupied he worked on the Towers, "days and nights and Sundays." He was proud to build them himself, he said, because he couldn't afford to hire anyone. He described how people donated the materials and how he picked up sea shells along the beach while walking from San Pedro to Long Beach with an old cement sack on his back. The water was clear there, he said, not like in Martinez, and cement was good deal cheaper then. (This gave him an exit to harangue about the prices today and 50 years ago and the general state of the world's corruption.)

He told me repeatedly, "I don't care about them now" and at one point said he thought the Towers had been given to the state. During another of these "Tower interludes" he said something about getting $20,000 or $30,000. But what he meant wasn't clear. He looked a little sly and turned away as he usually did when he got on the topic. I thought maybe he was angling after some compensation, but it's hard to say just what was on his mind.

At any rate he said that if he were still in Los Angeles he would still be puttering around them and working on them. He said words to the effect that a project like that is never finished.

As far as any recent work, he shrugged his shoulders and seemed annoyed that I should ask and said he was far too old.

One thing he repeated several times and with that same aroused bitterness: he regrets having left Los Angeles, or rather he found that things were no better in Martinez.

"I made a mistake. We all make mistakes," he said.

On the other hand he said he would never go back and that's part of his character as a cantankerous old man who likes to hear himself complain.

Most of his criticism of the United States and the modern world is of this nature. He likes to complain about taxes, prices, the corruption of the younger generation who must have "the machines" (cars) and can't save because they're constantly busy buying gas to run them. Whenever he saw a new car go by he would throw one of his little Rumpelstiltskin fits, dancing around and waving his arms and proclaiming Babylonia.

Many of his criticisms, of course, are justified. Martinez is a hideous little town based on the installment plan and it's depressing to see the green rolling hills that once were farms and ranches being carved up for pink and yellow housing developments. But occasionally when I put up a solid argument, just to provoke him a little, he would get flustered and quite angry. Most of his thinking follows Barry Goldwater lines with astonishing fidelity. Or maybe vice-versa: it's astonishing that Goldwater and Co. should advocate ideas propounded by an 85-year-old illiterate Italian immigrant. Anyway unions and their dues, taxes passed without the consent of the people, the constitution and all the rest of it came up again and again in his conversation.

"Son, if I were ten years younger I'd go to Canada," he said. His general description of the U.S. is that it is *"corrompito,"* a corruption of the Italian word *"corrotto"* from the verb *"corrompere,"* to corrupt.[1]

It was interesting to note that he like[s] to talk in triads (think of the three Towers). Thinking it over afterwards I made a little list:

- natural processes for growth (sun, earth, water) and you can't grow anything if one is missing.
- materials (copper, glass, steel) all basic to our civilization, he said, and all materials he used in the towers.
- St. Johns he listed three in the Bible, but he got them pretty well mixed up.

His learning is much like his work. It's a collection of bits and pieces which he picked up over 85 years of experience and has fitted into pretty patterns. It's often charming, but not always accurate.

Other examples: Galileo, the man who built the tower of Pisa and then got his head cut off because he said the earth moved around the sun; the great Dante Alighieri who came after Galileo and wrote the *"Divina Commedia,"* a book about teams of armed knights who battled to prove the existence of God. Dante had his head cut off too.

On religion, he urged me to read the Bible. He said I di[d]n't have to believe it, as he himself no longer believed it, but it was worth reading and studying.

His own life, as he describes it, was a perpetual wandering. He worked as a locomotive fireman in Wyoming. He claims he lost property in Washington because he failed to pay taxes. He said he was a night watchman in San Francisco and he was quite explicit about his job as a bricklayer on an Eastern Star home in 1934 in Los Angeles.[2] (That came up in a harangue against a former fellow worker who made good and then repudiated his working class background).

He said he was born in a village 11 km. from Rome.[3] His people had land and he made out that they were reasonably well off. He spoke of hanging out salamis and making wine from a vineyard on their land.

On the subject of his father, as you can imagine, he was quite touchy. He claimed he had none and that his mother was a hardworking woman, but he was muddled and deliberately obscure.

* * * * *

As you can see, none of this is really new material. There are extra flourishes here and there, but I got little from him that was fresh about the Towers or his background. I did better by talking to the relatives.

Bill Calicura is one of the three Calicura brothers who run a butcher shop on Main Street. He is a nephew.

Far from disclaiming any knowledge of Sam, Bill seemed to take an affectionate interest in his "eccentric uncle." He said the old man was getting on in years and had some "outdated" ideas, but added that he didn't think Sam was completely cracked. It was just that the old man was quite eccentric and extremely proud. Apparently he arrived from Los Angeles with a money belt tied to him.

"We took it away from him, deposited it in a bank and he draws on it and uses his social security for his livelihood," Bill said.

The relatives tried to get Sam to live with them, but he was too cantankerous and finally elected to live in that little two-room place he occupies now. For awhile apparently he swept out the butcher shop and the Calicuras fed him, but he was too proud even to accept that.

According to Bill, Sam has definite ideas about his wardrobe, too. He tore the silk lining out [of] a new jacket that was a gift from his brother, Antonio (who died last week), and he replaced all the buttons at the cuffs which he said were no good.

He prefers to walk around as he does in the old blue jacket and shirt, and cuffless gray trousers and the canvas shoes.

Bill says he doesn't like fancy things and is quite uncertain how to react when people praise him for his Towers. The recent Cal Lecture and the dinner you bought him, apparently left him disturbed. When the relatives asked him about it afterwards, he said he didn't like these "fancy dinners" and all this fuss and he didn't know why they were fussing so much with him.

Bill said Sam was on "Omnibus" a couple of years ago and refused any money for the appearance.

Bill's own private theory about the Towers is that while Sam was away for awhile, he came back to find that his wife had taken a lover. He was so upset that he walked out on her and kept on walking until he reached Seattle. He never saw her again. To take his mind off the jilting, he set to work on the Towers. A couple of children are living in Oakland and called some time ago, hoping to see the old man but he refused to have anything to do with them.

Bill says Sam is very affectionate with children and is especially fond of the grand nieces and nephews.

He says he saw the Towers while he was stationed near Los Angeles. His reaction to them: "What can I say about them—they're beautiful."

He told me Sam had three other flowerpots in his usual style which were sitting in the front yard of the Calicuras in Martinez.

* * * * *

I went to see them (at 515 Mellus Ave.). They're beautiful, in the same collage style with the pots piled up one on top of the other. The effect is something like a fountain.

The house itself is charming. It is surrounded by a large, well-tended garden full of roses and a nice lettuce patch toward the back. In the rear is a leafy arbor—which made me think of the patio by the Tower—with a cageful of canaries.

The house, which [h]as yellow-green shingled walls, belongs to Sam's brother-in-law, Saverio Colacurcio. He and Sam's sister who died 18 years ago had 17 children. Twelve are still living.

Saverio is of the same thick, stocky peasant build that has kept Sam going all these years, but he's much more the simple minded, well-intentioned oaf than Sam is.

According to Saverio, Sam, whose real Christian name is Sabatino [Sabato]—not Simon—was born in the little village of Rivottoli in the province of Avellino, about 2½ hours by train from Naples. He said they grew up together and went to school—at least as far as each went to school.

Saverio said Sam never went to school because he was too rebellious. He himself got as far as the third grade. He said Sam is illiterate. (I'm inclined to believe him. Sam was always evasive when I asked him where he got all his information—had he actually read it somewhere? The Martinez city librarians don't remember him ever coming in to read.)

According to Saverio, Sam's father had a reasonably good piece of land—for Italy, anyway—with vineyard and a few chestnuts. The trouble was that he constantly sold

bits of it instead of working it until he finally died without leaving enough money for his funeral. The mother was good and hardworking, apparently and pious.

Sam's father was not. According to Saverio the Rodia[s] were constant troublemakers in the village. They were violently anti-clerical and made their sister cry when they sang anti-church songs. They were like dogs who were constantly barking, Saverio said.

Things got so bad that the elder Rodia borrowed money for passage to send the older boy away. Shortly afterwards he got deeper in debt by borrowing money to send Sam to America too. But far from settling down, the boys did nothing but vagabond all their lives.

Saverio, who was born in 1885, came to the U.S. when he was 14 and worked in the Pennsylvania coal mines for five or six years until he returned to Rivottoli to marry Sam's sister and take her to America with him.

For awhile they lived in Philadelphia, but Saverio's wife insisted that she wanted to visit her brother in California and so they went West. At this time Sam was apparently living near what is now Albany, with a wife, three sons and a daughter. For awhile they lived together until Saverio's wife beat up Sam's and Sam threatened to retaliate. Saverio said it would be over his dead body.

They split up then. Saverio continued working on construction jobs as a laborer and mule skinner. (He says to this day he could tame any wild horse or mule until it was "like a baby.") He went from job to job, providing for his 17 children, and finally retired after thirty years as a night watchman with an oil company near Martinez.

But Sam, the rebel, didn't sit still. Saverio says he left that wife in Albany and ran off to Mexico where he became mixed-up with a Mexican girl, some hot-blooded brothers and a revolution. Saverio didn't know whether Sam actually married the girl. He came back afterwards, anyway, and settled in Los Angeles, "alone like dog."

He had no woman to clean up for him, no one to make his food. He was a lone wolf and he built those towers day and night.

(Here the character of the two men came in sharp relief. Saverio is the dutiful, God-fearing, law-abiding citizen. All of his values are the typical values that you still find in Italy today. Education is precious. The family is the rock of society. To abandon it as Sam did is not only irreverent, but violation of a taboo at the foundation of a decent citizen's beliefs. This was the good bourgeois excoriating the rebel artist.)

Sam was not only a rebel, but he had the hot temper of the Rodias. Arguments with him always concluded with knives. (Saverio says Sam served eight months in jail in Italy for stabbing a cousin). Only last year the two met on the street while watching a construction job. They began an argument about men replacing machines and the problem of unemployment. Apparently even at eighty-four, Sabatino hadn't learned from his days in Rivottoli: he pulled a pocket knife on his brother-in-law (and Saverio showed me how by pulling his.)

"Now you wouldn't keep a man like that around your house, would you"? he asked me.

He says he has never seen the Towers and doesn't think much of them.

"What good are they?" he said. People go to see them because they're beautiful, he supposed, but he thought that anyone with a little bit of common sense could have sat down and figured out how to build them.

That's it. I think the portrait becomes a little clearer, thanks to Saverio.

You've got a highly intelligent, but illiterate rebel who was crossed in love or suffered some great shock which drove him to become a recluse and to pour out his soul in the Towers.

As far as feeling very sorry for Sam now, I think the sympathy is partly wasted. He's a cantankerous old man—the old rebel from Rivottoli—who chose to end his days as he is doing. I'm sure that all the Calicuras (the boys changed the spelling from Colacurcio) will be on hand for the funeral and they'll probably be at his bedside when he dies.

I don't know about more recognition for Sam while he's still alive. I think Bill is right when he says the old man doesn't quite know how to act. He's still the illiterate Italian peasant, awed by fancy hotels and people making a fuss over him.

And it's very hard to penetrate to his world. As I talked to him, I saw people walking by and smiling to themselves—the "harmless old coot" smile. It was difficult for me to put up with him for any length of time. You're constantly on the edge between his natural intelligence, his sharp observations and the ramblings of a complaining old man. I think he's happier with his Socratic walks around town and his can of beans.

If you can get Yorty[4] to proclaim a "Sam Rodia Day"—so that the council can adjourn—and a dedication of the Towers as a park, maybe you can get him down and give him his moment of triumph. Otherwise I guess he'll live out his life, grumbling in Martinez. He's not exactly a misogynist because he likes to say hello to everyone on the street. But he did say to me at one point, "God made people wrong" and his parting words were, "Son, don't trust anyone."

I think it helped to speak Italian to both Sam and Saverio. As I expected, they didn't speak it too well and preferred to fall back on the macaroni English they were used to. But it did help loosen them up at first.

I'm writing to you in detail because I was sure you'd be interested and the letter may be useful to your Committee files. Sam's background remains pretty hazy, as you can see. I may try to contact the children in Oakland, but I've got most of the material I need. A lot of this stuff (the stabbings, and Saverio says there was also a church burning near Rodeo) is nice to know but unprintable.

I'm going to do a brief piece for *Los Angeles Magazine* and as soon as you send me the photographs the citizens of Martinez will be enlightened. Beyond that I'm not sure who will be interested. Enclosed is the UPI [United Press International] story I did after our evening together and my visit to the Towers. The ensemble impressed me deeply. The Towers are big, but the patio is charming.

I'm through with UPI and am currently doing a little work on my own at home until I go into the army for six months in February.

Tell me how things went at the Los Angeles lecture and what the current status is with the city. And I'd appreciate the pics as soon as you can.

Cheers,
Claudio Segre[5]

Enc.
1-9-62

"New Yorker Reporter [Calvin Trillin] Visits Rodia"

Report to the CSRTW, from Jeanne Morgan, Re: Interview with Simon Rodia and Rela-
tives, by Calvin Trillin (*New Yorker*), Nicholas King, Jeanne Morgan, and Beniamino Bu-
fano ("speaking Italian")

Martinez, California, August 30, 1964

[From Jean Morgan Archive, also in UCLA Library Special Collections, No. 1388]

Participants: Calvin Trillin, *New Yorker Magazine*
 Nick King, Committee for Simon Rodia's Towers in Watts
 Jeanne Morgan, Committee
 Beniamino Bufano, artist/sculptor from San Francisco

Report to: Committee for Simon Rodia's Towers in Watts
From: Jeanne Smith Morgan, CSRTW

On August 30, 1964 about a year before Rodia died, and 40 years after he began build-
ing his towers in South Central Los Angeles, some of his friends took a famed *New Yorker*
reporter, Calvin Trillin, to visit the old man where he lived in Martinez, California, north
of San Francisco. Trillin had travelled across the continent to gather details for his *New
Yorker* profile on Rodia and the great sculptures called the Towers in Watts. (A Reporter at
Large: "I Know I Want to Do Something;" *New Yorker Magazine*, May 29, 1965.)

Trillin couldn't interview the Italian-born artist in L.A. because Rodia had abandoned
his work several years earlier, given away his gigantic sculptures to a neighbor and
moved to Martinez, where some of his relatives lived. In ill health and frightened by in-
creasing attention to his innovative structures from city bureaucrats and tax collectors,
he vanished and went "up north" where he intended to die with family.

To produce a thorough profile, Trillin needed to see the old man himself; he was un-
der some pressure to do it soon because the fragile Rodia was then 85 years old. In L.A.
Trillin had assiduously researched the Towers, visited the enormous lacework structures
repeatedly and prowled the Watts terrain where Rodia had worked on his unique project
for 34 years. Trillin had explored the files and archives of The Committee for Simon Ro-
dia's Towers in Watts. A nonprofit citizen group, the Committee was formed to purchase
and save the Towers in 1959 after Rodia abandoned his work in 1955. Its dedicated mem-
bers fought City Hall and won cancellation of a city decision to demolish the entire sculp-
tural assemblage. Today Rodia's work still stands, on a triangular lot at 1765 East 107
Street in the heart of what is now L.A.'s black ghetto. It was a thriving community trans-
portation hub for the big Pacific Electric Red Cars when Rodia settled there in 1921.

The Martinez trip was organized by Nick King, an actor, who, along with film editor
Bill Cartwright, had founded the Committee which had owned and protected the Towers
since 1958.

I had been at the founding meeting of the Committee, overjoyed to find others, in
addition to my small crowd of art student friends, who cared about Rodia's beautiful,
abandoned work. In 1958 I had organized a little group of Towers supporters in two L.A.
art schools, Chouinard and the Otis Art Institute, but as students we had too little clout
to save the Towers, but we tried. On one occasion a fellow student, Jim Muhs, and I made
a foray into the richly carpeted depths of the *Los Angeles Times* editorial offices where we

attempted to see and get helpful publicity from *Times* editor, Otis Chandler. We got as far as the shed-sized desk of his outer-office secretary, who observed our agitated manner and paint-spattered jeans. She deftly cooled our ardor and sent us away. We were over-awed and we failed.

We gratefully attended the founding meeting of the larger Committee with its more mature architects, lawyers, engineers, artists and citizens, who were able to fight City Hall and ultimately prevailed in saving the Towers by running a successful stress test which proved the towers' strength and cancelled the City's demolition order.

When Nick King organized the Trillin trip three years later he asked me to go along because I had been visiting Rodia, had won his confidence and knew his unusual personal qualities. We also took San Francisco sculptor, Beniamino Bufano, as an Italian speaker and fellow sculptor. We three, plus Trillin, drove to the little town of Martinez near the Carquinez Straits, where Rodia walked the streets daily, appearing to be a ragged local fixture whose reputation as an internationally known artist had been noted in the local press. This gave him some slight protection from local residents' scorn despite his evident poverty and eccentricity.

This trip was unusual. We never took merely curious people to see Rodia; he wasn't an exhibition or an artifact to be passed around, but a cantankerous, proud artist—an old man who knew what he had accomplished, even if nobody else understood. Our previous visits had been opportunities to tell him that others did understand, that the Committee treasured his Towers and exhibited them every day of the year to thousands of appreciative people; he could feel assured that he was not alone in thinking his work to be important. He could not fully understand this new situation but he was immensely pleased when we offered him our love and respect and listened to his critique of society and humankind: a litany of interwoven historical and imaginative ideas.

We decided to take Trillin because he was simpatico, an aesthetic sophisticate who would be able to appreciate Sam, as his friends and neighbors called Simon Rodia, who had been called Don Simon by his Latino neighbors when he was building a structure on his property in Long Beach, years before he came to 107th street in Watts.

We felt certain that Trillin wouldn't insult Sam or consider him a curio. But we weren't sure that Sam would accept Trillin. As it happened, the old man graciously accepted all of us, and conversed with ease. When we returned from the trip I prepared this report for the Committee:

NEW YORKER REPORTER VISITS RODIA

Arriving at the dilapidated frame rooming house in Martinez where Rodia sleeps and eats, we noticed that the hallway had been given a facelift with fresh white paint. While the hall looks much cleaner than on our last visit, nothing has been improved inside Sam's room which is as grim and shabby as ever.

Because Rodia spends most of his time walking the streets, observing people and life, we weren't certain we'd find him. But we knocked at his rickety, paint-peeling door and called, "Hello Sam," so that he would hear our voices and recognize friends. He was there. A great scurrying began inside; we realized that Sam was pushing cartons under the bed, removing rags and towels from the table and the chair and trying to clean up for guests.

Sam opened his door and we saw his tiny frame, backlit by glare from his single window. He is about five feet tall. He peered up at us from his bright, whitish-brown,

aged eyes. His initial greeting is always gracious, a combination of interest, curiosity and caution, all mixed in words spoken softly on a rising note. He was wearing an old green cotton flannel shirt with sleeves shortened by himself. He had cut off the cuffs and hemmed the ends of the sleeves with big stitches sewn with a heavy white cord. He wore his customary old, ragged baggy pants and his brown cotton shoes. His white hair is abundant, his wide smile displays snagged, deteriorated, painful-looking teeth. His hands and arms are amazing; great ropes of muscle loop downward under his shirt sleeves. One can't avoid thinking of the three decades of astounding labor building the largest sculptural structure ever made by a single person.

He looked up at us from shining, watery ancient eyes. His smile was wide and free, as always, and he thrust a gnarled hand at us. We all shook hands and we introduced Bufano, whom he seemed to acknowledge as a landsman, and Trillin, whom he accepted at once. He invited us to come in and hastened from bed to chair, smoothing and arranging surfaces for us to sit. Bufano sat on the one chair, Nick, Trillin and I sat on the bed. Rodia sat on a box.

The room measures about 6 feet by 10 feet. A clothes closet stands by the door, filled with old, clean white shirts in many sizes along with an assortment of varicolored clothing, most of it resembling the poorest stuff one finds at rummage sales or the Goodwill. One chair stands against the wall. A shelf holds boxes overhead. A narrow bed, covered with worn blankets, fills most of the room. A broken and torn window shade and a towel cover the window. Long strips of torn rags and sheeting hang on nails along the wall. Sam's personal hygiene system, a bottle of rubbing alcohol and clean rags, appeared in a corner. For my part I have never seen anything quaint or colorful or picturesque in this shabby room which shouts both poverty and independence; it would depress, to the point of despair, anybody less tough than Rodia.

Sam was gracious, friendly and open, talking about the usual things, the single-minded circular things we've heard from him many times. But this time his manner was less intense. He seemed, perhaps, more lucid, more able to actually converse and exchange ideas, less off on his own tangents and monologues. But the substance of his thoughts was exactly the same. Perhaps he phrased his comment about the "woman with the paint" and the neglect of children a bit differently this time. Perhaps he sounded less like an anguished phonograph record.

He told us that the police have to make trouble. If they didn't make trouble how could they keep their jobs—there'd be no work for them to do.

He spoke of Jefferson, of Columbus, of Galileo, of all his heroes who "died in chains." He said, "A man should die in his home." As usual, he refused to talk about the Towers.

Sam said that cement used to cost 64 cents a sack, in a cloth sack. And now it cost $1.85 and it doesn't even come in a cloth sack anymore but in thin paper. Paper breaks!

He quoted for us the prices of bread; a loaf of bread 30 years ago, ten years ago and now. He was indignant at the increase.

He explained again that he is "not on the pension." People on the pension can have a five-room house. People on the pension can be anybody. No, he WORKED for his money. He worked a long time and he earned the social security. This seems to be a kind of moral issue with him.

He talked at great length about railroads, naming all the lines in the East and chronicling their history. He listed the first line built and named, in a kind of poetic

sequence, all the railroads ending with the cross-country Union Pacific. He described his own work on that project. He was evidently a water boy at some point, because he said, "I carry the pails of water and I come and run and go."

He told us he was 14 when he first got to New York from Italy and described being there completely alone for many months until he could get to his brother who was working someplace in a quarry. This must be the brother who was killed in a dynamite blast.

Sam said he knew Jack London, that he worked with Jack London on "the buildings in Berkeley, the school place, the university." Does he really mean he knew Jack London and worked on jobs with him or does he mean that he worked as a laborer, building the university, and there met anarchists and people who talked about Jack London and read his books? One can't tell.

Sam told us that he had food for four more days. It was evident that his social security check wasn't due for a week. But his niece and nephew, the Sullivans, own a grocery store where he is entitled to get free food as much as he likes. But Rodia's pride is intransigent and we couldn't seem to find a way to help him at that moment. I went to see him alone a couple of days later and was able to give him some help.

Basically he is really ok because the Sullivans watch out for him and make certain that he's ok. What he does with whatever help he gets is anybody's guess. When we once gave him some blankets and a record player with Caruso records and other gifts he gave them away to his niece's children and probably very much enjoyed being able to do something generous in the midst of his fierce independence.

Rodia soon grew restless and wanted to end the interview. He walked us down the hall toward the exit. He stood in the middle of this shabby dark hallway and jumped up and down as if he were 18. The floor shook. The walls trembled. "You see that? Look at that! It's no good. Bad work," he said in a rasping, disgusted tone. Sam is still sensitive to careful constructions, still a craftsman/artist.

When we left we invited Sam to come and have some coffee with us, but no matter how insistent or appealing Bufano and Trillin and Nick became, Rodia refused. He made it clear that he was ashamed to go into a restaurant in his clothing. What could be said to overcome his distress? We couldn't find the effective thing and we finally left, bidding Rodia farewell on the sidewalk in front of his rooming house.

<p style="text-align:center">* * * * *</p>

We left Sam and went over to see his brother-in-law, hoping to get some insights for Trillin's article. Little we knew. Sam's brother-in-law is named Calicurchio [Colacurcio] and he is a terrible old man, a kind of creature, so different from Sam that he might be from another planet. They were born and raised in the same tiny village, but that ended their similarity.

Calicurchio's house at 515 Melus Street, is a rose-covered cottage about two blocks from Sam's miserable rooming house. The yard is bursting with roses, with riots of flowers in pinks, melon oranges and rosy yellows. Even the daisies were pink. In the yard several small spires and garden ornaments stand; not major works, but obviously Sam's work. They carry his usual charm and inventiveness, though they are modest. Calicurchio said Sam was there making them about 1930. He said, "around the time of the earthquake." He said, with the scorn and envy that underlay all his remarks about Sam, "He went a'running back down to L.A. to see about his towers, to see if the earthquake hurt his towers any."

It is revealing to contrast Calicurchio's physical environment with Sam's environment. Calicurchio's house is a two-storey frame bungalow very well kept and solid. The whole place cries out solidity, conformity, stability and worldly success in getting security. A long flight of steps leads from the flowery yard to the front porch. This porch, with every inch well painted, carried an evidence of Calicurchio's attitude toward material things; every crack, every chink in the flooring or around the door and windows, had been crammed full of putty or some solid filling substance. But every crack. There is a glass front door with 24 small panes, a white window shade inside, drawn down to the bottom, a new, sturdy (Sears and Roebucks best) aluminum screen door on the outside. The window to the left of the door has thin, nylon ruffled curtains and a white shade with a "crystal plastic" shade pull at the bottom. Two sturdy lawn chairs are on the porch, covered with the ubiquitous pink—an old chenille bedspread. We knew a homemaker/consumer was inside before we saw her.

We pushed the bell. No one answered but we felt thoroughly observed during a long, long wait. Finally a big, old woman appeared behind the screen door. White hair with a "pretty permanent," a heavy jaw, lipstick and three strands of green and metallic plastic beads. Were these added hastily for us? She was wearing a blue, pretty, ruffled-sleeve dress. She was smilingly gracious, completely in control of the situation, the hostess, but with an edge of suspicion.

We thought: this is a well-fed, well-kept woman who cooks, cleans, nags, prays, loves colors and is old but still a vivid and voluble person with plenty of emotional energy. She might be 65 or 75. This woman, obviously Calicurchio's wife, was not Rodia's sister, now dead, but a recent second wife.

In these first moments as we met this impressive woman, we set the emotional tone for the encounter. Everything that followed was probably caused by the initial approach we took. Maybe it was for the best—I don't know—I wished at the time that it had gone differently. But the subsequent hostility really didn't matter. Our role as guardians of Sam's welfare didn't extend to his relatives.

In an ordinary social encounter I would have stepped forward, being the only woman in our group, and greeted this big woman warmly and courteously, said hello and admired the roses and given her all the friendly signals which would make a reassuring beginning for our discussion. Instead we played it differently.

Trillin was our leader. It was his trip now and he took the initiative. Much too quickly for graciousness and with an authoritative manner, he said, "Does Mr. Calicurchio live here?"

Some slight fencing began. Trillin never dealt with this firm old woman as though she were a person herself but acted rather crisp and brusque (on purpose, I thought) and increased the atmosphere of hostility with every word.

The woman finally said, "You're looking for my husband," and he appeared behind her. He shoved her aside, literally, and pushed his big gray-stubbled jaw toward us. The silent message he sent us was something like, "Who the hell you think you are, standing up here inside my front porch?" What he actually said was, "Yah, well, whatta you want?"

Trillin began questioning him about Sam, and about his relation to Sam. Mr. Calicurchio opened with hostile remarks about Sam, and maintained this attitude throughout the discussion. He finally came out of the house, slamming the screen door behind him, and stood nose to nose with us. He rapidly concentrated on talking about himself. Every

time we tried to deflect him into a discussion of Sam his little eyes would narrow and he would say (almost in so many words) "If you want to hear about Sam you gonna hear about me first."

He is a short heavy man with a big barrel chest and a paunch, very thick neck, splotchy red coloring, very powerful arms and shoulders and huge hands which have been maimed and are lacking some fingers. He was wearing a work shirt with underwear showing at the collar and a pair of pants which had been part of a striped gray suit. These pants, held up by suspenders, had been let out to make them bigger with a piece of dark blue wool in the back seam at the waist. He has a heavy accent, less than Rodia's, but still quite pronounced. He speaks with a blunt, cudgel-like manner and his mouth and eyes twist in the pattern of his thoughts. He emphasizes a point by pushing his big jaw forward and reaching toward you with both hands.

He told us that he and Sam had been born in the same village in Italy: Serena [Serino]. He said he had married Sam's sister many years ago and brought her to America. He said Sam was "no good," even as a child. Sam's father was "no good; drank all the time."

Calicurchio described working in the mines in Pennsylvania. He was smarter than the others. He had a few minutes of spare time in his job, which was checking the loads of miners. He used this time to add coal to the carts of certain miners, who would pay him for these additions. With relish he described his cunning—he knew where the soft coal was, he could get it faster. He charged for his services of adding to certain miner's loads and he proudly told us, "I save $800 in one year's time." He was very proud of his smartness in the mines.

Sam had gone on to California before this time. Calicurchio described how his wife evidently wanted desperately to see her brother, to be near some family person. She got a letter from Sam. Calicurchio said, "She was wild to go out to California to see Sam. Was talking and crying and wild so that I take her out to California."

I can well imagine her feelings with this brutal man. In a visit with Sam he had told me that his sister, Angelina, had married Calicurchio, "who was never any good; he was a dumb man." She married him only because their father was "always drunk" and beat them up very bad and she had to get away from home.

Calicurchio's story of his arrival in Berkeley with his wife was loaded in every sentence with accusations and bitterness toward Sam. Every distressing thing that happened was Sam's fault. He described their arrival:

"We get off the train in Berkeley. There's nothing. No hotel, no wagons, nothing. Dark a night. We see a long ways off a hotel, a house. We walk and walk and get to that place and stay there. Next day we try to go to Sam's house. No Sam to meet us or help us. No way to get to Sam's house. No streetcars, no wagons, no nothing. Finally we get to Sam's house. No foundation." His voice is sneering and scornful now. He detailed a long account of how much money he spent for furniture in California and for rent and how much money he spent for clothes for his wife and household equipment, and all this because they could not stay with Sam.

He said, "Put us in a little room, maybe the size of this porch. No foundation to the house. All boards. Nothing nice, just a little room, a bed, a chair, no nothing."

"All the time, night after night, Sam he sits in the kitchen with his gang and they sing terrible songs and they laugh and say bad things about the church and about mother and God and they make a racket all the night. My wife she cry and feel bad. I feel bad. Sam

he betray the church, all the time, all his life, he betray God. In that house I tell Sam we not going to stay any more with him."

Calicurchio told us that when Sam left the Towers for good and came to Martinez, he had come to Calicurchio's house, to his sister who was then still alive. Calicurchio said, with bitterness, "Sam come up here, stay with us. I take him in. I feed him. I even give him a bath. I take him in my arms and I put him in the bathtub. I take good care of him just like a little baby." At this point Calicurchio raised his voice and pounded out each word, saying, "HE NO THANK ME. He no thank nobody, ever. He talk against God here. He talk against the church. I don't know where he went. I don't want to know where he went. I don't want anything to do with him."

He told us that he is a good Catholic. "I am a GOOD MAN and I believe in God. I pray every night. I give my wife fifty cents, a dollar to put in the basket and I pray. I'm a good man."

He spoke about his way of life and contrasted it with Sam's. "I'm working alla my life. I'm working hard in the mines and save my money. I'm a smart man. People think I'm a dummy and I keep quiet and I make money offa them. I save my money and I have the children and I have the house and I have the 22 grandchildren. Reduplico! Reduplico! Like the flowers." He pointed to the mass of roses in the yard. "I pray to God and I save my money. Looka what I got.

Look around you. What's Sam got? Nothing! He got nothing!"

We said Sam had the Towers.

Calicurchio cried, "The Towers! The Towers! What's the Towers? What's the good of it? It's no good. He's no building nothing. I'm building better. I'm a good man with good skill. I'm a butcher for the meat. I make plaster and blacksmith and iron and plenty good things. Sam make something—what is it? It's no good."

We pointed to the little spires and minarets covered with colored glass gleaming among the roses in his garden. He shouted, "Sam no make that. I make that. I make that with Sam. I bring the iron. I help make that every day. That's a no Sam's. That's MINE. You want to buy that? I wouldn't sell you that for one million dollar. You want to buy that? That's on MY property."

He insisted on taking us around the side of the house and into the backyard, showing us his vegetable garden, every onion plant, pointing out every rock and bottle. In the backyard he proudly showed us a little covered patio full of pink-colored lawn furniture and crowded with plastic flowers.

Beniamino Bufano had been listening to Calicurchio's ravings about Sam with less and less tolerance; as we paused in the backyard Bufano began saying a few well-chosen things to our host. Careful things. Things about the value of Sam's gift to the world, the pleasure his work has given to many people; a few words in praise of Sam's life and motives.

Evidently Calicurchio thought Bufano was contesting his version of Sam, his estimate, and thereby attacking Calicurchio's honesty. He said, "I'm a honest man. I never lie. You want to know why I never lie? I tell you. It's because when I was a little boy I tell a lie and my father, he pick me up by my ears like this..."

At this point his big, meaty hands reached out and those knockwurst fingers closed around the tops of Bufano's ears. Like Sam, Bufano is about 4 feet 10 and weighs perhaps 90 pounds. He has little bones like a bird and an extremely beautiful, small head with

great, dark almond-shaped eyes. Bufano stood very still, looking up into Calicurchio's red, grizzled face. The big man said, "Don't be afraid little man. I'm not going to lift you. I just pick uppa your ears, like this—that's how my father do, and pick me up offa the ground. I never lie no more. I'm a honest man." Snorting, he released Bufano.

Bufano, who has lost a finger or two, and Calicurchio, with his missing fingers, stood face to face, speaking harshly and quickly and pointing at each other with their maimed hands; Bufano's hands very small and slender and elegant; Calicurchio's hands poking and pushing at Bufano's thin little chest. Their voices rose.

We broke it up and insisted that we had to leave and began herding the group around the house toward the street, trying to make an exit and get away from this brutal man. Bufano turned to him and looked into his big-jowled, ruddy face. He stared into Calicurchio's little, cunningly narrowed eyes, and he said, "Sam is a better Christian than you are."[1]

Calicurchio became more violent, louder, more vocal and we understood him when he said to Bufano, "You get offa my land, little man. Go away. Get offa my property. Alla you. This is MY property and I'm telling you, get OFF."

We continued to walk calmly (but briskly) to the car. The raving man continued to follow us. No one said goodbye. We looked at him as we got into the car; his face held a very strange and indescribable expression which might have been hatred, or anger, or confusion or something very close to tears. I know the three men in our group did not feel fear, but I did. He felt to me like an unpredictable and savage animal and I was very glad to climb inside the VW's shell of safety and head back to San Francisco, leaving Calicurchio and Rodia two blocks and several philosophies apart.

A.8. Conversations with Rodia, Report by Jeanne Morgan, September 10, 1964

Re: Visits in Martinez, California, May 20, June 15, July 5, August 10, September 10, 1964, and comments on *New Yorker* visit of August 30, 1964.

[Four-page typescript from Jeanne Morgan Archive; also in UCLA Library Special Collections]

TO: Committee for Simon Rodia's Towers in Watts
FROM: Jeanne Morgan
RE: 9-10-64 Conversation with Rodia

Being here in the Bay Area this year has given me an opportunity to spend several afternoons visiting Sam Rodia in the little town of Martinez, about 30 miles north of here. Now that I am, happily, a member of the Board of Directors I feel somehow less shy and able to use my own initiative in keeping up a contact with Rodia. It has been very pleasing to do this. At this moment, as a matter of fact, I should be planning another visit and postponing this letter a few days until I've gone to Martinez again. But let me rather not delay, so that this report can join others in Kate Steinitz's excellent archive. I've seen Sam four times this summer. Nothing changes from one visit to the next, except that Sam becomes warmer and we do begin to think of each other as friends, I do believe. Let me report some of the information I've gained about Sam's health and personal life. Sam has less of the jumping vigor that Mae and I observed in him on our trip in 1960. But he is still very mobile. He is still walking the streets although his feet hurt him very, very much and he cuts the sides out of his brown canvas shoes to endure walking. He mentioned that he didn't know what he was going to do for shoes in the rainy and cold winter time ahead. Sam's teeth are mostly gone now; I couldn't determine that he is suffering any special complaints with those that remain. His eyes, however, are now very bad; he has real difficulty in seeing. Sam probably has constant and severe arthritis. He spoke of pains in his back and his shoulders. He has a definite tremor in his hands and has to handle things carefully to avoid dropping them. Sam evidently has a slight hearing impairment, but not to an extent that requires yelling at him. Distinct enunciation in a clear voice seems to communicate well.

Of course it is evident that some all around medical attention would be a great help to him. If he could make the full tour of an internist for a general physical, a dentist, an eye doctor and chiropodist for his poor feet, he would probably be suffering less. Yes, he is suffering. I've thought that his niece, Virginia Sullivan, might be able to bring about this medical attention if our Committee were to underwrite the bills. I went to the market near Sam's rooming house and talked with Sam's nephew, Leonard Sullivan, who owns the place. He was very friendly, very open to discussion. He invited me, or other Committee people, to visit him and meet his wife, Virginia, who is Rodia's niece, the daughter of Sam's sister, Angelina Rodia Calicura. I have not yet done this. Mr. Sullivan explained that his wife worries about Sam and tries to do something for him. Their address:

Leonard and Virginia Calicura Sullivan
9 West Hayward, Martinez, CA (228-6231)

Mrs. Sullivan's interest in Sam is evident in his rooms, I believe. There are many items of Goodwill-type clothing which she must have brought for him. There is a box under his bed which holds about 15 pair of socks. It must be Virginia who has thought of providing him with basic comforts. Mr. Sullivan takes a friendly and concerned view of Sam, but concludes that there is nothing they can do for him. Sam doesn't want to accept any good advice. Sullivan seems puzzled and a little impatient with Sam as though he's said to himself, "Well, he's a hopeless case."

I think the Sullivans are open to suggestions from us. They are definitely open to conversation and discussion, and their invitation encourages us to communicate with them. Sam talked about his nephew once in rather bitter terms, "They build a great big dog house on their property, but do you think they build a little house in the back for me to live in? No. They build for the dog." Whether Sam was ever capable of communicating his willingness to live in a little house in the back is anybody's guess. My impression is that this idea was never raised between them.

We might consider thinking about Sam's housing problem and ways to improve it. If he could be closer to family people with someone to keep an eye on him, without infringing on his freedom, I'm sure it would improve his daily life. However, if he were to live on the Sullivan's property he would be very far, indeed, from the town and the interesting and stimulating streets he haunts. In the past this would certainly have been a consideration for him but now that he is more aged and feeble he might consider isolation from the town less of a problem.

One possible way to improve his situation might be to consult with the Sullivans to put a trailer on their property where Sam could live. This might give him both freedom and proximity. I hope we can at least give this idea some thought. We could certainly raise the money for a trailer for Sam Rodia. He has a pension of $70.10 a month. His rent is $30. Sam smokes Chesterfields, but not very many. He really hasn't retained many vices unless we called his daily dawn to dusk walking a vice. He walks all over Martinez and with his very painful feet he continues his daily observations. I hope his feet do not become so painful that he is deprived of these journeys, which seem to be his chief pleasure. Certainly Sam would be very pleased if we got together a kind of scrapbook for him. He has very little visual evidence of the impact of his work. Perhaps this would make a pleasing Christmas gift. Sam could use one or two blankets for the coming cold weather.

On my last visit Sam sat me down in his kitchen and brought out a box. Inside was a shoebox. Inside that was a collection of brochures, small magazines and his "papers." These personal effects he showed me, one by one. He had a few clippings about the Towers, with pictures. These were newspaper clippings from L.A. papers. He had some commercial brochures, saved for no reason I could determine and there were his personal effects, his union and social security cards.

SOCIAL SECURITY CARD #
DATE 3-29-37
NAME; SAM RODIA
An employer listed: K. R. Bradley, 1833 W. Pico Street [sic] BIRTH DATE April 15, 1886 [sic] FATHER LISTED; Frank Rodia MOTHER LISTED; Angelina Rodia

These parental names could be inaccurate, as could other data of course.* Entries were written in various dissimilar hands. The signature of Rodia, himself, was large and slowly scrawled, with an appearance of partial or questionable literacy.

*Mae Babitz's research in Serena developed the date Feb. 12, 1879 for a Sabatino Rodia's birthdate[1] with parents Francesco and Nicoletta Rodia. [see Appendix B.3]

A SLIP OF PAPER HELD THE NOTATION:
The Bank of California N.A.
634 Perry St., Martinez
94-0304228
The name, Mrs. Leonard Sullivan, was scrawled at the paper's edge

A UNION CARD: INTERNATIONAL HOD CARRIERS AND BUILDING AND
COMMON LABORERS' UNION, LOCAL #300
#6719, June 25, 1946

A UNION CARD: AMALGAMATED MEAT CUTTER AND
BUTCHER WORKMEN
LOCAL #563 Los Angeles
Card #366-D

Sam said he travelled for the railroad from Detroit to New Castle, Wyoming: "Worked on the railroad. Carried the water." At this same time he said that his beloved brother who was killed in a dynamite blast was named Dick. Sam also said that he started the Towers in 1921. Sam has told me three rather curious and interesting stories about himself: He said he was sent by the Army, but he was "not in the Army." I had asked him if he was in the Army in the First World War. He was sent "by the Army" to Houston, Texas to a big hospital . . . "there was lots of the Spanish flu and lots of people was dying." At the hospital they put him on a job running the elevator and he helped carry up and down all the people dying from the Spanish flu. The date of these events was not clear. My impression was that this occurred either immediately after or before the First World War. Perhaps, also, this was an elevator connected to the hospital morgue. Another story Sam told was about his visit to the San Diego Exposition. It was a story of being inspired. He was very specific about this and used the whole term: San Diego Exposition.[2] He said he saw some very beautiful towers there. I haven't checked on the date or nature of such an exposition and can't add any verifying data at this time. But Rodia's manner was convincing. He knew what he was talking about. Rodia's third story described a job he once held in a bank as a night watchman. He described the big walls with huge doors and all the money inside. He spoke of the clocks which he carried around his neck and demonstrated how he walked through the halls from hour to hour "putting the clocks on" seemingly like a padlock. The key or something like a key had to be turned by him. He described his dismay one night when he realized he had fallen asleep and missed the proper time for placing one of the "clocks." With a certain glee he described how he took the clock "off the neck" and smashed it down on the floor and broke it. He said, "When the boss come next day I tell him it fall off me I have a accident, and so he say OK and I don't get fired." I believe this story is a very accurate description of the plot of an early Charlie Chaplin film. It is important to remember that his neighbors always describe

Sam as a man who adored movies and who went as often as he could. Perhaps the most remarkable of Sam's stories was told during Calvin Trillin's visit. I've just realized that this story has never been recounted in any of my reports. I hope someone else tells this story, either Nick King or even Trillin in his *New Yorker* profile on Sam. We were all so touched by this story and it seemed so very personal. Perhaps that's why I've guarded it unconsciously and failed to share it. Sam told us about working on the Towers in L.A. and how the City made trouble for him. The City said the Towers were no good. He was in great distress and didn't know what to do. He was afraid. So he went up to the capitol and there he went to a very big building and up many, many stairs. He came to a room where there were many old men sitting high up. They were all dressed in black. They had long white beards and a big moustache. One of these old men called him forward. This was the finest looking man. Very grand, the top man. The leader. The top man called Sam to him and as he got near this man reached out his arms to Sam. He took Sam in his arms and kissed him on the top of his head. He held Sam out before him, gripping his shoulders hard and said, "You are good. You do a good work. You go back and finish your work. What you do is right." Sam said he came back to L.A. and worked hard and felt all right. We realized in the car, as we were leaving Sam, that this story was his memory of a very vivid dream. There was no indication from Sam that this story was anything but absolutely real, that it had absolutely happened. But from the internal evidence, of course, we understood that he was telling us a dream—perhaps the most important dream of his life. We understood, too, that it was not a dream for Sam.

<p style="text-align:center">* * * * *</p>

Thank you very much for requesting my reports. I've been glad to be thinking of Sam's life and remembering as many details as possible while writing this. I will be going to see Sam quite soon and will let you know what happens. This next trip will be the last I can undertake on a frequent basis for a few months. I hope Nick King's visits will make up for my absence for a little while.

Best wishes to all of you—oh, I just remembered: as we were driving away from Martinez on the Trillin visit Beniamino Bufano said, "When the President invites artists to the White House he should really invite Sam."

Jeanne Morgan
September 10, 1964
Berkeley, California

A.9. Last Conversation with Sam Rodia, Report by Jeanne Morgan, December 23, 1964

Re: Visit in Martinez, California, December 22, 1964

[Jeanne Morgan Archive; also in UCLA Library Special Collections, No. 1388]

TO: Committee for Simon Rodia's Towers in Watts
FROM: Jeanne Morgan
RE: Last conversation with Sam Rodia

Due to personal problems that are causing me to move back to LA, I can't be driving up to Martinez any more to see Rodia. It was so very sad to see him, yesterday, probably for the last time. He is so ill. So sad to see him in his bed of pain, age and defeat. But you know, he was not wholly defeated even in this bad situation.

With my moving truck almost around the corner, I drove up to see him because Nick King called to tell me that Sam had suffered a heart attack and was in a nursing home. Well, we've all been waiting for this inevitability and there's probably nothing at all to be done about it. Sam is in one of those small convalescent homes in a quiet suburban setting. His bed is on the ground floor next to a window. There is a much better atmosphere here than if he had stayed in L.A. and ended up at the County Hospital where one lies in a gray cement-walled 17-storey prison with bars on the windows and a psychotic in the bed next to you while overworked nurse's aides never appear. Here the nurses and their aides seemed to have time enough to be humane.

However, it did not seem humane to me to find Sam strapped down in his bed. Shocking. Painful beyond words. I was not prepared for that. He seemed alert, as oriented as ever. He looked pale and weak, surrounded by white sheets, fastened down in a hospital gown. It was hard to see him robbed of his mobile street vigor and chestnut brown hands and face. His nurse said that he was a courtly old man who was receiving many visitors; that he was pleasant unless you did something he didn't like. Then his language would "blister the walls."

The nurse said that he had tried to run away—that he had left the bed and run out the door and across the fields in his gown. I think of his many past discussions about hospitals and his conviction that they kill you in the hospital. He must be full of great fear right now. It's hard to understand that a man capable of running across the fields might still be sick enough to require life-saving care to merit keeping him in restraints. A heart attack. Of course they want to set up a treatment and prevention plan. But how HARD, HARD for him. His head has been full of words about "dying at home" for years. He knew me, knew exactly who I was. He was glad to see me. He was very afraid. He spoke in a hoarse whisper. He said, once again, "Man should die at home with the family." I held his hands and bent close to talk with him. Pulling on the restraining straps with his big muscular hands, he hissed at me repeatedly, "Get a knife, bring a knife."

I was not good enough for this occasion. I had no truly helpful words to say, such as, "Come with me Sam. I'll take you home right now and get you out of this." That would

have helped his feelings. As it was, I held his hands tight and told him that we love him and then I left. Inadequate, inadequate!

Jeanne Morgan
Berkeley, CA
December 23, 1964

[JSM's NOTE: This was the last time I saw Rodia. He lived until July 16, 1965.]

A.10. Interviews with S. Rodia, by Norma Ashley-David (with Jonathan David)

Martinez, California, March [1964?], on two successive days.

[Fifteen numbered page (and some unnumbered) typescript (by Mae Babitz and Kate Steinitz?). Digitized sound recording (from a 90-minute Memorex tape) and transcription. UCLA Library Special Collections, No. 1388, Box 5, File 1 (audio), File 5 (transcript). Retranscribed by Luisa Del Giudice.]

Norma Ashley-David (Int. [NAD]): There we go [adjusting machine].

[p. 1]

Now, would you tell me again why you built the towers?

Simon Rodia: Well, I was [I was, I was] drinking too much / and I lay off on the job, and I lost a job.

Int.: And then what about the light?

SR: In other word, I read about Gabrillio [Cabrillo]—New Orleans. United States ma'am. I bet you born here. You really don't know—99% they don't know. No use talk. United States. He buy, he buy, state of Pannsylvania from Halland [Holland]. New Aireans [Orleans] was belong to Franch [French], and the state of Mondana [Montana]. He buy—$30,000,000.

Int. [NAD]: Who is Gabriano?

SR: Eh?

Int.: Who is Gabriano?

SR: Gabrillio

Int.: Who is Gabrillio?

SR: He was, he was what they call *ammiraglio* [Italian, "admiral"]. They had no steamship then cu, l'..., I mean a oil ship. They had windship [sailing vessel]. They took 4 months from Italy come here.

Int.: Oh, he was a sailor? an explorer?

SR: They send G a b r i l l i o. Franch; he was a Franchman. They send Gabrillio. Settle up [...] United States. And there was a Franch girl, 18 years old, she hide on the ship. That was a windship, wood.

Int.: Yes.

SR: And she hide on the ship. When she came to New Orleans—

Int.: New Orleans?

SR: Well, you see she hide on the bottom of the ship.

Int.: Right

SR: And [...] they had a high-class haul, you know, for Gabrillio. He was one a big *ammiraglio* in the world. General, I mean. [child's voice, then NAD says to her son: "no, don't touch it John"] And, then they said, "When we get to New Orleans, we lock 'em up." She was a gypsy. Afrikee [African]. Fortune taller.

Int.: She told fortunes?

SR: Oh, we had a lotta thing, *mamma* [Italian, "heavens"] lotsa thing we don't know. We had a gypsy people, Afrikee.

Int.: Right.

SR: Afrikee, half a nation of white people. *Marocco* [Italian, "Morocco"]

[p. 2]

Look: Spain on this side, *Marocc* on that side. That's white people. [child and mother
whispering: "OK, John"] See? And they lock 'em up. She took her shoes off, brake
a glass on the ship, and they comin' out. And they had a . . . big dance. All dukes,
high-class people. And they had a big party. And she went there. [sound of child
sipping from straw.] She stole a dress, from a rich woman, duke's wife, principal
[Italian: *principale*, "boss"] wife. Because that was before we had a Repubric here.
We had an England control. There was a king here. George Washanton [Washing-
ton] w[e]nt an made 'em. George Washanton was English. He was a general. En-
gland send him here. And . . . up Gabrillio, he get off the platform, "Hey!" he says,
"you woman," he says, "Take a hands off that young lady! Take a hands off!" he says.
"If you no do this," he said, "I was a going to give you [. . .] the state of New Ar-
leans, Lousiana. If you don't, I'm no going to do it." Oh, then they offer her dresses,
everything, see? Well, an I say meself, "My God, Gabrillio, he doin' something." He
got a book up here in the library, in the school. [NAD's son, Johnny: "mommy"] Big
ammiraglio in the world. [Johnny: "momma"] Biggest ship. And now says I'm a
going to do something *da ora innanzi* [Italian, "from now on"]. There you are, see.
I quit on drinking, I told you. I quit on drinking.

Int.: Right. Well, the towers are all beautiful shapes, odd shapes. Did you make lots of
drawings of the towers before you started?

SR: Lady, 'scusa me [Italian: *scusami*] ma'am, please. That tower something, in other
word, can't do it, they want big a one. That tall, build without a scaffold.

Int.: *Without* a scaffold?

SR: I got a four tower, five tower in there. I never use no scaffold on the tower. Dishes,
bottle, glass, I don't know where I put it on in that. I work in the night, midnight,
I work on the job on the daytime. On that time, in the night, I work midnight,
sleep 5 hours a night, work two hours in the morning. Sunday, Christmas Day,
and the tower build without a scaffold. If a world [. . .] to that. "How in the world,
how in the world he get up that no scaffold?" I bring the material up that without
a scaffold.

Int.: Now, I have a friend . . .

SR: . . . Wait a minutes ma'am. When Galileo Galileo [*sic*] read, he said the earth a
movin'. He says, the earth, in the bible. That's in the bible. The earth solid [*sale*?
Italian, "rises"]. That's what they say on the bible.

Int.: The old what?

SR:

[p. 3a]

Galileo Galileo, he says that the earth a movin'. They cut 'em a neck off. He no was; he
was a German—half a Franch and half a German. And he proved where the earth
movin'. Now I built that tower there The tower build without a scaffold. How
you climb that, how you carry your material up that?

Int.: How? How?

SR: Hell, there you are, see? [Ashley laughing.] You gotta do something they never got
'em in the world.

Int.: And as you were building, as you were . . . you just formed the towers without any drawings beforehand as you were climbing up?

SR: *Mamma!* [exasperated; Italian, "what's wrong with you?" or "not again!"]

Int.: I'm not smart!

SR: You born United States, you only got three men.

Int.: Who?

SR: 100,000,000 people, 170,000,000 people. When I come here was 4,000,000. United States. You only got 3 men [i.e., important men]: George Washanton, Abraham Lincoln, *e* [Italian, "and"] Thomas Jaffason [Jefferson]

Int.: But they're all gone . . .

SR: I know, but there is a million people but only 3 men that get the name. Somebody else didn't do that, die: goodbye. We got a million king all over the world, but what is their name? King? Gone.

Int.: Now wait, wait; we're going astray. Let's go back to the towers. Where did you get all the materials that you built the towers with?

SR: Buy!

Int.: Your own money?

SR: Eh?

Int.: Your own? All your own money?

SR: Cement buy. Cement at that time—you couldn't do it [now]—that time, cost a 40 times more now. Cement was a 20 cents a sack, cloth sack, cloth. Now a $1.80.

Int.: Very good.

SR: Sand was 80 cent a ton. Now $10 a ton. Steel was a $14 a ton, and now you want, it cost $300 a s[h]eet. I build a fire, then I bend the steel on the fire, in the night.

Int.: And you had . . .

SR: . . . And on that a time, work on the *torre* [Italian, "tower"] at night, work a home. On the tape [?].

<div align="right">[p. 3b—unnumbered]</div>

Int.: Where were you working during the day?

SR: Eh?

Int.: Where were you working during the day? When you weren't working in the towers, where did you work?

SR: Oh lady, I was work on the court. I been working on the court for 30 years. This country, this land, they no had a nothing. They no had no bank. You know, you only got two bank in the United States, you know. Bank American and then National Bank. Bank American, that's a Bank of Italy. National Bank, Bank o[f] London. I say lady we no had no bank! [impatient, getting aggressive; Ashley trying to ask another question] You had to bury your money. I was night-watchman on a court 7 night a week, 364 nights in a year. Watchin' a [at night?]. We no had any safe. I told you, the banker come from London here, from Italy—Bank American [Bank of America and Italy], that was the Bank of Italy, in Chicago. In Nova York was Bank a London. We no hadda here, they finally land here but they no find nothing to eat, lady . . .

Int.: . . . Mr., Mr. Rodia, the land that the towers are built on, did you own that land?

SR: Why sure I was own that land.

Int.: You owned that land?

SR: Yeah, I was the owner. No more.

Int.: No more. And did you sell it to somebody in the neighborhood?

SR: No. I sold it? No, no. No sold it.

Int.: Well, I don't understand. The towers have changed hands, and now they're owned by the Committee. The Towers Committee.

SR: Well, I say, Gabrillio do something.

Int.: And you do something [chuckles].

SR: Now, I'm a gonna do something—that's all.

Int.: You know what I wish you would do? When we make a movie, about the towers, I wish that you would come to Los Angeles, and let us photograph you at the towers. Do you think you could do that?

SR: Go to Los Angeles?

Int.: Yes.

[p. 4]

SR: Oh no I can't go even, I cannot go back.

Int.: Why not?

SR: No, no.

Int.: We would drive you there.

SR: L a a a d y, 'scusa me.

Int.: What?

SR: We don't know nothing. 'Scusa me. The people a today he don't know nothing. 35 years, that's media [middle] age. 70 years, you too old. When you 65, you old. They no want you on the job. You working? Ain't that right? Before you 6 years old, they no want you in the schools. Before you 18, they no want you on the job. You got to be 18 years old. That right? When you 65, get out. No good no more. The life, 70 years, average.

Int.: That's what it says in the bible.

SR: I'm, I'm [adult male voice in background: "I got to go"—Ashley responds: "all right, I need you to come . . ."] 89, 89.[1]

Int.: You're 89?

SR: Yeah. On the 15 a next month, I'll be 90. I make my own cook here, wash my own dishes, patchin a clothes.

Int.: You're doing pretty good.

SR: Oh lady, 'scusa me.

Int.: Why, why . . . ?

SR: That's the world, that's all over the world. That's for rich people.

Int.: What's for rich people? The world?

SR: The world, yeah.

Int.: But tell me, what's that got to do with why you won't come to Los Angeles?

SR:

[p. 5]

Why? Because I'm too old. Maybe I die on the train, die on the road.

Int.: Well, and you want to die in this room?

SR: What I want to do any more with the tower? I gotta, I'm a worry about something else. I got here I come up here, I got 9 nieces here. My sister daughter and four boys. 3 of 'em die, 1 alive. I got one niece, my sister daughter. One a niece in *Giappone*

[Italian, "Japan"]; one a niece Guatemala. One a niece Puerto Rico. [NAD: "John!"] They laugh at their husband and they went for another man. You see, U.S. control *Giappone,* you know. He gotta bank over there. That boy was work American bank, in *Giappone*. And she *had* a husband, married [*marito?*], *olio* [Italian, "oil"] company, Shell Co. She left her husband went there, living [?]. I gotta one a Guatemala. That's in New Mexico.

Int.: Well, *I* understand that you would rather be near people that you love, your sister and your nieces; but we would drive you to Los Angeles.

SR: Ma'am *'scusa* me, ma'am, *ma* [Italian, "but"] *'scusa* me. That, this no want 'em at all. Don't you see when people past 70 years old, they talkin' alone on the sidewalk, on the street, "mumumumumumum." [babbling, mimicking the speech of an old man]

Int.: But you know—

SR: Wait a minute!

Int.: All right!

SR: And some of 'em . . . [adjustments] And some of 'em . . . That's in a *book*, up here, in the library. All over American. 35 years, that's middle [*media*] age. 70 years., your time to go. No go out today, go out tomorrow. I'm too old now.

Int.: But I don't feel that way. And you don't feel that way, really.

SR: Don't feel it? Sure I feel it.

Int.: Well, what I would like to ask of you is . . .

SR: Sure I feel it ma'am.

Int.: Well, I feel every day, I feel older too. But what I would like to ask of you—if we came up in an automobile and drove you to Los Angeles, or put you on a train . . .

SR: No, no, no. I can't go. I can't leave here.

[p. 5b—unnumbered]

Maybe they break it up and steal everything. I got lotsa stuff here, in the other room.

Int.: We could lock that up.

SR: This is all a bummin' a people here, drunkin' a people. This is an old barn ma'am, what are we talkin' about? Look here. Look a' this [?] Look a' here. [door closes] They built in 1901. This was hay up here. And a horse on a bottom. I say, [getting insistent, aggressive] there was hay up here. Barn. Barn. A horse.

Int.: Tell me something. How long are the [to]wers going to last?

SR: Eh?

Int.: How long will the towers last?

SR: Well, I don't care now? What I care? Let a fall down and no fall down.

Int.: They're not going to fall down. You know they're not going to fall down.

SR: No. This a lumber. They don't build any more a lumber house. [NAD: "Put it down," to her son.] When the cold night come, lumber, when they new, they put 'em together . . . No, you see, they have . . .

Int.: . . . Tell me something.

SR: No, you see over here, they have . . . when the cold . . . [distant from microphone, trying to show her something]

Int.: Mr. Rodia . . .

SR: They use a lotta money. I gotta lotta money, myself, I gotta two whole box . . . stove, there.

Int.: Mr. Rodiia, when you were building the towers, what did people who lived around you think of it?

SR: But the U.S. was *different* then. Good people.

Int.: What? There are good people . . .

SR: GOOD people.

Int.: Am I bad?

SR: Poor-man wife she want to wear pants, no buy dress.

Int.:

<div style="text-align: right">[p. 6]</div>

I ask you, am I bad? Are you bad? Is my little boy here bad?

SR: You no way 'em but they way 'em. [?]

Int.: But, just as, just as . . .

SR: Moth . . . there's no more mother in the United States. [cross-talk] I don't know [?] Ma'am *'scusa* me. Because, a mother gotta give a baby milk. Is no mother a U.S The government done that. Government made them wear pants. I told you.

Int.: You listen to me. When you built the towers, there were bad people then and there were good people then.

SR: No, there was good people.

Int.: There were bad people too. And now, when you see bad people, more bad people, it's because you *see* them that way. And there are still good people. And the good people would like you to come to Los Angeles, to your towers, [SR grumbles] and let you be photographed so that this picture of the towers can go all over the world where other people can see them too. Where the towers will live, which is what you wanted, I think; where the towers will live for everybody to see them.

SR: You know how much I get in a months?

Int.: Where do you get it? From the government?

SR: How much I get in a months, to live on.

Int.: How much?

SR: $74 a months.

Int.: $74 a month?

SR: Yeah, I pay $29.50. How much a money I got left?

Int.: Let me ask you; let me ask you as a businesswoman—

SR: Eh?

Int.: Could I *pay* you to go down there?

SR: I no want that.

Int.: Well then, what are you complaining about?

SR:

<div style="text-align: right">[p. 6b—unnumbered]</div>

Oh I no want that. Maybe tomorrow morning I find this bust up and they taken away everything. I no want 'em anymore ma'am.

Int.: But . . .

SR: [aggressive] Ma'am I don't want anything to do anymore for that. That's done. *'Scusa* me. Looka da window here. Looka da window here. [moving something across floor] I gotta put the window, closed way [I've got to close the window].

Int.: Tell me . . .

SR: THEY NO USE, that, no more. MY GOD, it here, I SAID. [flustered . . .]

Int.: That's right. Tell me, I want to know . . .

SR: He was [supposed] to come 'anna look? [struggling with window, having trouble because it won't close?]

Int.: Tell me something. Mr. Rodia, when you were building the towers, there were good people there, right? There were good people, when you were building the towers . . . ?

SR: Sure there was, otherwise I wouldn't do it.

Int.: There were good people. What did the good people say about the towers? What were they saying about the towers?

SR: Well, thatsa say, I'm done. That's 20 years ago.

Int.: But that's what I want to know, what they said then.

SR: Eh . . .

Int.: No more. I think you're getting tired.

SR: That's a . . . Galileo Galileo, he said the earth movin', you know, when you goin' all over the world, he say, here's a moon; they cut 'em the neck off . . .

[in background, NAD: "I'm getting tired. Johnny's getting tired too."]

SR: That's all.

Int.: Well, I think we'll go now.

[in background, NAD says, "Can we close this other door?"] [Sound of door closing.]

[Brief interview with Hank Nelson, Shell station attendant immediately follows, regarding Rodia's daily routine starting at 6:30 to 7:00 a.m.: "You'll see him go out in the morning and then maybe an hour, hour and a half later, he'll come back into his house, or where he stays; he'll stay oh maybe 15 minutes, half an hour and then he's out again. I sometimes see him uptown—when I go to the bank or to go get supplies, I'll see him walking around town. [. . .] He has an old hat, an overcoat, blue tennis shoes—I made the remark to my helper many times that I think he's the lonesomest man in town."]

2ND INTERVIEW WITH SIMON RODIA [p. 9]

[Interview continues, next day. As NAD sets up recorder, Sam fusses over a more rambunctious Johnny in the background, in solicitous tones, afraid he will hurt himself.]

SR: . . . he falla down; hmm? Hello honey . . . that's it, see [Jonathan banging on something]. You hit the dog when no behave yourself . . . don't hit your head! . . . don't hit your head!

Int.: What ya doing John? What are you doing? [Jonathan chuckles] That's a microphone [NAD chuckles] Want to sit down John?

Int.: Mr. Rodia, I don't want to take too much of your time, and I think I tired you out yesterday. But I wanted to ask you, before we were recording yesterday, you told me about traveling in other countries, and working there, and you said you went to the . . . I don't remember all the places you went, and I thought you'd tell me again. You went to Argentina?

SR: Argentina? Yeah. I been to Buenos Aires.

Int.: And where else did you go?

SR: Eh?

Int.: Where else?

SR: Buenos A i r e s.

Int.: And the other places you went to . . .

SR: Oh, I was a Puerto Rico, Guatemala, Mexico. I been a Canadá, Montreal. Oh, I been Victoria. You see, they don't cost me nickel then. [?] Lady, excuse me, no use [?] We wasting time. I told you before, before poor people was a millionaire. You stand down there on the street, 5, 6, men; man who come around [?] with a chain here. Say: you boys want, you fellows want a job? I'll pay you fair. Not a common labor, up here, union . . . You pay, you gotta pay. They gotta pay 75 dollar [to] join it. And . . .

Int.: But . . .

SR: . . . Wait a minute ma'am, no use [*accomend?*] And you ain't got a $75 join the union, you can't get a job. Boss can't hire you. How do you feed you children? Tell me?!

Int.: Did . . .

SR: 60 days, you no pay, you out. Throw you out. $60 a month you gotta pay. Over here, labor union, truck operator, $100. Drive a truck.

Int.: Well . . .

SR: You tell me when you go, you want a house you gotta have you money on the hands.

Int.: All that's true, Mr. Rodia, but I want to talk to you about the towers. And I wanted to ask you if, when you were traveling, you went to see art museums.

SR: It never cost me nickel.

Int.: I know, I know, but the thing about the towers that I would like to know is: where did you get the *ideas* for the towers? of what *form* they would take?

SR: Well, I told you yesterday, Mrs. Excuse me! I told you yesterday.

Int.: Yesterday?

SR: I was too drunk, all the time, drinkin', work like, work like . . . then, in the night and drinking. And I say, I quit on drinking.

Int.:

[p. 10]

No, but that's not what I want to know. I know you told me that yesterday. What I want to know is: the *form* that the towers take, their shape. They're very beautiful, they're very unusual, and they have definite *shape* to them, you know, and they come in different groupings. And where did you . . . how did you conceive of your idea for the towers, how they would look?

SR: Ma'am, *'scusa* me. No use talkin' a[bout] this. You think it over in that time: When Jesus was on the ground—you believe in God?

Int.: Yes, yes.

SR: Well, when Jesus was on the ground, they had, every man had long hair. You know why?

Int.: Why?

SR: We no *had* no steel. Man [invention?] no steel.

Int.: We didn't have any what . . . ?

SR: We [invention?] no steel. Persia, Egyptee, Afrikee (call "nigger," they call 'em; colored people—I no call 'em "nigger"), they invention copper. You no had no copper, and . . . Egyptee invention glasses and copper. You no had no glass, you no had no light. [Interviewer confused, apparently, pauses]. Glasses. Glasses! That globe there. And copper. You gotta have copper. Automobile, you gotta machine *there*. You gotta have copper wire.

Int.: Yes.

SR: Well, and there you are—that's a thousand years ago. And one man doin' something, another man doin' something, another man—ladies too.

Int.: Well . . .

SR: We gotta ladies on the book. We gotta ladies on the book. A Holland lady—she got a big book. She make 'vention. Louisa Michele, name: Louisa Michele.

Int.: Louisa . . . ?

SR: . . . Michela.

Int.: Louisa Michele . . .

SR: Louisa Michele, she make 'nvention Holland; she invention chocolate.

Int.: I don't know her.

SR: Chocolate! Chocolate!

Int.: Chocolate!

SR: Chocolate candy.

Int.: Oh! Chocolate, chocolate!

SR: Chocolate, yeah. Told you. Holland . . . we got three cheese in a world: Normanny kind of cheese, Roman cheese, Holland cheese, and Swish cheese. [Interviewer laughs: "riiight"] When they discovered America, they was a livin' on the green grass, eat. Fish.

Int.: Yes, that's right.

SR: They no had any home, any house, any dressed up. They dressed up with bamboos. Covered up. Like a horse. Like the animal. Only 400 years ago.

Int.: I know. Well, I know you're leading up to telling me how the towers come out of all this, but I don't see how. You mean that the towers, your ideas for the towers come from . . .

SR:

[p. 11]

Who give a man idea make a cotton and make you shawls, you coat?

Int.: Who?

SR: Well, there you are.

Int.: Who? Who?

SR: Who give an idea to make shoes? We no had no shoes, ma'am. You get the English Encyclopedia. Go up the library. That's a big book in the world. They cost a million dollar. English Encyclopedia [*Encyclopedia Britannica*]. 80 books.

Int.: Do you read the encyclopedia?

SR: Eh?

Int.: Do you read the encyclopedia?

SR: Well, I was a read it. I was a read it, I told you, I work on the court. The United States, they no had anything. They find land, but they had to bring stuff over from old country for one year [child talking] Listen ma'am: you plant what, you gotta wait one year. You plant the *patata's* [Italian, "potatoes"] one year. Beans, one year. Peases, one year. I mean: plant it, before you start to eat it. [child: "I'm hungry"]. Pear, apple, apricots, peaches—they had it a here, but they was wild. [. . .] In New York state, they was wild apples, wild pear, wild apricots, wild peaches. Who told the first man [child getting restless], who told the first man: cut the peach with a knife, then cut 'em here peach, come sweet apple, sweet apricots? Who told that?

We got a *million* thing, a million thing. We had long hair. You couldn't cut it when Jesus on the ground. You see the picture of that. Well, we [?] because we no had any scissors to cut it. How do they cut it? Who told man how to make that?

Int.: You mean, nobody told you how to make the towers and that they just came from your own mind. I understand that, but you look at lots of things, and you understand many things . . .

SR: Galileo Galileo, he's [?] Jesus. They cut 'em neck off. He's the man who told the world the earth movin'. You understand?

Int.: Yes, I do.

SR: And he build a tower in Italy, 400 feet high. [child: "I'm hungry" repeatedly]. Tower lean over [Leaning Towers of Pisa]. See, he say, that no fall. They thought that the world—go up the library, get you a book. Get the *World History*. The *World* [p. 12] *History* tell you e v e r y nation in the world. You no cost you a nickel, go up the library.

Int.: I know.

SR: They give it to you.

Int.: I've studie[d] about Galileo and I studied about Kepler—

SR: Well, then, that's enough . . .

Int.: All right. [chuckles]

SR: That's enough.

Int.: Well, I've done all that but I know that when you look at . . . That a man like you, who likes beautiful things and likes to look at beautiful objects, like my son here.

SR: Yes ma'am. But I had a chance learning it. I told you, I had a . . . with a chain, couple of chain. Every hour, 7 to 5:00, 100 kilos. In the morning, the man in the city hall, in the court, he open up and he see if I drink [?] it.

Int.: Oh . . .

SR: 9:00 . . . Because we no had a bank. Money, you know, they had, they had, they had a 'luminum door, I mean a tin door. They no had no steel. I told you . . . had no steel. And they buildin' the railroad. You no had no railroad, no steel, you no had nothing. You no had no glasses, you couldn't read it. 40% of the people ma'am, 40% they ain't got 'a glasses, they can't read. When they 45 years old up. And some are born that way too. I saw baby little big than this wear glasses, I seen it.

Int.: I know. One of my children was like that. Mr. Rodia, Johnny says he's hungry. May he have a cookie please?

SR: Oh . . . [affectionately] he's a hungry. Well, sure, wait a minute.

Int.: Where did we hide those cookies . . .

SR: I'll get you a cookie, son. I just forget where I put it.

Int.: Well, the cookies, are they on top?

SR: No, I got a dozen package.

Int.: Here they are. Mr. Rodia. Here they are. Over here.

SR: Well, take 'em all! Take 'em all![2]

Int.: Just one, Johnny. Just one.

SR: You wann 'a milk? Milk? I give you milk. Come on, take it all! There we are . . .

Int.: What do you say, Johnny? Oh that's plenty, oohhh.

SR: See, I don't buy, see I don't buy, go the market. I buy $70, $80 worth a stuff.

Int.: My goodness!

SR: See, look at the milk I got 'a here. I buy 8 bottle at a time.

Int: How much!?

SR: 8

Int.: 8!?

SR: This is stuff when I cook.

Int: Oh . . . do you . . .

SR: I can make a little [?]

Int.: Oh, do you do all your own cooking?

SR: Eh?

Int.: Do you do all your own cooking?

SR: Yes ma'am. I patchin' the clothes. I put the button on the clothes. 90 years old, 91 year old man.[3] Women, give 'em a milk. Somebody bring a' milk yesterday. . . . Too much . . .

Int: Here, let me do . . . I've got it for you.

SR: That's all right

Int: Here Mr. Rodia, it's already open.

SR: There you go, honey.

Int: I've got this one. Mr. Rodia. Here.

SR: No, put away, I got another cup. Put 'em here ma'am.

Int: I know where it is. All right, all right [washing cup]. Here you go, Johnny. Oh, there's something in the bottom of this one. There's something in this one, Mr. Rodia. [water running in sink]

SR: I used to. In Los Angeles, I used to go to pictures. When I come and I find the door bust up . . . stealin' clothes, stealin' everything what you had.

Int.: This has dirt on it, Mr. Rodia. Wait a minute. [washing]

SR: What's the matter?

Int· The cup has dirt in it. Let's get the glass up here.

SR: No, the cup is all right!

Int: The cup is clean?

SR: See.

Int: It has some dirt on it. [more water] OK, John.

SR: Lady, 'scusa me. United States, I told you. United States in danger.

Int. Johnny . . . [Johnny: "want to sit, mom"] Sit right there. [more fussing]

SR: Here's my cup, here. See, I don't buy stuff cheap.

Int.: Olive oil . . .

SR: $2 . . . olive oil, well, you see, I buy. . . . See, I don't cook with a' lard and grease.[4]

Int: And I see you have . . .

SR: Olive oil . . . see.

Int: Olive oil, and tomato paste, and . . . peas and carrots.

SR: See.

Int: And what else?

SR: That's a', that's a' . . .

Int.: Tomato paste.

SR: That's tomatoes, see?

Int: And what's that?

SR: Vegetable, that make it tasty. There they are.

Int: Spinach! Spinach. What do you cook best? What do you like to cook best? What do you like to cook.

SR: Well, I want to be careful about stomach. That's the reason I'm living so long. Ma'am, what is funny?

Int.: Nothing's funny, I think it's great.

SR: Well, you see I got stomach trouble.

Int.: Me too. Me too.

SR: You can't go to the toilet, you eat meat. I eat meat, here. That's meat in there. I cook for 4 days, 3 days.

[Little boy spills milk.]

Int.: Oh Johnny, Johnny!

SR: I gotta mop here, wait a minute, ma'am.

Int: John. Thank you, Mr. Rodia. John likes it here. Johnny likes to visit you.

SR: Yeah, come, wait a minute, sit down. I fix this. I clean 'em up. [cleaning]

Int.: Oh . . .

SR: I gotta clothes. When I sleep, sleep there. I show you.

[p. 13]

I got 75 pants, 75 underwear, 75 shorts, 75—[5]

Int.: What are you going to *do* with them all!?

SR: Well I spend a money, but you need it! I no spend a money [I] goin' to pay the pool hall. I'm a [not?] gonna go a pool hall. Tonight, every night in the year: I buy 50c I buy chocolate candy, package a' cigarettes, and coca cola. No beer, no whiskey, no wine. (Wait a minute, I mop it again; this mop no . . . this mop no mop good) [. . .]

Int: What a mess you made, Johnno! Uh. Johnny, *you* should clean that up!

SR: I told you I quit on drinkin' in 1919. I don't drink wine if you give [?]), if you give me $100. No touch it. Because a man got to be in one way. Woman got to be in one way. Good, good, good, or bad, bad, bad.

Int.: And there's no in-between?

SR: No, no . . . that's what they call, *World History* tell you this, up here in the City Hall, in the court. The *World History*, the World Book. Every nation in the world.

Int.: You're good good good or bad bad bad? Well maybe maybe you're right.

SR: You be half good, and half no good, well that's no good. When I was drinking, and drunk, working hard for nothing. I got lay off 3, 4 time on the jobs. Then I throw the damn bottle away. I done it. Same place I build the tower up, I throw the bottle away. I say no more on drinkin' for me. And I save money I spent on drinking, I started to build—and I pass my time. That job, that job, I never lost a minute on that job—I was workin'! That job, *every* Sunday in the year. 9, 10:00 in the night, coupla hours in the morning, before I goin' a work.

Int.: What did your neighbors think of all this down there?

SR: Well, that's what they call [. . .] That job ma'am, no use I recommend talking. What's the use? That job built without a scaffold.

Int.: I know.

SR: That job, that job, no stepladder, get up on a' top. You got a stepladder there. I built stepladder, cement, put a shell on, and dishes on it. And then you climb on that. Nobody knows that. I had a money saved, they get up that. Couldn't get up that. Not the big one. That other one, little bit one. You know they move it. You see, they move it [she laughs]. You see ma'am, when you work and the steel bend, it don't break. If hard, you bend it, they bust up. Everything steel inside, steel. I spend over

$3000 worth of steel there, put wire mesh around steel, bend her over [p. 14] like this, where you want it; then you put wire mesh, copper wire on the mesh an' no gets rusty. If it gets rusty water gets in there, then cement peel off.

Int.: And it's all copper wire underneath?

SR: All copper wire.

Int.: I see.

SR: Galvanized mesh. Little mesh, see?

Int.: Didn't anybody ever say anything about what you were doing? Didn't they want to help you? The people that lived around there, didn't anyone want to help you?

SR: Nooo. How they going to help me? That's in the morning, in the night, on Sunday.

Int.: Well if you were able to do it, they would be able to do it.

SR: No, no you can't help it. You see, I was working on the job, and one month buy something—$50, $100 worth of stuff—and next months buy another $50. I was gettin' big wages you know, and I'm a big . . . I lay bridge. First union, Boston, Mass., brick mason.

Int.: Oh is that where you first worked?

SR: Yes, they cut the necks off 19 men.[6]

Int.: They cut the necks of 19 men!?

SR: 19 men. Boston Massachusetts Union. That's first union made in United States. We got money happening, young lady, in the world.

Int: Johnny, look at Johnny. He's just eating away . . . Those must be awfully good cookies, John!

SR: When they comin' here, I told you, when they come in the State of Vermont. Fourteen years, after Puerto Rico discovered. You born in the United States. *Read United States history!*

Int.: I do. I was born in Massachusetts, as a matter of fact.

SR: No, you no need to go, I mean. Read history, what happen. Fourteen years after Christopher Columbus. He discovered, he no discovered New York. State of Vermont! That's north side of New York. Before you get to New York, that's 500 miles. You get the state of Vermont, Haywood.

Int.: Did you ever work in Boston or Vermont?

SR: Well, I been in Boston. I worked maybe 2, 3 days, 1 day, half a day. Then we go on the windship. We goin' a' put on elevators in factory, in the building. We no had the elevator. And the elevator we put on, you all had a man to run it. Now, you push a button, you got 5,000,000 people, lady you buy lotsa thing [. . .] You got 5 million young people United States laid off. Every building, wait a minute, every building, you want to go 3rd floor, 4th floor, "Which floor you want?" Open a gate. Lock gate. Start the elevator. Steam, wood, oak wood on the boiler room. No coal mine. That's only 72 years old. We run [10?] on the wood. No more coal. They usin' oil, they usin' something else.

[p. 15]

Int.: What did you use on your furnace? You used coal in your furnace, for your steel? You had a furnace at the towers you used to bend your steel. To heat your steel, to bend it?

SR: I bend steel on the track, on the rails.

Int.: Oh it runs right outside the towers. That's right, that's right.

SR: Bend steel on a rail.

Int: Oh! John, I think we're getting Mr. Rodia tired. We should come back and talk to him another day. Tell me the name of your nephew down at the, you said you had a nephew that worked at the railway station. What does he do there?

SR: He got two shift down there, see? He come on 11:00, see?

Int: What does he do?

SR: Oh, you got seventy-five men down there. What do they do? . . . They got 75 men down in the depot.

Int: Does he work in the yard or in the station?

SR: Yard? No, no, in the depot with the . . . He talkin' . . . 10 call men. "Los Angeles train" "Chicago train," "San Francisco, Oakland, Berkeley." When he come from SF he tell . . . Chicago, Seattle, Tacoma, Portland, Nebraska, Idolway [Iowa], and Chicago . . .

Int: We'll have to take John to hear that. I think he wants to go home, that's what I think!

[interaction with child]

[55:40]

[Mention is made, in closing, of a nephew who works in Los Angeles.]

A.11. Interview (Excerpts) with Rodia's Neighbors ("Pete Scanlon's in-laws"), by Bud Goldstone, Long Beach, California, 1963

[Digitized recording 73:28 (Part 1 of 1:13:27; made from Scotch 7" reel-to-reel magnetic tape; for Part 2 of this recording, see Appendix A.4, 1961 interview with Ed Farrell, Jody Farrell, Bud Goldstone, Seymour Rosen). In UCLA Library Special Collections, No. 1388, Box 5, File 1. Paraphrased summary with excerpts (due to poor sound quality and disjointed conversations) by Luisa Del Giudice.]

Bud Goldstone: [To himself] 515 [?] Street, yellow and white house, lots of succulents and fruit trees, pedestal with new shell, flower pot, against garage. Other side of front entrance, two things reminiscent of Watts Towers: one is remarkable state of bowls with succulents (seven, each smaller than last) 8 feet high, left apex of one of the towers, three elements of metal covered in cement, broken glass and crockery—form almost exactly like Tower tips. Another stack of vases (five vases high) 4 feet high. Many succulents, among shrubs and plants.

Hello, I'm Bud Goldstone.

[Woman with a Mexican accent, recalls Simon. With her is her son, Tony. Shows photographs of Simon and his wife.]

Neighbor: [Simon] was married in El Paso, Texas. The first time . . . [1] [and I] Think it was 10 years after . . . [that he married] Benita. I think she went back to El Paso . . . And then he met this [other] girl . . . She just walked out. [He] came home and found the house empty (her sister was Aurora Morales . . . Hernández). I don't know where they live. Second wife's first name [was] Carmen. Haven't seen her for ages . . . [but] saw [the] sister, Maria. She [Carmen] was dead.

[Someone comes into room]

BG: My name is Bud.

Woman's voice: Hi, Mary.

Neighbor: [Speaks Spanish to people entering room]. He [Rodia] didn't talk much about it, you know. [She says that she went to visit him at the Towers and took pictures but couldn't find them now. Towers weren't very high then: they only had tile on the walk (not mosaic)]. Everything had to be pieces [the arch]. With first wife, he built that house [in Long Beach] . . . bulldozed.

BG: No one tried to stop them from tearing down?

Neighbor: I don't think so.

[BG says that there was nothing in the papers . . . one wheel made of cement, pole, playground apparatus. Neighbor says that she had looked around for pictures, got names but didn't find them, that someone who had gone to Arizona, would be back soon, and she could ask that woman when she returned. Someone else enters, male voice. BG refers to university . . .]

BG: Mainly he takes care of himself . . . some social security . . . in Martinez now. [Shows them pictures of where Rodia lives, in two rooms, paying $28 a month.]

Neighbor: How old is he?

BG: He's 83 . . . This is a new book [phone interruption].

[Neighbor is still looking at photos.]

BG: One of the houses was burned down about 1966, "but [the] Towers are still there . . . Behind [the] house is where he buried the car . . . [his] red [car]. He worked for [?], [and the] Brothers Lumber Yard. He used to commute every morning . . . [The]

police following him; [he was] always in a hurry, [so the] police [were] after him . . . No one [could] find it [the red car] . . . [But it was] right behind [his] house, behind the wall. "That's fantastic!" [It was] a Hudson!] . . . What kind of work [did he do] . . . janitor, tile work? In Martinez he talked about shoveling coal for General Miller.

Neighbor: [Didn't know him then]. We met him in 1919 . . . [when] he lived in house two blocks away.

[BG reviews Rodia's topics of conversation: Marco Polo, Columbus dying in chains, what women and fathers do to children, people buying a "machine" (car) when you don't even have a home for the baby! And he talked about Rome.]

Neighbor: He knew quite a bit, everything he heard . . . with Italians . . . club . . . [2]

BG: I think he first lived in Philadelphia, when he came over from Rome [sic—Rodia was born in Rivottoli di Serino, province of Avellino] . . . Canada [. . .]

Neighbor: He don't know how to read or write. [Someone else enters]

BG: [His] initials in the towers, SR, [are] everywhere! [He plays a recording of Rodia speaking, so they can hear him, showing pictures to them (1936, "they call him Simon"). Talks of measuring the Watts Towers' height, of Rodia climbing them with cement bucket in hand, etc. never allowing anyone to bring him cement. ("He buys the cement"), used wheelbarrow for mixing cement, didn't let anyone climb, because it was dangerous.]

Neighbor narrates how one time Rodia went to work and returned home to find everything had been stolen. Rodia had said that people had changed, and that years before, everyone had been nicer. B.G. affirms that "I don't think the people change, the times make people change." He tells of Rodia's creative impulse and "his imagination: no one knew what he was going to do next." Rodia said that "it's my idea," and that others should create their own projects ("you do yours!"). No one could have made any suggestions to him about how to proceed. B.G. talks about the construction process and the sequence of structures: he built the entrance first, then the cylinders, and table (bench went all the way around). The wall was first and he wanted to keep it closed. BG thought the house was already there, and Rodia added cement to the front, then the sides, next to Towers, then the back wall by the track, and later he decorated the front. The kitchen was all cement and broken glass. There was already electricity in the house, and Rodia put lights in the Towers himself. The three tall towers were there before the Long Beach earthquake, but no damage was done to the Towers yet the houses were damaged. They inspected the Towers and someone had come to tell Rodia he couldn't build any higher (in 1933). He was told by the inspector not to build any higher than 100 feet and wanted to have them measured. Rodia responded to: "you think I'm crazy like you?!" City engineers are usually wrong. BG continues, explaining how the towers tied together came first, and the single highest one measuring 99½ feet came last.

The neighbor talks about the kind of man Rodia was, that he never did drink, in all the years they had known him! BG says that Rodia had told him that he was drunk for three days before he began building the Towers. The neighbor responds that he did not! But that "he probably did before." Rodia loved the movies and went to the movies every weekend! . . . They didn't know if he danced or not but he loved to go to dances, and met the girls over there, but that he always went alone. They

never saw him with any friends at all, and they thought they were the only people he ever knew. They tell of how Rodia, at the age of 13, running away from his father, and that he loved his mother very much. Once when he was very sick (maybe before earthquake), he didn't go to work, and tried to get help from neighbors but they refused to do anything for him, because they thought he was eccentric, crazy, and they had nothing to do with him. No one looked after him. BG asks if he had any lady friends and they respond that Simon had a lady friend a long time ago. . . . As for baptisms at the Towers, Rodia's LB neighbor didn't know about that. On the topic of savings, she states that "he never had any money" and that he spent it. Although he talked about saving money, he did not save very much, because he'd buy cement, go to the movies, and so forth. He worked most of the time ("McGrew" Co.?). BG states that Rodia had never worked as a tile-setter. He was a laborer! Perhaps a cement finisher. He lived as a laborer, but was an artist. That it was easy for him to find a job because of his personality (he was very polite) and because he was a "very very hard worker!" There was no fooling around, and that he was always looking for work. Rodia would talk mostly about history, politics, Romans, S. America (Guatemala). BG concedes that "sometimes he made mistake." Rodia was alone much of the time and he was so happy when members of the CSRTW (Committee for Simon Rodia's Towers in Watts) went to visit. . . . They brought many children (Rodia loved children), and he liked people very much. There were good times and bad times, and sometimes they admired you and sometimes not, but he mostly liked to be left alone. He did good work and he would talk to people who came to visit, coming down from tower to talk to the people. On the question of why he built them, BG asserts that "he wanted to leave something to people," that Rodia said: "I have no kids, no friends, no nothing" [and therefore left his legacy to the people]. He never said anything about the hearts. He mentioned that the fountains actually worked, and water flowed in them.

"Everyone used to call him crazy [that he was . . .] wasting time and money . . . We should all be so crazy!"

These Long Beach neighbors seemed to be his best friends. They only saw him at the Towers, and a couple of times gave him a ride.

BG states that Rodia put "Nuestro Pueblo" on cement before the book came out and that they used this name of the book because of the Towers. There were now quite a few books about the Towers all over the world: in England, Holland, Italy and that Rodia was surprised about the fame he had achieved. He concludes that there was an Italian in Fresno and they said he was crazy too![3]

[Part II, beginning at 30:49 is not relevant and records a family conversation, singing, tales, and news from the *Los Angeles Times*, and some CSRTW business.]

A.12. Interview with S. Rodia, by Nicholas King, Martinez, California, September, 1960

[Paraphrased Excerpted Transcription by Edward Landler. Edward Landler Private Archive. Reproduced with permission.]

California, no night in the year you can sleep outside. Night you get cold. I left a window open one night. I have to get up . . . When is summer, spring, fall, winter.

San Francisco is the worst climate in the United States. I went to San Francisco 1898. That time, San Francisco is 210,000 . . . June, July, August, there be a lot of work, then be hot. Oh, no, not here. In September, people got to have a leather coat. You workin' on the building, cold wind come from the ocean . . . That's a reason Los Angeles more big than San Francisco.

I been all over the America. Mexico, they got 80% Indian blood . . . United States take a Texas, biggest state. We took 'em away from Mexico . . . and New Mexico . . .

We got a nation in Europe, got a million. Denmark, three million and a half; Norwegia [Italian: *Norvegia*, Norway], 3 million; Sweden, 4 million . . . mostly Scandinavian people. We got three race in Europe, 2 races here: Indian and Latin . . .

Workin' there on the railroad . . . In Poughkeepsie, New York, seventy miles from New York—Hudson River, Albany, here on both sides, apricot, peach, grapes. They was weighed. You couldn't eat it. It was sour. They cut 'em on the tree, sold 'em in the mill, put the dirt in there. Everything was weighed. We pick up strawberry a basket. Thirteen, twelve years old.

This Indian land. Every state you find a people . . . Indian. You don't find a white people. You don't find a colored people. My niece say, "We want to get out of Martinez. They got too many nigger." Don't blame the colored people, blame the government. They bring them here, gotta keep 'em.

Over two hundred million people in United States.

They write a book, cost three and a half dollars . . . *Los Angeles Times*, about that thick, about that wide. I had a one book, I give it away. They send me one book . . .

No steel on that tower . . . Tower of Pisa . . . forty, fifty feet, then forty, fifty feet the other . . . Galileo Galilei. The Pope was boss then. He cut his neck off. He says the earth move. Good idea, you know. So, I want to do something.

Dear sons, United States 150,000,000 people. You only got three men up here in the library . . . Los Angeles, New York, Chicago . . . Thomas Jefferson, Washington, Abraham Lincoln, president he die.

Thomas Jefferson, he write a Constitution in the United States and they don't use. Washington, he take 'em away from England. Lincoln, he want to free the colored people, they shot him in the back. The rest 'em born and die, no name. We have over two hundred president in the United States.

You got a book here in the United States about big bandit . . . Jesse James and Frank James. He got a book in the library . . . two brother. One was 22, the other one was 20. They kill their mother, when they went home, they found a mother shot on the lawn, killed. "My

mother die"... Frank and Jesse. People come down and say: "they kill them." "Who kill them?" "The soldier, the law." They want to make them go through on the land. He was no bandit. He want to get even with the people who kill the mother. Kansas, Missouri. That only one hundred and twenty-five years ago.

Young lady, I can't not move at all. You know, the morning, one man die of old age. Two, three women, six, seven children, maybe in the hospital. That's a happen to me maybe... who knows when you die? Man a die. Someone come and want to see me. Get a doctor, get a doctor, go away. Three bosses on this road. This was up here, horses on the bottom. Other man work for sail company. He rent from doctor. He's a doctor, own a tenant home. Another doctor on the bottom. Tino, he work for sail company. He come around a month, he pay the doctor.

Something the people they don't want to understand.

We had a restaurant over there where there gasoline station. We had a restaurant on the other side of doctor. We had a restaurant around the corner and gasoline station. Seven years ago, the restaurant close, gasoline station closes up. They close fourteen restaurant. Now one restaurant left.

They have a poorer class of people—they only get so much a day. They spend them in one way and then no money to buy the other way.

General Kelly [sic],[1] 1917 told me something I never forget about. They send me down there, 1917. Spanish flu. People a dyin', fall down and die. They sent me from San Diego to Houston, Texas. They pick me up, go Houston, Texas, be operator in Army Hospital. Coronet play—tum te tum—one half hour, another one...

In a night, I was go out. One General Miller sat down to me he say, he say: "Where you goin' every night? I don't see you." "Well, general," I says—you know, I was a young man then. "Listen," he says. "You put five dollars in your pocket and you spend a nickel here, fifty cent there, twenty-five cent hotel, a dollar, five dollar gone... People of today, they workin', don't do no good 'cause they spend 'em in a way and then no money to get the other way. 'Cause that's all you get." I never forget that. He don't want me to go out. He want me to save a dollar. Miller, General Miller. That war, 1917. That was a big war.

They send me there. No matter how old I was, how young I was, you gotta go. They came and got me on the job. I was in San Diego. I was operator in hospital, running elevator, shoveling coal. We no have electricity elevator then, was steam. Was boiler on top running. They say: "You gotta go. We need you." Twenty-seven months in Houston. We had a Spanish flu. Young people die, twenty years old, fifteen, twenty...

Start to build... I was a worker... That was in the night, on a Sunday, in the morning, couple hours in the morning, two, three hours in the night. In the night, I make it in the house. I build in the house on the table. Then Sunday, you went out to work. I take it all outside and connect, like a railroad. Already made. All you gotta do is connect like a railroad. Put it on afterwards, everything...

The big post that made the inside, that's a galvanized pipe. Everything that's galvanized, buy 'em.

I was workin' you know. I was workin' at that time. One week I buy steel. Another week . . . That time, cement was twenty-two cents a sack; cloth sack, twenty-two cents one sack of cement, one hundred pounds. Sand, seventy cents a load, a truck, a truckload. Now, cement is two dollar ninety cent a sack, paper sack. Steel, you want any kind of steel eighty dollar up. I pay forty dollar a ton.

Gasoline was fifteen cents, eight cents. I had a machine [car] in Seattle, eight cents a gallon. Now, you got to pay ten cents tax on a gallon.

You pay, got to pay more for what you eat. You got to pay more for what you sleep. Go up on a man. Don't do that. He wants to get more money. When you workin' and a rainin' on your back and you workin' for nothing' when you get a job and you workin' . . .

You got to pay twenty-seven cents on the dollar, they take it off. Seventeen cents income tax, four cents for the hospital, four cents for security employed. How you gonna collect? One time you work in the sun, you work a dollar a day, you *get* the dollar, you know that.

When you got a machine, then you pay twenty cents tax on the gasoline. That's the tax you pay there—ten cents.

When you buy a pants, you pay five times four cents on the dollar. When you buy pants, you pay four times income tax. You pay four time income tax. Man on the farm, you get a eat, he got to pay seventeen cents income tax, four cents for hospital, that's one. Another man higher up, he make the clothes, he got to pay income tax, that's two. Then a horses (today they got truck), he got to pay income tax. Bring them in the railroad, he got to pay income tax. Then roadman, they got to pay income tax 'cause you don't pay for the government, five. In the factory, that's six. Bring 'em in the clothes store, that's a seven. Money pass through seven hand, seven people . . . People today workin' harder for nothing.

They don't build a single home . . . Los Angeles, San Francisco, Oakland, Berkeley put in a big market, then city of Martinez close up . . . We had fourteen restaurant, only one now. They close one on south of depot on the other side. Eight-seven years, twenty-four hours a day: that's where I eat twenty years ago. Night and day, eight years ago. They close her up.

Meat was fourteen, twelve, twenty, eighteen cents a pound. Now good meat is one dollar and a half a pound (T-bone steak). Then you got restaurant, you gotta pay license, you got to pay income tax, you got to pay big rent . . . more bill, bigger bill. You sell for three dollar, four dollar, little bit of T-bone steak . . .

United States is in danger . . .

The first nation in the world, that's the Greek . . . Constantinople, that's the oldest city in the world. Rome saved it. I mean the white people . . . You believe in God, young lady . . .

Constantine, Emperor of Rome . . . Go down to the library, you ask for the Bible. Don't call it Italian Bible. When the priest read the Bible on top of the platform, he no say *Italia Catholic—Cattolico Apostolico Romano*—Roman Catholic. Roman made that Jesus. They made him and the Roman last two thousand years. Christ was a Jew. Three times, that's in the Bible, three times. Pontius Pilate, the judge in Jerusalem. He was a Jew. He say three times: "King of the Jews, King of the Jews, King of the Jews." Jesus. He no king of

Germany, in France, in England, in Denmark, Holland, Spain. He King of the *Jews*. He made then, that he knows true . . .

They don't call him Italia at all. They call him *Imperio* [*Impero*] *di Roma*, *Imperio* [*Impero*] *di Roma*, *Imperio* [*Impero*] *di* Constantinople. No, that's Arabian, the other nation. Constantinople, no more Greek, at all.

He was afraid that the United States would have an Italian (?) war. You see, in Europe they start to want Communism. You got a hundred thousand land, turn it over to people, split it.

United States, they smart . . .

I tell them they pay more money and they got to pay more . . .

The people, you see . . . Are you gonna build a home because you want to get so much a day. We pay your mortgage money and you get to pay more for what you get. You ain't got nothing to sell, you got to buy everything . . .

When you go to Los Angeles, five hundred miles from Oakland, you only meet one town—Fresno. One family own forty, fifty, seventy-five miles of land on both sides of railroad. Hundred thousands of family, they want to buy a lot. They want five thousand dollars for lot. You understand the point, young man? You got to buy everything, you ain't got nothing to sell. The man who got the stuff, he make the money . . . and that's the reason the restaurant close up . . .

Rent of restaurant two, three hundred dollar a month for rent. Go up, have a sandwich, eat so much. Then pay the bill, how much? Two dollar. Two dollar? Cup of coffee, little bit of hamburger and bread. Two dollar a meal. One time, was twelve cents, fourteen cents. Don't you see here? This was forty, fifty years ago. Three dollar a month, two dollars a month. He pay bigger tax. Any restaurant you rent, you pay for it . . .

You remember when gasoline was twenty cents a gallon. Now twenty cents for tax. I know gasoline.

We got three class of people all over the world: Chinee, Afrikee, Europo, American [four are mentioned]. Three class: Millionaire class, media class, poor class. Poor class of people all over the world—they no free. Woman too—woman no free. Woman get a job in the store. Hey, no wear that. Put that on. Men today, he no wear no hat. When he go on a job, the boss says: look, you watch. Please, young lady, watch a policeman when you meet him. He got to have a gray cap and a brass work penny here. You see him. You never see the short cut hair like me, blue coat or green coat. Gray coat and brass button . . . Conductor on the train—blue coat and brass button, blue cap and brass ribbon. You got to do what the boss want, wrong or no wrong. Do what I tell you, he say. Miller told me, he say: "You put a dollar in your pocket, dollar here, or you cannot built, do home for your children."

Travellin' around, we never married . . . [2]

I was one of the bad man in the United States . . .

I was sleepin' there two days and two nights on the side of the house. That was in my own home . . . I fall down, down there with that tower . . . The girl was about eighteen

years old, her name was Marguerite. "Samuele, Samuele, you forget to shut off your light, burnin' two nights and two days." I'm not worth there Marguerite (cross the street, Mexican girl, born in Los Angeles) . . .

I was a drunk, drinking bottle on the sidewalk one night in Chinatown in 1906. On the curb, I sat down . . . See, we had the earthquake. They put in a law 9:00, everybody home. They blow the whistle—too-too—9:00, you got to go home. He was sitting down on a corner, I say: "Mister, where's a Market Street?" He got up. He pick me up. He says: "I'll give you Market Street! You supposed to be home 9:00! Where you work?" I told him where I work. I work on Examiner building, seventeen storey high, at Fifteenth and Market. "Where you live?" "I live in Oakland." "You goin' home." He shake me up. "I don't want to put you in jail—two, three months on a chain gang. No do that no more." But there was a law, gas on a street, rail, roof, too dangerous, see. He was a detective, but he was a worker. He had a million dollar, but he work.

. . . All (?) . . . They sendin' boy like me, fourteen year old to United States. That's a my mother, my father fault. I have no father. Me no need to come to America. I had one of the (best or bad?) man in the world, my father. We had a lot of property. We raise a lot of potatoes, wheat, corn, cherry, pear, apple, apricot, peaches. We go fourteen years, thirteen years old, bare foot, no shoes.

We spend the money on the saloon. I told you, men spend the money on the one way, then you ain't got no money on the other way. You only get so much a day. Millionaire, he get five thousand a day interest, different. But the poor man only getting so much a day. When you go to boss, you say: "Boss, I'm short here." When they pay money, no check. Well, that's all you get . . . and that's the reason the United States and Los Angeles, the same thing: debt.

Look at Martinez here. Never build no single home. You never find a room. You never find a house. You look around when you go home with the machine [car] on the street. See if there's any sign on the sidewalk for rent. I told you, there was fourteen restaurant to eat. You only got one left in town. They been open and closin' five times. There's a saloon on the corner. That's all. You look around and see if there's any more restaurant. A man want a cup of coffee. How you gonna get it? Ain't no restaurant. Close up.

Però, non tengo [*sic—tengono*] *la colpa* ["but it's not their fault"]. The people know. No people are for it. I told you he was afraid. You see, they start to accumulate more in Germany, in Denmark, Holland, Sweden, and how happy the people. They don't care for nothing.

You had one restaurant, you had two restaurant—one there, one by the hardware store. You only got one market, right there, quarter of a block, parking machine, one over there by National Bank. Six, eight years ago—close up, go away. What? People no eat anymore? Why they close up?

This is the richest town in United States. You gotta oil here. You go over there, oil tank and the pipe. Shell Company, Association Company, Union Company. You go to Benecia. They had a leather factory, close up. They had a cement factory, close down. They had a clothes factory, shoes, pants, close up. Don't you see the high class store . . . Look at the dirt . . .

I remember when wife start to get in family way. Two week, tell the husband every night, we got to save a little money. We got to build another room. We got a two baby boy, maybe a baby girl . . . and make the home big. When I was a young man, I tryin' to save a dollar. The world is money. No matter who you are, what you are, you ain't got a dollar in the pocket, you in the hole . . .

Look at a me. I'm a getting seventy, eighty dollar a month. My check come on the seventh of the month, the eighth of the month. I'm a no pension. You get the security, you get no pension. You get the pension, you get no security. I still got ten, fifteen dollar at the end of the month. You got to have money in the pocket. You got to have the money first, before you get the key.

I told you, the gasoline was eight cents a gallon. A Hudson, my machine, used six, seven gallons a day. Hudson, that was the first one make. The second one was a Dodge . . . No, six or seven cents a gallon. Then it was eleven cents, thirteen cents. Now, they is seventy-five cents, a dollar, then a penny, four cents on the dollar . . .

Pay thirty-eight dollars, two room up there by City Hall, with the park in back. Find all of my sheets, blankets, everything gone . . .

Woman is a woman, a man is a man . . . mother raise the children. She wear the pants up here and the little girl say "Mama." That's all. Mother, mother, child, mother, miracle, milk. Mother gotta milk here and she want to buy bottle . . . What she know what kind of milk in the bottle . . .

Some of these days, stamps gonna be fifteen cents. Look at the policeman. Policeman got a machine and they raise the tax, put bigger tax on. They don't pay, they make you up. You got eighty-eight machine in Martinez.

I was in the paper you know, Los Angeles. They sent one up to the post office. Captain says: come and see me some time. I like to see you every day. Eighty-eight machine up here. Who gonna pay the car, the gasoline. They put the tax on the house and they raise the room . . .

That tower was built without a scaffold, in a spare time. I was workin' on a job. How you building a home without a scaffold? How you build a house without a scaffold? Not a single piece of wood in that.

You see them rings running around. Well, you get up on the first one. I was working on the ledge. Next week, up on that, I carry the pail of cement on the shoulder, on the arm. Next week, I put another one . . .

I work thirty year on that. You know fifty-two Sundays in the year and the holiday. In truth, you got a hundred days in the year. See, you got lots of time. You see what I mean? The book said so.

There was a tiling in there. How do I get up there? I hold the cement. I carry the steel.

The *Los Angeles Times* say he built that tower up without a scaffold. How a man get up there? They no appreciate that I had to eat . . .

You no work for government. You get no pension, no security. Wait till you get the security, pension, when you sign them up. When a man get the pension and security, they don't know the people he's a slave. Sign your name and see no hand on your shirt . . . When you gonna be that old, eighty, ninety, ninety-five, your hand gonna shake—the same thing . . .

General Miller, General Miller . . . They sent me there, when they had the Spanish flu . . .

Government don't give no pension. They take 'em away from the people. That's the reason people gotta pay income tax, security. Pay old people. A lot of people think government gets that money and it gets all the way to the saloon . . . I do like that too but I quit. I wouldn't drink a glass of beer or a glass of wine if you give me a hundred dollars. I don't touch it.

I got to Berkeley once a year, once in a while. I build the university. University, they build 1895, 1900. I was a bricklayer. I was a general foreman. My job to lay brick.

But I am an operator too, run the elevator. Elevator no run with electricity then. It run with steam. Shovel coal in the boiler room.

Something wrong with the United States . . . You come to Martinez pretty near every day. You see any home being builded . . . In a town so children can grow, where they gonna sleep . . . I never see home builded over here in this town ever since I come here . . .

Seven in the family, seven garage . . . one garage is enough . . .

Poor man, poor man wife . . .

Christ, I build seven home in United States . . . I build a home in Poughkeepsie, New York, 1902, when I build. Build myself, no permit, don't need permit. Buy a lot for $30. You buy lot now, $10,000, right.

I told you, buy quart of milk, five cents here, right. Buy a loaf of bread, five cents. Money so . . . Buy pants thirty, forty cents, fifty cents . . .

Building permit . . . Oh Christ, I got 'em in Sacramento . . . I met the president. He had the whiskers that long. President George, boss. He cry, I seen him cry. He said: "My son, go on home. Do what you doin'. Do your workin'. Today, you gonna get a letter in the county Los Angeles. He's gonna have a letter, 1919."

They want me to take it off fifteen feet. I had a permit but I want it more high. I talk to those fellows in Sacramento, seventy-five a day . . . Gentlemen, everything they do them . . .

Abraham Lincoln, he's the one who organized the United States, and they shot him in the back. We have Abraham Lincoln Day, a couple of years ago, they don't kill anyone . . . Thomas Jefferson, he write the Constitution in the United States. Mr. Jefferson hold a candle . . . I had in the book.

Galileo, they cut him neck off. He built the Tower of Pisa. He say the world move. Now they sorry, too late. They got (?) da man when he's right. I never know.

I build the tower, the people like, everybody come . . .[3] I never know there was a . . .

Gentleman . . . Sacramento . . . he's the boss in California state . . .

I'ma makin' a money for California . . .

I had a seventy-five hundred machine . . . that's the invention. Government use the gasoline . . .

President, he took a hold of me. He say: "Sam, go home, do your work. Keep on do your work the way you want."

The fellow want to go to Mexico. He was Mexican. I pay nine hundred dollar cash for the property and the house . . .

Galileo Galilei . . . I see the tower in the picture. I say, "My God. I gonna make the tower different from Galileo." I couldn't make it like he make.

(Where did you get the idea?)

Galileo tower . . . hundred feet like that, another hundred feet like this, and another one hundred feet like this. This is the man, the biggest man in the world, the man that say the earth move. The Bible say the earth stand. He told them. But they don't listen. They cut him neck off anyhow . . .

There wasn't no steel then. I was a steel man.

You see when I come to the United States, United States was different. Man say I pay you fare. I want you to go New York, you work. He pay you fare and *salute* [Italian, "goodbye"]. They don't do that no more.

I told you the Spanish flu. I had to leave a home, Los Angeles. I had to leave a tower. They come and gotta me down there. They gotta me. They say, 1917, when United States go to war . . . There was three (?) . . . There was England and Germany . . . the war . . . Here, they dying—fifteen, thirty a day. Son, you gotta come with us. You gotta operate the elevator. Bring the dead people down.

(Had you already started building the towers then?)

Yes, I just started. I had to leave, I had to leave it. I was afraid the Mexicano . . . (?)

That time, they couldn't get men who run the elevator. Only was three, four in the United States who know how to run the elevator . . . I work in the hospital, run the elevator, shovel the coal in the boiler room too, steam, two boiler on the top go round . . .

United States . . . He took California, New York, Massachusetts, Ohio, Illinois, State of Texas, two thousand mile, big enough for seven state . . . California, big for five states . . . United States have thirteen state—New York, Massachusetts, Vermont, Ohio, Pennsylvania, Pennsylvania Dutch . . .

They cut off them neck off, I told you. Forty-eight men in Boston, Massachusetts . . . Put a neck in that an knife come down and cut it off. That's a union . . . That's a (?) . . .

This country no have nothing . . . no roads . . . sign a law like that . . . They had to bring stuff from England. They have to bring stuff from old country to eat. They don't find no lettuce, cabbage. They don't find no pear, no apple . . . 1492 . . . fourteen years after Puerto

Rico discovered . . . Peru, Colombia, Buenos Aires, Puerto Rico, Brazil, Mexico, Guatemala, Argentina, Canada. This is thirteen nation. Brazil three times as big as United States. Million and another hundred thousand mile square. United States is four hundred thousand. There was Indian—they kill them. You go to Mexico, Brazil, Argentina, you find a lot of Indian there, Seattle . . .

What the hell has they got to do bringing the Japanese here. Ain't enough land, enough work for white people . . . Leave the goddam Japan alone.

You go Canada, you find a lot of Indian there. Victoria, Vancouver, Montreal, Winnipeg. Canada, one time and a half bigger than United States. I told you Canada is second largest, Brazil . . .

This not the United States . . . English. When you go to court to get permit to build a home or something, you think the judge say: "Are you read and write United States? Are you read and write *English*? When you go to Brazil, they don't say: "Are you read and write Brazil? Are you read and write *Portuguese*?" When you go to Argentina, Spanish. They don't say you read and write United States. In Italia, they don't call 'em Italian, Roman. In Spain, there was the name Castilian. Castiliano soap . . . wash the face. Castiliano cheese . . . Three kinds of cheese: Roman cheese, Holland cheese, Castiliano cheese.

All over the world, when you read what the other man write, you don't mention the letter yourself, you . . . (?)

When you take a picture, you take a picture, another man invention. Sewing machine, making the pants, making the shorts, another man invention. One man make the invention, then there are gonna be millionaire people gonna be millionaire . . .

Three nation: white people, yellow people, nigger . . . Arabia, Arabian invention of steel. Yellow nation . . . Egypt, Afrikee, Nigger, invented copper and brass—no copper, no light.

We had olive oil . . . charcoal. Holland cheese, windmill.

I tell you the truth. I don't care today for nothing, not a thing. I'm a thinking about what are the people gonna do ten years from today.

You go to Berkeley there on a highway. They close every goddam market . . . Twenty-five thousand going to one market. We had seven market. We had a market up the street.

That's a lot of Irish. He got English. Can you read and write English. They don't ask: do you read and write *Irish*.

You say you gotta have a blue coat and a brass button. Policeman.

Knocking down the country, a little at a time.

They left from that job. Then they look for other kind of work and that's the reason they don't work no more.

My sister had a farm on the other side of town. So there's a horse . . .

Notes

Introduction: Sabato Rodia's Towers in Watts and the Search for Common Ground LUISA DEL GIUDICE

1. Rodia's art may be considered "Outsider" in more ways than one: It was created by an unschooled artist, that is, outside any art establishment; and it was created *en plein air*, that is, outdoors in his own yard. Many retellings of this core narrative may be found in print and film (e.g., Goldstone and Paquin Goldstone 1997; Landler and Byer 2006; Ward 1986, 1990) as well as in briefer overviews (e.g., Hernández 2001).

2. Both spellings co-occur even at the local level, although *Ribottoli* (*Ribóttoli*) appears to be a more archaic form. Inhabitants of this *frazione* (hamlet) consider themselves to be from Serino, its municipal administrative center.

3. The name one gives the events of 1965 reflects one's ideological and social perspective, of course. "Rebellion" acknowledges the element of social protest that led to the community's uprising. Both terms have been used within and outside the community. In November 2013, the Watts Village Theater Company staged a play in the Mafundi Auditorium entitled "Riot/Rebellion" (written by Donald Jolly and directed by Barbara Roberts), about the times and circumstances surrounding the historic events, based on oral history research with living witnesses to them.

4. His grave marker reads 1875–1965, but his Rivottoli, Sant'Antonio, parish baptismal certificate notes that he was born February 12, 1879, and delivered by godmother (*matrina*) and midwife Rafaella Viola. (His parents' names were Francesco Rodia and Nicoletta Cirino Rodia.) Rodia believed his birthday to be April 15, 1875, and it was celebrated as such in the family. Do we attribute this oscillation to oral tradition, senescence, or in part to Italian cultural practice? Further, having died around midnight, between July 16 and 17, his date of death also oscillates between the two, although the funeral home document records it as July 17. Variation in dating has some important implications for evaluating key aspects of Rodia's biography, starting with his age at time of emigration in 1890: Was he a boy of 11–12 or 14 (as he himself repeatedly stated)?

To accept his age as 14 at time of emigration, we must presume that he embarked not in 1890 but 1892–93 (although there is no Ellis Island record of a Sabato arriving during these years). If we posit an Italian practice of calculating age, which (from an Anglo-American perspective) makes one a full year older—because Italians distinguish between a year completed and the year into which one is entering (e.g., "13 anni compiuti, entrati nei 14")—Rodia may have completed his 13th year at the time of departure from Italy and, entering his 14th year, referred to his age as 14, following Italian custom. Rodia would have had to emigrate between February 12, 1892, and February 12, 1893, to have considered himself a 14-year old on the date of departure. Either Rodia was mistaken about his year of birth and perpetuated the incorrect date as 1875 (hence considering himself a 14-year-old when he left Italy), or the parish records themselves are incorrect (which is not likely). That Rodia may not have been clear on all the facts of his own life is not atypical in predominantly oral societies. Family oral tradition could conflict with legal tradition and be revealed only at the time of death, emigration, or other "bureaucratic" moment, when legal documents were required. See Del Giudice, this volume, n. 5.

5. Was Rodia sent to America to avoid conscription into a newly unified nation's army (as Sullivan, in *I Build the Tower*, maintains, despite the fact that Rodia was only 12–14 years old when he departed for America)? Or were his parents trying to remove him from a milieu of violence? (For example, Rodia's brother-in-law Saverio Colacurcio (Calicura) maintained that Sabato Rodia served eight months in jail in Italy for stabbing a cousin; see Appendix A.6, Letter to the CSRTW, by Claudio Segre.) Or did the Rodias wish to give their children economic prospects not possible in Italy? In the late nineteenth century, there seems to have been a local panic concerning the future of the Sabato Valley: Naples was purportedly to take ever larger quantities of the region's most precious natural resource—water—thereby threatening to leave the valley high and dry. Or so ran rumor and fear, disseminated by local civic authorities. The fact is, the entire South of Italy was to be thrown into deep economic crisis as a result of Unification. A convergence of these factors likely led to the Rodias' decision. They were among the earliest to emigrate, in any case.

6. See the chapter on Rodia in the forthcoming volume on art and trauma by Daniel Wojcik, *Outsider Art Realms: Visionary Worlds, Trauma, and Transformation.* Jackson: University Press of Mississippi.

7. Those recently-deceased include: Nicholas King (d. April 23, 2012), Bud Goldstone (d. September 13, 2012), and William Cartwright (d. June 1, 2013).

8. For example, in the late 2000s, the city designated a "Via Italia" in San Pedro (Los Angeles has since become a sister city of Ischia, Italy), although Italians had already claimed their place in the historic heart of the Pueblo of Los Angeles (Olvera Street) on the invitation of then-curator of the El Pueblo Historic Monument Jean Bruce Poole, and thanks to the early efforts of Maria Luisa Cooper and historian Gloria Ricci Lothrop. Since the 1990s, the local Italian American community has been engaged in renovating the historic Italian Hall, soon to open as the Italian American Museum of Los Angeles under Marianna Gatto.

9. On the occasion of the 50th anniversary of the "stress test," Los Angeles mayor Antonio Villaraigosa issued a proclamation commending the CSRTW (as Mayor Tom Bradley had done on its 25th anniversary, with a parchment beginning "Happiness Is"—which has recently apparently gone missing from UCLA Library Special Collections). And on Monday, October 18, 2010, at the Istituto Italiano di Cultura, in Westwood, Cartwright, Goldstone, Morgan, and King were publically recognized by Consul General of Italy Nicola Faganello, for their role in saving this significant work by an Italian immigrant from destruction. Cartwright alone was in attendance.

10. Rodia himself said as much, according to William (Bill) Hale's 1953 encounter with him: "Towers as representative of all the cultures; 'all the people.' All who contribute to our whole world. All his work is in dedication to people—Chinese ceramics are a bow to the Chinese. Japanese things to the Japanese. Italian marble. Roman symbols. Lot of this he dedicates to the Romans" (see Appendix A.2, Interview with Simon Rodia, by William Hale and Ray Wisniewsky).

11. "Migrating Towers: The *Gigli* of Nola and Beyond," Charles Mingus Youth Arts Center, September 25, 2010–April 4, 2011, a photographic exhibition on this topic, co-curated by Ballacchino and Ceparano, itself "migrated" to the John D. Calandra Italian American Institute in New York, opening to coincide with the *Giglio* of New York in 2011, and was on view from June 22 to August 19, 2011. See also Ballacchino's and Ceparano's essays, this volume.

12. On December 4, 2013, the Gigli di Nola, after several attempts over the span of at least a decade, were finally inscribed on the UNESCO World registry of Intangible Cultural Heritage, along with other "macchine a spalla" (largescale festival structures carried on shoulders). The other spire-based festivities included in this first collective Italian candidacy are: the Candelieri of Sassari (Sardinia), the Varia of Palmi (Calabria) and the Macchina di Santa Rosa of Viterbo (Lazio).

13. Artifacts from that history were the subject of an exhibition co-curated by Luisa Del Giudice and Susan D. Anderson in UCLA's Powell Library (see Appendix D.5), a selection of which are also published here for the first time in Appendix A2.

14. On painted and metal ex-votos, see for example, the recent publication Briscese and Sciorra (eds.) (2011), which treats the Italian ex-voto collection of Leonard Primiano. I expand the notion by considering how Rodia's work might be viewed within the context of this Italian devotional practice.

15. Although neither writing is included in this volume, their position, articulated in oral presentations during both conferences (and published in volume *Fuori cornice*), form a significant point of reference for several of the essays presented here.

16. Did such resistance and outright disdain represent yet another example of the missing narrative of Italian diaspora history and culture from Italian academic discourse ("il rimosso"—"the repressed"—according to some)? Or might it represent a legacy of exceedingly resistant class bias against southern Italian peasants and immigrants—despite attempts by Italian American scholars to identify and counter such biases in research, writing, and public programs? Conversely, the comment could express a legitimate (and unspoken) fear of awakening Italian nativist identity politics and essentializing discourses, resurgent today on the European political Right. Indeed, we are witnessing a rise in fascist activity, racism, and xenophobia (e.g., against so-called *extra-communitari*, "those outside the community" of the European Union). But the situation was quite the reverse for early Italians in America, who were discriminated against and have (for a host of reasons) been cut off from their own histories, especially from those narratives that recognize their past as peasants and migrant workers. Rodia's own words confirmed his general sympathy for the plight of workers and immigrants.

17. The issue of who constitutes the community of Watts, whether it can speak with one voice, and who is accorded voice within the community and arts center is frequently unspoken yet palpable. The large and growing Latino demographic is rarely represented within WTAC programs. The annual Day of the Drum music festival, however, seems to serve as a sort of multicultural "catch-all," regularly featuring Japanese, Native American, Latino, and, more recently, Italian and Italian American performers. The official face of Watts and of its key institutions is still largely African American.

18. In the early twentieth century, Watts was considered to be something of a backwater. Mencken, in exploring other "joke-towns" such as Podunk, Squedunk, Hohokus, Goose Hill, and Hard-Scrabble, concludes: "Almost every large American city is provided with such a neighbor. . . . For many years *Hoboken* was the joke-town of New York, Watts was that of Los Angeles" (Mencken [1919] 1938: 553). In support of this thesis is the fact that the "gang" or "club" of Watts wore overalls and were known as the "Watts Farmers," as opposed to neighboring "Slauson Businessmen" (Linden Beckford Jr., local historian, personal communication, March 28, 2009, at the meeting of the Southwest Oral History Association, held at the University of Southern California).

19. Some poignant films addressing Watts's social problems were produced during this period. I thank the Downey Historical Society for providing copies of these: *Felicia* (Roe 1965) tells the story of a junior in high school reflecting on her life and expressing the desire to better herself and the community of Watts. The film portrays those who had given up, as well as a younger generation that had not. Another film (with photography by Les Blank), *Watts Towers Theatre Workshop*, follows Steven Kyle Kent (a University of Southern California drama major and teacher of communications skills and improvisation) and his 1965 Watts Towers Theatre Workshop for teenagers (part of "Join for the Arts, Inc."). The film seeks to present raw energy and violence "just like Watts," together with the need to mentally transcend the limitations of living in Watts. "If you really don't want to do nothing in life, Watts is the place for it," one of the teenagers memorably states, starkly adding: "I hate Watts."

20. There were other areas of conflict internal to the CSRTW. For example, in her essay, Morgan contends that Seymour Rosen, one of the key proponents in the Campaign to Save the Watts Towers in 1959 and founder of SPACES (Saving and Preserving Arts and Cultural Environments) transferred CSRTW materials to the new archive while he was still CSRTW chair, thus weakening the Committee. Hernández (who inherited the directorship from Rosen) alludes to complex personal dynamics between early members that have not yet fully been explored, but also adds that Rosen was more interested in fieldwork and photography than organizational administration, and thus was likely uneager to stay atop of the paperwork two entities would have required (personal communication, December 21, 2013).

21. "Los Angeles is the uncontested gang capital of the world. About 720 gangs call Los Angeles home, according to a 2006 gang study commissioned by the city council. And despite 23 anti-gang programs, $82 million spent, gang violence in the city overall rose by 14% in 2006, while in South Los Angeles, by 25%" (Foote 2008: 91).

22. The controversy over the campus's development pits those for and those against a skateboard park. As I stated in letters written to Mayor Villaraigosa, Councilwoman Janice Hahn, and then to her successor, Joe Buscaino: "The campus is actively engaged through its adjacent Arts Center in encouraging the youth of the area in the direction of creative self-expression through art classes, music programs, major festivals and cultural programs. *This* is the sort of 'common ground' we should be encouraging on the Watts Towers campus. *This* is the mission we should be enhancing. A skateboard park simply does not contribute to this mission. Instead, a skateboard park (as many Watts residents could attest) would create distraction, noise, potential conflict, and be in direct opposition to maintaining an island of peace, artistic beauty, contemplation, and creative self-expression. . . . Local, no less than national and international, communities look with dismay on the skateboard proposal, and hope for responsible leadership in this matter. Please re-consider the location of the skateboard park."

23. Arceneaux has since stepped down as its executive director (see Finkel 2012).

24. In the CSRTW files, we note how the Committee was at times judged by Watts residents to represent outsider elites from Hollywood and the Westside. The Committee itself referred to the social divide as "uptown/downtown." To facilitate this geographic and social divide, one suggestion was to meet midtown, at St. John's Episcopal Church, acknowledging that it was as scary for a black resident of Watts to come to the Westside, as it was for a white Westsider to go to Watts. The Common Ground Initiative sought to do precisely that: bring Westwood to Watts and Watts to Westwood.

25. Rosen recalled in the book *In Celebration of Ourselves* (1979) that although the Arts Center had proved to be a crucial local resource, its mission over time had become too narrowly focused on the immediate community, to the exclusion of sustaining interest in the Towers themselves. "When you go into the center, there are no books on outsider art. There is no larger context for the work. . . . There is very little that would be of interest to the outside world." Margie Reese, former general manager of the city's Cultural Affairs Department, stated the opposite concern: "My frustration is explaining to people that the Watts Towers as a tourism destination right now is a fallacy. . . . Once I've taken the tour and seen the glamorous towers, I'm still curious. I want to know about the community that surrounds this icon. In my mind the story is unfinished." There may be little to appeal to outsiders, according to Reese, but much to be concerned about, especially the conditions and needs of the residents who live there.

26. Former Arts Center director, John Outterbridge recalled that on one occasion a large church group arrived in buses and that the minister accompanying the group explained that the artist was a black man. Such reinterpretations, Outterbridge contends, are a clear sign of the site's ongoing vitality, and he was heartened during the many years he worked there to see people "reinvent the story of the Towers as they embraced them in their own way."

27. For example, WTAC as a predominantly black community arts center has for decades presented the Simon Rodia Day of the Drum (since 1981) and Jazz (since 1976) Music Festivals as expressions of African and African American musical cultures (see, e.g., Gilmore 1989; Hooks and Sharpe 2005; Isoardi 2006; *The Watts Towers: 50 Years of Inspiring Art, 1959–2009*), although the Drum Festival has, in time, come to include other ethnic musical traditions.

28. The discourse around the Watts Towers as "sacred space" has become increasingly more explicit: see Davis and Rauner 2006; Paul Harris (in the 2005 McNamara film *Watts Towers* and in this volume); or Augustine Aguirre, in "Artists in Conversation."

29. There are other Rodian pilgrimage sites on the California map, especially Martinez. It took two trips to the police station, many calls to the St. Catherine of Siena parish office (in order to procure a key to the cemetery gate), and finally a call to its custodian, who guided my husband and me to the grave site (via cell phone directions), before we were able to visit Rodia's resting place on a visit in 2010. I stood by the graveside to pay the elusive Sabato Rodia/Uncle Sam my respects and express gratitude.

30. The issue of "encroachment" and boundaries is a sensitive one, I will admit, but anecdotal evidence and personal experience suggest that many have experienced the Watts Towers campus as a highly regulated one, where visitors (especially journalists, scholars and filmmakers) are kept on a short tether and where recorded word and image are carefully monitored. This wary gatekeeping role the WTAC has assumed in recent years seems at times to discourage rather than welcome outsiders and unwittingly to counter "common ground" efforts.

31. On the final day of the Watts Towers Common Ground Initiative, at its very closing reception, a fierce storm struck the plane tree in front of the Watts Towers Arts Center, bringing it crashing down on the roof. The remaining three-branch stubbed trunk has since been transformed into an art piece (featuring three towers) by Charles Dickson.

32. Italian Consul General Mario Tedeschi supported the 1959 campaign by writing a letter on the Towers' behalf (see online Appendix B.2, "Campaign to Save the Watts Towers"). Mayor of Serino Armando Ingino provided a commemorative plaque of their native son to Councilwoman Janice Hahn on April 14, 2003 (postponed from its original September 26, 2001, date because of the events of September 11; communication of Mariella Salvatori, of the consular office, 2008. But it has largely been since 2005 that Italian authorities have paid closer attention to the legacy of the Towers and have become more directly involved with them and the WTAC administration—beginning with Consul Diego Brasioli, who, along with Clara Celati (of the Istituto Italiano di Cultura - the Italian Cultural Institute [IIC]), addressed the public at the Leo Politi exhibition opening at the WTAC. Brasioli began to enthusiastically count the Watts Towers among the significant contributions Italians had made to Los Angeles, writing on May 26, 2004: "Italy is present in three of the great landmarks of Los Angeles: the visionary Watts Towers, built by the Italian artist Simone [*sic*] Rodia; the Getty Center, with its "travertine" marble from Tivoli and the stunning collection of Roman antiques and Renaissance masterpieces; and the Walt Disney Concert Hall, with its titanium-steel curvaceous shell, designed by Frank Gehry and entirely made in Italy" (http://www.ilsegnalibro.com/weblog2 /2004_05_01_archive.html) Giuseppina Candia, acting director of the IIC, continued the Italian pres-

ence at the WTAC by organizing the Francesco Perilli exhibition *Neutralismo* in 2006. Consul Nicola Faganello also sponsored the Common Ground Initiative, personally assisted the St. Joseph's Day communal table efforts in Watts, and facilitated the "Watts Towers in Italy" programs during the summer of 2011. Consul Giuseppe Perrone and IIC director Alberto di Mauro continued to promote the Towers and to contribute Italian programs to the WTAC's music festivals. On April 3, 2013, Italian ambassador Claudio Bisogniero made an official visit to the Towers. (See Appendix D.7 for images of these events.) Further, it is worth noting, that the IIC has lent support to and helped sponsor this very publication.

33. The growing interest of Italian academics in the Watts Towers may be seen in Dal Lago and Giordano 2009 and Mina 2011 (see also Del Giudice 2011).

34. For example, WTAC director Rosie Lee Hooks and I engaged in several "Watts Towers in Italy" programs during the summer of 2011 in Rome, Ischia, and Nola, culminating in Rodia's native Rivottoli (see Afterword). And several Italian and Italian American programs have taken place at the WTAC itself, including exhibitions (e.g., Leo Politi in 2005, Francesco Perilli in 2006, "Migrating Towers" in 2010); a performance by the Mediterranean Italian music ensemble Musicàntica in 2010; a reading by Mary Bucci Bush from her 2011 novel *Sweet Hope* in 2012; and, for the first time in the history of the Simon Rodia Watts Towers Jazz Festival, the participation of an Italian jazz musician, Andrea Marcelli Trio, in 2012. In 2013, Alessandra Belloni of New York, performed the ritual healing pizzica music of tarantismo at the Drum festival.

Local Art, Global Issues: Tales of Survival and Demise Among Contemporary Art Environments JO FARB HERNÁNDEZ

NOTE: Unless otherwise indicated, all photographs are © Jo Farb Hernández

1. Portions of these thoughts have been previously published in Hernández (2005 and 2013).

2. Saving and Preserving Arts and Cultural Environments (SPACES) grew out of the group of concerned citizens who informally banded together in 1959 as the Committee for Simon Rodia's Towers in Watts (CSRTW) to save the Watts Towers from the city of Los Angeles's efforts to demolish them. SPACES was formally organized in 1969 and received its nonprofit status in 1978. Originally based in Los Angeles, it is now located in Aptos, California, and directed by the author. It is recognized internationally as the largest and most complete archives on art environments and other self-taught artistic activity. See Morgan, this volume, for her thoughts on the relationship between CSRTW and SPACES.

3. There are no reliable figures for how many such art environments (extant or destroyed) have been created all over the globe. Records in the SPACES archives count more than nine hundred sites in the United States alone.

4. The number of art environment builders who are male is exponentially higher than those who are female, although the latter have created some extraordinary sites (Tressa "Grandma" Prisbrey's Bottle Village in Simi Valley, California, and Helen Martin's Camel Yard and Owl House in Nieu Bethesda, Eastern Cape, South Africa, are among two that are particularly compelling). My hypothesis explaining this disparity is that while men may retire from their decades-long vocation—be it farmer, sailor, construction worker, or something else—and then feel the need to fill their newly available leisure time with an alternative activity, women—particularly those who marry and raise families—are rarely able to "retire" in the same way, and thus tend not to achieve the level of free time necessary to create such labor-intensive sites over such prolonged time periods. The bulk of Prisbrey's work, for example, was undertaken after the death of her husband and most of her children; Martin never married. Exceptions to this theory, of course, do exist.

5. Rodia is one of the very few artists who has been documented as separating himself from his environment prior to such incapacity. Although he gave different reasons to different people at different times for leaving his Los Angeles property, during his 1961 presentation at the University of California, Berkeley, he indicated that his increasing frustration with the changing neighborhood and the escalating petty "attacks" on the Towers pushed his level of irritation to so high a level that he chose not to remain and watch the slow dissolution that he anticipated and feared. "Los Angeles change. That's

why I leave. They steal my things. Clothes, radio. Children break the Towers no good," he said. Quoted in an unpublished manuscript attached to a letter from Claudio Segre to N. J. "Bud" Goldstone, Committee for Simon Rodia's Towers in Watts, January 26, 1962, SPACES archives.

6. Described by Schwitters himself as his "life's work," this constructivist-inspired space was actually begun three separate times in three different countries, the first in his family home in Hannover, Germany. Conceptualized as a work that would never be completed and that would embrace all of the arts, the "spoils and relics" that formed its basis were continually being covered up with new acquisitions, so that, as with "outsider" art environments, the site required a time-based approach to study. There are numerous publications on or including the *Merzbau*; further specifics may also be found on the Web site www.merzbau.org.

7. In a special exhibition on assemblage, Rodia's Towers were featured alongside works by such famed mainstream artists as Picasso, Braque, Gris, Man Ray, Duchamp, Schwitters, and Cornell (Seitz 1961). The following year, a display of Seymour Rosen's photographs of Rodia's Towers was installed at the Los Angeles County Museum of Art, the first exhibition devoted solely to art environments.

8. Until the mid-1980s, even those museums with major collections of historical folk art did not seek to acquire twentieth-century materials, in all likelihood because the formalist qualities of the former that were so appealing to curators and collectors were not replicated in newer works reflecting contemporary aesthetics. More recently, however, a few museums have begun to add pieces removed from art environments to their permanent collections. In almost every instance, this process has engendered debate about contextual issues, with the ideal of maintaining the complete work in situ challenged by the increased protection (at least parts of) the environment would be afforded by removing the items to a climate-controlled facility. Related concerns include the irrefutable change to the art environment if it is statically maintained and frozen on-site at a given moment in time, no longer a work in progress constantly in flux and dependent on the artist's changing visions. U.S. institutions that have such works in their collections include the American Folk Art Museum in New York City; the American Visionary Art Museum in Baltimore; the High Museum in Atlanta; the John Michael Kohler Arts Center in Sheboygan, Wisconsin; the Lehigh University Art Galleries in Bethlehem, Pennsylvania: the Milwaukee Art Museum; the Oakland Museum of California; and the Smithsonian American Art Museum (formerly the National Museum of American Art) in Washington, D.C. Public collections in Europe and Asia also include the works of environmental artists; for further information, see Maizels (2009).

9. The built landscapes of the "common man" were rarely commented on in historical published materials; authors tended to focus on the extravagant or fanciful architectural or garden whimsies of the aristocracy. Several recent books on follies have included a few more "vernacular" sites, but still tend to focus on the commissioned structures of the wealthy. Midcentury compilations include Jones (1953) and Lancaster (1960).

10. These artists were described as "primitives" by Seitz (1961: 72–73). This term, now considered pejorative, continues to be used, although less often than earlier.

11. Artist Mark Bulwinkle, quoted in Crease and Mann (1983: 91).

12. See, for example, Evans 1972; Ferris 1982; and Relph 1976.

13. French philosopher Denis Diderot (1713–84) proposed that during periods of creativity an artist "passes into an uncontrollable state which must be classified as pathological insanity, only to emerge again into the clear light of reason" after this period has passed. From *Pensées Philosophiques: Oeuvres Complètes de Diderot* (Paris: 1875), quoted in Gisbourne (1994: 245).

14. Quoted in Laporte et al. (1962: 11).

15. Jazz musician Charles Mingus, growing up in the neighborhood, is one of those who watched Rodia build. See his autobiography (Mingus 1991: 37).

16. Most egregiously, Jean Dubuffet's appropriation of the conceptual, physical, and aesthetic creations of the self-taught French artist Gaston Chaissac (1910–64) stands out. For further information on other such links, see, for example, Tuchman and Eliel (1992).

17. This is thoroughly discussed, for example, in Burger (1984: 72).

18. Regarding André Breton, surrealism, and Cheval, see, for example, Conley (2006). For an account of the situationist ideology and such "outsider architecture" as Cheval's *Palais*, see, for example, Montpied (2000–1).

19. Numerous other artists, particularly those whose work could be included in the pop art genre, from Red Grooms to Niki de Saint-Phalle, were also heavily and specifically influenced by Cheval's *Palais.*

20. For example, in the first major exhibition of American art environments, *Naives and Visionaries*, installed at Minneapolis's Walker Art Center in 1974, Director Martin Friedman makes specific reference to Gaudí's *Sagrada Familia* temple when discussing Rodia's Towers (Friedman et al. 1974).

21. Folklorist Joseph Sciorra has done important work documenting innumerable lesser-known and more "modest" yard shrines, birdbaths, and fountains of Italian immigrants (see Sciorra 1989). Additional comments on the propensity of Italian Americans to decorate homes and yards are found in Sheehy (1998). See particularly chapter 5, "Neighborhood and Nation: Shared and Distinctive Practices in American Yard Art."

22. I am grateful to the Fulbright Commission for granting me a Senior Scholar Research Award in 2007–8 to research and document Spanish art environments.

23. The word *capricho,* or whim, is used both in its playful sense and in a darker, more sarcastic sense, such as in the suite of eighty etchings published by fellow Spaniard Francisco Goya beginning in 1799. González Gragera, whose nickname "Cotrina" was also used by his grandfather, a shoemaker, uses this term to describe his art environment in the first sense, of being a caprice or a playful whimsy.

24. On-site field research on Francisco González Gragera's work was carried out during July 2003, April 2008, and September 2011, with additional investigation carried out by telephone and mail from 2008 to the present.

25. On-site field research on Justo Gallego Martínez's cathedral was carried out during April 2008.

26. The Basilica-Cathedral of Our Lady of the Pillar is in Zaragoza, capital of the Spanish province of Aragón; it honors the only apparition of Mary prior to her Assumption, seen by the apostle Saint James, who is himself honored as bringing the Gospel to Spain. Baroque in style, the Basilica-Cathedral was the first chapel built to honor Mary, and its present form was constructed primarily between 1681 and 1872.

27. Comments by Flora Saura, spokesperson for the Mejorada del Campo municipality, quoted in Giles 2006.

28. On-site field research on Francisco del Rio Cuenca's *Casa de las Conchas* was carried out during April 2008 and March 2009.

29. On-site field research at José María Garrido's Museo del Mar was carried out during March 2009.

30. Garrido's finds included objects of such historical or archeological significance that at least one scholarly document has been written based on the primary materials in his collection. See de Amores Carredano and Lloret Marín (1995).

31. On-site field research at Julio Basanta's site was carried out during May 2008, March 2009, and July 2010.

32. On-site field research on Josep Pujiula i Vila's work has taken place fairly continuously from 2000 to the present. Between annual on-site visits, I have corresponded with the artist and members of his immediate family through telephone, e-mail, and post.

33. For example, Fred Smith (1886–1976) of Phillips, Wisconsin, included statues commemorating a famous local double wedding, his hardworking logger buddies, a prize-weight muskie fish, and local Indian elders among the more than two hundred figures in his Wisconsin Concrete Park. Smith's work, which was purchased by the nonprofit Kohler Foundation and gifted to the county in which it is located, is thoroughly treated in Stone and Zanzi (1991, 1993).

34. Samuel P. Dinsmoor (1843–1932) of Lucas, Kansas, may be one of the better-known environmental artists who utilized his constructions as an opportunity to voice his social and economic views. The complex figurative sculptures surrounding his "stone log cabin home" propound his populist opinions on labor, banking, government, and religion. An early but still complete account of Dinsmoor's Garden of Eden may be found in Blasdel and Larson's essay in Friedman (1974), as well as in Dinsmoor's (n.d.) self-published account, *Pictorial History of the Cabin Home*; a reprint of the original pamphlet is available at the site.

35. Howard Finster's (1915–2001) Paradise Garden in Pennville, Georgia; Father Mathias Wernerus's (1873–1931) grottoes in the Holy Ghost Park in Dickeyville, Wisconsin; and Leonard Knight's (1931–2014) Salvation Mountain near Niland, California, are but three examples of extensive environments

created with the intent to enhance worship and religious fervor. As Baptist preacher Finster is quoted as having said, "One night I asked what I had preached on that morning and everybody forgot my message. And that's why I decided to build my garden, so they can't forget" (Doss 2000: 69). For additional information on the Midwestern sites, see Stone and Zanzi (1993); for Finster, see Peacock (1996); for Knight, see Yust and Knight (1998).

36. I am not contending that Pujiula is the only artist without a paramount, central conceptual overlay. French postman Ferdinand Cheval's (1836–1924) Ideal Palace in Hauterives, France; Nek Chand's (b. 1924) vast expanse of figures in his rock garden in Chandigarh, India; and Sabato Rodia's (1879–1965) Towers in the Watts area of Los Angeles are only a few examples of creators inspired by more personal experiences or the desire to leave their mark. For Cheval, see Jouve, Prévost, and Prévost (1981); for Chand, see Aulahk (1986); for Rodia, see my article (Hernández, 2001). John Maizels's *Fantasy Worlds* (1999) provides a good introduction to a variety of art environments.

37. It is ironic that the destruction so polarized the village of Argelaguer that it became a major issue in the next mayoral campaign. Pere Oliveras, the mayor who forced its dismantling, declined to stand for reelection and later admitted that he regretted his actions.

38. A major campaign was launched by SPACES, at that time headed by founding director Seymour Rosen and headquartered in Los Angeles, with the help of the UK-based journal *Raw Vision* and Randall Morris's outsider art Listserv, based in New York City.

39. Given the tremendous amount of publicity that Pujiula's works have received over the past decade, the municipal and regional authorities are now much less cavalier about insisting on destruction, despite the legal mandates. In fact, they appear to be searching for a solution that, while addressing their concerns—particularly those related to public security and safety—will enable what remains of the art environment to be preserved.

40. See comments, for example, in Bryan (1967: 6).

41. Seymour Rosen, personal communication with author, March 11, 2001.

42. I have chosen not to treat the issues of the commodification of "outsider" art in this essay, as it is worthy of significant and in-depth study on its own. But surely the fact that art environments are as a whole immobile has contributed to society's generally casual response to these sites, as market value tends to be equated with aesthetic or cultural value. Art critic Jerry Cullum (1998: 14) somewhat caustically remarks that "the market has behaved towards them as it does towards inconveniently situated art in archeological sites: either it has carved up their constituent parts like Mayan or Cambodian temple friezes, or it has bulldozed the whole location out of existence because it didn't recognize anything readily salable." Jeanne Morgan (1984: 75), indefatigable defender of the Watts Towers and original member of the CSRTW, hypothesizes that one reason onlookers looked negatively on Rodia's work— and one could extrapolate here to most art environment builders—is that his long hours and painstaking labors had no commercial or monetary objective but were created to fulfill personal and aesthetic goals, thus showing an "alarming lack of respect," she suggests, "for ordinary community values."

Sam Rodia's Watts Towers in Six Sections in Succession PAUL A. HARRIS

1. Rodia's work, begun decades before Jean Dubuffet coined the term, came to be seen as a forerunner of the form, particularly inspiring many members of the California Assemblage movement. Museum of Modern Art curator William Seitz, in his seminal 1961 book *The Art of Assemblage*, speaks of Rodia's "innate artistry," "evident everywhere in masterful contrasts and analogies of sizes and textures, manmade and natural materials, organic and geometric form" (cited in Goldstone and Paquin Goldstone 1977: 18). In my view, Seitz's well-intended but somewhat condescending reference to Rodia's "innate artistry" seriously underestimates the sculptural, architectural, and conceptual sophistication displayed by the Watts Towers.

Without Precedent: The Watts Towers THOMAS HARRISON

1. Calvino [1965] 1968: 146; cf. Paul Valéry's (1960: 549) saying that poetry is at bottom "the development of an exclamation."

2. These statements and a good deal more by Sam, or Simon, or (his christened name) Sabato Rodia are recorded in the captivating 2006 film documentary by Edward Landler and Brad Byer, *I Build the Tower*.

3. The likelihood of Fellini's knowing of the Watts Towers is less remote than it may seem considering that Simon Rodia was familiar enough a figure by 1967 to be featured in the company of Marlon Brando, Karl Marx, Sigmund Freud, Marilyn Monroe, and dozens of other cultural celebrities on the cover of rock music's most famous album: the Beatles' *Sgt. Pepper's Lonely Hearts Club Band*. Rodia stands in the back, in the third row, just to the left of Bob Dylan. One might even wonder whether Calvino's story about the construction of the mollusk's spiral shell (*The Cosmicomics* was published in 1965) bears reference to the story of Rodia and his Towers.

4. Although it has been noted that the phrase *nuestro pueblo* is underwritten (intentionally or not) by the original name of Los Angeles—El Pueblo de Nuestra Señora de los Angeles de la Porciúncula— what has been left in the dark is the uncanny relationship between the cultural origin of the city name (which is St. Francis's *porziuncola* outside of Assisi) and the *pueblo* built by Rodia. The story is this. The settlement of Los Angeles dates back to 1781 at a location along a "beautiful river" that had been spotted by the Franciscan missionary friar Juan Crespi in August of 1769. Laying eyes on this river, Crespi immediately christened it *Nuestra Señora de los Angeles de la Porciúncula*. The name commemorated the fact that the date of the sighting—August 2—coincided with the annual feast of St. Francis's *Perdono* at the little chapel of the *porziuncola* ("very small parcel of land") on the outskirts of Assisi. This chapel had been given to Francis in a condition of complete disrepair in 1208 by Benedictine monks and apparently contained a fresco behind the altar depicting the Virgin Mary surrounded by angels. This is how the chapel henceforth came to be known: Santa Maria degli Angeli alla Porziuncola (in Spanish: *Nuestra Señora de los Angeles de la Porciúncula*).

Now legend has it that the chapel had originally been built in the fourth century by outsiders to the area—hermits from the Valley of Josaphat—around relics they had brought to Italy from the grave of the Blessed Virgin. Iconographically, her ascent into heaven was often represented as accompanied by angels (as was presumably the case in the chapel's fresco). According to some reports of the time, even the singing of angels was frequently heard at the *porziuncola*. Whatever the real story about how the *porziuncola* came to be associated with Our Lady of the Angels, what is beyond doubt is that Francis rebuilt the rundown chapel with his bare hands. Later, as he gained followers, the *porziuncola* turned into a small *pueblo*, gathering the community of his small order of friars. (For a vivid depiction of life on the *porziuncola*, see Roberto Rossellini's *Francesco, giullare di Dio*, 1950.To be sure, it was a different "chapel" that Simon Rodia built with his own hands, yet still a place at which some witnesses said that baptisms and weddings were celebrated. Simon's work was accompanied not by the singing of angels but by the voices of Italian opera, one of them his own and others booming from his gramophone as he worked up in the Towers. One can only wonder whether Rodia was familiar with the story behind the city in which he lived—El Pueblo de Nuestra Señora—when he named his own mini-village *Nuestro Pueblo* and whether he knew about the *porziuncola*'s small, utopian society of Franciscan friars, and about how the chapel was restored by hand, and about the reports of singing angels.

5. The public "uneasiness or hostility" toward Rodia's work, reflects what one of the Towers' earliest defenders, Jeanne Morgan (1984: 74–75), has called "an inevitable response to Rodia's total freedom from any intent or hope of monetary gain." More recently, we have discovered that the hostility was also nourished by a municipal designation of Watts as a slum-clearance area, with almost 3,000 properties next to the Towers slated to be razed to the ground in keeping with "a program 'to clean up slum and blight conditions'" in Los Angeles (Schrank 2000: 376).

6. This curiosity is revealed in Landler and Byer's film, *I Build the Tower*. Landler confirms in personal correspondence (June 10, 2009) that this student, Tony Vellani, had the story about this other compelling property straight from Rodia during the making of William Hale's film in 1953. Landler's co-filmmaker and Rodia relative, Byer, received corroborating reports about Rodia searching for a triangular lot from his family in Martinez, where Rodia went to live after leaving Los Angeles.

7. The lot immediately to the left of the one Rodia considered buying was purchased in 2006 for no less than $500 million, making it the second most expensive property sale in the history of Southern California. The buyer was reported by the *Los Angeles Times* to be committing an additional $500 million to building a luxury condominium on the site. See Roger Vincent, "In Beverly Hills, High End Indeed," *Los Angeles Times*, April 11, 2007, http://articles.latimes.com/2007/apr/11/business/fi-luxury11.

8. In the film *The Towers* we can observe Rodia bending his steel rails into semicircles by slipping them under the railroad tracks and pulling upward. This additional function of the train tracks lends an interesting twist to Paul A. Harris's suggestive reading of *Nuestro Pueblo* as Deleuzian "folding architecture," where the inside of a structure incorporates its outside (Harris 2005).

9. On the vicissitudes of the Towers' relationship to the municipal politics of Los Angeles, see the recent studies of Schrank 2008 (one of which is reprinted in this volume). On the history and cultural politics of Watts, see Ray 1985, Whiteson 1989, and Sides 2004.

10. Calvin Trillin, one of the first journalists to report responsibly on the Towers (1965), began the second of his two articles for the *New Yorker* by noting that it is not ironic, but perfectly appropriate and exemplary, that these Towers stand in Watts—for their entire history is one of "not fitting in" (Trillin 1971: 136). Six years earlier, Trillin had already seen the structures as presenting "the aspect of a world that has no relation to the drab row of bungalows across the street" (Trillin 1965: 77). Analogously, the critic Beardsley argued that vernacular art environments like the Watts Towers always bear witness to that "uneasy relationship between the individual and the community" that is one of America's "deepest social paradoxes" (1995: 189). Rodia's sculpture was also and no less emphatically an offering, reaching over to fellow immigrants and denizens of Watts by way of the *nuestro* preceding the *pueblo*.

11. Cardinal's influential idea of outsider art (1972) grew out of his reflections on the collections and criticism of *art brut* by the French painter Jean Dubuffet (who went on to declare the Watts Towers "the greatest work of art in America" and Rodia "more important than Matisse" (in Rose 1974). Dubuffet's specific criteria for *art brut*, according to Cardinal, were that "[t]he artist shall be innocent of pictorial influences and perfectly untutored; he shall be socially nonconformist, even to the point of diverging violently from the psychological norm . . . and he shall not cater for a public" (Cardinal 1978: 2; see also Maizels 1996). In that sense the motivation and objective of the work of such outsiders is always in some sense "without precedent," certainly more so than that of official artists (even if *not* without influence). Despite the basic soundness of this concept of the outsider artist, the scholar-artist team Dal Lago and Giordano (2008) understandably denounce its moral and aesthetic consequences, which isolate creators like Rodia "outside" the reputedly pure and institutionally controlled frames of art—outside the same frames that embrace the likes of Marcel Duchamp and Andy Warhol, who were no less transgressive and eccentric. Erika Doss gives a culturally more local spin on Rodia, reading him in terms of Greil Marcus's image of the American artist as a fixated, underground figure, a radical, unconventional individualist who is deeply committed to an "invisible republic." For Beardsley, *Nuestro Pueblo* is a symbolically alternative Los Angeles—a walled compound shutting out the world in order to rise above it, or to voyage imaginatively beyond it. Analogously perhaps, for Teresa Fiore (2004) and Dal Lago and Giordano (2008), Rodia's ship-shaped lot is a "heterotopia." It shows "resistance to assimilation into the American mainstream" and "reverses the subjugation of the exploited immigrant construction worker" (Fiore 2004: 36; see also her dissertation: Fiore 2002). Be that as it may, this particular heterotopic space is still tied to a collectivity (*Nuestro Pueblo*) and thus not altogether separate from and "other" to its urban context. The assembled sculpture embodies "both church spire and the modern skyscraper and the stalagmites, both a cactus garden and apartment buildings rising up from the ground" (Cándida Smith 1996: 31); that is to say, it incorporates and refashions features of modern urbanism and of the community in which it stands (Hernández 2001 and Banham 1971), embracing not only strong characteristics of Rodia's own heritage in southern Italy (Posen and Ward 1985) but also that of his Mexican neighbors.

12. Nor does it make sense to divorce the Towers in style, form, and intention from that "veritable Tower of Babel" that the elderly Rodia considered the United States to have become (*I Build the Tower*). An interview and article from 1951 even quotes Rodia calling his own work a Tower of Babel (Langsner 1952: 25). In that respect, its heterotopic space would be an "immanent critique" (an internal reassessment) of the culture he observed around him. Furthermore, interviews with Rodia in Martinez strongly suggest that the construction of the Towers served as an act of atonement for him, even if it remained unclear just what he had to atone for (he was always drunk, he claimed on various occasions; he was not good to his children and wife, whom he abandoned; he buried his wife under the Towers, he told a German magazine in the early 1950s [Goldstone and Paquin Goldstone 1997: 39]; he was given to having brawls with drawn knife according to Sam's none-too-friendly brother-in-law in Martinez; he may even have killed a man). Whatever his wound, Rodia implied that he was expatiating himself in building these Towers (see Sciorra's and Del Giudice's essays in this volume). You are "either good good good or bad bad bad," he harped

(*I Build the Tower*), and at some level he interpreted his Towers as an effect or enactment of spiritual conversion. A sense of these struggles with his inner demons is strongly conveyed by taped interviews and notes of meetings that Committee members had with Rodia in the early 1960s. These are now archived in the Department of Special Collections of the Young Research Library at the University of California, Los Angeles (Committee for Simon Rodia's Tower in Watts, Records 1954ff, Collection 1388). Of these, see especially Jeanne Morgan, "Visit to Simon Rodia in Martinez, California During September 1960" (October 17, 1960); and Letter to Mr. N. J. Goldstone by Claudio Segre (January 26, 1962), this volume: Appendix A.6.

An Era of Grand Ambitions: Sam Rodia and California Modernism RICHARD CÁNDIDA SMITH

1. Quoted in Los Angeles County Museum of Art (1962: 11).

2. On race relations and civil rights movements in California, see McWilliams 1943, 1949a, 1949b, and Brilliant 2010.

3. See Cándida Smith (2009b: 59–74, 130–53) for a more detailed discussion of Rodia's relationship to California modern art as practiced between 1920 and 1960.

4. Quoted in Glaser 1966: 58–59. On the influence of Stella's work on the American art world at the end of the 1950s and the beginning of the 1960s, see Fried 1965; Rubin 1970; Rosenblum 1971; and Cooper 2006.

A California Detour on the Road to Italy: The Hubcap Ranch, the Napa Valley, and Italian American Identity LAURA E. RUBERTO

1. The general premise from which this essay developed was first published on my blog (Ruberto 2008). I presented versions of this essay at the 2008 conference of the American Italian Historical Association in New Haven, Connecticut, and the 2009 Mediterranean Studies Congress in Cagliari, Sardinia. I would like to thank Dina Fachin, Teresa Fiore, Matthew Mulligan Goldstein, Richard Heyman, Phil Pasquini, and Joseph Sciorra for their useful comments on drafts of this essay; much gratitude to Luisa Del Giudice, especially for her vision of this volume as a whole.

Within and beyond the interdisciplinary field of California studies, much scholarship exists about the concept of California as an escape, as a retreat, and/or as a state that has historically been seen to accept those who want to live life outside of conventions. In addition, these images of the Golden State have been connected to (in a typical chicken-and-egg fashion) much of the artistic, innovative, and even entrepreneurial output of the state's residents. For a general history of California, which also covers the idea of the state as a modern Shangri-la, see Starr 2007. For an example of scholarship that deals specifically with creative productions, see Barron, Bernstein, and Fort 2000.

2. For discussions of terminology that may come to mind in relation to the Hubcap Ranch and other sites (folk art, outsider art, self-taught art, etc.) see, for instance, Jones 2001 or Wojcik 2008.

3. Romano Gabriel's use of wooden fruit and vegetable crates makes for another interesting link to a West Coast Italian American experience. The history of the wooden boxes, with colorful graphic designs on one side marketing the produce within, is tightly connected to the development of California's agricultural industry and to the Italian immigrants who worked within it (see Ruberto 2009).

4. A fifth Italian American site-specific environment in California is the now extinct *Capidro* concrete garden made by John Giudici in Palo Alto (see Phil Pasquini's "Capidro: A Garden of Concrete Ideas"). We might also consider the assembled space *La Casa Formica,* created by Joseph Formica in and around his El Cerrito house (mostly extinct now), the cement artichokes of Martin Dioli in Menlo Park (see Phil Pasquini's "Menlo Park, White Cement Artichokes" and Bishop et al. 2006), and Theodore Santoro's wooden sculptures, displayed on his front lawn on Easter and Christmas in Oakland (see Ruberto 2012), as likewise part of a larger narrative of self-taught Italian American artists in California.

5. Richard Cándida Smith (2009) in *The Modern Moves West: California Artists and Democratic Culture in the Twentieth Century* makes a compelling argument regarding California's relative isolation and the particular brand of modernist art that developed on the West Coast in the twentieth century, suggesting that the work of self-taught artist Sabato Rodia was, in fact, emblematic of (and at times influential to) the work produced within established California art circles of the era. Although there is no clear discussion of ethnicity (i.e., Jay De Feo's Italian ethnicity is never raised although Rodia's is), Cándida

Smith suggests that California "would be a culture where the ideal of creating something new while building on the achievements of [artists'] heritage would take root and guide the cultural activity of the future" (57), thus reinforcing the need for regional-specific ethnic studies.

6. See, for instance, Kevin Starr's *Material Dreams*, where he states Rodia was born in Rome (1991: 225). For examples of Rodia being misidentified as African American or Latino, see the interview with John Outterbridge, former director of the Watts Arts Center, in the documentary *I Build the Tower* (Landler and Byer 2006) or see Luisa Del Giudice's essay in this collection, where she describes how she came to learn more about Rodia's Italianness.

7. This is not to suggest that there is no scholarship on Italians in California (or otherwise outside of the East Coast) but rather that general histories and cultural perspectives of Italians in the United State tend to recognize the East as the de facto place where Italian American identity gets formed and understood. For studies that focus on Italians in California, see, for instance, Cinotto (2012), Di Leonardo (1984), Rolle (1999), and Sensi-Isolani and Martinelli (1998).

8. The marker, placed by the California Department of Parks and Recreation in cooperation with SPACES (Saving and Preserving Arts and Cultural Environments), reads:

> This is one of California's exceptional Twentieth Century folk art environments. Over a period of
> 30 years, Emanuele "Litto" Damonte (1892–1985), with the help of his neighbors, collected more
> than 2,000 hubcaps. All around the hubcap ranch are constructions and arrangements of hubcaps,
> bottles and pulltops which proclaim that Litto, the Pope Valley Hubcap King, was here.

9. Alongside the pull-tab garland, there was a garland of Juicy Fruit gum wrappers, now extinct.

10. The older Italian American style of the region is still apparent, but it is much more understated and less connected to the areas' more visible tourist trappings. One example of a continued presence of an older Italian American culture—although known mainly only to locals—is Clemente Cittoni's *malfatti*, which he makes for takeout only and sells out of a liquor store in downtown Napa. Customers bring their own containers, and Cittoni fills them with cooked pasta and his signature tomato sauce (Interview, Bettina Cassayre Moore, October 20, 2008).

11. The Pope Valley land was to be used as a country house for Damonte and his family, and only later did it become his permanent residence. At the same time, such a connection between the city and country, the rural and the urban, points to the many ways that the two spaces are not, in fact, in contradistinction (see Cronon 1992).

12. See Robert Louis Stevenson's *The Silverado Squatters* (2005) for a lively description of his 1880 journey from San Francisco up to the Silverado Trail and other nearby areas, including the region's early wineries.

13. Capidro's history requires more research. According to Phil Pasquini (email correspondence, February 2010), who has collected stories about Capidro from friends of the Giudici family, Giudici's son nearly drowned rather than actually drowning—nevertheless causing serious concern for the family and leading to the construction of the vernacular architecture space.

14. This concept of Italian American culture as malleable and hybrid fits nicely with Michael Owen Jones's (2001) emphasis on recognizing a distinction between a fixed material culture and in-flux, material behavior.

The *Gigli* of Nola During Rodia's Times FELICE CEPARANO

1. The Museo Etnomusicale I Gigli di Nola (the *Gigli* of Nola Ethnomusicological Museum), founded in 2000 (www.giglidinola.it),

> collects materials around the vast musical patrimony of the Feast, and [its archive] is comprised of
> LP recordings, audio-cassettes, CDs, music sheets, but also a large visual heritage of photographs
> and films, in addition to critical bibliography. A further commitment, too, has been made to
> collecting and cataloging all materials possible on the other, not less worthy, *Gigli* festivals, both
> local and international, not the least of which is the much-loved Feast of Brooklyn, proud point of
> reference for its thriving Italian American community. In addition, new museum activity has
> extended the life of the Museum beyond the merely archival: conferences, exhibitions, publica-

tions, internship programs for graduate students, collaboration with schools (through innovative projects such as "Schools Adopt a Festival"), and with established scholars, with fieldwork and interviews of producers of the festival. Not least has been the felicitous initiative of making the Feast of the *Gigli* of Nola a candidate as a UNESCO Intangible Heritage of Humanity site, in collaboration with the Neapolitan Song Archive.

[*raccoglie l'immenso patrimonio musicale della Festa, costituito da dischi, audiocassette, cd, spartiti, ma anche l'altrettanto vasto patrimonio visivo, foto e filmati oltre che la significativa bibliografia. L'impegno ulteriore e' stato quello di raccogliere e catalogare anche tutto il materiale possibile sulle altre, non meno nobili, feste dei Gigli, locali ed internazionali, non ultima l'amata Festa di Brooklyn, orgoglioso punto di riferimento per la vitalissima comunità italo-americana. Inoltre, una nuova considerazione dell'attività museale, ha esteso la vita del Museo oltre le semplici collezioni: convegni, mostre, pubblicazioni, attività di tutoraggio per laureandi, collaborazione con le scuole, attraverso progetti innovativi, quali "La scuola adotta una festa," ed affermati studiosi,interviste ed attività "sul campo" coi protagonisti della Festa. Non ultima, la felice intuizione di candidare la Festa dei Gigli di Nola come Bene del Patrimonio Immateriale dell'Umanità all'UNESCO, e l'interessante collaborazione con l'Archivio Sonoro della Canzone Napoletana.*]

2. Joseph Sciorra's communication "*Il Giglio a New York*," at the international conference held in Nola, June 24, 2002, and organized by the Ethnomusicological Museum I Gigli di Nola.

The Literary and Immigrant Contexts of Simon Rodia's Watts Towers KENNETH SCAMBRAY

1. See also Crosby (1993: 40–44) for the demographic distribution of Italians in Los Angeles.

Sabato Rodia's Towers in Watts: Art, Migration, and Italian Imaginaries LUISA DEL GIUDICE

1. Parts of this essay have been published in Italian, in a volume on Italian art environments, edited by Gabriele Mina (see Del Giudice 2011), and have been presented at several meetings, beginning in 2009—at the American Folklore Society, Boise, Idaho; Mediterranean Studies Association, Cagliari, Italy; Italian Folk Art Federation of America, Las Vegas; Southwest Oral History Association, Los Angeles; Italian American Historical Association, Baton Rouge; "Watts Towers in Italy" programs in Italy (summer of 2011)—and as a lecture for San Diego State University, California State University Northridge, and the Italian Cultural Center in San Diego in 2013. This essay is best read in conjunction with the Introduction to this volume as well as with the Afterword.

2. In some cases, the noncomprehension of Rodia by his interlocutors is almost comical, as in the Ashley-David interview (Appendix A.10) where, to be fair, the interviewer was partly distracted by the presence of her young son, Jonathan. Claudio Segre, as a co-ethnic, represents the other end of the spectrum and seems better attuned to the linguistic, familial, and cultural parameters of Rodia's life (Appendix A.6).

3. Without citing any source, Whiteson (1989) asserts that Sam was intended for the priesthood because he was called "Sabato" (meaning "Sabbath")—curious indeed, considering his family's known anticlerical leanings. Despite the fact that the Italian *Sabato* (Saturday) derives from the Latin *sabbatum* (in Hebrew, *Shabbat*), such names could mark the day of the child's birth (i.e., *Sabato* could mean Saturday's child as *Domenico* could mean Sunday's child). But neither February 12, 1879 (parish record), nor April 15, 1875 (Rodia's own presumed birth date)—the two contending dates of Rodia's birth—fell on a Saturday. Interestingly, and perhaps suggesting a further link between Nola and Serino, we find that "Sabato" was (formerly) also a common male name in the Nola area (and generally celebrated on the day between Good Friday and Easter Sunday, that is, Easter *Saturday*).

4. The aqueduct linking Serino to Naples and Miseno was established during Augustan rule (first century B.C.E.), when a reservoir terminus (*La Piscina Mirabilis*) was constructed to provide fresh water for the Roman naval fleet. The largest Roman cistern ever to have come to light, it measures 12,000 cubic meters, encompasses forty-eight columns in four rows, and is cruxiform, resembling "an immense underground cathedral." See De Biase 2006 on the importance of Serino's waters throughout its history. The mermaid on this inland town's crest (formerly known as Serena, "mermaid") links it

to the Ancient Maritime Republics (*Antiche Repubbliche Marittime*) under whose administrative jurisdiction it formerly lay.

5. The Ellis Island Port of New York passenger records (1892–1924) list many Rodias emigrating from Serino at the end of the century during these very years: 1892 (Salvatore, Matteo), 1893 (Raffaele, Carmine), 1894 (Giovanni), 1895 (Vincenzo, Gaetano), 1896 (Pasquale, Luigi, Innat, Anna), 1897 (Carmine), 1898 (Vincenzo di Luigi), 1899 (Lucia, Ferdinando). The last recorded is in 1924 (Benedetta). The majority instead immigrated during the first decade of the twentieth century. There is no record of a Sabato Rodia entering the country as an adolescent in 1892 or thereafter (only a Sabato Rodio, immigrating from Ceraso in 1903, at the age of twenty-four). Immigrants with this surname generally hail from other provenances, including the Puglia region (Locorotondo, Alberobello, Petrizzi), Sicily (Catanzaro, Martina Franca), and even Turkey (the surname has Hellenic origins, and refers to the island of Rhodes). We must conclude from the record that Sabato Rodia likely entered the United States prior to 1892. As far as toponyms are concerned, misspellings of *Serino* in these records are rife: Lerino, Serina, Serico, Sernio, Sermo, Cerina, Serinos, Serin, Serim, Suino, Seniro, Serics (http://www.ellisisland.org accessed August 23, 2011). See Introduction, n. 5.

6. In the monosyllabic *Sam* converged a range of names without an easy Anglo-American cognate (cf. "Giuseppe," which was Anglicized as "Joe"). This principal of translation was widely applied to foreign names. For a general discussion, see Mencken [1919] 1938 "Given Names." In *The American Language: An Inquiry into the Development of English in the United States*.

7. In all my programming around the Watts Towers, I have insisted on Sabato Rodia's name of origin.

8. Although this hybrid language is known by several terms, this one was coined in the 1970s by linguist Gian Renzo Clivio (University of Toronto), engaged in compiling a dictionary of the English spoken by the predominantly Italian dialect speakers of the post–World War II Italian community of Toronto.

9. Rodia mentions the *Encyclopedia Britannica* several times, but I surmise that he enjoyed perusing rather than reading such sources of general knowledge. He marveled at the fact that such books were accessible to all (unlike Italy where it remained the domain of the privileged) and that "It never cost you a nickel!" (he even suggested that his interlocutor, Mrs. Ashley-David, go down to the library and check out a few facts on world history).

10. On the affinities of early Italians and Mexicans in California, see Ricci Lothrop 2003; Rolle [1968] 1999. Rodia would have acquired familiarity with Hispanic cultures also in Mexico, Puerto Rico, Guatemala, and Argentina, places to which (by his own account) he had traveled.

11. It is unclear even to his family whether these were legal or common law marriages as certificates were never found (Appendix C.2, Byer interview).

12. Rodia patched his own clothes and threw away nothing: "Never throws anything away. Sells it. Sash weights, jacks, etc. Sells to junkman" (Appendix A.2, interview with Simon Rodia, by William Hale and Ray Wisniewsky). This sense of thrift may even have been a motivating factor in Rodia's artistic project, as he describes how a General Miller impressed upon him that Rodia was wasting money in dribs and drabs (see Appendix A.10, Ashley-David interview).

13. One of the topics that was passed over in the archived Ashley-David interview transcription (and restored in my reedited version) regards the topic of food. Rodia counted olive oil and tomato paste among the items in his pantry, foods that clearly required frequenting Italian grocers (and hence neighborhoods). He mentioned the high cost of the oil, affirming that he valued high quality, presumably for its health benefits (Appendix A.10, Ashley-David interview).

14. One of the cardinal points in immigrant ideology is that one does not forget one's origins and never betrays one's class (see in Del Giudice 1994 the song *U zappatore:* "A digger of the soil never forgets his mother"). In the Segre letter (Appendix A.6), he notes how Rodia railed against a coworker who had made good and immediately moved up the social ladder, forgetting his humble fellow workers. Rodia never forgave him. A 1953 interview with Rodia attests to this as well: "Twenty years ago used to have 30 people here every night. Now nobody. Why? They get high class" (Appendix A.2, interview with Simon Rodia, by William Hale and Ray Wisniewsky).

15. Such rants against modern women, of course, also contain elements of traditional misogyny. Women interviewers, always treated with deference and addressed as "kind lady" (*cara signora*), none-

theless felt they had to remove their lipstick and to dress modestly before visiting (e.g., Appendix C.1). Other women, too, had noted the importance of appearance (and the presence of children) in order to be perceived by Rodia as a good woman and hence facilitate conversation. For example, "At the time, I had long hair parted in the middle with a bun in the back, no make-up and low-heeled oxfords. To Mr. Rodia's stereotyped conception of womanhood, this physical appearance must have been the encouragement to communication. The presence of the four children with me must have helped" (Mrs. Mollie Siegel, August 26, 1959; UCLA Library Special Collections 1388, Box 1, File 9).

16. Traditional Italian women simply did not or could not leave home (as Lucy Ucci seems to have done), partly because in the old country there was no divorce.

17. His Mexican friends suggested he attended a club (likely the Italian Mutual Aid Society or the Garibaldina Club—both of which met at the Italian Hall, the center of the community on the plaza of El Pueblo from 1907 onward). He would have frequented Italian grocers to buy his olive oil and tomato paste, at the very least. Many Italian merchants were to be found in the Pueblo itself (e.g., Vai Brothers) although Rodia was in Martinez when he made these food comments and likely shopped at his niece's store.

Other likely social venues might have been linked to Italian churches. For example, in 1904, emulating East Coast practice within the Catholic Church, Cardinal Conaty of Los Angeles established a mission church, Saint Peter's Italian Church (a "national ethnic parish" for Italians of the entire archdiocese), "to produce good Catholics according to Italian tradition." The first church was a temporary frame structure built on North Spring Street, while the cornerstone for the new church on Broadway Avenue (now Chinatown) was laid down July 21, 1946 (http://stpeterschurchla.org/historyofstp.pdf). The church and social heart of San Pedro's Italians instead has always been Saint Mary Star of the Sea, the "Fishermen's Parish" (established in 1889), one of the oldest in the Los Angeles archdiocese. Today it features many motifs (ships, water, Peter at sea) recalling the area's early fishing populations and their descendants (e.g., the crest of Ischia embedded in its stained glass). Rodia would certainly have known these Italian community foci and their celebrations, even if he did not attend mass. For images of these churches, see www.ItalianLosAngeles.org.

18. Recall that southern Italians were not necessarily considered "white" at this time, according to their certificates of residency, which designated them of "South Italian" race (separate from other "Italians"). See also Guglielmo and Salerno 2003 on Italians' place on the white–black spectrum.

19. Although they possessed and worked their land, the family kept selling off parts of it to make ends meet, to repay debt, and to pay for their sons' passage to America.

20. It may be relevant to recall that Serino's sister city is Paterson, New Jersey, the destination of thousands of Serinesi from its earliest days of migration. Paterson became a key site in the labor movement of the early twentieth century, for example, the silk workers' strike, which predominantly involved Italian Americans. Many immigrants became politicized in places such as Paterson (or Barre, Vermont) as well.

21. Dal Lago and Giordano (2008) focus on the migratory nature of Rodia's art: "l'aspetto migratorio dell'artista, Rodia, di un'anima sempre in movimento. . . . Per averne un'idea, ci sembra sufficiente riflettere sulla figura di un artista essenzialmente mobile che, come molti immigrati, assorbe e metabolizza gli ambienti che conosce." ["the migratory aspect of the artist, Rodia, a soul always in movement. . . . To get an idea, it seems sufficient to reflect on the figure of an artist who is essentially in motion and who, like many immigrants, absorbs and metabolizes the environments he encounters."].

22. "Someone in his family has a nine-year-old son who was born in Japan. As he talked about this child, Sam sang a fragment of a lullaby in a quick and supple melody." See Del Giudice 1994 for the factors working against local traditional song repertoires in the diaspora.

23. Colacurcio recalled how Rodia's father had been physically abusive with his children but also recalled Sam Rodia's tendency toward violence and how Rodia had pulled a knife on him during one of their interminable arguments. Colacurcio almost came to blows with his interlocutors when he attempted to demonstrate one of these techniques, the pulling of ears (Appendix A.7, "*New Yorker* Reporter Visits Rodia"). *I Build the Tower* (Landler and Byer 2006) states further that Rodia had physically abused his wife.

24. Pietro Gori (1865–1911), an attorney, intellectual, and poet arrested and exiled from Italy multiple times, spent critical years in the United States and Canada, spreading his anarchist ideas far and

wide. Rodia could have come into contact with this socialist fervor in a variety of places during these years. Gori also authored one of the best known anarchist songs, "Addio, Lugano Bella," which includes a refrain that might have appealed to immigrant workers as well as to exiled anarchists: "Nostra patria è il mondo intero / nostra legge è la libertà / ed un pensiero / ribelle in cor ci sta. / Dei miseri le turbe sollevando / fummo d'ogni nazione messi al bando." [Our country is the whole world / our law is freedom / and the thought / of rebellion in our hearts lodges. / From the poor the cry rising / We were from every nation cast out.]

25. Its virulent verses called for arson and murder: "Bruceremo le chiese e gli altari / bruceremo i palazzi e le regge / con le budella dell'ultimo prete / impiccheremo il papa re . . . / e il Vaticano brucerà / con dentro il papa! . . . / Sono stato sul Monte Amiata / dove è morto Gesù Cristo / anca lu l'era un socialisto [sic] / e morì per la libertà." [We'll burn down the churches and altars / we'll burn down palaces and thrones / we'll hang the Pope-king . . . / and the Vatican will burn / with the pope inside! . . . / I've been to Mount Amiata / where Jesus Christ died / He too was a Socialist / who died for freedom.]

26. Rodia may have been opposed to the Catholic Church establishment or felt excluded for yet another reason: As a divorced man, he could not have participated, even if he had wanted to.

27. We do not exactly know what Rodia's role was within these tent revivals. He could have been witnessing, rather than preaching, that is, using his personal life story as an example of spiritual transformation and the achievement of true freedom.

28. Rodia's four funeral prayer cards (traditional for Italians) include images of the Madonna in prayer, the Holy Family, Saint Ann reading with her daughter, Mary, and Nossa Senhora do Rosario da Fatima. All were printed in Italy and include the same prayer text on the retro:

Jesus, meek and humble of heart
make my heart like unto Thine.
✚

IN LOVING MEMORY OF
SAM RODIA
1875 1965

O GENTLEST Heart of Jesus, ever present in the Blessed Sacrament, ever consumed with burning love for the poor captive souls in Purgatory, have mercy on the soul of Thy departed servant. Be not severe in Thy judgement, but let some drops of Thy precious Blood fall upon the devouring flames, and do Thou, O merciful Saviour, send Thy Angels to conduct Thy departed servant to a place of refreshment, light and peace. Amen. May the souls of all the faithful departed, through the mercy of God, rest in peace. Amen.

29. I do not know how much of this pro-Roman sentiment is attributable to a vaguely assimilated Fascist rhetoric of the times, increasingly filtering into Italian American communities and their media in the 1920s. The degree to which Rodia might have been connected to such communities and their media is not clear, although he frequented downtown Los Angeles and had resided in Long Beach—areas historically inhabited by Italians. On the early history of Italian Los Angeles, see Ricci Lothrop 2003; and for visuals, see Gatto 2009.

30. For example, "Look at the opera in New York / . . . / That was Italian man composer / English man writin' / Shekespeare / But Aida, its Etschiptian [Egyptian] / They want to respect for that / . . . / The people in the United States / they don't want to tell George Washington / Englishman." See Appendix A.1.

31. "The Shinesh [Chinese] something like my towers / Now you see Chinese / look at the Chinese Main Street / North Broadway Chinese town / small but like my towers [referring to fountain complex?] / Eshiptic [Egypt] the same thing . . . they all mould it outside . . . / They take the windows out / That is because I call them "PIEBLO [Pueblo]." See Appendix A.1.

32. A much later southern Italian (folk) artist, Leonardo "Diobello" Sileo, might have been more direct in stating such a desire to be remembered: "per lasciare il nome" ("to leave one's name"; Byrne-Severino 1991; see Bilancioni, this volume).

33. For example, some of Rodia's friends, a Mexican family living in Long Beach, noted how once when Rodia was very sick and had not gone to work, he tried to solicit help from neighbors but they

refused to have anything to do with him, considering him eccentric. Another time, when Rodia returned from work, he found that everything in his house had been stolen. See Appendix A.12.

34. Italian immigrants have frequently delighted in nature's bounty by hunting, foraging, and fishing in the "commons"—practices frequently denied to them as peasants in Italy. See note 9.

35. On such artistic expressions of faith in Italian immigrant milieus, see the work of Sciorra on yard shrines, *presepi* (nativity scenes), and other art forms (1989, 1993, 2001, 2010) and forthcoming (Sciorra 2015) titled *Built with Faith: Italian American Imagination and Catholic Material Culture in New York City.*

36. According to Morgan (personal communication, 2009), Rodia had been a Catholic who was no longer observant. A crockery-encrusted cross used as a grave marker that Rodia made for an Italian neighbor has recently surfaced.

37. On the Gigli di Nola, see: Avella 1999, Lucarelli and Mazzacane 1999, as well as essays of Ceparano and Ballacchino, this volume.

38. Examples include Saint Paulinus and the *Giglio* tradition for Nolani in New York (Posen, Sciorra, and Cooper 1983); Madonna del Soccorso (Our Lady of Aid) for Sicilians from Sciacca, in Boston's North End (Harrington 1986); and Madonna della Luce (Our Lady of Light) in eastern Massachusetts for immigrants from Palermiti, Calabria (Gulla 1986). The list is long. See also Orsi [1985] 2002 and Ferraiuolo 2009.

39. Of course, the poor are thrifty and resourceful (and the world's best recyclers) by necessity: For example, Rodia used discarded and found objects; and all parts of a *Giglio* structure are recycled from year to year: wood, nails, papier-mâché. This pragmatic approach to materials may also be reflected in the attitudinal divide at play in past Watts Towers conservation scandals. That is, the professional art conservator's tendency is not to intervene, interpret, or replace fallen mosaics and shells, whereas a no-nonsense "repair and fix it" approach seems to speak to a layman's understanding of the task. For example, city contractor Vaughan defended his work of conservation by using the metaphor of the "cavity" whereby the tooth needs to be cleaned and filled (see "False Restoration," Morgan, this volume). Byer instead uses an auto-mechanical metaphor: "It's like if you stack up a Ferrari . . . you rebuild it and restore it to the point so that you can't tell it was wrecked, right? . . . Just use some common sense, man. That's all." See Appendix C.2.

40. The feast of the *Gigli* of Nola represented Italy's nomination to UNESCO's "Oral and Intangible Heritage of Humanity—Proclamation of Masterpieces" in the late 1990s (*Concorso* 2000; Lucarelli and Mazzacane 1999; see Ballacchino, this volume). Unsuccessful in that candidature, a new proposal, this time placing the *Gigli* within a network of feasts that use *macchine a spalla* (festival apparatuses carried on shoulders), was successful. On December 4, 2013 the *Gigli* were indeed inscribed in the UNESCO Intangible World Heritage registry, along with the Candelieri of Sassari (Sardinia), the Varia of Palmi (Calabria) and the Macchina di Santa Rosa of Viterbo (Lazio).

41. In a recent lecture (at the Santa Monica Museum of Art) on Italian POWs in the United States during World War II, Laura Ruberto showed a photograph of soldiers standing around a *Giglio* constructed to celebrate Saint Paulinus's release from captivity—a nice irony, given that they were prisoners themselves at the time. See Ballacchino, this volume, for more current war-related *Giglio* experiences.

42. For example, I seriously doubt that a reference to an apparently slurred reference (by Rodia) to a "Barco di Polo" was a mishearing of "Barco (barca) di (san) Paolo (Paolino)," as Morgan maintains (Appendix C.1).

43. Rodia never went the route of "Tivoli Miniature World" in Vineland, Ontario, which contains miniature replicas of Saint Maria del Fiore in Florence; the Colosseum, Saint Peter's Basilica in Rome, and many others. But, art environments cover a wider range of approaches, as seen in the rich archives of SPACES (cf. Hernández, this volume).

44. I have written elsewhere about the festivalization of the quotidian, the ideal of conviviality, and the cult of abundance in immigrant lives (Del Giudice 2001a, 2001b, 2001c, 2009c). Public display and the blending of private and public is also a common feature of Italian artisan and folk art traditions in diaspora contexts (see Sciorra, this volume and the forthcoming *Built with Faith*). Compare Rodia's expansiveness with the gesture of solitary land artist Baldassare Forestieri, "the Human Mole" who literally burrowed tunnels and underground gardens (Scambray 2001 and this volume). Rodia, in his early days (1920s), practiced hospitality by hosting frequent gatherings in his home (see note 14). It is worth

noting that the Watts Towers in time did become a site of major public festivities: the Simon Rodia Jazz Festival (begun in 1976) and the Simon Rodia Day of the Drum (in 1981).

45. Byer, who from age four to eleven knew his great-uncle, noted how Rodia was "charismatic without saying a word." As an object of fascination and mystery, silence would greet Rodia as he entered the room, which would then soon after be transformed by a shouting match between the Sams. See Appendix C.2, Byer interview.

46. I would surmise that some of these feelings may have been at the source of the vehement verbal battles between brothers-in-law, as well as some of Rodia's resentment toward women. Rodia knew the normative Italian immigrant cultural rules and had broken many: He had had three "marriages" (only one legitimate, according to Catholic law), abused alcohol (cf. Del Giudice 2001c on Italians' attitude toward drunkenness), and failed to provide for his family.

47. "They come from all over to see my work. . . . I use everything they give me, stones. . . . They offer money but I don't want any. I am happy the way I am and I want to be buried right here" (*Los Angeles Examiner*, September 3, 1950).

48. See by way of comparison the folk motif of the immured body, as a form of human sacrifice, in the foundation tales of many a monastery or convent and in nonreligious construction as well (e.g., bridges). Cement-encased masons and bricklayers were also a macabre historic reality for more than a few immigrant migrant workers (cf. Di Donato's 1939 *Christ in Concrete*).

49. Rodia waxed poetic on the topic of nature's abundance, lovingly recalling all the trees and crops grown in the fertile lands his family owned in Serino. He had a keen eye for vegetation and reproduced idealized natural landscapes in the Towers (just as Italian peasant immigrants have continued to do in their vegetable gardens). On the importance of gardens and the attachment to the land as expressed by immigrants, see Grillo's film, *Terra sogna terra*, and Klindienst 2007.

50. Serino was known for its nail-making tradition. "Nail-maker" (from simple nail worker, *lavorante chiodaio*, to a master nail maker, *mastro chiodaio*) is an occupation frequently recorded in Rivottoli land records, from as early as the eighteenth century, and was likely common much earlier (see, e.g., De Biase 2003). We note that heavy-gauge Serino nails were also used in Nolan *Gigli* construction. Serinesi affirm that Rodia, as everyone who had done manual labor in the area (including peasants) had, likely learned to work iron. An interesting archival document in UCLA Library Special Collections No. 1388 shows drawings of the typical tools of Serino (identified by their Italian names) corresponding to those embedded in Rodia's "lunette" or tool signature. This legend was one of the results of a research trip Mae Babitz conducted in Italy for a book she and Laurence McGilvery were to have co-authored.

51. Corroborating Rodia's banking practices is the fact that when he arrived in Martinez in 1954, he was carrying approximately $10,000, a small fortune, in cash, according to his niece, Virginia Sullivan (*I Build the Tower;* Landler and Byer 2006).

52. Rodia, too, was well aware of this heritage, however imprecise his "facts" might have been: "All America is discovered from Italian people. England. . . . He had Giovanni Cabbots [Giovanni Cabotto, i.e., John Cabot] . . . was born in Venice . . . discovered New York. . . . Emilio Gerrio he discovered Canada [?]. . . . Amerigo Vespucci he discovered Brasil" ("Great Men," Appendix A.1).

53. Columbus had become quasi-proverbial among Italian immigrants and in time became the namesake of their heritage day. A Columbus Day was instituted as a state holiday in Colorado in 1906 (thanks to the lobbying of an Italian) and as a federal holiday in 1937.

54. One is struck by Rodia's ability to inspire true believers among his followers. At times, this hagiographic aura creates dissonance, as when some have denied that Rodia was an alcoholic or ever beat his wife (that he had, in fact, been "bad bad bad"; even though Rodia himself admitted that he had been a "bad man of the United States"). On the "good good good" side of the equation, Morgan even posits that Rodia's variant name "Simon" came from his remarkable physical similarities to San Simon: a contemporary-looking Mexican saint who wears a fedora, smokes a cigar, and was widely known in Los Angeles County (even though he was a folk saint of Guatemala; see Brujo Negro, "San Simon": http://www.brujonegrobrujeria.com/page/page/3100370.htm, accessed September 6, 2011). Morgan suggests that Rodia may actually have been considered a saint by Latinos, by virtue of this physical resemblance (I would surmise that this was perhaps due to his involvement with the Spanish-language evangelical church).

55. These are lyrics from the Neapolitan song "Lacrime napuletane" (Neapolitan tears), which was something of an immigrant's "anthem." See Del Giudice 1994.

"Why a Man Makes the Shoes?": Italian American Art and Philosophy in Sabato Rodia's
Watts Towers JOSEPH SCIORRA

1. Glassie (1988: 71).

2. Quoted in Goldstone and Paquin Goldstone (1997: 82).

3. See Trout (1999) for an excellent biography of Paulinus.

4. See Maganelli (1973) for anthropological analysis of the feast in Italy.

5. See also Appadurai (2003) for his focus on imagination and improvisation in cultural work.

6. For earlier critiques, see Quimby and Swank (1980) and Vlach and Bronner (1986).

7. I thank Dan Ward, who shared his collection of previously recorded interviews conducted with Rodia over the years.

8. Rodia was appreciative of those who spoke to him in (standard) Italian (Ward 1990: 164, f45). See Appendix A.1.6, where Claudio Segre reports: "I think it helped to speak Italian to both Sam and Saverio. As I expected, they didn't speak it too well and preferred to fall back on the macaroni English they were used to. But it did help loosen them up at first."

9. My investigation of the hybridity of the Towers and their maker is mindful of the historicity of the reconfigurations. See Kapchan and Strong 1999: 240–53; Howard 2008: 192–218.

10. Gabriele Mina, a scholar of Italian "fantastic architecture," has noted the importance of tracking Italian emigrant builders of such structures (2011, 25, note 23).

11. There are conflicting dates for Rodia's birth and emigration. See Goldstone and Paquin Goldstone 1997: 27–42; Hernandez 2001: 32–39; and Ward 1990: 164–65.

12. La Sorte summarizes immigrant anarchist Bartolomeo Vanzetti's twelve-year work experience until his now infamous arrest in 1920 that included jobs as dishwasher, farm worker, factory worker, quarry worker, a return to dishwasher, pick-and-shovel worker, factory worker, and finally a casual day laborer that included "ditch-digging, fish vending, ice cutting, snow shoveling, and clam digging" (La Sorte 1985: 68–69).

13. Posen and Ward state that there is no evidence to support the claim that Rodia ever worked as a tile setter (1985: 153), which is not surprising, given his unconventional handling of crockery and other materials. See Grossutti (2008) and Rubini (2006) for information on Italian terrazzo and mosaic artisans working in the United States.

14. See D'Ambrosio 2010 for discussion of Placido Tobasso's plaster sculpture in Utica, New York.

15. Grizzuti Harrison's travelogue *Italian Days* (1989) makes several observations as asides about Italian American aesthetics and vernacular practices but with a degree of superciliousness that could be interpreted as self-hate. See my discussion about her comments in Sciorra 2011, 4.

16. In his dissertation preface, Ward recounts an anecdote of a fellow graduate student who commented on the "tile and shells in concrete walls" used in the Watts Towers as being similar to decorative work made by "Old Italians" in his New Jersey hometown (1990: xiv–xv).

17. My thanks to Joanna Clapps Herman for bringing this site to my attention.

18. In a previously published essay (Sciorra 1989: 190, fn 8), I mistakenly reported that Fernando Corvino was the name of this man.

19. The grotto was listed in the National and New York State Registers of Historical Places in 2000.

20. As the character Dr. Barbato observers in Puzo's *The Fortunate Pilgrim*, "It was always the men who crumbled under the glories of the new land, never the women" (1985: 101).

21. Scholars have noted the "almost pathological concern with ethnic power prestige" (Harney 1993: 7) among Italians in North America and the establishment of a pantheon of historic men as a salve to their "ethnic self-disesteem" (Ibid., 11; see also Bianco 1974: 59–60; Del Giudice 1993: 1–9).

22. See also Rodia's statement about abandoning the Towers: "If your mother dies and you loved her very much you don't talk about her (Trillin 1965: 101; see Appendix A 1.7).

23. "Tell him that I suffer but I go on writing; that I wrote about all the outrages one by one, and about all the outrageous faces that laugh at the outrages they have inflicted and going to inflict" (Vittorini 1961: 117).

24. Benedetto Croce characterized the baroque as the "ricerca dell'inaspettato e dello stupefacente" (quoted in Barzini 1965: 331).

25. See D'Acierno's parsing of this Italian American "key term" (1999a: 712–13). See also Del Giudice, this volume.

Parallel Expressions: Artistic Contributions of Italian Immigrants in the Río de la Plata Basin of South America at the Time of Simon Rodia GEORGE EPOLITO

1. Italian immigrants entered Río de la Plata Basin before they entered the United States. For this reason, many Italians of Rodia's generation were actually born in the Americas or were taken there at a very young age by their Italian parents.

2. Statistics vary, but to better understand the difference in Italian immigrant populations in the Americas, I refer to three separate sources. Devoto states that Italian immigration peaked in New York at 7.0 percent of its population, while it made up 25–33 percent of the residents of Buenos Aires (see Devoto 2001: 41). Goebel points out that in 1889 the population of Montevideo was composed of 47 percent Italians and 32 percent Spanish immigrants (Goebel 2010: 198). Harrison explains that of the more than four million people who migrated to Brazil between 1884 and 1939, the largest group was Italian, making up 33 percent of the population, with most settling in São Paulo (70 percent of Italians settled there; see Harrison 1997: 127).

3. The "whitening" of lands was a political tool used in Latin America after the French were overthrown in present-day Haiti. Fearing similar uprisings would occur where African slaves outnumbered the Creole elite, the latter sought to increase the overall population of whites.

4. As Mangione and Morreale (1992) point out: "In 1904, [the] South Carolina state legislature restricted immigration to 'white citizens of the United States and citizens of Ireland, Scotland, Switzerland, and France together with all the other foreigners of Saxon origins.' Alabama and North Carolina followed suit with similar legislation."

5. This initial rejection of Italian values seemed to reverse with succeeding generations born in the States.

6. I do acknowledge that there were Italians who fought in the American Civil War and that that Philip (Filippo) Mazzei was a close confidant to Thomas Jefferson, but their roles were minor in proportion to those of Garibaldi and his Italian legions.

7. Il Duce's reincarnation of the Roman Empire in the Basin was largely predicated on ignoring the multiracial composition of its peoples in lieu of promoting a common ancestry of *Romanness* for its Iberian and Italian peoples. Argentina was of particular interest to Mussolini. "Between 1922 and 1931 the Fascist regime wanted to convince the Argentines that their history, or part of it at least, was a direct outcome of Italian historical agency." Finchelstein 2010: 87.

8. Although Becker states "Italian submarines," it is probably more accurate to say that Italy's Axis partner Japan was the more realistic threat in this situation. It is hard to imagine how Italy would have logistically managed to get its submarines offshore in California, but at the same time, it is easy to imagine how "kids" would not understand the particularities of the situation.

9. To fully appreciate the extent of this movement of (Italian) Argentines and their travels to study under the masters of northern Italy, see Pacheco 1992: 126.

10. To better understand the difference in how a painter of Italian descent varied from one of Iberian descent, Jacqueline Barnitz points out that Portinari depicted African Brazilian laborers as strong and stoic, whereas Tarsila do Amaral portrayed them as more exotic. Barnitz ascertains that Portinari's empathy stems from his parents having worked on coffee plantations. In contrast, do Amaral's parents were owners of coffee plantations. See Barnitz 2001: 85.

11. Marinetti had been so impressed with Pettoruti that he tried repeatedly, to no avail, to get the young Italian Argentine to commit to the futurist movement.

12. The exhibition had previously toured many European capitals, but in the United States it landed only in Pittsburgh, which was not an influential center of cultural production. There was also an important exhibition of architecture organized by art critic Pietro Maria Bardi in 1933, which promoted, rather falsely, the collective works of *il Razionalismo* as achievements of Fascism.

13. Although Italian Argentine Berni was directly influenced by De Chirico, he was active in a collective of artists who were united against Fascism.

14. In hopes of promoting his aesthetic version of futurism (and to profit financially), Marinetti went on a lecture tour in the Basin in 1926. He started in Rio and moved on to cities with high concentrations of Italian expatriates, such as São Paulo, Buenos Aires, Rosario, Córdoba, and Montevideo. There was an assumption that expatriates would support the Italian poet, but this strategy backfired, as most were skeptical of Marinetti's links to Fascism. Marinetti did meet with Pettoruti in Buenos Aires.

15. Many of Il Duce's Fascist ideologues did believe in the superiority of Old World Italian art, particularly Sarfatti.

16. *Italianità* is a term that transcends "Italianness" and ventures into political propaganda.

17. "Família Artística Paulista" 2002. *Carcamanismo* is a pejorative term with reference to Italians, along the lines of the derogatory American terms "Dago" and "Wop."

18. Ibid.

Fifty Years of Guardianship: The Committee for Simon Rodia's Towers in Watts (CSRTW) JEANNE S. MORGAN

1. By Grant Deed No. 2691, June 30, 1961, Book D-1271, p. 688, Office of the County Recorder, founders Nick King and Carol and William Cartwright deed the Towers property to CSRTW.

2. Agreement and Conveyance No. 8526 of 10-24-75, Transfer of Watts Towers and Community Art Center to City of Los Angeles.

3. Operating Agreement, Watts Towers, August 23, 1977. (State leases Towers to City.)

4. An Evaluation of the Restoration Work of Ralph Vaughn, Deposition of Jeanne Morgan for the Center for Law in the Public Interest, September 26, 1978, re Civil Case C259603, Superior Court, *Committee for Simon Rodia's Towers v. The City of Los Angeles*.

5. Please note the phrase: "at the Towers site" . . .

6. In conservation terms, "savage restoration" refers to work done outside professional standards.

7. Letter from Carlyle W. Hall, Jr., to Jeanne Morgan, August 30, 2001.

8. This is not enforced, Security must patrol the entire, block-long area that includes two art center buildings and extensive parking lots. Full-time security is lacking "at the Watts Towers site," since no security is assigned to the site full-time.

9. Letter from Ruth Coleman, Chief, State Department of Parks to Margie Reese, General Manager, Cultural Affairs Department, City of Los Angeles, October 15, 2003.

10. Editor's note: This report was circulated at the 2009 Genova conference, thereby integrating the CSRTW into the conference debates, despite the fact that no one from the Committee could be present to speak for themselves. This decision created a stir, and opposition to it was voiced by several city-affiliated participants.

11. Memorandum of M. Wayne Donaldson, State Historic Preservation Officer to Ruth Coleman, Chief, California State Parks, July 7, 2006.

12. Editor's note: the new councilman, Joseph Buscaino, has continued Hahn's effort to support a skateboard park on the Watts Towers' campus.

13. Editor's note: See the article by Jori Finkel, "Edgar Arceneaux Steps down as Head of Watts House Project," *Los Angeles Times*, April 8, 2012.

14. H. L. Manley, Office Manager of the Van Nuys District Office of the Los Angeles Department of Building and Safety, formerly the Chief of the Conservation Bureau, quoted in *Los Angeles Free Press*, July 16, 1965.

15. William Osmun, Senior Curator, Los Angeles County Museum of Art, quoted in *Los Angeles Free Press*, July 16, 1965. Editor's note: Further examples may be found in Appendices A.2 and A.3.

A Custody Case: Ownership of Rodia's Towers JEFFREY HERR

1. Los Angeles County Assessor, *Los Angeles County Assessor's Map Book*, No. 599, 1920–1927, 41.

2. Los Angeles County Assessor, *Los Angeles County Assessor's Map Book*, No. 599, 1954–1958, 12.

3. Ibid.

4. Walt Secor, "Gigantic Watts Towers Stir Colossal Debate: Work of Man with Big Ideas Brings Huge Argument on Whether to Raze It, Save It," *Los Angeles Times*, May 24, 1959, 3.

5. Leon Whiteson. *The Watts Towers* (Oakville, Ontario, Canada: Mosaic Press, 1989), 27.

6. "'Torture Test' Due For Watts Towers," *Los Angeles Herald Express*, October 10, 1959, 1.

7. Virginia Kazor, personal communication, January 8, 2010.

8. Council File 71-3270-53, Office of the City Clerk. An electronically accessible summary of the file may be viewed at www.LACITY.org by clicking on LACityClerk Connect.

9. Ibid. (The lease spans a fifty-year period.)

10. As part of the state's responsibility, it commissioned the Ehrenkrantz Group to produce a *Maintenance and Restoration* guide in 1983 that is used today as the standard for preservation and conservation activities. [January 1, 2011 the Department of Cultural Affairs contracted with the conservation department of the Los Angeles County Museum of Art to provide an assessment of the city's existing conservation and preservation plans; data management, physical analysis, environmental conditions monitoring, and site preservation and maintenance will produce an updated comprehensive conservation plan by 2014.]

11. Sean Woods, Superintendent, Los Angeles Sector, California State Parks, in an e-mail message to Jeanne S. Morgan, CSRTW member, July 30, 2008.

12. Melvyn Green, personal communication, February 24, 2010.

13. Cathleen Decker, "City Ends Dispute over Watts Towers," *Los Angeles Times*, October 16, 1985, 1.

14. Ibid.

Nuestro Pueblo: **The Spatial and Cultural Politics of Los Angeles's**

Watts Towers SARAH SCHRANK

1. I would like to thank Judson Powell, Joan-Claire Kleihauer, Jeanne Morgan, Bud Goldstone, Michael Cornwell, Seymour Rosen, and Brigitte Kueppers for their help and support in the writing of this article. Special thanks to Jeanne Morgan, who supplied many hours of her time providing me with historical information and editorial advice. I must also thank all the members of the Committee for Simon Rodia's Towers in Watts, SPACES, and the staff of the Watts Towers Art Center who have worked so hard to keep *Nuestro Pueblo* intact.

2. Philip J. Ethington, "Ghost Neighborhoods: Space, Time, and Alienation in Los Angeles," in *Looking for Los Angeles: Architecture, Film, Photography, and the Urban Landscape*, ed. Charles G. Salas and Michael S. Roth (Los Angeles: Getty Research Institute, 2001), 29.

3. Roger Keil, *Los Angeles: Globalization, Urbanization and Social Struggles* (New York: John Wiley and Sons, 1998), xiv.

4. Mike Davis, *City of Quartz: Excavating the Future in Los Angeles* (1990; New York: Vintage 1992).

5. David Harvey, *Spaces of Hope* (Berkeley: University of California Press, 2000), 12–15.

6. Rodia has been called Sam, Simon, and Sabato. By many accounts he went by Sam although the City of Los Angeles officially uses Simon.

7. See Colin Rhodes, *Outsider Art: Spontaneous Alternatives* (London: Thames and Hudson, 2000); John Maizels, *Raw Creation: Outsider Art and Beyond* (London: Phaidon, 2000); and Jo Farb Hernandez, "Watts Towers," *Raw Vision* 37 (Winter 2001): 32–39.

8. Sarah Schrank, "Picturing the Watts Towers: The Art and Politics of an Urban Landmark," in *Reading California: Art, Image, and Identity, 1900–2000*, ed. Stephanie Barron, Ilene Fort, and Sheri Bernstein (Berkeley and Los Angeles: University of California Press, 2000), 373–86.

9. Norman M. Klein, *The History of Forgetting: Los Angeles and the Erasure of Memory* (London: Verso, 1997).

10. Josh Sides, *L.A. City Limits: African American Los Angeles from the Great Depression to the Present* (Berkeley: University of California Press, 2004), 170.

11. See George J. Sánchez, "'What's Good for Boyle Heights Is Good for the Jews': Creating Multiracialism on the Eastside During the 1950s," *American Quarterly* 56, no. 3 (September 2004): 633–61.

12. Los Angeles County Museum, Los Angeles History Division 1900–61, California file no. 371134, Huntington Library, San Marino, Calif., 53.

13. Sheri Bernstein, "The California Home Front, 1940–1960," in Stephanie Barron et al., *Made in California: Art, Image, and Identity, 1900–2000* (Berkeley: University of California Press, 2000), 167.

14. "L.A. Shows World How to End Slums." *Los Angeles Examiner*, Special Edition Reprint, October 11–12, 1959. California Ephemera Collection 200, Box 61, UCLA Department of Special Collections.

15. See Eric Avila, *Popular Culture in the Age of White Flight: Fear and Fantasy in Suburban Los Angeles* (Berkeley: University of California Press, 2004); George Lipsitz, *The Possessive Investment in Whiteness: How White People Profit from Identity Politics* (Philadelphia: Temple University Press, 1998).

16. Bud Goldstone and Arloa Paquin Goldstone. *The Los Angeles Watts Towers* (Los Angeles: Getty Conservation Institute, 1997), 84; "Watts Towers Face Threat from Freeway," *Los Angeles Times*, June 5, 1963, 25.

17. Jeanne Morgan, "Rodia's Towers: Nuestro Pueblo, A Gift to the World," in *Personal Places: Perspectives on Informal Art Environments*, ed. Daniel Franklin Ward (Bowling Green, Ohio: Bowling Green State University Popular Press, 1984), 80.

18. Leon Whiteson, *The Watts Towers of Los Angeles* (Oakville, Ontario, Canada: Mosaic Press, 1989), 25.

19. Goldstone and Paquin Goldstone, *The Los Angeles Watts Towers*; Jeanne Morgan, "My Life with the Watts Towers," Jeanne Morgan Papers, Archives of American Art, Smithsonian Institution, West Coast Regional Center, Huntinton Library, San Marino, Calif. (hereinafter referred to as the "Jeanne Morgan Papers"); Calvin Trillin, "I Know I Want to Do Something," *The New Yorker*, May 29, 1965, 72–120; Whiteson, *The Watts Towers of Los Angeles*.

20. Goldstone and Goldstone, *The Los Angeles Watts Towers*, 25–28.

21. There is exciting new work on the Towers' meaning as an immigrant intervention into the American cultural landscape, particularly that of Teresa Fiore, *Pre-Occupied Spaces: Re-Configuring the Italian Nation Through Its Migrations* (PhD dissertation, University of California, San Diego, 2002).

22. Joe Seewerker and Charles Owens, "Nuestro Pueblo: Glass Towers and Demon Rum," *Los Angeles Times*, April 28, 1939, sec. 2, p. 2.

23. "Immigrant Builds Towers to Show His Love for U.S.," *Los Angeles Times*, June 8, 1952, part 1A, p. 26.

24. *The Towers*, directed by William Hale (Los Angeles: University of Southern California, 1953).

25. Richard Cándida Smith, "The Elusive Quest of the Moderns," in *On the Edge of America: California Modernist Art, 1900–1950*, ed. Paul Karlstrom (Berkeley: University of California Press, 1996), 32.

26. Reyner Banham, *Los Angeles: The Architecture of Four Ecologies* (1971; Berkeley: University of California Press, 2000), 111.

27. *The Towers*.

28. I. Sheldon Posen and Daniel Franklin Ward, "Watts Towers and the Giglio Tradition," in *Folklife Annual 1985* (Washington, D.C: American Folklife Center at the Library of Congress, 1985), 143–57.

29. Jeanne Morgan, correspondence with author, August 6, 2005.

30. "Flashing Spires Built as Hobby," *Los Angeles Times*, October 13, 1937, part 2, p. 2.

31. "Immigrant Builds Towers to Show His Love for U.S.," *Los Angeles Times*, June 8, 1952, sec. 1A, p. 26; Paul V. Coates, "Confidential File," *Los Angeles Mirror-News*, October 4, 1955, sec. 1, p. 6; Candída Smith, "The Elusive Quest of the Moderns."

32. Goldstone and Goldstone, *The Los Angeles Watts Towers*.

33. Morgan, "My Life with the Watts Towers."

34. Ibid.

35. Ibid.

36. Goldstone and Goldstone, *The Los Angeles Watts Towers*, 85.

37. "Are they Fine Art or Junk?," *Los Angeles Examiner*, April 3, 1959; "Hearing to Preserve Watts Towers Opens at City Hall," *Los Angeles Examiner*, July 7, 1959; "Watts Towers Pass Safety Test," *Los Angeles Examiner*, October 11, 1959; Interviews with Rodia, Jeanne Morgan Papers.

38. Goldsone and Goldstone, *The Los Angeles Watts Towers*, 92–95.

39. "Are they Fine Art or Junk?"; "Hearing to Preserve Watts Towers Opens at City Hall"; "Watts Towers Pass Safety Test"; Interviews with Rodia, Jeanne Morgan Papers.

40. Committee for Simon Rodia's Towers in Watts, "The Simon Rodia Arts Workshops," 1966, Department of Special Collections, UCLA, collection 1388, Committee for Simon Rodia's Towers in Watts, box 2, folder 1.

41. Authors interview with Sandra Rivken, Public Relations Office, Cultural Affairs Department, City of Los Angeles, February 20, 2001.

42. "City Takes New Approach to Art," *Los Angeles Times,* April 23, 1951.

43. "Outdoor Art Shows Chairmen Appointed," *California Eagle,* September 14, 1950; "South Park Festival Success," *California Eagle,* October 19, 1950; microfilm reel no. 37, Southern California Library for Social Research, Los Angeles.

44. Building and Safety Committee Report, November 5, 1951, Los Angeles City Archives, city council file no. 50460.

45. "Second Round of Art Row Before Council," *Valley Times,* October 31, 1951; "City Tightens Art Exhibit Purse Strings," *Los Angeles Mirror,* November 7, 1951; Bowron Papers, Huntington Library, San Marino, Calif., box 92.

46. Letter from the city clerk to the Municipal Art Commission, filed September 1, 1955, Los Angeles City Archives, council file no. 64886; Letter from the Mayor's Office to the Municipal Finance Committee, June 24, 1957, Los Angeles City Archives, city council file no. 79872.

47. Nightclub owners' concern about the popularity of the coffeehouses encroaching on their business went so far as a $100,000 damage suit lodged against Herb Cohen for purposefully turning a night club into a "beatnik hang-out." "Judge Hears Beat Café Suit," *Los Angeles Examiner,* December 17, 1959.

48. "All-Night Coffeehouses to Pay Entertainment Tax," *Los Angeles Examiner,* January 28, 1959; Patrick McNulty, "Beatniks and Venice Square off in Fight," *Los Angeles Times,* August 4, 1959; "Police Oppose Permit: Beatnik Hearing Becomes Fuzzy," *Los Angeles Examiner,* September 2, 1959; "Gas House Defended," *Los Angeles Examiner,* September 3, 1959; "Beatniks 'Cut Out' of Hearings: Police Examiner Biased, They Say," *Los Angeles Examiner,* September 9, 1959; "Squareville Heatnik Scorches Beatniks," *Los Angeles Examiner,* October 28, 1959; "Judge Hears 'Beat' Café Suit," *Los Angeles Examiner,* December 17, 1959.

49. Frank Laro, "Tourists Make Beatniks Flee Coffeehouses," *Los Angeles Times,* June 2, 1959, part 2, 8.

50. Marylou Luther, "L.A. Has Many Attractions Not Included in Guidebooks," *Los Angeles Times,* March 17, 1960, A1; "Watts Towers Topic of L.A. Art Panel," *Los Angeles Times,* March 13, 1960, 16; Beverly E. Johnson, 'The Watts Towers," *Los Angeles Times,* April 24, 1960, L28.

51. Whiteson, *The Watts Towers of Los Angeles,* 83. The Towers were officially designated a Los Angeles Cultural Heritage Monument in 1963. Their current status as a National Landmark was achieved in 1990.

52. Committee for Simon Rodia's Towers in Watts, exhibition catalog, Los Angeles County Museum of Art, 1962, 6.

53. Noah Purifoy, quoted in Ronald H. Silverman, "Watts, the Disadvantages, and Art Education," *Art Education* 19, no. 3 (March 1966): 16–20.

54. Noah Purifoy, interviewed by Karen Anne Mason, African-American artists of Los Angeles oral history transcript, 1990, UCLA Library Special Collections; Morgan, "My Life with the Watts Towers"; Interviews with Dale Davis, John Outterbridge, and Cecil Fergerson, July 29, 1994, John Outterbridge Papers, Archives of American Art, Smithsonian Institution, West Coast Regional Center, Huntington Library, San Marino, Calif.

55. Purifoy, African-American artists of Los Angeles oral history transcript, 58–63,

56. Committee for Simon Rodia's Towers in Watts, *The Watts Towers,* pamphlet, n.d.

57. Trillin, "I Know I Want to Do Something," 107.

58. Purifoy, African-American artists of Los Angeles oral history transcript, 69.

59. Author's interview with Judson Powell, April 15, 2007.

60. State of California, Department of Parks and Recreation, Division of Beaches and Parks, *Watts Towers Study: Requested by House Resolution No. 464, Statutes of 1965,* June 1965, 3.

61. Ibid., pp. 3–4.

62. Jeanne Morgan, correspondence with author, March 7, 2005.

63. Governor's Commission on the Los Angeles Riot, *McCone Commission Report! Complete and Unabridged, December 2, 1965* (Los Angeles: Kimtrex Corp., 1965); Gerald Horne, *Fire This Time: The Watts Uprising and the 1960s* (Charlottesville: University Press of Virginia, 1995).

64. Chester Himes, *The Quality of Hurt: The Autobiography of Chester Himes* (Garden City, N.Y.: Doubleday, 1972), 73–74.

65. Jack Jones, "Visions Point to Park-Like Future for Watts," *Los Angeles Times*, January 17, 1966, A1.

66. Peter Bart, "Center Planned at Watts Towers," *New York Times*, March 20, 1966, 84.

67. Jones, "Visions Point to Park-Like Future."

68. Drawing of "The Simon Rodia Community Art Center," Department of Special Collections, UCLA, collection 1388, Committee for Simon Rodia's Towers in Watts, folder 2, box 1, miscellaneous.

69. "The Simon Rodia Workshops," Department of Special Collections, UCLA, collection 1388, Committee for Simon Rodia's Towers in Watts, box 2, folder 1.

70. "Rodia Towers Art Center Drive Begins," *Los Angeles Times*, August 10, 1966, A2.

71. "Watts Holds 'Dig-in' for Community Art Center," *Los Angeles Times*, June 25, 1967; Governor's Commission on the Los Angeles Riot, *McCone Commission Report*

72. Lizetta LeFalle-Collins, *Noah Purifoy: Outside and in the Open*, exhibition catalog (Los Angeles: California Afro-American Museum Foundation, 1997), 10–11.

73. Art Seidenbaum, "Cultural Approach to Watts," *Los Angeles Times*, December 8, 1965, D1.

74. Art Berman, "Watts Easter Week Art Festival Puts Riot Debris to Cultural Uses," *Los Angeles Times*, April 8, 1966, A1.

75. Joyce E. Widoff, "Out of the Ashes . . . Art and Understanding," *Tuesday Magazine*, August 1968, 5–15; Noah Purifoy Papers, Archives of American Art, Smithsonian Institution, West Coast Regional Center, Huntington Library, San Marino, Calif.; Purifoy, African-American artists of Los Angeles oral history transcript, 70, 138.

76. Thanks to Victoria Holly Scott for pointing out the irony of exporting American ruins to Europe.

77. The Watts Art Festival at Markham Junior High may have helped lay the organizational groundwork for the more radical Watts Summer Festival in August 1966, a fete attended by over 10,000 in a musical tribute to the thirty-four killed the year before. The Watts Summer Festival still takes place each year.

78. Thomas Pynchon, "A Journey into the Mind of Watts," *New York Times*, June 12, 1966. I gratefully thank Brett Mizelle for pointing out the value of this piece for understanding post-1965 views of Los Angeles.

79. Ibid.

80. "Suit Assails City's Handling of Watts Towers, Calls for Private Ownership," *Los Angeles Times*, October 27, 1978, part 2, 8; "Private Boost for Watts Towers," *Los Angeles Times*, February 22, 1985.

81. Davis, *City of Quartz*, 182–86.

82. Letter to Mae Babitz from the Office of the Mayor, June 28, 1978, Department of Special Collections, UCLA, collection 1388, Committee for Simon Rodia's Towers in Watts, correspondence folder 16, box 12.

83. Keil, *Los Angeles*, 82.

84. It is significant that the city now claims its murals as important emblems of cultural activity and "diversity" or "multiculturalism," particularly since the 1984 Olympics, when the Bradley administration commissioned forty-seven freeway murals as part if its controversial downtown "clean-up." In appropriating murals, the city has acknowledged, even legitimated, the wall as civic space. But even as the city cleaves art from its politics (this is made obvious by the appalling police murals on the 110 freeway), graffiti artists remind us when they tag officially civic murals that wall space is at a premium and claims to the exterior wall are hotly contested, despite city efforts to render murals conflict-free. I am grateful to the work of Marcos Sanchez-Tranquilino for his discussion of the political conflict between Chicano muralists, representing an "official" form by the late 1970s, and graffiti artists who, in Los Angeles, remain on the margins. This is useful for understanding why civic appropriation of the mural form attracts so much attention from taggers throughout the city. Marcos Sanchez-Tranquilino, "Space, Power, and Youth Culture: Mexican American Graffiti and Chicano Murals in East Los Angeles,

1972–1978," *Looking High and Low: Art and Cultural Identity*, ed. Brenda Jo Bright and Liza Bakewell (Tucson: University of Arizona Press, 1995), 55–88.

85. "Save the Watts Towers," *Los Angeles Herald-Examiner*, April 22, 1985, sec. 2, 1.

86. Davis, *City of Quartz*, 78.

87. Tricia Rose, *Black Noise: Rap Music and Black Culture in Contemporary America* (Middletown, Conn.: Wesleyan University Press, 1994), 2.

88. *Colors*, directed by Dennis Hopper (Los Angeles: MGM Studios, 1988), with performances by Sean Penn and Robert Duvall.

89. *Ricochet*, directed by Russell Mulcahy (Los Angeles: Warner Brothers, 1991), with performances by Denzel Washington, John Lithgow, and Ice-T.

90. Tyrese, *2000 Watts*, RCA Records, 2001.

91. Levi's advertisement, *The Big Issue*, Summer 1999, 20–21.

92. Community Redevelopment Agency of the City of Los Angeles, *Watts Redevelopment Project Biennial Report*, November 4, 1991, John Outterbridge Papers; William Fulton, *The Reluctant Metropolis: The Politics of Urban Growth in Los Angeles* (Baltimore: Johns Hopkins University Press, 1997), 297.

93. Daniel B. Wood. "Activists Build Culture from the Ground Up," *Christian Science Monitor*, June 8, 1992, 9.

94. Elizabeth Christine Lopez, *Community Arts Organizations in Los Angeles: A Study of the Social and Public Art Resource Center, Visual Communications and the Watts Towers Art Center* (PhD dissertation, UCLA, 1995), 49.

95. Matea Gold, "A New Watts Awaits Visit by President," *Los Angeles Times*, July 7, 1999, part A, sec. 1; Steve Schmidt, "Watts Shows off New Look / Tourists Invited to site of '65 Riots," *San Diego Union-Tribune*, August 29, 1999, A3; Paul Chavez. "Promises Linger in Watts: Despite Federal Pledge to Help, Area Still a Blight," *San Diego Union-Tribune*, November 4, 1999, A3.

96. Jennifer Kelleher, "In Watts, Towers Stand for Hope," *San Diego Union-Tribune*, September 27, 2001, E1.

97. Lewis Mumford, *The Culture of Cities* (San Diego: Harcourt Brace, 1938), 3–5.

Reading the Watts Towers, Teaching Los Angeles: Storytelling and Public Art MONICA BARRA

1. I quote this term as it is one used by many writers and scholars whose work is about revealing alternative histories of Los Angeles that focus on marginalized groups that are often forgotten in the shadows of the glamorous Hollywood trope of the city. See such works as Sawhney 2002.

2. This is a term borrowed from French urban sociologist Henri Lefebvre. It is used predominately in his seminal texts on the social dimensions of cities and urban life. See *The Social Production of Urban Space* ([1974] 1991), *Writings on Cities* (1996), and *The Urban Revolution* ([1970] 2003).

3. I am clearly invoking the work of Michel Foucault here. Although Foucault's work is not specifically mentioned in this chapter, some of his writings that have been central to these pieces are *Knowledge/Power* (1980) and *Language, Counter-Memory, Practice* (1976).

Spires and Towers Between Tangible, Intangible, and Contested Transnational Cultural Heritage KATIA BALLACCHINO

1. The project was part of the PhD course "Etnologia e Etnoantropologia," begun in 2005. My University of Rome "Sapienza" dissertation, entitled "La Festa migrante. Etnografia di una passione: I Gigli di Nola fra mutamento, dislocazioni e patrimonializzazione," was submitted in 2009.

2. For a general introduction to the feast, see the following contributions: Avella 1993; Manganelli 1973; Mazzacane 2000.

3. For only a few of the many publications on the Watts Towers, see Goldstone and Paquin Goldstone 1997; Greaves n.d.; Harris 2005; Hernández 2001; Madian 1968; Minar 1994; Ray 1985; Scambray 2001; Seewerker and Owens 1940; Ward 1986; Whiteson 1989; Hale 1952; Watts Towers of Simon Rodia 1983; Zelver and Lessac 1994.

4. Further, the name of Serino conveys the meaning of "clear," an adjective that refers to the pure water springs that occur within the area. Historically, and thanks to an aqueduct, the water that rises in Serino was transported to several places around Naples, including Nola. Even today you can see the name Serino on some of the antique fountains surviving from the late 1800s, a period in which Rodia still visited and when the relationship between the two villages could have been very strong due to economic ties. See Del Giudice, this volume.

5. The *maestro di festa* in Nola is the person who, together with his family (and after his selection via a long bureaucratic procedure, including requests to the town council),receives the honor and obligation to build a *Giglio* according to his own aesthetic tastes and who takes responsibility for the organization of the feast over a twelve-month period. The *maestro* must also economically sustain the numerous meetings and activities tied to the feast, a figure that today can run from 70,000 to 150,000 Euros.

6. The foundation myth to which the Nolans refer—to confer a mythical past to the feast—is full of contradictions and is historically unclear. San Gregorio Magno recounts a story that at the beginning of the fifth century, Bishop Ponzio Meropio Paolino (353–431 A.D.) freed Nolan prisoners from a people described only as "Barbarians" who had held them as slaves in Africa. Paolino was to be given as prisoner to the "barbarians" in return for the release of a widow's son, but thanks to his sanctity he won not only his own freedom but that of the other captured Nolans as well. Some sources sustain this thesis, while others admit that the place where Paolino was held prisoner along with the Nolans was not Africa but the coast of Calabria (referred to as "Africa" during the fifth century). In this case, the hostage taking took place in an Italian region rather than abroad, and the perpetrators were not dark-skinned Arab pirates but rather soldiers of Alarico's Goths returning from the sacking of Rome. It appears that the Arabs reached the coast around Nola only in the eighth century see Remondini 1747. For documents relating to these origins and to the feast in general, see (with due caution) Manganelli 1973. There are further references to the feast in Aglialoro [1971] 1996 and Battista 1973. See Ceparano, this volume.

7. The comparison that Whiteson (1989) proposes between Rodia's sermonizing tendencies and that of the celebrated Renaissance mystic Giordano Bruno seems improbable. Burned at the stake by the church for heresy, Bruno's birthplace, interestingly enough, was Nola.

8. I should state here that my knowledge of the subject is exclusively bibliographic as I have never carried out research on the Watts Towers.

9. See an emblematic contribution that traces an enormous variety of (some fantastic) possible interpretations of the history and meaning of Rodia's work, demonstrating how it may be seen as a versatile object with a multitude of evocative charges: Harris 2005.

10. There are many examples of modern architecture which, once monumentalized, become valued and therefore protagonists in the revaluation of the territory. An example is the famous *Kurfürstendamm*, or *ku'damm*, in Berlin, the main road of the ex-Western zone that faces another monument, *Gedächtniskirche* (church of memories), also known as "the rotten tooth"—a bombed-out cathedral left over from World War II and little more than a shell with remaining belltower. The church has been left in this state of ruin to value memory of the past. In the 1970s, a new modern church with a new belltower was constructed and was harshly criticized by many. An even more famous example is Berlin Wall, which divided the Eastern part of the city from the West in a tangible sign of the conflict between different social systems, and which has become a tourist site and a place of divergent memory and meaning. On the one hand, many individual monuments remember the victims of the division of Germany. On the other, the tracing of the borderline represents a unique monument in the history of Germany. And looking at Italy, we find an example of the monumentalization of industrial archaeology in the *Serpentone* of Corviale, on the outskirts of Rome, a symbol of degradation that the town council wants to declare a monument of modern architecture, in order to prevent its demolition. Finally, we may consider the case of the old brickworks in Testaccio as a revalued site that now hosts MACRO, a museum of contemporary art, as well as "the alternative economy city" and the social center Il Villaggio Globale.

11. For disputes over the cultural ownership of heritage, here mainly with reference to the case of Quebec City, see Handler 2000.

12. The platform is held up by two types of beam known as *varre or varritielli,* that 128 men called *cullatori* or *collatori,* together forming a *paranza* (crew), shoulder, carrying and dancing the machine.

13. Some data would lead us to think that the evolution of the structure was probably suggested by Ferdinando Sanfelice, an aristocratic architect who worked in Nola on the new church of Santa Chiara

in the first half of the seventeenth century and whose hobby was making scenery. He was known as *Lievat'a'sott* in local dialect, or "pull yourself out from under" due to the fact that the structures he proposed were extremely fragile and apparently destined to collapse.

14. Here I refer especially to the imposing Torre Belvedere di Sanfelice, constructed in 1740 in honor of the birth of the princess of Spain: we are speaking therefore of a civil feast celebrated with a *Giglio* decorated with secular designs; see Zampino 1997.

15. Another text was produced for the exhibition in the Palazzo Venezia, in Rome, about feasts in the Italian capital between 1570 and 1800: Fagiolo dell'Arco and Carandini 1977–78; Monaco 2003; For another example of the study of feast machines, specifically to those in *Cuccagna* Carnival celebrations, see Del Giudice 2001.

16. Other local literature exists that highlights the comparative possibilities with other machines used in Italian festive contexts; see, for example, Centro di Cultura del Molise 1997. This said, many of the machines described in these texts are different from the *Gigli* of Nola because they are fixed. An example is the mysterious feast machines of Molise about which Letizia Bindi has written. They are eighteenth-century machines conserved and reused each year for the feast of Corpus Domini. They are therefore unique artworks, probably not reproducible due to their particular and no longer used production techniques. See Bindi 2009.

17. In the baroque period, instead of using antique silver statues, copies were made with papier-mâché in order to preserve the originals. Therefore, paper was already being used and reused instead of the actual statue in the 1700s in order to save and protect the object of cult devotion.

18. On this note, the way contemporary artists such as Matta-Clark are seen is interesting. He produced ephemeral works, destined not to last very long, and often on buildings that are being demolished (and therefore, in some way, also being recycled). A reflection on the possibility of understanding and appreciating the meaning of this art through documentary films and photographs, as well as documenting works that might otherwise be lost, also becomes part of the artwork itself. This concept might be useful for a discussion of the hyper-reproducibility of the scenes of the *Festa dei Gigli* through the hundreds of photos and videos that have been created and those scenes that remain in Nolans' memories. In this way, the reproducibility of the *Giglio* image itself becomes an artwork and projection of the feast, perpetuated and indelibly fixed in time, and constantly visible, even when the *Giglio* is not materially present on the streets of the historic town.

19. In these cases, we are not dealing with specifically named *Gigli*, such as those of Nola, but with obelisks that are almost always constructed for ad hoc groups of *collatori* or for local dances from which they take their names. Some of the main towns where *Gigli* are danced are Barra (today at least seven *Gigli* are constructed, but in the past there were as many as twelve); Brusciano (at least six *gigli*); Casavatore (at least four); Crispano (at least four); Cimitile (at least two); and Mariglianella (at least two). Other towns where similar constructions are built include Recale di Caserta, San Giovanni a Teduccio, Ponticelli, Camposano, Villaricca, Casaluce, San Rocco, and Caivano and, more recently, Mondragone, Taurasi, and San Paolo Bel Sito. Within this list are towns that use a smaller *Giglio*, from 18 to 21 meters high (roughly equivalent to 54–63 feet).

20. Among the many testimonies gathered during these research years, I have heard many almost legendary stories of youngsters who have deliberately broken various bones (typically fingers) or done other damage to make themselves ill in order to get leave during military service and return to Nola for the feast. There are videos on YouTube showing how even while on duty abroad in Afghanistan or Germany, young soldiers or emigrants who are fond of the feast build a smaller *Giglio* copy and dance it to their own favorite feast music on their MP3s or mobile telephones. For the concept of "passion" in such cases, see Ballacchino 2011.

21. Avella is a local historian who has helped shed light on many aspects of the feast. Among his numerous works on the feast, see Avella 1989.

22. For example, in 1923, a *Giglio* accidentally split, but as the local news reports of the time narrate, it was made to dance equally well although mutilated. The Nolans' attachment to the feast has also resisted disasters and disgrace, as another photograph demonstrates, depicting the *Giglio* in all its monumental glory in front of the bombed-out ruins of the town hall (Avella 1989: pt. 1, 147)—perhaps another analogy with Rodia's Towers and the community of Watts. Yet another photograph represents a *Giglio* from 1937, decorated to look like Mussolini, giving the obelisk political connotations of the

period. But over and above the political elements in the *Gigli,* they are decorated with banners and photographs of deceased friends and relatives, life stories, religious messages, or the names of sponsors who have contributed to the feast.

23. Today, in the United States, the feast is celebrated each year in Williamsburg, a district of Brooklyn, New York, and in Harlem. Historically, it was also celebrated in other areas and organized by local associations. See the numerous contributions on this topic, including Posen 1986; Posen, Sciorra, and Cooper 1983; Primeggia and Primeggia 1983; Primeggia and Varacalli 1996; Sciorra 1985, 1989, 1999. Varacalli, Primeggia, LaGumina, D'Elia, 2004; and, more in general, see Sponsler 2004.

24. In the 1950s, the neighborhood church adopted the *Giglio* feast and almost completely took overcontrol in managing it, and unlike the *Gigli* in Nola, it became the only one to actually make money on the feast.

25. A recent proposal by the feast of Nola committee regards the modeling of the architecture in the historic town center, based on the route taken by the *Gigli* during the feast. For another level of analysis focusing on the body, see Ballacchino 2011.

26. On this note, *Giglio* tattoos that Americans (almost none of whom are of Nolan origin) display on their bodies all year round are emblematic.

27. This procedure is common to many Italian feasts celebrated in the United States in which the regional or municipal origins of the participants become progressively less important. In recent years, I have also studied a Sicilian pilgrimage repeated in America, with hundreds of participants, all of whom originate in the same Sicilian town where the ritual itself has its origins: the pilgrimage of the *Nuri* to San Sebastiano di Melilli, recreated in Middletown, Connecticut. This is an interesting exception to which I continue to devote attention.

28. This happens according to a process that reminds us, among other things, of the devotion to the Madonna of Mount Carmel in East Harlem studied by Orsi. Orsi demonstrates that the feast of Our Lady of Mount Carmel, celebrated only in 1881 by immigrants from the village of Polla (Salerno), went on by the end of the 1800s to include not only the Italian community of East Harlem and its surrounding boroughs as a whole but came to include Haitians in the 1880s, underlining how the feast of Mount Carmel represented a mode of inclusion (see Orsi 2002).

29. Sciorra has written about themes relative to the dynamics of social inclusion and exclusion of Italian migrants, reflecting on the dynamic process of the identity construction of a new ethnicity involving "Italian American."

30. For example, some images can be seen of a *Giglio* constructed in accordance with all structural rules on Second Life, one of the most avant-garde virtual worlds on the Internet today. Even in a parallel and virtual world, a *Giglio* is needed to complete the island known as Napoli (Naples).

31. Las Fallas are tens of large, fixed structures, made from wood, papier-mâché, and polystyrene, found all over the city of Valencia. They depict various scenes of contemporary society and are destroyed in a bonfire each year, to be rebuilt anew the following.

32. These events are part of the European Festival *Sete Soìs Sete Luas,* organized by an association that is interested in street art and had chosen the *Giglio* as the most spectacular machine and made the dancing *Giglio* a guest of honor at events organized with Portuguese and Spanish institutions.

33. See Dal Lago and Giordano 2008. In some ways, these authors also look at the phenomenon of the Watts Towers as an "extraordinary performance" and Simon Rodia as a "mobile" artist, due to his being a migrant, and they place his work within the history of nineteenth-century architecture, following on Zevi's work, and against all of those who had dismissed it as mere extravagance. See Zevi 2004.

34. UNESCO proposed a new convention regarding so-called intangible heritage in 2003. It was ratified in Italy only in 2007. For terminological and conceptual problems tied to the Italian translation of the convention, see Mariotti 2008; and Cirese 2002, a text that proposes the value of the volatility of heritage due to its temporary nature. For a critical approach to UNESCO's logic regarding intangible heritage, see, for example, Bortolotto 2008; and Kurin 2004; Produrre culture ai tempi dell'Unesco 2011. I should state that the United States was not a member of UNESCO between 1984 and 2003. In reality, however, the consolidated migration of the *Giglio* in the North American context is an element that contributes to making the feast more interesting, from a scientific point of view, due to its intensity and secularization, and may help in respecting one of the new criteria of the UNESCO 2003 convention,

which, as Bortolotto notes, tends to favor an idea of heritage tied to cultural practices and processes transmitted from the *community* and not just from the *territory*.

35. The slow process of becoming aware of the existence of many categories for different types of tangible cultural heritage (but not only tangible), due in part to advancing globalization, which for UNESCO represents a threat to cultural diversity and against which local identity must be claimed, has pushed UNESCO to reformulate the concept of heritage (cf. criticism from Eastern countries such as Japan that want a convention that is distanced from the static, monumental, and conservative trend of the 1972 convention). The old paradigm promoting a museum and archival approach should be slowly substituted by a movement toward the *transmission* and not only the *conservation* of heritage. UNESCO approved the Convention for the Safeguarding of "Intangible Cultural Heritage" at the Thirty-Second General Conference in Paris in 2003.

36. This event was organized by the anthropologist Paolo Apolito, who at the time was president of the *Commissione scientifica per la valorizzazione delle tradizioni* (Institution of the Ex-Vice-President of the Italian Ministries, as well as the Ministry for Heritage and Cultural Activity).

37. The event was part of a two-day national program on September 29 and 30, 2007, dedicated to the Italian ratification of the UNESCO convention for intangible heritage.

38. Today, the Sardinian *canto a tenore* and the Sicilian *teatro dei pupi* are the only two examples of Italian heritage that have obtained UNESCO recognition as "masterpieces of humanity." Today, however, UNESCO candidatures for traditions seem to be everywhere in Italy and beyond, creating interesting changes in local cultural politics but also in the heritage practices themselves.

39. For modern art as postindustrial or postmodern, using the notion of recycling of "the distant other" in a union of the common, the industrial, and through constant movement through hybridization in modern art, see Amselle 2007.

40. There are many Nolan expressions linked to the feast and its metaphoric *greatness*. It is the language itself that is *giglio*-ized. For example, "votà tutto a festa dei gigli" (everything is transformed into the Gigli feast), meaning that everything done or said during the year must be transformed into a *giglio* and therefore must take its form (literal or linguistic), "as if" the *giglio* already existed.

41. For contributions on the European debate regarding the relationship between monuments and culture, see Fabre 2000, 2006; Handler 2000; Isnenghi 1996–97; Lombardi Satriani 1999; Palumbo 2003.

42. More generally, the valorization of cultural dynamics as though they were objects of patrimony entails changes in the management of such cultural goods, both on the political and community levels. Among the greatest innovations due to the introduction of the concept of intangible heritage are the passage from the conservative idea of "protection" of heritage, to "safeguarding," to the reelaboration and negotiation of culture. On the linking of heritage to community rather than to territory, the decline in the presupposed ethnocentric concept of "authenticity," and of "exceptional universal value,"see Bortolotto 2008: 148, note 9.

Artists in Conversation

1. Rogelio Acevedo is Education Coordinator at the Watts Towers Arts Center.

Afterword: Personal Reflections on the Watts Towers Common
Ground Initiative LUISA DEL GIUDICE

1. We have noted elsewhere that Rodia did not likely marry a second and third time, after being officially married to Lucy, but rather lived in common law arrangements with Benita and then Carmen. See: Appendix C.2, Interview with Brad Byer.

2. As Lucille Krasne, the first art teacher at the Watts Towers Arts Center, attests: "I armed them [the children] with paint brushes and pots of paint and let them go." She then recalled how suddenly she had help in the project in the person of Leo Politi: "Here was this quiet little man standing there and he said, 'I'll help you!', and he did. . . . Mr. Politi's flowers on the front wall are alive with color and his painted birds are multi-hued and full-throated, as if they are about to burst into song" (in Bryan 1967).

Politi often visited the Towers and was personally inspired by Rodia's work, so inspired that he, too, tried his hand at mosaic work in his own garden (personal communication, Paul Politi, 2004).

3. In my own experience and understanding, the process of deep listening and social action are circularly linked (see Del Giudice 2009). Good listening leads to responsible social engagement, allowing us to give what is actually needed in a way that supports local action. Therefore, as a result of the Politi exhibition-related encounters, I determined that extended and focused interviews with key players in the Watts Towers "project" might increase my own understanding of the campus, its communities, and their goals. See Appendix C, In Their Own Words: Interviews with Jeanne S. Morgan, Brad Byer, Edward Landler, and Rosie Lee Hooks.

4. Beginning in 2004 with my attendance at a Beijing Circles national meeting in New York, held in conjunction with the UN Commission on the Status of Women's international meeting, I have been actively involved with the Beijing Circles process. Beijing Circles focus on Millennium Development Goals, as they disproportionately affect women, in issues that include education, economic development, health, infectious diseases, and child mortality. A key and often-repeated narrative revolves around "sweeping at your feet" as told by a Tanzanian woman. When a Western woman, overwhelmed by the daunting reality of Africa's pressing problems, asked her African sisters how she could help, the Tanzanian woman answered with a personal story: As a young girl, confronted with the task her mother had set before her of cleaning the entire hut, and not knowing how to manage it, she was told by her mother to "start sweeping at your feet!" I took this parable to mean two things: Start in your own community, and start small. With other concerned friends in the Saint Alban's Westwood Interfaith Beijing Circle, we had been considering ways of addressing many urgent problems in our own "backyard" (Los Angeles). Our Los Angeles Beijing Circle came to a close on December 2, 2013.

5. I was invited to the Istituto Italiano di Cultura by Clara Celati, along with many others, to begin exploring the idea of a University of Genova conference on the Watts Towers, which Alessandro Dal Lago and Serena Giordano wished to host. That conference was organized by Dal Lago (chair), Giordano, Thomas Harrison, and me. It was the first of a two-stage conference initiative. The second responded to the UCLA International Institute's encouragement (and partial funding) to produce a conference in Los Angeles.

Appendix A.1, Interview of S. Rodia, with William Hale and Ray Wisniewsky, 1953

1. That is, you've got to know what hunger is before you can understand some things.

2. Guglielmo Marconi (April 25, 1874–July 20, 1937), Italian inventor, known as the "father of long distance radio and for his development of Marconi's law and a radio telegraph system. Marconi is often credited as the inventor of radio, and indeed he shared the 1909 Nobel Prize in Physics with Karl Ferdinand Braun in recognition of their contributions to the development of wireless telegraphy." (http://en.wikipedia.org/wiki/GuglielmoMarconi accessed September 9, 2011).

3. Machine, from the Italian *macchina* (car)

4. He is likely referring to the *Encyclopedia Britannica*.

5. This term seems to allude to the distinction Italians make between *furbi* (the sly, the clever) and *fessi* (fools). The man who is *furbo* is sometimes admired, as he who can hoodwink the less clever. Sam Calicura (Saverio Colarcurcio) considered himself a *furbo*, without using this term (see Appendix A.6, Claudio Segre Letter to the CSRTW).

6. Interference from Italian, where the verb *scopare* "to sweep" is derived from the noun for "broom" *scopa*. Hence scopa > scopare; broom > brooming.

7. There is some confusion here: the tallest mountains (all under 30,000 ft., all in the Himalayas) which border China are: Mountain Everest, K2, Lhotse, Makalu, Cho Oyu.

Appendix A.2, Interview with Simon Rodia by William Hale and Ray Wisniewsky, at the Towers Site, Standing Outside Rodia's House, 1953

1. The Los Angeles City Hall, now an LA Historic-Cultural Monument, was dedicated on April 26, 1928.

2. Likely the Dickeyville Grotto and Shrines erected on Holy Ghost Parish grounds, the work of Matthias Wernerus, Catholic priest of the Parish from 1918 to 1931. "His handiwork in stone, built from 1925–1930, is dedicated to the unity of two great American ideals-love of God and love of Country. These religious and patriotic shrines were constructed without the use of blueprints." (http://dickeyvil legrotto.com/ accessed December 10, 2013. It is probably this job to which Rodia refers in A.1. " Hypocrisy" where the priest would not pay his worker, invoking the greater glory of god.

Appendix A.4, Interviews, Part A, B, with S. Rodia, by Ed Farrell, Jody Farrell, Bud Goldstone, Seymour Rosen, Martinez and University of California, Berkeley

1. Perhaps: Port Phillip, Nova Scotia, Canada

Appendix A.6, Letter to the CSRTW, by Claudio Segre [Segrè], Re: Visit with Rodia in Martinez, California, January 25, 1962

1. Rodia seems to be using Spanish (*corrompido* from *corromper*) in this instance, rather than an incorrect form of Italian (*corrotto* from *corrompere*). Or at least this demonstrates interference of Spanish with Italian in Rodia's mind, as a kindred Romance language.

2. The Spanish Colonial Revival home built in 1931 was designed by William Mooser, and is located at 11725 Sunset Blvd., in Brentwood.

3. Rodia has a poor sense of local geography, perhaps because he had little occasion to travel as a young boy growing up in Rivottoli di Serino, or did not travel far. The distance from Serino to Rome is 270 km.

4. Samuel William Yorty (October 1, 1909–June 5, 1998) was the thirty-seventh mayor of Los Angeles through the turbulent years 1961–1973 (http://en.wikipedia.org/wiki/Sam_Yorty; accessed September 28, 2011).

5. Claudio G. Segre [Segrè](1937–1995) was a journalist, professor of modern European history, and expert on Italian Fascism. He was the son of Emilio Segre, a Nobel Prize-winning physicist and disciple of Enrico Fermi, who fled Italy on the eve of the Fascist (anti-Semitic) racial laws of 1938. See his obituary of May 30, 1995 (http://www.sfgate.com/news/article/OBITUARY-Claudio-G-Segre-3031506.php #ixzz25Z1IDcjl, accessed September 4, 2012).

Appendix A.7, *"New Yorker* Reporter [Calvin Trillin] Visits Rodia"

1. Perhaps, Bufano intended: "Sam is a better man than you are." In popular Italian, *cristiano* is a generic term for "human being."

Appendix A.8, Conversations with Rodia, Report by Jeanne Morgan, September 10, 1964

1. See Introduction, this volume, note 4.

2. The Panama–California Exposition was held in San Diego, California (Balboa Park), between March 9, 1915, and January 1, 1917. It was designed by Bertrand Goodhue and (later) Carlton Winslow in an ornate Spanish Baroque style. "Taken together, they [buildings] comprised something like a recapitulated history of Spanish colonial in North America, from Renaissance Europe sources, to Spanish colonial, to Mexican Baroque, to the vernacular styles adopted by the Franciscan missions up the California coast." Rodia is likely referring to the domed-and-towered California State Building. (http://en.wikipedia.org/wiki /Panama%E2%80%93California_Exposition. Accessed Dec. 12, 2013)

Appendix A.10, Interview with S. Rodia, by Norma Ashley-David, 1964(?)

1. Rodia believed his birthday to be April 15 (probably 1875, not February 12, 1879, as is stated on his birth record) and says he was fourteen when he arrived in America (see Del Giudice, this volume). Therefore, this interview takes place in March [1964?].

2. The following exchange with Johnny confirms an indulgent "Uncle Sam," who greatly enjoyed children.

3. Note that the day before Rodia says that he is eighty-nine (about to turn ninety). The following day he states he is ninety or ninety-one. Rodia seems to oscillate on his own age. See Introduction, note 4, on Italian custom of calculating age and the confusion surrounding his date of birth.

4. This passage had been edited out of the original transcription, likely because the topic did not interest the transcriber. I have here included this interesting and telling exchange on foodways because it reveals important Italian cultural information about the man. The fact that Rodia purchased good-quality olive oil and tomato paste confirms that he was still attached to Italian food practices to the end of his life. He likely purchased these from his nephew, Leonard Sullivan's grocery story in Martinez. It is also likely that while in Los Angeles, he also paid attention to the quality of food and frequented Italian grocers—and hence neighborhoods—perhaps in downtown Los Angeles, or San Pedro, where there was a significant number of Italian merchants.

5. This extraordinary number seems to mimic the review of a dowry or *corredo* inventory in Italian tradition. He clearly stockpiled clothing and food supplies.

6. Rodia may be referring to the noted and largest lynching of eleven Italians in New Orleans 1891. Three such lynchings occurred in Louisiana, while three others occurred in Colorado (1893 and 1895) and West Virginia (1891). But it is unclear what similar event might have taken place in Boston.

Appendix A.11, Interview (Excerpts) with Rodia's Neighbors ("Pete Scanlon's in-laws"), by Bud Goldstone, Long Beach, California, 1963

1. Rodia's first marriage to Lucy Ucci ended in 1910. There is some debate about whether this second "marriage" (and his third) were actually official or common law arrangements (see C.2 Byer interview).

2. Rodia's Long Beach neighbor here confirms Rodia's link to the Italian community and to a "club" –perhaps the (mutual aid) Garibaldina M.B. Society (Società Garibaldina di Mutua Beneficenza, est. 1877) in Los Angeles, or an association closer to Long Beach or San Pedro.

3. Baldassare Forestieri and his Underground Gardens, see Scambray, this volume.

Appendix A.12, Interview with S. Rodia, by Nicholas King, Martinez, California, September, 1960

1. In the next sentence (and later in the interview as well) Rodia mentions that the general's name was General Miller. We presume is talking about the same man and merely used the wrong name here.

2. He is likely talking about his second "wife." See A.11 and C.2 for a discussion on his two common law marriages with Mexican American women, Benita and Carmen.

3. The 2006 Landler and Byer film, *I Build The Tower,* derives from these poignant words of Rodia. Its theme song, written by jazz musician/composer, Nate Morgan (d. November 21, 2013), repeats this phrase as a leitmotif.

Contributors

Augustine Aguirre, a former building contractor, has practiced art since 1982, beginning with copper wire sculpture and later pursuing vivid color and solid form. Several collaborative canvases were enclosed in a millennium time capsule in 2001. He is one of the WTAC-based participants in the "Trading Dirt Happening," and has participated in an exhibition at Plaza Mexico, where some of his work was auctioned to benefit underprivileged children in Mexico—combining his passion for art and family. He credits his inspiration as an artist to his mother Beatrice Aguirre, quiltmaker; to Pablo Picasso; Michelangelo Buonarotti; Vincent van Gogh; and to local, world-renowned sculptor, Kenzi Shiokava.

Katia Ballacchino obtained her PhD in ethnology and ethno-anthropology from the University 'Sapienza' of Rome. She is currently working on post-doctoral research and is adjunct professor at the University of Molise, collaborating with the University Suor Orsola Benincasa of Naples and the University 'Sapienza' of Rome. Her main research topics are: Popular Traditions and Intangible Cultural Heritage in the Center and South of Italy; Visual Ethnography; Migration; Social and Cultural Mediation and Human Rights. She is the author of several publications on these topics.

Monica Barra is a doctoral student in cultural anthropology at the CUNY Graduate Center in New York City, where her research and work focuses on relations between the social and cultural production of urban built environments, aesthetics and arts praxis, and the afterlives of outmoded urban infrastructures in U.S. cities.

Guglielmo Bilancioni is professor of history of architecture at University of Genova, Italy. He has published books on Behrens, Lauweriks, and Portaluppi. A collection of his essays, *Spirito Fantastico e Architettura Moderna*, was published by Pendragon Press in Bologna. For Pendragon he directs the architectural series Tecnica e Tradizione. He is currently researching Buddhist architecture.

Gail Brown, is an artist and founding director of *From Where I'm Standing* photo-documentary workshops. The workshop has been exhibited throughout Southern California; featured in the *Los Angeles Times* and the *Pasadena Weekly*; and televised on KCET's *California Connected*. Brown was artist-in-residence at Watts Towers Arts Center from 2005 to 2013, and teaches in the art and photography departments at Los Angeles City College. Brown's photographs have been widely exhibited in venues on the east and west coasts, including the National Museum for Women in the Arts, Washington, D.C., the Los Angeles Central Library, The Huntington, and Armory Center for the Arts.

Brad Byer was the maternal great-nephew of Sam Rodia. He received a Bachelor's degree in English from the University of California at Davis and worked as a writer and editor for the U.S. Forest Service in Northern California. After viewing the Watts Towers, he began documenting Sam Rodia's life and relocated to Southern California to make *I Build the Tower* (with Edward Landler). While working on the film, he operated his own home and office moving business. He died November 15, 2012 at the age of 58.

Richard Cándida Smith is professor of history at the University of California, Berkeley, where he teaches intellectual and cultural history of the United States. His books have explored the social position of the fine arts in modern, liberal societies, often with a focus on California, as with *Utopia and Dissent: Art, Poetry, and Politics in California* (1995) and *The Modern Moves West: California*

Artists and Democratic Culture in the Twentieth Century (2009). He is currently working on a book on inter-American cultural markets and debates on "American" identity.

Felice Ceparano has been an ethnographer since 1982 (a student of Franco Fontana and Ermanno Olmi), currently directs the Ethnomusicological Museum of the Gigli of Nola (Museo Etnomusicale I Gigli di Nola). He initiated and coordinated the UNESCO candidacy of the Gigli of Nola feast in 2001, 2003, and 2005. He collaborates with the Sound Archives of Neapolitan Song (Archivio Sonoro della Canzone Napoletana) and has been a guest on several national radio programs on Rai Uno and Rai Tre. He has edited several volumes and produced films on the Gigli of Nola and traditional music in Campania, among which is *Itinerari della Tammorra* (with the Politecnico of Milan, 2004).

Luisa Del Giudice is an independent scholar, former university academic (University of California Los Angeles, Addis Ababa University, Ethiopia), public sector educator (Founder-Director of the Italian Oral History Institute), and community activist. She has published and lectured widely on Italian and Italian American and Canadian folklife, ethnology, and oral history, and has produced many innovative public programs on Italian, Mediterranean, regional, and folk culture, and local history in Los Angeles. In 2008 she was named an honorary fellow of the American Folklore Society and knighted by the Italian Republic. She is the coordinator of the Watts Towers Common Ground Initiative.

Charles Dickson has been an award-winning multimedia sculptor for fifty years, consumed by how things work "in a mechanical, creative, spiritual and political contest," exploring the nature of materials, challenging their properties, to understand the truth of their essence. His work with Black Nudes led to an artistic dialogue on the politics and spiritual influence of indigenous beauty (and the consequences of slavery) in contemporary society. He is artist in residence at the Watts Towers Arts Center and caretaker for LACMA and the Watts Towers Monument. He is both an activist leader and mentor for community betterment.

George Epolito is a senior lecturer in architecture at the Manchester School of Architecture in the United Kingdom. His research explores the intersection of politics and culture with an emphasis on the innovative aesthetics produced by people who have been displaced to the social margins. His particular interest is in the cultural and sociopolitical contestations between people of African, Iberian, and Italian descent in Rió de la Plata Basin, and the hybridized cultural products that emerged from their methods of appropriation during the nineteenth and twentieth centuries. George holds a Master of Architecture degree from the Southern California Institute of Architecture in Los Angeles.

Paul A. Harris is professor of English at Loyola Marymount University, where he teaches courses on literary theory and interdisciplinary themes such as Wonder, Chaos, Time, and Nothing. Co-editor of the literary theory journal SubStance, he has published widely on philosophy, theory, and American literature, and writes constraint-based poetry that he performs with jazz musician David Ornette Cherry.

Thomas Harrison is professor and chair of the Department of Italian at the University of California Los Angeles. He is the author of *1910: The Emancipation of Dissonance* (1996) on European expressionism in literature, painting, music, and philosophy; and of *Essayism: Conrad, Musil and Pirandello* (1992). He has edited *Nietzsche in Italy* (1988) and *The Favorite Malice: Ontology and Reference in Contemporary Italian Poetry* (1983).

Shirmel Hayden currently lives in Southern California and is the associate director of the Social Justice Learning Institute; part-time facilitator at the University of Phoenix; and is currently working on completing her Ph.D in Public Policy and Administration with a focus on Nonprofit Leadership and Management from Walden University. In her spare time she enjoys reading, traveling, cooking, and gardening.

Jo Farb Hernández, director of the nonprofit archives SPACES (Saving and Preserving Arts and Cultural Environments) is also director of the Art Gallery and professor at San José State University. She is a contributing editor for Raw Vision; a member of the Editorial Board for the International Journal of Self-Taught and Outsider Art; and serves on advisory boards for several art environments. She has authored or co-authored over thirty award-winning books and catalogues, and received a 2008 Fulbright Senior Scholar award to research Spanish art environments. The resulting book, *Singular Spaces: From the Eccentric to the Extraordinary in Spanish Art Environments*, was published by Raw Vision in 2013.

Jeffrey Herr is curator and preservation specialist for the City of Los Angeles's Department of Cultural Affairs and is responsible for the care of Simon Rodia's Towers in Watts and Frank Lloyd Wright's Hollyhock House. He has organized exhibitions for the Los Angeles Municipal Arts Gallery at Barnsdall Park where he lectured and also advised private collectors. The editor of *Landmark L.A.: Historic-Cultural Monuments of Los Angeles*, Mr. Herr also serves on the board of the American Friends of the Attingham Summer School, an educational organization for the study of the British country house.

Rosie Lee Hooks, a twenty-year employee of the City of Los Angeles Department of Cultural Affairs, is Director of the Watts Towers Arts Center Campus, which includes the ninety-two-year-old Watts Towers of Simon Rodia, the fifty-two-year-old Watts Towers Arts Center, the Charles Mingus Youth Arts Center, Arts & Museum Education Programs, Watts Towers Tour Program, and Curator of Exhibitions. While working at the Smithsonian Institution, she traveled under "Official Passport" as Diplomatic Liaison to countries in the Caribbean, South America, and Africa, delivering government-to-government invitations from the United States to the Ministries of Culture in those nations. She is also an award-winning actor of forty years.

Edward Landler is an independent filmmaker and media educator. He made "I Build the Tower" in collaboration with Brad Byer. Graduating from Yale with a B.A. in Literature and Film, his training includes experience with Satyajit Ray in India and Luis Bun?uel in France. He is a founder of the Independent Feature Project/L.A. (now Film Independent), a filmmakers' support organization, and has taught at California State University, Northridge, U.C.L.A. Extension, and Woodbury University. He is a regular contributor to *CineMontage*, the magazine of the Motion Picture Editors Guild. A presence in Watts for over thirty years, he serves on the boards of two community organizations based at the Watts Towers Arts Center.

Jeanne S. Morgan MFA (from Otis Art Institute) is an artist-journalist. She is a charter member of the Committee for Simon Rodia's Towers in Watts, founded in 1958 with 50 members, of whom only four survive; and served on the CSRTW board intermittently through five decades, contributing critical policies. She was board chair from 1978 to 2012 and her letters on the Towers have appeared in the *Los Angeles Times* since 1965. She visited with Rodia from 1960 to 1965, and published on the Towers in *Personal Places, Perspectives on Informal Art Environments*, edited by Daniel Franklin Ward, 1984.

John W. Outterbridge directed the Watts Towers Arts Center from 1975 to 1992, and created both the Watts Towers Day of the Drum Festival and the Simon Rodia Watts Towers Jazz Festival. An established artist and mentor when he accepted his post, he brought a deep commitment to the art community he served, and continues to be significant to it in his retirement. In June 2002, his name was forever linked to the Center when the John Outterbridge Plaza was dedicated near the Watts Towers Amphitheatre. He is considered one of Los Angeles's most significant artists and his story forms an indelible part of the history of American Art.

R. Judson Powell is a native of Philadelphia who migrated to Los Angeles in 1958. In April of 1964 he was one of the three artists who established the "Teen Post" program that opened the Watts Towers Arts Center. He eventually moved on to become the Deputy Director of the Compton Community Action Agency and developed the Communicative ARTS Academy in the City of Compton that survived until the early 1980s. Powell continues to be involved in multiple community groups and exhibitions in South Central Los Angeles.

Laura E. Ruberto is a professor in the Humanities Program and co-chairs the Department of Arts and Cultural Studies at Berkeley City College. She authored *Gramsci, Migration, and the Representation of Women's Work in Italy and the U.S.*; co-edited *Italian Neorealism and Global Cinema*, and translated *Such Is Life, Ma la vita è fatta così: A Memoir*. Her research has been supported by a Fulbright Faculty Research grant and an NEH summer grant. She co-edits the book series Critical Studies in Italian America (Fordham University Press) and is the Film and Digital Media Review Editor for the *Italian American Review.*

Betye Saar as an assemblage artist was partly inspired by Rodia's Watts Towers, which she witnessed being built in her childhood. She typically arranges found objects drawn from her own mixed heritage (African, Native American, and Irish) within boxes or windows. She has transformed African-American stereotypes into political statements; explored African ritual and tribal objects; assembled shrine-like family memorabilia; and created monumental Vodou-inspired shrines combining technology with mystical amulets. She has been part of the black arts movement since the 1970s and continues to challenge myths, stereotypes, and negative ideas of African Americans.

Kenneth Scambray is professor of English at the University of La Verne. His published works include *A Varied Harvest: The Life and Works of Henry Blake Fuller* (University of Pittsburgh Press, 1987); *The North American Italian Renaissance: Italian Writing in America and Canada* (Guernica, 2000); *Surface Roots: Stories* (Guernica, 2004); and *Queen Calafia's Paradise: California and the Italian American Novel* (Fairleigh Dickinson Univ. Press, 2007). His essay on the Watts Towers and the Underground Gardens appeared in *Italian Folk*, ed. by Joseph Sciorra (Fordham University Press, 2011). His poetry and fiction have appeared in national journals.

Sarah Schrank is professor of history at California State University, Long Beach, and the author of *Art and the City: Civic Imagination and Cultural Authority in Los Angeles* (University of Pennsylvania Press, 2009). She has written extensively on the relationship of modernism to urban life in the United States and is currently writing a new book on popular environmentalism and changing concepts of the natural body.

Joseph Sciorra is a director at Queens College's John D. Calandra Italian American Institute. He is the editor of the journal *Italian American Review* and the book *Italian Folk: Vernacular Culture in Italian-American Lives* (Fordham University Press, 2011); co-editor of *Embroidered Stories: Inter-*

preting Women's Domestic Needlework from the Italian Diaspora (2014) and *Graces Received: Painted and Metal Ex-votos from Italy* (2012); and author of *R.I.P.: Memorial Wall Art* (1994; 2002).

Kenzi Shiokava, a sculptor, is inspired by archaeology which "makes the mind wonder and brings . . . emotion . . . understanding, and an indelible mystery of presence." In the essence of his materials he uncovers the physical and spiritual traces of the process of history, together with the potential of presence. He uses discarded wood, railroad ties, telephone poles, beams, and other wood shaped by the elements, working with their natural qualities and vitalities. Final form is achieved not through preconception but rather through interaction with the medium's own natural life history, and executed using only hand tools. As a humanist his art evolved from spirituality and is rooted in freedom of spirit.

Index

NOTE: Page numbers followed by *f* indicate a figure.